Opening Up Middle English
Manuscripts

Opening Up Middle English Manuscripts

Literary and Visual Approaches

Kathryn Kerby-Fulton,

Maidie Hilmo, and

Linda Olson

Cornell University Press

Ithaca and London

Title page art adapted from the opening folio of ND MS 67 ("Mirror for Devout People").
Reproduced by kind permission from the original held by the Department of
Special Collections of the University Libraries of Notre Dame.

Publication of this volume was made possible in part through the kind support of the
College of Arts and Letters, University of Notre Dame.

First published 2012 by Cornell University Press
First printing, Cornell Paperbacks, 2012

Printed in China
Design, composition, and art production by BW&A Books, Inc.

Excerpt from "Marginalia" from *Picnic, Lightning* by Billy Collins © 1998.
Reprinted by permission of the University of Pittsburgh Press.

Library of Congress Cataloging-in-Publication Data
Kerby-Fulton, Kathryn.
Opening up Middle English manuscripts : literary and visual approaches /
Kathryn Kerby-Fulton, Linda Olson and Maidie Hilmo.
p. cm.
Includes bibliographical references and index.
ISBN 978-0-8014-5053-2 (cloth : alk. paper)
ISBN 978-0-8014-7830-7 (pbk. : alk. paper)
1. Manuscripts, English (Middle) 2. Manuscripts, Medieval—England.
3. English literature—Middle English, 1100–1500—Manuscripts.
4. Paleography, English. I. Olson, Linda, 1962–
II. Hilmo, Maidie, 1942– III. Title.
Z106.5.G7K47 2012
091—dc23
2012008006

Cloth printing 10 9 8 7 6 5 4 3 2 1
Paperback printing 10 9 8 7 6 5 4 3 2 1

To our families
without whose inspiration, love, and support
this project, many years in the making,
would not have been possible

Contents

Illustrations

Illustration credits appear on page 373.

CHAPTER 4. Professional Readers at Work

Preface

The Essay That Started a Field

It is not often that we can pinpoint the moment a new field begins to blossom, but in 1978 two scholars of Middle English paleography published an article with implications that would make Middle English manuscript studies mandatory for the larger literary world. In that year, A. I. Doyle and M. B. Parkes published "The Production of Copies of the *Canterbury Tales* and the *Confessio Amantis* in the Early Fifteenth Century." Coauthorship, still not often practiced in the humanities, allowed them to see what likely neither of them could have seen alone: that among the five scribes who copied Cambridge, Trinity College, MS R.3.2 (hereafter, the Trinity Gower) in apparently prearranged pieces or stints, three were known elsewhere as prolific copyists of Middle English texts (Scribes B, D, and E; see front plates 4, 5, and 7). Moreover, no certain signs of supervision were evident in the manuscript, and disconnections strongly suggested that the scribes were not working together at one site. With the arrival of this single essay, long-held scholarly assumptions of commercial bookshops and vigilant supervision of working scribes crumbled on the spot. Since Middle English book production was still a relatively small, even niche, market circa 1400, these hands, already well known in that niche, working together on this particular project had to be more than coincidence. Suddenly we knew that scribes of Chaucer and Langland worked together (two poets whose audiences had been assumed by New Critical scholarship to be mutually exclusive); that, indeed, one man could copy both and Gower, too (Doyle and Parkes knew that their fourth scribe, Scribe D, had copied all three poets in the course of his career). Their second scribe, Scribe B, was already known as the copyist of the two most important extant *Canterbury Tales* manuscripts, Aberystwyth, National Library of Wales, Peniarth MS 392D (known as the Hengwrt MS) and San Marino, Huntington Library, MS EL 26 C9 (known as the Ellesmere MS). Moreover, Thomas Hoccleve himself, disciple of Chaucer and chief representative of the next generation of Middle English poets, deigned to copy alongside these scribes as E, albeit fleetingly.

Doyle and Parkes's article, as revolutionary as it was and remains, is still really read only by specialists in codicology today. Many other articles and books of great importance have been published in Middle English codicology

both before and especially after this landmark (see especially the materials listed below, including those identifying some of Doyle and Parkes' scribes), but almost none of these reaches beyond a codicological readership today. The reasons are not far to seek: the language is specialized; the scholarship is buried in specialist journals or publications; manuscripts are geographically difficult of access; moreover, trends in literary theory at the end of the twentieth century too often relegated this kind of work to the dustbin of positivism without stopping to ask what it could contribute to interpretation. Times have changed. And even geographical distances are being minimized as digital images of entire collections of manuscripts are mushrooming on the web. This book hopes to help make Middle English manuscript studies accessible to a wider audience by combining an introduction to its basic techniques with serious literary and cultural analysis.

How to Use this Book

There are three things one should know about this book. First, it is an *introduction* to manuscript studies in Middle English, not a *survey*. Our goal has been to use examples that typify what can be done with manuscript studies, not encompass it. Second, we have mainly chosen to highlight literary texts most often taught and the manuscripts that contain them. So, for instance, we focus heavily on the major Ricardian poets and women mystics, and we have consulted standard teaching anthologies in choosing shorter texts like lyrics or romances. Third, the book is written for *tiers* of readers. The glossary, the front plates, and the "Bare Essentials" entries throughout "How to Transcribe Middle English" and chapter 1 are meant to introduce readers who are new to concepts and terminology in manuscript studies (e.g., chapter 3 teaches how to approach illustrations in literary texts). Some of the chapters and sections, meanwhile, model detailed analysis of a single codex, such as Linda Olson's in-depth studies of key monastic manuscripts (chapter 6), where Middle English literature was read in relation to devotional works less known than the Ricardian poets. The range in the volume is quite deliberate and meant to accommodate the spectrum of readers now interested in Middle English manuscript studies, both new and advanced.

Manuscript studies is not paleography, though it uses paleography as a basic tool (much as, for instance, chemistry uses math). It is, rather, multidisciplinary, a mixture of codicology (the study of the whole codex), literary history, art history, textual criticism, dialect study, reception study, and the physical and social history of the book. Middle English manuscript studies, ideally, also illuminates and changes the literary analysis of texts, because it can shed light on how authors worked, what they seem to have cared about in the physical presentation of their writings, and what their first audiences cared about in the text's transmission. This book proceeds, then, often by in-depth analysis of selected manuscripts of the period's major authors and much-loved genres, not by surveys of every manuscript extant. The goal is to illuminate a manuscript, first by explaining its technicalities but ultimately also its literary or artistic achievements. This broad range in literary manuscript studies—from the technical to the artistically interpretive—is what makes it at once so challenging and so rich a field. It does require both specialized and interdisciplinary training, and our hope is that this book will open doors to the key concepts and methods for those new to the field, while at the same time offering some new insights into the manuscripts and texts discussed here for long-time codicologists, literary critics, and art historians.

Technical terms are defined in the glossary and printed in boldface throughout "How to Transcribe Middle English" and the glossary itself; fundamental methods and concepts (e.g., transcription, editing, dialect analysis) are introduced in the "Bare Essentials," sections that may be skipped over by more advanced readers. The "Note on Transcriptions and Transcription Symbols" explains in detail the standard principles of setting out transcriptions here. "How to Transcribe" and the front plates offer sample transcriptions and definitions of the scripts most commonly found in Middle English manuscripts between c. 1275 and 1540, together with brief commentary on the manuscript's history and typical features of decoration and layout (the kinds of things often not covered in straight paleography books).

For detailed paleography textbooks teaching Middle English transcription, the reader should consult Petti 1977, Rycraft 1973, Parkes 1979, Preston and Yeandle 1992, and Roberts 2005. These are listed below, along with sample recommendations for textbooks dealing with Latin manuscripts and their codicology. Also listed below are some classic items of background—and foreground—reading and the URLs of websites that are now revolutionizing and democratizing the field by making high-quality digital images of entire manuscripts available to the reader anywhere in the world. Items too recent for integration in this book are marked with an asterisk. They are testimony to the fast pace of this young field.

Kathryn Kerby-Fulton

ACCESSIBLE PALEOGRAPHICAL STUDIES
FOR MIDDLE ENGLISH SCHOLARS

Anthony G. Petti, *English Literary Hands from Chaucer to Dryden* (Cambridge, MA: Harvard University, 1977).

Ann Rycraft, *English Mediaeval Handwriting* (York, U.K.: Borthwick Institute, University of York, 1973).

Malcolm Parkes, *English Cursive Book Hands, 1250–1500* (London: Scolar Press, 1979). Includes Latin and French as well; introduces both *Anglicana formata* and Secretary hands.

Jean Preston and Laetitia Yeandle, *English Handwriting 1400–1650* (Binghamton, NY: Medieval and Renaissance Texts and Studies, 1992).

Jane Roberts, *Guide to Scripts Used in English Writing up to 1500* (London: British Library, 2005). Includes Old English as well.

GUIDES TO LATIN MANUSCRIPT STUDIES
AND PALEOGRAPHY

Raymond Clemens and Timothy Graham, *Introduction to Manuscript Studies* (Ithaca, NY: Cornell University Press, 2007). Beautifully illustrated introduction to the basics of physical codicology largely from Latin manuscripts.

Michelle P. Brown, *A Guide to Western Historical Scripts from Antiquity to 1600* (London: British Library, 1990).

IMPORTANT BACKGROUND READING

C. Paul Christianson, *A Directory of London Stationers and Book Artisans, 1300–1350* (New York: Bibliographical Society of America, 1990).

A. I. Doyle and M. B. Parkes, "The Production of Copies of the *Canterbury Tales* and the *Confessio Amantis* in the Early Fifteenth Century," *Medieval Scribes, Manuscripts and Libraries: Essays Presented to N.R. Ker*, ed. M. B. Parkes and Andrew G. Watson (London: Scolar Press, 1978), 163–212.

A. I. Doyle, "English Books in and out of Court from Edward III to Henry VI," in *English Court Culture in the Later Middle Ages*, ed. V. Scattergood and J. Sherborne (New York: St. Martin's Press, 1983), 163–81.

J. Griffiths and D. Pearsall, eds., *Book Production and Publishing in Britain, 1375-1475* (Cambridge: Cambridge University Press, 1989). A good general overview, full of now classic essays.

*Alexandra Gillespie and Daniel Wakelin, eds. *The Production of Books in England, 1350-1500*. Cambridge Studies in Palaeography and Codicology (Cambridge: Cambridge University Press, 2011). An updating of the Griffiths and Pearsall volume, though not available in time for use in the present study.

Simon Horobin and Jeremy Smith, *An Introduction to Middle English* (Edinburgh: Edinburgh University Press, 2002). A good general introduction to language and dialect.

Angus McIntosh, Michael L. Samuels, and Michael Benskin, *A Linguistic Atlas of Late Medieval English*, 5 vols. (Aberdeen: Aberdeen University Press, 1986–87). Invaluable for geographical mapping of dialect areas to locate manuscript production.

Charles Moorman, *Editing the Middle English Manuscript* (Jackson: University Press of Mississipppi, 1975).

Malcolm B. Parkes, "The Literacy of the Laity," in *Studies in the Communication, Presentation, and Dissemination of Manuscripts* (London: Aldus, 1991), 555–77.

Malcolm B. Parkes, "The Influence of the Concepts of *Ordinatio* and *Compilatio* on the Development of the Book," in *Medieval Learning and Literature: Essays Presented to R. W. Hunt*, ed. J. J. G. Alexander and M. T. Gibson (Oxford: Clarendon Press, 1976), 115–43.

Malcolm B. Parkes, *Pause and Effect: Punctuation in the West* (Berkeley: University of California Press, 1993).

Malcolm B. Parkes, *The Medieval Manuscripts of Keble College, Oxford: A Descriptive Catalogue* (London: Scolar Press, 1979). Considered a gold standard for manuscript descriptions.

INVALUABLE CATALOGUE WEBSITES

Catalogue of Digitized Medieval Manuscripts (site mounted by the Center for Medieval and Renaissance Studies at the University of California, Los Angeles)
 http://manuscripts.cmrs.ucla.edu/

British Library Catalogue of Medieval and Renaissance Illuminated Manuscripts
 http://www.bl.uk/catalogues/illuminatedmanuscripts/welcome.htm

British Library Catalogue of Manuscripts
 http://www.bl.uk/catalogues/manuscripts/INDEX.asp

Bodleian Library Online Catalogues of Western Manuscripts
 http://www.bodley.ox.ac.uk/dept/scwmss/wmss/online/

Hengwrt Chaucer Digital Facsimile, edited by Estelle Stubbs
 http://www.sd-editions.com/hengwrt/home.html

Corpus Christi College MS 198 (*Canterbury Tales*)
 http://image.ox.ac.uk/show?collection=corpus&manuscript=ms198

Corpus Christi College MS 201 (*Piers*)
 http://image.ox.ac.uk/show?collection=corpus&manuscript=ms201

Guide to Medieval and Renaissance Manuscripts in the Huntington Library (searchable by author index for Chaucer, Hoccleve, Gower, Lydgate, and other Middle English writers; by title index for *Piers Plowman*, and other works; by scribe index for John Shirley, Hoccleve, and others)
 http://sunsite3.berkeley.edu/hehweb/authors.html

Auchinleck Manuscript (site mounted by the National Library of Scotland, Edinburgh)
 http://www.nls.uk/auchinleck/

*Identification of the Scribes Responsible for Copying Major Works of Middle English Literature, website developed by Linne R. Mooney, Simon Horobin, and Estelle Stubbs, University of York, supported by the Arts and Humanities Research Council of the UK, 2007–11 (mounted October 3, 2011, so not available to the present authors)
 http://www.medievalscribes.com/

Acknowledgments

We would like to thank many different medievalists, librarians, and curators without whom this book would have been unthinkable. Derek Pearsall read most of the text in manuscript and made insightful recommendations for revision, as did two unidentified readers on behalf of Cornell University Press. Several other scholars have read specific chapters or sections and offered valuable assistance: Susanna Fein, Alastair Minnis, Stephen Partridge, Kenna Olsen, Melinda Nielsen, Nicole Eddy, and Sarah Baechle. Still others have offered helpful critique in response to oral versions of disparate sections: Tony Spearing, Barbara Newman, Paul Saenger, Felicity Riddy, and Mike Johnston. Nicole Eddy has been an unfailingly dedicated and enthusiastic research assistant, giving meticulous help with proofreading and a host of other things. Katie Bugyis, Theresa O'Byrne, Sarah Baechle, Karrie Fuller, and Andrew Klein have also been assiduous research assistants. Special thanks also are due to Gray Sutherland for his invaluable help in proofreading chapters 3 and 5. Mike Johnston actually taught chapters of the book while they were still in draft form to his graduate students at Purdue University, so we are grateful for his energetic support.

Other scholars and curators have patiently answered our questions about specific, thorny problems: Mary Robertson (Huntington Library), Paul Saenger (Newberry Library), Linne Mooney, Ralph Hanna, Jane Roberts, and Jacob Thaisen. Ray Clemens has been a great supporter of the prospect of our book appearing in tandem with his and Timothy Graham's, and we have been honored by his enthusiasm.

We would also like to thank our editor at Cornell University Press, Peter Potter, who has always been perceptive and supportive, helping us solve problems throughout the book's gestation. The College of Arts and Letters, University of Notre Dame, and the research account for The Notre Dame Professor of English chair (held by Kathryn Kerby-Fulton) provided a large subvention toward the reproduction of color images for this book and extensive funding for research assistants; we are extremely grateful for their unfailing generosity. Our copy editor, Karen Hwa, has helped us create consistency of reference across the text, challenging for such a book, all the more with three authors. Andrew Klein cheerfully took on the massive task of indexing.

We owe a great debt of gratitude to all the librarians who granted us reproduction rights of materials in their possession (all of which are credited in our list of illustrations on page ix and on page 373). But we owe an especially large debt to the librarians and their staff who waived their reproduction fees or substantially reduced them. In particular, we would like to thank: the British Library, the Bodleian Library, Lincoln Cathedral Library, the Rosenbach Museum and Library (Philadelphia), Longleat House Library (Warminster, UK), Cambridge University Library, Corpus Christi College Library (Oxford), Folger Shakespeare Library (Washington), Chetham's Library (Manchester), Durham Cathedral Library, Durham University Library, Huntington Library (San Marino, CA), Senate House Library, University of London, The Worshipful Company of Scriveners (London, UK), The City of London Corporation, London Metropolitan Archives, Koninklijke Bibliotheek (Den Haag, The Netherlands), Ushaw College (Durham, UK), University of Glasgow (Department of Special Collections), Trinity College Cambridge, Professor Toshiyuki Takamiya, Corpus Christi College (Cambridge), the National Library of Scotland (Edinburgh), and the National Library of Wales.

Without all the libraries, museums, and private collections that have lovingly preserved the Middle English manuscripts discussed here, and those that also generously make them available to the public online, our task would have been impossible. To these unsung heroes, we hope at least to offer here much more than the usual pro forma gratitude of academic acknowledgments, and we hope the book will do even more to help younger scholars tap into the riches of their collections, and of the enduring legacy of Middle English scribes and artists.

Abbreviations

Add.	Additional
ASCO	All Souls College, Oxford
BL	British Library, London
Bod.	Bodleian Library, Oxford
CCCC	Corpus Christi College, Cambridge
CCCO	Corpus Christi College, Oxford
CUL	Cambridge University Library
ECC	Emmanuel College, Cambridge
EETS	Early English Text Society
Folger	Folger Shakespeare Library, Washington, DC
Huntington	Huntington Library, San Marino, CA
IMEV	*Index of Middle English Verse*
LALME	*A Linguistic Atlas of Late Medieval English*
LSA	London, Society of Antiquaries
ME	Middle English
MHE	Middle Hiberno-English
ModE	Modern English
MSS	manuscripts
NLS	National Library of Scotland, Edinburgh
PCC	Pembroke College, Cambridge
Rosenbach	Rosenbach Museum and Library, Philadelphia, PA
SJCC	St. John's College, Cambridge
SJCO	St. John's College, Oxford
SWM	South West Midlands dialect
TCC	Trinity College, Cambridge
TCD	Trinity College, Dublin

Glossary of Key Manuscript Terminology

NOTE TO THE USER: In creating this glossary, we have chosen the terminology most pertinent to Middle English literary and visual manuscript study, excluding terms from other fields that the beginning student is unlikely to need at this stage (e.g. diplomatics, legal and liturgical terminology—such terms are available in the bibliographical sources mentioned below). We have relied heavily and gratefully on Michelle Brown's 1994 guide to technical terms (which is also available on the British Library website) and also on Leonard Boyle and Michèle Mulchahey (1969) 1991, Petti 1977, Roberts 2005, and Parkes 1979. We are also very grateful for the research assistance of Nicole Eddy. See also Joan M. Reitz, ODLIS—Online Dictionary for Library and Information Science at http://lu.com/odlis/search.cfm. In addition to the figures in this book illustrating these terms, photographs illustrating many of these technical points can be found in Brown 1994 and in Clemens and Graham 2007, along with more detailed information on some subjects. The definitions here are intended to be merely introductory and succinct. References to other glossaries are given by name and date only, since all glossaries work by alphabetical order, as here. Terms printed in boldface can be found elsewhere in the glossary.

ABBREVIATION A mark used to save space by shortening a given word. Brown 1994 identifies three types: suspensions (a graphic symbol above or at the end of a word); contractions (reducing either the beginning or the middle of a word); or replacing the word entirely with a symbol or **brevigraph** (such as the Tironian sign for *et* [and], derived from a shorthand system traditionally attributed to Tiro, Cicero's secretary).

ACANTHUS A stylized form of ornamental leaf or foliate decoration (not necessarily accurate botanically as acanthus) often used in borders of illuminated manuscripts. See ch. 1, fig. 19, for an instance of this widely used form of decoration from a Gower manuscript.

ANNOTATION Additional material added to a text after it is written, most often in the margins. See also **gloss** and ch. 4, sec. I.

ANNOTATOR A scribe or later reader providing annotations.

ANTHOLOGY A collection of texts deliberately gathered by one scribe or editor (or more than one working together), focused on particular genres or topics. The Findern MS, for example, is an anthology gathered by several hands, focusing especially on love literature (see ch. 2, sec. III).

ARCHETYPE As used in editorial studies, the term means the common source of all surviving manuscripts (which may or may not be the author's original version).

ASCENDER The vertical stroke of a letter that extends above the letter, sometimes exaggerated in length for decorative effects; see the Ellesmere MS (ch. 5, fig. 17) and the Takamiya Chaucer (ch. 5, fig. 10).

ATELIER French for "workshop." See **workshop**.

AUTOGRAPH A manuscript written in the author's own hand and signed by the author. See ch. 1, fig. 25, for Hoccleve's autograph. See also **holograph**. Scribal signature and authorship are discussed, for instance, in ch. 2, sec. III and figs. 36a and b.

BAS-DE-PAGE Figures or scenes at "the bottom of the page" that may or may not relate to the main text. See ch. 3, figs. 8a and b, showing romance scenes in a Book of Hours.

BIFOLIUM, BIFOLIA A sheet of parchment, vellum, or paper folded in half, creating two leaves (see **folio**) and four pages for writing. **Bifolia** (the plural form) folded together create a **quire**.

BINDING Typically, finished **quires** were sewn together onto cords, which were then attached (via channelling and pegging) to **boards** (normally made of wood in the Middle Ages); these were then usually covered with leather, often somehow decorated. For an

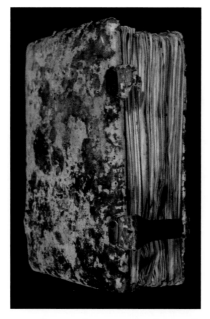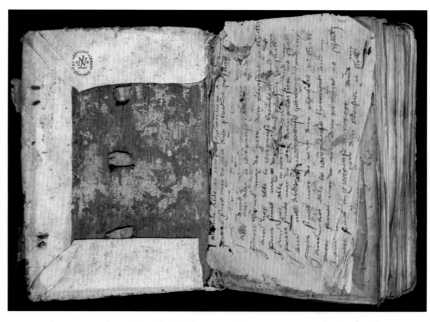

G1. A fourteenth-century binding with two clasps, one broken. Chicago, IL, Newberry Library, MS 31. See **binding**.

G2. Inside cover with cords embedded in wooden boards via channeling (creating grooves) and pegging (wooden pegs). Chicago, IL, Newberry Library, MS 31.

example of a fourteenth-century binding, see Chicago, Newberry Library, MS 31, shown above in fig. G1. See ch. 1, fig. 20b, for a view of quires and cords taken during the disbinding of a *Piers Plowman* text (San Marino, Huntington Library, HM 114). Fig. G2 shows the inside cover of MS Newberry 31, with cords embedded in wooden boards via channelling (creating grooves) and pegging (wooden pegs).

BOARDS Covers for books often made of wood covered with leather but sometimes made of cloth, parchment, or paper. See fig. G2.

BOB Part of the bob-and-wheel, a Middle English stanza form used most famously in *Sir Gawain and the Green Knight*. The bob is a very short, two-syllable line that shares its rhyme with the second and third lines of the final, four-line "wheel" (three stressed syllables per line). Traditional editorial practice places the bob between the main body of the stanza and the wheel, but this practice is not represented in medieval manuscript layout. See ch. 1, fig. 8, for treatment of the bob in the Harley lyrics; figs. 9 and 11 for *Gawain*; fig. 12 for "Sir Thopas"; fig. 13 for *Susannah*. See also ch. 2, sec. I, for its treatment in *Sir Tristrem* and the *Simonie* (fig. 9).

BOOKHAND One of two broad categories of medieval scripts, the other one being documentary hand. Bookhand includes a wide variety of scripts, but the category is distinguished from documentary hand mostly on the basis of the content being copied. Documentary hand was developed largely for writing documents but was later adopted for literary use; earlier bookhand texts were mainly written in *textura*

(or *textualis*) scripts, though in late medieval England increasingly documentary scripts, *Anglicana,* and then later Secretary scripts, came to be widely used for literary texts as well. See the introduction to the front plates for distinctive script types and examples illustrated there.

BOOKLET A **quire** or group of quires containing one or more written texts prepared with the intention of being bound or kept together. The Lincoln Thornton MS, for instance, is made up of three generically distinct booklets: the first containing romances, the second devotional works, and the third an encyclopedic collection of medical recipes (see ch. 2, sec. II). See also **collation**.

BORDER A decorative surround to a manuscript page, most commonly in foliate or paneled form.

BREVIGRAPH A type of **abbreviation**, usually representing by use of a single symbol two or more letters. The symbol is sometimes purely arbitrary in its appearance, and sometimes resembles one of the letters it represents. Brevigraphs may be fixed in their meaning or may vary in what they represent according to their context of use. Petti 1977 includes a list of common brevigraphs and their meanings. See front plate 10, below line 9, in margin "Wndyrst*on*dynge" for an especially long instance, covering more than one syllable.

CADEL A calligraphic drawing of animal or human heads or decorative ornament extending, for example, from the **ascenders** at the top of a page or the descenders at the bottom; see ch. 3, figs. 36a–d.

CATCHWORD A word or phrase written in the lower right margin (generally) of the final leaf of a **quire**, repeating the first word or phrase that appears at the top of the first page of the next quire (e.g., ch. 1, fig. 24, and p. 91). Catchwords aided the binding process and also helped orient scribes, especially when coordinating different stints (e.g., the case of Scribe D's copy of Gower's *Confessio amantis* described in Kerby-Fulton and Justice 2001).

CHAINING The process whereby a chain and staple can be affixed to a book for permanent retention in a medieval library.

CODEX By the later Middle Ages, this denotes a book composed of **parchment**, **vellum,** or **paper stock,** made up of folded and sewn sheets, as distinct from a **roll**.

CODICOLOGY The study of codices (see **codex**), especially physical make-up, textual history, scribal activity, dating, origins, and provenance.

COLLATION A numerical formula given in modern manuscript descriptions showing the **quire** structure of a manuscript and the number of booklets (if more than one). So, for instance, in San Marino, Huntington Library, HM 114, *Piers Plowman* forms the first **booklet** of the manuscript, even though it has many quires: the collation of the first booklet is: 1-6^{16} 7^{18} 8^{16} (meaning that the first six quires have 16 leaves each, the seventh quire has 18 leaves, and the eighth has 16 leaves). Other booklets in the manuscript, also copied by the same scribe, contain other long works: *Mandeville's Travels, Susannah,* and the *Three Kings of Cologne* form a second booklet; and *Troilus* and the *Epistle from Lucifer to the Clergy* form the third (see ch. 1, sec. IV, and fig. 20a showing the quire count in the scribe's hand). Roman numerals appearing before or after a collation refer to the number of flyleaves or endleaves. A quire with a missing leaf is often recorded this way: "1^8 (wants 3)," indicating that the third leaf is missing from the first quire. Booklet sections are frequently distinguished in a collation by a vertical line between the relevant quire numbers.

COLOPHON An inscription at the end of a manuscript or printed book, recording the circumstances of its making, including often the name of the author, scribe, or printer, the location, or the date. See ch. 6, figs. 10, 14, and 25.

COLORED CAPITAL In late medieval English books, often referred to as Lombard capitals, often alternating in red and blue, these help break the text into divisions (see **ordinatio**; see ch. 1, fig. 10, an instance from *Patience*).

COMMENTARY A discussion of a text added, whether in the margins (see **annotation** and **gloss**), or incorporated into the text space itself. The lines being commented on, especially with biblical verses, are usually distinguished from the commentary by being rubricated (see **rubrication**) or copied in a more formal **script**.

COMPILATIO (COMPILATION) A medieval genre involving the gathering of extracts or shorter works from various authors, joined together by explanatory material provided by the **compilator (compiler)**.

COMPILATOR (COMPILER) One who creates a compilation; see **compilatio (compilation)**.

COPYIST A scribe copying from an **exemplar.**

CORRECTOR Manuscripts were corrected sometimes by the scribe himself or by another scribe whose job it was to correct (sometimes as a supervisor), or by a **stationer**, an owner, or a later reader. Sometimes a corrector's mark in the margin denotes a place where a correction should later be made (sometimes these were completed, sometimes not). Methods of correction include: scraping words to be erased with a knife or pumice (**erasure**), crossing out (see the instance in the *Book of Margery Kempe*, ch. 3, fig. 8b), **expunctuation** (dots beneath the letters or words to be omitted), and insertions (often interlinear or marginal), using a mark of insertion such as a caret. The work of a professional corrector, the Carthusian James Grenehalgh, is discussed in ch. 6, sec. IV.

CURSIVE See **script**.

DECORATED INITIAL An initial letter normally enlarged and painted or colored in some ornamental way. See also **historiated initial** and **inhabited initial**, as well as **pen-flourished initial.**

DE LUXE Expensive, grand or lavish, normally used to describe manuscripts with **illumination**.

DEMI-VINET BORDER A border that usually extends from a large initial and brackets the text on three sides. It consists of a vertical double bar along the left margin and extends horizontally to become a vegetal spray at the top and bottom of the page. See the Ellesmere MS, ch. 5, fig. 6.

DESCENDER The vertical stroke of a letter that extends downward below the main part of the letter; for a playful instance, see the *p* at the bottom of "Explicit" that is nipped by the beak of the stork, ch. 3, figs. 38 (a–b).

DISPLAY SCRIPT A higher grade of script, used for emphasis. See **script**. Fine examples of the amateur scribe Robert Thornton's attempts at display script appear in ch. 2, figs. 14 and 17.

DOUBLE BAR BORDER A border or frame usually consisting of a gold bar beside another bar of alternating blue and pink segments from which leafy decoration appears to grow. For a full (closed) bar border see the Hengwrt MS, ch. 3, fig. 5. See also **demi-vinet border.**

DRY POINT See **hard point.**

EDITOR A person, medieval or modern, who revises a text for re-presentation, by emending or otherwise altering the text based on comparison with other copies, or on his or her own sense of how it should read. In modern scholarship, an edition is not a transcription (see **transcribe**).

ENDLEAVES Blank leaves at the beginning and end of the book, serving either as **flyleaves** or, if the book is bound, as **pastedowns. Pen trials**, short texts (like verses and quotations), and ownership inscriptions (see **ex libris inscription**) were often added to endleaves.

EXEMPLAR Any text from which a copy is made.

EX LIBRIS INSCRIPTION Information regarding the library (institutional or personal) from which a book comes. See ch. 6, fig. 26, and **provenance.**

EXPLICIT The words or phrase at the end of a text (*explicit,* "it ends," e.g., ch. 1, fig. 20a). As many medieval works in manuscripts have no titles or authors, the explicit and the **incipit** may often be the only means of identifying the treatise.

EXPUNCTUATION A method of correction that indicates the cancelation of a word or words by the drawing of one or more small dots below the word(s) to be deleted.

FILLER ITEM Items added to fill the spaces originally left before, after, between, or even within the text in a manuscript. Unused space is sometimes filled with a diverse variety of items both practical and otherwise. The Yorkshire gentleman Robert Thornton, for instance, filled the gaps in one of the manuscripts he prepared for his family with pieces as various as a birth record, weather prognostications, drawings, and charms (see ch. 2, sec. II, especially figs. 13, 19, and 28), the last of which reveals that filling gaps became a family affair for the Thorntons.

FLESH SIDE The side of a sheet of parchment or vellum that originally faced the animal's body, as opposed to the hair side (exterior), which carried its hair. The flesh side is softer and less discolored.

FLYLEAVES Outer pages, usually blank, at the front and back of a book, intended to protect the other pages from damage (see also **endleaves**). In an unbound book, the flyleaves are the outermost, exposed pages. In a bound book, "flyleaf" refers to the free portion of the **pastedown** endpaper **bifolium**, protecting the text in case of damage to the binding. Flyleaves were frequently used in the Middle Ages as a free space for pen trials, signatures, ownership marks, and occasional jotted notes, and are now useful in providing clues to **provenance.** See ch. 6, fig. 26, for an annotated pastedown inside a Wynkyn de Worde printed edition of Hilton's works.

FOLIATE BORDER Border with leaf-like or vegetal ornamentation (see front plate 3). See also **acanthus** and **border.**

FOLIO One leaf of parchment, vellum, or paper (see **bifolium**); its sides are designated **recto** and **verso** (abbreviated *r* and *v* or sometimes *a* and *b*, though the latter combination is now more usually used for designating two columns on the same side). Foliation, unlike pagination in modern books, assigns only one number to a leaf, distinguishing front and back by *r* and *v*: for example, fol. 2r and 2v (or also fol. 2 and 2v). If the folio has columns, 2ra and 2rb would denote the side by side columns on the front page; 2va and 2vb, those on the back or verso.

FRAME RULING Ruling that outlines the space in which the text will be written.

GATHERING A **quire.**

GILDING The application of gold or silver to the page (see **illumination**).

GLOSS Words or passages added to translate, clarify, or comment on words or segments of the main text (see **commentary** and **annotation**; for distinct types of glosses found in, for instance, Chaucer manuscripts, see ch. 4, sec. I).

GUIDE LETTER A small letter, usually left by the scribe, to indicate to the **illuminator** or **rubricator** which initial or **littera notabilior** to write or paint. The guide letter is usually written in the empty space that will later be covered by the initial or written discreetly in the margin. In unfinished manuscripts these can be easily seen, and mistakes occur relatively frequently (see the Julian of Norwich manuscript, ch. 4, fig. 9b). Clear guide letters by the amateur scribe Robert Thornton can be seen in ch. 2, figs. 11 and 22).

GUTTER The crease or fold of a **bifolium** bound to the spine of a book; sometimes letters or words are rendered illegible in the gutter by tight binding (see "Note on Transcriptions and Transcription Symbols").

HAIR SIDE The rougher side of parchment or vellum originally the side carrying the animal's hair. Follicles can often still be seen on manuscript pages, resembling dots or speckles. See **flesh side.**

HAND An individual scribe's writing of a particular **script.**

HARD POINT A pointed instrument (or stylus) for writing or drawing on a surface by making grooves, without leaving a colored mark (as with ink, **metal point**, or **plummet**). Hard point was often used for instructions, annotations, and preliminary drawings.

HISTORIATED INITIAL A letter containing figures or scenes, most often relating to the text. See also **inhabited initial** and **border.**

HOLSTER BOOK A small **codex** with a narrow account-book format (see ch. 2, fig. 7, for an example). Some believe medieval holster books to have been tools of the trade for professional traveling minstrels, but their portability would also have served traveling clergy in their work, while their affordability would have answered the needs of families unable to meet the cost of larger books.

HOLOGRAPH A manuscript written in an author's own hand (see ch. 1, sec. VI, and fig. 24 for Hoccleve's holograph manuscripts). See also **autograph.**

HOUPELAND, HOUPELANDE A circular-cut outer garment with a high neck and voluminous sleeves that can be worn long by women and long or short by men; see the *Pearl* manuscript in ch. 3, fig. 17 (a-b).

ILLUMINATION The decorating or illustrating of a manuscript with colors, especially gold and silver (from the Latin word *illuminare*, to enlighten or illuminate).

ILLUMINATOR The artist or scribe who carries out the illuminations, whether in a monastic scriptorium or in an urban **workshop**, where the trade was learned by apprenticeship. Illuminators often worked collaboratively with each other, with scribes, and with stationers and patrons.

INCIPIT The words introducing a text (*hic incipit*, "here begins"), frequently serving to identify a medieval text in the absence of a title. See also **explicit.**

INHABITED INITIAL An enlarged letter that contains figures or narrative scenes not obviously relating to the text. See also **border** and **historiated initial.**

INSCRIPTION See **colophon** and **ex libris inscription.**

INSULAR Having to do with Britain and Ireland, particularly in contrast with the continental European mainland.

INTERLACE Interwoven vines or other bands that are used to decorate borders and initials.

LAUREATION, POET LAUREATE Crowning with a laurel wreath, used to confer the highest honor on poets, a custom derived from classical times for celebrating heroes and poets. The position of poet laureate was not yet an official title in England in Chaucer's time, but he was regarded as worthy of such status by his successors.

LEAF See **folio.**

LITTERA NOTABILIOR An enlarged letter, provided for emphasis or clarification.

LIRIPIPE A long piece of fabric extending from the tip of a hood or turban-like hat; see the *Pearl* manuscript in ch. 3, fig. 13, and the Ellesmere MS in ch. 5, figs. 2 and 17.

LOCUS AMOENUS From Latin for "a pleasant place." The decorative features of some borders or historiated initials sometimes visually create a setting that suggests an idealized space for aristocratic pursuits or the composition of verse; see for example, the Lansdowne Chaucer in ch. 5, fig. 7.

LOMBARD CAPITAL See **colored capital**. See the example from *Patience* in ch. 1, fig. 10.

MANUSCRIPT a handwritten text (from the Latin *manu*, "by hand," and *scriptus*, "written"), usually a **codex.**

MARGINALIA A wide range of items found in the margins of manuscripts; see **annotation, commentary,** and **gloss**. Ch. 4 discusses all types of marginalia, including pictorial devices, found in Middle English manuscripts. Marginalia can be extremely diverse, ranging from Latin glosses (see ch. 4, sec. I) to amateur attempts, as in the Lincoln Thornton MS (ch. 2, figs. 29a and b and 30a and b) or to schoolboy obscenities, like those found in the Macro MS (front plate 10 and ch. 6, sec. V).

METAL POINT Various metals, including lead (see **plummet**) were used for **ruling, annotation,** and drawing. Ferrous point (brown), silver, lead, and copper (a greenish hue) were all used in medieval book production.

MINIATURE A freestanding image, not part of a **border** or a **historiated** or **inhabited initial.**

MINIM The shortest vertical stroke, used to form one of the following letters: *i, u, m, n.*

MISE EN PAGE The French phrase for the layout of a page, which can be complex in medieval manuscripts, involving **ruling** to include boxed illustrations, **historiated** or **inhabited initials**, and **glosses** (see ch. 4, figs. 2 and 3, comparing the differing layout of glosses in the Hengwrt and Ellesmere *Canterbury Tales* manuscripts). See also **ordinatio**. For an example of informal and unusual layouts, see Bod. MS E Museo 160 where the Carthusian scribe and author develops his mise en page as he composes (ch. 6, sec. V, and figs. 31a and b and 32a and b).

ORDINATIO The organization of a text for the page, including arrangement of columns, **rubrics**, chapter divisions, running heads or titles, **decorated** and **pen-flourished initials**, images, **annotations,** and other ways of breaking up the page or incorporating finding devices.

ORTHOGRAPHY The spelling practices of a given scribe that help modern scholars to identify both individual scribes and their geographical origins via dialect. (See, for instance, front plate 1, of *The Land of Cokaigne*, copied in Ireland in an Hiberno-English dialect).

OTIOSE STROKES Superfluous flourishes on letters sometimes difficult to discern from a scribe's intention to abbreviate. See **abbreviation**, "Note on Transcriptions and Transcription Symbols," and "How to Transcribe Middle English."

PALEOGRAPHY The study of the history of scripts and transcription practices. See also its sister study, **codicology**.

PAPER STOCK Paper is generally made of compressed pulp from various materials, often linen or cotton rags. The mesh screens used in the production process often contained an emblem that left an imprint known as a **watermark** on the finished sheet of paper. Watermarks can be a means of identifying where paper stock for a manuscript comes from (see Briquet 1923). In England, paper was slower to replace parchment than on the Continent, and William Caxton was still importing supplies from Italy and France in the late fifteenth century. The first English paper mill was established in Hereford in 1490 (Boyle and Mulchahey [1969] 1991). Parchment was often used as the outer **bifolium** of a paper **quire** to enhance durability, as, for instance, the University of Victoria manuscript of Lydgate's *Fall of Princes,* which can be seen at http://library.uvic.ca/site/spcoll/sc_digital/sc_digital_lydgate.html.

PARAPH, PARAF A mark used to designate the start of a new text, section, or annotation; see, for example, fig. T1 in "How to Transcribe Middle English," where paraphs are the common *C-* shape; another common type looks like a backward *P*. See the gold and blue paraph markers in the Ellesmere MS, ch. 5, fig. 2. Paraphs are frequently rubricated (see **rubrication**), as in ch 1, fig. 1.

PARCHMENT A general term used for animal-skin-based writing surfaces, usually sheep and goat skins. See **vellum**.

PASTEDOWN A leaf glued to the inside of the board cover (front or back) of a manuscript or printed book to hide the mechanics of binding. Fragments of older manuscripts considered no longer useful were sometimes recruited as pastedowns for new books, which tend to accumulate inscriptions, dates, contents lists, and other precious bits of information. See, for instance, the heavily annotated front pastedown of Walter Hilton's *Scale of Perfection* in ch. 6, fig. 26. See also **endleaves**.

PATRON The person who commissions a book to be made.

PECIA A system by which exemplars of books approved for university study were made available to scribes via stationers for piecemeal copying, often by quire (from the Latin *pecia,* "piece"), thereby improving efficiency in book production. There is less evidence of this method at Oxford than at Paris, but see Piper and Foster 1989.

PEN-FLOURISHED INITIAL A delicate method of decorating an initial using only ink, most often colored blue or red, and a thin pen.

PEN TRIAL Letters or words a scribe has written, most often on flyleaves or in margins, to test the way his pen is performing. Pens (which were made from feathers, from the Latin *penna,* "feather") required frequent trimming and were cut by the scribe according to the kind of script required: **cursive** scripts, for instance, required a thin pen, while formal scripts a broader one (Brown 1994). A related but distinct phenomenon is evidence of schoolroom or nursery writing trials (see, for instance, ch. 2, fig. 32a).

PLUMMET Lead point used to rule, draw, or write, often for instructions. See **ruling** and **metal point**.

PRICKING Tiny marks like pin pricks made by a pointed instrument at equal intervals on the inner and outer margins of the folio to guide ruling. In **Insular** manuscripts, unlike Continental ones, pricking usually occurs in both inner and outer margins (Boyle and Mulchahey [1969] 1991).

PROVENANCE The history of a book's entire ownership, not just its original ownership. Among the many kinds of evidence used to establish provenance are: **ex libris inscriptions**, heraldic devices, distinctive medieval library markings, and other historical records.

QUIRE A number of **bifolia** (or even just one **bifolium**) folded together, that is, a single gathering of sheets for writing. Most often in late medieval England quires are composed of eight leaves, but quires running from two to twenty or more are common. Complete quires are gathered in even numbers because they are made up of *bi*folia, so an uneven number of leaves normally indicates page loss, whether deliberate (a scribe or owner may remove one) or through damage. (A single

leaf is called a singleton). The number of quires in a manuscript, their sequence, and their division into **booklets**, is shown in the manuscript's **collation**.

QUIRE SIGNATURES A system of numbers and/or letters usually written in the extreme bottom corner of a folio, on the recto of each page of the first half a quire. In a standard quire of eight placed at the beginning of a volume, the first four leaves will be numbered (e.g., ai, aii, aiii, aiv), but there is no need to number the last four since they are **bifolia** (that is, attached to the other half of the sheet). Quire signatures were often cropped during binding. For an instance of continuing the numbering of leaves into the second half of quires, see the work of Thomas Hyngham in ch. 6, sec. V, and front plate 10.

RECTO See **folio.**

ROLL A format used in the later Middle Ages most frequently for record-keeping, especially in government offices but also for specific genres such as genealogies, certain kinds of chronicles (especially with genealogical material), and prayer rolls—most often texts that were illustrated and used for display. Rolls were made of parchment segments sewn together and rolled up vertically.

RUBRIC Title, chapter heading, or other summarizing information that is used to tell the reader the content of the following text. Rubric comes from the Latin *rubrica* ("red"), a name deriving from the use of red ink for such headings. See, for example, the rubricated names in the Winchester Malory MS (ch. 2, fig. 1); or the rubricated underlining in MS Harley 7333, in John Shirley's Prologue to Chaucer's *Canterbury Tales* (ch. 6, fig. 11).

RUBRICATION The supplying of rubrics and other red ink for highlighting words or letters in a manuscript, normally done by a scribe acting as a **rubricator** (whether the scribe who copied the main text or another), normally added after the text has been copied.

RUBRICATOR The role of supplying **rubrication**.

RULING This could be done in **plummet** or in another **metal point** or even in **dry point**. In the mid-thirteenth century writing practices changed from beginning above the top-line to below the top-line, important evidence for dating manuscripts.

SCRIBE The copyist of a book or document, whether as a member of a religious order or (increasingly from the thirteenth century onward) working independently in an urban setting or attached to a household or government office. Independent scribes were often clerks in minor orders or educated laymen trained as scriveners (documentary scribes, such as Chaucer's

scribe, Adam Pinkhurst, a scrivener to the Mercers' guild), especially by the fifteenth century. More rarely, women were also known to be scribes, and both male and female authors sometimes acted as their own scribes (Thomas Hoccleve and Christine de Pizan, for instance).

SCRIPT A wide variety of forms of handwriting used in medieval manuscripts according to disciplined rules for copying specific letters in specific ways. Professional scribes knew how to write in several different scripts. The history of scripts from the Late Antique period is a complex one; those most pertinent to the study of late medieval English manuscripts have been described and exemplified in the front plates of this book. Broadly speaking, they are drawn from **bookhand** and documentary hand types. Scripts are often divided into three kinds according to levels of formality: set scripts (produced slowly and deliberately for formal effect), cursive scripts (more efficiently written with less lifting of the pen), and current scripts (very rapidly written and less easily read). Literary texts are normally written either in set or cursive scripts.

SCRIPTORIUM The room (normally in an ecclesiastical institution) where books are copied.

SERIF A decorative finishing stroke or lozenge-shaped tip or ending to a stroke made by the scribe in the formation of a letter, normally used in more formal **bookhands**. See front plate 6.

SHELFMARK The name and number by which a manuscript is known in modern library collections. See also **siglum**.

SIGLUM (or **sigil**), **sigla** A single letter or other short form chosen to represent a manuscript in the editorial apparatus of an edition. For example, in editions of the C-text of *Piers Plowman*, the manuscript with the modern **shelfmark** Oxford, Bodleian Library, MS Douce 104 has the siglum D.

STATIONERS Stationers provided materials for the book trade and held exemplars of books in frequent demand for copying, especially in university towns. They apparently played some role in coordinating scribes and clients, but in English book production (which was a small, niche market) their role is much less clear.

STEMMA A family tree of extant manuscripts of the same text, showing how the manuscripts relate to each other for editorial purposes.

TRANSCRIBE To create an exact transcription of a medieval text, without emending it (as one does in editing a text) or modernizing its language or syntax in any way (as one does in translating it). See "How to Transcribe Middle English."

UNDERDRAWING Before painting the illustrations, medieval artists often made an underdrawing either with a dry point stylus (**hard point**) made of metal or bone to incise the outline, leaving slight indentations, or with a silver stylus or piece of lead (**plummet**) that leaves a gray trace or from iron that leaves a brown trace.

VEGETAL ORNAMENT, SPRAY, FLOURISH A general term to designate stylized plant motifs that may or may not be identifiable as specific flowers or leaf forms.

VELLUM Veal parchment (calf skin) or the skin of kids or lambs. **Vellum** is extremely soft and was the most expensive writing surface available, the most prized form being abortive or uterine vellum. See **parchment.**

VERSO See **folio.**

WATERMARK An identifying mark left in paper, advertising the manufacturer. Paper is made when a mixture of rag pulp suspended in water is pressed onto a screen (see also **paper stock**). Wires twisted into an image, attached to the mesh grid, will transfer the image into the texture of the paper, visible when backlit. Such images can be used to identify the time and place of the paper's manufacture and therefore to locate the origin of a manuscript; numerous reference works provide extensive catalogues of watermarks specific to particular regions and time periods. See ch. 2, sec. II and sec. III, on watermarks in the Findern and Thornton manuscripts.

WORKSHOP In an urban setting, illuminators often worked together in shops, where they would have taught apprentices as well. They must have interacted with scribes in such settings, but there is little or no evidence that scribes themselves had their own urban workshops. Scribes, so far as we can tell, often worked at home or for periods on the premises of the patron who hired them (presumably for the security of the exemplar). See also **stationers.**

Note on Transcriptions
and Transcription Symbols

PUNCTUATION

/ represents the virgule, a versatile indicator of pause.

. represents the point, another indicator of pause.

⁚ indicates the *punctus elevatus*, a pause with the voice rising.

⁏ represents the *punctus versus*, a pause with the voice falling.

: indicates the same mark in the manuscript.

' represents an uncertain stroke within or at the end of a word, in most cases an otiose stroke but at times one that may indicate an abbreviation that remains unclear.

= indicates that a word has been split at the end of a line and continued on the next.

ORTHOGRAPHY

"u" and "v" have been transcribed as they appear in the manuscript.

"i" and "j" have both been transcribed as "i" in all instances, except for Roman numerals.

Capitals in manuscripts have been maintained, though we have sometimes normalized where capitalization is ambiguous; for colored or enlarged capitals **boldface** font has been used (see below).

Spacing and separation of words have been adjusted to conform with modern orthography, except where otherwise indicated.

Ampersand and Tironian *et* have been expanded alike, as *and* in English (or the equivalent appropriate to the scribe's dialect), and as *et* in Latin.

SPECIAL CHARACTERS

þ is a thorn, indicating a *th* sound.

Þ is an uppercase thorn.

ȝ is a yogh, usually indicating a *g* or *gh* sound medially, a *y* sound initially, or an *s* or *z* finally.

Ȝ is an uppercase yogh.

ð is an eth, usually indicating a soft or voiceless *th* sound.

Đ is an uppercase eth.

ƿ is a wynn, a runic letter usually indicating a *w* sound.

Ƿ is an uppercase wynn.

FONTS

Boldface font has been used in transcriptions to indicate headings, rubrics, and enlarged or colored capitals. (In accordance with normal art historical practice, boldface font is not used in chapters 3 and 5 on illustrations.)[1]

Italics have been used in transcriptions to expand all abbreviations in Latin as well as English, including superscript letters (within square brackets [*italics*] indicate that missing or lost abbreviations have been expanded: see below).

~~Struck out~~ words and letters indicate deletions by a scribe or corrector, which may take a variety of forms, including crossing out, erasure, and expunctuation.

1. Brown 1994, Camille 1993, 1995, 1998, Hamburger 1998, Hardman 2003, Rickert 1940, and Scott 1995, 1996, for example, do not use boldface font for headings, rubrics, or enlarged or colored capitals. These chapters follow the practice of Brown 1994 of italicizing single decorated initials.

BRACKETS AND SYMBOLS

^ ^ surround words and letters inserted by the scribe or corrector, either above or below the main text line or in the margins.

⟨ ⟩ surround words written over erasure.

[] have been used to enclose our own additions, such as letters and words supplied in the transcription when they are lost or hidden in the manuscript due to damage or binding; when no traces of abbreviation marks remain, *italics* have been used to expand them within square brackets; our own translations and comments are also enclosed in square brackets.

. . . indicates that text is missing in the manuscript and has not been provided via correction or transcription.

~ indicates that text has been omitted between two extracts but that the omitted portion is complete in the manuscript so far as this can be determined.

| marks line endings in both verse and prose when these have not been maintained from the manuscript.

¶ represents a paraph or capitulum in the manuscript.

Other signs and symbols are used as needed to approximate unique marks in an individual manuscript or in the hand of a particular scribe.

DATING

s. abbreviates *saeculo*, so s.xiv indicates the fourteenth century.

c. abbreviates *circa*, with c. 1400 referring to the turn of the fourteenth to the fifteenth century.

in. represents the first half of a century, with s.xiv in. indicating 1300-1350.

med. refers to the middle half of a century, with s.xiv med. representing 1325-1375.

ex. indicates the second half of a century, so s.xiv ex. is 1350-1400.

superscript 1 indicates the first quarter of a century, so s.xiv^1 refers to 1300-1325.

superscript 2 refers to the second quarter of a century, with s.xiv^2 indicating 1325-1350.

superscript 3 refers to the third quarter of a century, with s.xiv^3 indicating 1350-1375.

superscript 4 refers to the last quarter of a century, with s.xiv^4 representing 1375-1400.

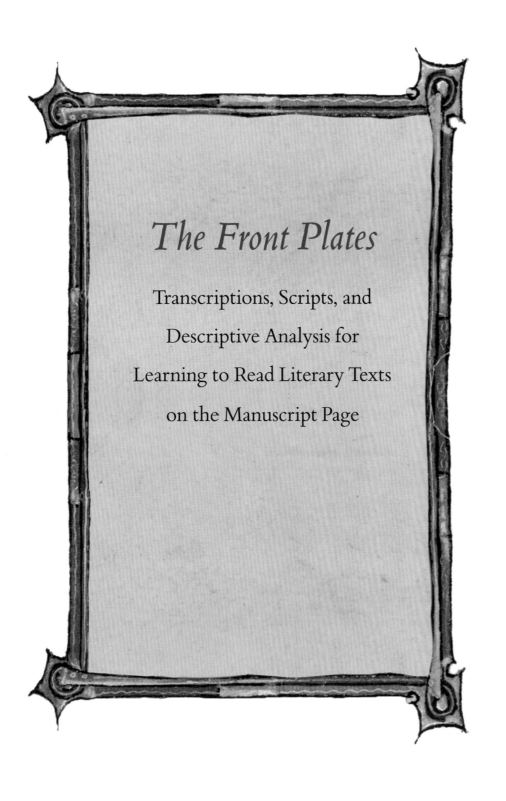

The Front Plates

Transcriptions, Scripts, and

Descriptive Analysis for

Learning to Read Literary Texts

on the Manuscript Page

How to Transcribe Middle English

KATHRYN KERBY-FULTON

THE PURPOSE OF THIS SECTION is to give concrete advice on how to **transcribe**, both generally and more particularly given that Middle English poses several field-specific problems in transcription and uses several now-archaic letter forms. This section assumes no knowledge of manuscript studies; all specialist terminology here has been printed in boldface, indicating its inclusion in the "Glossary to Key Manuscript Terminology."

The manuscript with the **shelfmark** London, British Library, MS Arundel 292 is written in a clear, simple hand (see fig. T1) and in a script known as Gothic *Textura rotunda*, one of four types of *Textura*, an important **bookhand** of late medieval England (the Jesus College *Owl and the Nightingale* manuscript and the *Gawain* manuscript, for instance, are also written in this hand). *Rotunda* is the least formal of the four *Textura* scripts and gets its name from the fact that there are fewer breaks (that is, lifts of the pen to change direction) in the formation of letters. These tend to be more rounded than those in the other three types of *Textura* (see front plates 1, 2, and 6 respectively below, and descriptions). *Rotunda* is also simpler because the tips and ends of letter forms do not have **serifs**, that is, lozenge-shaped decorative finishes (compare front plates 1 and 6 below).

MS Arundel 292 is simple to read paleographically, but its Early Middle English texts contain a wide range of archaic letter forms, some of which date back to the Anglo-Saxon period. It was in the Norwich Cathedral Library in the fourteenth century, and much of it is in Latin, but it has three unique alliterative Middle English works, each independently entered in the manuscript over a period of some one hundred and fifty years (see ch. 1, sec. I below). The manuscript also opens with a copy of the *Credo in deum (Creed)* and the *Pater Noster (Lord's Prayer)* in Early Middle English (pictured in fig. T1), texts so central to lay culture that it would be hard to find a more basic entry point to vernacular manuscript studies of the period. Notice in fig. T1 that the first letter of every line has been splashed in red for emphasis by the **rubricator**, and that rubricated titles of the *Credo in deum* and *Pater Noster* appear in the margin with **paraph** marks (shaped like a capital C). Beside the titles in red one can see fainter, abbreviated versions of the titles in the extreme right hand margin: these were written as instructions to the rubricator, left by the scribe to show where and what to put in the red titles. Above the text a large "C . X ." can be seen: this is the medieval press-mark for Norwich Cathedral Library, showing, that is, where the book would have been shelved in the cathedral library, just as today a library book has a call number.

The first four lines of the poetic texts of *Credo* and the *Pater Noster* are transcribed below alongside quotations from the modern EETS edition of these texts. Comparing these will show the difference between an edition and a **transcription**. For a guide to recording **abbreviations**, omissions, additions, deletions and other challenges in transcribing, see the "Note on Transcriptions and Transcription Symbols" for the basic rules that govern transcriptions in this book and commonly in the field of Middle English.

EETS EDITION	TRANSCRIPTION OF ARUNDEL 292, FOL. 3	MARGINAL RUBRICS
I leue in Godd almicten Fader, Ðatt heuene & erðe made to gar, & in Ihesu Crist his leue Sun, Vre onelic Louerd ik him mune. (*Credo*, fol. 3, 1-4)	I leue in godd al micten fader . ðatt heuene *and* erðe made to gar . *and* in ihesu crist his leue sun Vre onelic louerd ik him mune .	¶ Credo in deum . *[in red]*, Credo *[in faint brown ink, an instruction to the rubricator in extreme right margin]*
Fader ure ðatt art in heuene blisse, Ðin heȝe name, itt wurðe bliscedd; Cumen itt mote ði kingdom; Ðin hali wil, it be al don. (*Pater Noster*, fols. 3-3v, lines 23-26)[1]	Fader ure ðatt art *in* heueneblisse ðin heȝe name itt þurðe bliscedd . Cumen itt mote ði king dom . ðin hali þil it be al don .	¶ Pater noster . *[in red]*, Pat*er* noster *[in faint brown ink, instruction to rubricator in extreme right margin]*

1. Wirtjes 1991, appendix.

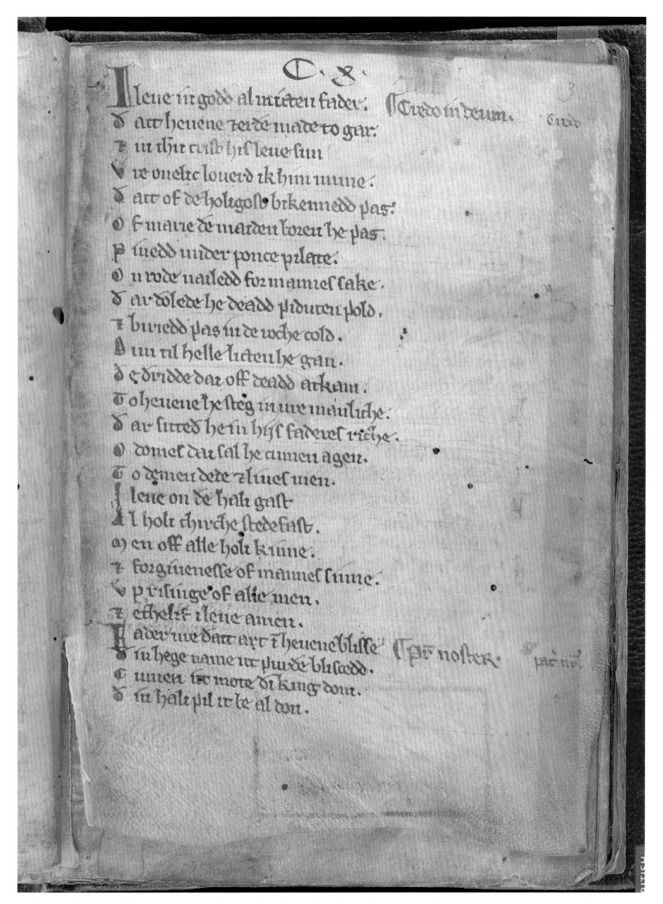

T1. The texts and rubricated titles of the *Credo in deum* (Creed) and *Pater Noster* (Lord's Prayer), the instructions to the rubricator, and the medieval press-mark for Norwich Cathedral Library at the top. London, British Library, MS Arundel 292, fol. 3r.

~ BARE ESSENTIALS *1: A Transcription Is Not an Edition*

A transcription seeks to record exactly what is on the page of the manuscript; an edition aims to create a readable text for modern scholars.[1] Even though an edition will usually reflect the original spelling of a text, its editor has created the published text by comparing different copies or versions (where they exist), correcting obvious scribal mistakes (e.g., supplying missing words and deleting repeated words), and emending where necessary to make sense out of grammatical nonsense. A transcription, however, is mainly concerned with recording exactly what the scribe has written on a particular page—including any mistakes, however obvious, he or she made. A transcription is unique to a given manuscript.

Notice the differences between the transcription and the edition in fig. T1 and the chart above: the modern edition of these Arundel texts expands **abbreviations** silently while the transcription italicizes expansions to show what the transcriber added (e.g., "ih*esu*" in *Credo*, line 3; or "i*n*," in the first line of the *Pater Noster*). Middle English scholars always italicize abbreviations when they expand them: unlike Latin, Middle English has no fixed spelling system and differs greatly across dialect areas. So, for instance, the heavily abbreviated Latin words in the instruction to the rubricator reading "Pat*er* n*oste*r" [our Father] technically do not need to be represented with italics showing how they are expanded because there is only one way to spell these words in Latin. (The italics are used here to help beginning students.) In Middle English, however, even a simple word like "in," often but not always written with an **i** and an abbreviation bar on top, can be spelled out in multiple ways (such as "ine", "hin", or "jn" depending on dialect or orthography). The expansion "i*ne*" would provide an extra syllable, which could be important for the metrics of a poem), so italics tell the reader that this is the modern transcriber's choice of spelling. If the scribe has elsewhere spelled the word in full (as in the first line of the *Credo*), the transcriber should use that spelling, as I have here, but you will find that scribes are often inconsistent and will spell the same word multiple ways. Abbreviations for silent *e* are especially tricky. In verse they can matter metrically, in alliterative poetry or prose less so; often a sign for an abbreviation can be difficult to distinguish from a decorative flourish; the latter are called **otiose strokes** and are signaled in transcription with an apostrophe (see "Note on Transcriptions and Transcription Symbols"). The front plates below present more complex examples.

Likely the comparative lack of abbreviation in this text is related to its being copied for pastoral purposes, which also makes it a handy learning text for modern students. The scribe had no need for these texts in English for himself, being quite capable of using the Latin (as we know from his copying elsewhere), but the fact that these are rhyming translations is another clue that they were meant for the semiliterate (for memorization). Note also that it can be difficult to tell whether a scribe intends a capital letter or not (e.g., the *P* in the instruction "Pat*er* n*oste*r" instruction could be *p*), but since the rubricator (likely the scribe himself, judging by the hand) interpreted it as a capital, I have, too (the *C* of "Credo" is certainly a capital). These may seem like tiny questions, but the transcriber is responsible for representing the text as faithfully as possible, and in literary works, the question, however minute, may not be tiny if a matter of interpretation turns on it (see the example of "king dom" below).

In transcription of Middle English one normally preserves **u** and **v** distinctions, which are a feature of orthography—**u** can be a consonant and **v** can be a vowel in Middle English—but **i** and **j** variations tell us virtually nothing that is linguistically useful (often **j** will be used for the second **i** when double **i** is intended, so as to distinguish the double **i** from other **minims** since **i** is often not dotted; double **i** can be mistaken for **u** or **n**, for example). The EETS edition quoted above understandably substitutes **w** for the archaic letter wynn: ƿ (e.g., "ƿil" for "wil" in the fourth line of the *Pater Noster*), but the transcription here preserves the original letter. A wynn in use at a late date like this is important linguistic and cultural information. The edition also

1. See Parkes 1969, xxviii.

introduces normal word separation, where the transcription here chooses to retain the manuscript's (see, for instance "heueneblisse" in the first line of the *Pater Noster*). This last choice is optional for transcribers, who will more often choose to normalize syllable separation, as explained in the "Note on Transcriptions and Transcription Symbols," but it can be done (as here) in order to offer fuller information about the scribe's practices of **orthography** and dialect. It can also offer significant poetic information. For instance, "king dom" with its word separation intact in the third line of the *Pater Noster* preserves a richer, multivalent sense: the original Anglo-Saxon compound word "cynedom," ending in "-dom" (a masculine abstract suffix meaning "state" or "power") has now acquired in this Early Middle English usage a stronger and additional sense of "dom" as an independent word meaning "judgment"—much richer poetically for a translation of this famous prayer.

While the manuscript leaves a space between the first letter of each first word and the remainder of the letters, the edition elides this space to help modern readers (in fact, this kind of separation became increasingly less common later in the fourteenth century, as scribes moved more rapidly toward modern practice). My transcription here also normalizes the spacing between the first letter and the second at the beginning of each line (as is common practice), but in some different manuscript contexts one might want to retain the archaic spacing in a transcription, since it was sometimes exploited to showcase a mnemonic or an acrostic device in earlier poetic texts, at a time when such devices were in fashion, a technique that survives sporadically into the fourteenth century.[2]

2. See, e.g., Roberts 2005, plate 35. Bodley Rolls 22, containing alliterative poetry likely meant for guild devotional use, is an example of Middle English verse that exploits first-letter acrostic devices as late as c. 1400. See Kennedy 2003, plate across from p. xi.

Late for its date is Arundel's use of archaic letter forms such as eth, ð, or Ð (in uppercase), along with other letters that hark back to Anglo-Saxon orthography. In most manuscripts of the fourteenth century, Arundel's "ðin" (thine) would be spelled "þin" (that is, with a thorn rather than an old-fashioned eth). Arundel also has, as we saw, the archaic wynn, ƿ (as in the word "ƿil" [will]). And there are two types of *g* forms, one of which, as Roberts notes, is clearly a yogh[2] (ȝ): the second line of the *Pater Noster* (line 24 of fig. T1) has a word that looks like "hege" (high), but the form of the *g* differs from the *g* in, for instance, "king" (next line), so it should be transcribed "heȝe." As Jane Roberts writes of the Arundel scribe:

> The scribe generalizes ð, against the trend under way from the early eleventh century; and because he does not use þ, there is little possibility of misreading his ƿ with its distinctive rectangular body. Unusually, he differentiates ȝ from **g** by using a final head-stroke only for the latter."[3]

Thorns and yoghs, as every student of Middle English knows, are in use well into the fifteenth century in many dialects, but the ƿ and ð are very unusual by 1300. The Arundel scribe, then, provides a remarkable snapshot of a man teetering between two worlds. Not all the transcriptions in this book are quite this close, and most do not use so many archaic letter forms, but having encountered them here, the student of Middle English will at least know how to handle them and be alert to the possibility of archaism. In the present instance, where it looks like the scribe is trying to indicate or preserve distinctions in pronunciation (of great interest to Middle English dialectologists), this kind of transcription does justice to his work.

In the front plates that follow, full transcriptions of pages of script are offered, along with descriptions of each hand and the manuscript context from which it comes. These are intended for preliminary practice, and advice on books and online sites with further examples for practice are given above, pp. xvi–xviii.

2. Roberts 2005, 3.

3. Ibid., 141, and see plate 34 and discussion.

Introduction

The Order of the Plates and Scripts
Most Commonly Found in Middle English Literary Texts

KATHRYN KERBY-FULTON

THE PLATES HERE are organized in chronological order, and their aim is to introduce the student briefly to the main types of script the reader of Middle English manuscripts might normally encounter, as they developed historically. In addition, these plates exemplify briefly the main features one might normally encounter in transcription, including abbreviations, punctuation, dialect differences, scribal idiosyncrasies, and decorative or illustrative programs. These ten plates are not intended to take the place of a full-scale textbook devoted to paleography in Middle English (for two admirable and strongly recommended examples suitable for beginners, see Petti 1977 and Roberts 2005). Rather, the plates offered here serve as a succinct overview of common fourteenth- and fifteenth-century vernacular scripts, and a reference point for script names used elsewhere in the book. Since terminology for scripts differs significantly among paleographers, here we follow the terminology established by Malcolm Parkes's *English Cursive Book Hands* (1979), which has been the most influential in Middle English manuscript studies to date. (See Roberts 2005, 161 and 211, for helpful conversion charts to other standardized terminologies the student might encounter.)

Students who prefer to start with more familiar late fourteenth-century Middle English language, and defer tackling more difficult cursive hands until later, might prefer to do the plates in this order, beginning with the *Anglicana formata* ones:

Plates 4 and 5 (two famous early Chaucer scribes,
 Scribe B/Adam Pinkhurst and Scribe D)
Plate 3 (*The Pricke of Conscience*)
Plate 8 (Douce *Piers Plowman*)

The *Textura* hands represented here (*prescissa*, *quadrata*, and *semiquadrata*)[1] might make up the next easiest group for beginners and could be tackled in this order (that is, in the order of rising linguistic difficulty):

Plate 6 (Wycliffite sermon) — *quadrata*
Plate 2 (religious lyric, "Ihesu Swete") — *prescissa*
Plate 1 (satire, The *Land of Cokaygne*) — *semiquadrata*

Finally, the student could tackle the fifteenth-century cursive hands[2] (the developing Secretary hand, often mixed with *Anglicana cursiva* features), in this order of rising difficulty:

Plate 7 (Scribe E/ Thomas Hoccleve)
Plate 10 (morality play, *Wisdom*)
Plate 9 (romance, *Sir Degrevant*)

Perhaps the hardest hand here is also one of the latest and most intriguing, the amateur hand of a female scribe copying *Sir Degrevant*. It is included here partly to foreground the fact that scribes were not always professional nor always male.

1. For Gothic *textura rotunda*, the fourth and last type of *textura* hand, see fig. T1 above, the text of the *Credo* and *Pater Noster* from MS Arundel 292. I thank Theresa O'Byrne and Nicole Eddy for their meticulous help in proofreading and formatting these front plates, and Linda Olson for contributing plates 9 and 10.

2. For a standard example of fourteenth-century cursive *Anglicana*, see ch. 1, figs. 4 through 8, from Harley 2253.

LITERARY TEXT	SCRIPT	DATE	SHELFMARK
1. Satire, *The Land of Cokaygne*	Gothic *textura* (or *textualis*) *semi-quadrata*	1320s–30s	London, British Library, MS Harley 913
2. Religious lyric, "Ihesu Swete"	Gothic *textura* (or *textualis*) *prescissa media*	s. xiv[3]	Chicago, IL, Newberry Library, MS 31
3. *The Pricke of Conscience*	*Anglicana formata*	s. xiv[4]	Chicago, IL, Newberry Library, MS 32.9
4. Geoffrey Chaucer's "Cook's Tale" (Hg)	*Anglicana formata*	c. 1390–1405?	Hengwrt MS, Aberystwyth, National Library of Wales, Peniarth MS 392 D
5. Geoffrey Chaucer's "Cook's Tale" (Cp)	*Anglicana formata*	c. 1390–1405?	Oxford, Corpus Christi College, MS 198
6. Wycliffite sermon, *Omnis plantacio* (formerly *The Clergy May Not Hold Property*)	Gothic *textura* (or *textualis*) *quadrata*	s. xv.in.	San Marino, CA, Huntington Library, MS HM 503
7. Thomas Hoccleve's "Chanceon to Somer" and Envoy to *Regiment des Princes*	Secretary (*secretaria formata/ facilis*) and Bastard (*secretaria hybrida*)	s. xv[1]	San Marino, CA, Huntington Library, MS HM 111
8. William Langland, *Piers Plowman*	*Anglicana formata*	1427	Oxford, Bodleian Library, MS Douce 104
9. Romance, *Sir Degrevant*	Informal cursive script blending *Anglicana* and Secretary forms	mid-fifteenth century	Findern MS, Cambridge, University Library, MS Ff.1.6
10. Morality play, *Wisdom*	*Anglicana cursiva* with Secretary features	s.xv[4]	Macro MS, Washington, DC, Folger Shakespeare Library, MS V.a.354

1. *The Land of Cokaygne*

KATHRYN KERBY-FULTON

MS: London, British Library, MS Harley 913 (traditionally known as the Kildare MS), fol. 3r, opening of the poem

SCRIPT: Gothic *textura* (or *textualis*) *semiquadrata*

DATE: 1320s–30s

INTRODUCTION

The Land of Cokaygne is a brilliant goliardic satire, surviving uniquely in MS Harley 913 (fols. 3r–6v), a compendium full of satirical writing and the jewel in the crown of fourteenth-century Anglo-Irish literature.[1] The manuscript, moreover, bears precious witness not only to the vitality of contemporary colonial writing but also to Middle English poetry itself during decades when relatively little survives even in England. Several poems in the manuscript deal with Irish concerns or places (Moore counts fifteen such poems in total), including the "Song" composed by "Frere Michel Kyldare" (fol. 10), which originally gave the manuscript its traditional name. It is now, however, thought to have had Waterford provenance as suggested by a surviving ownership inscription of George Wyse, mayor of Waterford in 1561. Moreover, the close textual connections of MS Harley 913 with another collection of Irish materials (BL Lansdowne 418) made by Sir James Ware (d. 1632) support Harley's associations both with Waterford and New Ross. Ware refers there to "a small old book . . . called the Book of Rosse, or of Waterford," which scholars believe to have been our manuscript (Lucas 1995, 17). The presence of Franciscan convents in each of these places, together with the general Franciscan penchant for gathering vernacular lyrics for preaching, may account for MS Harley 913's compilation. Other well-known poems in the collection concerning Ireland include the parodic eulogy, "Pers of Birmingham" (Pers died in 1308 and was buried at the Grey Abbey, Kildare); the hilariously irreverent "Satire" (incipit "Hail seint Michael") on the foibles of saints, religious orders, and town artisans (which mentions Drogheda), and the poem about the spirited cooperative fortification of an Anglo-Irish city, "The Retrenchment of New Ross," in which all social groups, even women, help build the wall.

Cokaygne is markedly different in tone and sophistication from its Old French analogue, the much tamer *Le Fabliau de Coquaigne*, which the poet may have known; like the Latin song in *Carmina Burana*, which also contains an "abbot of Cokayne" (abbas Cucaniensis), and like the "Abbot of Gloucester's Feast" later in the manuscript, the poem portrays monastic misbehavior with hilarity. MS

TRANSCRIPTION

Fur *in* see bi west spayngne .
is alond ihote cokaygne .
þ*er* nis lond vnd*ir* heuen riche
of wel of godnis hit iliche .
5 þoȝ p*ar*adis be miri a*nd* briȝt .
cokaygn is of fairir siȝt .
what is þ*er* i*n* p*ar*adis .
bot grasse a*nd* flure a*nd* grene ris .
þoȝ þ*er* be ioi a*nd* gret dute .
10 þ*er* nis met bote frute .
þ*er* nis halle bure no bench*e* .
bot watir man is þursto qu*enche* .
beþ þ*er* no men bot two .
Hely a*nd* enok al so .
15 elinglich mai hi go .
whar þ*er* woniþ men no mo .
¶In cokaigne is met a*nd* drink .
wiþ vte care . how a*nd* swink .
þe met is tr*ie* . þe drink is clere .
20 to none . russin a*nd* sopper .
i sigge for soþ boute were .
þ*er* nis lond on erþe is pere .
vnd*ir* heuen nis lond iwisse .
of so mochil ioi a*nd* blisse .
(lines 1–24)

Harley 913 itself also includes an analogue in the *Missa de Potatoribus* (drinkers' mass).[2] *Land of Cokaygne* is unusual in its comic use of the Earthly Paradise, which, the poet tells us (see lines 22–24), surpasses Heaven itself, portrayed as dull and dour. Its frank anecdotes later in the poem about antics in a mythical abbey and nearby nunnery give it the risqué quality for which this most famous of fourteenth-century Anglo-Irish poems is known. Gaelic-Irish diction is evident (e.g., in this extract "russin," meaning a light meal, line 20), as are Middle Hiberno-English (MHE) dialect features: for example, word separation for a genitive ending: *man is* = *manis* (ModE *man's*), line 12; and "ir" spellings for "er" (e.g., "watir," line 12).[3] Seventeenth-century foliation indicates that the manuscript's original first page was likely this one; now a single bifolio con-

1. See Thompson 2007, Hatfield Moore 2001, and for an accessible edition, Bennett and Smithers 1966.

2. See Bennett and Smithers 1966, 137–38, on the poem's analogues both in MS Harley 913 and elsewhere.

3. For a full description of MHE dialect, see McIntosh and Samuels 1968.

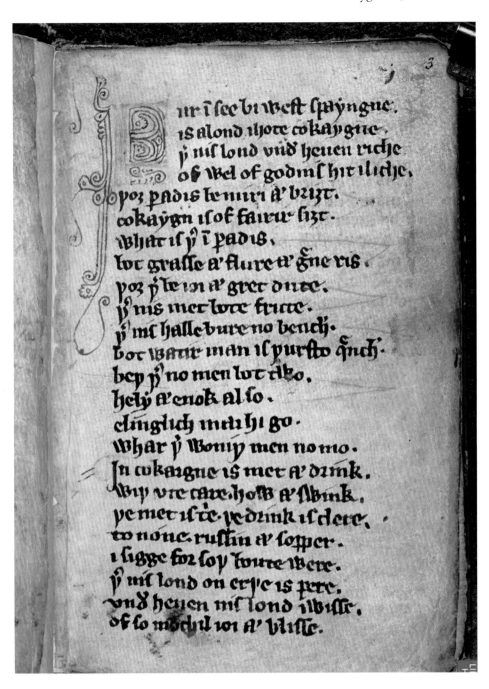

taining only a Latin text ("The Significance of the Letters of the Alphabet") precedes it. The scribe's compiling habits over a stretch of time are reflected in the manuscript's complex collation and in his pricking and ruling practice, which varies according to what he thought a particular text required.[4]

CHARACTERISTICS OF THE HAND

The scribe responsible for copying and probably gathering most of the texts in the Kildare Manuscript writes most often in a Gothic *textura* (or *textualis*) *semiquadrata*, mixed with *Anglicana* forms (such as the 8-shaped **g** visible in the word "cokaygne," line 2). However, in copying three indulgence texts into the manuscript (fols. 24v–26), he employs "a competent *Anglicana currens*, small and heav-

ily abbreviated."[5] The influence of this script can be seen in the present plate in the height of **a**, which often rises above other letters, a feature of earlier fourteenth-century *Anglicana* but not of *textura semiquadrata*. Even though the two-compartment *Anglicana* **g** appears, the *Anglicana* two-compartment **d** does not. *Semiquadrata*, like *textura quadrata* (see front plate 6 of San Marino, Huntington Library, MS HM 503) is a squarish script: both kinds of *quadrata* are also known as *fracta* or *fractura* because of their fractured or broken letter forms made without curves, and "with lozenged serifs at an oblique angle at the head and feet of

<hr />

4. See Lucas and Lucas 1990; and Hatfield Moore 2001, 326n1.

5. See Benskin 1990; Hatfield Moore 2001, 327.

most uprights" (Petti 1977, 13). *Semiquadrata* or *semifractus* "usually has the lozenge serifs at the head but not at the feet, which generally end in a slight angle, hook or curl" (ibid.). This can be seen in MS Harley 913, for instance, in the treatment of 2-shaped **r** appearing after rounded letters (e.g., "drink," line 19) or in the other *semiquadrata* **r** form ("Fur," line 1). Biting is also frequent (e.g., lobes of **b** and **o**, "bot," line 8).

Abbreviations and Orthography

The scribe correctly dots **y** to distinguish it from **þ**. Standard abbreviations appear for minims (e.g., i*n*, line 1), for *er* (e.g., þ*er*, line 3), for *ar* (p*ar*adis, line 5), for *ue* (q*ue*nch*e*, line 12). Unusual, as Roberts notes (169), is the use of the Latin abbreviation for *autem* to represent *and*. I have preserved MHE word separation in transcribing.

Punctuation

Very little, but the poet uses a *punctus* at the end of nearly every line and sometimes within a line to mark a caesura.

Decoration

Decoration is minimal and includes a four-line initial in red, enhanced by black ink flourishing. Paraph marks and brackets denoting couplet rhyme are in red ink, though now fading.

Bibliography

Bennett and Smithers 1966; Benskin 1990; Hatfield Moore 2001; Lucas 1995; Lucas and Lucas 1990; McIntosh and Samuels 1968; Thompson 2007.

2. "Ihesu swete"

Kathryn Kerby-Fulton

MS: Chicago, IL, Newberry Library, MS 31, fol. 135r, opening of poem

SCRIPT: Gothic *textura* (or *textualis*) *prescissa media*

DATE: s.xiv³

INTRODUCTION

"Ihesu swete" is a love poem to Christ (*IMEV* no. 1743.3), anticipating at different points both Julian of Norwich's treatment of the Passion and William Langland's penchant for fleeting, lyrical allegory (e.g., lines 5 and 7 below). In this romantic form of affectivity Christ is imag-

ined, for instance, as having his arms spread for "cleppyng" (embracing), his head bowed for "kyssyng" and his side opened "to loue schewyng." The poem (on fols. 135–136v) is one of two Middle English religious lyrics appearing in this manuscript, which otherwise contains Latin devotional works by writers such as Richard Rolle, Bernard of Clairvaux, Pseudo-Bonaventure, and William of Rymington. Saenger notes in his *Catalogue* description that the manuscript was likely written during Rolle's lifetime (52–53), referring especially to the first booklet of the manuscript (fols. 1–73), which is ruled differently and written in

TRANSCRIPTION

Ihesu swete his þo loue of þe
Non oþur þynge so swete may be[1]
Al þat .I. [2] may wyt heun[3] se
To hafwn a swetnes lorde to þe
5 No songe nys murwor
No no þoth in herte blysfulore
No no pyment swettur
No no þynge þat makut me staluyere
Ihesu my loue ihesu my lyth
10 I wolo[4] þe loue and þat is ryth
Do me þe loue wyt al my myth .
And for þe mowron day and^e^[5] nyth
Ihesu do me so to loue þe
Þat my þout euere on þe be [.][6]
15 Wyt þy suete syth þou loco[7] on me
Þat .i. of synne euere be fre
Ihesu þy loue be alle[8] my þouth .
Of oȝur[9] þynge rekke me noth
Bote þe to loue þat hast me ^i^ wroȝth .
20 And dere op on þe rode .I. bouth[10] .

1. Note that the scribe does correctly distinguish þ and **y** in this line but not before or afterward. I have silently corrected his usage throughout.

2. The pronoun "I" here and "i" below are treated like the Roman numeral "i" in Latin, with the *punctus* on either side. The scribe seems much more comfortable in Latin: compare, for instance, the facing page, 134v, the end of William of Rymington's *Stimulus peccatoris*, with this one (135).

3. For ME "eyen."

4. For ME "wole," which the scribe reads as Latin "volo"? See "Abbreviations and Orthography" below.

5. A minute superscript *e* (visible with magnification) is written after the symbol for *and*. It appears to be a correction for metrics.

6. The punctus here is uncertain owing to a blotch.

7. For a ME form of "look," as Robbins shows (1940), 321.

8. Oddly abbreviated but perhaps "al*le*" for metrics.

9. For ME "oþer" mistaking yogh for thorn.

10. The crossed *o* appears to be a corrected error.

a different hand (early s.xiv *Anglicana formata*). The second booklet (fols. 74–136), which contains our poem, is written somewhat surprisingly in Gothic *textura prescissa media*, normally a much earlier script (see "Characteristics of the Hand" below), but likely datable here at least to the third quarter of the fourteenth century because of the presence of the Cistercian William of Rymington's works (fl. 1358–1384).[11] The manuscript has a medieval press-mark indicating that it came from the parochial library of Whitchurch, Hants; it is very small, measuring 152 × 114 mm (Saenger 1989, 53), and may have been used as a cleric's or friar's vade mecum book. (Preachers of both kinds used vernacular religious lyrics for homiletic purposes.) The poem transcribed here is based on a famous Latin text, *Jesu dulcis memoria*, and also appears in Middle English in BL Harley 2253 and University of Glasgow, Hunterian Library, MS 512 (Gray 1975, #47). R. H. Robbins commented that collections of the Newberry 31 type, mixing Latin and English lyrics "as an integral part of the whole are not all that frequent" (1940, 329). In fact, the scribe has a great deal of trouble with the Middle English: see "Abbreviations and Orthography below," and see Robbins 1940 for an edition from this manuscript and dialect analysis.

CHARACTERISTICS OF THE HAND

The hand in the portion of the manuscript containing the two lyrics, the Pseudo-Bonaventure and the William of Rymington, departs from the *Anglicana formata* of the other texts and presents a Gothic *textura prescissa media*, which Saenger notes "appears to be a conscious imitation of proto-gothic script of the twelfth century, consistent with the presence of hard-point ruling in this portion" (1989, 53). The same spirit of conscious archaism also appears to have been used to copy the works of the *Gawain* poet during about the same period.[12] Gothic *textura* scripts, of which there are four styles in total, are graded according to how minims are made. The *prescissa* (or *praescissa*), like the *quadrata* forms of Gothic *textura,* are the formal styles

of the script (for an instance of *quadrata* see front plate 6 below). As Roberts explains, "the feet are entirely cut off in *littera prescissa*, which has therefore the alternative description *sine pedibus* (without feet). This, the earliest of the four types, is a highly formal script, much used in psalters." Among the letter forms distinctive to Gothic *textura*, as Roberts summarizes them, are the following: the **a** (in contrast with Protogothic) is now closed, the round form of **r** is found after many bowed letters (murwor, line 5), round **s** replaces the straight **s** in final position (swetnes, line 4), and round **d** becomes common. The Tironian sign for *and* (Latin *et*) also has a bar.

ABBREVIATIONS AND ORTHOGRAPHY

There are very few abbreviations, most conventional. "Ihesu" is repeatedly abbreviated in a commonplace way with a curled brevigraph proceeding from the ascender of the **h** (Ih*e*su, line 1); also sometimes abbreviated are final *e* (e.g., in lord*e*, line 4 or song*e*, line 5), *n* (i*n*, line 6), *at* (þ*at*, line 19), and the Tironian symbol for *and* (line 12). In contrast, the scribe's orthography is highly unusual: R. H. Robbins noted that the poem is written in a South West Midlands dialect, yet the scribe frequently writes **o** for unaccented final **e**, creating strange forms like "blodo" or "godo"—seen in the transcription above in "loco" (line 15). Moreover, he does not understand the distinction between **þ** and **y** (traditionally dotted); in the second line of the poem, which he must have copied letter by letter from his exemplar, he gets it right, but elsewhere, thorn and **y** are indistinguishable, and *both* dotted! Moreover, he confuses yogh and thorn (see line 18, n. 10), and sometimes appears to mistake Middle English forms for Latin ones (see notes to lines 3 and 10 above). One can only assume that the scribe had little or no experience copying Middle English, which, given the date of this manuscript and its clerical contents, is plausible.

PUNCTUATION

None to speak of, but there is a *punctus* on either side of **I** or **i** (see line 3, n. 2), and a *punctus* at the end of some lines, such as 19 and 20.

DECORATION

The only rubrication is a two-line initial in red ink. Rhyme brackets, which have faded, are partially supplied in brown ink.

BIBLIOGRAPHY

IMEV; Gray 1975; Robbins 1940; Saenger 1989.

11. Paul Saenger has kindly informed me that he does not see "any reason to state that the second hand is not contemporary with the first; note the change of hand comes within a gathering. Today I would be inclined to date the binding as contemporary with the texts; and to suggest that it was restored in the second half of the fifteenth century (when the paper fly leaves would have been added)." Private communication, March 22, 2010.

12. Roberts 2005, 170 and plate, describing the hand of the *Gawain* Manuscript as Gothic *textura rotunda media*, s.xiv ex. On this manuscript, see ch. 1, sec. III.

3. *The Pricke of Conscience*

KATHRYN KERBY-FULTON

MS: Chicago, IL, Newberry Library, MS 32.9, fol. 2r,
opening of the poem

SCRIPT: *Anglicana formata*

DATE: s.xiv[4]

INTRODUCTION

The Pricke of Conscience, one of the most popular Middle
English poems of the later Middle Ages, was originally
composed c. 1350 in the north of England. For a long time
attributed to Richard Rolle (as, for instance, in Lydgate's
Epilogue to his *Fall of Princes*), it survives in over a hundred
manuscripts, outnumbering even the extant manuscripts
of Chaucer's *Canterbury Tales* and representing all major
dialects (see Lewis and McIntosh 1982). Among Middle
English texts, only the Wycliffite Bible is extant today in
more copies. This long poem concerning salvational issues
and the Last Judgment is ostensibly addressed to the un-
learned ("lewed men that er unconna[n]d") and those who
"can no Latyn undurstand."[1] Many copies, however, con-
tain a Latin commentary, and the work was translated into
Latin, perhaps because of its "unusual attention to up-to-
date theological detail" (Wogan-Browne et al. 1999, 241).
MS Newberry 32.9 is written on parchment and savagely
trimmed to 195 × 132 mm, cropping part of its elegant dec-
oration. The poem is written here in long lines of poetry,
about 26–31 lines per page, in a Midlands dialect possibly
Northamptonshire (Lewis and McIntosh 1982, 49). The
manuscript was bound c. 1540 in London and is currently
made up of two booklets with a collation as follows: 1–9[12],
10[6]. Though now paginated separately, the booklets were
written in the same hand and have the same rubrication:
the first containing the *Pricke of Conscience* (quires 1–9) and
the second a *Lapidarye* (quire 10) attributed to "Philippe
kynge of Ffraunce" (Philip the Fair), on the magical prop-
erties of stones and their virtues (Keiser 1984b). Saenger
notes, however, that under ultraviolet light one can see
reference to a third text listed in the table of contents of
s.xvii on the verso of the front cover called "Rebianus (sic)
concerning the beginning of the world" (Saenger 1989,
58), now lost. Together these texts once made for a hand-
some medieval collection on the history of the world and
its properties.

1. For an edition of the Prologue, see Wogan-Browne et al.
1999, 243, lines 11–12.

CHARACTERISTICS OF THE HAND

This manuscript is written in an *Anglicana formata* hand,
with the characteristic clarity, regularity, and roundness
of that script, although especially in the first section of
the opening page the script "approaches bastard *Angli-
cana*," a short-lived attempt at more formality (Saenger
1989, 58); see, for instance, the single-compartment **d** in
"goodnesse," line 3; the squarish treatment of **h** and **e**, in-
cluding hairline decoration in "mighte" (line 1) and the
formal treatment of **r** ("fader," line 1). This degree of for-
mality, however, is not sustained even on this page, and
the scribe soon slips into more comfortable standard fea-
tures of *Anglicana formata* (e.g., in the two-compartment **g**
and **d** ("good," line 8), the less squarish two-compartment
a (e.g., "alle," line 8). Other standard features of *Anglicana
formata* can be seen here in the roundness of the minims,
with curved or hooked foot serifs or links at both ends,
and ascenders with rounded ends. Two-compartment
a is about the same height as the other letters, typical in
later fourteenth-century *Anglicana formata* (contrast front
plate 1, MS Harley 913). A wide variety of initial **s** can be
seen: long **s** ("specially," line 7), sigma **s** ("shulle," line 11), a
more formal version of long **s** ("same," line 12). Other typ-
ical *Anglicana* features are the broken, squarish 8-shaped
s often used in final position ("my3tes," line 4), and the
2-shaped **r** appearing most often after **o** ("lord," line 4).

ABBREVIATIONS AND ORTHOGRAPHY

These include brevigraphs for *er* (eu*er*e, line 12); for *e* (ma-
ner*e*, line 18); the Tironian *et* sign for *and* (which looks
like a crossed 7 with a bar over it, line 4); a bar indicat-
ing the need for a minim or minims (e.g., i*n*, line 13 and
substau*n*ce, line 17). Syllable separation occurs in certain
words (e.g., be gynnynge, line 7) and the *y* is occasionally
dotted (my3ty, line 23).

PUNCTUATION

The minimal punctuation includes a *punctus*, at the end
of a hairline after *Amen* (line 8) and the large red brackets
provided by the rubricator at the end of the lines, indicat-
ing rhyming couplets.

DECORATION

The text begins with an illuminated initial three lines
high, blue and rose-colored with white highlighting on
a gold background, and terminals ending in swirling pat-
terns. A full bar border in gold is also decorated with al-
ternating sections of rose and blue bars from which single
leaves in the same colors project. From the interlace knots

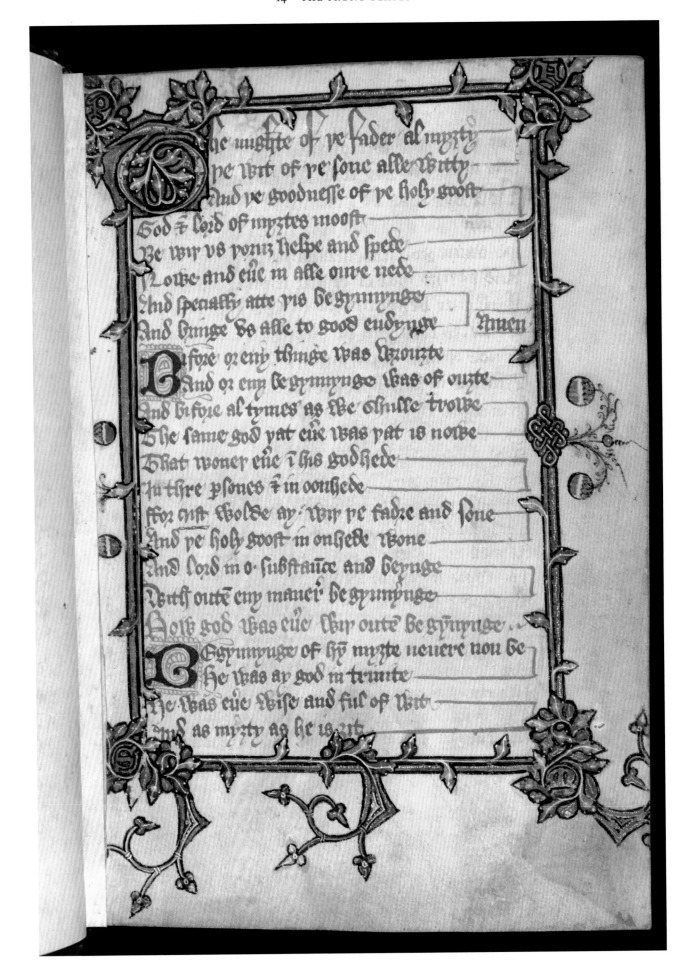

TRANSCRIPTION

The mighte of þe fader al myȝty
þe wit of þe sone alle witty
And þe goodnesse of þe holy goost
God *and* lord of myȝtes moost
5 Be wiþ vs þoruȝ helpe and spede
Nowe and eu*ere* in alle oure nede
And specially atte þis begynnynge
And bringe vs alle to good endynge Amen .
Bifore or eny² thinge was wrouȝte
10 And or eny begynnynge was of ouȝte
And bifore al tymes' as we shulle trowe
The same god þat eu*ere* was þat is nowe
That woneþ eu*ere* i*n* his godhede
In thre p*ersones and* in oonhede
15 For <u>crist</u>³ wolde ay ⁊ wiþ þe fadre and sone
And þe holy goost in onhede wone
And lord in o . substau*n*ce and beynge
Withe oute*n* eny maner*e* begynnynge
How god was eu*ere* wiþ oute*n* begy*n*nynge . .
20 **B**Egynnynge of hy*m* myȝte neuere non be
He was ay god in trinite
He was eu*ere* wise and ful of wit
And as myȝty as he is ȝit

on either side midway down spring two daisy buds with green calyxes and closed rose-colored petals, on feathered stems with a green wash, separated by "ball and squiggle" motifs. Gold initials in the middle of the swirling blue and rose patterns at each corner are set in green medallions, and read clockwise: P, A (or F), M, S. It is not known to whom or what these initials refer, but it is possible that the manuscript may have been prepared for a married couple. The foliate sprays have been badly cropped, but we are still able to see extending from the bottom border sprays blue and rose-colored trefoils on gold triangular panels, visually echoing, as Maidie Hilmo notes, the arced edge at the top of the illuminated initial which opens the text, as well as the Trinitarian theme of the text itself. Typical features of the period include the "ball and squiggle" motifs and the daisy buds, the latter usually suggesting a date prior to 1400 or close to it. A nearly identical border to the Newberry one in BL Harley 401, dated 1396, is described by Kathleen Scott: "the daisy bud motif is typical of later 14th century borders, more usually as pairs on a sprig. . . . The calyx of the buds is of a wash green, with rose used at the tips of the unopened petals" (2004, 28).

BIBLIOGRAPHY
Keiser 1984b; Lewis and McIntosh 1982; Raymo 1986; Saenger 1989; Scott 2004.

2. Read here a dotted **y** (as in "begynnynge," line 18), though most are left undotted by this scribe, so another plausible reading is "eu*ery*." The "eny" in line 10 is undotted.

3. Underlined in black ink by a later hand.

4 and 5. Geoffrey Chaucer's "Cook's Tale" (two versions)

Kathryn Kerby-Fulton

MS: (first) Aberystwyth, National Library of Wales, Peniarth MS 392D (*olim* Hengwrt MS 154), fol. 57v; (second) Oxford, Corpus Christi College, MS 198, fol. 62r, both showing the end of the tale

SCRIPT: *Anglicana formata*

SCRIBES: (first extract) Adam Pinkhurst/Scribe B of Trinity Gower; (second extract) Scribe D of Trinity Gower[1]

DATES OF BOTH: c. 1390–c. 1405, with Hengwrt perhaps earlier than Corpus

INTRODUCTION

Chaucer apparently left the *Canterbury Tales* unfinished, and even the earliest extant copies, including the two represented here, show various scribal attempts to handle the inconclusive "Cook's Tale" (whether or not Chaucer meant it to be dramatically unfinished remains unclear).[2] Here we see two strategies: in Hengrwt (Hg) Linne Mooney identified Scribe B as Chaucer's scribe, Adam Pinkhurst,[3] who wrote this ending on the eighth leaf of quire 8 and left space presumably in case further copy arrived (front plate 4). When it did not, he wrote "Of this Cokes tale | maked Chaucer na | moore" in a different ink, likely at a later date. Various interpretations of this note have been offered (see ch. 1, sec.V below), but it does not necessarily mean Chaucer was already dead. Corpus (Cp) shows a different strategy altogether (front plate 5), and one found in many copies of the *Tales*: the addition of the spurious romance of *Gamelyn*, in which a younger son of a knight is maltreated by his older brother and turns outlaw to win back his share of the inheritance. Given the early and relatively authoritative nature of Scribe D's Cp manuscript, the question arises whether *Gamelyn* was somehow found among Chaucer's own papers. The jarring literary and social class shift from the fabliau genre of the "Cook's Tale" (which ends abruptly while describing a wife who runs a shop as a front for a brothel) to the formulaic romance opening of *Gamelyn* would appear an odd solution were it not for the fact that both tales portray a protagonist act-

ing illegally, and the fact that Gamelyn is ordered at the outset to be his brother's cook—provoking the moment of his rebellion. "Revel," rebellion, and cookery seem to have been the themes inspiring this substitution. Hg, as the earliest known copy of the *Tales*, has been extensively studied and shows a great deal of experimentation in layout, tale ordering (see ch. 1, sec.V), and incorporation of glosses (see ch. 4, sec.1). Cp, as Estelle Stubbs has shown, also shows internal changes in decoration patterns and tale ordering, perhaps to accommodate shifts in exemplars reflecting ongoing changes by Chaucer. It is not impossible that Cp, like Hg, was at least begun during Chaucer's lifetime, even if it was finished closer to 1405.

CHARACTERISTICS OF THE HANDS

The hand of Scribe B, probably if not certainly Adam Pinkhurst, in Hengwrt is a large, clear hand with characteristically thick strokes and narrow spaces between words, and little indication of Secretary influence (apart from some of his side notes in Latin, not visible here).[4] As Doyle and Parkes note, either the scribe or his director

TRANSCRIPTION

Excerpt from Hengwrt, fol. 57v[5]

Ther fore / his maister gaf hym acquitaunce
And bad hym go / with sorw / and *with* meschaunce
And thus this ioly prentys / hadde his leeue
Now lat hym riote / al the nyght / or leeue
5 And for ther nys no theef / with oute a lowke
That helpeth hym / to wasten and to sowke
Of that he brybe kan / or borwe may
Anon / he sente his bed / and his array
Vnto a compeer / of his owene sort /
10 That loued dees / and reuel / and disport /
And hadde a wyf / that heeld for contenaunce
A shoppe / and swyued for hir sustenaunce

Of this Cokes tale
maked Chaucer na
15 moore

1. Cambridge, Trinity College, MS R.3.2; see preface above on the Doyle and Parkes 1978 study identifying these scribes. On the Pinkhurst identification, see Mooney 2006, and see below, ch. 1, p. 81, on acceptance of the attribution and some disputing opinion. Linne Mooney and Estelle Stubbs have also proposed that the identity of Scribe D is John Marchaunt: see below, ch. 1, p. 40 (n. 4) and p. 70.

2. For more detailed discussion of these manuscripts in relation to other early *Tales* manuscripts, see ch. 1, sec.V.

3. Mooney 2006.

4. See, in addition to Doyle and Parkes 1987, Petti 1977, 47, and Mooney 2006 for fuller descriptions.

5. Lines equivalent to *Riverside Chaucer*, Fragment I, 4411–22, where the base text is the Ellesmere MS.

His maister shal it in his shoppe abye
Al haue he no part of the mynstralcye
For thefte and riot they been convertible
Al konne he pleye on giterne or Ribible
Reuel and trouthe as in a lowe degree
They been ful wrothe al day as men may see
This ioly prentys with his maister bood
Til he were neigh out of his prentishood
Al were he snybbed bothe erly and late
And som tyme lad with reuel to Newegate
But atte laste his maister hym bithoghte
Vp on a day whan he his papir soghte
Of a prouerbe that seith this same word
Wel bet is roten appul out of hoord
Than þt it rotie al the remenaunt
So fareth it by a riotous seruaunt
It is ful lasse harm to lete hym pace
Than he shende alle the seruantz in the place
Ther fore his maister gaf hym acquitaunce
And bad hym go with sorwe and wt meschaunce
And thus this ioly prentys hadde his leeue
Now lat hym riote al the nyght or leeue
And for ther nys no theef with oute a lowke
That helpeth hym to wasten and to sowke
Of that he brybe kan or borwe may
Anon he sente his bed and his array
Vn to a compeer of his owene sort
That loued dees and reuel and disport
And hadde a wyf that heeld for contenaunce
A shoppe and swyued for hir sustenaunce

Of this cokes tale
maked Chaucer na
moore

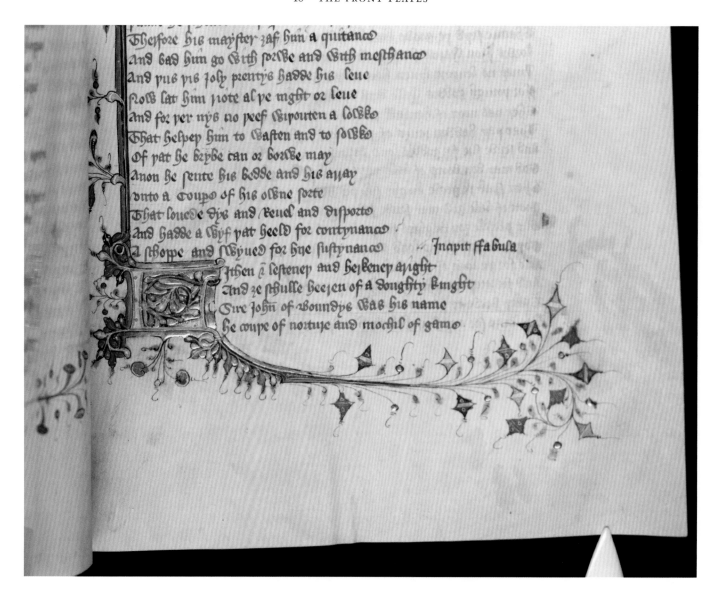

felt that the traditional *Anglicana formata* script was more appropriate to vernacular book production than the Secretary script just coming into fashion.[6] Scribe B writes a standard *Anglicana formata* script (note that the minims have "feet"), the main features of which include: a two-compartment **a** (earlier in the century, extending even further above the other linear letters, a trait still visible here in "bad," line 2 of boxed extract), **d** with a looped ascender, a two-compartment form of **g** (figure 8 in shape, "gaf," line 1), a long forked **r** often with a steep shoulder ("riote," line 4), and (most usually) a form of **w** resembling two looped **l**s and a **3** ("sowke," line 6). One telltale idiosyncrasy (although there are not many) of Scribe B/ Pinkhurst's hand is a tendency to add a downward hairline to the cross stroke of final **t** ("nyght," line 4) which apparently doubles as a virgule here; these are not abbreviations and the metrics of Chaucer's line tell us that a final "e" would be unnecessary in these cases, so they have been read here as a virgule in such cases.

In Corpus, the hand of Scribe D, the most prolific known copyist of Ricardian literature, has been called the "classic Middle English hand."[7] His is a lovely *Anglicana formata*, that, as Petti notes, is rounder and smaller than Pinkhurst's (Petti 1977; Doyle and Parkes 1987). His **a** barely rises above the bodies of the other letters, suggesting that he was trained later in the century than Pinkhurst (who must have been older). His **a** and his **e** are also more pointed, suggesting slight Secretary hand influence, visible, too, as Petti notes, in his French cursive "B" form of **s** ("his," line 1). Two further distinctive features of Scribe D's hand are the right hand curl of his **y** (always dotted; "mayster," line 1) and the fulsome leftward curl below the line of his **h** ("his," line 1).

6. *Hengwrt Facsimile*, xxxiv–xxxv.

7. Derek Pearsall's phrase (2004, 81); see ch. 1 below, n. 105, for a full list of manuscripts.

Transcription

Parallel Excerpt from Corpus 198, fol. 62

Therfore his mayster ȝaf him a quitance
And bad him go with sorwe and with meschance
And þus þis Ioly prentys hadde his leue
Now lat him riote al þe night or leue
5 And for þer nys no þeef wiþouten a lowke
That helpeþ him to wasten and to sowke
Of þat he brybe can or borwe may
Anon he sente his bedde and his array
Vnto a Conp*ere*[8] of his owne sorte
10 That louede dys and Reuel and disporte
And hadde a wyf þat heeld for contynance ⸴
A schoppe / and swyued for hire sustynaunce // Incipit Fabula[9]
LIthen *and* lesteneþ and herkeneþ aright
And ȝe schulle heeren of a doughty knight
15 Sire Joh*an*n of Boundys was his name
He couþe of norture and mochil of game

ABBREVIATIONS, ORTHOGRAPHY, AND PUNCTUATION

Pinkhurst uses relatively few abbreviations, and those are entirely commonplace: for instance, "w*ith*" (line 2), "p*ren*tys" (line 3). More interesting is his use of a faint virgule in midline (recorded in the transcription above), apparently inserted to aid the reader in knowing where to pause when reading Chaucer's poetry, and perhaps a hint that it was intended for reading aloud. Pinkhurst rarely uses **þ**, in contrast to Scribe D, who also uses **ȝ**. There are very few abbreviations in Scribe D's lavish manuscript, in keeping with criteria of plentiful space and ease of reading. The Tironian sign for *et* (and) is used once in the opening line of *Gamelyn* but in the same line is dropped in favor of full spelling out of "and." The *er* abbreviation appears in "Conp*ere*" (line 9, which is visibly capitalized, though midline, as are the words "Reuel" [line 10] and "Ioly" [line 3]—words the scribe apparently wanted to highlight). The scribe religiously dots **y** to distinguish it from **þ**, which he uses interchangeably with **th**. He prefers long **s** initially and medially in words, but the French cursive "B" form of **s** in final position (e.g., "sente," line 8, but "his" in the same line, or "mayster" in line 1).

DECORATION

In B/Pinkhurst's Hg, no decoration is visible in this extract, though there is one blue paraph further up the page. In Scribe D's Cp, there are well-executed three-sided gold borders, similar to those found on text pages in the Ellesmere Chaucer (see ch. 5). The four-line initial opening *Gamelyn* is pink with white highlighting, set on a gold ground, with swirling blue, rose, and pink foliage, which continues along the gold border. Gold ball and penwork "squiggle" motifs supplement the foliage decoration, some of the latter splashed in green. This decoration is typical c. 1400 (Scott 2004, 28).

BIBLIOGRAPHY

Corpus Christi College, Oxford, MS 198 Facsimile; Doyle and Parkes 1978; Kerby-Fulton and Justice 2001; Knight and Ohlgren 1999; Mooney 2006; Stubbs 2000.

8. Cf. "compeer" in Hengwrt above, meaning "peer" or "fellow."

9. Here *Gamelyn* begins; discussed ch. 1, sec. V; for a modern edition, see Knight and Ohlgren 1999.

6. *Omnis plantacio* (formerly *The Clergy May Not Hold Property*)

Kathryn Kerby-Fulton

MS: San Marino, CA, Huntington Library, MS HM 503, fol. 1r, opening of extended Wycliffite sermon

SCRIPT: Gothic *textura* (or *textualis) quadrata*

DATE: s.xv.in.

INTRODUCTION

The Wycliffite polemic that appears here in Huntington Library, MS HM 503 is a kind of extended sermon against clerical corruption. The Victorian editor, F. D. Matthew, printed a tract version of this text in 1880 under the title "The Clergy May Not Hold Property" from London, Lambeth Palace, MS 551, but its most recent editor, Anne Hudson, edits it under the title of its incipit, *Omnis plantacio*, as a long sermon. Both versions attack the vices of the clergy as an egregious departure from the sanctity and poverty of Christ and his disciples, and challenge the clerical right to hold temporalities on this basis. In this manuscript its controversial nature also attracted a great deal of marginalia in both Latin and English, some of it openly derisive (on fol. 11 for instance, next to the comment that while the clergy "stonden obstinate in þese synnes & mani mo þei doen no meedful (11v) dede toward euerlastinge liif" a marginal note reads "Fy"!). This text is also found in London, British Library, Egerton 2820, and Cambridge University Library, Dd.14.30 and Ff.6.2. Hudson's edition is based not on our manuscript, but on the Egerton manuscript, and the closely related copy in Dd. As Hudson first noted in 1978, the Egerton and Dd copies "are written in the same early fifteenth-century hand; these two and H[M 503], of a similar date, are very similar in format and probably derive from the same scriptorium."[1] This evidence of coordination in Lollard book production methods is very valuable, since the question of how the movement's texts were reproduced—that is, to what extent the process had to be surreptitious or whether it could at times be carried out in ordinary commercial ways—is still not fully understood by modern scholars (evidence of both processes survives).[2] Hudson dated the initial text of the sermon to a time before the death of Archbishop

1. Hudson printed an extract in 1978 under the title "Mendicancy," 93–96, collating HM 503, ff. 109v–122v, but not the portion transcribed here. She notes that her extract comes from after the last parallels of the two versions. Hudson describes HM 503 in her 2001 edition, xx. The online Huntington Library Catalogue description calls the text a tract, using the title *That the Clergy May Not Hold Property* (http://sunsite3.berkeley .edu/hehweb/HM503.html). I would like to thank Fiona Somerset for her advice about this text.

2. For a recent summary of scholarship regarding both types of Lollard book production, see Kerby-Fulton 2006, especially appendix A; for a classic treatment see Hudson's chapter, "Lollard Book Production," in Griffiths and Pearsall 1989.

3. Final *s* unclear, crammed in and apparently inserted over erasure along with "b*ut.*"

4. Continues on fol. 1v: "tene him þat wel doiþ," that is "main-tene" (maintain). I would like to thank Kathryn Veeman for checking this reading for me.

TRANSCRIPTION

> **In no[m]i[n]e p[at]ris et filii et sp[iritus] s[an]c[t]i ame[n] ;**
> **Omnis plantacio qua*m* no*n* planta =**
> **uit pater meus celestis eradicabitur //**
> **AL**miti god þe tri ¶ **Matteus . xvᵒ. /**
> 5 nite fadir *and* sone *and* hooli
> goost . boþe in þe oolde
> lawe *and* in þe newe haþ
> foundid his chirche vpon þre staa =
> tis ⁊ answerynge or acordeinge to
> 10 þese þre persoones *and* her propur =
> tees / so þat to þe fadir in trinite to
> whom is apropirid power ans =
> weriþ þe staat of seculere lordis .
> fro þe hiȝest kniȝt . þat is or schulde
> 15 be emp*er*our to þe lowest squier ⁊
> þat bi weie of office or of his sta =
> at beriþ þe swerid / for þis staat in
> hooli chirche seint poul **ad roma*n*os 13ᵒ .**
> calliþ powers . *and* seiþ þat þis pow [=]
> 20 er þe swerd ⟨:⟩ not wiþ out causes³ b*ut*
> to avenge þe wraþ of god in to hi*m*
> þat misdoiþ : *and* to supporte *and* main [=]⁴

Arundel in 1414 on the basis of a reference in another tract by the same preacher (Hudson 1978, 186), which is printed alongside *Omnis plantacio* in Hudson's 2001 edition. She points to internal references in the text suggesting that it was originally written for use by an itinerant Lollard preacher and notes that the audience would have been similar to the one William White taught and preached for in the Norwich area c. 1430: an audience, that is, full of laity and likely including women adherents, such as were documented in the Norwich trials.

One unusual aspect of this manuscript is that at the end of the sermon, in a hand of c.xv.med., there is a love poem copied on fol. 129v, beginning "Sche þat y luue alle þer moost *and* loþist to begile," and ending with the poet lying "loue sik in my bed y bed non oþer leche"—a delight-

ful pun on "bed."[5] The hand, though larger, is trying to imitate the formality of the main text and is not that of the annotator scandalized by the Lollard anticlericalism; that another Lollard reader or adherent may have added it is entirely possible and charming.

CHARACTERISTICS OF THE HAND

The scribe writes in a small *textura* (or *textualis*) *quadrata* script.[6] Like *textura semiquadrata* (see front plate 1 from MS Harley 913, *The Land of Cockaygne*), *textura quadrata* is a

5. See Greene 1961 for the entire text; Hudson identifies it as *IMEV*, 3098.5.

6. See Petti 1977, 13, or Roberts 2005, 141–42, for a full description of Gothic *textura* scripts (Roberts uses the term *textualis*).

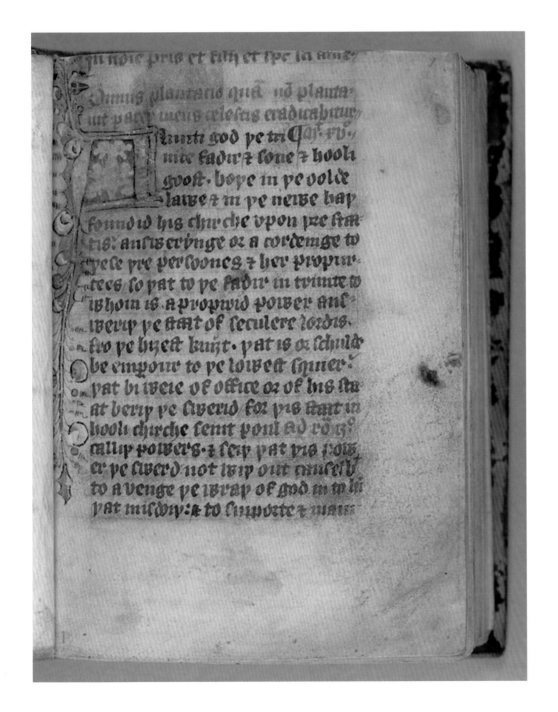

squarish script. Both kinds of *quadrata* are also known as *fracta* or *fractura* because of their fractured or broken letter forms made without curves, the *quadrata* characteristically appearing "with lozenged serifs at an oblique angle at the head and feet of most uprights" (Petti 1977, 13). These lozenged serifs are everywhere evident in MS HM 503, giving it a more formal appearance (note the treatment of the feet of the minims throughout (e.g., "tri-nite," lines 4–5). This script was often used, as here, where "ease of reading must have been a requirement, for there is none of the closeness that typifies so many professional hands," as Roberts notes describing another Wycliffite manuscript, the Glossed Gospels, also written in *textura quadrata* (BL, MS Add. 41175, dated c. 1400). Most features Roberts points out that promote ease of reading in Add. 41175 are equally present in MS HM 503: scarcity of bitings (mostly occurring in final **e** in **de** combinations such as "oolde," line 6, or "schulde," line 14); round **r** is restricted to following bowed letters (e.g., "þre," line 8); **u** and **v** are positionally distinguished (e.g., "vpon," line 8, but "out," line 20) as are long and round **s** ("staa-tis," lines 8–9). **3** and **þ** are both in use, but **þ** is used without an ascender, in keeping with the "tidiness" of the script (Roberts 2005, 180). See "Punctuation" below for further evidence that ease of reading was paramount in Wycliffite texts such as these.

PUNCTUATION

There is a fair amount of punctuation in this sermon, consistent with the potential for its oral performance, as well as for the private study indicated by the presence of biblical references inserted in the text in red ink. Among the marks used are the *punctus elevatus* (e.g., lines 9 and 15), which indicates a pause with the voice rising, and a *punctus versus*, which can indicate a stronger pause with the voice falling, here used to mark the end of a rubricated liturgical reference, line 1, and used consistently to mark the end of rubricated biblical quotations (e.g., fol. 10v).[7] Also occurring are colons in lines 20 (added in faint ink later by a corrector) and 22 (added at the time of writing), both used to signal that further new information is coming. There are numerous uses of the *punctus* (a single point), such as line 13, where a modern reader might find a pause awkward; or line 14, where it marks off a restrictive clause; or line 19, where it is used as a modern writer would use a comma. The text is thus heavily pointed (punctuated) compared to most of the other plates in this section, suggesting it was marked both for intelligent reading and for oral delivery.

ABBREVIATIONS AND ORTHOGRAPHY

The scribe carefully dots **y** to distinguish it from **þ**. He is comfortable in Middle English copying, including **3**, which he uses correctly (in contrast with the scribe of front plate 2). He consistently employs double dashes to indicate that further syllables of a single word will appear in the next line. Abbreviations are strikingly few on this page apart from the symbol for *and*, the "b*ut*" (which, however, may have been added over erasure and therefore crammed in line 20) and the minim abbreviation in "hi*m*" (line 21). The Latin, however, uses several abbreviations (cropped in line 1). This, too, points to the Middle English having been copied with clarity of reading in mind. *LALME* places H in Huntingtonshire; its dialect is analyzed by Hudson 2001, xxviiiff.

DECORATION

Like the Wycliffite Glossed Gospels mentioned above (Add. 41175) and many other extant Wycliffite texts, no shyness is evident in MS HM 503 about using professional, colorful decorative motifs and even gold.[8] There is an opening blue four-line initial infilled with a white vegetal motif on a rose pink ground. The floral spray contains fleshy multilobed leaves in blue and pink with white highlighting.[9] The initial, which has been heavily rubbed, suggesting a great deal of use, is set on a gold ground attached to the colorful floral spray also of gold. The spray is decorated with "ball and squiggle" ornamentation typical of this period of book production generally. The book measures a tiny 129 × 95 mm (which would have made it suitable for pocket carrying and even hiding), and is written on parchment with generous margins, though badly cropped at the top. Latin passages and authorities are in red, and blue paraphs are used throughout.

BIBLIOGRAPHY

de Hamel 2001; Greene 1961; Hudson 1978; Hudson 2001; Huntington Library Manuscript Catalogue, http://sunsite3.berkeley.edu/hehweb/HM503.html; Kerby-Fulton 2006.

───────

7. This may be seen online at the Huntington Library's link for MS HM 503 at http://dpg.lib.berkeley.edu/webdb/dsheh/heh_brf?Description=&CallNumber=HM+503.

8. See de Hamel 2001 on the "carriage trade" element amply evident in Wycliffite bible production.

9. See also the *Huntington Library Catalogue*, vol. 1, 240, MS HM 503 description.

7. Thomas Hoccleve's "Chanceon to Somer" and Envoy to *Regiment des Princes* (first stanza)

Kathryn Kerby-Fulton

MS: San Marino, CA, Huntington Library, MS HM 111, fol. 39v

SCRIPTS: primarily Secretary (*secretaria formata/facilis*) for text, Bastard (*secretaria hybrida*) for heading

SCRIBE: Thomas Hoccleve

DATE: s.xv[1]

INTRODUCTION

Thomas Hoccleve, the hand Doyle and Parkes designated as Scribe E of the Trinity Gower, naturally follows any study of his coworkers on that project, Scribes B and D (see front plates 4 and 5). Famous in his own right as a poet and disciple of Chaucer, Hoccleve was a younger man than Pinkhurst, which we know from life records but might guess from his use of the newer Secretary script for vernacular books, a script he would have learned in his work at the Privy Seal (see ch. 1, sec.VI). Much of his poetry emanates from and for these important reading circles within the government offices, like the "Chanceon" transcribed below, which was composed for Henry Somer when he was Under-Treasurer (*Souztresorer*), a post he held between 1408 and 1410. This little begging poem Hoccleve wrote on behalf of himself and three office colleagues (Baillay, Hethe, and Offorde).[1] The "Chanceon," meant ostensibly as a song (*chanson*) celebratory of summer (a pun on Somer's name), caps off the "Balade" which is, as John Burrow notes, perhaps the most successful of Hoccleve's short occasional verses (1994, 16). This work of literary mendicancy is in the same genre as Chaucer's "Complaint to his Purse" and is likely much influenced by the master poet: its playful references to the sun recall Chaucer's own poem, and the first stanza of the envoy to the *Regiment* beneath it makes marked allusion to Chaucer's tale of Griselde (with its trope of approaching authority dressed only in a "kirtil bare"). Both poems on this page suggest a mingling of whimsicality and self-deprecation that is Chaucerian in feeling. Both the "Chanceon" and a later begging poem written after Somer's promotion to Chancellor of the Exchequer suggest the "clubable" (33) dimensions of Hoccleve's life, as Burrow has noted. For all his poetic petitions for payment, however, of which the

Regiment, addressed to Prince Henry (later Henry V) between 1411 and 1413 is the most ambitious, Hoccleve often had to wait a long time for his annuities to be paid. Hoccleve's headings here and elsewhere in MS HM 111, a manuscript of his own making, suggest precedents for the kind of informational headings about a poem's genesis that the book producer John Shirley would supply in later decades (see Veeman 2010) — indicating a new literary professionalism for Middle English writing. MS HM 111 contains a great deal of Hoccleve's short and occasional verse, apparently a self-made anthology. It has none of the grand decoration (such as gold lettering) evident in the Durham autograph manuscript (see ch. 1, fig. 25, below) made for presentation.

CHARACTERISTICS OF THE HAND

Hoccleve writes a "fairly neat, compact and fluent bookhand form of the fifteenth-century Secretary script" (Petti 1977, 55), a script that began to gain ground in government offices early in the reign of Richard II. It often retains, however (as in Hoccleve's case), a few *Anglicana* features, such as the two-compartment **d**. Entirely pure forms of this script in vernacular copying are not common before s.xv[3] (see, for example, the copy of the *Regiment* in ch. 1 below, fig. 23, by the unknown scribe of Newberry Library MS f 33.7). This script spread slowly into the vernacular book trade from the beginning of the fifteenth century onward, gradually overtaking the older *Anglicana* hand that fourteenth-century scribes (such as Scribe B/ Adam Pinkhurst and Scribe D used in late Ricardian/early Lancastrian copying). These scribes, as some of their marginal instructions show, also knew the newer Secretary script but apparently thought *Anglicana* preferable for vernacular book production (see front plate 4). Standard features of Secretary evident in Hoccleve's script here are: "pointed" or "diamond-shaped" forms in the bodies of round letters (Petti refers to these as "horns and indentations," 1977, 55), as in letters such as **a** and **e** ("mannes," line 1); **a** is now a single compartment letter, as is **g** (and in the purest form of the script, though not here, **d** as well); forked **r** is less frequent and usually now only in final position ("Somer," line 6); in other positions **r** is shaped almost like a **v** ("rypest," line 1); 2-shaped r is retained after **o** ("For," line 9) and some other rounded letters. Final **s** is of the "B" type, with a little point at the top ("mannes," line 1).

Hoccleve's hand is both characteristic of the script at this period and also distinctive owing to his use of some idiosyncratic features; in a recent study of Privy Seal records written during his time in that office, Linne Mooney notes

1. The "Balade" begins on the previous page (running fols. 38v–39), with the heading: "Cestes Balade & chanceon ensuyantz feurent faites a mon Meistre H. Somer quant il estoit Souztresorer," and the incipit, "The Sonne with his bemes of brightnesse." See *Huntington Library Manuscript Catalogue*, description for HM 111, item 8, available at: http://sunsite3.berkeley.edu/hehweb/HM111 .html.

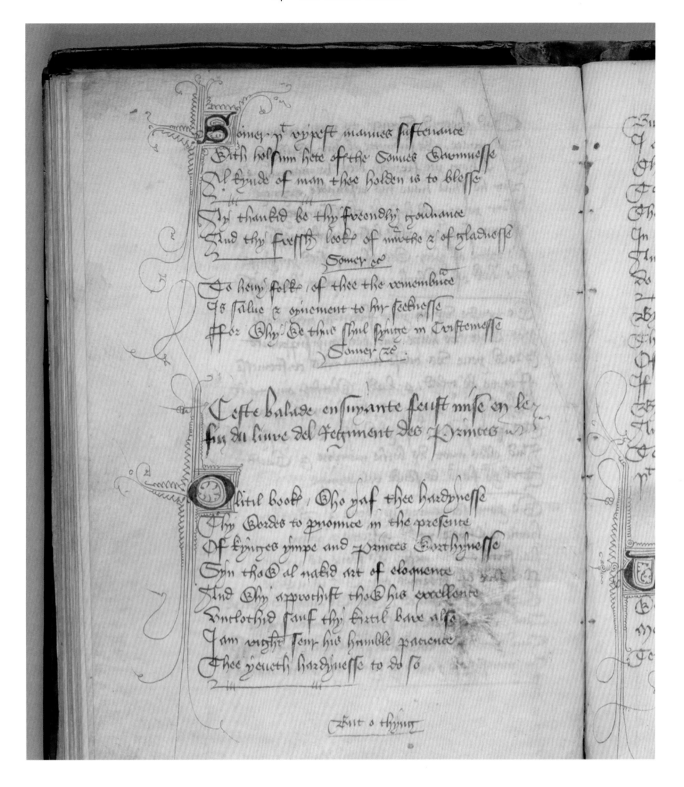

TRANSCRIPTION

Somer *þat* rypest mannes sustenance
With holsum hete of' the Sonnes warmnesse
Al kynde of man thee holden is to blesse

Ay thankid be thy freendly gou*er*nance
5 And thy fressh look*e* of mirthe *and* of gladnesse
 Somer *etcetera*

To heuy folk*e* / of thee the remembr*a*nce
Is salue *and* oynement to hir seeknesse
For why we thus shul synge in Cristemesse
10 Somer *etcetera* .

**Ceste balade ensuyante feust mise en le
fin du liure del Regiment des Princes**

O litil book*e* / who yaf thee hardynesse
Thy wordes to p*ro*nounce in the presence
15 Of kynges ympe and Princes worthynesse
Syn thow al nakid art of eloquence
And why approchist thow his excellence
Vnclothid sauf thy kirtil bare also
I am right*e* seur his humble pacience
20 Thee yeueth hardynesse to do so
 But o thyng[2]

that it is not difficult to discern Hoccleve's hand from those of his colleagues, even amidst a great many documents (2007, 294). Four idiosyncratic features of his hand that were isolated by Schulz many years ago are easily visible in the present plate: his **A**, with the large figure 8 loop ("Al," line 3); **g** ("gladnesse," line 5); the **y** with the tail ascending above the line ("thy," line 5, Hoccleve's way, incidentally, of dotting his **y** to distinguish it from **þ**, suggesting that he is well aware of traditional vernacular English copying practice); and his "circle and 2" **w**, which, as Petti notes, goes back in vernacular copying as early as the Harley 2253 lyrics at least (e.g., ch. 1, fig. 8; Petti 1977, 55). As Schulz also showed, Hoccleve writes at least three different hands (not counting instances of his Bastard Secretary, visible in the heading here, which would be a fourth), depending on the level of formality required. The present plate shows two of these: the Bastard hand of the heading and Hoccleve's medium-grade hand in the main text, which has none of the formality attempted in his envoy to the Countess of Westmoreland (see fig. 25 and discussion below, ch. 1). Compare, for instance, the treatment of **w** and of **r** in the present plate and in fig. 25, where he mostly abandons, for instance, the "circle and 2" **w** in his envoy to the Countess. For a less formal hand, see the marginal note visible in the bottom left in fig. 24 (which is entirely cursive).[3]

ABBREVIATIONS AND ORTHOGRAPHY
There are relatively few abbreviations. In the present plate, they include: "þ*at*," line 1; "gou*er*nance," line 4; and the symbol for *and* (throughout). More puzzling is the flourish or hook he adds to words like "look*e*," line 5, which may be indicating the addition of an *e* but may also simply be otiose (the metre here does not appear to require it).

DECORATION
Large blue initials, one or two lines high, with red pen flourishing.

BIBLIOGRAPHY
Burrow 1994; Burrow and Doyle 2002; Furnivall 1970; Mooney 2007; Schulz 1937.

2. Catchword, linking the end of this quire to the start of the next; all are quires of eight (that is, all quires have eight leaves) in this section of the volume.

3. Petti summarizes the features of Hoccleve's least formal hand this way: "many more ligatures, cursive reversed **e**, and the *Anglicana* forked **r** and sigma **s**" (Petti 1977, 55), features most easily found all together in his documentary writing. See Schulz's image of BL MS Add. 24062, fol. 101v.

8. William Langland, *Piers Plowman* (C text)

KATHRYN KERBY-FULTON

MS: Oxford, Bodleian Library, MS Douce 104, fol. 109v

SCRIPT: *Anglicana formata*

DATE: 1427 (dated by scribe)

INTRODUCTION

MS Douce 104 was written and illustrated in Anglo-Ireland, both tasks likely done by the same scribe who wrote its colophon and dated it by the regnal year (as government documents were).[1] This and other evidence suggests he was a Dublin civil servant; the Douce *Piers Plowman* is the only known copy translated into Middle Hiberno-English

(MHE) and the only copy with a cycle of illustrations. The passage transcribed here is from C.XXII.193–225, and starts in the midst of Will's rueful but graphic description of the distress of his wife after Elde's attack upon him leaves him impotent: "for þe lym þat scho loued me for" (line 195) he says, he "myȝth in no maner : mak it at hir will." Will then cries out to Kynd for advice in avenging Elde, and Kynd counsels him to retreat to Unity (Holy Church), and "lerne to loue" (line 208), promising that he will never lack life's necessities: "and þou loue ⟨treuly⟩ : lake schal þou neuer." This line is one of many places in Douce where the corrector has visibly supplanted a word

1. Fol. 112v; see Pearsall and Scott 1992, ix, for the colophon; Kerby-Fulton and Despres 1999 for evidence of civil service connections; see ch. 4, sec. II below (on the annotations) and ch. 3, sec. V, on *Piers* illustrations.

2. That is "I ne"; syllable separation abounds in Douce 104 and in MHE, preserved here.

3. Probably an otiose stroke: final *e* has no morphological significance in MHE; see McIntosh and Samuels 1968, 5.

4. Illegible letter written over erasure and blotched.

5. Written over erasure.

6. "Sorely" is also a possible reading, but "soþely" is most common in other manuscripts; Russell and Kane emend to "s[ikerly]" (1997, XXII.215).

TRANSCRIPTION

	And of þe wo þat I was in : my wyfe had rewþe
	and wissed wel witterly : þat I were in heuen
	for þe lym þat scho loued me for : *and* lefe was to felde
	on nyȝthes namely : when we naked were
5	Ine[2] myȝth in no maner : mak it at hir will
	so Elde and scho : hit had for bette
nota how kynde	and as I sate in þis sorow : I saugh how kynd passed
passite	and deþe drow ney me : for drede I gan to quake
	and cryed to kynd : out of care me bryng'[3]
10	lo how Elde þe hore : haþ me be sey
	a wreke me ȝif þi wil be : for I wold be hennis
	ȝif þou wilt be wroke : wend in to vnite
	and hold þe þer euer : tyl I send for þe
	and loke þou con su*m* craft : are þou come þennis
15	Consaileþ me kynd q*uod* I : what craft i⟨s⟩[4] best to lere
	lerne to loue q*uod* kynd : and leue al oþer
	how schal I come to catel so : to cloþe me and to fede
	and þou loue ⟨treuly⟩[5] : lake schal þou neuer
	Wede ne wordely mette : while þy lif lasteþ
20	and I by consail on kynde : comsed to rombe
	þroȝth contricio*u*n and confessio*u*n : til I come to vnite
	and þere was consciens constable : cristen to saue
	Beseged soþely[6] : wiþ seue*n* grete geauntes
	and wiþ antecrist helden : hard a ȝenes consciens
25	Sle⟨ȝ⟩th wiþ his slyng' : and hard saute he made
nota de	Proud prestes come wiþ hym : passyng an hondered
⟨prowt⟩	In paltokes and pyked schoes : and pyssers long knyues
prestis	Come a ȝenes consciens : wiþ couetys þei helden
	by mary q*uod* a mased prest : was of þe march of wales
30	I counte no more consciens : so I cacche siluer
	þan I do to drynke : droȝth of gode ale
	and saide syxti : of þe same contre
	and schotten a ȝenes hym : wiþ schot many a schef of oþe[s]

And of ye wo yat I wroughte my wyfe hud I tolde

and cursed hir bitterly: yat I wey in heuen

for ye tyme yat scho laued me for I lese war to felde

on nyghtes namely. When we naked were

Iue myrth in no maner: mak it at hir will

Go elde and scho: hit had far bette

god kynd
passus and as I sate in pis sorow: I saugh holp kynd passe

and deye dolw ney me: For drede I gan to quake

200 and cryed to kynd: out of care me brynge

to holp elde ye hore: hap me be sey

a wycke me zif pi wil be: for I wold be henne

zif you wilt be wroke. wend in to vnite

and hold ye yer euey: tyl I send far ye

And take you con sir gaft: aye you come yenn

Counsaley me kynd qd I: What gaft is best to leye

leyne to loue qd kynd: and leue al oyer

Holp schal I come to eriat so: to clope me and to fede

and you loue rith: lake schal you neuer

210 Mede ne worldly mette: While yi lif lastey

and I by counsail on kynde: comised to somne

prouch contricion and confession: till come to vnite

and ye war consciens counstable: cristen to saue

Beseged sorely. Wiy seue grete geauntes

and wiy euuerist helden: hayd a geues conscieus

Slezth wiy his slyng: and hayd saute he made

Proute prestes come wiy hym: passyng an houdeyed

In paltokes and pyked schoes and pyssyr long knyues

come azeues conscieus: Wiy couetyr yei helden

220 by mayr qd a naked prest: war of ye march of wales

I counte no more conscieus: So I catche siluer

yan I do to dryuke a drozth of gode ale

and saude syxti of ye same contre

and schorten a zeues hyni: way schot many a ocfefaf oyer

he thought his MHE audience would not understand (see "Dialect and Correction" below). Will makes his way to Unity, only to find it besieged by seven great giants (the Seven Deadly Sins), Antichrist, and "proud priests," one of whom is depicted in the lower left margin. These foes of the Church are here accompanied by another unique product of the MHE corrector's pen, Sle⟨3⟩th (Trickery); see "Dialect and Correction" below. A leaf earlier (108v), Sle3th has been portrayed pictorially as a Gaelic-Irishman, reflecting the colonial context in which Douce was produced (Kerby-Fulton and Despres 1999, 98). Another delightful substitution, this one seamlessly made by the main text scribe (or his exemplar), appears when the "proud priests" engaged in attacking the Church are said to be from the "march of Wales" rather than from "the march of Ireland" (line 221), as all other manuscripts read (Kerby-Fulton and Despres 1999, 19). This combination of Irish patriotism and distrust of the Gaelic-Irish, with whom the Anglo-Irish were often but not always at strife, is typical of the worldview of MHE speakers, who thought of themselves as "of the middle nation," caught, that is, between England's administrators and Gaelic Ireland's ancient and foreign culture (Lydon 1984). Douce was made on a low budget: thus the use of the margins for illustrations, not inset boxes within the text, and the use late in the cycle of only rubrication colors on the drawings, as here.[7] But the manuscript is nonetheless a compendium of brilliant early audience response to the poem, both pictorial and annotative (its annotations are discussed in ch. 4, sec.II, below). The artist was most likely trained for work in the Dublin Exchequer Office, from which a composite drawing of its clerks also survives, strikingly similar to Douce in artistry (Kerby-Fulton and Despres 1999, frontispiece). He drew on an immense clerical, cultural, and iconographical repertoire, evident in the pictorial choice made here (see "Decoration and Illustration" below).

CHARACTERISTICS OF THE HAND AND ABBREVIATIONS

The hand of Douce 104 is slightly old-fashioned for its date (Adam Pinkhurst was writing this kind of *Anglicana formata* during Chaucer's lifetime, as we have seen). Apart from this, there is nothing unusual about the script (see Pearsall and Scott 1992, xiv). There are relatively few abbreviations, but they include, e.g., qu*o*d, line 15; henn*is*, line 11 (for the standard -*es* abbreviation; see "Dialect and Correction," below); the Tironian sign for *and*, a bar for minims (e.g., su*m*, line 14; seue*n*, line 23), and standard *re* abbreviation: t*re*uly, line 18 (in a corrector's hand).

DIALECT AND CORRECTION

The MHE translation in Douce was either made by or copied by the main scribe and augmented by the work of the annotator-corrector. Two such corrections are visible here: "Sle⟨3⟩th," line 25, in which the **3** is always written over erasure each time the name appears, was originally a form of the word "Sleuthe," meaning Sloth, not Trickery (cf. Russell and Kane 1997, C.XXII.217). The second is "⟨t*re*uly⟩", line 18, inserted over erasure in the spindly hand of the corrector, typical of his tendency to suppress Langland's South West Midlands words like "lelly" (C.XXII.210), here, as elsewhere, spoiling the alliterative line. Other features of MHE dialect are evident in this passage, including syllable separation (e.g., "a 3enes" [against], "A wreke" [avenge]); -is/-ys for genitive endings or -ir/-yr generally for Middle English (ME) -er or -ur; "th" for ME "t" (e.g., "my3th," line 5); "hir" for ME "her." The corrector of Douce is also the annotator, and his work can be seen in the left-hand margin as well, supplying topic or narrative finding notes. In fact, his priorities often do not agree with the illustrator's, and his note on the proud priest is not a caption: rather, it is but one manifestation of the production team rivalry the two often exhibit, in which he brazenly writes his notes right over top of the illustration.

ILLUSTRATION AND DECORATION

The drawing of a proud priest in the lower left margin (pointing to the text's words "Proud prestes") is both a common means of character identification in Douce and also an indication that the character is about to speak (the gesture echoes *declamatio* iconography, here ironically).[8] As noted above, the priest is part of a large contingent of Antichrist's army; he is dressed inappropriately for his calling in tight-fitting, fashionable clothing, with a large sword dangling phallically between his legs. Parallel iconography appears in, for instance, an illustration to the popular pastoral manual, *Oculus sacerdotus*, which shows a group of just such dandified renegade priests, the state of whose morals (*etate grauia detrimenta*) allegorically pulls apart the church.[9] In the text itself, there is no decoration on this page, only a faint splash of red on the **C** of "Come" right beside the priest's sword, also outlined faintly in red (as are his arms and the features of his face).

BIBLIOGRAPHY

Kerby-Fulton and Despres 1999; Lydon 1984; McIntosh and Samuels 1968; Pearsall and Scott 1992; Russell and Kane 1997.

7. Marginal illustration of this type appears in other Anglo-Irish manuscripts, such as Dublin, National Library of Ireland, MS 700, containing the *Topographica Hibernica* of Giraldus Cambrensis. See Kerby-Fulton and Despres 1999, 52.

8. See Kerby-Fulton and Despres 1999, 19–20.

9. Kerby-Fulton and Despres 1999, fig. 56, of Hatfield House, Marquess of Salisbury, MS Cecil Papers 290, fol. 13, from England, s.xiv[2].

9. Sir Degrevant

LINDA OLSON

MS: Cambridge, University Library, MS Ff.1.6 (Findern MS), fol. 96r, opening four stanzas (lines 1–64) of the romance, with the opening two stanzas (lines 1–32) transcribed

SCRIPT: Informal cursive script blending *Anglicana* and Secretary forms

SCRIBE: Elizabeth Francis or Elizabeth Cotton

DATE: Mid-fifteenth century

INTRODUCTION

Sir Degrevant is a tail-rhyme romance composed in a northeastern dialect between c. 1400 and c. 1446, most probably in the first decade of the fifteenth century. Its verses make considerable use of alliteration and are organized into stanzas of sixteen lines with the usual rhyme scheme of *aaab cccb dddb eeeb*. The *b* lines are the tail-rhymes, which are incorporated into the columns here but written out to the right in Lincoln, Cathedral Library, MS 91 (see ch. 2, fig. 12). The romance is extant only in these two manuscripts (both discussed in ch. 2). The scribe Robert Thornton in Lincoln MS 91 largely preserves the original dialect, but the two scribes of the text in CUL MS Ff.1.6 introduce their own dialects, with the first (featured here) containing forms from Southeast England, likely Central Sussex, or possibly the southern portion of the West Midlands, and the second demonstrating forms associated with southern Derbyshire and the surrounding area "within twenty miles or so of Findern" (Johnston, forthcoming, ch. 5). MS Ff.1.16 contains 159 surviving folios of an original total around 184, with the folios measuring between 220 × 153 mm. and 212 × 146 mm. It was written piecemeal by more than forty scribes in both professional and amateur hands between c. 1446 and c. 1550, with the section of the manuscript that includes *Sir Degrevant* most likely copied around the middle of the fifteenth century. *Degrevant* itself, the only complete romance in the volume and the only text written in double rather than single columns, appears to have been copied by two female scribes, identified by the second as "Elisabet koton" and "Elisabet frauncys" (on fol. 109v; ch. 2, fig. 33). Though we cannot know which of the two worked on the opening folios of *Degrevant*, their names in the manuscript along with those of members of other Derbyshire gentry families (like the Finderns, who may have been the primary owners and after whom the volume is named, and the Tates, whose motto appears at the top of *Degrevant*) suggest that the book was informally produced by a local network of readers interested in the themes of courtly love and playful debate, as highlighted by its contents (see the discussion in ch. 2, sec. III). Among the texts also found in Findern are Chaucer's *Parliament of Fowls*, Hoccleve's *Letter to Cupid*, Roos's *La Belle Dame sans Mercy*, Clanvowe's *Book of Cupid*, Lydgate's *Treatise for Launderers* and *Pain and Sorrow of Evil Marriage*, excerpts from Gower's *Confessio Amantis*, and a number of unique English lyrics, some of which appear to be the product of the Derbyshire women involved in the manuscript's production. Later owners of the manuscript include Thomas Knyvett (c. 1539–1618), his son of the same name (1596–1658), and John Moore, bishop of Norwich and Ely (1646–1714), whose collection was purchased by George I and given to the Cambridge University Library in 1715. The book was rebound in half morocco in 1896.

CHARACTERISTICS OF THE HAND

The hand is almost certainly that of either Elizabeth Francis or Elizabeth Cotton, known as Scribe 21 in Harris 1983, 332, and Hand A in Casson 1949, xii–xiv.[1] Both Beadle and Owen 1977, xi, and Thompson 1991, 32, believe the same scribe also contributed a couple of unique lyrics on fols.143v–145r, likely at a later date, suggesting ongoing access to the volume, but Harris 1983 sees the hand of the lyrics as different (her Scribe 31). Various less-than-complimentary adjectives have been used to describe this cursive and informal mid-fifteenth-century hand—amateur and workaday (both of which it certainly is), as well as loose, sloppy, untidy, uneven, irregular, badly formed, blotchy (all applicable, especially in certain spots), and finally, unique (again, a certainty). But I believe we can place the scribe among the copyists of smaller vernacular manuscripts who achieved an "amalgam," though not one of the more "successful" ones admittedly, "of Anglicana Formata and Secretary, which is almost a separate style" (Parkes 1969, xxiii). Written currently—note the cursive form of **e** throughout—it blends Secretary forms like the **g** in "knyght," "myght" and "hyght" (lines 9–11) with *Anglicana* forms like the long **r** in "trynite" (line 1) and "bryttayn'e" (line 22) that gives the scribe so much trouble (see "Corrections" below). Her **d**'s have looped ascenders from *Anglicana* along with the broken lobes of Secretary, as in the hero's name (line 11 and the title, which, like the running headings up to fol. 99v, are also in the hand of Scribe 21), and she uses both the more elaborate *Anglicana* and simplified Secretary forms of **a** (compare two-compartment

1. Although the two names recorded in the hand of *Degrevant*'s second scribe on fol. 109v (see ch. 2, sec. III and fig. 33) are most obviously understood as belonging to the text's two scribes, this is not absolutely certain. Johnston, for instance, in *Romance and the Gentry*, ch. 5, suggests that the scribal signature is found in the so far indecipherable letters that appear beside the two women's names.

Transcription

<div style="margin-left:2em">

Sir*e* degre*uu*aunt t theynke and thanke[2]

[Column a]

¶ Lord' gode in trynite

yeff home hevene ffor' ^to^ se[3]

That louethe Gamen' *and* Gle

And Gesstys to ffede

Þ*er* ffolke sitis in ffere

schullde men' herken' *and* here

Off Gode that beffore ^hem^ were

8 That leuede on arþede

And y schall karppe off a knyght

That was both hardy *and* wyght

Sir*e* degre*u*aunt that hend' hyght

That dowghty was ~~and wyght~~ ^of dede^

Was never*e* kyngh that ^he^ ffond[4]

~~In ffraunse~~

In ffraunce ne in Englo*n*nd'

Myght sette a schafft of hys ho*n*nd

16 On' a styþe stede

¶ Wyth kyng' Arrtor' y wene

And wyth gwennor' the q*ue*ne

he was known' ffor kene

That Comelych knyght

In heþenesse *and* in spayne

In ffraunce *and* in bryttayn'e

Wyth p*er*sevall *and* Gawayne

24 ffor herdy and wyght

~~he was herdy and wyght~~

he was dowghty and der*e*

And ther nevew ffull ner*e*

Þ*er* he ~~myght~~ of dedys myght' yher*e*

By days or by nyght

[Column b]

fforþy they name he*m* þ*at* stounde

A knyght of tabull Round

As maked' is in þe mappe mou*n*d

32 In storye ffull ryght

</div>

2. Although the ink is a very similar color to that of the main scribe here, "theynke and thanke" (the motto of the Tate family who owned property close to the town of Findern in the sixteenth century) appears to have been added by a later hand. The symbol I have transcribed as *t* (perhaps indicating the Tate name or simply a false start on the motto) could alternatively be read as "and."

3. The scribble to the right of this line may be the product of the same hand that adds "to" in the line: see "Corrections" below.

4. The word "kyngh" should perhaps read "knygh" for "knyght" but if so, it was missed by both the scribe and the corrector.

Anglicana **a** in "ffraunce" line 22 with the single-compartment Secretary **a** in the same word line 14) and **w** (compare the *Anglicana* **w** in "gwennor'" line 18 and "known" line 19 with Secretary **w** in "were" line 7 and "was" line 10). Like the letter **d**, some words reveal the qualities of this blended script particularly well: "were" in line 7 with its Secretary **w**, *Anglicana* long **r** and cursive **e**'s; "karppe" in line 9 with *Anglicana* **r** and single-compartment Secretary **a**; and "dowghty" in line 12 where *Anglicana* **w** is followed by Secretary **g**. She has a special fondness for double **ff**—only in the word "of" here does she use a single **f**—and occasionally her word separation is unclear or differs from our own, as in "aschafft" (line 15), which has been adjusted to "a schafft." Though legible (for the most part) the general appearance of the script and page is unprofessional, with the second column containing far more lines than the first, an imbalance likely caused by errors and the desire to fit the fourth stanza on the page.

The second scribe of Findern's *Degrevant*—Scribe 22 in Harris 1983, 332, and Hands B and C in Casson 1949, xiv–xv—comes across as much more accomplished and aware of what a book ought to look like, and perhaps that is why

she takes on a larger part of the text (fols. 100r–109v, while Scribe 21 completes only fols. 96r–99v). She pricks and rules her pages in dry point, produces a tidy bookhand laid out in balanced columns, and even adds some decorative flourishes (see "Decoration" below), but her hand does grow progressively loose as she works, leading Casson to suggest the possibility that a third scribe finished the romance (1949, xiv–xv). It seems likely that the *Degrevant* exemplar was split between the two scribes (in the middle of a stanza, in fact, at line 564 in Casson 1949, 37: see ch. 2, figs. 34a and b), who work in different quires, perhaps in different locations, and if the alterations in their scripts and pens are a safe indication, in various stints as well.[5]

Abbreviations

Though an amateur, Scribe 21 uses several abbreviations, including:

- superscript **e** above **þ** for "þe" (lines 16, 31, etc.) and above **q** for "que" in "quene" (line 18)
- superscript **t** above **þ** for "þat" (line 29)
- a brevigraph looping up from **g** indicating the missing "re" in the hero's name (title and line 11), and from **Þ** indicating the missing "er" in "Þer" (lines 5 and 27)
- a brevigraph curving up from final long **r** indicating a final "e" as in "Sire" (title and line 11), "nevere" (line 13), and "dere," "nere," and "yhere" (lines 25–27)
- a bar over the letters of a word indicating a missing "m" or "n" as in "hem" (line 29), "mound"(line 31), and oddly suggesting an extra "n" in "Englonnd" and "honnd" (lines 14 and 15)
- a bar across the descender of **p** for the missing "er" in "persevall" (line 23)
- ampersand for "and" (lines 21–23, etc.)

The dots after the short **r** at the end of "ffor" (line 2), "Arrtor" (line 17), and "gwennor" (line 18), like the stroke after "myght" (line 27), seem otiose and are represented as such here. The stroke of letter **g** ends with a distinct curve upward in "kyng" (line 17) and that of **d** with a line that descends more than usual in some instances ("Lord" in line 1, "hend" in line 11, and "Englonnd" in line 14, for example): both of these have been marked as otiose as well. So have the upward curves that follow final **n** in many places, though this presents a particularly tricky case: sometimes an *e* or *n* might be intended (as in "herken," line 6), but in

most instances adding either would make little sense (as in "men," also in line 6), and in one case the scribe herself appears uncertain: it seems she initially wrote "bryttayn'" in line 22 with this characteristic final **n**, then added a final **e**, as though the extra curve hadn't suggested its presence at all.

Punctuation

There is no punctuation, but the scribe does use paraphs to mark the beginning of many of the stanzas, including the four that appear on fol. 96r.

Corrections

Scribe 21 makes many errors as she works. A few of these have received no correction at all, like the possibly erroneous "kyngh" (line 13), but most have been attended to in some way. Scribe 21 corrects several errors herself:

- crosses out "and wyght" and adds "of dede" above it in line 12
- inserts "he" into line 13
- crosses out "In ffraunse" after line 13, beginning the line again below
- crosses out the first "myght" in line 27

A somewhat later and tidier hand—Hand D in Casson 1949, xiii—corrects in a gray-black ink that in most instances is quite distinct from the browner ink used by the scribe. This corrector:

- adds "to" in line 2 and very likely the scribble to the right of the line
- clarifies or corrects the first long **s** and adds a tail to change the **u** to a **y** in "Gesstys" (line 4)
- inserts "hem" into line 7
- seems to treat the word that looks like "on" in line 14 as though it should be "in" and dots the **o**
- seems to be the one who crossed out the extraneous line after line 24

The corrector appears to touch up or repair the scribe's script in other places as well. It is very difficult to determine whether the corrector or the scribe herself has gone over some of her less carefully formed letters, since the darkening effect of the ink may simply be the result of the thickening or oxidization of the original brown. In a few instances, however, it does seem as though the corrector's hand may be at work, as in the second **d** of "dede" added by the main scribe (line 12), and the thickening of the long **r**'s that appear to have given the scribe considerable trouble (as in "arþede," line 8, to which compare "bryttayn'e," line 22). Given that the corrector's hand also adds "howe say ye˞ will ye any more of hit˞" immediately after Scribe 21 writes "Her endyth þe first ffit" (fol. 98va), it may be that this corrector was preparing the romance somewhat playfully for reading aloud.

5. As mentioned above, they also worked in different dialects, which could suggest that they used entirely different exemplars. See Johnston, forthcoming, ch. 5, who also argues that Scribe 21's section of *Degrevant* was a later replacement for a damaged portion of the original text in Scribe 22's hand.

Decoration

As is generally the case throughout Findern, there is virtually no decoration in *Degrevant*, though decorative ascenders do grace the top lines of some pages—fols. 104r–108r, for instance, by the second scribe. Slightly enlarged and elaborated capitals open a couple of the texts in the manuscript, like the initial **A** on fol. 45r adorning the *Three Questions* excerpt from Gower, a text that also receives decorative top-line ascenders (see ch. 2, figs. 38a and b). The margins contain a few informal drawings, like the odd little face at the bottom of fol. 158v and the scrolls and rebus of the scribe "A god when" on fols. 137v and 139r (see ch. 2, fig. 36b).

Bibliography

Beadle and Owen 1977; Casson 1949; Hanna 1987a; Harris 1983; Johnston, forthcoming, ch. 5; McNamer 1991; Robbins 1954; Thompson 1991.

10. *Wisdom*

Linda Olson

MS: Washington, DC,
Folger Shakespeare Library,
MS V.a.354 (Macro MS),
fol. 114v, three and a half
stanzas (lines 801–28) of the
play

SCRIPT: *Anglicana cursiva*
with Secretary features

SCRIBE: Thomas Hyngham,
monk of Bury St. Edmunds

DATE: s.xv[4]

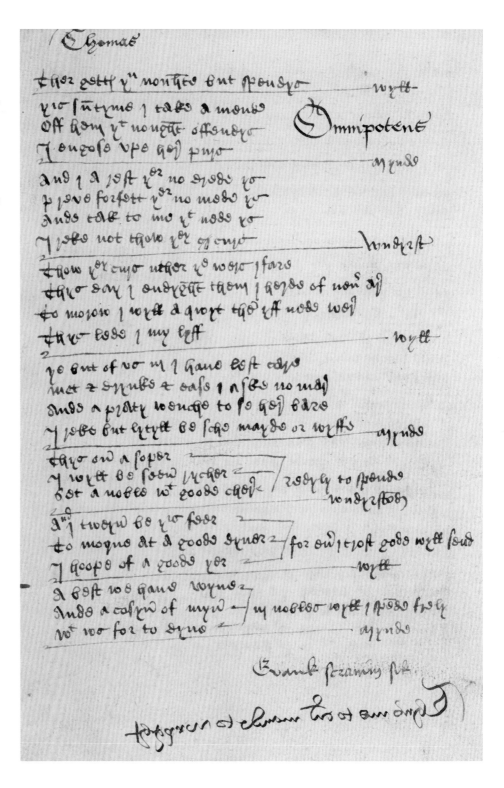

INTRODUCTION

The English morality play *Wisdom* was composed in the second half of the fifteenth century. The text is written almost exclusively in eight-line tail-rhyme stanzas with a rhyme scheme that often varies depending on the character speaking and the moral context of each speech. In the three and a half stanzas transcribed here, in which the speakers are Mind (who utters the first line as indicated at the bottom of fol. 114r), Will, and Understanding, the pattern is *aaabaaab*, with lines 5–7 rhyming on the same word ("ys"), and the tail-rhyme lines 20, 24, and 28 written to

the right, revealing the inconsistency with which the tail-rhyme lines are positioned in both this and the second (incomplete) copy of the play. This second copy is found in Oxford, Bodleian Library, MS Digby 133, and though it stops about four hundred lines short of the Macro MS's version, it is closely related and may (in its complete state) have been the exemplar for Macro's *Wisdom* (Riggio 1998, 1, 4, 6–18 and 75). The two copies were written by different scribes, both most likely in the last quarter of the fifteenth century, and both exhibit an East Midlands dialect with East Anglian features, with the Macro scribe using

TRANSCRIPTION

Thomas[1]

Ther gett*ys* þ*u* noughte but spendys
2———————————————— wyll'
yis su*m*tyme I take amend*ys*
Off hem þ*at* nought*e* offendys Omnipotens[2]
I engose vpe her*e* purs[3]
2———————————————— Mynde
And I arest þ*er* no drede ys
preve forfett þ*er* no mede ys
Ande tak to me þ*at* nede ys
8 I reke not thow þ*ey* ~~er~~ curs
2———————————————— Wndyrst*ond*ynge
Thow þ*ey* curs uther þ*e* wers I fare[4]
Thys day I endyght*e* them I herde of neu*er* ar*e*
Tomorow I wyll aqwyt the*m* yff nede wer*e*
Thys lede I my lyff
2———————————————— wyll'
ye but of vs iii I haue lest care
met *and* drynke *and* ease I aske no mar*e*
Ande a praty wenche to se her*e* bare
16 I reke but lytyll be sche mayde or wyffe
2———————————————— Mynde
Thys on a soper 2———————┐
I wyll be seen rycher 2———┐ │
Set a noble w*yth* goode cher*e*[5] / │ redyly to spende
2———————————————— wndyrsto*nd*ynge
A*nd* I tweyn be þ*is* feer 2———┐
To moque at a goode dyner 2——┤
24 I hoope of a goode yer 2———┘ for eu*er* I trost gode wyll send
2———————————————— wyll'
A best we haue wyne[6] 2———┐
Ande a cosyn of myn 2———┤
w*yth* ws for to dyne 2———┘ iii nobles wyll I spe*n*de frely
2———————————————— Mynde

Evank scranim sik[7]

Thus me to cu*m*mande to wryght[8]

1. One of many names written by various hands in the folios of the Macro *Wisdom*, "Thomas" here was not written by Hyngham, though the hand is similar to that in "Omnipotens" added to the right a few lines down and its opening *T* not unlike that beginning the mirror writing that appears at the bottom of the page.

2. Not in the hand of the scribe Hyngham but possibly the work of the individual who wrote the name Thomas at the top of the page.

3. The word "engose" may be an uncorrected error for "engrose."

4. The word "uther" might be read "nther" or even be an uncorrected error for "never."

5. There may be a hint of a final **e** here, as though the scribe first abbreviated it from the long **r**, then began to add the character as well.

6. The **A** opening this line may, like that starting line 21, indicate an unfinished "And."

7. Backwriting for "kis min arcs knavE" in a hand later than Hyngham's.

8. In mirror writing, which is used by the same hand (not Hyngham's) on fol. 98v (ch. 6, fig. 36a), where the line is finished "w*ith* my left hande."

x for the **sh** sound in words like "shall" and "shulde," a consonant use common in Norfolk and Suffolk (no examples of the **x** appear in this plate, but see line 15 on fol. 121r, ch. 6, fig. 34a). The scribe of the Macro *Wisdom* has been identified as Thomas Hyngham (the name of a village in south central Norfolk), a fifteenth-century monk of Bury St. Edmunds whose ownership inscriptions appear in three places: on fol. iii verso of Oslo and London, Schøyen Collection, MS 615, a copy of John Walton's translation of Boethius's *De Consolatione Philosophiae* (s.xv[1]); on fol. 121r of the Macro MS at the end of *Wisdom* (ch. 6, fig. 34a); and on fol. 134r of Macro at the end of the morality play *Mankind*, which was also copied (save for a few folios) by Hyngham. Though bound together now, *Wisdom* and *Mankind* (copied in a more compressed format probably a few years after *Wisdom*) were originally separate playbooks, as was the *Castle of Perseverance* (copied c. 1440 by a different scribe), which now opens the Macro MS. Although *Mankind* and *Wisdom* lack rubrication and headings, they are particularly rich in marginalia, with both sporting a number of names (some with connections to Bury St. Edmunds), *Mankind* bearing a school exercise in English and very poor Latin at its end, and *Wisdom* containing several playful codes and ciphers, some simple drawings and bits of verse, as well as instances of back-writing and mirror writing (examples of these last two appear at the bottom of fol. 114v here, including the amusing "kis min arcs knavE") that suggest some less-than-serious use of the playbooks by youthful readers and players (see ch. 6, figs. 35 and 36a and b). It is possible both plays were studied and performed by students of the Bury abbey's three medieval schools, particularly perhaps the free school for the sons of Bury's burgesses, which survived the dissolution as the town's free grammar school, included drama in its curriculum, and was supported in the seventeenth and eighteenth centuries by the Macro family who acquired Folger MS V.a.354 and lent it their name (see the discussion in ch. 6, sec. V).

CHARACTERISTICS OF THE HAND

Hyngham's hand has been examined in detail by Beadle, who notes that *Wisdom* and *Mankind* are "copied in the same general variety of fifteenth-century cursive script for which *anglicana cursiva currens* might be a fair generic designation" (1995, 319), and that Hyngham achieved "a distinctly individual realization" of this script (333). Characteristic features of Hyngham's hand include: both an *Anglicana* double-compartment style **a** (as in "care" and "mare," lines 13 and 14) and a simplified headless Secretary **a** (as in "haue" and "ease" in the same two lines), with the latter very rare in *Mankind*; *Anglicana* long **r** (as in "purs" in line 4 and "rest" and "drede" in line 5), as well as a smaller 2-shaped **r** (as in "ther" in line 1 and "forfett" in line 6), which often appears in a superscript position (as it does in "þer" in lines 5 and 6); Secretary **w** (of which there are four examples in line 11: "Tomorow," "wyll," "aqwyt," and "were") and a distinct current **g** which, like **y** (written exactly as **þ** is here), has a tail that sweeps to the right as in "noughte" and "engose" (lines 3 and 4); **p** with the top left of its lobe open (as in "purs" in line 4 and "praty" in line 15) and a form of **h** in which the loop of the ascender is often flattened down over the body of the letter (as it is in "thow" in lines 8 and 9, and "wenche" and "here" in line 15). Also idiosyncratic is the scribe's use of **w**. Although **w** for "gh" in words like "thow" (lines 8 and 9) is not unusual in the work of East Anglian scribes, **w** instead of **u** as a vowel in words like "ws" (line 28), "aqwyt" (line 11), and "Wndyrstondynge" (marking that character's speeches) is very rare and among those features of Hyngham's writing that help us determine with such certainty that both *Wisdom* and most of *Mankind* (fols. 122r–132r) are his work. The informality of his scribal practices is also distinctive: he rules for neither play text, includes no titles or running headings, and (perhaps redundant as well as most unusual) he continues his leaf signatures into the second half of quires.[9]

ABBREVIATIONS

Like other aspects of Hyngham's script, his methods of abbreviation tend to be idiosyncratic. The brevigraph curving up from final long **r** to indicate the missing "e" as in "are" and "were" (lines 10 and 11) is ordinary enough, as are the brevigraphs for "er" in "euer" (line 24, to the right) and "neuer" (line 10) and for "ys" at the end of "gettys" (line 1) and "amendys" (line 2), though the shape of that last example is a little unusual. The Tironian *et* used twice for "and" in line 14, and the bar over **u** and **e** for the missing "m" in "sumtyme" (line 2) and "them" (line 11), and over **o** for the first missing "n" in "Wndyrstondynge" (second instance) are standard, but the suspension of "Wndyrstondynge" at **t** in the first instance and **d** in the second is unique and probably used because it would be relatively obvious by this point in the play which character was intended. The bar that sometimes cuts through the top of

9. As Beadle explains, "the original purpose of leaf signatures was to preserve the correct ordering of loose sheets in a gathering without having recourse to checking the continuity of the text, and it was naturally unnecessary to continue numbering beyond the first half of the sheet constituting the innermost bifolium of the quire. To number the leaves in the first half of a gathering was the widespread conventional and 'professional' practice, but

to continue the numbering to the leaves in the second half was highly unusual, not to say eccentric" (1995, 322). If, however, the scribe Hyngham anticipated young readers using his playbooks for actual performance (as he may well have done: see ch. 6, sec. V), then he may also have anticipated the plays returning to him in so torn and damaged a condition that having each half of a bifolium numbered would have aided with reconstruction.

the letter **h** is also inconsistent in meaning: in "noughte" in line 1 it seems to indicate a missing **g**, but in the same word in line 3 it is the final **e** that is missing, and final **e** seems the scribe's intention in "endyghte" (line 10) as well. Hyngham's use of superscript letters is quite extensive, with **e** after þ for "þe" (line 9), and **t** after þ for "þat" (lines 3 and 7) and after **w** for "wyth" (lines 19 and 27) common, but **er** (lines 5 and 6), **ey** (lines 8 and 9) and **is** (line 21) after þ for "þer," "þey" and "þis" respectively are not, and neither is the **nd** after **A** for "And" (line 21), though I suspect that may be a correction for letters missed (see "Corrections" below). Most of this scribe's superscript characters do not constitute true abbreviations since no letters are actually missing and they seem the ad hoc creations of someone "more accustomed to setting down more densely abbreviated material, doubtless Latin" (Beadle 1995, 330). The elongated stroke through the double **l**'s in "wyll" (as a speaker three times) does not seem to indicate missing letters and is thus represented as otiose here.

The later hand that adds in mirror writing the final annotation uses an elaborate barred brevigraph to represent the missing *m* in "cummande."

PUNCTUATION
There is no punctuation, but the scribe does draw a line (flourished to the left with what looks like an Arabic 2) between the speeches of characters in both *Wisdom* and *Mankind*, with the speaker of the following verses appearing at the right end of each of these lines. He also brackets the three rhyming lines preceding a tail-rhyme line when he writes the latter out to the right, as he does with lines 17–28 here.

CORRECTIONS
The only corrections were done by the scribe Hyngham and seem to have been made in the process of copying–what Beadle calls "*currente calamo*" (1995, 321; literally "with running reed"). There is an example in line 8, where the scribe began with "cr," then crossed it out to write "curs." The "And" opening line 21 may be another such correction, with the omission of "nd" only discovered after the line was finished, so that the missing letters had to be added superscript, resembling some of Hyngham's unusual abbreviation methods. The same omission may have occurred at the beginning of line 25, but remained uncorrected. The words "engose" (line 4) and "uther" or "nther" (line 9) may also be uncorrected errors.

DECORATION
There is no formal decoration in the *Wisdom* and *Mankind* playbooks, but there are some informal drawings that may be related to costume design on fols. 98v and 121v of *Wisdom* (see ch. 6, figs. 35 and 36a), and some rather accomplished decorative doodles were added to fols. 115v–116r of the same text. A little red ink appears on fols. 160v–161r of the earlier *Castle of Perseverance* booklet, which also contains an annotated illustration of an elaborate stage design for that play (fol. 191v).

BIBLIOGRAPHY
Beadle 1984 and 1995; Bevington 1972; Eccles 1969; *Folger Shakespeare Library, MS V.a.354*; Griffiths 1995; Riggio 1998.

CHAPTER ONE

Major Middle English Poets and Manuscript Studies, 1300–1450

KATHRYN KERBY-FULTON

A Brief Overview of Topics Covered in This Chapter

Even though London is now thought of as the cradle of English literature, earlier in the fourteenth century regional centers were far more important, and London itself was something of a backwater.[1] This chapter therefore does not begin in London but rather with important Middle English literary manuscripts from the (so-called) Alliterative Revival and other early traditions, made famous in the Harley lyrics, *Piers Plowman*, and the *Gawain* poet's works. Before the rise of London's importance, we can find evidence of strong regional book production centers, especially in Worcestershire, East Anglia, Yorkshire and, more fleetingly, Anglo-Ireland.

From East Anglia comes a Middle English anthology that epitomizes this multiregional diversity within a single collection: a rare survival, made c. 1300 or a little earlier, and now British Library MS Arundel 292, it contains an alliterative East Midlands *Bestiary* and other English texts copied with archaic letter forms, some of which date back to Anglo-Saxon England. The volume was later augmented twice over more than a century, once with a poem likely from Yorkshire and then much later with one from East Anglia. The Arundel manuscript is also an ideal poster child for the early trilingual origins of Middle Eng-

lish writing, as well as for the vitality of native and regional verse forms well into the fifteenth century.

We move then to the more famous Harley 2253 manuscript (c. 1340), with its growing evidence of an alliterative tradition, and its poetry of all types, some of which is marked for traditional oral performance. Harley is especially fine evidence of the role of the legal and clerical community in fostering trilingual literary culture. It was this trilingual culture that the next literary generation would cut their teeth on, as the sources for the *Gawain* poet, Langland, and Chaucer make clear (sections III, IV, and V below). The *Gawain* manuscript forms a perfect link between the world of early and late fourteenth-century book production: its treatment of meter, for instance, looks backward, belying its date of c. 1400 by at least a generation.

London rises to special significance with the appearance of the three most important scribes so far identified in Ricardian manuscript studies, the three whom Doyle and Parkes labeled Scribes B, D, and E in their landmark study[2]: Scribe B (now usually but not universally thought to be Adam Pinkhurst, Chaucer's scribe) was the copyist of many works by Chaucer, not only the Hengwrt and

1. Noting the importance of Worcestershire, Yorkshire, East Anglia, and Lincolnshire prior to the rise of the London book trade, Ralph Hanna writes: "Rather than the 'provincial' identifying the backwater, ample evidence implies that the developed London book-trade Doyle and Parkes discuss had been preceded by a discontinuous series of robust indigenous literary cultures" (Hanna 2005, 2). To his list should be added Anglo-Ireland. I would like to thank Derek Pearsall and Susanna Fein for their

careful readings of this chapter; Kenna Olsen for her reading of the Gawain section; Stephen Partridge, Linne Mooney, Jane Roberts, Alastair Minnis and Ralph Hanna for specific advice on particular questions, and generous sharing of their pre-publication research; Nicole Eddy for her meticulous help as a research assistant, and Sarah Baechle, Katie Bugyis and Andrew Klein for specific advice.

2. Doyle and Parkes 1978.

Ellesmere *Canterbury Tales* manuscripts but perhaps also (though this is less certain) the Trinity College, Cambridge B.15.17 manuscript of *Piers Plowman,* on which all modern scholarly editions of the B-text are based.[3] Scribe D was the copyist of two other significant early *Tales* manuscripts, along with the famous Ilchester *Piers Plowman,* and a staggering number of copies of Gower's *Confessio* (see sections IV and V below, and n104). In research as yet unpublished, Linne Mooney and Estelle Stubbs have identified Scribe D as John Marchaunt, the Common Clerk of the City of London from 1399 to 1417.[4] Mooney and Stubbs speculate that the working environment of Marchaunt and other scribes of Middle English connected with the London Guildhall likely facilitated the production and sharing of vernacular literary texts, perhaps creating an informal clearinghouse of some kind.[5] When their research emerges, it will greatly enhance our understanding of the role that the civic secretariat may have played in propagating English literature. Since their work is unavailable at present, however, we are unable to use the name "Marchaunt" throughout the present book.

Scribe E, Thomas Hoccleve, a poet and revealingly "confessional" scribe, was perhaps as active in Chaucerian book production as in his own. But he, too, had a little-noticed ear for alliterative verse (discussed in section VI). The extant work by these scribes is critical to our knowledge of how these poets composed. So, for instance, we see intimately how Langland worked by studying the textual layers in Scribe D's copy of the Ilchester *Piers Plowman,* which bears evidence of the poet's method of drafting new verses—verses that appear to have been leaked too soon—on "hot topics" for his C version. Similarly, Scribe B's Hengrwt manuscript, when seen alongside the first stage of Scribe D's Oxford, Corpus Christi College, MS 198, provides the earliest glimpses of the *Canterbury Tales* and the struggle to order them, perhaps partly based on *in vita* authorial drafts. This chapter will also examine the history of Middle English textual transmission in the circles of secular clerics, legal and civil service employees, groups from which authors and scribes most often came (chapter 6 below deals with literary transmission among the regular clergy). Thomas Hoccleve is a superb case in point: a clerk of the Office of the Privy Seal (that is, an office for documents issued under the King's own seal), he created his poetry and even his holograph manuscripts from this civil service office environment, revealing a world of in-house publishing and patronage in the early reading circles of Middle English literature.

I. BL MS Arundel 292, Archaism, and the Preservation of Alliterative Poetry c. 1300–c. 1450

Something over a hundred years before Chaucer's death in 1400 and the rise of London book production at that point, what did Middle English manuscripts look like? Arundel 292 (which we have already briefly met in "How to Transcribe Middle English" above, fig. T1) provides us with a snapshot of this early moment, though a better metaphor might be that of an intergenerational family photo album. It hails from Norwich Cathedral Priory, as we saw, but with a likely early provenance among not only monks but choir clerks there.[6] Arundel 292 stands as a precious witness between the brilliant survivals of thirteenth-century Middle English production such as the *Owl and the Nightingale,* *Ancrene Wisse,* or the fabliaux of Digby 86,

and the mid-fourteenth-century rise of the lyric in the Kildare Manuscript, and Harley 2253.[7] English literary culture was very much the younger sister to a sophisticated French literary culture. Originally written not later than c. 1300 (perhaps even as early as c. 1275), Arundel 292 contains an important Early Middle English alliterative *Bestiary,* a fascinating testament to the vitality—and also the growing pains—of the rise of the alliterative long line (see fig. 1). It also contains an addition, likely c. 1350, of an important semi-alliterative rhymed poem about the woes of boy choristers, like the long-suffering little "clergeoun" in Chaucer's "Prioress's Tale" beaten for neglecting his primer. Now called *The Chorister's Lament,* it begins:

3. Doyle and Parkes 1978; Mooney 2006; Horobin and Mooney 2004; for a full discussion of the Pinkhurst identification, see sec. IV below, p. 81.

4. Mooney and Stubbs have both worked on this identification, and given oral accounts of it (the most recent was offered by Stubbs in "The London Guildhall Scribes of Chaucer and Gower," a paper given at the York Manuscripts and Early Book Society Conference, in York, U.K., July 4, 2011). The same paper enlarged on their identification of the scribe of Huntington Library, HM 114 (discussed later in this chapter) as Richard Osbarn, the Clerk of the Chamber of the City from 1400 to 1438. This work is part of an Arts and Humanities Research Council project titled, "Identification of the Scribes Responsible for Copying Major Works of Middle English Literature," which builds on work begun by the late Jeremy Griffiths. Their forthcoming book is to be published

by York Medieval Press with the proposed title of *Scribes and the City.* Nothing as yet from this project is available, but see the brief summary "Scribes and the City of London" on the City of London website: http://www.cityoflondon.gov.uk.

5. See Mooney on scribes who worked for the City of London, including the scribe of HM 114, in relation to the various liberties of the city and the Textwriters' guild (2008, 201–2).

6. See Holsinger 1999, 99–141.

7. For facsimiles see Ker 1963; Tschann and Parkes 1996. Digby 86 contains "prayers and devotional texts, romances, fabliaux, humorous lyrics, a game and party tricks, medical recipes for both humans and birds, prognostications and tidbits of useful information (like the different procedures for ridding a house of malignant spirits, and guests who have outstayed their welcome)"(Tschann and Parkes 1996, xi).

1. Passage on the nature of the fox, *Bestiary*. London, British Library, MS Arundel 292, fol. 7r, in alliterative verse but written out as prose.

"Uncomly in cloystre . i cour*e* ful of care" ("unbecomingly in the cloister, I cower full of cares"; see fig. 2). It shows striking parallels with *Piers Plowman* in its familiarity with choir vocabulary and also gives unique insight into how clerics were taught liturgy, the backbone of their early education.[8] The plague of 1348–49 perhaps accounts for the relative rarity of examples of poetry from the third quarter of the fourteenth century,[9] a rarity that makes *Choristers* especially important. Then in the early fifteenth century, an even more famous poem was also added to the manuscript (see fig. 3), our unique witness to the delightful, much anthologized alliterative sound poem known today as *The Blacksmiths*. It is written out in prose, however, with a complex system of punctuation apparently designed to guide intonation of the voice falling and rising. In origin, medieval punctuation was closely related to the markings developed for singing the words of the liturgy, but *Blacksmiths* seems unusually sensitive in its pointing, as we will see below. In a modern edition, the poem opens this way:

Swarte smeked sithes smattered with smoke
Drive me to deth with din of here dintes
Swich nois on nightes ne herd men never:
What knavene cry and clattering of knockes!
The cammede kongons cryen after "col, col"
And blowen here belowes, that al here brain brestes:
"Huf, puf!" saith that one; "haf, paf!" that other

(1–7)[10]

8. Wirtjes 1991 and Holsinger 1999.
9. See, however, front plate 2.

10. Sisam and Sisam 1970, 372.

2. Detail of the opening of
The Choristers' Lament.
London, British Library, MS
Arundel 292, fol. 72v, c. 1350
or slightly later.

3. *The Blacksmiths*. London,
British Library, MS Arundel
292, fol. 71v, (top half only),
added in a later hand (s.xv
in.), in alliterative verse
though written out as prose.

The comedy of the smiths blowing on their bellows so
that "al here brain brestes" is accompanied by a spate of
sheer delight in noise: "Tik, tak! Hic, hac! . . . Lus, bus!"
(19–20), represented in the manuscript as: "tik . tak . hic
. hac . tiket . taket . tyk tak" and so forth, a line carefully
marked off metrically at the end with a punctus elevatus
(⸵), a mark originally designed to indicate a rising voice
(see fig. 3, line 13). This tour de force of East Anglian al-
literative diction—a rare species—is a significant witness
to the fact that alliterative poetry was not just a phenome-
non of the West Midlands. Among its earlier contents, the
manuscript also contains Anglo-Norman religious verse,
including the debate among the four daughters of God
(*De quatre sorurs vus uoil dire*), as well as a fragment of the
Historia regum Britanniae, *St. Patrick's Purgatory* (Latin), a bi-
lingual *Distichs* of Cato (French and Latin), and Latin rid-
dles of the kind popular in monastic houses. Students who
know *Piers Plowman* well will instantly see in the Arundel
manuscript a configuration of just the kind of literature
Langland knew and grew up on—including, as Holsinger
notes, the monastic riddles.[11]

11. Holsinger 1999, 130. See Wirtjes 1991 for these contents.

When reading these poems in their manuscript context, however, much more suddenly becomes clear about the growth and trajectory of alliterative writing from c. 1300 onward, and about the way this native tradition interacts with its Latin and French neighbors. In the *Blacksmiths*, for instance, as Salter showed, medieval readers would have associated the smithy descriptions with the scenes of hell as a "vast smelting furnace under the direction of yelling demon-smiths"—which is surely why the writer added it on a blank page facing the opening of the *St. Patrick's Purgatory* (see fig. 3, extreme right, just visible in an earlier hand).[12] In fact, she was right on the mark. The *Purgatory* was considered by medieval readers to be the centerpiece of the volume. If one looks up Arundel 292 in N. R. Ker's *Medieval Libraries of Great Britain* (one of the most basic tools for tracing ownership and provenance of extant manuscripts from medieval institutional libraries), the volume is listed with the typical brutal economy of medieval library titles as: "Purgatorium Patricii, etc."[13] If the manuscript had not survived, we would not know it had ever contained English poetry. It bears the press-mark "C. X." on fol. 3 (see "How to Transcribe Middle English," fig. T1, top) and also on fol. 114v, a Norwich mark of c. 1300. A table of contents in the hand of the main scribe refers to an item now lost (owing to a missing quire) about a fire in Norwich Cathedral in 1272.[14]

Looking at these pages in Arundel, as we saw with regard to fig. T1, one feels one has almost stumbled back into Anglo-Saxon England. Thorns and yoghs would hold on well into the fifteenth century in certain dialects, but the use of **p** (wyn) and **ð** (eth) in Arundel 292 is unusual by 1300. One wonders what ancient English models or exemplars the original scribe knew or had at hand in Norwich Cathedral, for though he copies Latin in the same script (Gothic *textura rotunda*),[15] his Latin does not look quite so archaic because, of course, the archaic vernacular letter forms that hark back to Anglo-Saxon orthography (discussed above in "How to Transcribe Middle English") do not appear. Moments of alliteration also hark back to Anglo-Saxon poetic forms, for example, in the *Creed* Christ "Pinedd under ponce pilate" ("Suffered under Pontius Pilate;" see fig. T1, line 7). We do not always get such a regular Anglo-Saxon line as this but often some memory of it. What this man's relation to Norwich Cathedral was is unclear, although secular clerks, we know, were brought in to supplement the choir in this period, as

Holsinger notes.[16] One clue to his identity, as Jane Roberts notes, is that he seems to be "a scribe accustomed to writing legal documents and perhaps ill at ease with Gothic *textualis*."[17] He may be a member of the clerical proletariat to whom we owe so much original composition and preservation of Middle English.

If we turn now to the justly celebrated *Bestiary* he copied at the same time, however, Arundel 292 suddenly seems more like a herald of the future, at least of the Alliterative Revival typified by the poems of protest in Harley 2253 (c. 1340). The *Bestiary* uses the same orthography and also contains an array of different metrical types, though it is written out as prose. But several of the key animal descriptions are done in alliterative long lines of vigor and charm. The fox, for instance, of which the poet says, "Husebondes hire haten for hire harm | dedes," (fig. 1, fol. 7r, lines 7–8) likes to play dead in order to attract birds, which, even though it will shortly be moralized, the narrator recounts in full-blown minstrel style: "Listneð nu apunder" ("Listen now to a wonder," line 11). He narrates eagerly how she

goð o felde to a furʒ [furrow] . **and** falleð ðar inne ~ (12)
 ~ **N**e stereð (13)
ʒe [she] noʒt ~ (14)
 ~ **Ð**e rauen is spiðe redi [quickly ready] . (15)
Þeneð [thinks] ðat ʒe rotieð . **and** oðre fules hire
 fallen bi . **F**or to (16)
pinnen fode ~ (17)
 ~Liʒtlike (18)
<u>ʒe</u> lepeð up . **and** letteð [prevents] hem sone ~ (19)
~ <u>T</u>etoggeð **and** tetireð hem . **M**id hire teð sar- (20)
<u>p</u>e [Tears them to pieces and pulls them to pieces (21)
 with her sharp teeth].
(fig. 1, fol. 7r, lines 12–21, with omissions and my emphasis)[18]

Even though the text is written as prose, a punctus (point) marks the caesura, and even from these few lines one can see a whole range of alliterative patterns, from the highly ornate *aa/aa*, to *aa/xa*, to the more standard *aa/ax*. And those who know texts such as *Piers Plowman* or the alliterative Harley lyrics (discussed below) will instantly recognize the roots of those poems in this earlier one, especially in the verses underlined above. Compare Langland's description of Liar, a direct poetic descendent of the moralized fox as deceiver:

12. Salter 1988, 213.

13. Discussed in Wirtjes 1991, xi; for the entry see Ker 1964, 138.

14. Labeled "De conbustione ecclesie cath*olice* sancte trinitatis Norwic*iensis*." For this, and the gap in the quire signatures and the collation, see Wirtjes 1991, xi. The manuscript was not made in booklets.

15. See Roberts 2005, 154–56, for details of this script in Arundel 292, which she calls Gothic *litera textualis rotunda media*, and dates to s.xiii ex.

16. Holsinger 1999, 132.

17. Roberts 2005, 154. Fol. 72r may be seen online at the British Library gallery of illuminated manuscripts, http://www.bl.uk/onlinegallery/onlineex/illmanus/index.html. See also Roberts 2005, 141.

18. Letters splashed in red are transcribed as capitals; manuscript's punctuation and lineation is preserved. These correspond to lines 269–79 in Wirtjes 1991.

Lyhtliche Lyare lep awey thenne,
Lorkynge thorw lanes, tologged of moneye.
 (C.II.228-29; my emphasis)[19]

Elizabeth Salter memorably wrote of these lines in *Piers* that Liar "leaps into the poetry with the sure energy of an English medieval line-drawing."[20] The "sure energy" here, however, is that of the early alliterative tradition, which Langland drew on with a sure ear.

The Arundel manuscript furnishes yet another example of this alliterative vigor in a poem so Langlandian it has even been claimed for the (post-) *Piers* tradition. *The Chorister's Lament*, beginning "Uncomly in cloystre . i cour*e* ful of care" (fig. 2) was analyzed in relation to *Piers* by Bruce Holsinger.[21] Holsinger notes, for instance, that in the *Lament*, the narrator complains that he fails at singing his Psalter:

I ga gowlend [go wailing] aboute also dos a goke
 [cuckoo]
mani is þe sorwfol song i[c] singge vpon mi booke.
 (5-6; my emphasis)[22]

This is not unlike Langland's line about faulty legal scribes and liturgical performers:

The gome þat gloseþ so chartres for a goky is holden
So is it a goky, by god! Þat in his gospel failleþ,
Or in masse or in matins makeþ any defaute.
 (B.XI.306-8; my emphasis)[23]

Both use the word *goke/goky* (a cuckoo). *Chorister's* is in a northern dialect, and Langland's is South West Midlands (SWM) dialect, but even Langland here reaches for the more northern word *gome* to alliterate. Whether this is a sign of intertextuality or simply an idiom among clerks is unclear. Another parallel Holsinger notes is that the *Chorister's* poet moans in line 30:

I donke vpon dauid [pound upon David] til mi tonge
 talmes [tires],

which is similar to Langland's comment about priests and parsons who

…dyngen vpon Dauid eche day til eue.
 (B.III.312; my emphasis)

Again, an idiom passed around in the clerkly world or a signal of influence?

Where manuscript studies can help in a conundrum

like this is in noting that the hand that transcribed it is easily dateable to "as early as c. 1350"—in fact, it is not impossibly even a little earlier.[24] This documentary hand shares features with manuscripts as early as that of Harley 2253's scribe[25] and other pre-Ricardian hands: looking at fig. 2, note the height of the two-compartment **a** (often as high as the two-compartment **d**); the circular **w**, the way the double-lobed **g** does not descend too low, and even the split ascenders occasionally on **l**—all features of early fourteenth-century *Anglicana*. Now, paleographical dating is not an exact science: one can be fooled by, for instance, an older scribe who has not kept up to date with changes in script, or a young scribe trained by an older one in some remote area, or a scribe who is simply albeit awkwardly imitating an older hand (we can see a clear instance of the last in front plate 2 from Newberry Library MS 31). But, if we were to get out Ockham's razor and date this hand in the usual way, the date could certainly be used to support the reversal of Holsinger's argument: that is, that Langland wrote *after* this poem was copied. Langland, too, we must remember, would have been trained in a song school.

Whoever copied the poem into Arundel in the third quarter of the fourteenth century knew what he was about and saw the book as a growing word hoard of alliterative verse. There are no rhyme brackets to call attention to the rhyme, but the scribe has regularly provided a midline punctus (see fig. 2) to draw attention to the caesura in the alliterative line (e.g., "I ga gowlend abowte . also dos a gok*e*," line 5). The choristers, Wa(l)ter and William, despite constantly being in trouble with the master, persist in flaunting a highly specialist knowledge of musical terminology, a knowledge the poet expected his reader to share. Song schools, as Katherine Zieman has shown, were integral to clerical literacy and therefore part of the rite of passage to professional life.[26] The final stanza takes us right inside the trilingual environment of the song school, a mirror of the manuscript's own:

Qwan ilke note til oþer lepes and makes hem asawt,
Þat we calles a moyson [measure] in gesolreutȝ en
 hawt [the note "sol," sung high].
Il hayl were þu boren ȝif þu make defawt
Þanne sais oure mayster "Que vos ren ne vawt" ["My,
 but you are worthless"]. *(49-52; my emphasis)*[27]

In this final stanza, some of the alliterative style fades as French diction takes over (underlined above), and from the last line we learn that the boys are being instructed in

19. Russell and Kane 1997
20. Salter and Pearsall 1967, 10.
21. Holsinger 1999.
22. I quote Holsinger's edition, with corrections. For a full translation of the poem alongside an edition, see Sisam and Sisam 1970, 184–85. Their transcription differs from Holsinger's in orthography, which they normalize to some extent. Holsinger 1999, 123ff., makes these parallels.
23. Kane and Donaldson 1975.

24. Hanna 1999, 509–10.
25. Compare fig. 4 below.
26. Zieman 2008.
27. Holsinger 1999, note to line 52. Sisam and Sisam translate the stanza: "When every note leaps at the other and they clash together, that we call a melody in high G. You would be unlucky to be born if you make a mistake: then our master says that you're no good" (1970, 187).

French to sing Latin chant, yet complaining in English alliterative verse. This is despite the fact that it was written in a northern dialect (perhaps Yorkshire),[28] yet copied by a scribe who likely came from King's Lynn in East Anglia (as the "qw" spellings indicate), one of the important areas of Middle English book production prior to its rise in London.

The final English addition to our little volume is much-anthologized. *The Blacksmiths*[29] is an alliterative poem ostensibly against the policy of allowing smiths to work at night but in fact luxuriating in the very sounds of the smithy, which it seeks to imitate in exuberantly over-alliterated lines, from its opening, "Swarte smekyd smeþes smateryd with*e* smoke," to its closing line, in which one can hear the water hiss with the hot metal: "may no man for brenwater*ys* on nyght' han' hys rest" (fig. 3, 71v). It has been compared by Elizabeth Salter to the "urban disturbance" genres in Horace, Juvenal, and Martial, and to further schoolboy exercises in rhetorical ornament in Geoffrey de Vinsauf's *Poetria Nova*.[30] This parallels an exercise in the art of composition from Geoffrey that involves transposing Latin verbs into objects to imitate the activities of blacksmiths making armor.[31] *The Blacksmiths*, then, too, likely has the smell of the schoolroom about it, despite its heaping slice of social life. It also, I would suggest, has the smell of the choir: it is most elaborately and unusually punctuated to mark off the alliterative line units (fig. 3). Take the first three lines, as they appear in the manuscript:

Swarte smekyd smeþes smateryd with smoke : dryue
 me to deth

wyth den of her*e* dyntes ∮ Swech noys on nyght*e* ne
 herd men

neu*er* : what knauene cry *and* clateryng of knockes ;

There are three different marks here, showing the voice rising to pause after "smoke" (the *punctus elevatus*, the forerunner of the colon), pausing after "dyntes," and falling after "knockes" (the *punctus versus*, where the voice falls to stop).[32] This worthy companion to *Choristers* was added sometime in the first half of the fifteenth century, and this tells us that for over a century, perhaps a good century and a half or more (given the presence of thirteenth-century entries on the flyleaf),[33] this little volume was treasured, in part as an archive of the native form of verse, in part as a cleric's (though likely not a monk's) working book. Salter's fine detective work in determining that *Blacksmiths* was composed out of good, solid East Anglian words, perhaps in imitation of the more traditional East Midlands alliteration in its old poetry like the *Bestiary*, is further testimony to the creativity this little book exudes. Made of often misshapen parchment, this was paradoxically a personal book shared among many persons both at once and over a long stretch of time. And despite its archaic orthography (did readers in 1450 even know how to read **ð** or **þ**?) even the early poems were kept, treasured, and multiplied with ever more vigorous examples of native verse.

These are precious early appearances of alliterative style from at least three different areas of England (the East Midlands, Yorkshire and East Anglia), as is evidence offered in *Chorister's Lament* of a still comfortably, playfully trilingual world. One reason one might be tempted to suggest that the maker of Arundel was looking not only backward but forward is that even his *Bestiary* has lines that are dead ringers for those found a few decades later than its copyist was working—that is, c. 1340, about the time that Harley 2253 was being written.

II. BL MS Harley 2253 and Principles of *Compilatio*, or: Why Read the Harley Lyrics in Their Natural Habitat?

One of the most remarkable and mysterious survivals of early fourteenth-century book history is the famous Harley MS, perhaps the only manuscript shelfmark universally known to scholars of medieval England, even those who might not otherwise engage in manuscript studies. Harley 2253 looks—at first glance over the facsimile done by N. R. Ker in 1965—like a modest affair at best, perhaps downright disappointing to those who have seen images of the beautifully illuminated pages of the Ellesmere Chaucer or its ilk. But the manuscript contains a literary treasure trove of material dating from pre-1349 England, including

"works of exquisite emotive utterance, political-historical rarity, and notoriously unrestrained ribaldry," as Susanna Fein writes.[34] Many of the most famous lyrics in Middle English—lyrics, that is, that fill a disproportionate space in modern anthologies—are preserved, often uniquely, in its large, utilitarian folio pages. These poems epitomize the next generation of English poetry after the Arundel *Bestiary*. Speaking especially of Harley's alliterative verse, Thorlac Turville-Petre notes that "none of the most heavily alliterated lyrics is on religious topics. Several that express social comment or satire are important precursors

28. Hanna suggests York or Beverly Minster (1999, 310).

29. It comes just after a text on what to do if, as a priest, one has an accident with the host ("Si aperta quod absit neglicencia de corpore aut sanguine Christi acciderit," fol. 68r).

30. Salter 1988, 211ff.

31. Ibid., 211, and 334–35 for the full Latin text.

32. Ibid., 329–30; Roberts 2005, xiii, for the types of punctuation. The ∮ is a *virgula suspensiva*.

33. Viewable online at http://www.bl.uk/catalogues/illuminatedmanuscripts/welcome.htm (choose Arundel 292, fol. 114v).

34. Fein 2007, 68.

of *Wynnere and Wastoure*, *Piers Plowman* and *Mum and the Sothsegger*."[35]

They are important precursors, in fact, to *all* the major Ricardian poets. So, for instance, the Harley lyric beginning "Ich herde men vpo mold make muche mon" chronicles the kind of oppression of the poor we find in poems of the *Piers* tradition and especially the type of complaint about taxation we see later in the literature of 1381. Take, for instance, these lines showing evidence long before 1381 of the unpopularity of Exchequer documents sealed in green wax, with which the poet says tax officials hounded their victims:

> Þus þe grene wax vs greueþ vnder gore [to the quick],
> Þat me vs honteþ ase hound doþ þe hare.
>
> (55–56)[36]

But the same poem also uses an alliterating stanza and rhyme structure somewhat similar to that of *Pearl*,[37] while Harley's "Of a mon Matheu þohte" retells the parable of the laborers in the vineyard, just as the *Pearl* poet does.[38] Other poems in the manuscript anticipate Chaucer, such as *Alysoun*, with its "love-struck refrain" so like the idiom of the "Miller's Tale,"[39] and the rollicking French poem "Gilote et Johane" is a match for the "Wife of Bath's Prologue" any day. Of this poem, Carter Revard wrote a delightful article with the apt title: "The Wife of Bath's Grandmother: Or, How Gilote Showed her Friend Johane that the Wages of Sin is Worldy Pleasure, and How Both Then Preached This Gospel throughout England and Ireland."[40] These marvelous poems and many more were copied by a scribe working in Ludlow, Shropshire, located in the South West Midlands region, in, that is, England's most important, historic vernacular book-producing region at the time.[41]

The Harley scribe and compiler—scholarship assumes that one man wore both professional hats[42]—was an artist in his own right. Making intelligent selections from a much larger body of work than is extant today, he shows unusually fine skills in *compilatio* and *ordinatio*. The *ordinatio* of Harley (that is, its layout and organization on the page),

though at first glance scrappy, reveals how he placed many of the poems in mirror fashion on the page, apparently so as to evoke counterpoint between different texts. Revard demonstrated a brilliant instance of this where the compiler set "a mocking Middle English poem that celebrates the 1264 triumph of Simon de Montfort, alongside a mournful Anglo-Norman one lamenting the 1265 defeat and death of Montfort, . . . [and] a pairing of *memento mori* quatrains, one in Middle English, the other in Anglo-Norman."[43] In terms of *compilatio* (the gathering together, and framing or shaping of disparate materials in a manuscript),[44] he apparently rewrote the beginnings and endings of some poems to make them fit their context in his anthology. He also collected poems in a range of dialects from a country-wide network for poetry in English— much of which has not survived elsewhere—as well as in French and Latin. He was, in short, a gifted, creative person. He was the scribe responsible for fols. 49–140 of Harley 2253, much of the largely French manuscript London, British Library, MS Royal 12.C.xii (perhaps his commonplace book) and Harley 273 (largely devotional), in addition to forty-one extant deeds and charters from the Ludlow area.[45]

Where did the compiler learn this technique of mirroring? An important clue lies in the genre of the *contrafacta*. *Contrafacta* were lyrics that took their opening lines and music from known models and changed the theme, often from secular to religious, a common practice among Franciscan preaching friars, for instance, who avidly used and collected popular songs just for this purpose (as in Harley's cousin, the Kildare manuscript).[46] As Richard Firth Green has shown,[47] the layout on folio 128r (see fig. 4)[48] contains two mirrored poems, the first religious, the second, a secular love poem, with the same incipit. The ascenders of the top one are elongated with strong, thick flourishes in the minimalist style of decoration derived from legal documents and used by the scribe throughout Harley. The poem opens with the idea that no one knows enough of how love bound Christ to his painful task of redemption on the cross:

35. Turville-Petre 1989, 10. Fein traces the metrical genealogy of *Pearl*, examining three distinct styles of twelve-line stanza, in which "Ich herde men" is identified as having an octet/quatrain stanza, and lacking the refrain of *Pearl*'s ballade stanza (1997). But as Fein notes, they are similar (ibid., 380) because of their alliteration and concatenation, making it a likely antecedent of *Pearl*'s (ibid., 393). I am grateful to Susanna Fein for advice and Andrew Klein for research.

36. Turville-Petre 1989, 19.

37. Ibid. The stanza is twelve-line with alternating rhymes.

38. Brown 1932, 143–45.

39. Susanna Fein 2000b, 351–52; and see Donaldson 1983, 13–29.

40. Revard 2004.

41. In addition to the Ludlow connections revealed by Revard, Birkholz explores Harley 2253's implicit ties to Hereford, and possibly to the cathedral and its clerical *familia*; Birkholz supports

his thesis by dividing off the role of the scribe from the role of the compiler(s) (1999). Hines enlarges upon Revard's thesis of an association with a Shropshire knight, Lawrence de Ludlow, at Stokesay Castle (2004, 79, 88–93). I am very grateful to Susanna Fein for her advice.

42. Fein 2007, 352n5. Birkholz 2009 has a different view.

43. Revard 2007, 96.

44. See Parkes 1976, Minnis 1988, and, on Harley in particular, Fein 2007.

45. See Revard 2000, 65ff.

46. See Ker 1965, xxii–xxiii; see front plate 1 on relations with the Kildare Manuscript, see Jeffrey 2000.

47. Green 1989.

48. Ker 1965, articles 92 and 93. Quoted below from the manuscript but for an edition, see Brook 1956, 70–72.

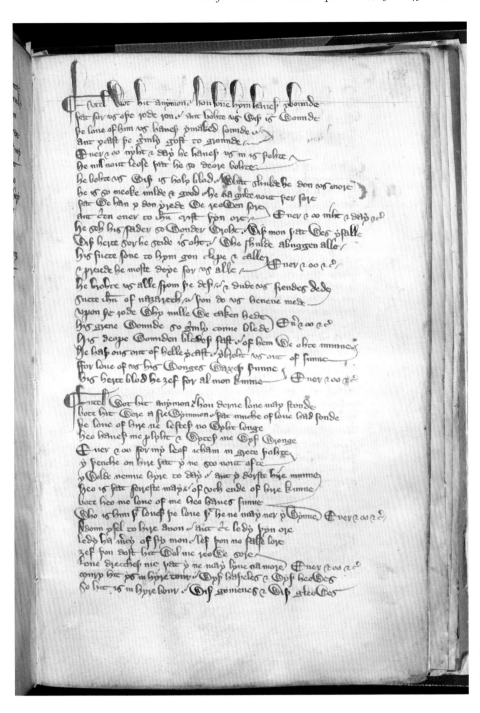

4. Mirrored *contrafacta* poems, both beginning "Lutel wot hit anymon." London, British Library, MS Harley 2253, fol. 128r.

LVtel wot hit anymon ⁊ hou loue hym haueþ ybounde
Þat for vs oþe rode ron ⁊ ant bohte vs wiþ is wounde
(fol. 128r)

The second half of the page is occupied by a poem with the same opening line, and the audacious statement that no one knows much of how secret love may be, unless it be a noble, gracious woman who has experienced (or dealt with) a great deal of love:

Lutel wot hit anymon ⁊ hou derne loue may stonde
Bote hit were a fre wymmon ⁊ þat muche of loue had fonde

The Harley page, then, shows the opposite process, and this makes it even more audacious in form: a religious poem re-worked as a secular poem, in fact quite an erotic one. This suggests the kinds of *contrafacta* created in the traditions of the *puy*, an originally French form of social gathering or club for poetic competition, for which there is some evidence of English imitation. Green notes that "around 1260 a *jeu-parti* held at the Arras Puy . . . was judged by no less distinguished a guest than Edward I of England."[49] There was a London *puy* in the thirteenth century, and scholars have long sought evidence—some of which may survive in a manuscript now in Philadelphia—that Chaucer was part of a *puy* tradition.[50] Be that as it may, there is no doubt here

49. Green 1989, 311; see also Fein 2007, 71.
50. See Anderson 1986, 1–3, on University of Pennsylvania MS Fr. 15, and plate 1; see also Wimsatt 2009.

that the Harley scribe had gotten hold of just such a *jeu* and that, despite much evidence elsewhere of his piety, he was content to let the reversal stand in the direction it did. The second poem has erotic lines like "Mury hit ys in hyre tour ⸭ ~ So hit is in hyre bour" (see bottom two lines of fig. 4), connected by internal rhyme. Both poems have the same refrain line ("Euer & oo niht & day &*cetera*"), placed between the end rhymes of couplets, connected to the text with brackets that attach to the end rhymes. As one can see from reading the poem in the manuscript itself, the re-

frain can work after *either* line, not just where it is placed in modern editions. For instance, one can put "Euer & oo niht & day . . ." *after* either bracketed line in the first lyric, which is exactly how it is placed (see lines 9 and 10 of fig. 4):

Þat we han y don yrede we reowen sore \
Ant crien euer to ihesu crist þyn ore /

This comes to be important not only in the Harley lyrics but, as we will see, in the manuscript of *Sir Gawain and the Green Knight*.

～ BARE ESSENTIALS 2: *Anglicana Script and Profiling the Individual Scribe*

Copied in a documentary hand—what Ker called a "business hand," and Parkes would later name generically as "anglicana"—there is little to distinguish the Harley MS visually from a set of household accounts or copies of deeds or legal documents:

> Harley 2253 was written at a critical moment in the history of script, when scribes were trying to find a book hand which was not so difficult to write on a small scale as the traditional *textura*. . . . [Harley] is an example of the more formal manner of writing the ordinary business hand, such as we find in headings or in letters patent or in registers. . . . The formality consists mainly in writing rather larger than usual and in avoiding links between the strokes of *m, n* and *u*.[1]

Not only does the scribe use his documentary hand (with the minor adjustments noted by Ker, a half-hearted attempt to write more formally, which he often slips out of when writing prose), but he also decorates the manuscript, as we saw in fig. 4, in the minimal way a legal document is usually decorated, using elongated ascenders on the top line (compare fig. 5, a charter copied by the same scribe in 1338).[2] Scribes trained in the legal profession or, increasingly throughout the fourteenth century, in the writing offices of government or administration formed the backbone of vernacular book production outside of the monasteries (and later, to some extent, even within them). This most especially applies to early English book production—in the mid-fourteenth century French and Latin still had much more clout, their readers having more access to formal styles of book production. Early writing office scribes, writers of what in the fourteenth century was called court letter, share some key characteristics: notably a tendency to copy pages with minimal or even no ruling, what art historian Lucy Freeman Sandler, describing a book copied by an Exchequer clerk in the 1360s, aptly calls "a casual treatment of page."[3] Art historians, we might note, are used to looking at "beautiful" books. Harley, a book even less lavish than the one Sandler is describing, was created for more utilitarian purposes, apparently for a household by a man who was a legal scribe working in the Ludlow area between 1314 and 1349. It is poignant that the latest document in this scribe's hand (in Revard's list, #41), is dated 1349, a date suggesting that he may have died of the Great Plague in that year, alongside so many of his countrymen.

The forty-one legal documents by this scribe that survive allow us to trace the changes in his handwriting over these three and a half decades. In a brilliant table,[4] Revard records the letter forms of the Harley scribe across all forty-one documents, showing especially that "the most unusual features" of his hand (his periodic use of a "flat-bottomed *g* and the stroke over *i* made with a double

1. Ker 1965, xviii. 2. Revard 2000, plate 18.

3. Sandler 1989, I:13, discussing the *Omne bonum* manuscripts; see Christianson 1990 for the medieval London listing of writers of court letter.

4. Revard 2000, 59.

5. Charter copied by the scribe of Harley 2253. London, British Library, MS Add Ch. 41302, 1338.

hook") appear consistently both in the legal documents and in the literary manuscripts he copied (Harley 2253, Royal 12.C.Xii, and Harley 273).[5] Revard shows, for instance, that the flat-bottomed **g** appears in all the holographs, but the double-hooked **i** appears only in documents from 1331 onward (see fig. 4, line 4, "grounde" for the **g** and line 7 of the second poem "hire" for the **i**). By showing the scribe's usage of these features in relation to other more standard features of *Anglicana* script in the period, Revard was able to show that we do not in fact have two different scribes creating the different types of **i** and **g**, but the same scribe, who changed some features of his hand over the period—both those unusual to him and some which change generally during this time as, for instance, the use of split ascenders on **L** and **b**. Split ascenders begin to disappear in manuscripts after the early fourteenth century, a standard factor in dating practices of modern scholarship. Revard's research shows that in documents, our scribe uses the split ascender on **L**, for instance, rarely after 1316. Taken all together, Revard's evidence is able to show, then, criteria for dating the three literary manuscripts of this scribe: on the basis, for instance, of the increasing use of the double-hooked **i**, we know that "all of Harley 2253 is post-1329."[6] Moreover, on the basis of the names in the various documents, Revard is able to give us a sense of the social and historical milieu of this legal scribe, working in Ludlow (in the West Midlands), an area highly significant to post-Conquest preservation of English literature and the Alliterative Revival. The paleographical importance of Revard's work cannot be underestimated; it verges on the heroic. It is a superb model for students of any period, showing how to tackle the following kinds of problems:

1. How do we decide whether two or more texts are written by the same scribe? (Note that Revard's methods here, comparing unusual features with usual ones in a standard script of the period, are the traditional ones of paleographical scholarship; a somewhat different approach has more recently been developed by Linne Mooney in relation to the study of Chaucer's scribe, as we will see below).
2. Do scribes change features of their writing either in relation to changing script fashions or more idiosyncratic preferences?
3. How can we localize a manuscript? (Note that a range of techniques is used: historical evidence of a scribe's or owners associations; social class evidence, and dialectal evidence).[7]

5. Ibid., 32. 6. Ibid., 62.

7. Brook summarizes the dialect and provenance evidence (1956, 2ff.).

1. Trilinguality, Social Tensions. and Creative *Compilatio* in Harley

But we are still left with several puzzles posed by the contents of the manuscript especially. This trilingual treasure trove, a too-rare survival of lyrics in all three of England's working languages,[51] remains a mystery to scholarship in part because of (1) the large geographical range of the dialects represented in the poetry; (2) the extraordinary care the scribe took to place poems or prose selections alongside each other in—apparently—thematic schemes; (3) the way English is granted parity with the other two languages—a rare whiff of linguistic democracy.

The startling range of dialects represented in the manuscript shows that the scribe was part of a network interested in poetry in *English*, still a minority interest among the literate in the 1330s and, among book producers, indeed, nearly a rarity.[52] Susanna Fein has remarked that the evidence of scribal miscopying in one instance (the scribe had copied the second side of a single sheet first, thereby inadvertently beginning a piece halfway through) tells us that he was likely often copying from single sheets or rolls, the most likely medium for vernacular verse, often circulated in these ephemeral forms.[53] The Harley scribe was apparently an aficionado of poetry in English, his mother tongue, though his preferred working language was French, and he handled clerical and legal Latin daily. As scholars have often pointed out, a Harley lyric written in the persona of a student in Paris summarizes this trilinguality aptly. In the last stanza of the macaronic poem *Dum ludis floribus,* the student uses Latin to speak of writing his song "in tabulis" ("in [wax] tablets"), French to speak of his home ("mon ostel") in Paris, but English to speak of his lover:

Scripsit hec carmina in tabulis;
Mon ostel est en mi la vile de Paris;
May y sugge namore, so wel me is;
ʒef hi deʒe for loue of hire, duel hit ys.[54]

In all likelihood, as we saw in section I, the compiler of Arundel 292 was not much different, at least in linguistic orientation. As one can see examining these lines in the manuscript itself (bottom two lines in fig. 6), the poem is written as prose, and all three languages are treated exactly alike (one might contrast, for instance, the differential treatment of the Latin lines in many *Piers Plowman* manuscripts). The Harley compiler's political interests and affinity can be further gleaned from his manuscripts: he copied and likely composed the French summaries of biblical stories in Harley, emphasizing particular issues, such as overtaxation of the clergy, as John Thompson has shown.[55] Discarded material used as endleaves for binding Harley show a close connection with both Anglo-Ireland (Ardmulghan) and with Hereford, which the baronial Mortimer household moved between.[56] At the time Harley was made, Anglo-Ireland was already an established center for superb lyric poetry, judging by the quality of the Kildare manuscript. The close connections between Anglo-Ireland and the West Midlands of England (including migration and settlement of the colony, magnate and civil service activity, and traffic in poetic manuscripts) account in part for the literary strength of Middle Hiberno-English manuscript production (see front plate 1).[57]

What do we learn from studying the Harley manuscript itself—or at least the facsimile—that we would not learn from one of the many editions of the Harley poems? Take, for example, the layout of *In the Ecclesiastical Court,* one of the most prized of the manuscript's alliterative poems, anticipating the *Piers* tradition poetry in its harsh satire of clerical corruption and maltreatment of the working

51. Tschann and Parkes give evidence that Digby 86 was of little interest to its early modern antiquarian owners, a factor that could be extrapolated to explain losses of certain categories or genres of English manuscripts, thereby perhaps somewhat skewing our sense of the rarity of these texts in their own time (1996, xi).

52. See Fein 2007, 72, for evidence of the scribe's choices of poetry from a range of dialects.

53. Rare examples of these kinds of sheets and rolls from the same period can be seen in Bod. Rawlinson D. 913 and in Bodley Rolls 22 respectively.

54. Brook 1956, 55, lines 17–20.

55. Thompson 2000.

56. Ker 1965 xxii. See Revard 2000, 21–30, on Roger Mortimer of Wigmore (d. 1330), his influential family and their connections with Harley 2253.

57. See also Kerby-Fulton and Despres 1999, ch. 2 and Thompson 2007.

6. Detail of *Dum ludis floribus,* showing the poem at the bottom of the page, written out as prose, with line breaks indicated only by punctuation (a virgule), and "democratic" treatment of all three languages. London, British Library, MS Harley 2253, fol. 76r.

poor, and both Langland and Chaucer in its portrait of the corruption of summoners. Of the six or seven summoners in court the poet says, "Hyrdmen [retainers] hem hatieþ, ant vch mones hyne [man's servant]," one of two lines in the entire poem the Harley scribe foregrounds with his standard flourishing at the top of the page (see fig. 7b), an alliterative line almost exactly echoing Arundel's *Bestiary* on how much farmers hate the behavior of foxes ("husebondes hire haten for hire harm dedes").[58] The main drama of the poem, however, portrays the plight of an unlearned man in a courtroom, skewered by the pens of the unscrupulous learned: "Heo pynkes wiþ heore penne on heore parchemyn" ("They stab with their pens on their parchment," 25). In terse lines jammed with wordplay, alliteration, and rhyme (a mix of native and Continental poetic styles), it portrays legal process gone awry and self-justificatory misogyny ("of wymmene wo," 33). The narrator is brought to ecclesiastical court by summoner coercion on charges of fornication, forced to marry a woman "vncomely under calle," the antitype of the heroine of alliterative convention, a formula we also saw used satirically in *Chorister's Lament*. To cap off this portrait of ruthless clerical power, the narrator is eventually flogged around the church and marketplace, a severe punishment for fornication, to his shame and that of his kin: "At chirche ant þourh cheping ase dogge y am dryue" (82), the other line in this poem foregrounded by the Harley scribe with elaborated red ascenders (as he did in fig. 7b, top line).

The Harley scribe copied this poem in a long column on the left half of three sides of three pages (figs. 7a, b), using the right column for the *Labourers in the Vineyard*, the retelling of the parable from Matthew (a later version of which forms the physical core of *Pearl*). At first sight, it is hard to know why these two poems would be juxtaposed. While the shorter metric length of *Labourers* may offer some clue (it can be squeezed in the narrower right margin left by the long alliterative lines), it does not explain the specific choice of this text: after all, at the end of *In the Ecclesiastical Court* he chose to copy perhaps Harley's most famous love poem, *Spring* ("Lenten ys come wiþ loue to toune")—equally short in metrical syllables—into the left column below *Court*. *Spring*'s theme of disappointment in love is a brilliant riff on the last line of *Court* (90), which warns of "wymmene ware" (both a commercial and sexual image). So the choice of the gospel account of *Labourers in the Vineyard* to place beside *Court* is an odd and deliberate one, both thematically and spatially, since it leaves significant blank space in the column afterward,[59]

as it runs alongside the lengthier *Court*. He had to sacrifice space to make this parallel. Why choose it?

If we look more closely, both *Ecclesiastical Court* and *Labourers* are overtly about two themes of interest to the Harley compiler: the power of literacy and the powerlessness of the lower social orders to change a seemingly adverse ruling made by figures in authority.[60] *Court* begins:

> Ne mai no lewed lued libben in londe
> Be he neuer in hyrt so hauer of honde
> So lerede vs bíledes.

> [No unlearned man may live in the land, be he in court ever so skilful of hand, in such a way that the learned will not persecute us.]
>> *(1–3; see fig. 7a, my emphasis)*

Note that the "vs" refers to the unlearned, not the learned—the narrator ostensibly showing his cards at the outset. But for all the undoubted sympathy with the unlearned, indignation at the learned, and outrage with summoners that *Court* excites, it does not wholly exonerate the young man (who is no chaste Susannah among the corrupt elders, to name a contemporary alliterative poem in which a lay person is utterly cleared of sexual wrongdoing).[61] Moreover, its author must necessarily have been himself more learned than his fictional narrator (likely the author was also multilingual as the Harley copyist was). His position, then, is complex, though his choice of language (English) and style (alliterative) betrays his allegiance with both the unlearned and the native (non-French) literary traditions.

Counterintuitively running parallel to *Court* is Christ's parable (Matthew 20:1–16) retold in *Labourers*: those who work in the vineyard from the break of day receive the same wage (a penny) as those hired after "evesong" (line 13).[62] The poem is a complex twist on its biblical source, because the Middle English author chose to foreground social issues rather than Last Judgment themes, and perhaps for this reason distances the tale from Christ, who is never mentioned. Matthew becomes its author:

> Of a mon Matheu þohte
> Þo he þe wynʒord whrohte
> Ant wrot hit on ys boc
>> *(lines 1–3; fol. 7ov, fig. 7a)*

These lines begin not directly across from *Court*'s first line, as one might expect, but rather a little lower, after blank space, alongside *Court*'s "So lerede vs bíledes [persecute]"—so Matthew's writing "on ys boc" takes on

58. Line 40 in Turville-Petre 1989; line numbers in *In the Ecclesiastical Court* given here and below correspond with Turville-Petre's edition; cf. fig. 1 for the parallel Arundel line above, fol. 7r, line 7).

59. Both on 71r (fig. 7b) and 71v. Ker 1964 wisely gives the blank an article number "42. Vacant."

60. Themes discussed by both Fein 2000a and by Scattergood 2000.

61. *Susannah* travels with *Piers Plowman* in MSS HM 114 and in the Vernon Manuscript.

62. I quote Brown 1932, 143–45, but give the folio numbers referring to figs. 7a or 7b.

(here and facing) 7. First two pages of *In the Eccesiastical Courts* (beginning "Ne mai no lewed lued"), alongside *Labourers in the Vineyard* (beginning "Of a mon matheu"). London, British Library, MS Harley 2253, (a) fol. 70v, (b) fol. 71r

a new and more disturbing quality than it might have in another context. Literacy is power, and by the end of the poem, it is Matthew, oddly enough, not Christ, who is the giver of the all important penny:

> Þis mon þat Matheu ȝef
> A peny þat wes so bref.

(Brown, lines 55–56; see fig. 7b)

And the punchline of the poem—against the grumbling workers who arrived early and bore the heat of the day—is actually ambiguous: "ant gonne is loue for-lete" (60). The parable comes to be about the breakdown of feudal loy-

alties, but even the political focus never swerves from the power of the written word and of him who wields the pen, topics nowhere to be found in Christ's version as recorded in Matthew.

Placement on the page of these two poems appears stage-managed: an accident, one might say? Perhaps, but if so, why did the Harley compiler leave a blank space and start *Labourers* two lines lower than he did *Court*? Moreover, the top of the page is (or can be) a significant position in Harley because in this largely undecorated manuscript, top lines are embellished with long ascenders, which are then lightly rubricated to make them stand out. The only

color normally on any page of Harley, apart from red splashes of first letters, is the red paraph mark that begins a new poem (in Harley the old-fashioned "C" type), and the rubrication of the ascenders on the top line. We have seen the drama of both lines so situated in *Court*. The whipping scene ("At chirche ant þourh cheping ase dogge y am dryue," 82) is perhaps the poem's most sensational and chilling line, like the trailer for a movie or picture on the cover of a popular novel highlighting the most lurid part, the part that causes the narrator the most shame. The other line in the poem that gets foregrounded this way, coming midway, is the most shocking of his socio-ecclesiastical comments: "Hyrdmen hem hatieþ, ant vch mones hyne" (40; fig. 7b). Even more loudly rubricated, it highlights the poet's hatred of summoners in a way that makes even Langland and Chaucer look timid.

Do scribes plan this kind of thing? There is a great deal of evidence that they do,[63] and Harley, we remember, is not ruled, which gives the scribe a fair amount of elbow room (as Ker first noticed, the scribe is skilled at writing

—————

63. Hardman 1978; Revard 2007; see Kerby-Fulton and Despres 1999 for evidence of illustrations being aligned in this way, e.g., 102–11.

without ruling, a legacy of his legal training).[64] The Harley compiler, who took the trouble to copy several such alliterative poems showing the powerful in a bad light must have known what he wanted to emphasize. He also knew, however, that life was complex, that even though summoners are corrupt, laymen also fornicate.

2. Visual Aids to Reading: Performative and Metrical Devices in Harley

When we consider how medieval people used books, the relatively few anyone had—poring over them, utilizing their long training in meditative and mnemonic techniques—aspects of layout, even in a modest manuscript become important. As scholars have long known, many of the love poems are similarly mirrored as are the political-historical ones. The technique is so common in the Harley compilation that to read the poems in modern editions (none of which reflect this layout) is to miss the point.

Other aspects of the manuscript's *ordinatio* are important for the modern reader. So, for instance, the mise en page of the French poem *Gilote et Johanne* suggests that it was something of a party piece. It is centered on the "feminist" preaching of Gilote, whom Revard has referred to as the Wife of Bath's grandmother.[65] Gilote, like her distinguished granddaughter, draws on antimatrimonial writings to paint a terrible picture of married life:

> Je serroi pris de su en ma mesoun,
> Desole e batu pur poi d'enchesoun
> E auer les enfauntz a trop de foysoun.

> [I should be taken into the upper regions of my house, abandoned, beaten for trivial reasons, and have a superabundance of children.]

> (57–59)[66]

Having dispatched marriage, Gilote also dispatches Johane's praise of virginity, by noting what escapades Mary Magdalene must have had before her repentance, and counsels a similar—if possible even more belated—eleventh-hour repentance (noting the easy virtue of friars similar to the one Langland portrays with his Lady Mede). The dialogue between the two gives Gilote especially a chance to assume many voices, as Mary Dove notes.[67] Calling itself "vne bourde" (a joke), the tale is clearly writ-

ten and copied for amusement—for just the kinds of party games the manuscript might have been useful for in a large household. Whether or not the manuscript was actually used as a prompt book for such entertainments, still there is sound evidence that the scribe intended it to be useful in this way—or copied it from a manuscript that was. In *Gilote* he has gone to the trouble of marking the speakers in the margin: a *J* or *I* for Johane, a *G* for Gilote. Scribes and annotators did not often bother to do this; quotation marks as we know them today were not in use in the Middle Ages (authoritative quotes from the Bible and certain other sources were rubricated or underlined, but ordinary dialogue was often not marked in any way).[68] Here and in other French poetry he is also careful to mark double vowels that may indicate two separate syllables, recognition of which would be vital for correct metrical reading aloud (e.g., "grée" or "volentéé," fol. 67rb). Whether or not this French poetic text was written for performance, in Harley it was ready for performance.

That Harley was meant to be read visually as well, however, is clear in another of the poems most heavily anthologized today, the *Follies of Fashion*. The poem largely attacks "boses" (line 16), the curls or buns of hair that stood out on either side of a fashionable woman's face, and the various forms of engineering and chemistry required to keep these curls in their place: the charge is that they look like pig's ears, and the poet goes to endless trouble to associate them with mischief and devilry. The poem is endowed with a tough rhyme scheme ("four mono-rhymed long-lines with medial rhyme, followed by a bob and two shorter lines all rhyming together"),[69] worthy of the *Gawain* poet. Seen on the manuscript page, the bobs in *Follies* (fig. 8) jump out at even the most casual observer, written usually beside the third line of the first quatrain and joined to all four lines by a sweeping bracket. The medial rhyme in these quatrains is an *a* rhyme, the end word always a *b* rhyme, and the bob always a *c* rhyme. This package is then followed in each case by a longer line with a caesura (marked by a slash): both the word at the slash and the word at the end are *c* rhymes, tying in, that is, with the bob. But compare fig. 8 to the way it is printed in Turville-Petre's edition,[70] which I reproduce exactly as it stands on the page:

> ȝef þer lyþ a loket by er ouþer eȝe
> Þat mot wiþ worse be wet for lac of oþer leȝe,
> Þe bout ant þe barbet wyþ frountel shule feȝe.

64. See Ker 1965, xvii, on the scribe's ruling practices.
65. Revard 2004.
66. Translated by Dove 2000, 347.
67. Ibid.
68. See Sebastian Langdell's forthcoming article, "From Conversation to Conversation: A Study of Speech-Markers in the Early to Mid-Fifteenth Century Hocclevian Manuscript Tradi-

tion." Manuscripts of Gower's *Confessio amantis* often "have the main speakers ('Confessor' and 'Amans') identified in the margins, especially the de luxe copies"; see Roberts 2005, 221, for a plate of BL MS Add. 12043, fol. 10v, showing this kind of marginal aid.
69. Turville-Petre 1989, 9.
70. Ibid., 12–13.

Habbe he a fauce filet he halt hire hed heȝe
> To shewe
Þat heo be kud ant knewe
For strompet in rybaudes rewe.

[If there lies a hair-curl by the ear or else the eye that
must with something worse be wetted for lack of
another (type of) lye, the loop (*bout*) and the cloth
band with the band across the forehead shall match.
Has she a false fillet she holds her head high to show
that she is well-known and recognized as a strumpet
in the company of dissolutes.]

(29–35; my emphasis)[71]

In accordance with standard modern editorial practice,
Turville-Petre chose not to follow the manuscript's *ordi-
natio* and gives instead the impression—as do modern edi-
tors of *Gawain*—that the bob always hangs off the last
line. Bobs are indeed constructed this way in manuscripts
much later than Harley, such as Ellesmere's "Tale of Sir
Thopas" and HM 114's *Susannah* (see figs. 12 and 13 below).
But not in Harley, as fig. 8 clearly shows. Turville-Petre
also divides the final line to make two lines where the
manuscript had one, thereby foregrounding the internal
c rhyme word that rhymes with the bob (note, however,
that he did not break the lines above to foreground their
internal *a* rhyme).

My point here is not to quibble about layout (Turville-
Petre's is an excellent modern edition), but to show that
we miss something significant if we do not see visually
how the medieval scribe treated the bob: we miss the point
that it can be applied to all *four* lines that are bracketed,
not just the last. In the case of the stanza above, the bob
(underlined) "to shewe" can float among the lines, nicely
embodying the folly of all the technical cosmetic and
fashion terminology in the quatrain, used "to show [off]"
as we might say today. The stanza is so crammed with ter-
minology as to indicate the poet's intimate knowledge of
women's toiletries—an oddity in a male poet professing
such disdain as the poet's narrator pretends to do. But the
poem—if we look closely—is not really about misogyny
but rather about social class. It is especially about the vio-
lation of sumptuary laws (laws dictating what various so-
cial classes might or might not wear, in a usually futile
effort to stem the tide of upward mobility in an increas-
ingly cash-oriented society). It is not even impossible that
the poem was written by a woman rather than a man. The
manuscript layout cannot finally help us decide on au-
thorship, but the bobs floating down the right margin are
powerful didactic and mnemonic devices, epitomizing the
entire poem. They are, in order:

8. *The Follies of Fashion*, showing metrical structure, especially
bob verses. London, British Library, MS Harley 2253, fol. 61v.

Line 5 In wunne (in bliss)
Line 12 In prude
Line 19 In helle
Line 26 Vpo lofte
Line 33 To shewe

They act as a succinct mnemonic for the tale of the Fall
and the peril of unredeemed (as yet) female vanity. For
even more complex use, however, of manuscript *ordinatio*
and similar visual metrics, we turn now to what happens
when we read *Sir Gawain and the Green Knight*, in situ.

71. Ibid., 13.

III. *Gawain* and the Medieval Reader: The Importance of Manuscript *Ordinatio* in a Poem We Think We Know

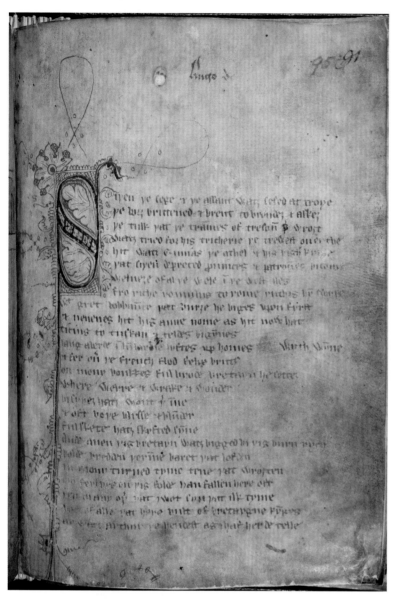

9. *Gawain*, showing the opening page with its eight-line initial, distinctive stanza structure, and bob-and-wheel placement. London, British Library, MS Cotton Nero A X, Art. 3, fol. 95r (old foliation 91r).

One of the major Middle English poetic manuscripts, British Library, Cotton Nero A X, Art. 3, is famous as the only surviving manuscript to contain just alliterative poetry. It is the unique witness to four poems: *Pearl, Cleanness, Patience,* and *Sir Gawain and the Green Knight.* As mysterious in its way as Harley 2253, two of the poems in its precious cargo are central to the modern canon of the Middle English field. But despite the fact that the facsimile has been available via the EETS since 1923, the scribe's work presents unsolved mysteries to this day. The pictures in the manuscript, likely slightly later additions, are discussed by Maidie Hilmo in ch. 3, but the text alone, written throughout in one hand, is an important landmark in the history of Middle English alliterative copying. Here we will focus primarily on the *Gawain* portion, since it is the most heavily taught of the poems—but students who think they know this text from modern editions will be especially surprised at what the manuscript has to teach us about it.

The first thing to notice about the text is its strange hand—strange, that is, for an English poetic text in the time period in which it was written (see fig. 9, showing the scribe's hand on the opening page of *Gawain,* the flourished eight-line initial and distinctive stanza structure). We know that the manuscript postdates 1348 because on the last leaf of *Gawain* is the motto of the Order of the Garter, founded about this time by Edward III: "Hony soyt q*ui* mal penc*e*"—written, however, in a somewhat later hand and in blue. And it may not be that this hand is so much later but rather that the main hand looks so much earlier. The script of the main hand, which copied all four poems, has puzzled paleographers for decades: the weight of most recent opinion, however, agrees on it as a form of *Gothic textualis rotunda media*[72]—a script that usually belongs to the thirteenth century, not the second half of the fourteenth century. Doyle judiciously notes that the "scribe was more at home in more cursive script,"[73] so why would he[74] choose to write in a hand he was not comfortable in? One likely answer emerges if we compare the hand of the Jesus College *Owl and the Nightingale* (s.xiii²)[75]

72. I follow here Roberts 2005, 170, plate 37. Petti had labeled it quite similarly, with a question mark, however: "fere-textura rotunda facilis?" (1977, 49, plate 4). He makes this slightly paradoxical remark: "An extremely small, compressed and angular book-hand, with an impression of irregularity both in size and formation of letters, and closest to textura rotunda, being sparing of breaking and serifs. It is probably one of the most distinctive and easily recognizable vernacular book hands of the period, *though this is the only example that has come to light*" (my emphasis).

73. Doyle 1982, 92. His view is that the script is a form of Bastard *Anglicana,* and he points to "awkwardnesses and anomalies

(e.g., in final *s* and *w*) reveal[ing] that the scribe was more at home in more cursive script, though parallels may be found in Anglo-Norman manuscripts."

74. "He" (rather than "she") is assumed throughout this discussion, but unlike the Arundel and Harley manuscripts, the Cotton Nero manuscript is the first examined in this book so far for which a woman scribe could not be utterly ruled out. See Olson's discussion of female scribes in the Findern manuscript, below in ch. 2.

75. Roberts 2005, plate 32, Oxford, Jesus College 29.

or the hand of the Arundel 292 *Bestiary* (s.xiii[4] or c. 1300, shown above fig. 1). Roberts labels these as *Gothic littera textualis rotunda media*, and it is just such early literary hands, I would suggest, that the Gawain scribe is trying to imitate. She makes the point that both the *Owl* and *Gawain* hands are old-fashioned for their day—but they are at least one hundred years apart, so this makes the Gawain scribe extra old-fashioned. Why? Likely either he, his supervisor, or his patron felt that this was the kind of script appropriate to English verse (we just saw a similar tendency toward archaism in Arundel). Some further parallels, as Doyle mentions, also occur among Anglo-Norman texts as well, appropriately, given the Anglo-Norman romance sources that went into the creating of *Gawain* by its author (not to be confused, of course, with the present scribe).[76] As Gollancz noted long ago in the facsimile introduction the orthography of the scribe (or of his exemplar), especially the use of **t3** for **z** or **s** is "derived evidently from an Anglo-French scribal mannerism."[77] Altogether, we can say our scribe is someone very similar to the Harley 2253 scribe in literary perspective: aware of vernacular English traditions but likely more accustomed to work in Anglo-French and in *Anglicana* legal texts. But apparently, unlike the Harley scribe, he was not writing to please himself. Either he was working on a commission, and someone he was working for wanted this text to *look* traditionally English, or he felt constrained by his sense of tradition to do so. We will see later in this chapter how the look of English manuscripts changes definitively by the last quarter of the fourteenth century, in the copying of Langland, Chaucer, and Gower. But that is looking forward. The *Gawain* scribe, even if he was writing in the Ricardian period, was looking back.

Though new evidence as yet unpublished may ultimately suggest Yorkshire origins for the manuscript and perhaps even the poet,[78] the authorial dialect of the four poems in the Cotton Nero manuscript has always been identified as Cheshire (with scribal dialect placed in Staffordshire), a locale that fits well with the knowledge of north Wales that informs the poet's account of Gawain's journey to find the Green Knight.[79] It has often been thought that the dialect—which is much more difficult for us today than Chaucer's London English—indicates remoteness or provinciality.[80] In fact, we have to be careful of such assumptions: medieval Chester was an important city, and one with a culture important in its own right,[81] and those readers or patrons able to appreciate fully the kind of courtly world mirrored in *Gawain*, with its detailed attention to etiquette, armor, and hunting, would have been at ease in baronial company elsewhere in the country, including London. The Stanley family of Cheshire and Staffordshire owned an important Chaucer manuscript, for instance.[82] Moreover, there are connections between the manuscript of *St. Erkenwald* (Harley 2250), a poem also in a Cheshire dialect and sometimes attributed to the *Gawain* poet, and a family of Dunham Massey, Cheshire, in the sixteenth century.[83] In a superb piece of historical detective work, John Scattergood has shown that a "John Mascy" can be connected with a manuscript of Middle English devotional literature containing dialect material from Staffordshire as well. And the "Maister Massy" referred to deferentially by the poet Hoccleve can be connected with William Massy, a Lancastrian financial officer.[84] These associations are all firm. Uncertain, however, remains the identity of "Hugo de ⟨...⟩" found on the recto of the first leaf of *Gawain* and whether or not there is a name visible there reading "J. Macy" in the marginal decoration is disputed (on fols. 62v and 114r in the manuscript). More generally, however, we can point to these other connections between Cheshire area residents, Middle English literature, and London bureaucratic reading circles—our manuscript may fit somewhere in this milieu.

76. Doyle compares it to BL Egerton 3028, containing *La Légende de Roland*: "a similar duct and size, early mid-fourteenth century" (1982, n. 12).

77. Gollancz 1971 (1923), 8.

78. Ralph Hanna kindly informs me that both editorial evidence and Early Modern provenance may point to the possibility of Yorkshire origins for the poet himself; he also notes that not much evidence survives generally for literary activity in Cheshire before the mid-fifteenth century (private communication, Aug. 27, 2011). Based on analysis of local decorative motifs from the 1390s onward, Joel Fredell has also made a case for York origins of the manuscript, which he believes to be at least six removes from the poet. His unpublished paper, "The Green Knight in York: Evidence that the British Library Cotton Nero A.X was Written for York" was given July 6, 2011, at the Twelfth York Manuscripts and Early Book Society Conference, York, U.K. Fredell also notes, however, that Yorkshire artists moved around and that their practices influenced scribes elsewhere. I am grateful to Sarah Baechle and Karrie Fuller for their advice on this. The Cotton Nero A X

Project (www.gawain-ms.ca), which is digitizing the complete manuscript and already has detailed descriptions online, follows the traditional views of provenance, and we have maintained those here (see Olsen 2011). I would like to thank Kenna Olsen for her advice on this and other matters.

79. See McIntosh, Samuels, and Benskin 1986–87, 1:23–24, 3:37–38 (LP 26 Cheshire).

80. However, northern English was actually ahead of London English in its dropping of disyllabic –e, making it closer to modern English in this regard; see Tolkien and Gordon 1967, xxvi.

81. See Barret 2009.

82. Edwards 1997, 198.

83. Key annotations relating to this family appear on fols. 64v ("Thomas masse") and 75v in Harley 2250. See Scattergood 2001, 91–102, for these and a complete summary of the scholarship on Massy evidence and the Cotton Nero manuscript.

84. For Hoccleve's connection with the civil servant William Massey, see Burrow 1994, 23.

1. Medieval *Ordinatio,* Modern Editions, and the Informed Reader

The *ordinatio* of the manuscript lays out a series of initials and small markings for distinguishing the stanza structures of the poems. Each poem begins with a large initial (fifteen lines high for *Pearl* and eight lines for the others, as in fig. 9), and there are smaller initials (blue with red penwork) dividing up each of the poems (see fig. 10, showing a three-line initial and the long alliterative lines of *Patience*). These initials are an aspect of *ordinatio,* and as such are crucial clues to medieval ways of highlighting significant units or points in the poem, though modern editions so often omit these, even, for instance, the marvelous edition by Andrew and Waldron. At the *Patience* initial shown in fig. 10, for instance, Jonah cries "Lorde to þe haf I cleped *in* care3 ful stronge | out of þe hole þ*u* me herde of hellen wombe" (corresponding to lines 305–6 in Andrew and Waldron), alluding to Psalm 68, a psalm which, as the editors mention in their note to those lines, in medieval Psalters is often illustrated with an image of Jonah emerging from the whale. The three-line ini-tial, then, is not just randomly placed for decoration, but highlights this dramatic moment of rescue from "hellen wombe."

Even more revelatory, however, is the use of such initials in the *Gawain* portion of the manuscript, also not recorded by editors. As all undergraduates learn, the poem is divided into four "fitts"—but what they are usually not told is that these divisions were introduced by the first editor, Sir Frederic Madden, in 1839 and are, as A. S. G. Edwards notes, misleading. In fact, *Gawain* is divided structurally in the manuscript by nine large initials, and these give a very different sense of the poem's progress.

As we see from the chart below, the manuscript's *ordinatio* is much richer and more complex than the one the Victorian editor, Madden, extracted from it to create his four "fitts" (a word not used in the manuscript). The manuscript instead privileges nine passages: (1) England as the new Troy, (2) the "morning after" sobriety following the "beheading game," (3) the Pentangle, (4) the miraculous appearance of the Castle in answer to Gawain's prayer, (5) the first hunt, (6) the second hunt, (7) the third hunt—but unlike the previous two, here the moment the fox is

LINE NUMBER OF LARGE INITIAL	FOLIO NUMBER	VERSE AND NARRATIVE EVENT INTRODUCED[1]
1 (Madden's Fitt I) "S"	91r (old foliation, for 95 in new foliation)[2]	"Siþen þe sege and þe assaut watz sesed at Troye"—opening history of Europe since the siege of Troy and diaspora leading Brutus to settle Britain
491 (Madden's Fitt II) "T"	97v	"This hanselle hatz Arthur of auenturus on fyrst"—reflection back on the questionable wisdom of the beheading game in Arthur's hall and the grim work ("sturne werk") for Gawain ahead
619 "T"	99r, initial historiated with the face of a man (Gawain?)	"Then þay schewed hym þe schelde"—description of the pentangle as the climax of the arming of Gawain
763 "N"	105r	"Nade he sayned himself, segge, bot þrye"—having just made the sign of the cross three times after praying for harbor to hear mass, Gawain is suddenly aware of a castle in a moat
1126 (Madden's Fitt III) "F"	110r	"Ful erly before þe day"—guests depart and the host sets out for his first morning of hunting
1421 "S"	114r	"Sone þay calle of a quest"—the boar hunt begins
1893 "N"	120r	"Now hym lenge in þat lee, þer luf hym bityde"—the narrator leaves Gawain making merry, having just confessed to the priest after the last bedroom scene, and turns to the finishing off of the fox
1998 (Madden's Fitt IV) "N"	121v	"Now ne3es þe Nw 3ere, and þe ny3t passez"—after a sleepless night, Gawain sets out for the Green Chapel
2259 "T"	125r, initial historiated with grotesque face—the Green Knight? Or a comic profile?	"Then þe gome in þe grene grayþed hym swyþe"—the Green Knight prepares to strike the first blow

1. I quote Tolkien and Gordon 1967 here so the reader can see how these divisions relate to the modern four-fitt structure. The manuscript itself is quoted in other examples below.

2. I use the old foliation for the purposes of this chart to allow readers to follow the facsimile, the Tolkien and Gordon edition (1967) and the Andrew and Waldron edition (1978).

10. Passage from *Patience*, in long alliterative lines, showing a three-line Lombard capital in blue with red flourishing at line 305, an important feature of *ordinatio* often missing in modern editions. London, British Library, MS Cotton Nero A X, Art. 3, fol. 91r, bottom half.

finally trapped and killed, (8) setting out on New Year's for the Green Chapel, the final leg of Gawain's journey, and (9) the first moment of Gawain's threatened beheading. One could make several observations: first, the divisions closely parallel the spirit of the medieval narrative summaries marking progress through romances—these tend to mark knightly clashes, deaths, and miraculous events.[85] Second, perhaps more profoundly, the medieval divisions mark moments of soul searching: Aeneas's treachery, Arthur's court regretting its actions, Gawain being shown his shield with its image of impossible perfection, Gawain's postprayer experience, Gawain's postconfession experience (which we cannot fully know from the narration), Gawain's sleepless night before setting out for the Green Chapel at last, and Gawain waiting for the axe to fall.

2. CASE STUDY: Conscious Archaism in *Gawain* and the Changing Treatment of Rhyme in Middle English Manuscripts

The treatment of rhyme in Middle English manuscripts changed importantly across the fourteenth century, so what we see in Harley 2253 and in Cotton Nero is very different from what we see in later manuscripts such as Hengwrt and Huntington Library HM 114 (compare, e.g., figs. 12 and 13 below). Since the Cotton Nero manuscript

is often considered as virtually contemporary with a manuscript like Hengwrt, *Gawain* makes an intriguing case study in conscious archaism.

As every undergraduate also knows, the stanza structure of *Gawain* is that of the bob and wheel following on a varying number of alliterative long lines. These lines, as Andrew and Waldron put it, are "rounded off by … the 'bob.'"[86] (The bob here is a line of one stress "followed by a rhyming quatrain [the 'wheel'] of three-stressed lines, the second and fourth of which rhyme with the bob.") It was J. R. R. Tolkien and E. V. Gordon, in their brilliant edition of the poem, who pointed out something that most editors do not comment on: "In Gawain the short 'bob' lines, which metrically follow each group of long lines, are written to the right of the long lines, sometimes opposite the last of these but often two or three lines up."[87] Yet all modern editions, including Tolkien and Gordon's own, all products of New Critical ideas, insist on laying out the bob and wheel in strict uniformity, immediately after the long lines, with the bob given a full line of its own. No such uniformity occurs in the manuscript, where the bob never has its own line and is variously placed. It is always written either with angled parallel slashes, similar to the kind used in the period to direct the rubricator to provide a splash of colour, or sometimes a tiny decoration (e.g., a small leaf) at the end of one of the long lines (represented in print below as ⟨⟨). The bob is sometimes

85. See Nicole Eddy's forthcoming dissertation, *Marginal Annotation in Medieval Romance Manuscripts: Understanding the Contemporary Reception of the Genre*, University of Notre Dame; Eddy 2011; Field 2001.

86. Andrew and Waldron 1978, 49.
87. Tolkien and Gordon 1967, xi.

11. Passage from *Gawain*, showing the bob placement standard throughout much of the poem: here bobs are at lines 2207, "Bi rote," and 2232, "on snawe". Both positions put the prepositional phrase in immediate proximity to the verb, making much more sense grammatically (e.g., "strydez on snawe") than does modern editorial placement. London, British Library, MS Cotton Nero A X, Art. 3, 124v.

at the very end, where modern editors put it, but more often two or three lines up, and sometimes even further down, alongside the wheel. Even the first few stanzas of the poem demonstrate this variety: the famous first stanza, for instance, places the bob after line 12 (fig. 9), not after line 15 as modern editions universally do. As we will see, there was a codicological reason for the scribe to do this: his placement system is much closer to the way bobs are treated in earlier manuscripts such as Harley, than in later manuscripts such as Huntington Library HM 114 (see fig. 13 of *Susannah*) or even in Hengwrt's "Tale of Sir Thopas" (fig. 12). This difference strengthens the case for the *Gawain* manuscript being modeled on earlier manuscripts, not Ricardian ones—even if the scribe is copying it in the last quarter of the fourteenth century (or as some scholars believe, even a bit later).

In Tolkien and Gordon's edition, the opening stanza speaking of the founding of European countries after the fall of Troy (beginning with Romulus founding Rome) goes on to read:

> Tirius to Tuskan and teldes bigynnes,
> <u>Langaberde in Lumbardie lyftes vp homes</u>
> And fer ouer þe French flod Felix Brutus
> On mony bonkkes ful brode Bretayn he settez
> Wyth wynne,
> Where werre and wrake and wonder
> By syþez hatz wont þerinne
> And oft boþe blysse and blunder
> Ful skete hatz skyfted synne.
>
> *(11–19; my emphasis)*[88]

88. Ibid., 1.

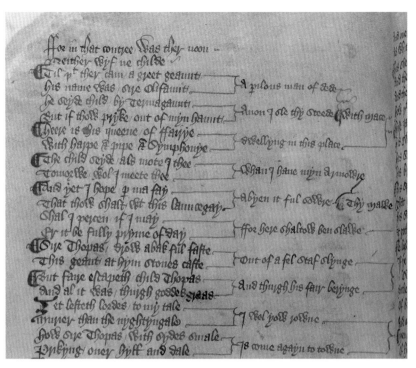

12. Passage from "Sir Thopas" in the Hengwrt *Canterbury Tales*, showing bob structure (upper two stanzas, extreme right). Copied by Scribe B/Adam Pinkhurst, identified as Chaucer's scribe. Aberystwyth, National Library of Wales, Peniarth MS 392D (*olim* Hengwrt MS 154), fol. 214v, c. 1390s–c. 1405?

13. Passage from *Susannah* showing bob structure. San Marino, CA, Huntington Library, MS HM 114, fol. 185v, c. 1425.

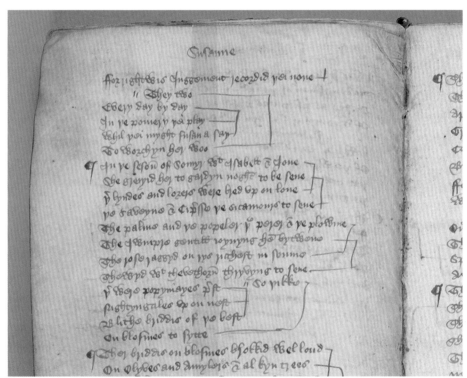

Compare the lines I have underlined above with the manuscript version in fig. 9:

ticius to tuskan *and* teldes bigy*n*nes
langaberde i*n* lu*m*bardie lyftes vp homes ⟨⟨ wyth wy*n*ne
and fer ouer þe french flod felix brut*us*
on mony bonkkes ful brode bretayn he sette
where werre *and* wrake *and* wonder[89]

(lines 11–15)

As one can see, the scribe does not give the bob its own line, nor does he place it literally after the founding of Britain. In its manuscript placement, segmented by its decorative mark, the bob has the scope to apply to several of the stanza's final lines at once. Here the effect is to highlight a much more transnational perspective: the "wyth wy*n*ne" (with joy) is no longer an exclusively patriotic moment for Britain; it applies to the building of Italy (probably Rome but certainly Tuscany and Lombardy) and

––––––
89. Cotton Nero A. x, Art. 3, opening folio of poem, 95r (91r in old foliation). Tolkien and Gordon emended "Ticius" to "Tirius," known as founder of Tuscany.

takes in the "french flod" (an emphatically different way of seeing the "English Channel") as it sweeps along to "Bretayn." This torrent of "joyful" international settlement comes much closer not only to what trilingual scribes of the fourteenth century would have seen as important, but it would be especially appropriate to a Cheshire cultural production: "Bretayn" included Wales, which figures strongly in the poem, both in geography and in romance sources; the Franco-centric allusion to the "french flod" parallels the use of French orthography throughout the manuscript, and certainly the poet's impressive knowledge of French romance. Most intriguing is the gesture to highlight Italy by the placement. Though it might be merely coincidental, it is worth noting that critics such as A. C. Spearing, P. M. Kean, and David Carlson have argued that Dante's and Boccaccio's works might have been known to the *Gawain* poet.[90] The evidence of *St. Erkenwald*, a poem certainly by a Cheshire poet and perhaps also by the *Gawain* poet (similarly beginning with a broad view of Christendom) opens with a reference to "London in Englond," spurring Turville-Petre to note that historically Cheshire "considered itself rather separate from the rest of the country."[91] In short, the manuscript's use of the bob, both in this stanza and throughout, is much more capacious than modern editions show. Here the difference is geographical and political; elsewhere the difference is interpretive; in some places it is even editorial. In others, of course, it makes no difference whatsoever to how we read, but in some it is markedly more elegant. Since word order in Middle English is still an understudied phenomenon, style can be hard to judge, but one might point

to the high tolerance for challenging word order even in Elizabethan poetry and prose. The important thing is that modern literary readers know what the manuscript does.

As the chart below indicates, far more stanzas in the poem do not set the bob in the place modern editions put it (just above the wheel) than there are stanzas that do. Those that do number 24, but a staggering 74 stanzas place it elsewhere, usually two or three lines above the end (see fig. 11 for two such instances). For some reason, three further instances occur in which the bob is placed lower, beside a line in the wheel. These statistics are striking, but hard to explain; equally hard to explain is the fact that, after shifting back and forth in his placements during the first half of the poem, the scribe never places a bob immediately before the wheel after line 1366—that is, never during (roughly) the second half of the poem.

Looking at a chart like this, one realizes that modern editors should be much more frank with their readers about the fact that the bob floats a great deal. While editors themselves may realize that they are creating an artificial uniformity that alters the majority of the actual placements, very few readers do. What does this mean about how the bobs were to be read by medieval readers or even by the poet himself? We have only our sole extant manuscript by which to judge.

Bobs are presumably placed where they are in modern editions because it accentuates the rhyme connection with the wheel. But very often the bob makes more sense grammatically where it is actually placed in the manuscript, as opposed to where modern editors place it, where it is often awkward, redundant, or empty. Scholars

BOB PLACED TWO OR MORE LINES *ABOVE*	BOB PLACED IMMEDIATELY *AT* LAST LONG LINE	BOB PLACED *BELOW* START OF WHEEL
12, 53, 77, 123, 144, 172, 196, 225, 293, 336, 437, 460, 434, 509, 529, 583, 612, 706, 733, 835, 894, 988, 1013, 1039, 1125, 1234, 1255, 1346, 1395, 1414, 1447, 1469, 1501, 1528, 1551, 1574, 1616, 1641, 1661, 1683, 1712, 1743, 1763, 1785, 1810, 1839, 1862, 1886, 1915, 1944, 1971, 1991, 2017, 2040, 2062, 2084, 2011, 2133, 2153, 2182, 2205, 2231, 2251, 2277, 2302, 2323, 2351, 2382, 2400, 2422, 2449, 2472, 2498, 2525	31, 244, 273, 317, 360, 384, 411, 560, 634, 664, 685, 757, 779, 805, 869, 922, 964, 1100, 1144, 1172, 1202, 1284, 1313, 1366	103, 1075, 1597

90. Spearing summarizes the scholarship, especially in relation to *Pearl* (1970, 17). See also the excellent study by Carlson, who examines the extant manuscript evidence for the circulation of Boccaccio's *Olympia* in England during the poet's lifetime (1987). Since Carlson wrote, scholars have begun to push the possible dates for the poet slightly later, which makes Carlson's evidence even more compelling than it was in 1987. There is no reason that

the poet might not have been, like Chaucer, a member of the civil service, or a chaplain or secretary to a Cheshire magnate traveling abroad on government or other business. However, as noted above, Ralph Hanna has mooted the possibility of his having Yorkshire origins.

91. Turville-Petre 1989, 102, citing historical studies.

have often commented on the nonsensical or vapid quality of bobs in romances generally, which usually consist of a prepositional phrase (e.g., in londe) and may often be simply rhymed filler. Take for instance, these comments from the *Riverside Chaucer* on Sir Thopas, a tale that parodies the bob rather brutally:[92]

> The remaining five stanzas incorporate a one-stress line or "bob" (first at VII.793). . . . Perhaps Chaucer had in mind the pointless metrical variations to be found in some popular romance texts (e.g., the Auchinleck *Bevis*) . . . , e.g., "In towne," 793, "In londe," 887, etc.

Both of these examples, we might note, occur in *Gawain*. Chaucer, in fact, begins to employ bobs at the point where his little romance really begins to unravel into nonsense. The problem is that, while we want to think better of the *Gawain* poet, and do, nevertheless bobs often do hang rather redundantly (or worse) off the end of even this great artist's long lines. The instance of this can be dramatically reduced, however, when one reads the bob in its manuscript placement—although not slavishly, however, for the placements, as we saw in the Harley 2253 manuscript, are meant to float. Take one of the empty ones complained about by the *Riverside* editors, "in londe." Compare these lines from the end of the first section, describing the feasting at Arthur's court

Wyth alle maner of mete and mynstralcie boþe,
Wyth wele walt þay þat day, til worþed an ende
 In londe.
 (484–86)[93]

Wyth all maner of mete and mynstralcie
 boþe ⟨⟨ in londe
Wyth wele walt þay þat day til worþed an ende.
 (fol. 97v)

This way, the "in londe" heightens the "all," instead of landing with an irrelevant thud. Similar rescues of the *Gawain* poet's dignity can be made elsewhere (see chart above).[94] More interestingly, they also allow for wordplay and multiple meanings—something this poet is especially famous for. A brief example of each will have to suffice. When Bertilak is explaining to Gawain why he feigned his first two strokes with the axe, he doubles the sense of "bout scaþe" by using two words, both meaning "offered":

Þou kyssedes my clere wyf—þe cossez me raȝtez [offered].
For boþe two here I þe bede [offered] bot two bare myntes
 boute scaþe.
 (2351–53)[95]

The manuscript, however, places the bob here:

Þou kyssedes my clere wyf þe cossez me
 raȝtez ⟨⟨ boute scaþe
 (fol. 122v)

The flexibility of the bob's position suggests that the first two kisses were also offered back "without scathe" (that is, Gawain held nothing back, so the exchange was unmarred), just like the "myntes" then offered by the Green Knight. The next and final instance takes us firmly into editorial terrain.

Given the old-fashioned character of the script of the *Gawain* manuscript and its alliterative content, it would surely be more the kind of model used in Harley (see fig. 8) that he has in mind. What was the scribe (or the poet himself?) trying to convey by the shifting placements? Or by the favorite placement two lines above the start of the wheel? When one thinks of the wide latitude for clause, adjective, and adverb placement in Middle English and even in Early Modern English, it is clear that our modern editions need to be more flexible as well. At the very least, why would we want to miss this kind of playfulness in our modern editions? It is just such editorial complexity, multiplied exponentially, that we are about to meet in the manuscripts of *Piers Plowman*.

92. *Riverside Chaucer* 1987, 917. The *Riverside* further comments that bobs "often take the form of a prepositional phrase with indistinct meaning" (note to *Canterbury Tales* VII.793). If we look at the Hengwrt Chaucer, the earliest surviving copy of the *Canterbury Tales*, we see how a scribe who knows the contemporary conventions of medieval rhyme bracketing has handled the bobs that appear, briefly, in four of Chaucer's stanzas. Fig. 12 shows two of them, hanging off the extreme right of the margin, with rubri-cation (here in turquoise) to pick them out, and rhyme brackets to connect them to the correct rhyme words.

93. Tolkien and Gordon 1967.

94. At line 509, for instance, the manuscript reading has birds singing "bi bonk," much preferable to the "softe somer þat sues þerafter / bi bonk."

95. Tolkein and Gordon 1967.

Assessing Emendation in a Modern Edition

Knowing what we now know about how modern editors have handled both the overall structure of *Gawain* (since Madden's "fitt" division) and their handling of metrical structure, the student is now ready to examine places where editors actually emend the text to make their own interventions work. Often such interventions are entirely necessary to make sense of a defective exemplar. But a gray area is one like the following, in the passage involving the host's attempt to get Gawain to tell him where the kisses come from, to which Gawain quips (in modern editions):

> "Þat watz not forward," quoþ he, "frayst me no more.
> For ȝe haf tan þat yow tydez, trawe non oþer
> ȝe mowe."
>
> *(1395-97)*[1]

The manuscript, however, reads:

> Þat watz not forward quoþ he frayst me no more ⟨⟨ ȝe mowe
> For ȝe haf tan þat yow tydez trawe ȝe non oþer
> *(fol. 109v, my emphasis)*

If we remember that editors provide modern punctuation where there is none in the manuscript, the manuscripts then also offer more scope for different or fluid readings. The transcription above could be translated into idiomatic modern English as: "That was not in the agreement," he said, "You may ask me no more! | For you have taken what belongs to you, believe you none other." Notice that Tolkien and Gordon have edited out the "ȝe" in the manuscript underlined above.[2] How would you know this without consulting the manuscript? If you look at the bottom of their page 38, you will see the following variant:

> 1396 trawe] trawe ȝe

For those unfamiliar with reconstructing variants, what this tells you is that what appears on the left side of the bracket is the reading present in this edition; what appears on the right side of the bracket is what the manuscript reads. As you can see from the transcription of these lines directly from the manuscript, emendation is not necessary if the bob is not forced into a place at the end of the long lines.

Using a "floating" system, the reader can play with the bob—which is precisely what the scribe and most likely the poet hoped. We do not know for certain whether the scribe copied his exemplar's placement faithfully or if it reflects exactly how the poet handled the bobs. What we can reasonably say is that the poet was familiar with the handling of bobs as floating marginal devices, often shown in the early and mid-fourteenth century with more all-encompassing brackets (e.g., fig. 8). And we can have no doubt that the *Gawain* poet was ready to exploit any possible ambiguities or wordplay to hand.

1. Tolkien and Gordon 1967.

2. Andrew and Waldron leave in the "ȝe" in this line at the expense of clunkiness and have to add a word in parentheses to make their emendation work (1978).

IV. The Rise of English Book Production in Ricardian and Lancastrian London: Professional Scribes and Langland's *Piers Plowman*

Piers Plowman was wildly popular in its day. With this popularity came a great deal of reader engagement and scribal "participation" (the polite word for spontaneous textual interference) in the text. This was so rampant that today we confront not only the different authorial versions of *Piers Plowman* (called the A, B, and C texts by scholars) but also its widespread "social authorship."[96] Unlike the situation for any work so far studied in this book, the sheer number of *Piers* manuscripts and their chaotic state overshadows every other aspect of modern scholarship and long ago compromised any New Critical ideals of getting back to what Langland originally wrote. One might think of social authorship as the Wikipedia treatment, so to speak, of medieval literary texts in a manuscript culture: the more popular the work, the more temptation for scribes to engage. An important example of this kind of scribal participation and the havoc it can cause in modern literary scholarship is the case of Victorian editor W. W. Skeat's choice of C-text. His *Three Parallel Texts* edition of the poem, still much in use today, chose as a base C-text the manuscript that is now Huntington Library HM 137.[97] The beautiful clarity of its hand and *ordinatio*[98] seduced Skeat utterly, especially with its hierarchy of scripts: *Anglicana formata* for the main text, and red *textura* script for the Latin quotations—a double privileging of the form and color of the Latin, making the poem look like an authoritative biblical commentary. What Skeat did not realize is that this manuscript (and a small group of others) carried a spoiled version of the C-text, in which a pedantic scribal redactor had intervened to rewrite the poem in a "clearer" way. So, for instance, in the Prologue where Langland sarcastically says that pilgrims and palmers go forth "with many wyse tales," HM 137 reads "vnwyse" (49)—just to be sure no simple mind misses the point. The impact of Skeat's edition was (and remains in many ways) enormous: it spawned the authorship controversy that dragged studies of the poem into decades-long, fruitless disputes about how many authors the poem had; its legacy for the poorer reputation of the C-text is felt to this day. Editorial decisions, then, matter in Langland studies, and it is only by way of a brief introduction to these that we can finally get at our subject here: the codicology of the poem.

The modern Athlone Press critical editions of the poem, masterminded by the late George Kane and at once indispensable and controversial, were utterly committed editorially to getting back to what Langland had written.[99] With their serious manuscript descriptions and massive, highly technical editorial introductions, they set out the formidable parameters of the subject.[100] Not only did they set the bar for editorial theory in Middle English studies (and arguably for all English studies), they made key editorial choices on the basis of the sophisticated dialect study led by Angus McIntosh and Michael Samuels for the *Linguistic Atlas of Late Medieval England*.[101] The result—whether one agrees or disagrees with their editorial choices—is a professional standard for the field. Readers who are not familiar with the principles of editing, scribal behavior, and types of written standard in Middle English that have formed the basis of much modern decision-making in Langland studies and in the field generally should first read Bare Essentials 4 below for a brief introduction before moving on to the main contents of the chapter.

In this chapter, we will see how Scribe B/Adam Pinkhurst's colleague, Scribe D, responded to dialect issues, as well as metrical and political ones in his copying of the Ilchester manuscript's text of *Piers Plowman* (now London, Senate House Library, MS SL V 88). And we will examine how he and the scribe of the *Piers* text in San Marino, CA, Huntington Library, HM 114 together preserve a fragmentary snapshot of a stage in Langland's revision process not extant elsewhere.

96. See the important article "The Logic of Textual Criticism and the Way of Genius: The Kane-Donaldson *Piers Plowman* in Historical Perspective," in Patterson 1987, 77–114; see esp. note 8 for Jerome McGann's comments on social authorship. For the disputed "Z" text, see Schmidt 1995–2008; Schmidt accepts Z as authentic and adds it to his parallel-text edition along with A, B, and C.

97. Skeat 1886.

98. See the images of HM 137 online at: http://scriptorium .columbia.edu/huntington/search.html.

99. Kane and Donaldson 1975; and Russell and Kane 1997.

100. See Schmidt 1995–2008, II, for a commentary on textual matters and a comprehensive bibliography. Schmidt also includes the history of Z-text disputes.

101. McIntosh, Samuels, and Benskin 1986–87.

Editorial Principles

The principles of editing Middle English texts suddenly became important—and highly controversial—with the Athlone Press editions of *Piers*. The hallmark of these editions was their choice of a "best text" as a base text, collated against all the other surviving manuscripts (excepting the true mavericks) and freely emended according to the editor's own sense of alliterative meter and discourse. This daring technique was deemed necessary because the time-honored method of creating a stemma (a family tree of manuscripts descending from an author's original) was, the Athlone editors argued, impossible. So much scribal contamination—that is, error introduced by scribes—made it impossible, they felt, to create a stemma for any of the three versions of the poem. The Athlone Press editors instead used methods for determining scribal error, many of them traditional (such as noting places where scribes had repeated words or lines accidentally or, alternatively, skipped or transposed words or lines).[1] Sometimes the same error might be introduced into more than one manuscript independently (this is called convergent variation), making it even more impossible to create family trees of the manuscripts, since editors traditionally did this by following the trail of deviation down the family tree, much as a biologist might trace a deviant gene (for instance, color blindness) passed down the generations of a family. In the case of *Piers*, the Athlone editors used a toolkit including the readings for any given word or line found in the other manuscripts of that version. And, most controversially, the toolkit also included readings found in a different version—so, for instance, Kane and Donaldson, in creating their B-text edition, sometimes import readings forward from A, or back from C. This they did after coming to the conclusion that even the archetype of all existing B-texts was corrupt (that is, they all go back genetically to a copy that was not the author's own original), so that it was their job to restore it by correcting alliteration, comparing other versions to restore the text to something *more* original than any extant B version today. In a brilliant piece of editorial detective work, they concluded that Langland did not even have his own original copy when he created the C-text.[2] The discussion of the Ilchester and HM 114 manuscripts below examines some of these mavericks and unique readings they contain against variants recorded in the Athlone Press C-text, as examples of how scholars try to distinguish scribal from authorial readings.

Types of English

Kane and Donaldson chose as their base text for B the manuscript Cambridge, Trinity College, B.15.17, to which they gave the siglum (or sigil) W. They were influenced to choose W as their base text in part because it had been designated as a standard form of London English. But in a methodologically important article, Horobin and Mooney have questioned the basis for this choice, arguing that W's scribe was the same man who copied both the Hengwrt (Hg) and Ellesmere (El) manuscripts of the *Canterbury Tales*.[3] If this were the case, this man, whom Mooney shortly thereafter identified as Adam Pinkhurst, Chaucer's scribe, would have had access to the best texts available of London's top poets during the Ricardian period. This is a very attractive thesis, though not all scholars to date agree with its findings.

1. See Kane 1960b, 115–72, where the specialized terminology used by editors for scribal errors can be found. See also Moorman 1975 for a student introduction to editing and its terminolgy.

2. Widely accepted but recently challenged by Jill Mann in "Was the C-Reviser's B Manuscript Really So Corrupt?" at New Directions in Medieval Manuscript Studies and Reading Practices: A Conference in Honour of Derek Pearsall's Eightieth Birthday, London, October 20–22, 2011.

3. Hanna mentions this claim as "stronger" but does not press it (2005, 244); Horobin and Mooney discuss A. I. Doyle's reasons for seeing Scribe B as a separate but similar scribe (2004); see also Doyle 1986, 39. For bibliography regarding dissent to the attribution of all these manuscripts to the same scribes, see Roberts 2011; Roberts's assessment is discussed in more detail below.

Linguist Michael Samuels had designated four "Types" (I–IV) of written standard English in texts copied during the fourteenth and fifteenth centuries. As Horobin and Mooney succinctly summarize:[4]

> Type I, also known as the Central Midlands Standard, is found in a number of texts associated with John Wycliffe and the Lollard movement. Type II is found in a group of manuscripts copied in London in the early fourteenth century, exemplified by Hand A of the Auchinleck MS, as well as several manuscripts of the later fourteenth century, such as three copies of the Middle English *Mirror* [*Sermons from Advent to Sexagesima*]. Type III is the language of London in the late fourteenth century, recorded in a number of London documents, the Hengwrt and Ellesmere manuscripts of the *Canterbury Tales*, Corpus Christi College, Cambridge 61 of Chaucer's *Troilus and Criseyde*, the Hoccleve holographs, and Trinity, B.15.17. Type IV, labeled Chancery Standard by Samuels and more recently King's English by Benskin, was used by the clerks of the medieval administration from about 1430.[5]

By Samuels's reckoning, then, the W copy of *Piers*, along with the most important Chaucer and Hoccleve manuscripts extant today, are Type III English, demarcated by a propensity for certain spellings of common words. These are determined by linguists through the use of a "questionnaire." One, in effect, "asks" the manuscript which forms it uses for certain words.[6] So, for instance, in Type III, the Modern English word THROUGH is commonly spelled "thurgh" or "þrouȝ": the Modern word NOT is commonly "nat"; SUCH is commonly "swich"; THEIR is usually "hir(e)" and so forth. (Dialectologists often capitalize the modern word so as to avoid confusion with the Middle English one). However, one instantly sees that spelling variations occur throughout W (and virtually all medieval texts), since, as Jeremy J. Smith helpfully points out, Samuels's Types are "focused" standards, rather than "fixed" ones.[7] In fact, Trinity's spelling proves statistically less normative for Type III than Hg's and El's, which Horobin and Mooney attribute to the W scribe's having changed over time. This is entirely possible, but other scholars might use this variation to question the attribution. Dialect analysis, just like paleographical analysis (as we will see in the question of Pinkhust's identity below), is a valuable but not always a conclusive science.

Using such a "questionnaire," Horobin and Mooney study the development of scribal habits: first, they suggest that the scribe would had to have copied W *before* he copied Hg and El—that is, that his spelling preferences changed over time (the dialect of a scribe's exemplars can gradually seep into the scribe's spelling habits). Second, they suggest that what Samuels had taken as a piece of evidence of the spread of Type III English (that is, the similarity of W's language with Hengwrt and Ellesmere), could in fact look now rather more like the prevalence of a single scribe, copying both Langland and Chaucer. Their thesis, however, does not disprove the *existence* of Type III English; rather, it queries how quickly it may have spread.

Scribal Behavior

Given that there are at least sixty-one manuscripts and fragments of *Piers Plowman*, in diverse dialects, the work of McIntosh, Samuels, and Benskin in compiling the *Linguistic Atlas of Late Medieval England* is invaluable, both for the study of Langland and for other Middle English texts. *LALME* is the indispensable tool of our trade for mapping Middle English manuscripts geographically. There are three possible kinds of scribal behavior we see when a scribe confronts a text in a dialect that is not his (or her) own, as originally distinguished by Angus McIntosh:[8]

4. Samuels 1963.

5. Samuels 1963, quoted from Horobin and Mooney 2004, 73–74. See Benskin 1992 for more on the concept of "King's English."

6. See Horobin and Mooney 2004, table 1, a typical example of this method. The word examples given here are quoted from this table.

7. Smith 1996, 73–78.

8. McIntosh 1963, summarized here by Horobin and Mooney, who also discuss "constrained selection" as a more complex example of type C, examining "active" and "passive" repertoires available to a scribe (2004, 76); see also *LALME*, 1:1–55.

A He [or she][9] may leave the language of his copy-text unchanged, producing a literatim transcription of that text.

B He [or she] may "translate" the language of his copy-text into his own dialect.

C He [or she] may do something in between types A and B, thereby producing a mixture of his own forms and those of his exemplar.

In the Hengwrt and Ellesmere Chaucer manuscripts, Scribe B copied according to type C above, that is, creating a mixed copy, and this is also what happened in the *Piers* text, W, which was likely copied in London from an exemplar at least one remove from the B version's archetype.[10] Horobin and Mooney show a variety of mixed forms in W and, accordingly, in London English at the time the W scribe (later identified as Adam Pinkhurst, Chaucer's scribe) was active. Whether or not their thesis about the identity of the scribe of W is universally accepted, they demonstrate valuable methodolgies for analyzing scribal behavior and show beyond doubt that, during the reign of Richard II, Type III English was probably linguistically less quick off the mark than Samuels had assumed.[11]

9. I have added the "[or she]" since we do know that women were sometimes active as text-writers, both in nunneries and elsewhere. See Christianson 1990; and ch. 2, where Olson treats the female scribes of the Findern Manuscript.

10. Kane and Donaldson 1975, 2:49–51. W is also related to HM 128 (Hm), Crowley's printing of 1550 (Cr) and Sion College arc. L. 40 2/E (S); for this reason, it is referred to as the WHmCrS archetype.

11. Horobin and Mooney 2004, 92–93.

1. The Codicology of *Piers* Manuscripts

As important as the editorial aspects of the poem are, the codicology of these manuscripts is a field in itself.[102] With some sixty-one extant manuscripts and fragments, a complete study of *Piers* codicology would require more space than this entire book fills. The focus here will be on a few key manuscripts that tell us something important about Langland's (and in the case of HM 114, also Chaucer's) working habits or the poem's earliest reception, and which introduce readers to some standard methodologies regarding authorial revision, scribal behavior, dialect, editorial choice, and textual reconstruction. Other discussions of *Piers* manuscripts (illustrated, annotated, or monastic in origin) are found elsewhere in this book (see chs. 3, 4, and 6, respectively). Here we will look at two important manuscripts that emanate from some of the poem's earliest professional, London-area scribes: first, in the Ilchester *Piers* (fig. 14, a C-text cross-pollinated with an A-text), a maverick, as we will see by comparing it with San Marino, CA, Huntington Library, MS HM 143 (fig. 15, the base text for modern C editions). Second, we will also compare Ilchester's *Piers* text, which has the siglum J, with

HM 114's (siglum Ht, fig. 20b), a B-text fascinatingly redacted with A and C material, alongside an early version of Chaucer's *Troilus*. Ilchester and HM 114 have the distinction of carrying material likely originating in authorial papers that contained premature drafts, perhaps leaked or somehow loosed from Langland's desk before they were finished.

About the time the B-text first emerges (that is, any time after c. 1377–79 when it was likely composed), London is poised to rise to prominence in the English book trade. A crucial factor in this process is the centralization of government there, especially in Westminster, with its large body of writing offices for government business. But Langland's poem and its popularity appear now to be key factors in London's increasing English book production. Although we still know next to nothing factual about the poet himself, we know his dialect is that of the South West Midlands, the area of the Malvern Hills of which he writes. It is also clear from the legal knowledge in his poem and the clerkly (even musical) knowledge in it[103] that he was at some stage in his life like both the Harley and the Arundel compilers in their vocational background. His interests in the political, legal and social problems of London and

102. The classic introduction to *Piers* manuscript studies is Doyle 1986. In addition to the resources mentioned in this book, see also the *Piers Plowman* Electronic Archive project, headed by Hoyt Duggan, which has now started to publish the manuscripts digitally, with detailed introductions. Online at: http://www3.iath.virginia.edu/seenet/piers/, listing the 61 MSS.

103. Holsinger 1999; as mentioned in section I above on *Choristers* and its possible relation to *Piers*.

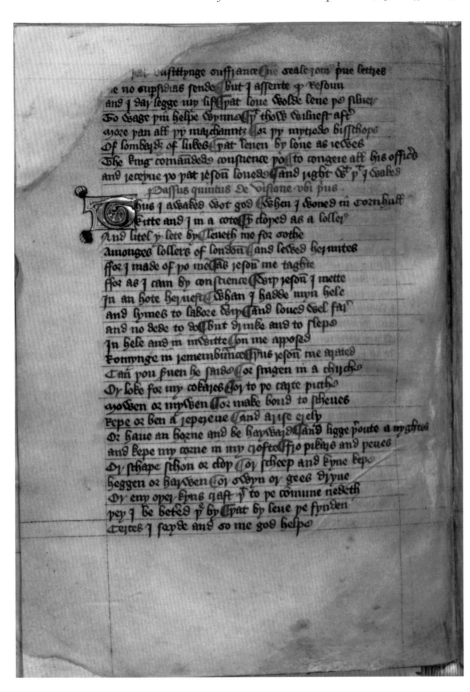

14. The hand of Scribe D, also showing decoration of the late fourteenth century, with daisy bud motifs. London, Senate House Library, University of London, MS SL V 88 (Ilchester MS), fol. 25v.

Westminster further indicate that he himself was probably among the stream of clerical or semiclerical migrants from all over England who came to work in one of the many metropolitan writing offices (royal, governmental, episcopal, legal, municipal, or in noble households). Here we have an important topic in the study of *Piers* manuscripts and Middle English manuscripts generally: the migration of texts and scribes from regional centers to London. From our study of earlier alliterative writing so far in this book, we know that Langland's own regional centre

(SWM) already had a far more ancient and sophisticated literary tradition than London did at the beginning of Richard II's reign in 1377.

An important manuscript for the study of this migration is the Ilchester manuscript, copied by Doyle and Parkes's Scribe D, who himself came from Langland's own dialect area to work in London. Scribe D is quite simply the heavyweight champion (as measured in sheer numbers of lines per lifetime) of Middle English copyists in this period.[104] As Derek Pearsall remarks, "His is the 'classic' hand

104. The manuscripts are two of Chaucer: CCCO MS 198 and BL MS Harley 7334; one of Langland: London, Senate House Library, University of London SL V 88; one of Trevisa: BL MS Add. 27944; and the eight of Gower: Oxford, Christchurch College, MS 148; New York, Columbia University, MS Plimpton 265; Bod. MS Bodley 902 and MS Bodley 294; BL MS Egerton 1991; CCCO MS 67; Princeton, Princeton University Library, MS Taylor 5; and TCC MS R.3.2. See Doyle and Parkes 1978; see also Kerby-Fulton and Justice 2001; Stubbs 2010.

15. Opening of *Piers Plowman*. San Marino, CA, Huntington Library, MS HM 143, fol. 1r, base text for all modern C-text editions.

of early fifteenth-century English literary manuscripts."[105] HM 143 is also, like Ilchester, written c. 1400 in a SWM dialect, annotated and corrected by a government-trained hand, and the most textually authoritative C-text extant today.[106] Though probably just slightly younger, representing the next generation of *Piers* copying in the early fifteenth century as parchment loses ground to the newer, cheaper technology of paper, is another important Middle English scribe. Ralph Hanna called him "one of the most prolific known copyists of alliterative poetry . . . [including] the most popular such works: *Piers, The Siege of Jerusalem, Susannah, The Awntyrs off Arthure.*"[107] Hailing from Essex, he copied Huntington Library, HM 114, creating his own "best text" *Piers Plowman* by cherry-picking from all three versions of the poem. He also twice copied Chaucer's *Troilus* (once into HM 114 itself), as well as several other Middle English bestsellers, and is known to

have copied London city records.[108] In research by Linne Mooney and Estelle Stubbs as yet unpublished, he has been tentatively identified as Richard Osbarn, the Clerk of the Chamber of the City from 1400 to 1438, another of the scribes who worked in the civic secretariat at the London Guildhall, like Scribe D (whom, as we saw earlier, they have tentatively identified as John Marchaunt, employed there 1399–1417).[109] Although we are unable as yet to adopt these names, these identifications are certainly plausible, and in the mean time, much else about these scribes can be studied. Both bridged the supposed chasm between the alliterative and the rhymed, and between Langland and Chaucer, a chasm that grows tinier the more we study the early manuscripts of these two London literary giants— although it was a divide Chaucer's Parson at least felt unable or unwilling to cross.

2. Scribe D's Ilchester Manuscript and His Oeuvre: Dialect, Dating, Damage, and Discernment of Scribal Redaction

The Ilchester manuscript (J) is fronted with what Russell and Kane rather dismissively called "a compiler's prologue."[110] J's prologue has several unique features: notably, it lifts one of Langland's most popular new C-text passages from Passus IX and shoves it into the poem's Prologue, itself strangely redacted in J. The same passage, in much the same form, was shoved into Ht's text immediately after Piers's confrontation with Wastor in the B-text. Both copies of the interpolated passage show strange metrical forms, yet despite all this redaction, they may "contain some very good readings . . . which may derive from the poet's first drafts,"[111] and as such have been objects of fascination to Langland scholars for years. We start with J, the earlier of the two.

Physically Ilchester (see fig. 14) exemplifies the new look for vernacular manuscripts during the reign of Richard II, as does front plate 3, Newberry Library MS 32.9, *Pricke of Conscience*, and the Vernon manuscript (see ch. 3, fig. 12), all with characteristic daisy-bud decoration. This new look is a later, more sophisticated Ricardian version of the workaday *Anglicana* hand we saw in Harley 2253, now fully adapted as a book hand.[112] By the time Ilchester is made, the Gothic *textualis* script we saw nostalgically reproduced in the *Gawain* manuscript has in most Ricardian manuscripts given way to a settled *Anglicana formata*, a hand that had been in widespread use in records done in all three languages for decades. One of the few hints in

105. Pearsall 2004, 81.

106. See Grindley 2001.

107. Hanna 1989b, 121.

108. Hanna 2005, 28–29. Hanna also gives evidence of his work copying records for the City of London.

109. See note 4 above. Again, because their evidence is not yet

accessible, I have not adopted the names of these scribes in this study. One hopes to be able to do so in the future.

110. Russell and Kane 1987, 186.

111. Petti 1977, 51.

112. Roberts 2005 has several plates tracing this development.

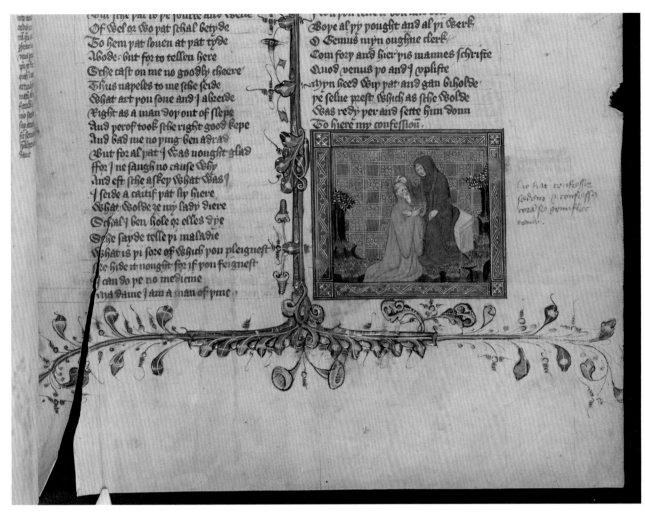

16. Scribe D's text of *Confessio Amantis* with an image of Gower kneeling before the Confessor and Scribe D's informal, Secretary-influenced script writing instructions to illustrator: "hic fiat confessor | sedens *et* confess*us* | cora*m* se genuflec | tendo." Oxford, Bodleian Library, MS Bodley 902, fol. 8r, bottom half.

Ilchester of D's proficiency in native English manuscript production is his consistent use of a very squat thorn (þ) for "th" (as in the *Gawain* manuscript).[113] His is otherwise a very professional, up-to-date hand: fig. 16 shows D's hand also writing marginal instructions for the illustrator in a confident cursive script containing features of the new secretary hand (which we will meet in Hoccleve later), quite unlike the *Anglicana* he uses for the main text of his English writing. If, as Mooney and Stubbs suggest, he does indeed turn out to be John Marchant, a member of the Guildhall secretariat in the early Lancastrian period, I would nevertheless suggest that he must have copied Ilchester earlier in his career, given its decoration and its linguistic features, as we will see below.

The "compiler's prologue" of J (see fig. 17 showing the facing fols. 4v–5r of this prologue) was damaged by water and by rodents sometime before it came into the care of the University of London's Senate House Library. On the right folio, six lines up from the bottom, can be seen the opening lines of the C Prologue passage in which Con-

science accuses prelates of idolatry and laxity, in a scathing new piece of writing. The lines are illegible on this page, but if you look across to the opposite folio (4v), you can see the damp has caused an imprint of the damaged lines to be left there, but backward, of course (referred to as an "offset" by editors). Offset letters are readable only with a mirror (a hand mirror, by the way, should be in every codicologist's toolkit, along with a magnifying glass), unless one happens to have Leonardo da Vinci's or William Blake's skills in mirror writing.[114]

In this steaming passage Conscience is accusing prelates of tolerating idolatry ("ydolatrie ȝe soffren" [Prol. 96]), and of setting forth boxes bound with iron (that is, donation boxes at shrines) to collect "vntrewe sacrifice [misguided

113. Petti 1977, 51.

114. A similar problem occurs in the *Gawain* manuscript, referred to in the apparatus of Tolkien and Gordon 1967 as, e.g., "reading aided by offset" (1967, 64).

17. Damaged leaves of the Prologue, the Ilchester *Piers Plowman*. Black-and-white photo. London, Senate House Library, University of London, MS SL V 88, fols. 4v–5r. The box shows the imprint of letters on 5r, and the arrow shows the start of the Passus IX interpolation.

ILCHESTER MS	EDITION IN RUSSELL AND KANE 1997 (BASED ON HM 143)
Conscience accused hem þat al þe comune herde	Consience cam and [ac]cu[s]ed hem—and þe commune herde hit—
And . . . ffre ydolatrie in sondry places many	And seide, 'ydolatrie ȝe soffren in sondrye places manye
. . . broght forþ bounden wiþ Irne	And boxes ben yset forth ybounde with yren
. . . þe tol of vntrewe sacrifice	To vndertake þe tol of vntrewe sacrefice.
In me . . . miracles moche wax þer hangeþ	In menynge of miracles muche wex hangeth there;
al þe worlde wot it wel <u>þat it was neuer trewe.</u>	Al þe world wot wel <u>hit myghte nouȝt be trewe.</u>
(fol. 5)[1]	*(C.Prol.95–100)*

1. For the complete transcription, see Kerby-Fulton 2001, which corrects some errors in Russell and Kane 1997.

donations]." "Yn <u>menynge</u> of miracles / muche wex hangeth there," he charges (since candles were expensive), even though "Al þe world wot wel / <u>hit might nouȝt be trewe</u>" (emphasis mine in this quotation and those that follow). The line "in <u>me[nynge</u> of] miracles" ("<u>implying</u> miracles") is daring enough, but J goes further in the next line, saying that all the world knows well "þat it <u>was neuer</u> trewe," while HM 143 (along with most C manuscripts) sticks with the more cautious "hit <u>myghte</u> nouȝt be trewe." If we check the variants for all C manuscripts in Russell and

Kane 1997, we see only two, and only one other with as vehement a reading as J's: MS Douce 104 reads "neuer" for the majority C tradition's "nouȝt" (as represented in HM 143):[115]

 100 Nouȝt] neuer D. myghte] may N

Even Douce (which generally has a demonstrably radical reformist agenda), however, does not supplant the

115. See Russell and Kane 1997, variants for C.Prol.100; see front plate 8 for the Douce MS.

"myghte" (or "may" in N) of all other manuscripts, leaving J's version of this passage as the most damning of shrines and miracles now extant. But was this what Langland wrote, or once wrote, and perhaps later revised? Or is the J scribe (Scribe D) or perhaps some other redactor improvising? Since Russell and Kane do not collate the unique Ilchester prologue, modern readers do not even see J's "was neuer" reading in their variants—though as a reading, J's fits Langland's overall tone of indignation in this brief passage quite plausibly. In fact, there are other places, too, where Scribe D's copy has preserved much richer readings than other manuscripts. Did he have access to an exemplar that—in places at least—preserves readings that go back to Langland's authorial papers?

To answer this—or any question like it—we need to know a great deal more about a scribe's behavior and about Langland's working method. The interest in finding the answer, then, goes far beyond this little passage.

3. Scribal Perfectionism, Interference, and a Snapshot of Langland "In His Working Clothes"

There is another intriguing wrinkle in the passage from which the lines above come (Prol. 95–124): only the Ilchester version (J) has entirely polished alliteration—in all other manuscripts of the C-text this passage travels with deficient alliteration. This oddity in the C tradition—there is a similar crux in the Pardon scene of A[116]—once led scholars initially to believe that J was the unique witness to Langland's own original version of the passage, such was the quality of the alliterative style. As Derek Pearsall showed, however, it was likely Scribe D himself who created the alliteration for this passage.[117] A few sample lines (C.Prol.110ff.) set next to the HM 143 manuscript itself will demonstrate the problem. In this passage, Eli is criticized because he did not chastise his children, who became lax priests:

The J version is so determined in its correction of alliteration we find every strategy from padding (e.g., "for so þe book te⟨lles⟩") to the importation of French (e.g., "peres of the holy chirche") to get an *aa/ax* line. Again, since Russell and Kane do not collate J's "compiler's prologue," these variants are not recorded in their apparatus either.[118] But at a glance one can see that J's version always delivers alliteration on both halves of the caesura, mostly *aa/ax* or even *aa/aa* alliteration: Scribe D (as we also know from his Chaucer manuscripts) was a metrical perfectionist.[119]

How did scholars decide that Scribe D, and not Langland, was responsible for these metrical changes? Both Scribe D and the scribe of HM 114 had access to an alternative version of the long passage new to Passus IX in the C-text—this passage, too, oddly was interpolated into the "compiler's prologue" of J. Part of it can also be seen in fig. 17: If you look on the left-hand side, across from the passage about Conscience's accusation cited above, you will see a chunk of this interpolated passage (starting thirteen lines up from the bottom of folio 4v, beginning "þe cause of þis caitifte,") from C.IX.255ff., about corrupt bishops as poor watchdogs. Since the interpolation survives in J and in Ht without the B lines it travels with elsewhere, there is a strong possibility that both this and the Eli passage were perhaps leaked from Langland's work-in-progress at an early stage.[120] Langland may never have intended for either of them to emerge in this form. Both of these instances, then, tell us something about Langland "in his working clothes" (in Derek Pearsall's memorable phrase): that he apparently drafted lines without alliteration, perhaps as rough notes, and then worked them up; second, that he wrote new material initially without integrating lines from his previous version (in this case, the B-text) in his first draft. He apparently sometimes used cue lines from the previous version for adding material on loose sheets.[121]

As Wendy Scase recognized some years ago, J and Ht

And chastisid hem noght þerof / and nolde noght rebuken hem[1]	And chastised not his children of her euel chekke⟨s⟩
~/ anon he ful for sorwe	He stombled doun fro his stool in stede þer he sat
Fro his chayere þer he sat / and brake his nekke atwene	And brak his nekke bon in tuo for so þe book te⟨lles⟩
And al was for vengeance / he bet noght his children	For þay were prestes vnpure peres of holy chirche.
And for þei were prestis / and men of holy chirche	*(Ilchester, fol. 5v)*
(HM 143, fol. 2v)	

1. Omissions in the quotation here are to keep the text aligned with Ilchester's for comparing alliteration. In fact, there are differences in lineation here between the two texts; see Russell and Kane 1997, C.Prol.110ff. and variants.

116. Knott and Fowler 1952, 20–28.

117. Or, less likely, another SWM redactor he was copying from. But since Scribe D also altered Chaucer's metrics, we assume this is our man.

118. They do print the Ilchester Prologue in their introduction. However, there are some errors; for a corrected transcription, see Kerby-Fulton 2001, 159–67.

119. For examples of his extensive habit of correction and participation in Langland's text, as well as in Chaucer's, see ibid.

120. This theory is put forward by Scase 1987, building on Pearsall 1981; see Kerby-Fulton 2001 for further details.

121. The evidence for Langland's use of cue lines is complex: for the cues to an A-version Prologue at issue here, see Kerby-Fulton 2001, 154ff., citing previous studies.

uniquely share this alternative version of the C.IX passage, full of hot topics that Langland was adding to his new version. This passage is a lengthy discussion of whether one should give alms to beggars and to whom such alms should be given, whether the "deserving" poor or the possibly or merely fraudulent. The striking survey of social poverty issues ranges over poor women cottagers who are apparently single parents (perhaps the first such discussion in English poetry), "lunatic" wanderers (the mentally or psychologically impaired), and many others he calls "lollars." Langland's unique attempt to define the word "lollar," which was rising in use against followers of Wyclif during the 1380s, appears in this new passage as well. The enormous popularity of the new passage is testified in many annotations of the time (e.g., in the Douce Manuscript; see ch. 4, sec. II, below).

Among the unique features of this alternative tradition, however, is that in J and Ht its alliteration is defective. Where in Ht a line has been left defective, in J, Scribe D will sometimes write two or more lines, if necessary, to keep the sense of the passage but make it alliterate, as the comparisons below with the standard C-text tradition (representing majority opinion, so to speak, based on HM 143 in modern editions) show:

> **C** Godes munstrals and his mesage*rs* and his m*u*ry
> bordio*u*rs
>
> **Ht** Goddis own mynstrels & his myry bourdiours
>
> **J** Bringe in goddes bourdyo*u*rs and at ȝour boord
>
> . . .
>
> his oghne mery menstrals makeþ hem ⟨at . . .⟩
> *(C.IX.136)*

or:

> **C** And suffreth suche go so, it semeth, to myn inwyt,
> Hit aren as his postles, suche peple, or as his priue
> disciples.
>
> **Ht** he suffreþ hem to go so hit semeþ in my sight
> þei faryn as apostles & cristes owne disciples
>
> **J** and sithe he soeffreþ suche as sottes to wa . . .
> as of Dosen Dastardes þe desteny endure
> þay may be compered and called as cristes o⟨g . . .⟩
> *(C.IX.117–18)*

These lines are an excellent case study in McIntosh's Type C response (see Bare Essentials 4) when a scribe is confronted with a text in a dialect not his own. Both the Ht and the J scribe (Scribe D) respond differently. Ht's scribe, it seems, was systematically exacerbating the problem of his unevenly alliterated text by revising out dialect words he did not think his London audience would understand. In 117, he likely thought the word "inwyt" too provincial: the word does not, for instance, appear in Chaucer. Scribe D, however, responds to the incorrect alliteration with a fit of good, original composition worthy of a man who himself grew up with the SWM dialect and its rich

alliterative heritage. We do not know, for instance, who the "Dosen Dastardes" are that the J version alone contains, but their names are unmistakably capitalized in the manuscript—and they alliterate. But both of these passages contain Scribe D's use of a Kentish spelling he has apparently picked up (already—since Ilchester was an early commission of his) from copying Gower: "oghne" (for "own"). Both contain SWM pronouns, which he does not elsewhere always bother to alter from the northern Midlands forms in his exemplar.[122] He has taken in some non-SWM spellings (e.g., "menstrals"), but where he has had to supply a word himself, we usually get it in SWM spelling (e.g., "desteny"); moreover, he has also orthographically translated or partly translated certain words already in his exemplar into SWM spellings (e.g., "soeffreþ," "sithe"). It is significant that these passages come from Langland's description of the lunatic lollars, which clearly excited Scribe D because his participation in this little segment goes beyond his more usual doctoring of metrics: he even supplied the pun above on "boord / bourdyo*urs*" in his riff on IX.136, for instance, and SWM forms turn up again in his uniquely wistful rendering of the line on how the lunatics cannot preach:

> **C** Riht as Pet*er* dede and poul, saue þat þey pr*e*che
> nat
>
> **Ht** So as petre dide & poul saue þat þei preche not
>
> **J** So as . . . ⟨did⟩ and paule if þat þey preche cou̲þ̲e̲
> *(C.IX.112; my emphasis)*

Checked against Russell and Kane's variants for line 112, one can see that J alone among C-texts laments that the "lunatic lollars" cannot preach. Since Russell and Kane do not collate this section of J, calling it "a compiler's prologue," the heartfelt "if þat þey preche cou̲þ̲e̲" does not appear—yet this line, too, based on its poetic quality, at the very least deserves recording as a striking variant, because we do not know for certain who supplied it. Is *all* this variation the work of Scribe D? Or was it an earlier redactor whose work already lay in D's exemplar? Or may it even have been Langland himself?

Scribe D, as Jeremy Smith and others have shown, also intervened metrically in his Chaucer copying,[123] but not in his many Gowers, where he was apparently on a short leash (for reasons unknown but tantalizing: did he work directly for Gower?). As Smith has written: "It is possible that this state of affairs can tell us something about the literary standing of the two authors: Gower . . . a respected monument; Chaucer, with his unfinished poem ravaged by scribal intervention, a living poet."[124] What does this profile then tell us of his Langland interventions? Scribe D does not normally intervene where metrics are not at is-

122. See Horobin 2005, esp. 265ff.
123. Smith 1988. See Kerby-Fulton 2001, 144–47, for examples.
124. Smith 1983, 112.

sue, and those excessively rich readings (the "coupe" above or the "was neuer" in the passage about shrines) both occur in the fourth stave of *aa/ax* patterns, where alliteration is not needed. It is just possible then that some of the nonmetrically driven readings go back to Langland. We also know that Scribe D, like the Ht scribe, preserved the shape of what scholars have called an authentic alternative C tradition found only in these shared passages in J and Ht. These scribes did not preserve its metrics but its shape. This suggests that even a "compiler's prologue" is worth collating.

The confidence with which Scribe D handled Ilchester, to the extent of intervening in its metrics, suggests something of the confidence of swm book production, a stronger and more ancient tradition of vernacular writing, as we have seen already, than any London had to offer for most of the Ricardian period. One can imagine a young scribe determining to set the big-city dwellers straight on how it should be done.

4. Remnants of Authorial Activity and Government Reading Circles Preserved in HM 114's Texts of *Troilus* and *Piers*

Kane and Donaldson established that there were residual cue references in the *Piers* textual traditions, a complex topic made more complicated by the apparent absence of Langland's own B-text during the C revision process that the editors noted long ago.[125] While we have only textual clues to the likelihood that Langland used loose sheets and line cues for insertion, in Chaucer's *Troilus* we may have somewhat more direct evidence of this system of revising or expanding by marking a spot in a text and putting the new material on loose sheets or singletons added into the manuscript. In practice, works often got into circulation either before these additions were made, or after the material on the loose sheets was lost. In the case of *Troilus,* it has long been apparent to scholars that Chaucer probably only later added passages such as Troilus's song to love (III.1744–71).[126] Chaucer's process of revision has been the subject of much debate, but, for instance, in HM 114 the scribe who copied *Piers* also copied *Troilus,* and later added Troilus's song, as well as his soliloquy on God's foreknowledge (IV.953–1085) and Troilus's ascent to heaven (V.1807–27).[127] As Ralph Hanna notes, it was the HM 114 scribe, not

the twentieth-century editor, R. K. Root, who discovered that the "alpha archetype" of Chaucer's *Troilus* did not include the whole poem.[128] These later passages are added in the scribe's hand on sheets, with marks indicating where the interpolation should go. Figs. 18a and b show where Troilus's song to love goes: realizing that he did not have this (and the others), the scribe added it on an inset sheet, with this note in the margin: "Love &c~ | ad tale sig*num* § [at such a sign §]." Now, an unnoticed fact is that this type of formulaic note (ad tale sig*num*) is used in government offices: for instance, in the Exchequer to indicate where a document is stored. Fig. 19 shows one such Exchequer record, referring to business conducted for Edward III's mistress, Alice Perrers (who, of course, has long been thought to be a possible inspiration for Langland's Lady Mede). The formula went on being used well into the fifteenth century.

What is further significant about the little note in HM 114 is that it indicates that the scribe had had experience as a government professional, placing him in the same reading circles (though a generation on) of Chaucer's (and Langland's) first audiences.[129] It has usually been assumed that this manuscript was made on spec and often cited as a clear instance of a commercial scribe at work. In fact, we now know he was a professional one—he had a day job, apparently for a period of his life at the Guildhall,[130] and I would suggest that he had also had one at some point in the Exchequer (or another Westminster office). His textual alertness fits with what we know of his unique copy—really a complex redaction—of the B-text of *Piers* in HM 114, in which he had access to all three versions of the poem. Since he and his slightly older colleague, Scribe D, each somehow (and alone among *Piers* scribes) apparently got access to the unrevised material from Langland's C-text (the alternative C tradition discussed above), the city of London and its suburb Westminster were clearly rich in authorial or semi-authorial papers, if one knew whom to ask or where to look.

With Chaucer and Langland, we can only infer this sort of authorial modus operandi out of textual evidence, and, of course, not every scribal addition can be traced back to an authorial addition—most are simply scribal additions! But in the case of HM 114's *Troilus,* they are more. "Rolling revision," so hard for modern students of print culture to grasp, was a standard feature of medieval publi-

125. Kane and Donaldson 1975, sec. IV of introduction; Kerby-Fulton 2001.

126. See Owen 1987 for a full review of the scholarship on how Chaucer handled his revisions.

127. "The first two are adapted from Boethius and the last from *Teseide,* originally lacking in this manuscript. They were added later, though by the original scribe, on inset leaves, with their proper place in the context duly indicated by rubrics. The inset leaves are of the same paper as the rest of the volume; but the margins have

not been ruled" (Root 1914, 35, describing the Phillips manuscript, now Huntington HM 114).

128. Hanna 1989b.

129. Parkes 2008.

130. See Hanna 2005, 29, regarding his extant scribal work for the City of London; as noted above on p. 70, Mooney and Stubbs have tentatively identified him as Richard Osbarn, the Clerk of the Chamber of the City from 1400 to 1438, in work not yet published.

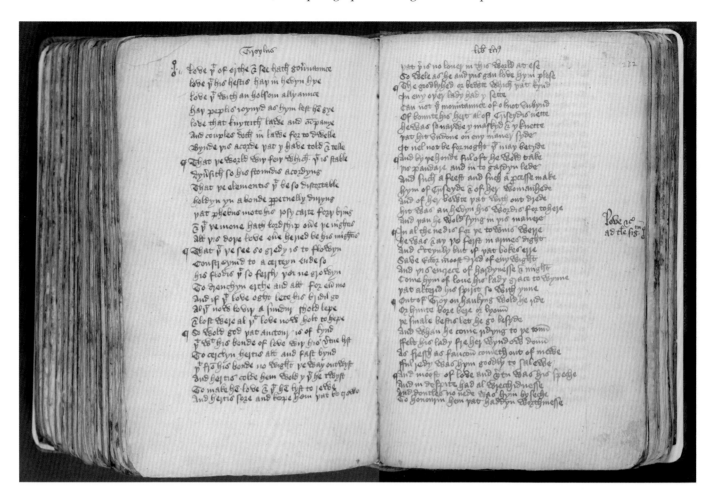

18. Passage from *Troilus*, showing the scribe's inset page, cued to a symbol in the marginal note on the recto page that reads, "Love *etcetera* | ad t*a*le sig*num*." The scribe used paper of the same stock as he did for the rest of the manuscript. San Marino, CA, Huntington Library, MS HM 114, (a) fol. 261v (b) fol. 262r.

19. An Exchequer document relating to Alice Perrers, the bottom line of which gives storage details "ad tale sign*um*" followed by the date ("anno xlvi^{to}" of Edward III). Black-and-white photo. Kew, Public Record Office, E 36/ 273.

cation; the fact that each time another copy was made it had to be done by hand, risking all the pitfalls of scribal participation and negligence each time, must have made it both tempting to revise anew constantly and perpetually risky for an author to allow work into wider circulation prematurely. As Daniel Hobbins has shown with respect to the prolific author Jean Gerson—about whose publication habits we happily have more evidence—Gerson continued to revise, even after releasing his work.[131] The Ht scribe, who was working probably a couple of decades after Chaucer's death, was nonetheless alert to the discrepancies between copies of both *Troilus* and *Piers*.

In the case of *Piers*, this scribe is famous for copying, and most likely himself creating, a sophisticated confla-

131. Hobbins 2009.

tion of all three texts of the poem, to which, uniquely among known *Piers* scribes today, he apparently had access. So, for instance, even though he was basically copying B, he incorporated an early version, as we have seen, of the passage Langland had added to C.IX about different kinds of poverty and begging, creatively adding it to the scene (one passus earlier) in which Piers confronts Wastor, whom Ht associates with "lollars." In Ht, the C draft passages are knitted together by a single spurious line,[132] and the whole is enthusiastically inserted into the B-text after VI.158. The alliteration throughout Ht is frequently defective, and, as both Scase and Hanna have shown, many of the poetic improvements in Ilchester were likely made in response to just such a defective exemplar further back in the Ht tradition.[133]

We do not have space here to examine the Ht scribe's astonishing pastiche and reworking of all three *Piers* versions into one, but a single example that confirms Westminster connections is revealing. Here is Ht's delightfully bureaucratic rendering of C.IX.138, the poignant line in which Langland says that the sins of "lunatic lollars" are "covered" under God's secret seal:

C For vnder godes secret seal here synnes ben
 keuered

Ht Wiþ goddis pryve seel her synnes be couerid

This is the only manuscript to contain the variant "pryve seel" (not noticed because, again, Russell and Kane do not collate Ht, considering it another "compiler's" version). This unique Westminsterish reworking of the line (if it is his own) is of a piece with his style of cueing insertions, suggesting that he was, like Hoccleve, in one of the many government offices (probably the Exchequer)—perhaps before he copied records for the City of London. If it is not his, and originates closer to the authorial source, it is even more interesting, and like Scribe D's Ilchester variants, deserves a home in the critical edition's apparatus.

5. Professional Scribes, Commercial Scribes, and Booklet Production

The Ht scribe, then, was, in the most recent terminology, likely a professional scribe, not a commercial one. According to Malcolm Parkes,[134] a professional scribe is one who was employed in a bureaucratic capacity (we might say at a "day job"), who nonetheless accepted commissions after

hours, so to speak—someone like Hoccleve, who worked in the Privy Seal by day, and moonlighted in Middle English book production, as Doyle and Parkes showed.[135] Scribe D, however, Parkes explicitly categorized as a commercial scribe (though if Stubbs and Mooney are correct in their identification of Scribe D as one of the civic secretariat, this would undercut Parkes's distinction, at least for this scribe). The Ht scribe, of course, was paid for his work, just as a commercial scribe would be: the evidence of quire tallying in HM 114 throughout the manuscript is observable, for instance, at the end of *Piers*, folio 130v (fig. 20a): in the extreme left-hand bottom corner in faint ink is written "hic 8 q*uater*[ni]" (or "quarter[n*us*]"?).[136] There is quire tallying in many Langland manuscripts, some we know to have been copied by professional scribes.[137] Scribes were paid in one of two ways: either by quire or by line.[138]

Long thought to have been created on spec as an early example of enterpreneurialism in the Middle English commercial book trade, in fact HM 114 challenges this hypothesis on closer inspection. It is true that it represents the new generation of Middle English manuscripts; unlike Ilchester and HM 143, it is on paper and brings together popular English texts. But the vastness of the project defies the notion that it would be made up just in the hope that a customer might appear: the cost in materials and labor alone would be prohibitive. A perfect example of booklet production, *Piers*, itself a long text, is accompanied in HM 114 by the alliterative *Susannah* (a text known to appear three times with extant *Piers* in manuscripts) and *Mandeville's Travels* (which appears an astonishing five times with *Piers*). It also contains an excerpt from the *Three Kings of Cologne* (brought to England by Edward III to boost his claims to sacral kingship),[139] and another massive text, the *Troilus* (found twice with *Piers*); and the "anticlerical" satire *Epistola Luciferi ad Cleros (Letter of Lucifer to the Clergy)*.[140] HM 114's "omnibus" *Piers* (Ht) alone represents work so labor-intensive that it now seems better described as a labor of love or a commissioned redaction (the two are not mutually exclusive) with a political agenda, as John Thorne has argued.[141] Mooney and Stubbs's unpublished

132. See Kerby-Fulton 2001, appendix, the line following line 281 in Ht; this spurious line may be based on A.Prol.93.

133. Even though Ilchester is perhaps a good thirty years older than Ht, it is Ht which preserves the oldest form of the text—in transmission history this kind of phenomenon, though counterintuitive, happens often.

134. Parkes 2008, 42 and 48n100, on Scribe D.

135. Doyle and Parkes 1978.

136. All that is really visible now is "q*uater*" (the same on fol. 325v). I would like to thank Nicole Eddy for her suggestion; the note is faint to read; the Huntington Library Manuscript Catalogue reads "q*uater*ni."

137. For the Douce manuscript, see Kerby-Fulton and Despres 1999; for HM 137 and 143, see the Huntington Library Manuscript Catalogue for these manuscripts and accompanying images.

138. Parkes 2008, 48–49.

139. See Brown 2010.

140. Images from all of these works can be seen online, at the Huntington Library Digital Scriptorium database http://dpg.lib.berkeley.edu/webdb/dsheh/heh_brf?Description=&CallNumber=HM+114

141. Thorne 2007.

20. (a) Detail of the end (*Explicit*) of *Piers Plowman*, with notation in bottom left corner showing the quire count to that point: "hic 8 qu*ater*(ni)" (or "quarter[*nus*]"?). San Marino, CA, Huntington Library, MS HM 114, fol. 130v; (b) Image taken during disbinding in 2000, showing the first page (opening of *Piers Plowman*) and the folded quires of booklets making up the volume, sewn together.

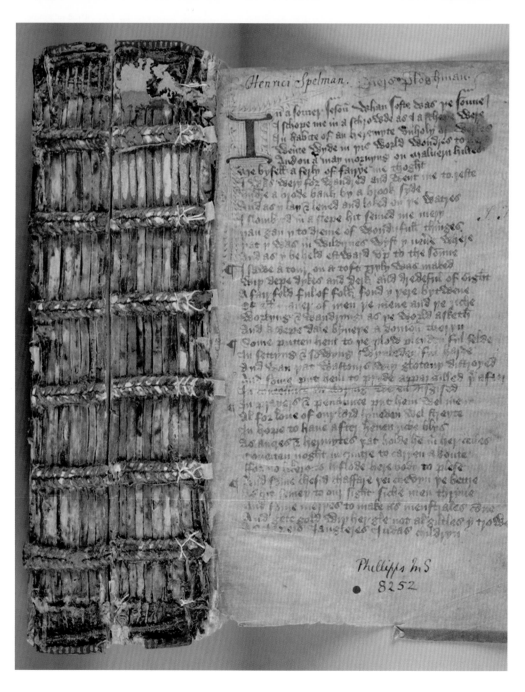

work offers yet another possibility: that HM 114 was pre-pared as a set of template exemplars to facilitate orders of these works, perhaps in the Guildhall environment. This, too, would make sense of the booklet structure. Fig. 20b shows the spine of HM 114 when the Huntington Library had stripped it for rebinding. One can see the quire struc-ture of the manuscript, neat and uniform, as well as how the works were commissioned in booklets, gatherings of quires that belong together and form a literary unit across quire boundaries. Reckonings of the number of quires in a booklet survive at the ends of three booklets.[142] These tell us that *Piers* formed the first booklet (its collation is 1–6[16] 7[18] 8[16]); *Mandeville, Susannah,* and the *Three Kings* the sec-ond booklet, and *Troilus* and the *Epistola Luciferi ad Cleros* formed the third.

Whether or not the book was created as a template or a "utility grade" manuscript for a specific client it shows deliberate choices of texts he made to include politics, religion, satire, women's issues, and travel. It also shows

that—now in another sense—the scribe played the role of the professional reader to the hilt: for instance in alter-ing and filtering his *Piers*—to the point of destroying the alliterative meter or shoe-horning in passages from other versions he thought pertinent in ways that have made him notorious today.

The copying of *Piers* was not always a metropolitan phenomenon. Other chapters in this book will deal with other aspects of *Piers* transmission (front plate 8 has already shown us a case from Ireland), but Scribe D and the Ht scribe together epitomize key issues with the copying of all three versions, including regional diversity of dialects, the extraordinary textual challenges prompted by scribal engagement, and the social diversity of *Piers* owners (from the beauty of Ilchester to the plainness of HM 114)—in short, the demand for Langland's poem in early metro-politan reading circles.[143] It is in the same world, and with the help of some of the same scribes, that Chaucer's ear-liest and most important extant manuscripts were made.

V. Some of the Earliest Attempts to Assemble the *Canterbury Tales*

As every undergraduate student of the *Canterbury Tales* knows, Chaucer apparently left this masterpiece unfin-ished at the end of his life—or, at the very least, if ever there was a finished copy, it did not survive to modern times, nor did any of its progeny. Scholars have long de-bated the meaning of its absence: was it premature death, a change of heart (perhaps indicated by the *Retractions*), or simply a tragic accident of manuscript loss? Four manu-scripts in particular have long held out the promise of an-swers, as they are likely the four earliest complete extant copies, two each copied by the scribes Doyle and Parkes designated as Scribe B (the Hengwrt and Ellesmere man-uscripts) and Scribe D (Oxford, Corpus Christi College, MS 198 and London, British Library, MS Harley 7334).[144] While other manuscripts also offer some interesting evi-dence (some of it discussed in ch. 4, sec. I below),[145] in the main, these four manuscripts have dominated Chaucerian textual criticism for some time.

1. First Shots or Shots in the Dark? Evidence from the Four Earliest Complete Extant Manuscripts

Recently, Estelle Stubbs has drawn attention to the role that codicology can play in shedding new light on the blindspots impenetrable to textual criticism.[146] A routine event in the library conservation history of one of these manuscripts—the disbinding of Corpus 198 in 1987—uncovered a wealth of hitherto inaccessible de-tail, offering a different picture of the development of the *Tales* than had Manly and Rickert (whose eight-volume 1940 edition remains the basis for many modern textual assumptions). In her 2007 article, "Here's One I Prepared Earlier," Stubbs showed that differences in the vellum throughout Scribe D's manuscript suggest that an earlier copy of the *Tales* was "brought out of retirement and re-furbished in a final burst of activity," and specifically, that changes of vellum and other physical evidence show an at-tempt to revise earlier tale order and links between tales, revisions dateable perhaps even to before Chaucer's death. One example of such evidence occurs between folios 101v and 102r (see fig. 21), where a catchword in the bottom left margin of folio 101v ("Our*e* lord") does not match the opening words of the first line of folio 102r ("That some

142. "On ff. 130v, 192v, and 325v, at the end of the three book-lets which constitute this volume, the number of quires has been reckoned" (description of HM 114 and a online at http://sunsite3 .berkeley.edu/hehweb/HM114.html).

143. Doyle 1983.

144. Doyle and Parkes 1978; Hengwrt's full shelfmark is Ab-erystwyth, National Library of Wales, Peniarth MS 392D (*olim* Hengwrt MS 154). Ellesmere's is Huntington MS EL 26 C 9. For the Ellesmere facsimile, see Woodward and Stevens 1995, and online images of El at the Huntington Library website, under Chaucer at http://sunsite3.berkeley.edu/hehweb/authors.html. For the elec-tronic Hengwrt facsimile, see Stubbs 2000. For the online Corpus 198 facsimile, see http://image.ox.ac.uk/show?collection=corpus &manuscript=ms198.

145. See especially Hanna 1989a, Partridge 2000, Partridge 2007. Partridge suggests "there's considerable evidence that there were multiple, collected exemplars behind those four early MSS that survive . . . and that conclusion is reinforced by Hanna's [1995] article." Private correspondence, February 28, 2011. I thank Stephen Partridge for his advice and for sharing his unpublished materials.

146. Stubbs 2007.

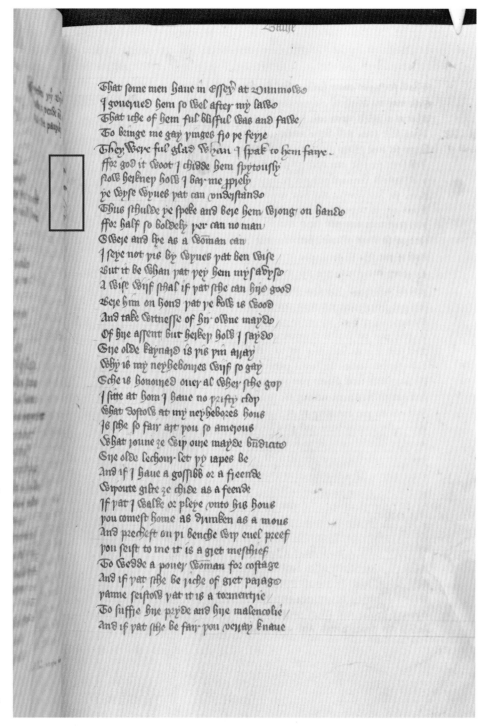

21. Passage from the "Wife of Bath's Prologue," *The Canterbury Tales*, copied by Scribe D. Remnants of a missing leaf that had contained border decoration are visible in gutter of fol. 102r from an earlier version of the "Prologue." The catchword (at the bottom of the facing page, fol. 101v, end of quire) does not match the first words (top recto 102), indicating a disturbance in the original production. Oxford, Corpus Christi College, MS 198, fol. 102r.

men . . .") as it should. A stub of once-decorated parchment is still visible against 102r, which would have displayed lines 146–217 of the "Wife of Bath's Prologue."[147] The decorated stub indicates that the manuscript once contained a shorter version of the "Wife of Bath's Prologue," the present "Prologue" being on a leaf of substituted vellum. This bit of evidence—one of many tiny pieces in the large jigsaw puzzle left for us by Corpus and the other three early manuscripts—confirms what textual scholars had guessed: that the nature and placement of the "Wife of Bath's Prologue" was under revision during Chaucer's lifetime, along with much else. Some lay-

ers of Corpus, it now appears, "may represent a pre-Hg period, others suggest changes in-line with Hg and access to Hg thinking."[148] Since Hg has always been assumed to be our earliest known manuscript of the *Tales*, this work on Corpus revolutionizes our knowledge of the Humpty Dumpty–size problem of putting the *Tales* together again. The scribes of Corpus and Hg were very likely sharing material or working together.

147. See ibid., n. 27 for further details.
148. Ibid., 151.

Stubbs's discoveries were made possible in part by the discoveries of Linne Mooney, who proposed the identification of Chaucer's "Adam Scriveyn" as Adam Pinkhurst (or Pynkhurst, the documentary spelling), an identification that has been widely but not universally accepted.[149] The sole direct challenge to the identification itself to date appears in Jane Roberts's forthcoming essay, "On Giving Scribe B a Name," which she has kindly shared with me in proofs. Roberts remains "unconvinced that Adam Pynkhurst, the scribe responsible for the flamboyant entry in the [Scriveners's] Common Paper, was necessarily the scribe of . . . Hengwrt, Ellesmere, and the other manuscripts" now attributed to him by Mooney and other scholars (233). The basis of Roberts's dissent is largely paleographical, though she also queries whether one man could have had as diverse a career as all the cumulative attributions to him would require (237). This objection might be met by comparing historically well-documented scribes with equally diverse careers, such as John Shirley or the Dublin author and notary James Yonge.[150] Roberts's paleographical analysis, however, tackles the methodological challenges posed by formally trained hands, a fair question, and notes a number of differences in letter forms potentially disturbing to the Pinkhurst attributions. Some of these, she admits, could be due to different levels of formality in choice of script, as scholars have always agreed, but Roberts's strongest case lies in the differences she notes in common punctuation and abbreviation styles (239). These are the elements a trained scribe might *unconsciously* carry over to a different script: we would be reassured to see Pinkhurst carrying them over, but this is a subject little studied as yet by paleographers in relation to scribal behaviour generally. Roberts's challenge, then, is inconclusive, but it deserves attention; at the very least it may whittle down the presently large and still growing corpus of non-Chaucer Pinkhurst attributions. If nothing else, it offers a caveat about newer methods of identifying hands (that is, by gathering a large number of fairly normative features under one umbrella, rather than the older method of looking for distinctive idiosyncrasies, a topic discussed below). In the absence, however, of a broader-based challenge to Mooney's identification (one that includes all the historical, codicological, literary and dialect analysis that Mooney engagingly brought to the problem), we will persevere here with the Pinkhurst identification at least for

Hengwrt and Ellesmere. But we will also keep Scribe B's original designation prominent in the discussion.

The history of this identification and the methods used to make it are complex, but we can learn a great deal from its methodologies. The name of Adam Pinkhurst had been mooted before, but to make this identification, Mooney went through a series of steps: she examined all of the manuscripts attributed to Doyle and Parkes's Scribe B, and several they had noted as "resembling" his hand; she also consulted the Scriveners' Common Paper (that is, the list of signatures and oaths for scriveners working in the London area, begun in 1392; see ch. 5, fig. 3) and found an "Adam Pinkhurst," who wrote like Scribe B (allowing for differences in levels of formality) in his especially flamboyant signature. (His entry, which she reproduces, takes up twice as much space as entries normally do!) Given that Adam is a relatively rare name in the records, the apparent specificity of Chaucer's little poem to Adam on the copying of his *Boece* and *Troilus*, and the tip John Shirley gave us in his rubric to that poem ("a Geffrey unto Adame his owen scryveyne"),[151] it seems a likely attribution. Mooney also consciously shifted the method of comparison from the traditional search for idiosyncrasies to identify a hand—which we saw with the identification of the Harley 2253's scribe's oeuvre (and will see with Hoccleve's)—to a method of collecting together more standard shared features, which she lists in a detailed appendix. These features might be found in any number of hands trained like Scribe B, but, she argues, only in Scribe B's manuscripts and in Pinkhurst's Common Paper signature entry do all of them coalesce in a single scribe. In short, what we have is the smoking gun, if not, so to speak, the murderer's documented confession.

One especially intriguing piece of circumstantial evidence Mooney notes is that Scribe B, in copying the earliest known *Canterbury Tales* manuscript (Hg), had omitted the "Adam" stanza from the "Monk's Tale,"[152] the stanza delineating how the first man had brought woe to the world. Now, scribes often inadvertently skip lines or stanzas (see Bare Essentials 4 above), but this seems more than coincidental given the name Chaucer himself gives his scribe, and the other evidence of Adam Pinkhurst's career. It appears that Adam was sensitive about his name (a lost cause in medieval Christianity, one would have thought), and it was left to another scribe to supply the missing

149. Mooney lists a number of manuscripts attributable to Scribe B/Adam, and the only published dissent seems to be over precisely which manuscripts he copied (2006). Of CUL MS Kk.1.3 (one leaf from the "Prioress's Prologue" and "Tale"), Daniel Mosser writes: "Doyle remains hesitant in this identification, as do I. Doyle believes that if this MS belongs in the list, it would fit last chronologically" (Mosser 2000, n.p.). Simon Horobin perhaps best summarizes current published opinion among those who directly address the issue: while accepting the identification, he cautions "we must be careful not to make the assumption that Pinkhurst

was employed by Chaucer as his personal copyist" (2010, 61). Gillespie finds Mooney's thesis "very persuasive" but cautions against an "overdetermined" reading of the poem "Adam Scriveyne" (2008, 272). Parkes apparently chose not to address the issue in print (cf. Parkes 2008). I am grateful to both Ralph Hanna and Alastair Minnis for their advice on this question.

150. On Shirley see Connolly 1998 and Veeman 2010.

151. *Riverside Chaucer*, 1083. Doubts about Shirley's reliability are a perennial topic for scholars; see Veeman 2010 for an overview.

152. Mooney 2006, 104.

stanza later. This scribe, too, is significant for our under-standing of early London book production: it was sup-plied by a hand[153] that may be that of the scribe of Arun-del 38, that is, the famous copy of Hoccleve's *Regiment of Princes* presented to the future Henry V (discussed below). Since Hoccleve himself would have been somehow in-volved in the commissioning or overseeing of this manu-script (see next section), it is especially interesting that a hand very like Hoccleve's own, called scribe F by scholars of Hengwrt, is also active. Here are the details as Daniel Mosser lays them out (with online images):

> Of special interest are hands C and F. Hand C adds the "Adam" stanza (MkT VII2007–2014 [B²3197–3204]) in the gutter of folio 89v, and could be the same scribe as that of BL MS Arundel 38 (cf. fol. 65r in the Arundel MS; note espe-cially the *W* form at the beginning of stanza 3 in Ar 38, the *a* graphs, majuscule *T*; the forms for *g*, though not identi-cal, have many points of congruency), Henry V's copy of Hoccleve's *Regiment of Princes*. Doyle and Parkes's obser-vations on hand F are particularly noteworthy: "Unlike hands *C, D* and *E,* hand *F,* was trying to deal with lacunae for which sufficient manuscript authority was not readily available. . . . *He may have relied on his own invention,* or his director's. Hand *F* is very like Thomas Hoccleve's hand in his own [holograph] poetical anthologies."[154]

Since we know Hoccleve collaborated with Scribe B/ Pinkhurst in the making of the Trinity Gower, the likeli-hood of his being involved in the Hg circle is good. Schol-ars have long speculated about his role in the making of El, especially since the famous Chaucer portrait in the prologue to Hoccleve's *Regiment* is so similar to the por-trait of Chaucer the pilgrim in El (see ch. 5 below), imply-ing connections with specific illustrators as well.

We are circling in here on a small group of scribes who were copying Chaucer (and Langland, as we saw above), perhaps even before Chaucer's death. It used to be as-sumed that both El and Hg dated from after 1400, but sev-eral pieces of evidence now point to transmission of *in vita* drafts to the Hg scribe.[155] This brings us to the question of availability of exemplars, and whether Chaucer himself, or a literary executor, was on the other end of the pro-cess. The available evidence of quire signatures in Hg (of-ten visible only under ultraviolet light) and the collation of Hg (shown in the online facsimile both in chart form and in color images of each leaf, with quire diagrams) suggest that the scribe received his exemplar *piecemeal*, in booklets.[156] As Hanna notes, not even all of Fragment I

was available to the scribe at once (quire 6 is a singleton, implying that the scribe was waiting for copy to arrive). Those who are used to reading the *Canterbury Tales* in the order given by El, and adopted in nearly all modern edi-tions, are always struck by the distinctive ordering of Hg, which looks like an early attempt to assemble the *Tales* based on access to some kind of authorial papers, though likely without direct authorial supervision. For instance, Fragment II (the "Man of Law's Introduction," "Prologue," "Tale," and "Epilogue," the former containing reference to Chaucer's own "canon," the latter containing a negative reference to Lollardy, later removed in El) is in a radically different place in Hg. The result is the distinctive ordering in Hg, over which scholars have so often puzzled:

HG (STRUCTURAL SECTIONS)	EL (FRAGMENTS)
I	**I**
General Prologue	General Prologue
Knight's Tale	Knight's Tale
Miller's Tale	Miller's Tale
Reeve's Tale	Reeve's Tale
Cook's Tale	Cook's Tale
II	**II**
Wife of Bath's Tale	Man of Law's Tale
Friar's Tale	**III**
Summoner's Tale	Wife of Bath's Tale
III	Friar's Tale
Monk's Tale	Summoner's Tale
Nun's Priest's Tale	**IV**
Maniciple's Tale	Clerk's Tale
IV	Merchant's Tale
Man of Law's Tale	**V**
Squire's Tale	Squire's Tale
Merchant's Tale (without	Franklin's Tale
Prologue)	**VI**
Franklin's Tale	Physician's Tale
Second Nun's Tale	Pardoner's Tale
Clerk's Tale	**VII**
Physician's Tale	Shipman's Tale
Pardoner's Tale	Prioress's Tale
Shipman's Tale	Sir Thopas
Prioress's Tale	Melibee
Sir Thopas	Monk's Tale
Melibee	Nun's Priest's Tale
	VIII
	Second Nun's Tale
	Canon's Yeoman's Tale
	IX
	Maniciple's Tale
V	**X**
Parson's Tale	Parson's Tale

153. Denoted as that manuscript's Scribe C by modern scholars.

154. My emphasis. Mosser (quoting Doyle and Parkes 1979, xlvi) lists the words and lines supplied by Hand F "all in blanks left by *A*" (2000). For comparison, Mosser adds a color facsimile of Hun-tington MS HM 111, fol. 16v, but laments the absence of Hoccleve's characteristic *w.* See the online facsimile: http://www.sdeditions .com/hengwrt/home.html. I would point out that Hoccleve abandons his characteristic *w* when writing formally; see below.

155. "Hanna suggests that Hengwrt was copied from '*in vita* drafts' (1989[a]) 74–5, thus raising the possibility that Hg could be even earlier than 1400" (Mosser 2000, n. 8). See also the important article Mosser 2008.

156. See Doyle and Parkes 1979, xxvi; Hanna conjectures that the single bifolium that constitutes Q [6] is indicative of the scribe's having failed to receive all of the copytext for Fragment I(A) at one time, and that the copytext for Qq [7–8] arrived later. Thus Q [6] represents a temporary "booklet boundary, later

Derek Pearsall, in discussing the confusing question of the ordering of the *Tales* in the large, jumbled manuscript tradition, suggests that we think of the fragments as movable packets of text (or sets of booklets), rather as one would have in a loose-leaf binder.[157] Hg does not include the "Merchant's Prologue" and the "Canon's Yeoman's Prologue" and "Tale." If Chaucer was alive at the time Hg is made, perhaps Chaucer himself had not written or assembled these items as yet, and even if he had, there is no clear evidence of Chaucer's direct involvement (though Partridge posits the descent from Chaucer of some of its information about links, as we will see).[158]

Some of the changes between Hg and El are very striking, such as the proximity of Chaucer's own tales ("Thopas" and "Melibee") in Hg to the "Parson's Tale" and to the somber end of the *Tales* itself. The awkward juggling of the "Man of Law's Tale," which ends up as its own fragment in El, is intriguing in relation to the removal of the infamous Epilogue to the "Man of Law's Tale" in which the Host "smelle[s] a Lollere in the wynd" (II.1173). Was it removed on Chaucer's watch or on the authority of a literary executor or a supervisory scribe? Recent consensus seems to lean toward Chaucer's having removed it himself prior to the making of Hg, both because there were reasons personal to Chaucer and his immediate circle in the 1390s that could account for such a change, and as Alastair Minnis has noted, perhaps because of the hard line Richard II himself took on Lollardy at court after returning from his trip to Ireland.[159] It is also about this time that Scribe D, who copied the Corpus 198 and Harley 7334 texts of Chaucer, along with the Ilchester *Piers Plowman*, begins to soften antimendicantism in his copies.[160] Scribe D is an important indicator of what the respectable reading public might think appropriate, since he worked for distinguished clients over the course of his career. Moreover, his collaboration on the Trinity Gower manuscript with Scribe B and the parallel evidence of how D handled missing links between the tales sheds further light on changes between Hg and El. The 1390s, moreover, seem to have produced new sensitivity to ecclesiastical controversy and a change of heart in Chaucer—and not just on Lollardy.

Scribe B's use of the past tense in a note at the end of the unfinished "Cook's Tale" has long intrigued scholars as a window on the whole compilation process, and if this is Adam Pinkhurst writing, the note takes on even more authority (see front plate 4). Doyle and Parkes had established that it is in the hand of Scribe B, appearing in what they designate as Structural section II (there are five) of the manuscript:

Structural section II [Fragment III] is written in a lighter shade of yellowish-brown ink, the same shade that appends the note *Of this Cokes tale | maked Chaucer na | moore* to fol. 57v, suggesting that the exemplar for Fragment III (D) was obtained separately and that the text was inserted between two other structural sections where it could most easily be accommodated.[161]

The note does not necessarily imply that Chaucer died (as some scholars assume). It simply says that Chaucer did not finish the tale—he may simply have decided not to. Fragment III contains the "Wife of Bath's Tale," the "Friar's Tale," and the "Summoner's Tale"—a fragment considered mature work by scholars. This suggests that both the note and III were part of a later campaign of work on the manuscript, perhaps material derived from another source (what Partridge calls a supplemental exemplar, perhaps descending from Chaucer's own notes).[162] Only in Structural section IV do quire signatures survive (and what they read, even under ultraviolet light, is disputed), so it is hard for us to reconstruct the intended order.[163] (Scribes normally gave their finished work back to the commissioning client as a set of booklets with quire signatures and catchwords still visible to guide the binder. In practice, these were often cropped during the binding process; quire signatures were especially vulnerable to both cropping and wear-and-tear destruction given their normal placement in the extreme bottom or top right tips of leaves.)

Why are these questions important? What makes them more than a codicologist's hobby? What we can show is that they offer us a reflection (or more likely a chance to "see through a glass, darkly") of some of Chaucer's own thinking, or remnants of it, about the puzzle of tale organization. They can also help assess why *Gamelyn* became a remarkably stable feature of *Tales* manuscripts. They can help us understand what "publication" meant in the 1390s, and why our notions from the print era are based on a book production concept foreign to manuscript culture.

2. The Mystery of *Gamelyn* and Scribal Attempts to Finish the *Canterbury Tales*

Neither Hg nor El contains one of the most consistent attempts to remedy the unfinished state of Chaucer's tales, that is, by the insertion of *Gamelyn*. The "Cook's Tale," which is unfinished perhaps because Chaucer intended it so dramatically, nonetheless troubled scribes; in this context Pinkhurst's note in Hg, "Of this Cokes tale | maked Chaucer na | moore" to folio 57v (front plate 4) looks quite authoritative. To provide a context for this comment

superseded. . . . But this momentary hesitation indicates that even continuous units of Chaucer's text were not always available in their continuous wholes to the scribe or to his director" (Hanna 1989a, 68–69). See also Partridge 2000.

157. Pearsall 1985, 51.
158. Partridge 2000.

159. Kerby-Fulton 2006, 351–57; Minnis 2009, 27.
160. Kerby-Fulton 2001.
161. Cited in Mosser 2000.
162. Partridge 2000, especially 63–75.
163. See Parkes 2008, 48–49.

we have to look at the treatment of this crux in a group of early *Tales* manuscripts.

Corpus 198 (Cp) and Harley 7334 (Ha4), were both copied by Scribe D—sometime, as dialect evidence suggests, relatively early in his career. Cp has often been dated 1410–20, but new evidence from the work of Estelle Stubbs and other scholars pushes it plausibly earlier and suggests its position, as Jacob Thaisen has shown, only one "layer" removed from Scribe B/Pinkhurst.[164] It looks as if B/Pinkhurst and Scribe D may have shared material aimed at solving the problem of the order of the tales, a problem all scribes of this first generation were wrestling with. The best example is the Cook-*Gamelyn* problem: in no less than twenty-five manuscripts (not counting a seventeenth-century transcription),[165] *Gamelyn* travels with the *Canterbury Tales*. As Edwards notes, "Indeed, *Gamelyn* owes its survival and its status as . . . the most popular surviving metrical romance, due to its incorporation into Chaucer's work."[166] *Gamelyn* is used to fill the gap that the unfinished "Cook's Tale" leaves. Cp's scribe finishes the "Cook's Tale" (fol. 61r) and on folio 61v we have (see front plate 5) "Incipit fabula [i.e., *Gamelyn*]" written in the margin.[167] In Ha4, Scribe D copies the "Cook's Tale," to quote Seymour's description:

> omitting 4375–6, 4415–22; ends imperfectly at 4414 which is added to last line at bottom of f. 58v, *Now let hym ryot al þe night or leue*, after which is another hand "Icy commencera le fable de *Gamelyn*". The rest of the quire, ff. 59–64, was originally let blank to await further copy, then filled with the first part of *Gamelyn*.[168]

This well-known note is likely in the hand of a supervisor (this was copied early in D's career).[169] *Gamelyn* is, in fact, very suggestive as a prospective replacement for or second try at the "Cook's Tale." The entire narrative, it is not often noticed, is launched from Gamelyn's moment of rebellion against his cruel older brother, "Thow shalt go bake thi self I will not be thi coke!" (line 920), making the choice a shrewd one to repair the rupture in Chaucer's *Tales*. Moreover, the tale treats an important social issue among the knightly class, especially where financial constraints prevailed: that of inheritance and primogeniture. It is also peppered with apparently deliberate verbal echoes of the "Miller's Tale" and the "Reeve's Tale" (the work, perhaps, of an imitator or coterie member of Chaucer's?). We do not know why the "Cook's Tale" stops where it does, but the possibility that it was being set up dramatically as something too offensive to be completed is possible, especially when we look at the manuscript evidence. Ha4's

ending at "Now let hym ryot . . . or leue" is suggestive, but even more suggestive is the handling of it in Lansdowne 851, another early manuscript "(c. 1400–25), written in an *Anglicana formata* with some chancery features" (that is, in just the kind of professional scribal circles Scribe B/Adam Pinkhurst traveled in), a manuscript closely affiliated textually with Corpus 198.[170] In Lansdowne (La), after the last known line of the "Cook's Tale" ("A schoppe and swyued [fornicated] for hir sustenance," 4422), there are four unique lines:

> Fye þer one it is so foule I will nowe tell no forþere
> For schame of þe harlotrie þat seweþ after
> A velany it were þare of more to spell
> Bot of a knyhte and his sonnes my tale I wil forþe tell.
> *(fol. 54v)*

La shares the same tale order as Cp,[171] and it is a beautifully produced manuscript, complete with an author portrait of Chaucer (see ch. 5, fig. 7). Though it is unlikely that Chaucer wrote these lines, and more likely that the hand with Chancery features that copied them did, they tell us what at least one intelligent scribe or redactor close to the London civil service world felt was appropriate in handling the unseemly and untidy "Cook's Tale" (which, after all, is the only one of Chaucer's tales set in London). Like the lines that another civil servant, Hoccleve, may have invented for Hg (if Scribe F is indeed Hoccleve), we see confident London scribal participation—on the part of scribes who knew the *Tales* well enough to imitate them. The rubrics of La indicate a very alert reader: most tales are called exactly what Chaucer's Parson implicitly and disapprovingly called them: "fabulae" (e.g., "Incipit fabula vxoris de Bathonia [The tale (or fiction) of the Wife of Bath begins]," fol. 97r), but there are subtle genre distinctions (e.g., the Parson's own tale is headed "Incipit sermo [The sermon begins]," fol. 230v, if not at 254v), and the Retractions are headed "Compositio [sic] huius libri hic capit licenciam suam" ("Here the [composer] of this book takes his leave [or license?]," fol. 255r). This is, to my knowledge, potentially one of the most sophisticated readings of the purpose of Chaucer's Retractions, medieval or modern. In medieval Latin the first and most ubiquitous meanings of "licentia" are (to quote the *Dictionary of Medieval Latin in English Sources*) "permission," "freedom," "leave," "licence," or "authority"; another possible meaning there is even "freedom in use of language, (poetic) licence." If so, the rubric above it implies that under cover of the Retractions, Chaucer grasped the opportunity to do pretty much what he pleased—or that some shrewd Chaucerian editor

164. See Thaisen 2008. But see also Partridge 2000.
165. Edwards 2005.
166. Ibid., 121.
167. Seymour 1997, 2:202.
168. Ibid.

169. Smith 1983 and 1988; Kerby-Fulton and Justice 2001; Partridge 2000.
170. Seymour 134.
171. *Riverside Chaucer* 1987, 1121; see Seymour 1997, 2:132, for the description of La.

thought he did. Another more classical meaning, however, in the same *Dictionary* is, as Nicole Eddy has suggested to me, "permission to depart" (meaning 4), and this may be what the rubricator has in mind, a possible echo of the rubric in the Ellesmere MS above the Retractions ("Heere taketh the makere of this book his leve"). But "leve" has the same double meaning in English, and compared to the rather tepid Ha4 heading, the "Preces de Chauceres [Prayers of Chaucer]," fol. 285v), the Lansdowne rubric appears, at the very least, rich and evocative—it seems hard to believe that the composer of the rubric was not playing with "licenciam." The scribe at least was certainly a member of documentary culture; in fact, what Seymour calls "chancery features" such as his were found in the offices like the Privy Seal very early (ch. 5, fig. 7): below, note the letter forms of **a**, **g** and the secretary **w**, plus the tendency to elaborate the ascenders of the top line.

Although the La lines following the "Cook's Tale" are unique, Cp and Ha4 are the earliest two extant manuscripts to contain *Gamelyn* (in Ha4 it is a later insertion),[172] and La is close in date to them both. We have seen how Hg handled this, and El handled it simply by writing the last lines of the "Cook's Tale" ("And hadde a wyf that heeld for contenance / A shoppe and swyued for hir sustenance"), leaving fols. 48r–v ruled but blank.[173] But Scribe D's supervisor or fellow scribe had a conscious awareness of what was coming. Moreover, Scribe D was an alert, intelligent scribe, but he was also not afraid to participate in the text of the *Tales* (or *Piers,* as we saw), altering and "improving" on Chaucer's lines at a local level, fixing meter, engaging in some small scale "conservatizing," and (whether he was the instigator or merely the messenger) producing a text with some "novel" features.[174] That he had worked with Scribe B/Adam Pinkhurst, and the fact that Ha4, Cp, and La share decorative design is an indicator of close-knit production circles in London c. 1400. Taken together with the fact that *Gamelyn*—with its many direct echoes of authentic *Tales* material—was likely composed by a member of a Chaucerian coterie or fan club,[175] this all points to its origin somewhere in these sophisticated circles.

Out of the jumble of tale orderings in Hg, Cp, and Ha4—some of them plausibly done during Chaucer's lifetime, if not soon after his death—we finally get the more settled-looking order in El, nicely captured on a single page added to El in a fifteenth-century hand (fig. 22). This very memorable table of contents, not originally part of the plan in Ellesmere, might even be given to today's undergraduates as a study sheet. It tells us much about how a medieval reader epitomized and remembered what each tale was about. It tells us, for instance, that the "Miller's Tale" was thought to be about a love triangle ("Of Alisoun *and* Absoloun *and* hende Nicholas")—and that Chaucer's insistent use of "hende" was as overt to medieval readers as it is to us. The "Reeve's Tale," however, suggests an answer to the Miller's by its title "Of the Myller of Trumpyngtoun." The London setting of the "Cook's Tale" is what is stressed ("Of the Prentys of Londoun"). The sophisticated tales of Fragment III are given suitably complex descriptive titles: the Wife of Bath's emphasizes and epitomizes her tale, more than her "Prologue" (which now fascinates modern readers more): "Of What thing þat women louen best." The key point of the "Friar's Tale's" for this medieval reader was the dysfunctional vow of brotherhood: "Of the Somonour *and* þe deuell his sworne broþer." Most hilariously, what stands out for this medieval reader is not all the Falstaffian con-artist humor of the friar in the "Summoner's Tale" but rather "Hough' a fart was departed in xii ⁊ among .xii. freres"—quite literally the *ars metric* of the tale. The title of the "Pardoner's Tale" goes straight to the eerie heart of the story: "Hough' iij Riotours founden deth."

We do not know who put this table of contents together, and much about El remains a mystery. But scholars have long believed that Thomas Hoccleve was involved in the initial shaping of both El and Hg. The later table of contents tells us he was not the only intelligent reader-critic involved in its making. It is to Hoccleve himself—poet, scribe, and creative imitator of all things Chaucerian—that we turn next.

172. Green 2009.

173. See the online Huntington Library Manuscript Catalogue, at http://dpg.lib.berkeley.edu/webdb/dsheh/heh_brf?Description=&CallNumber=EL+26+C+9

174. Seymour 1997 summarizes the "novel" textual features; see 127, 128, on shared decorative schemes.

175. For a parallel case, see the John But passus that "finishes" the A-text of *Piers Plowman,* discussed in Kerby-Fulton 2006.

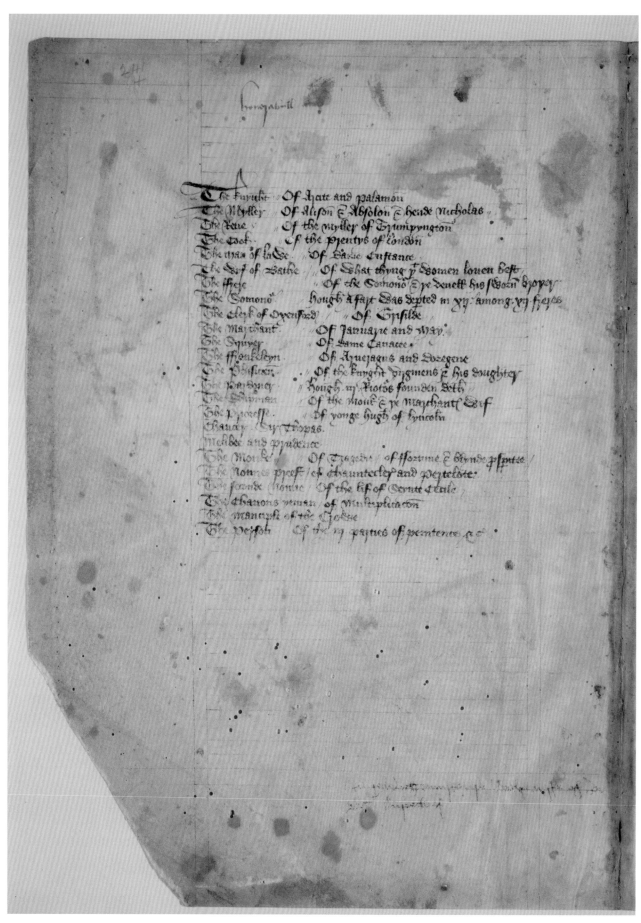

22. Passage from the Ellesmere *Canterbury Tales*, showing a table of contents added by a later fifteenth-century hand. San Marino, CA, Huntington Library, MS Ellesmere 26 C9, fol. vii verso.

VI. The Scribe Speaks at Last: Hoccleve as Scribe E

Doyle and Parkes's discovery that Scribe E of their Trinity College *Confessio Amantis* manuscript was Hoccleve opened an enormous number of windows on the history of book production. With Hoccleve, a member of the younger generation just behind Langland's and Chaucer's, we have not only a named scribe but a lifelong clerk of the Privy Seal office about whom we have many official records (some written in his own hand).[176] We also have a poet, an imitator of Chaucer to be sure, but also a very chatty, confessional poet, more than willing to talk about his job as a scribe, the camaraderie of the Privy Seal clerks, and the political issues of his day, including everything from coin-clipping to Wycliffite heresy. Partly as a result of very real cash-flow problems during the early years of the Lancastrian regime, Hoccleve was often short of money, and made the begging poem genre Chaucer had enshrined in "Complaint to His Purse" into a long-poem art form. Even Hoccleve's self-confessed period of depression and social recovery is matter for his poetry. As Derek Pearsall once wrote, "There is a colloquial ring about his dialogue, a sense of the speaking voice, which makes Hoccleve the only inheritor of Chaucer's well-bred low vernacular."[177]

In that "well-bred low vernacular," the figure of Hoccleve in the Prologue to his *Regiment of Princes* tells the Old Man advising him about the scantiness of his income and his inability to turn to plowing as an alternative, both because he lacks the knowledge and because his back has been ruined by stooping over a desk. This prompts a monologue on the woes of being a scribe, a subject with its own long literary tradition and literary conventions. This passage, with its blend of fact and fiction, makes a great point of entry into the subject of Hoccleve as a scribe and the literary study of his manuscripts. We will begin here, rather unconventionally, with Hoccleve's scribal portrait in the *Regiment*, and then in the next section move to an examination of Hoccleve's holograph manuscripts.

1. *The Regiment of Princes*: Hoccleve's Scribal Self-Portrait and its Roots

There is no extant holograph of the *Regiment*,[178] but BL Arundel 38 (a sample of which we will examine in more detail below in fig. 26) and its twin Harley 4866 are used as the base text and comparison text for modern editions, since it is apparent that Hoccleve directed their production in some way. As a result, all later copies (forty-three in total) tend to be ignored. One of Hoccleve's more recent editors, Charles Blyth, notes the possibility that some of the later copies may descend more directly from a copy in Hoccleve's own hand, and notes that his predecessor, M. C. Seymour, intended to record all the variants in his projected edition, but Blyth suggests that in the end such a "mass of trivial detail" is unimportant (16). One understands the common sense of this position, but Seymour's sixth sense that there were interesting things in the variants is vindicated in this small example we will examine below from the scene in the *Regiment*'s Prologue where Hoccleve talks about his scribal identity. This longish passage is remarkable in several ways, and especially if we compare the authoritative version of it from Arundel 38 (a lavish presentation manuscript likely orchestrated by Hoccleve) with a later manuscript, now held at the Newberry Library in Chicago (see fig. 23). The Newberry manuscript is in a lovely secretary hand, perhaps even dateable in the earlier range the catalogue suggests (s.xv med.), because it is a documentary hand.[179] In the passages underlined below (see table on p. 89), the Newberry manuscript departs significantly from the base text in Arundel 38.

What is intriguing about these variants, which are unrecorded so far as I know, is that the Newberry version produces more colorful readings. For example, as if to demonstrate his utter incompetence as a farmer, he would give his poultry to the kite (a bird of prey) to "bear" for him (me bere). This may be just a misreading of "byreve" in some earlier exemplar, but it is much more witty. More interesting still is Newberry's: "My bak vnbuxum' hathe swych swynk for sworne," fascinating in that both halves of the line alliterate, the second half (with Newberry's preservation of "swynk") much more strongly. It is unlikely that this scribe introduced the word. Notice that, when Hoccleve begins to discuss the plowman's vocation, he lapses sporadically into alliteration (e.g., "Scarsely kowde I charre away the kyte" [Arundel 38, line 978]). One wonders how much more alliteration may have been in Hoccleve's original? The passage is a lot like Langland's famous C.V "autobiographical" passage; indeed, the whole "vocational crisis" premise of the *Regiment*'s Prologue is rather Langlandian, being a theme especially developed

176. See Mooney 2007.

177. Cited in Blyth 1999, 13n8.

178. But see now Mooney 2011, printed after this book was typeset. Blyth also helpfully explains the importance of editing the *Regiment* in the light of Hoccleve's spelling system (as derived from the holographs of his other poems). Hoccleve was extremely careful to maintain the decasyllabic line. Blyth cites a study by

Judith Jefferson showing that in holographs, if one counts only lines that do not have a final –e, 98 percent of the time the lines have ten syllables. In all Middle English rhymed verse, final –e is problematic. For examples of the difference this makes, see ibid., 20–21.

179. See Saenger 1989, 61, for MS f33.7.

23. Passage from the
Prologue to Hoccleve's
Regiment of Princes.
Chicago, IL, Newberry
Library, MS f33.7, fol. 15r.

23. Passage from the Prologue to Hoccleve's *Regiment of Princes*. Chicago, IL, Newberry Library, MS f33.7, fol. 15r.

in C and even more in the unique Z-text. The Newberry manuscript, too, is written by someone with experience of documentary writing: note the elaborated ascender on the **h**, first letter of the first word of the page (fig. 23); as we saw in the case of the Harley 2253 scribe's work, documents often had no other form of decoration, so this is the trademark of a legal scribe. Note too the further strapwork style of upper case **C** (opening line 3 of second stanza) and **A** (in the opening line of the last stanza). These styles are repeated elsewhere in the book, often with more gusto.

Alliteration plays a role throughout Hoccleve's description of scribal life, which goes on for four more stanzas in the Prologue beyond what I have quoted above. So, for example, unlike "thise artificiers" (workmen) who talk and sing while they work, "we laboure," Hoccleve writes,

> in travaillous stilnesse
> We *s*towpe and *s*tare upon the *s*heepes *s*kyn,
> And keepe moot our song and wordes yn.
>
> *(1014–15; my emphasis)*

MS NEWBERRY F33.7, FOL. 15, HOCCLEVE'S *REGIMENT OF PRINCES*	NEWBERRY GLOSSES	ARUNDEL 38 (BASE TEXT)[1] (ONLY PASSAGES WITH SIGNIFICANT VARIANTS ARE SHOWN HERE)
Vj marke yerrely and no more þan þat		
Fadir to me / me þink it is to lyte		
Considering' how y am nat		
In hosbandrye lerned / worthe a myte		
Skarsly Coude y / char away þe kyte		Scarsely kowde I charre away the kyte
Þat me bere wolde my pullaile		That me byreve wolde my pullaille
And more axith husbondly gouernaile		*(978–79)*
With plow can y noght medle ne wᵗith [*sic*] harrow		
Ne wote noght what londe gode is for corne		
And forto laude a Cart or fille a barrow		And for to lade a cart or fille a barwe,
To wiche y neuer vsid whas to forne		To which I nevere usid was toforn;
My bak vnbuxum' hathe swych swynk for sworne		My bak unbuxum hath swich thing
At instaunce of writyng his werreiour		forsworn *(983–85)*
Þat stowpyng hath hym spilt with his labour		
Many men fadir / ween / þat writynge	Ars non *habet* inimic[u]*m* /	
No trauaile is / þei hold it / but a game	nisi ignorante*m* _____/	
Art hath no foo bot swich folk vnkonnyng		
But who so list disport hym in þat same		
Late hym cont[i]nue / and he shal fynde it grame	Cecus non iudicat'	
It is wel gretter labour þan it seemeth	de colorib*us* ___/	
Þe blynde man of Colours all' wronge demeth		

1. Quoted here from Blyth 1999, ll. 974–94, who records no variants or emendations from Arundel for these lines nor for the other two discussed below.

Unlike Chaucer, Hoccleve tends to use alliteration for effect—he was both a perfectionist in decasyllabic poetry as well as someone, I would suggest, with a native ear for alliterative style. This is not the place to explore the many parallels—and given the intimacy of London reading circles for English, likely the echoes—of Langland's style or alliterative poetry generally, but they appear in Hoccleve's fascination with "embryonic" allegories,[180] his boldness in articulating the plight of the unbeneficed but deserving cleric in a corrupt church, and his unembarrassed airing of his personal crisis of vocation. Those chosen for benefices do not care ("rekketh not") "though that hys chauncell roofe be al totorne, / And on the hye auter hyt reyne or snewe" (1422; compare *Piers Plowman* C.V.164). He tells the old man "Y gasyd longe fyrst and wayted fast aftyr sume benefyce" (1450), but having taken a wife, now subsists on the edge of church culture as a clerk but not a cleric (paralleled in the "autobiographical" passage in *Piers* C.V). Given this account, it is not surprising that about one third

of the Latin glosses in the *Regiment* come from the Vulgate, and many more from a commentary like Nicholas of Lyra's, or from *florilegia* (compilations of extracts) containing quotations from Boethius and other authorities. A large number also come from canon law (Gratian's *Decretum*), which would make sense for a "civil cleric"

180. Salter and Pearsall 1967, 10–12, especially on types of Langland's allegory. Blyth cites examples such as "riot" and "fauel" (1999, 202); Spearing commented on this "un-Chaucerian habit of Hoccleve's as the persistent use of small-scale personification. This is one of the hallmarks of his style throughout his work, and may conceivably indicate the influence of *Piers Plowman*, a poem that was certainly widely read in the London area in the early fifteenth century" (1985, 119), which Blyth cites with this remark: "However, Hoccleve's personifications are usually lightly suggested and never developed into Langlandian dramatic scenes. For that reason in this edition, except when personification is attached to a more or less consistently represented 'person,' such as Fortune or Flattery, I have chosen not to capitalize" (1999, 202n7).

24. Three levels of formality in Hoccleve's hand. San Marino, CA, Huntington Library MS HM 744, fols. 52v–53r.

of Hoccleve's background.[181] As Blyth rightly notes, these glosses are common to the majority of the manuscripts of the *Regiment* and are doubtless authorial, but, unlike the glosses accompanying early Chaucer manuscripts that we explore in more detail in chapter 4, they usually do not offer a complex reading of the *Regiment*. They are, however, part of the medieval reading experience and so are included here.

2. Hoccleve's Holographs and Scribal Work

We know and have access to a great deal of Hoccleve's handwriting, ranging from Privy Seal documents to his holograph poetry manuscripts. The Hoccleve holographs have been extensively studied by Burrow and Doyle, who compiled a facsimile of all three manuscripts;[182] more-

over, color images from the Huntington ones are now available on their website, as is the detailed manuscript description of the Durham copy. These materials make clear a great many things that I will only summarize here. For instance, Hoccleve had minute concern for the reading process, "us[ing] paraphs to mark change of speakers and other kinds of emphases in the text."[183] In fig. 24 of HM 744 one can see his use of capitulum marks to note changes in speakers (e.g., on fol. 53r) and a system of playful brackets marking stanzas in the poems on folio 52v. Here we can also see all three of Hoccleve's hands, as first described by Schulz[184] decades ago: his most cursive one for the catchword, his regular literary script for the poetry, and his most formal hand for the Latin heading to his *Lerne to Dye* ("Hic incipit ars vtilissima sciendi mori") which ends the *Series* poems. Note, too, the transitional

181. Blyth expresses surprise about this, but given the autobiography of at least the *character* of Hoccleve in the *Regiment*, there is no cause for surprise (ibid., 12).

182. Burrow and Doyle 2002.

183. A. I. Doyle, Durham University Library, unpublished catalogue of the manuscripts, 2006 description, consulted in the library. See also Langdell, forthcoming.

184. Schulz 1937.

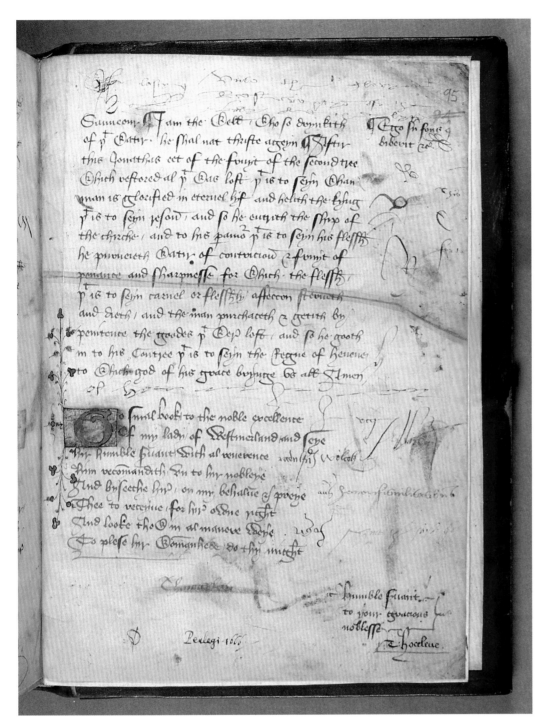

25. "Go smal book" envoy to "my lady of Westmerland" signed by "T. hoccleue" (signature has been touched up but is original). Durham, Durham University Library, MS Cosin V.iii.9, fol. 95r.

heading in English he writes between items (bottom of folio 52v), very like those chatty headings famously associated with John Shirley:[185]

> After our song our mirthe & our gladnesse
> Heer folwith a lessoun of heuynesse

The latter line appears to be written in part over erasure, suggesting a change in plans. The catchword ("Syn alle *etcetera*") correctly connects to the first words of *Lerne to Dye* ("Syn alle men") but not to the rubric in Latin, implying that the rubric was an afterthought, as does the fact that it is written above the writing space.

In the Durham manuscript, which is actually an autograph, Doyle notes the presence of prick marks in the inner halves of the top margin of fols. 15–20: "as if those sheets had originally been designed for short or wide warrants, oriented at 90 degrees from the present page, of the form customary in the Privy Seal office."[186] This explains how Hoccleve scraped together the parchment

185. Veeman 2010.

186. Doyle, Durham University Library, unpublished catalogue notes.

for the Durham manuscript (Durham University Library, Cosin V.iii.9), fig. 25, which was prepared with gold and blue alternating initials and a large gold initial on the page with the dedication to "my lady" of Westmoreland (who just happened to be Chaucer's niece), beginning "**G**o smal book' to the noble excellence," written in Hoccleve's most formal hand followed by his signature.[187] We know from Linne Mooney's work among the legal documents written in Hoccleve's own hand that he was in charge of buying parchment for his office,[188] and no doubt some of it "fell off the back of the truck" and found its way into his autographs. As these documents show, however, his contribution to the work of the office was massive, not to mention his composition of a large formulary. The latter, a set of sample documents for scribes of the Privy Seal to work from, includes, as John Burrow observes, a great many in the petition genre, which makes it all the more natural that Hoccleve would refract that genre through his poetry in a way unprecedented even in the work of his mentor Chaucer. Burrow and others have uncovered an intricate network of Hoccleve's associations with the influential people of his time, many of which we see mentioned in the poetry of the holographs.[189]

There is a long literature, especially in Latin, of scribal complaints, and what Hoccleve is signaling in the *Regiment* Prologue is that he knows this tradition and is ready to anglicize it.[190] Even though we have as yet no certain evidence for a bookshop specializing in English materials,[191] English book production had come of age in Hoccleve's London. Reading circles must have been still fairly small, but Hoccleve was, as we know, an associate of at least two scribes (Scribe B and Scribe D) whose prolific output of English manuscripts suggests a fast growing niche market.

Doyle and Parkes's study of Hoccleve's short stint as Scribe E on the Trinity Gower tipped scholars off to the fact that Hoccleve was moonlighting—that is, in Parkes's definition, he was a professional scribe, one that had a day job in the administrative writing offices of the metropolitan area.[192] Although there is substantial historical evidence to back up what Hoccleve tells us about his life, including his illness (the dates of which can be tracked in the payment records), there is no reason to take too literally all that Hoccleve writes by way of self-deprecation.

That goes with the literary territory for the narrator of any begging poem. In fact, the records show that Hoccleve was a highly trusted clerk, copying some of the most sensitive documents that came through the Privy Seal during Henry IV's bumpy reign. These include even Henry's payment to Chaucer, the one so wittily requested, we assume, in *Complaint to His Purse*. As Mooney shows, it is clear from the fact that the document is in Hoccleve's own hand, and the fact that he made special efforts to see that it was acted on in timely fashion, that the younger poet's claims to be acquainted with Chaucer have substance.[193] We have already seen that the reading circles for English in the city were intimate, and that there is evidence of Hoccleve's hand at work in Hengwrt. Maidie Hilmo (ch. 5, fig. 1) discusses the famous portrait of Chaucer Hoccleve commissioned for the *Regiment* and its relationship with Ellesmere, a manuscript that Hoccleve may have also had a hand in, though this is less certain.

Two manuscripts contain (or contained) that portrait: Harley 4866 and a second, nearly identical to it, Arundel 38, from which the Chaucer portrait was cut out sometime between its creation and the present time. Arundel 38, however, does contain a stunning presentation portrait (paradoxically cut out from its twin Harley 4866; see cover image),[194] showing Hoccleve (apparently)[195] kneeling before the young Prince Henry (later Henry V), presenting to him the *Regiment of Princes*. Although there is doubtless some idealization involved in both author portraits, the evident realism of the Chaucer portrait, and the youthfulness of Henry are convincing. If this is indeed a portrait of Hoccleve, it is, as Burrow notes, the only author portrait of him extant. The *Regiment* was written in 1411–12, about two years before Henry came to the throne. The two manuscripts, although written by two different scribes with distinctive spelling systems, are virtually identical otherwise in page format: "when one manuscript departs from the norm of four complete stanzas per page, so does the other one."[196] One comical instance of such a departure appears in Arundel 38 (see fig. 26). The scribe of Arundel 38 apparently missed a stanza in copying, which is placed in the margin, the part normally reserved for Latin glosses (one, beginning "Salamon vbi" can be seen just above the misplaced stanza). A little man dressed in the short tunic

187. Joan Neville, Countess of Westmorland (d. 1440), was Chaucer's niece and aunt to Henry V. For these connections and more, see Burrow 1994, 28.

188. Mooney 2007; see, e.g., 324–25, for records of his purchases of office supplies.

189. See Burrow 1994, 22–28.

190. Drogin 1983, 17–35.

191. As mentioned earlier, Mooney and Stubbs have suggested the Guildhall as an informal clearing house for such material, but their evidence is as yet unpublished.

192. Parkes 2008, 47ff.

193. Mooney 2007, 312.

194. The image that survives from Arundel 38 is of Hoccleve presenting his book to Prince Henry, the future Henry V (fol. 37r). Its companion manuscript, Harley 4866, has the famous Chaucer portrait on fol. 88r. See below for an alternative reading of the presentation portrait.

195. Scott notes that it might be John Mowbray, the nobleman whose arms are contained in this copy (in 1423 Mowbray paid Hoccleve to write some documents for him; see Burrow 1994, 17 and 19, where Burrow discusses the Arundel 38 portrait). This, however, would be a departure from the conventions of presentation portraits (Scott 1996, 1:28–30, plates 201–2), visible on our cover.

196. Blyth 1999, 15.

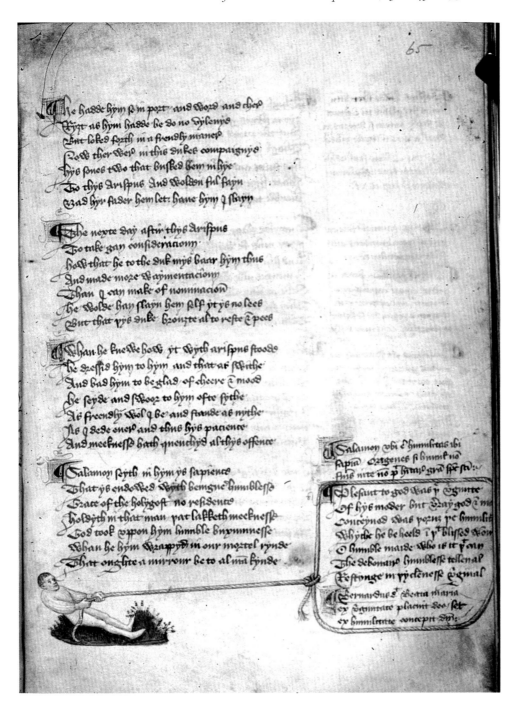

26. An inventive artistic remedy for a missing stanza. London, British Library, MS Arundel 38, fol. 65r.

of an active man (but not a laboring man, who would not have been shown in these bright colors or in such tight-fitting apparel), is seen pulling the stanza in with a rope. He is realistically braced against a little mound or tuft of greenery and the tension, in his body, in the rope, even in the knot, is highly realized. We do not know whether this was done by the artist, the border artist (if they were different people), or even by the scribe himself (the latter is not impossible, and the outline color of the man's face is not unlike the ink of the word "That" closest to it).[197] The

strange thing is that it was repeated in MS Harley 4866,[198] picture and all, by a different artist (in Harley the perspective is less accomplished, and facial features are different, but the clothing is most certainly that of a fashionable man). Apparently the visual joke was too good to pass up a second time, and scribes were creatures of habit: an exemplar is easier to copy if the stanzas appear in exactly the same place each time. The correction system in Arundel is superior to the one in Harley, but both were likely made under Hoccleve's watchful eye. On the basis of the

197. I thank Maidie Hilmo for her advice on this. According to Scott, the artist who painted the borders of Arundel 38 was "one of the illuminators of the Bedford Hours and Psalter" (1996, 1:29).

198. Visible online at the British Library Catalogue of Medieval and Renaissance Illuminated Manuscripts (choose Harley 4866, fol. 62r).

hashed-up gloss placement in Arundel (where the accompanying gloss from St. Bernard, too, has been forgotten and is stuck inside the lasso with the stanza), one might assume that Arundel came first and actually was the presentation copy. The lassoed stanza is itself interesting: it is about the virginity of Mary (as is the Bernard gloss), and is perhaps fittingly enclosed—a great mnemonic device. Another reason for thinking Arundel superior is that it is this scribe's hand that appears alongside Hoccleve's own in the Hengwrt *Tales* (see previous section). This, then, is someone Hoccleve actually worked with. Seymour and Blyth quite rightly both chose this manuscript as the basis for their editions.

Hoccleve produced a number of copies for patrons and dedicatees, and, as Blyth comments, these copies can sometimes preserve earlier readings than copies of texts in Hoccleve's own hand. That said, Hoccleve, being himself a scribe, had an unerring sense of how to exert authorial control and prepare work for posterity, a sense which Chaucer, Langland and the *Gawain* poet (at least so far as we can tell) did not have.

The Durham holograph (fig. 25) was likely intended for a patron, in this case, a patroness, the Countess of Westmorland (though a dedication does not necessarily imply patronage of any sort). Looking at the manuscript today, now badly scarred up with later marginalia, some of it apparently by schoolboys, it is hard to imagine that this was once destined for a countess. But if one mentally erases the marginalia, certain fascinating elements appear. Hoccleve, of course, wrote at least three different scripts as a professional scribe. Commercial scribes of Latin texts (one could likely not make a living doing solely English copying at this stage—probably not even if one were Scribe D) did writing samples showing their hierarchy of different scripts, sometimes even posting them for prospective customers.[199] Hoccleve had a very cursive hand, a medium grade hand and a top grade. The top grade we have just seen in the final stanza or envoy, "**G**o smal book' to the noble excellence | Of my lady of Westmerland" (fig. 25). What is curious is that by the seventh line of this stanza, he seems to have forgotten that he is doing his most elegant script: his characteristic round cursive *w* slips back in at that point (in "thow," corrected to his elegant secretary *w* in "weye" at the end of the line, and missing in action

again in the last line in "wom*m*anhede"). His *cursiva media* appears in the lines above the envoy, with far fewer pen lifts. His higher grade appears in his rubrics (or headings), usually in French, in his holographs generally. In Huntington Library HM 744, fols. 52v–53r (fig. 24) again all three grades can be seen, the most elegant in the heading, the least elegant in the marginal Latin note (this is Hoccleve's documentary hand: no pen lifts, no serifs, lots of abbreviation). Latin, interestingly, did not in and of itself call forth better treatment from Hoccleve (unlike, say, the Latin quotations in many traditional *Piers* manuscripts). Nor did it on the whole for Scribe D, a scribe Hoccleve very likely knew as well (we know they both worked on the Trinity Gower). For Hoccleve it was all about function, not language.

Hoccleve is a codicologist's poet. His poems and envoys are riddled with addresses to the book (or "pamfilet") itself: "Thow foul book " (HM 111, 33v); "Go smal book" (fig. 25); "Go little pamfilet"(HM 111, fol. 32v).[200] Hoccleve was also in touch with border artists and limners, some of the most elegant in the metropolitan area, as the Chaucer portrait suggests, often from the Low Countries (like the famous Herman Scheere), where techniques for portraiture were ahead of Insular styles. Scribe D also worked with these artists, as we saw, in his copies of Gower.[201] It is not surprising then that the Scribe B, Scribe D, and Scribe E associations that Doyle and Parkes and others have painstakingly uncovered over the last few decades should seem to get more intimate rather than less—from the Type III London English they shared to the crossover in limner stints to the appearance of the hands of B/Pinkhurst and Hoccleve together in Hengwrt or the evidence that Scribe D apparently puzzled along with Adam over the missing pieces of the *Canterbury Tales*. In Hoccleve, we have at last an autobiographical voice emerging from the clerkly but rapidly secularizing world of the scribe of Middle English: still trilingual, still hoping for benefices, still unable to survive wholly by English copying, but eager to do it.

199. Parkes 2008, 41.

200. See Mooney 2007, 308. One such pamphlet is preserved in the Newberry Library in Chicago.

201. Kerby-Fulton and Justice 2001.

CHAPTER TWO

Romancing the Book:
Manuscripts for "Euerich Inglische"

LINDA OLSON

THERE COULD HARDLY BE more knightly romances than the tales of Arthur, that "moost renomed Crysten kyng," completed by Sir Thomas Malory in 1469/70.[1] Little wonder that William Caxton, printing Malory's version of the Arthurian legend in 1485, suggested he was urged to the task by none other than King Edward IV (1, lines 23–31). "Noble prynces, lordes and ladyes" (3, lines 12–13) hardly constituted the whole of Caxton's anticipated audience, however; he had far too keen a business sense for that. He imagined "al other estates of what estate or degree they been" (2, line 40) with his new book in their hands as well and outlined for them just what might be found there:

> noble chyualrye, curtosye, humanyte, frendlynesse, hardynesse, loue, frendshyp, cowardyse, murdre, hate, vertue, and synne. Doo after the good and leue the euyl, and it shal brynge you to good fame and renommee.
>
> *(3, lines 2–4)*

Of course to make that a convincing argument, he may have had to suppress the fact that Malory had himself found notoriety instead of "good fame"—certainly Caxton's edition does not include the authorial confession found in the only surviving manuscript of the text (the Winchester Malory, London, British Library, MS Add. 59678) that the

book "was | drawyn by a knyght' presoner, Sir **Thomas Malleorre**" (fol. 70v, lines 26–27; fig. 1). By suppressing this vital information, along with other instances of Malory's name found at intervals in the Winchester MS (fols. 346v, 409r, and 449r), Caxton hid from posterity clues not only about the infamous author of *Le Morte d'Arthur* but about the way in which he gradually composed and structured his long romance.[2] Such clues are of enormous value to literary and manuscript scholars today, but Caxton's focus then was to sell books—good books—and in advertising the "renommee" a tale like Malory's could promote, he seems to have understood the readerly desires of "al" medieval "estates" very well indeed.

There are more than one hundred surviving manuscripts containing Middle English romances, most of which have not yet been associated with any specific medieval home.[3] A few have been linked to minor gentry and mercantile owners, while several others suggest by their quality— neither the most luxurious nor the least—as well as their widely varied contents that they, too, would have been particularly appropriate to such middling-class households. These books correspond neatly with a widespread assumption among scholars of Middle English that native romances were not the reading material of the highest courtly audiences. Lesser and provincial gentry, lower knightly families and rising professionals, the successful

1. Caxton's 1485 preface, line 6 in Spisak 1983, 1, from which the following quotations are also drawn.

2. See Eddy 2011 for a discussion of how the Winchester MS's marginal notes highlight military and chivalric concerns shared

by Malory. If they are Malory's own work, then they, too, provide insight into his understanding of his Arthurian project.

3. See the descriptive list in Guddat-Figge 1976.

1. The end of the first major section of Thomas Malory's *Morte d'Arthur*, featuring the hand of Scribe B and the name of the author, "Sir **Thomas Malleorre**". London, British Library, MS Add. 59678, fol. 70v.

and cultivated urban bourgeoisie—these are the groups mentioned most often when it comes to assigning patrons and owners to romance manuscripts. Yet there are obvious exceptions. The two most sumptuous of English romance manuscripts (Vernon and Simeon: Oxford, Bodleian Library, MS Eng. Poet. a. 1 and London, British Library, MS Add. 22283) could not have been produced on anything less than the most lavish of aristocratic budgets, and both of those books dash our expectations yet again with strong suggestions of production and use not by lay folk in a secular context but by religious communities (see chs. 3, sec. III and 6, sec. I). London, Lincoln's Inn, MS 150,

on the other hand, is a well-used holster book (a narrow format suited to both portability and affordability) containing four romances along with William Langland's *Piers Plowman* that have been specially edited for dramatic reading aloud, most likely in great halls and households, perhaps by some variety of professional minstrel.[4] And in the hands or hall of exactly what sort of readers might we appropriately place the stunning poetic and illustrative sophistication of *Sir Gawain and the Green Knight* found in the surprisingly workaday, even archaic London, British Library, MS Cotton Nero A X, Art. 3.[5]

Medieval manuscripts repeatedly warn us not to generalize—about texts and contexts, readers and their understanding, literary sophistication and taste (or the lack thereof)—and it is wise in the present state of our knowledge to recognize that we simply cannot be sure about who all the readers of Middle English romances might have been, or about their intellectual, economic, and social situations. Royalty and aristocracy may have preferred French in their halls and chambers, while religious folk bowed over Latin texts in their cloisters, but as the prologue for *Of Arthur and of Merlin* in the Auchinleck MS (Edinburgh, National Library of Scotland, MS Advocates 19.2.1) informs us, "euerich Inglische Inglische can,"[6] and for nearly every medieval English person there must have been a native romance that appealed. The genre was, after all, very broad indeed. Under the rubric "romance" in medieval manuscripts the reader can find epic, historical, and martial stories, the last also called chivalric, a term that can refer to courtly romances as well, and those in turn to love-interest tales, while all of these more secular categories can also overlap with what are called moral, homiletic, or didactic romances, where ethical and religious imperatives hold sway, or with narratives that read more like hagiography, their heroes better visionaries than warriors. Particularly popular among late medieval English readers, however, were tales of true social mobility—of the steward's son, to take one example, earning his marriage to the earl's, or better yet, the king's daughter. No doubt the dynamic, often fantastic action plots of such romances rendered them highly entertaining for a wide variety of medieval audiences, but it would seem their appeal was also related to very real aspirations of social, intellectual, chivalric, national, and religious dimensions.

To a degree modern readers might find surprising, the religious element of medieval romances extends across all the subcategories of the genre. The main heroes of Eng-

4. On holster books and their possible uses, see Guddat-Figge 1976, 30–36; Taylor 1991, 55–60; and Horobin and Wiggins 2008, who offer an analysis of Lincoln's Inn MS 150 and the unique qualities of its texts. For an example of a holster book, see figs. 7a and b.

5. See ch. 1, sec. III, and ch. 3, sec. IV. Recent but as-of-yet unpublished work by Ralph Hanna and Joel Fredell suggests that the manuscript may have originated in Yorkshire.

6. Quoting from fol. 201rb, line 24; see fig. 2. Burnley and Wiggins 2003 has been used for all line references to Auchinleck texts.

lish romances are or very soon become Christians, with those characters retaining other religious beliefs and affiliations best slaughtered. For the most part the tone of these romances is serious, often in keeping with this Christian ethos, which is not to say they lack humor—there are many instances to the contrary, both of light jest and grim cynicism—but they were probably not intended primarily or exclusively as fantasy or escapist literature as some would have it of romances today. Perhaps for some early readers romances would have filled such a purely entertaining role, and their appeal is undeniable, but the manuscript contexts of the majority of our Middle English texts suggest that medieval audiences frequently associated romances with religious and historical items, often of an overtly pious, political, or educational sort.[7] Most English romances are found in large collections, and in many of these books devotional and doctrinal items far outweigh the romances, some of which, like those included in the Vernon and Simeon MSS, are themselves highly religious in tone and content-suitable companions, that is, for the pious texts that accompany them. Works of both piety and history (or pseudohistory) appear in the Auchinleck MS, which boasts the largest number of English romances found in any extant manuscript (see "Middle English Romances in the Auchinleck, Thornton, and Findern Manuscripts" below), yet also contains eighteen distinctly pious and educational works, with the majority of these coming before its more secular contents and lending the entire volume a moral slant akin to that Christian ethos.[8] In Auchinleck we find, too, a much expanded English version of the *Short Metrical Chronicle* (here called the *Liber Regum Anglie* or *Book of the Kings of England*) that creates "a chronological grid" for situating in history a number of the heroes whose romances also appear in the volume, like King Arthur, Horn Childe, and Guy of Warwick—heroes of remote, if any, historical validity.[9] In the case of the historical Richard I, whose crusading adventures are related in Auchinleck through the popular *King Richard Coer de Lion* romance, the *Chronicle* actually borrows directly from the romance (both through quotation and paraphrase) to provide a lengthy "historical" account of King Richard's taking of Acre not found in other versions of the chronicle.[10]

There was for medieval audiences, then, a certain lack of distinction between what we generally consider separate literary categories, like romance and history, for instance, or more fancifully, fiction and fact. It seems inaccurate, however, to attribute this to naïveté among the early readers and writers of English romance. Instead, the authors of Middle English romances could well have made historical situations and claims an essential if elusive part of their fictional narratives in an attempt to express a new and nationally pertinent conception of the romance mode, one that reproduced encounters with not only authority and warfare but geography and a wide range of social relationships familiar to many English readers from contemporary experience.[11] The Middle English romance could be, then, a vehicle for serious social and political reflection and comment—for analyzing complex issues like kingship, loyalty, love, law, and just rule (at every level of society) that were immediately relevant to English readers of "al . . . estates." So when a text like the Auchinleck *Chronicle* seems to throw caution to the wind by adding to a brief mention of King Arthur the report of how Sir Lancelot held Queen Guenevere in Nottingham Castle (instead of Joyeuse Garde as in the French *Mort Artu*), we would be well-advised before disparaging the medieval editor's historical or literary understanding to ponder what he may be suggesting about Queen Isabella (whose husband Edward II had been deposed with her help) and her lover Roger Mortimer, who did in fact barricade themselves into Nottingham Castle in 1330, precisely when we believe the Auchinleck manuscript was in production.[12]

There can be little doubt that there were medieval audiences who would have recognized the allusion at once and would have known, too, how to read conventional romance adventures like the battles of disguised knights, the slaughter of giants, the theft of magnificent harts, and the conquests of the deadliest Roman or English dragons as symbols of similar contemporary issues. But whether they successfully recognized and exploited all such symbols or not, they could certainly have hoped along with the chivalric heroes Eglamour and Amadas that they might one day be able to wipe away the stigma of too "lytyll lond" and end up "wele more riall [royal]" by succeeding at "dedes

7. Of course, as Nicole Eddy has pointed out (personal communication, July 2010), this doesn't necessarily mean that the romances were considered equally serious works. Her doctoral work on "Marginal Annotation in Medieval Romance Manuscripts" suggests that medieval annotators tended to treat romances "differently from the nonromance texts in the same volume," often marking them less as though they were "less valuable as a didactic tool" or viewed as "breaks." Annotators may also have considered explanatory glosses less necessary for romances, which, as Eddy suggests, would capture the interest of young readers, drawing them also to the pious, historical, and moral pieces accompanying them.

8. Mordkoff 1980, 10–11, provides a list and brief description of Auchinleck's pious and educational works.

9. See Turville-Petre 1996, 108–9.

10. Turville-Petre 1996, 130–31. Richard's conquest of Acre is also the episode the Auchinleck illustrator chooses for a miniature at the head of *Coer de Lion* (fol. 326ra: see ch. 3, sec. II and fig. 5 there).

11. See Field 1999.

12. See Turville-Petre 1996, 111.

~ Middle English Romances in the Auchinleck, Thornton, and Findern Manuscripts

Auchinleck MS (Edinburgh, National Library of Scotland, MS Advocates 19.2.1)

London, between c. 1327 and 1340
17 romances among a total of 44 items:

King of Tars, fols. 7ra–13vb
Amis and Amiloun, fols. 48vb–61Ara
Sir Degare, fols. 78rb–84Ara
Floris and Blauncheflur, fols. 100ra–104vb
Guy of Warwick, fols. 108ra–146vb
Guy of Warwick Continuation, fols. 146vb–167rb (unique)
Reinbrun, Guy's Son of Warwick, fols. 167rb–175vb (unique)
Sir Beves of Hampton, fols. 176ra–201ra

Of Arthur and of Merlin, fols. 201rb–256vb
Lai le Freine, fols. 261ra–262Ara (unique)
Roland and Vernagu, fols. 262Avb–267vb (unique)
Otuel a Knight, fols. 268ra–277vb (unique)
King Alisaunder, fols. 278ra–279rb
Sir Tristrem, fols. 281ra–299vb (unique)
Sir Orfeo, fols. 300ra–303ra
Horn Child, fols. 317va–323vb (unique)
King Richard Coer de Lion, fols. 326ra–327vb

Thornton Lincoln MS (Lincoln, Cathedral Library, MS 91)

North Yorkshire, between the 1420s and 1460s
9 romances among a total of 80 items:

Prose Life of Alexander, fols. 1r–49r (unique)
Alliterative Morte Arthure, fols. 53r–98v (unique)
Octavian, fols. 98va–109rb
Sir Ysumbras, fols. 109rb–114va

Earl of Tolous (called *Dyoclicyane*), fols. 114vb–122vb
Sir Degrevant, fols. 130ra–138rb
Sir Eglamour of Artois, fols. 138va–147rb
Awntyrs of Arthur, fols. 154r–161r
Sir Perceval of Gales, fols. 161ra–176ra (unique)

Thornton London MS (London, British Library, MS Add. 31042)

North Yorkshire, between the 1420s and 1460s
4 romances among a total of 31 items:

Siege of Jerusalem, fols. 50r–66r
Siege of Milan, fols. 66v–79v (unique)

Duke Roland and Sir Otuel, fols. 82r–94r (unique)
King Richard Coer de Lion, fols. 125ra–163va

Findern MS (Cambridge, University Library, MS Ff.1.6)

Derbyshire, between c. 1446 and 1550
2 romances among a total of 64 items:

Sir Degrevant, fols. 96ra–109vb
Alexander Cassamus, fols. 166r–177v (unique fragment)

of armes" (or perhaps deeds of a less martial nature) set by an earl with a daughter both beautiful and available.[13] Though then, as now, the highest nobility can hardly be excluded from the drive to acquire more, the appeal may well have been particularly acute for those not of royal or aristocratic blood, since such men could not expect the hands of noble daughters by right. In a world John Paston II described to his mother as "ryght qwesye,"[14] members of the lower knighthood, minor gentry, and urban middle classes—the very groups most often discussed as the readers of English romance—would have worked a good deal harder to win a bride even remotely noble and might very well have identified very closely with the hardworking Eglamour, the ambitious Amadas, the humble cupbearer Guy of Warwick, and a host of other hopeful heroes.

For earnestly aspiring readers not of the highest classes there must have been an additional gratification provided by romances—the privilege of reading and owning books. It is essential to remember that books were extremely costly and elitist commodities throughout most of the medieval period. For centuries manuscripts in England had been written predominantly in Latin and to a lesser degree in Anglo-Norman; they were virtually the sole preserve of the wealthiest, most learned, and most overtly pious members of society. An air of authority and respectability, both courtly and spiritual, still wafted from their folios in the fourteenth and fifteenth centuries, though it bore at times the scent of paper instead of costlier parchment or vellum, and the whispers of native English. To the rising middle classes blessed at last with disposable income and perhaps even a little time on their hands, books as luxury items of conspicuous consumption must have had a powerful appeal, even though those books might have cost a fraction of the price paid by royal and aristocratic patrons for the most deluxe of late medieval manuscripts. The way in which these prestigious domestic possessions could also be used to provide examples of what seemed the courtly lifestyle, the *lettrure* and *noriture* of the highest strata of society, must only have increased the romance with the book experienced by those who wished more for themselves and their families, whether they had the desire and ability to be chivalric and heroic or not.

This chapter focuses in detail on three such romances with the book. The first is represented by the Auchinleck MS, a weighty fourteenth-century collection of seventeen English romances (see "Middle English Romances in the Auchinleck, Thornton, and Findern Manuscripts") along with pious, historical, satirical, and hagiographical works. Though we know it was professionally produced by six different scribes in London, we are left to conjecture from its contents and physical nature what sort of readers (and there are some fascinating possibilities) would have commissioned this wide-ranging and strikingly nationalistic compilation. More wide-ranging still is the fifteenth-century collection of texts assembled by the amateur bookmaker Robert Thornton into the two volumes now known as the Thornton MSS (Lincoln, Cathedral Library, MS 91 and London, British Library, MS Add. 31042). A gentleman of North Yorkshire, Thornton worked over many years gathering, copying, compiling, rubricating, and possibly decorating a variety of practical, spiritual, and romance texts to meet what he considered the reading needs and interests of his family, whose names, like Robert's own, appear in several places in the book (see "Thornton Names in the Lincoln and London Manuscripts"). The Findern MS (Cambridge, University Library, MS Ff.1.6) is also named after a gentry family and, like the Thornton MSS, was produced over several decades. It, too, reveals the work of amateur scribes, but it boasts professional hands as well, with more than forty copyists contributing to its anthology of well-known courtly literature and unique local poems focused primarily on the theme of love. The Findern MS contains only one complete romance and one fragment, but it sports the names and signatures of gentry women, both as scribes and readers, and thus opens a rare codicological window on women's literary culture.

I. Englishing Romance: The Auchinleck Manuscript

The unique prologue to the Auchinleck MS's *Of Arthur and of Merlin* proclaims a principle of educational theory both universal and timeless:

> Childer þat ben to boke ysett.
> In age hem is miche þe bett.
>
> *(fol. 201rb, lines 9–10; fig. 2)*

The poet quickly positions himself, however, by explaining that children thus graced with literacy can learn "godes priuete" (line 12) and ultimately save themselves from sin and eternal death. Yet they gain more mundane advantages as well, like being able to use their "Freynsch *and* latin eueraywhere" (line 18), an edge with obvious social advantages in a time when not even every English "noble . . . couþe seye" French any more (lines 25–26). Having thus cleverly addressed the concerns of readers noble or otherwise, both with French and without it, the poet is free to reject the properly *romans* languages of French and Latin to tell his Arthurian tale "on Inglische" (line 29). The compiler of the Auchinleck MS similarly prioritizes the vernacular, not only by gathering together so many native romances, but also by assembling an almost exclusively English collection of verse in a time when English

13. Richardson 1965: *Eglamour*, lines 64 and 225; and Mills 1973: *Amadas*, line 38.

14. Davis 2004: letter 261, line 30.

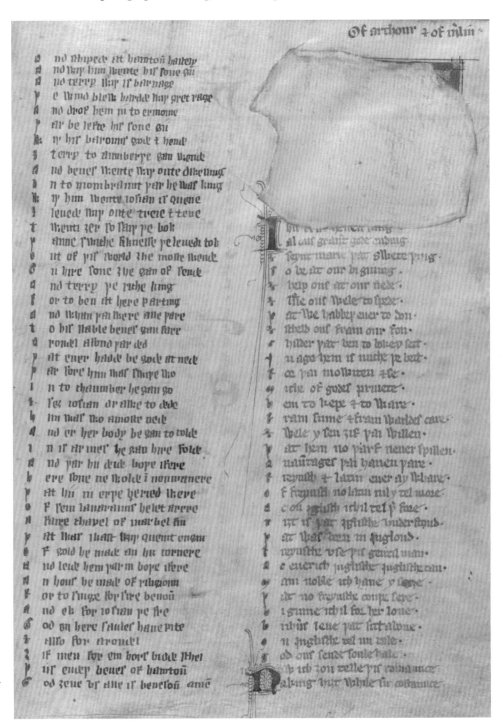

2. The end of *Beves of Hampton* in the hand of Scribe 5, and the title (in red) and opening for *Of Arthur and of Merlin* in the hand of Scribe 1. The miniature has been excised and the folio patched. Edinburgh, National Library of Scotland, MS Advocates 19.2.1, fol. 201r.

texts were almost always gathered together with Latin and Anglo-Norman pieces.[15] Since it is virtually certain that Auchinleck was a commissioned book contracted from a professional bookmaker in London,[16] we can assume that the English language was requested by the book's patron (perhaps with encouragement from the bookseller). Probably it is to that first owner (and the bookmaker's perception of that client) that we should attribute also what amounts to a kind of nationalism expressed in several of Auchinleck's texts, where English identity is repeatedly questioned, defined, and celebrated through chivalric en-

15. Exceptions to Auchinleck's Englishness are few and far between: in the manuscript's brief *Sayings of the Four Philosophers* we find alternating macaronic lines of English and Anglo-Norman; the English translation of Psalm 50 in *David þe King* includes the Vulgate Latin as well; Latin appears sporadically in the *Speculum of Guy of Warwick* (as on fol. 43r; see fig. 5); there are Latin speech-prefixes in the *Harrowing of Hell*; and headers and footers can be in Latin as well, like the explicit for the *Liber Regum Anglie* (fol. 317rb).

16. Shonk 1981, 31–49, discusses the different theories for bookshop production, presenting this scenario as the most likely: a London bookseller who was also a professional scribe (Scribe 1) took on a contract for the manuscript, most of which he copied himself before sending the quires to professional rubricators and illustrators for decoration, then retrieving those quires to assemble them into a volume for binding.

counters and conflicts with a variety of French and "Saracen" soldiers.[17]

With a production date between 1327 and 1340, the Auchinleck MS is one of the earliest manuscripts of Middle English romances to have survived—certainly the earliest extensive romance anthology.[18] It has suffered considerable losses,[19] but forty-four items remain (many of them imperfectly due to missing folios) and seventeen among these are considered romances, some of a more secular and some, a more religious tone.[20] The romance collection is particularly important because seven of the seventeen are found only in these unique Auchinleck copies (see "Middle English Romances in the Auchinleck, Thornton, and Findern Manuscripts"), while the remainder, with the sole exception of *Floris and Blauncheflur*, are the earliest extant copies. The variety of verse forms is also striking: couplet and stanzaic forms are the most common, with the development of the latter appearing in its very early stages in Auchinleck,[21] but there are also alliterative (and partially alliterative) poems (one of them the romance *Sir Tristrem*), indicating access to texts originating far from the book's London production site.[22] A couple of the manuscript's romances are translations of continental French originals (*Of Arthur and of Merlin* and *Floris*), but many are derived from Anglo-Norman ancestral romances—dynastic tales that functioned as "foundation myths, for a family, a locality, ultimately for the Anglo-Norman social order" by providing the ruling Norman magnates with a heroic English ancestry to match their military authority in a new land.[23] Both the historical skeletons (slender though they may have been) to which the fictional flesh of such tales clung, and the efforts of patrons and authors "to give fiction an appearance of fact"[24] must have contributed significantly to the historical impulse that characterizes the later English romances.

It may even be that a number of the Auchinleck romances were translated into English for this very manuscript project, perhaps by poets working in conjunction with or also as the Auchinleck scribes.[25] The theory is tempting given the large number of allusions, correspondences, and borrowings found among English texts both early and unique in Auchinleck, yet more accepted by modern scholarship is a scenario in which the majority, if not all, of the Auchinleck texts had already been translated into English before Auchinleck was copied[26] but were carefully chosen, and perhaps edited, even revised in some cases to fit the book's patron and purpose. The metrical *Chronicle*, for instance, appears to have been revised and extended not only to provide a historical backbone for Auchinleck's texts and characters but also to explore in greater detail certain key themes in the manuscript, like strong women, English kingship, and the origins of Britain. Similarly, the pious and hagiographical works in Auchinleck reveal certain distinctive preoccupations: a focus on religious differences, for instance, an abundant use of particularly clever and technologically advanced "Saracens," and a persistent call to the crusades even in the simplest Christian doctrine.

Guy of Warwick in the Auchinleck Manuscript

One of Auchinleck's chief preoccupations is the figure of Sir Guy of Warwick, who pops up in both the romance of *Sir Beves* and the metrical *Chronicle*, as well as featuring in his own two-part romance and informing another dedicated to his son (fols. 108ra–175vb: see "Middle English Romances in the Auchinleck, Thornton, and Findern Manuscripts"). Guy is an aspiring steward's son whose success in tournament and on the battlefield wins him the Duke of Warwick's daughter, Felice, the goal of all his chivalric aspirations. Very soon after marrying her, however, and establishing a noble lineage, he experiences a sudden change of heart and leaves both her and his newly conceived son to serve a higher Christian good—God

17. On the "Saracens" in Auchinleck, which include foreigners as various as northern Vikings and southern Arabs, see Calkin 2005.

18. CUL MS Gg.4.27.2, c. 1300, is the earliest extant English romance manuscript, but it contains only two romances—*Floris and Blauncheflur* and *King Horn*.

19. See Shonk 1981, 5–29. The most significant losses include five items missing from the opening of the book (the first extant item is numbered vi), at least nine full gatherings lost from various places in the middle of the manuscript, and a number of deliberately excised single and partial leaves, many of them removed for their miniatures. A few fragments have been recovered from bindings and are included in the appropriate places in both Burnley and Wiggins 2003 and Pearsall and Cunningham 1977.

20. By the count of Mordkoff 1980, 9, the romances fill approximately 235 of the current total of 334 folios (excluding fragments and stubs), or 68% of what remains of the manuscript.

21. See Hibbard Loomis 1962, 163.

22. Pearsall and Cunningham 1977, xix–xxiv, note the verse form of each item in Auchinleck.

23. Field 1999, 161.

24. Ibid., 162. Certain aspects of the *Guy of Warwick* romances were "lightly based on historical fact": Mason 1984, 31.

25. Hibbard Loomis 1962, 150–87, argued this, citing correspondences and borrowings among some of the Auchinleck romances, and several scholars have followed in her footsteps, lengthening the list of possible compositions for the manuscript. The idea of custom-made English poems for Auchinleck corresponds nicely with the manuscript's pride in its own Englishness, and later literary men like John Shirley and William Caxton were translators and poets as well as book producers, so Auchinleck's primary scribe could have been just such a bookman operating in fourteenth-century London.

26. Shonk 1981, 33–34, thinks it more likely that the Auchinleck romances were obtained from English exemplars than freshly translated for the project, and Mordkoff 1980 also argues for previous exemplars and borrowing among the poems "prior to" Auchinleck's production (59).

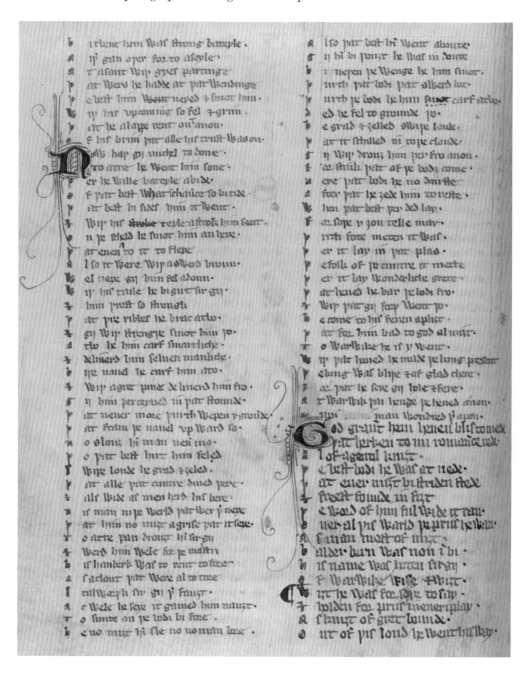

3. The change from couplets to stanzas in Auchinleck's uniquely organized romance of *Guy of Warwick*, with both parts copied by Scribe 1. Edinburgh, National Library of Scotland, MS Advocates 19.2.1, fol. 146v.

himself. The blend of military meritocracy and overstated piety smacks of Norman ideals, so it is hardly surprising that the original *Gui de Warewic* was an Anglo-Norman ancestral tale written (by 1205) to celebrate the union of the houses of Warwick and d'Oilly; the English translation (c. 1290–1330) may have served a similar purpose of consolidating power for the Beauchamps, who came to the earldom of Warwick through marriage in 1268.[27] Variations in the half dozen surviving manuscript copies of the English *Guy* mean, however, that there is no single English narrative of the hero's adventures. The Auchin-

leck collection provides us with both the earliest extant Middle English version and a unique rendition that makes three separate poems of the original one.

Auchinleck's divisions of the Guy of Warwick material are rooted in the Anglo-Norman *Gui*, which begins with Guy's adventures to win the woman he loves, and then tells of those to serve his God. The reviser of the Auchinleck text makes this bipart structure stylistically striking by changing midpoint in the romance from the traditional couplets used in both the Anglo-Norman original and the first half of Auchinleck's English version to the newer twelve-line tail-rhyme stanza (fol. 146vb, at line 6924; fig. 3). The hand is the same in both halves, and though larger script is used for the tail-rhyme continuation, which is also given a unique introduction and conclusion, the new opening is highlighted by no more than a capital just

27. Mason 1984, 31, provides the date for the Anglo-Norman poem and discusses its Warwick associations. For the date of the English version, see Mordkoff 1980, 33.

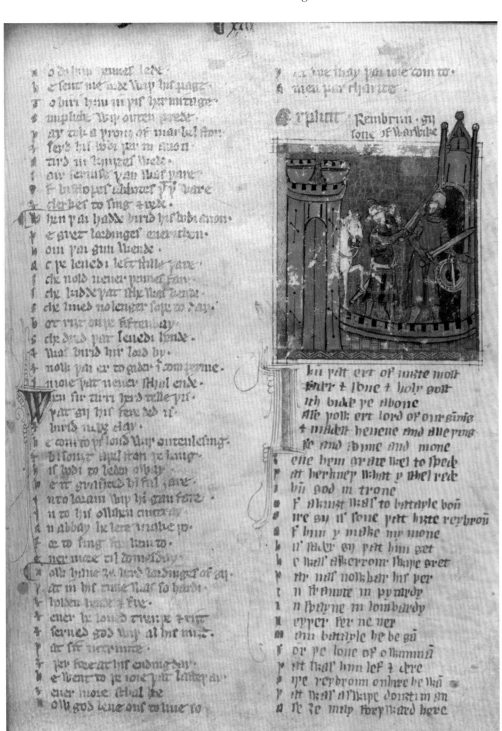

4. Scribe 1 finishes the stanzaic half of *Guy of Warwick* and adds the red title for *Reinbrun* (by Scribe 5) with its large miniature. Edinburgh, National Library of Scotland, MS Advocates 19.2.1, fol. 167r.

like those we find throughout the two *Guy* romances. The hand—"a practiced, legible, unadorned bookhand"—is that of Auchinleck's primary scribe (Scribe 1), who copied the grand majority of Auchinleck's texts and appears also to have been the individual responsible for organizing and compiling the collection, working throughout the manuscript and around the other scribes, writing catch-words, titles, and item numbers as he deemed necessary (for an example of the last two, see fol. 167r, fig. 4).[28] He is our best candidate for the bookseller who took on the contract for the Auchinleck MS, and it may be to him, too, that we should attribute this unique rewriting of the Guy romance.[29] Even if Scribe 1 took his distinctively divided text from an exemplar, however, what he presents for his

28. The quoted description is from Shonk 1981, 72; see 124ff. for Scribe 1's work on the titles, catchwords, and item numbers.

29. Hibbard Loomis 1962, 169, believed the person "responsible for planning the content and arrangement of the whole volume" was also responsible for the unique stanzaic versions of *Guy* and *Reinbrun*.

5. Scribe 2's work in the *Speculum of Guy of Warwick*, where Latin appears in red ink and a larger, more formal script. Edinburgh, National Library of Scotland, MS Advocates 19.2.1, fol. 43r (detail).

intended readers simplifies and clarifies the narrative, definitively separating worldly from spiritual concerns, and perhaps catching the waning attention of the audience with a fresh new meter in the middle of a long romance.[30]

Also simplified and clarified in Auchinleck is the story of Guy's son, Reinbrun. Generally in the Anglo-Norman original (as in other English versions of the romance) the son's adventures are woven episodically into the second part of Guy's own tale.[31] In Auchinleck, however, those episodes have been excised and made into a new romance, *Reinbrun, Guy's Son of Warwick*, which is written in a different hand (Scribe 5's), and highlighted by the largest of the miniatures still remaining in the manuscript (fol. 167rb, fig. 4).[32] Gathering Reinburn's adventures into a new romance deproblematizes the story to some degree, since

the suffering Guy's quest for God causes his abandoned wife, son, and steward is set aside until after Guy's own story is over. Once again, the change renders the models presented by Guy's chivalric prowess for the world and then for God clearer; the demands placed on each intrude less upon the other, lending them the appearance of greater balance and less conflict. This may not encompass the emotional dimensions of the situation, of course, but on the theoretical level it works, since Guy's conversion never becomes a true rejection of the world. Sins "wrouзt" by the "bodi" in its chivalric mode will, by Guy's oath, be "bouзt" by that same "bodi" in a penitential mode (*Guy of Warwick Continuation*, fol. 148vb, lines 7269–70), and the deeds he actually performs for God are every bit as physical and martial as those achieved to win his lady.

The spiritual ideal here is not to shun responsibility in the world, then, and not even to shun the wealth of the world if we listen to the pious teaching of Auchinleck's *Speculum* or *Mirror of Guy of Warwick*—teaching authorized by short Latin passages executed in red ink and a larger, more formal script (see fol. 43r; fig. 5). Quite the contrary, since positions of earthly responsibility and the duties they involve are a major preoccupation in the Auchinleck MS, where the reader is repeatedly urged not to reject wealth, power, and duty but only to subordinate all to the love of God and one's fellow Christian. It is a spiritual ideal that bathes Guy and his choice to leave hard-earned hearth and home to serve God in a kindly chivalric glow, and thus an ideal particularly well-suited to the military aristocracy in a crusading age. The desire for such teaching on the part of the book's patron (or the desire expected for it by its maker) could be a clue, then, that we should "look above the middle class for the owner of the Auchinleck MS."[33] And since the *Guy of Warwick* romances also form something of a "centerpiece" or "prestige item" in Auchinleck[34]—almost an axis around which other works in the volume revolve—it could be they were designed with the book's patron specifically in mind, and the most obvious recipients of such a compliment would certainly have been the earls of Warwick themselves.

30. Mordkoff 1980, 39–41, considers the idea that the two parts of *Guy* in Auchinleck stem from different exemplars, one of them possibly defective, and examines anomalies in other copies of the romance at the point where Auchinleck's stanzaic text begins.

31. But see Mordkoff 1980, 37, for exceptions.

32. See fol. 201rb, fig. 2, for another example of Scribes 1 and 5 working on the same folio. Shonk 1981 calls the hand of Scribe 5 the "least aesthetically pleasing" of the manuscript's six scribes, resisting accurate categorization (78), but notes how 5 "worked in close cooperation with the major scribe," perhaps as a "beginner or apprentice" (67–68). Four of the six extant illustrations in Auchinleck introduce romances: single-column miniatures adorn the *King of Tars*, *Richard Coer de Lion* (fols. 7ra and 326ra), and *Reinbrun* (fol. 167rb; fig. 4), while an historiated initial features what

appears to be the hero of *Sir Beves of Hampton* (fol. 176ra; fig. 6). On the illustrations in Auchinleck, see also ch. 3, sec. II.

33. Mordkoff 1980, 260.

34. Harpham Burrows 1984, 100, and Pearsall and Cunningham 1977, x. The opening of *Guy* has been lost due to an excised folio, most likely for the miniature which, judging by the number of lines missing, may have stretched to half a page, making it the largest of Auchinleck's illustrations. Since there are two other stubs in the *Guy* romances where folios have been removed, it is also possible, though unprecedented in the manuscript, that there could have been illustrations within the text of the romance, making it a prestige item indeed: see Mordkoff 1980, 89, and Shonk 1981, 18n28.

The Auchinleck Manuscript and the Earls of Warwick

At the time of Auchinleck's making, Warwick's earls were still members of the Beauchamp family, whose name appears on the list of Norman barons immediately preceding the *Guy* romances in the Auchinleck MS (the tenth name on fol. 106v, line 354).[35] Both William, who became the first Beauchamp earl of Warwick in 1268, and Guy, his son and the first of the family to bear that "ancestral" name, rose rapidly to the highest nobility through "fortuitous marriages"[36] just as the romance hero Guy did. Both men were also associated with romances: William gave a *Book of Lancelot* to his daughter Joan,[37] and in 1305 Guy gave to Bordesley Abbey several books, including Anglo-Norman titles like the "Romance de Gwy, e de la Reygne," several of which demonstrate a "strong crusading flavour" not unlike that which we encounter in Auchinleck.[38] Dialect hints of Warwickshire in the London language of Auchinleck's *Guy* further support an association between Auchinleck and the earls of Warwick,[39] who owned property in London, and the same is the case with many of the details about Guy's character and adventures in the romance — details that would have been read most effectively by the Beauchamps and other nobles well informed about aristocratic lineages.[40]

So there are compelling reasons to link Auchinleck and its *Guy* texts to the Beauchamp earls of Warwick, yet two problems remain. Why would such a noble family have wanted these tales in English instead of the original Anglo-Norman more often associated with the aristocracy? And why is the Auchinleck MS not of a more deluxe quality if its intended first readers were among the highest aristocracy? Assuming that relating "the story of their family's prestigious lineage and noble and chivalrous history"[41] in England must have been a significant part of the Beauchamp's goal if indeed they were involved in this retelling of Guy's romance, then both the focus and the inclusiveness of English would have appealed. As the *Of Arthur and of Merlin* prologue tells us, "euerich Inglische" person knew English, while some even among the nobles could no longer speak French (fol. 201rb, lines 24–26; fig. 2), so successfully reaching the widest English audience possible would no doubt have necessitated reaching it in English. Furthermore, by the 1330s when the Auchinleck was made and Edward III had begun pursuing his claims to France, many English nobles may have chosen for political reasons not to speak French anymore. Certainly in the Auchinleck MS being a "monoglot nobleman" becomes not a matter of shame but of pride, and the virtually exclusive use of English, "an expression of the very character of the manuscript, of its passion for England and its pride in being English."[42] In this book, then, the vernacular is not called upon as a compromise for the less learned or the lower classes, though they, too, could hear and understand Guy's story; rather, its use is a national triumph for "euerich Inglische."

Regarding Auchinleck's less-than-aristocratic quality, it is worth emphasizing immediately that the manuscript would have been far from inexpensive to produce. Even something as unremarkable to modern eyes as the empty space left by its scribes in several places is extremely telling given the high cost of the skins medieval books were written on. The Auchinleck's "size, the professionalism of its scribes, its illumination, would have made it a very expensive volume," affordable for "only a very rich family."[43] Yet in so many respects the Auchinleck is far from the most lavish of manuscripts.[44] It is large, yes — too large to be held comfortably in the hands, which may imply group more than individual use — but not extravagantly so like the Vernon MS.[45] Its scribes were professionals, yet even the primary scribe's hand varies considerably, presumably due to fatigue as well as intention, and whether to save time or money or both, certain works were farmed out to scribes less accomplished than the main copyist, like the rather inconsistent Scribe 2 who copied the *Mirror of Guy* (see fig. 5),[46] and the possibly less-experienced Scribe

35. See Turville-Petre 1996, 136–37, on the Beauchamps and Auchinleck.

36. Liu 2005, 277–78.

37. Warwick 1903, 76n1, and Mason 1984, 33.

38. See Blaess 1975, 513, and Turville-Petre 1996, 136.

39. See Wiggins 2003 whose work shows that "early in its history the A-redaction [Auchinleck text of *Guy*] was copied by a scribe from the West Midlands, possibly Warwickshire" (229).

40. Many of the romance adventures of Guy and Reinbrun, for instance, were based on the actual exploits of Brian fitz Count, who married a d'Oilly woman (the d'Oilly family being connected with the original Anglo-Norman *Gui de Warewic*) and held Wallingford Castle for Matilda during the civil wars of Stephen's reign. Wallingford in turn was the origin of Wigod (via the Latin Wido or Gwido it becomes Guy), the cupbearer of Edward the Confessor, whose daughter married Robert d'Oilly, Constable of Warwick. For these details and more, see Mason 1984, 30–32.

41. Wiggins 2003, 230.

42. Turville-Petre 1996, 138.

43. Turville-Petre 1996, 113 and 136. Mordkoff 1980, 251, suggests an original price of between £15 and £25, while Shonk 1985, 89, estimates the cost at about £10.

44. Pearsall and Cunningham 1977 describe Auchinleck as "a fairly expensive book," but not "in the *de luxe* class" (viii).

45. The Auchinleck measures at present 250 × 190 mm. and still contains 334 folios, close to the Vernon's remaining 350, but the Vernon measures in at a whopping 544 × 393 mm. Both books have suffered cropping and leaf losses so would originally have been larger and thicker.

46. As well as the *Sayings of the Four Philosophers* with its Anglo-Norman lines and the final work in the volume, the *Simonie* (see fig. 9). Scribe 2's large bookhand mixes *textura* and *Anglicana* features and has been described as "almost liturgical": see the discussion in Shonk 1981, 75–76.

5 who copied *Reinbrun* as well as *Sir Beves* and may have been Scribe 1's apprentice (see figs. 2, 4, and 6).[47] Similarly conflictive evidence is offered by the book's decoration and illustration, which is generous, with professional rubrication, blue and red capitals by a single artist, and a set of miniatures that appear (from the few extant examples) to have been the product of one craftsman associated with the workshop also responsible for the Queen Mary Psalter illustrations.[48] These miniatures reveal detailed knowledge and more than a superficial reading of the texts they introduce,[49] and they were obviously deemed fine enough by at least one reader for over thirty of them to be excised, likely for scrapbooks or other collections.[50] Yet they are small—never more than a column wide—and far removed from the deluxe illuminations found in the most lavish courtly manuscripts (like London, British Library, MS Harley 2278 made for a young king: see ch. 6, sec. III and fig. 17 there). Some have even judged Auchinleck's miniatures to be "two-dimensional," "stiff" and "unremarkable artistically," with their "modesty" setting the "value for the book."[51]

That value may well have been determined by a slump in the Beauchamp fortunes that followed the death of Earl Guy in 1315[52] (some said by poison in retaliation for his execution of Edward II's favorite, Piers Gaveston) and could well have dictated the need for some positive Warwick propaganda as well. But it is also possible that Auchinleck was the possession not of the Beauchamps themselves but of a family closely associated with their household, perhaps in an official capacity which lent a stake in Warwick fortunes and generated a desire to celebrate the illustrious family that enabled their own success. The emphasis on "the good steward" in the *Guy* and *Reinbrun* romances has been read, for instance, as a clue to the identity of Auchinleck's patron, who could have been just such an advanced retainer of the Beauchamps, perhaps one linked with a London property.[53] Supportive of this theory is the way in which loyalty—the actively tested, long-suffering sort that establishes friendships like that between good stewards and their generous lords—arises again and again as a key theme in the Auchinleck collection, with the trusty steward who holds Orfeo's kingdom for a whole decade

while he wanders mourning in the wilderness the perfect model of how a "trewe" servant should behave (fol. 302vb, line 554).

Of course, literary contents can take us only so far in identifying medieval owners and readers, but perhaps in the mysterious arms worn by the knightly figure in the illustration at the head of *Sir Beves of Hampton*, the romance that follows *Reinbrun* in Auchinleck, we are offered a clue to the identity of such a loyal and literate servant of the Beauchamp's (see fol. 176r; fig. 6). If so, it is an indecipherable one in the present state of our knowledge, for although the ornamented arms of the character Beves are described in his romance and the artist of the Auchinleck miniatures is generally very careful about portraying the details of the texts illustrated, here Beves is given an unidentified coat of arms.[54] Nor is this the only unusual aspect of the decoration for *Beves*, since the knightly figure appears in the book's "only historiated initial" and the folio also features "the only foliate border, making this page 'unlike anything else in the manuscript.'"[55] In addition, the figure is not engaged in any of the romance's adventures as, say, Reinbrun (fig. 4) and Richard (ch. 3, fig. 5) are in their miniatures, and though we might most obviously identify him as Beves, there remains some doubt about exactly who is portrayed and why. If, however, the patron of Auchinleck was a steward or forester or other elevated official in a noble household like that of the Beauchamps, then it is entirely possible that his still unidentified arms were quite literally embedded in the *Beves* text as a fitting companion to the Earl of Warwick's, which may well have appeared in the illustration lost from the opening of the *Guy* romances.

Romances for a Middle-Class Household?

As tidy as assigning Auchinleck to the Warwick household may be, however, it remains conjecture, and it may be that the uniquely decorated opening of *Beves* is instead a tribute to a "wealthy middle-class patron" who is thus endowed "with an imaginary coat of arms embodying his social aspirations to knighthood."[56] The theory that Auchinleck was commissioned and used by a member (or

47. Shonk 1981 argues most convincingly for piecework production of Auchinleck, in which Scribe 1 took the contract, directed the copying, completed 72% by the reckoning in Pearsall and Cunningham 1977, xv, but paid (or otherwise engaged) five additional scribes to copy certain works or groups of works to hasten production.

48. See the discussion of Auchinleck's decoration in Shonk 1981, 92ff., where he points out that J. J. G. Alexander identified the illustrations as "a later product of the Queen Mary Psalter atélier" (98).

49. Hilmo 2004, 112–25.

50. Thirteen miniatures have been cut out of Auchinleck (these appear patched in the manuscript now: see fig. 2 for an example),

and in eighteen more cases folios at the beginning of items have been removed, almost certainly to obtain miniatures.

51. Quotations from Shonk 1981, 94, 95, and 97. Pearsall and Cunningham 1977 call Auchinleck's "illustration, decoration and penwork . . . modest and workaday" (viii).

52. See Mason 1984, 36.

53. Harpham Burrows 1984, 183–84.

54. Hilmo 2004, 125.

55. Ibid., 124, quoting Shonk 1981, 95. The unique decoration of *Beves* could be due to its being planned and/or completed before the decorative patterns of Auchinleck were fully established. On the design and development of both decorative and textual layout in Auchinleck, see Mordkoff 1980, 91ff, and Hilmo 112–13.

56. Hilmo 2004, 125.

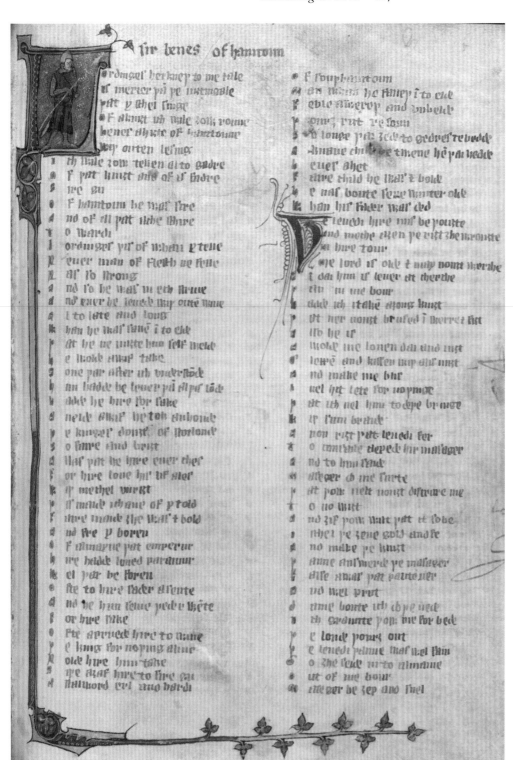

6. The opening of *Beves of Hampton*, copied by Scribe 5 and decorated with Auchinleck's only historiated initial. Edinburgh, National Library of Scotland, MS Advocates 19.2.1, fol. 176r.

family) of the urban bourgeoisie has been a popular one.[57] As a whole the manuscript presents the kind of extensive and varied contents—romances, hagiography, history, devotion, contemporary satire, didactic texts, and more[58]—found in books linked with middle-class families, who even at their wealthiest rarely owned more than a very few books, and often could afford only a single precious volume that to us would resemble a miniature library—what has been referred to as a "library *in parvo* [in small]."[59] Auchinleck also features middle-class characters like the

57. Shonk 1981, for instance, argues that the value of the book suggests a "bourgeois reader" (137), and Pearsall and Cunningham 1977 claim that the book was designed for an "aspirant middle-class citizen, perhaps a wealthy merchant" (viii).

58. See the contents lists in Pearsall and Cunningham 1977,

xix–xxiv, and Shonk 1981, 10–29, where scribes and quires are noted as well.

59. Bennett 1948, 165, discussing BL MS Egerton 1995 and NLS MS Advocates 19.3.1; Hardman 1978 explores the second as a miniature library in some detail.

merchants who steal the young Reinbrun, intending to profit from selling him, but end up proving themselves more "noble . . . , courteis, *and* fre" (fol. 168ra, line 134) than the reader expects by giving the boy instead to King Arguus of Africa, whose educated daughter instructs the young noble. I cite this example in particular because the mercantile class has received special attention in relation to Auchinleck, partly due to the manuscript's production in London where a thriving mercantile community existed in the early fourteenth century. More specific and compelling, if also more problematic, has been the suggestion that Geoffrey Chaucer, son of a vintner (or merchant of wine), may have been personally familiar with the contents of Auchinleck.[60]

Laura Hibbard Loomis was a great champion of the theory that Chaucer read and used the romances in the Auchinleck ms, citing numerous verbal and stylistic parallels between those texts and Chaucer's writings[61] to which other readers have added over the years. The parallels noted by the *Riverside Chaucer* as the "most striking verbal similarities" include those with *Guy of Warwick* (Chaucer's "chief model") and *Beves of Hampton*, two of the "romances of prys" mentioned in the "Tale of Sir Thopas," where they are listed along with *Horn Child*, a poem now found only in Auchinleck.[62] Meter, too, could have been borrowed for "Thopas" from *Beves*, where Chaucer's six-line stanza form appears, as well as from *Sir Tristrem*, where the bob or single-stress, two-syllable line found in five stanzas of "Thopas" is used.[63] And if the inconsistent meter of "Thopas" is also a parody of the verse forms of Middle English romances, then the Auchinleck ms is a perfect target: not only does it contain poems of different meters, but the romances of both *Guy* and *Beves* change meter midtext.[64] Perhaps Chaucer even learned something of literary genre from the texts of Auchinleck, since the shared prologue of *Sir Orfeo* and *Lai le Freine* has been seen as a source for "every one" of Chaucer's ideas about Breton lais stated in the prologue to the "Franklin's Tale."[65] And in Chaucer's familiarity with *Orfeo* and its tale of marital love enduring the worst of trials we might also see why he chose to write about married lovers instead of the courtly love

more common in such tales, and why he decided to call his own version of an Italian story a Breton lai.[66]

The argument for Chaucer as a reader of Auchinleck remains "irresistibly romantic,"[67] but it also makes reasonably good sense. If Auchinleck's early home was an affluent, middle-class, London household, the Chaucers are suitable candidates. They held property on Thames Street in Vintry Ward, "one of the two wealthiest wards in medieval London," where foreigners and wine merchants rubbed shoulders with mayors and nobles.[68] They were just the sort of family who could have afforded a book like Auchinleck and, given the growth in their fortunes and the ambitious careers of their son and grandson,[69] also the sort of family to have wanted a prestigious and elite domestic item that would enable the literary, spiritual, and social education of their children. Chaucer was, we believe, born in the early 1340s,[70] just after Auchinleck was completed, so he could well have encountered its texts as a boy, and it is easy to imagine how profoundly their celebration of English traditions and the English language in particular might have affected so bright a child. Not only does it seem appropriate if our first great English poet was influenced, even inspired, by this unique nationalist collection of vernacular poetry, but it would also prove the author of Auchinleck's *Of Arthur and of Merlin* prologue a prophet indeed if a boy like Chaucer set to that very English "boke" should have done so extremely well "in age" that he "elumened . . . alle . . . bretayne."[71]

Yet there is no concrete proof beyond Chaucer's profound familiarity with some of the Auchinleck romances (which might have been gained from copies no longer extant) to demonstrate that he ever actually saw Auchinleck itself. Nor do we have any tantalizing hints beyond his writing that the manuscript might have belonged to such an aspiring mercantile family. Indeed, one could argue a complete mismatch, since Chaucer's views of the world and the people he found in it are far more subtle, penetrating, and tolerant than those he would have discovered in Auchinleck's texts. Prohibitive to ownership by a mercantile family is the absence in Auchinleck of any of the sort of practical and mundane domestic materials gener-

60. Chaucer's grandfather was also a vintner, and both he and Chaucer's father held positions in the customs service, as Chaucer did after them: see the *Riverside Chaucer* 1987, xv–xvi.

61. See Hibbard Loomis 1962, 131–49 and 111–30, and Bryan and Demptster 1958, 486–559.

62. 917 and VII.897–99; all line numbers for Chaucer refer to the 1987 *Riverside Chaucer*.

63. See *Riverside Chaucer* 1987, 917, and Pearsall and Cunningham 1977, xi.

64. The first from couplets to stanzas as discussed above, the second from tail-rhyme stanzas to couplets at fol. 178va, line 475.

65. Hibbard Loomis 1962, 118, where the Prologue is printed from *Lai le Freine*. Although this Prologue likely appeared at the beginning of *Orfeo* in Auchinleck as it does in other versions

of the poem, only a thin stub now remains of the first folio of Auchinleck's copy.

66. Hibbard Loomis 1962, 121 and 123; see 116n11 on Chaucer's Italian source, Boccaccio's *Filocolo*. On other sources, see *Riverside Chaucer* 1987, 895, and Bryan and Dempster 1958, 377–97.

67. Pearsall and Cunningham 1977, xi.

68. *Riverside Chaucer* 1987, xvi.

69. Chaucer and his son Thomas, who had a "distinguished career," becoming "one of the most wealthy and influential men in England": ibid.

70. Ibid.

71. The assessment is Caxton's in his *Book of Curtesye*, as quoted by Brockman 1975, 59. Unfortunately, Chaucer also suffered extreme personal poverty "in age."

ally found in late medieval anthologies associated with both minor gentry and the rising middle classes. Examples abound: the Yorkshire gentleman Robert Thornton, whose two manuscripts are discussed at length below, finished his collection of romances and pious texts (Lincoln Cathedral MS 91) with a book of medical recipes (the *Liber de Diversis Medicinis*), and filled its gaps with short pieces as various as weather prognostications, charms, informal drawings, and a birth record. In the Findern MS (CUL MS Ff.1.6, also discussed below) a treatise on laundering, a record of the cost of "befe," "kalf," "shepe," and "Rostyng beeffe" (fol. 70v), a reckoning, and a domestic inventory keep company with the poetry of Chaucer, John Gower, John Lydgate, and Thomas Hoccleve.[72] In Oxford, Bodleian Library, MS Ashmole 61, a late-fifteenth-century holster book copied by the "idiosyncratic scribe" Rate and very probably associated with a mercantile family by that name in Leicester, we find along with five romances and many pious works a comic debate called *Carpenter's Tools*, a dietary, a short added piece on the rules for land purchase, and a number of amateur drawings (see figs.7a and b).[73] All three books are much later products than Auchinleck and that alone may explain some difference, yet it remains striking that nothing of this practical or informal sort appears in Auchinleck, which is in fact "a more elaborately and completely finished product" than any other extant collection of Middle English romances.[74]

Or Tales for the Noble Nursery?

Now it may be that those who commissioned the Auchinleck MS simply treasured it too much to allow the clutter of mundane documents and casual scribbles to rub shoulders with the verses of piety and romance collected between its boards. Yet the value perceived in a manuscript by its medieval owners could also be a reason for including (and thus preserving) the most practical and (to us) unsuitable information, provided it was deemed beneficial to the household or its members. So Auchinleck doesn't quite fit the image we have at present of a middle- or gentry-class household book, just as it isn't quite what we would expect of an aristocratic volume. What I would like to suggest instead doesn't dismiss the possibility of either context but does take us in a direction already indicated by both the *Of Arthur and of Merlin* prologue and Chaucer's narrator,

who tells us before he begins the "Tale of Thopas" that he learned his "rym . . . longe agoon" (VII.709). That is, what if the Auchinleck romances were originally commissioned and produced with young readers in mind? Could an anticipated audience of children explain the unique nature of the Auchinleck MS and its contents any better or more fully than the scenarios already outlined?

It has long been accepted that children were the intended audiences for many of the didactic texts surviving from the Middle Ages, and the earliest school texts that sought to teach children the rules of pronunciation, grammar and composition often contained fictional or entertaining elements. Courtesy texts, sometimes written by parents themselves, used exemplary tales to guide young readers in manners and other appropriate forms of behavior that enabled social mobility and worldly success; and such tales also appear in works specifically designed to instruct children in simple Christian precepts like the Ten Commandments, the virtues, and the seven deadly sins. We find such accessible, instructive works combined in children's primers,[75] but we also find them in Auchinleck, where texts like the *Pater Noster* (*Our Father*) "**vndo on englissch**" (fol. 72ra), the translation of Psalm 50 in *David þe King*, two pieces on the *Foes of Mankind*, and the *Seven Sins* are particularly well-suited to younger readers. The last even directs its "lore" of "holi cherche" to "children" first, then to "wimmen and men," stipulating a minimum age of "twelve winter elde and more" that helps us visualize with some precision an intended audience of adolescents (fol. 70ra, lines 12–14). Since the *Mirror of Guy of Warwick* uses the "question-and-answer format . . . characteristic of . . . medieval master-pupil dialogues specifically designed for children,"[76] it may be that its explanation of the moral principles behind the character Guy's conversion was aimed at youthful readers as well. And if the *Mirror* in Auchinleck was intended to help children understand Guy's choices, then the unique version of his romance in Auchinleck might well have been prepared for a youthful audience as well.

Romances themselves certainly suggest young nobles, particularly young noblewomen, as a primary audience. Chrétien de Troyes's *Yvain* describes an adolescent girl reading a romance to her knightly father, a detail the English redactor retains in his version,[77] and Auchinleck's unique English version of *Sir Tristrem* presents Isonde, a

72. For the Lincoln examples, see figs.13, 19, and 28; for Findern, see figs. 32a and b, and the transcriptions of the reckoning and inventory in Robbins 1954, 620–21.

73. See Blanchfield 1991 for a discussion of MS Ashmole 61, its contents, its scribe's editorial practices and his possible Leicester associations. Johnston, forthcoming, ch. 4, presents a compelling argument for the association of Ashmole 61 with a Leicester family of ironmongers who went by the name Rot, Rott or Ratt. I am most grateful to Michael Johnston for sharing his illuminating study of *Romance and the Gentry in Late Medieval England* prior to publication.

74. The quotation is from Mordkoff 1980, 225.

75. On the contents of children's primers in the Middle Ages, see McMunn 1975, 51. Orme 2001, 237–304, discusses children's reading in detail.

76. Adams 1998, 9, discussing the school texts of Donatus. The dialogue in Auchinleck's *Mirror* takes place between Guy and the great English churchman and teacher Alcuin, with the likely source Alcuin's *De Virtutibus et Vitiis Liber*: see Harpham Burrows 1984, 22–23.

77. See Orme 2001, 275, and Brockman 1975, 59.

king's daughter, as a girl pleased to hear "gle" and read "romaunce . . . ari3t" (fol. 288ra, lines 1257–58). Caxton seems to corroborate that evidence when he claims in the English translation of *Blanchardyn and Eglantine* he dedicated to Margaret Beaufort in 1489 that "gentyl yonge ladyes & damoysellys" can learn from his "storye" to be "stedfaste and constant," and goes so far as to suggest that reading romance is as valuable for them as excessive study "in bokes of contemplacion."[78] Whether so beneficial or not, however, romances were certainly owned by women: as I noted above, William Beauchamp gave his daughter Joan a *Lancelot*, a text Chaucer claimed was held "in ful greet reverence" by "wommen" (VII.3212–13). The signatures of both "Elysabeth the kyngys dowther" and "Cecyl the kyngys dowther" along with that of their mother, Elizabeth Woodville, queen of Edward IV, appear in London, British Library, MS Royal 14.E.iii, an anthology of French Arthurian literature presumably read by all three women.[79] Later but too striking to leave out is the autobiographical confession of Teresa of Avila: encouraged as a girl by her mother's love of romances, she developed such a thirst for chivalric tales that the time she spent on them left little space for her duties and won her father's strong disapproval, a perspective the mature Teresa clearly condones, judging such reading "useless"; but she nonetheless admits that she did not see the situation at all so as a girl, when without guilt she hid the books that made her "happy," and even collaborated with one of her brothers in writing a chivalric romance of her own.[80]

Girls and young women should be considered, then, a significant audience among medieval readers of Middle English romance,[81] but, like Teresa, they could not have been alone: Caxton considers his *Blanchardyn and Eglantine* "honeste & Ioyefull to alle vertuouse yong noble gentlymen & wymmen,"[82] and Aelred of Rievaulx appears to be addressing a common complaint among the young men he teaches when he has the novice in his *Speculum Caritatis* (*Mirror of Charity*) claim that in secular life he used to shed far more tears over Arthurian fables than he does in pious reflection during the first throes of religious life.[83] Indeed, boys are the perfect audience for medieval ro-

mance, where the emphasis is almost always on military and chivalric activities, and it seems that in some manuscript groupings we have romances gathered specifically for young male readers. In Edinburgh, National Library of Scotland, MS Advocates 19.3.1 (late fifteenth century), for instance, three homiletic romances appear to have been specially edited (likely by the manuscript's primary scribe, Richard Heege, after whom the book has been named the Heege MS) and then combined with instructional works for the benefit of young male readers.[84] The romances concerned are *Sir Gowther, Sir Ysumbras,* and *Sir Amadas,* all of them appearing in unique "edited" versions that reveal "a preference for direct over indirect speech, violent and bloody action, sinful, then repentant heroes . . . , and simple piety, with an absence of abstract thought and moral complexity."[85] Though not always associated with the best in either children's literature or medieval romance, such qualities are nonetheless associated with "popular success in children's literature" then, as now.[86] Each of these romances is then paired with a courtesy text: *Urbanitatis,* a treatise on manners for "young gentlemen" (mistakenly called *Stans Puer ad Mensam* in the manuscript), appears with *Gowther;* the *Lay-Folk's Mass Book* of proper behavior for the mass comes after *Ysumbras;* and the *Little Children's Book,* which claims that "courtesy from Heaven came," follows *Amadas.*[87] Each combination of romance and instruction is contained within a single quire, making up three separate and (judging by the wear and tear on their outer bifolia) separately used booklets now bound into a larger domestic collection.

Whether we posit for these booklets an audience of boys associated with the yeoman family of Sherbrooke in Derbyshire to whom the Heege MS has been linked or an audience of "boys of the merchant class," it would seem that their "fathers . . . were eager for their sons to learn the ways of gentlemen."[88] Either way, the manuscript presents an interesting parallel to Bod. MS Ashmole 61, the Leicester holster book I have already mentioned as a mercantile romance collection, for Ashmole 61 (figs. 7a and b) also sports something of a "children's corner" near the book's opening.[89] Rate, the scribe of that volume, gath-

78. Quoted in Goodman 1995, 27.

79. See ibid., 25–27. As Orme 2001, 282, points out, "the fact that each signature gives the woman's maiden name suggests that they all read the book in their teens, before they were married." Other women owners of romances are discussed in Meale 1996, 139ff.

80. Goodman 1995, 28–29. We know of Teresa's romance only from her autobiography (s.xvi); the text itself is lost, perhaps because it seemed of little value to her later in life.

81. Clifton 2005, 188, argues that many translations of popular French and Latin texts were made particularly for English "girls who were educated at home, while their brothers learned Latin and French at school."

82. Goodman 1995, 27.

83. II.51 in Hoste and Talbot 1971.

84. On the Heege MS, see especially Hardman 1978 and 2000.

85. Shaner 1992, 9, summarizing Hardman's observations 1978 on the revision of the three romances.

86. Ibid.

87. Quoting from Shaner 2003, 300, and Shaner 1992, 13. The Heege MS reads "curtesy from hevon com" (fol. 84v) and the same sentiment appears in Bod. MS Ashmole 61 (fol. 20r).

88. Quotations are from Shaner 1992, 14. Johnston, forthcoming, ch. 5, discusses the Heege MS's connections to the Sherbrookes, a family "best categorized among the upwardly mobile Derbyshire yeomanry."

89. Blanchfield 1991, 73n20.

7a and b. *Sir Ysumbras* and the *Commandments*, both signed by the scribe Rate, who also added the drawings to this domestic holster book. Oxford, Bodleian Library, MS Ashmole 61, fols. 16v–17r.

ered simple prayers along with some basic doctrine in the form of the *Ten Commandments* and reworked a number of courtesy texts well suited to the young, like *Dame Curtasy*, *How the Wise Man Taught His Son* and the *Good Wife Taught Her Daughter*, as well as a true copy of Lydgate's *Stans Puer ad Mensam* (literally *The Child Standing at the Table*), which he furnished with a unique prologue requesting for himself the "grace" to be "to chylder a bodely leche" in teaching them to "fere *and* ffle" all manner of "vyces," and an-

nouncing his primary "entent'" to "teche *chylder curtasy*" (fol. 17v, lines 5–9), one of the statutes of which involves, not surprisingly, honoring one's parents.[90] The five romances Rate includes among his more didactic pieces have also been edited—cleaned up almost, though his editorial and scribal work can at times be sloppy—with an eye

90. See also Evans 1995, 73.

to family values, morals, and piety,[91] and, I would argue, a special concern for younger members of a domestic audience. Certainly the simple fish and other drawings he leaves between texts mark the book's divisions in obvious visual ways and might well have appealed to young readers, while reminding them of the need to reel in the lessons encountered and store them, like fish, in the nets of the mind (see figs. 7a and b).[92] The still larger collection of romances (nine in total) along with pious and instructional texts in Cambridge, University Library, MS Ff.2.38 suggests similar concerns. Its romances are preceded by prayers and psalms, and pieces on the commandments, the virtues and the vices; the bodily and ghostly wits are covered, as are the articles of belief and the works of mercy; and courtesy texts like *How the Good Man Taught His Son* are included as well.[93] A Leicestershire book like MS Ashmole 61, it, too, gives every impression of a "compilation . . . intended as a reading book for all the members of a family" with a particular emphasis on "small children."[94]

The Auchinleck MS shares much with these later volumes: a number of romances (*Guy, Beves, Degare,* and *Orfeo*), the lives of Margaret and Katherine, the *Seven Sins* and the *Seven Sages of Rome,* among other texts. Like CUL MS Ff.2.38, Auchinleck's doctrinal and didactic works are, for the most part, placed before its collection of romances, and yet, like the Advocates 19.3.1 and Ashmole 61 collections, it also blends its most pious romances—the *King of Tars* and *Amis and Amiloun*—in with those more didactic works. Auchinleck even bears the fifteenth-century names of an unidentified Browne family (parents and seven children) who must have been using its texts around the time these other family libraries *in parvo* were created.[95] Perhaps in earlier generations of the Brownes we already have the particularly wealthy middle-class patrons of Auchinleck, but there is no evidence of their involvement in the fourteenth century, suggesting the manuscript came to them later in its history, and (as I've already mentioned) there is much to set the Auchinleck (and its patron) apart from these more bourgeois volumes. Beyond its professional production, more polished appearance, and lack of practical accretions, its emphasis on chivalric, courtly, and crusading concerns is especially revealing, and all the more so because of the contrast this presents to those middle-class

volumes. In MS Advocates 19.3.1, for instance, the scribal editor Heege tends to replace such aristocratic ideals with more domestic and materialistic values and in his edited romances even emphasizes "marital relations based more upon equality than upon the courtly-chivalric pattern."[96] And in MS Ashmole 61 the scribal compiler Rate tends to downplay the less forgivable aspects of the crusading mentality, as he does when he chooses not to include in his version of *Ysumbras* the intentions of the hero to slay all the pagans he has conquered if they resist baptism.[97]

The Auchinleck romances do just the opposite. The *King of Tars,* for instance, which addresses "boþe eld *and* ȝing" (fol. 7ra, line 1) and is the first romance to appear in the book, does not end with the joy of the now properly Christian couple like the sweetened version we find in the Vernon MS; instead, Auchinleck's text "continues with a long account of the violence done" by the converted Sultan and his wife's father "to five heathen kings and their followers who refuse conversion."[98] Auchinleck's crusading spirit is equally relentless. Its romances are peopled with "Saracens" from far-flung regions, all of them (save the few who convert) desirable if tricky targets for the swords of Christian heroes like Guy, Beves, and the great crusading king, Richard I. Even a simple moral piece like the *Seven Sins,* which specifically addresses "children," communicates religious intolerance with a distressing conviction:

> Sende pees þer is werre.
> And ȝiue cristenemen grace.
> Into þe holi lond to pace
> And sle saraxins þat beȝ so riue.
> And lete be cristenemen on liue.
>
> *(fol. 71vb, lines 288-92)*

Peace only through war in the Holy Land, then, and the principle extends in Auchinleck to political situations much closer to home as well. That of the young Arthur in the *Of Arthur and of Merlin* romance provides a classic example. The son of a king, Arthur is nonetheless hampered by misty origins and finds he must fight to win and retain a kingdom already his by right, a cause which means there "nas non harm" in his enthusiastic and bloodthirsty slaughter of his opponents (fol. 220rb, line 3336).[99]

91. As Blanchfield 1991 argues. Parkes 1991a, 293, describes MS Ashmole 61 as a "collection . . . selected and edited by Rate for family reading," while Taylor 1991, 59, calls it "a one-book library for family reading."

92. On fishing as a metaphor for recollection, see Carruthers 1990, especially 247, 345n67 and fig. 28.

93. See the list of contents in McSparran and Robinson 1979, xxi–xxv.

94. Ibid., xvii. Eddy, forthcoming, suggests that London, Lambeth Palace MS 491—another romance manuscript (see Guddat-Figge 1976, 226–28)—may also "have been used primarily by juvenile readers" (personal communication, July 2010).

95. On fol. 107r of Auchinleck appear the names "Mr Thomas Browne | Mrs Isabell Browne | Katherin Browne | Eistre Browne | Elizabeth Browne | William Browne | Walter Browne | Thomas Browne | Agnes Browne."

96. Shaner 2003, 299.

97. See Evans 1995, 73. Those violent intentions are voiced, however, in the copies of *Ysumbras* found in the Lincoln Thornton MS and MS Advocates 19.3.1.

98. Hilmo 2004, 115.

99. The equally straightforward judgment of wrongdoing—"it was wiþ wrong" (fol. 215ra, line 2424)—on Vter Pendragon for wreaking destruction as he steals Ygerne from the Duke of Tintagel presents a striking contrast.

Everywhere in the Auchinleck's *Of Arthur and of Merlin* there is a prominent focus on—almost a celebration of—violent encounters, with "political turmoil" consistently "expressed in battle rather than in discussion and maneuvering."[100] Combined with this thirst for blood is a marked focus on young men: the displaced heirs Aurilis and Vter who are too young to bear "armes" (fol. 202va, line 246) but return to England years later to claim their revenge; the precocious Merlin with his intellectual and prophetic superpowers; and the deadly yet kindly warrior-king Arthur, whose young life only is related in Auchinleck despite its being the longest version of *Of Arthur and of Merlin* extant.[101] Along with a simple plot and frequent repetitions of key narrative material to allow easy familiarity, such qualities do indeed suggest that the Middle English *Of Arthur and of Merlin* was adapted from its French original "in various ways . . . to please children,"[102] particularly boys who would one day bear arms and advise kings themselves.

This is not to suggest, however, that there is little in the Auchinleck MS for girls of a similar social class: on the contrary, Auchinleck has been referred to as a women's manuscript[103] and contains a number of works well suited to female readers. The unique Middle English *Lai le Freine*, for instance, presents itself as an ideal text for young noblewomen. It is one of the Auchinleck romances that focus predominantly on young heroes and heroines,[104] and when contrasted with Marie de France's original *Le Fresne*, the Middle English translation seems to aim for intellectual and emotional simplification, as well as moral and doctrinal clarifications that might well be judged appropriate for youthful minds.[105] The heroine Freine is an abandoned twin of ".xii. win*ter* eld" (fol. 262rb, line 238), precisely the age Auchinleck's *Seven Sins* imagines for its young readers, when she learns of her mysterious origins and becomes the lover of the nobleman she eventually marries. She faces tribulations before the marriage, of course, but she meets them with a generous and exemplary forbearance that no doubt rendered her as fine a model of ideal feminine behavior in the secular sphere as the saints Margaret and Katherine were in a more religious context. Katherine in particular, whose exceptional wisdom was attained through education rather than grace alone, would have provided a perfect example of humble piety, intelligence, self-discipline, and charitable household management for learning girls,[106] and more than one young woman in Auchinleck's romances proves equally exemplary. Beves's lady, the once "Saracen" Josiane, guards her virginity with a conviction and vigor to match that of the saints. Guy's Felice is trained in the seven arts and proves as much the hero's instructor as Herhaud;[107] she is also of a steadier temper than her husband. And the young heroine of the *King of Tars* "shows intelligence, breadth of vision, and strength of character," ultimately converting her "Saracen" husband and the whole of his land to Christianity,[108] which makes her a hero indeed between Auchinleck's covers.

So while the Auchinleck MS may well have been a middle-class family book with an emphasis on children's reading as later volumes were, another way to think of the manuscript might be as a children's literary corner itself, or more accurately perhaps, as the nursery library within a larger aristocratic book collection. It may even be the case that Auchinleck was designed to pair texts and tales in a way that promotes a reflective kind of children's reading based on the model of the *Seven Sages*, which uses paired stories to weave its larger tale of youth and truth triumphing over age and deception.[109] By pairing moral and didactic texts with more entertaining and engaging tales (much as the Heege MS booklets do), the compiler and patron of the Auchinleck MS might have hoped to encourage children not only to read the first but also to apply the lessons gained there to the second, and a book organized in this way would very likely satisfy the literary expectations of both children and their parents. We might, for instance, imagine parents in the Warwick household commissioning such a book for younger members of the family, and in this regard the situation of the Beauchamps in the early decades of the fourteenth century is particularly interesting. With the death of Guy in 1315, the house found itself bereft of a lord. His son Thomas had been born only a year or two before and was not knighted or granted control of his lands and appointments until 1330, just when we believe Auchinleck in production. Could such a book have been a gift for the young earl of Warwick, perhaps in preparation for or celebration of acquir-

100. Clifton 2003, 12.

101. The unique *Alliterative Morte Arthure* found in the Lincoln Thornton MS, on the other hand, tells only of Arthur's final battles and downfall.

102. Clifton 2003, 9.

103. By Felicity Riddy: see Fellows 2008, 104.

104. Though to be fair, young people, their *enfances,* and their *aventures* are prevalent in the genre of medieval romance as a whole, a trend that may provide another clue to intended audiences.

105. Beston 1976, 154–55, where he suggests that the translation is the product of a "clerical mind."

106. See especially the discussion in Lewis 1999. Hardman 2004, 56–58, notes that the Heege MS eliminates Katherine's martyrdom, perhaps in sensitivity to the young age of anticipated readers.

107. Harpham Burrows 1984, 108, discusses Felice's education and role as Guy's teacher.

108. Hilmo 2004, 114.

109. Clifton 2005 discusses this paired structure in detail, arguing that the paired texts following the *Seven Sages* in Auchinleck echo, contrast and "answer each other" (199), with one often more religious and the other more secular, and that the Auchinleck MS as a whole "testifies to a serious and sustained production and appreciation of medieval children's literature" (187).

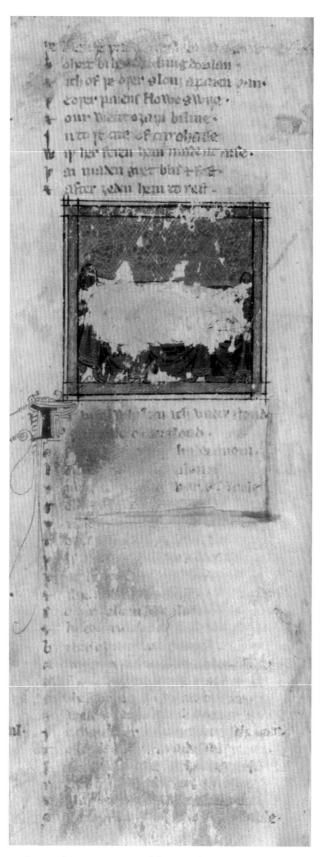

ing his majority? Might one of his guardians, possibly his mother, Alice de Toni, have commissioned Auchinleck with Thomas's training and future success in mind?[110] Possibly. Not only was the family already associated with romances, but like his father and grandfather, Thomas de Beauchamp was familiar with the legend of Guy, and he must have considered that legend a particularly valuable association for his family or he would hardly have named his eldest son Guy (after both his father and the hero) and his third boy Reynbrun (after the hero's son). Thomas could even have commissioned the Auchinleck MS himself as reading material for his sons, which might help explain why the *Reinbrun* romance stands on its own in Auchinleck and sports the largest of the miniatures remaining in the manuscript (only the missing illustration at the opening of the *Guy* romances might have been larger). The divisions and verse changes Auchinleck introduces into the long *Guy of Warwick* story, like the simplification of the text's more difficult ethical issues, can also be explained if we posit a poet or scribe aiming at a young audience, especially one for whom the Guy of Warwick legend was seen as too high a priority—too essential to the Beauchamp/Warwick heritage and authority, say—to be neglected due to the waning attention of childhood.

Some of the damage suffered by Auchinleck might also be accounted for by imagining a youthful aristocratic audience. Young readers and owners (then or later) might well have been responsible for excising Auchinleck's miniatures,[111] and what seems the deliberate rubbing of both miniature and text at folio 256vb may have been an effort (and a successful one at that) to remove content deemed obscene or at least inappropriate for younger audiences (see fig. 8).[112] We would not expect in a collection for young nobles practical entries associated with household management as we would were the readers the children of merchants, and we also would not expect noble parents, no matter how affluent, to pay the price of a deluxe manuscript for a book destined to spend its time in inexperienced and very likely less than careful hands. Of course a low point in Warwick fortunes could also have contributed to the less-than-top-shelf quality of Auchinleck, and

8. The text known as *Þe Wench þat Loved a King* has been rubbed almost completely away and both its miniature and red title defaced as well. Edinburgh, National Library of Scotland, MS Advocates 19.2.1, fol. 256vb.

110. Harpham Burrows 1984, 102, suggests Thomas as the possible owner of Auchinleck.

111. Assuming children a little more likely than adults to deface their books for the sake of pictures, and a book passed down through generations of children at particular risk.

112. The text is usually named *Þe Wench þat Loved a King* from the now rubbed title that was squished in at the top of the column, though the title may have originally been longer and more suggestive, as Macrae-Gibson 1979, 37n3, indicates. Because both text and miniature are so damaged, it is difficult to determine how obscene the content actually was, but both Macrae-Gibson and Furrow 1994, 441, see a bed in the illustration, and very likely two figures lying on it in the scraped central area.

9. The *Simonie* (by Scribe 2) uses a single-column format ultimately abandoned in the majority of the MS; the two-syllable bobs appear to the right. Edinburgh, National Library of Scotland, MS Advocates 19.2.1, fol. 328r.

it is essential to remember that the Beauchamps, though earls, had risen very quickly to their exalted position and were also servants themselves—the aspiring servants of kings. William de Beauchamp was one of the guardians of Prince Edward (later Edward II) and became also a royal constable and steward; his son Guy inherited and increased his father's honors and was councillor to the same prince and third sword at his coronation in 1308; Guy's son Thomas was the most accomplished of the three—pantler and third sword to Edward III, sheriff, constable and chamberlain in various places, chief justice, guardian of the peace, royal commissioner to parliament, captain of the army, chief governor, chief surveyor, and so on.[113]

The family's service to the Edwards may be particularly relevant to the inclusion of the *Simonie*, now the final item

in Auchinleck, though perhaps an early part of the project since it appears in the single-column format later abandoned by Auchinleck's scribes (see fig. 9). A contemporary "estates satire on the disastrous reign of Edward II,"[114] the *Simonie* might not seem a text designed for younger readers, but for the freshly knighted young Thomas faced with serving Edward III and helping him bring the country's high hopes for the new reign to fruition, it would have been appropriate. For him, an understanding of even the harshest political realities and the ways in which they were perceived and expressed by the people of England would have been a necessity. And the same would have been the case with the crusading mentality the *Simonie* demanded (and the whole of Auchinleck celebrated) in the aristocracy.[115] All three Edwards demonstrated at least the

113. See Warwick 1903, 78–79, 80, and 88–89.

114. Finlayson 1990, 163.

115. As Finlayson 1990 notes, the *Simonie* is outspoken about "the corruption of the aristocracy and their failure to expend their energies on fighting for Christianity in crusades" (163).

desire to crusade: Edward I went on crusade before he was crowned and vowed to do so again as king; his son offered the same vow to his people, though likely with somewhat less conviction; and there were plans for Edward III to take up the cross, "lead English knights to the Holy Land and redeem them from a shameful history of failed promises and mutual destruction."[116] Perhaps Thomas de Beauchamp would have followed in the footsteps of the hero Guy and at least one historical Warwick earl and gone crusading with his king,[117] but the growing war with France got in the way (or perhaps took pride of place), and it was there Earl Thomas truly distinguished himself on the battlefield with all the flair of Guy himself, fighting beside the Black Prince against those other enemies across the sea, the French soldiers who in a romance like Auchinleck's *King Richard Coer de Lion*—a text tellingly paired with the *Simonie* at the end of the manuscript—act every bit as "Saracen" toward the English crusaders as the soldiers of Islam do.[118]

There are good reasons, then, to consider seriously the possibility that the Auchinleck MS was made for aristocratic children, just as there are compelling arguments to support the possibility that the merchant's son Chaucer was among the manuscript's readers, but which, if either, more accurately reflects the mysterious fourteenth-century provenance of the book remains uncertain. Given the mobility of some medieval manuscripts, Auchinleck could even have found a home in both environments—an aristocratic gift, say, to a merchant family and their brilliant son, or even a wealthy merchant's gift to a noble overlord with the means to further careers. Medieval books all too rarely provide us with enough information to date and place them with certainty, and students of manuscripts soon grow accustomed to the richness of possibility presented by an anthology like Auchinleck. There are times, of course, when that one right answer is pleasantly unavoidable, but studying medieval manuscripts means enjoying the questions and the search as much as the answers in the recognition that careful and informed conjecture can open new vistas, widen our perspectives, reveal dead ends, and at its best illuminate our route to understanding the past through its textual and visual culture.

II. Romancing the Gentry Household: Robert Thornton's Homemade Family Library

The two romance manuscripts (Lincoln Cathedral MS 91 and BL MS Add. 31042) compiled by the gentleman Robert Thornton, lord of East Newton in North Yorkshire from 1418 until perhaps as late as 1468,[119] contain between them the second largest extant collection of English romances (see "Middle English Romances in the Auchinleck, Thornton, and Findern Manuscripts"). Yet the Thornton volumes share only one romance with Auchinleck—the crusading *King Richard Coer de Lion*, a revealing connection—and are altogether different books. Thornton begins his work nearly a century later; his books are larger,[120] but he uses paper instead of parchment; he and others add domestic material to the literary collection; and we find prose among the verse (though only in the Lincoln volume) and a considerable amount of Latin. Most important of all, instead of six professional scribes working quickly as we found in Auchinleck, we have one provincial gentleman working almost exclusively by himself to gather, copy, correct, organize, reorganize, and possibly decorate what became over the course of several decades from the 1420s to the 1460s two separate volumes. And instead of the professional anonymity of Auchinleck's scribes, we have a "gentleman amateur" who signs his name to his work several times.[121] He wrote in a cursive *Anglicana*, achieving for the most part a fast, fluent, legible script that varies considerably, however, in size, shape, and degree of formality and adornment depending on text, exemplar, language, function, space, fatigue, pen, ink, and

116. Turville-Petre 1996, 120–22.

117. Guy was a crusader in his romance, though he presumably lived long before crusading against the Muslims in the Holy Land was a possibility. On the historical Earl William of Warwick who was a crusader in the time of Henry II, see Mason 1984, 29–30.

118. Details of Thomas's involvement in the French campaigns can be found in Warwick 1903, 89ff.

119. On Thornton's life and family, see especially Keiser 1979 and 1983. As Johnston, forthcoming, ch. 6, points out, Thornton was certainly still alive in 1468, but may be the person listed as recently deceased in a deed dated to 1474.

120. The folios of Lincoln measure in at an average of 291 × 210 mm., and those of London, which has suffered a more severe cropping, at 275 × 200 mm. The books share paper stocks and were no doubt originally the same size, though London, with a present count of 179 folios, may never have been as thick as

Lincoln, which, with its lost leaves included, must have contained approximately 340 folios.

121. See Brewer and Owen 1975, vii, and see also "Thornton Names in the Lincoln and London Manuscripts" below and the figures referred to there for the frequent appearance of Robert's own name among those of other Thornton family members in the two manuscripts. There are very few exceptions to Thornton's scribal hand in the Thornton MSS, but most of the other Thornton names in the two volumes are not his work (the birth record on fol. 49v of Lincoln may be, however: see fig. 28), and in a couple of instances his own name may not be as well (in the scroll on fol. 93v, for instance, and perhaps in the "Here endes . . ." note beneath the *Alliterative Morte Arthure* on fol. 98v: figs. 18 and 17). Other examples of additions not by Thornton include the carol fragments at the top of fol. 94v in London, and in Lincoln the Arthurian epitaph on fol. 98v and the sixteenth-century material on fols. 50r–52r.

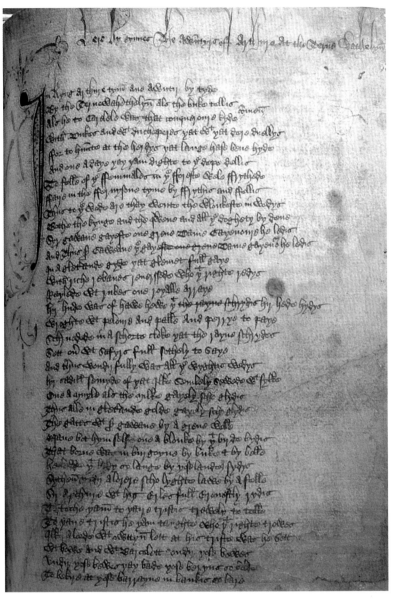

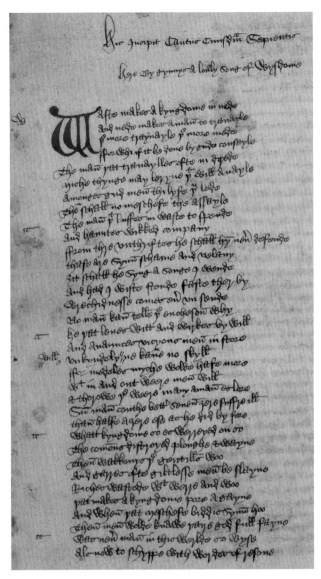

10. The tidy opening of the *Awntyrs of Arthur* with its display script title and finely decorated initial **I**; a diagonal tear across the bottom half has been carefully sewn. Lincoln, Cathedral Library, MS 91, fol. 154r.

11. The opening of the *Song of Wisdom* features a well-spaced title in both Latin and English, a fine though plain green initial **W**, and paraph signs to mark stanzas. London, British Library, MS Add. 31042, fol. 120r.

no doubt scribal mood and wider circumstances as well, such as light, weather, and age. All would have affected Thornton over the forty to fifty years of scribal work he put into his manuscripts. His books are homemade (though he might have sought the help of illustrators at times) and likely created primarily for family use, but he knew how a professional book ought to have looked and at times achieved a tidy, attractive layout, with his titles far more elegant in appearance than those squished into the Auchinleck MS by its primary scribe, and the Lincoln MS sporting some fine painted initials (see, for example, figs. 10 and 11). Yet Thornton's efforts at headings and *mise en page* are also "varied and . . . idiosyncratic,"[122] revealing the errors and uncertainties of an amateur even when he ap-

pears to be aiming for a clear, luxurious, even professional appearance (see figs. 12, 13, and 14).

Laying the Foundations of a Household Romance Library

Fortunately, Thornton's MSS have drawn a considerable amount of scholarly attention, and although we cannot say if he originally intended to create two volumes (or simply one, or three perhaps) or how much of his work is lost to us, there is a great deal that we can say about how he must have constructed his library *in parvo*. It is clear,

122. Thompson 1991, 22n15.

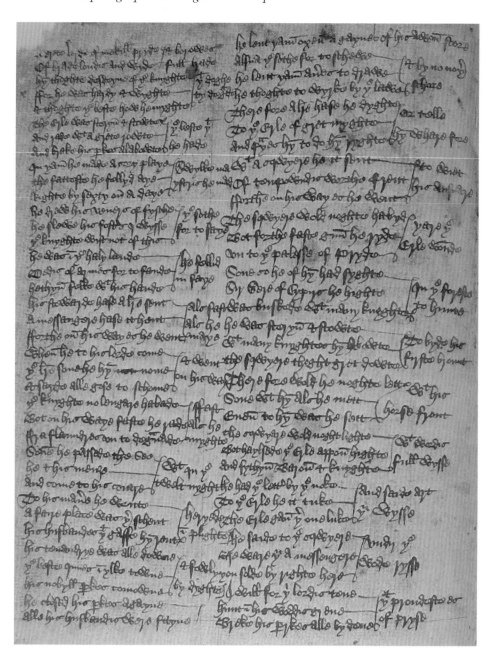

12. Thornton's attempt to mark and lay out the tail-rhyme verses of *Sir Degrevant* in a professional way results in an extremely crowded page. Lincoln, Cathedral Library, MS 91, fol. 130v.

for instance, that he worked to gather and copy the contents of both manuscripts simultaneously,[123] with some of the texts included in the Lincoln volume possibly acquired slightly earlier than those bound in the London collection, and Lincoln's unique *Alliterative Morte Arthure* (fols. 53r ff.) very likely the first item produced.[124] Thornton was a scribe faithful to his exemplars, leaving only a "Yorkshire veneer" on the works he copied from other dialectal regions.[125] So it is possible to determine that the

exemplars he used for the *Alliterative Morte* and the Middle English *Previte of the Passion* (also found in the Lincoln volume) shared a southwest Lincolnshire dialect and were "probably the work of a single scribe."[126] Thornton may well have found both texts in the same manuscript, but he clearly intended to separate the Arthurian romance from the Pseudo-Bonaventuran meditation, because although he used for the *Previte* the same paper stock on which he finished the *Morte*, he started a new quire for each text (now quires D and L: see figs. 15 and 16) instead of copying the *Previte* directly after the *Morte* onto the folios still

123. Often using the same paper stocks across both manuscripts, and without repeating texts, though Psalm 50 does appear in Latin in Lincoln and in English in London, while London contains both a false start and a complete version of the *Passionis Christi Cantus* on 94r–v, in the second instance with space above for an illustration.

124. See especially Keiser 1979, 178.

125. Hamel 1983, 122.

126. McIntosh 1962, 232–33.

13. Two charms against toothache were added rather sloppily after *Sir Perceval*; the name "Robert Thorntone" is inserted above the romance's explicit at the bottom left. Lincoln, Cathedral Library, MS 91, fol. 176r.

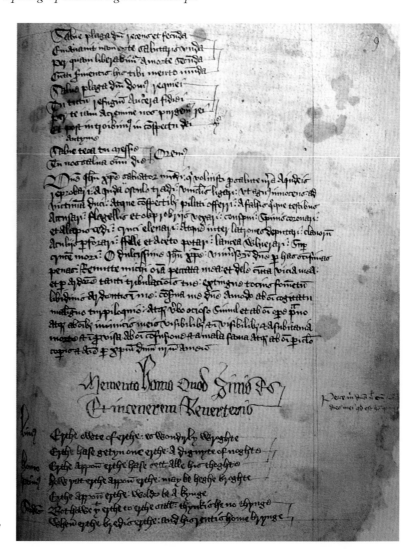

14. A number of short texts that show how Thornton mixed verse and prose (middle), Latin and English (bottom), and varied his script as well. Lincoln, Cathedral Library, MS 91, fol. 279r.

remaining in its final quire (F).[127] Like the compiler of the Auchinleck collection, then, Thornton appears to have observed something of a generic distinction between romance and spiritual works, but whereas the pious works come first in Auchinleck (though we cannot be entirely sure about the lost items that once opened the volume), Thornton's Lincoln MS prioritizes romance, presenting in its final shape all nine of its knightly adventures before the early *Previte* (on fol. 179r) and the doctrinal and devotional texts that follow it.[128]

Whether or not Thornton originally envisioned a large romance anthology, that is precisely what appears to have grown in more or less organized quires around the *Alliterative Morte*. The earliest addition appears to have been the *Awntyrs of Arthur*, which shares paper stock with the first part of the *Morte* although it now begins (fig. 10) about a hundred folios after the opening of that poem (fig. 15).[129] Next came the tales following immediately upon the *Morte*: these were copied (after some initial delay perhaps) in a straightforward manner, one after another, in double columns (rather than the *Morte*'s single columns: see fig. 17 for the shift), with the first three (*Octavian, Ysumbras,* and the *Earl of Tolous*) marked as romances by their incipit headings, and very likely copied from the same exemplar.[130] It is

127. Assuming the *Morte* was copied before the *Previte*, though even were they copied in reverse, Thornton did not choose to add the *Morte* to the end of the *Previte*, maintaining the generic distinction. On the watermarks and paper stocks in the Thornton MSS, see especially Thompson 1987, 71–73, and Hanna 1987b.

128. See the list of the manuscript's contents in Brewer and Owen 1975, xvii–xx. The devotional section of Lincoln shares paper stocks with a number of the manuscript's romances, indicating ongoing, simultaneous work on both sections of the book.

129. Both the *Awntyrs* and the *Northern Passion* (in the London volume) use the same paper stock as the first part of the *Alliterative*

Morte, suggesting that they may have been copied at the same time as or possibly even before the *Morte*: see Hanna 1987b, 52–54 and 56.

130. See McSparran and Robinson 1979, xvi, Thompson 1983, 119n11 (who looks at the makeup and production of Lincoln's romance section in some detail), and Hanna 1987b, 55 and 57. This exemplar appears linguistically to have come from the area where Yorkshire, Lincolnshire, and Nottinghamshire meet, and also seems to have provided the texts for *Perceval* and the *Abbey of the Holy Ghost* in the Lincoln volume, and for the *Siege of Milan, Winner and Waster,* and the *Parliament of the Three Ages* in London.

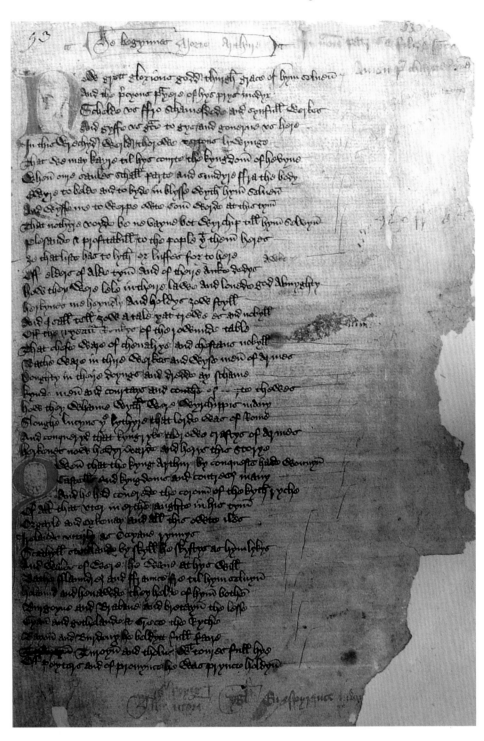

15. The well-worn opening of the *Alliterative Morte Arthure* sports an abundance of red ink, including a prayer (top right) and what seems a family motto (bottom). Lincoln, Cathedral Library, MS 91, fol. 53r.

true that before we come to the end of *Sir Perceval of Gales* (fol. 176ra; see fig. 13), the last of the Lincoln romances, we encounter a few pieces (most of them filler items) that seem not a perfect fit,[131] but for the most part, the romance

theme is maintained. With the exception of the particularly fine initials opening *Ysumbras* and the *Awntyrs of Arthur* (fols. 109r and 154r: see fig. 10), however, none of the romances following the *Morte* received the sort of generous rubrication and decoration Thornton lavished on the alliterative poem,[132] suggesting either that Thornton's original

131. The most difficult to account for is the *Vita Sancti Christofori* (fols. 122v ff.) copied in double columns along with the tail-rhyme romances. It may have been available in a romance exemplar used by Thornton, or perhaps it related enough of the saint's secular adventures for Thornton to blend it seamlessly (for a medieval reader) into his romance section, much as, in reverse, the *King of Tars* and *Amis and Amiloun* were included with Auchinleck's pious texts.

132. Neither does the *Previte*, which is in keeping with the general trend of the Lincoln volume, where the devotional texts sport less decoration than the romances. The London MS presents the opposite situation, with the devotional texts more generously provided with Lombard capitals, as well as introductions and colophons, than the more secular texts were.

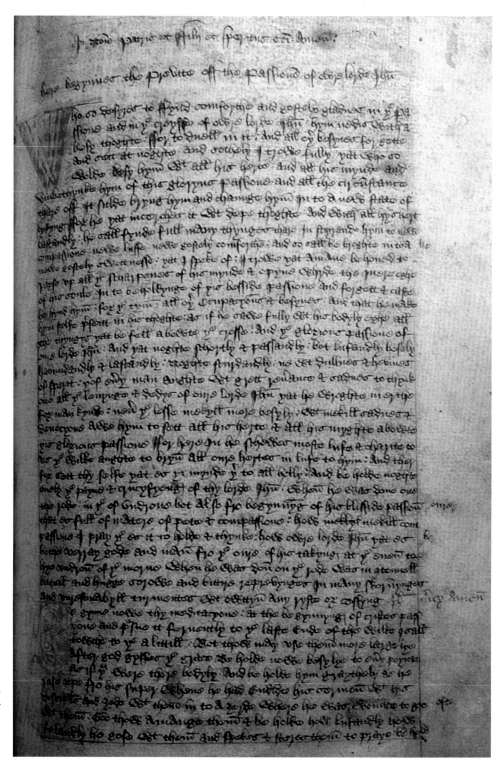

16. The *Previte of the Passion* shares paper stock, an opening prayer, and likely an exemplar with the *Alliterative Morte*, but not its quire. Lincoln, Cathedral Library, MS 91, fol. 179r.

plan for his romances was more elaborate than their layout actually proved to be, or that he had in fact intended the *Morte* to be something of a showpiece to open his budding romance collection. With its long lines framed by broad spaces and marked with red brackets, and its Lombard capitals illustrated with vines and historiated with animal, human, and hybrid figures extending into the margins, the *Alliterative Morte* would have made a fine opening piece for Thornton's collection (see, for instance, figs. 15 and 18).

The special attention Thornton lavished on the *Morte* might well have been inspired by a nationalism similar to that expressed in the folios of the Auchinleck MS. If so, this unique British version of the Arthurian legend would have suited his purpose well, but there may also have been something personal in his choice of opening romance. The scribe's name is recorded in his own display script at both the beginning (in what looks to be a red-ink family motto: see fig. 15) and end (fol. 98v; fig. 17) of the *Morte*,

and written yet again at the end by what may be a different hand (acknowledging Thornton as scribe).[133] It is also incorporated into the poem by the hand of the illustrator, perhaps Thornton himself,[134] who wrote the name "Robart Thornton" in a scroll held by a bird that extends into the left margin from the capital **K** of a passage where King Frederik of Frisia asks who the knight who so "greffede" them (line 3870) and now lies face down on the battlefield may be (fol. 93v; fig. 18).[135] The knight is the great Sir Gawain, as his killer Mordred soon confirms, but Frederik identifies him only by the "griffoune of golde" on his arms (line 3869). Is it this griffon that the artist has attempted to depict, however inaccurately? Or perhaps a "hawk of May," since that is what Gawain's name (Gwalchmai) means in its original early Welsh? And what was intended by this personal connection to Gawain? Was a paid artist complementing his patron by equating him with a British knight not only related to King Arthur but "makles one molde" (line 3875)? Or do we have Thornton himself, in a careful script, connecting his family with that line? Or perhaps a later hand writing a memorial after the scribe's death and suggesting that Thornton, too, unlikely as that may be, died a glorious and heroic death in battle?[136]

Whatever the reasoning behind the name was, the Thornton initial would have been a particularly fitting addition to the opening poem of a significant romance collection aimed at a family audience, just as the ink drawings that immediately precede the poem are a fitting introduction to both it and the romance collection as a whole (see fol. 52v; fig. 19). No Thornton references appear here—the import is more universal—but a simple drawing of a knight in full plate armor bearing a shield with three crowns on it, generally an allusion in Arthurian iconography to the three Welsh kingdoms traditionally associated with King Arthur. The knight holds his sword aloft to face a much larger warrior, who is often understood as

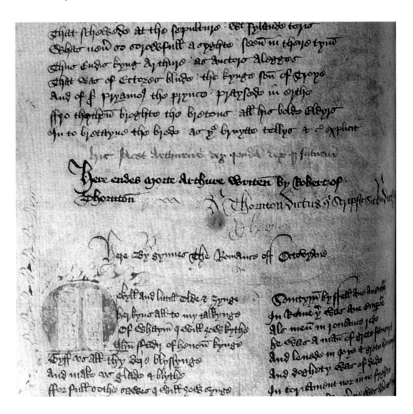

17. An Arthurian epitaph and the scribe's name (more than once) and prayer appear between the long lines of the *Alliterative Morte* and the shorter verses of *Octavian*. Lincoln, Cathedral Library, MS 91, fol. 98v (detail).

18. The name "Robart Thornton" appears in a scroll held by a bird that illustrates a passage of the *Alliterative Morte* dealing with Gawain's identity. Lincoln, Cathedral Library, MS 91, fol. 93v (detail).

133. As Johnston 2007, 309n28, notes, the motto on fol. 53r of Lincoln may be some form of the Percy motto, thus connecting Thornton and his loyalties to one of the most powerful families in fifteenth-century Yorkshire. The instance of Thornton's name in what may not be Thornton's hand at the end of the *Morte* is odd in using the form Robert of Thornton, but a claim established in 1398 refers to both the scribe's father Robert and another relative named Richard as "de Thornton" (Johnston 2007, 311).

134. The decoration and illustration of the two Thornton MSS seems in many instances to be Thornton's own work, a conclusion to which Thompson's work on the manuscripts has led him as well. Fredell 1994 identifies three different styles in the decorated initials of Lincoln and argues they are the product of three different, likely specialist hands, not any of them certainly Thornton's.

135. Quotations are from Lincoln; line numbers from Benson 1986.

136. The Muster Rolls for 1420 record a Robert Thornton esquire serving the English army in France, so it may be that the Thornton scribe was a soldier at some point in his life: see Johnston, forthcoming, ch. 6.

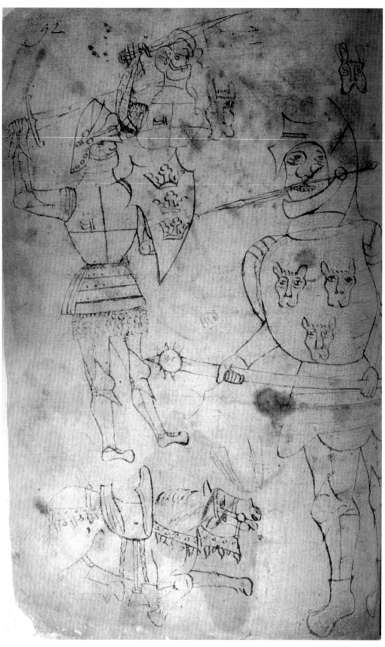

19. Added across from the opening of the *Alliterative Morte*, these interesting ink drawings play with chivalric themes from the manuscript's romances. Lincoln, Cathedral Library, MS 91, fol. 52v.

the giant Arthur vanquishes on Mont San Michel (the episode begins on folio 62r in the *Alliterative Morte*; lines 840–1221). The expression and features of the giant as well as his daunting club are fair representations of the bestiality described in the poem, but in the illustration he, too, is attired as a late medieval knight would be, complete with his own heraldic device of three lions' heads. Is the artist here having a laugh at the aristocracy's expense, or perhaps taking a serious jab at them by suggesting just where bestial behavior often lies?

He certainly seems to have read the *Alliterative Morte* with some care, since the giant's three lions recall the

"thre lyons: all' of whitte siluyre" that Mordred assumes as a device to hide his identity in his final battle with Arthur (fol. 96v, line 4183). The drawing may, then, depict Arthur fighting the monster his nephew has grown into as much as the monstrous giant, and Mordred is not the only warrior to display lions in the many battles Arthur and his men fight in the *Alliterative Morte*. We might see a reference, for instance, to the heathen king of "lebe," who rides into the battle "in lyones of siluere," "chaces þe childire of þe kynges chambire | And killes . . . cheualrous knyghttes" (fol. 72v, lines 1818 and 1821–22), rendering him a "Saracen" example of disordered violence to rival the giant. In crusade romances it is often the giant, after all, who is "the most formidable representative of heathenism,"[137] and viewing folio 52v's illustration as a depiction of Christian good conquering heathen evil in knightly combat seems appropriate. So, too, does an understanding of those rough drawings as a representation of the controlled aggression of proper rule holding its ground against the wilder, power- and possession-hungry sort that urges the giant's monstrous crimes or the Lybian king's misplaced military violence or the terrible personal betrayal of Mordred.

In the troubled English landscape of the fifteenth century, aggression must have seemed to part ways with control far too often, and in the epic landscape of the *Alliterative Morte* even Arthur (perhaps especially Arthur) is guilty of overacquisition and disordered violence, proving to be his own worst enemy by striving for more through battle and conquest while neglecting (and passing along to Mordred) what he already has and has a responsibility to govern.[138] Arthur's household, his ideal Round Table community of Christian knights, becomes from another perspective "a monstrous community of plenitude . . . that both gathers and destroys by doing so,"[139] ultimately destroying itself. Could an illustration that seems on first glance crude and unsophisticated—even the work of a child perhaps—in fact represent Arthur's metaphorical battle with a monstrous version of himself, the crowns of rightful rule transformed into beasts of prey? Or perhaps his struggle with a symbolic figure of aristocratic ambitions gone wild? The knightly garb of the larger figure makes good sense either way, and it may well be that the point of the drawing is less to depict any one scene than to represent in a symbolic way the chivalric battle with one's greatest enemies, whoever or whatever they may be, which would be a particularly fine way to illustrate a medieval romance collection.

137. McAlindon 1963, 367.

138. As Smith 2003, 67, has argued, Arthur's greatest flaw is his "tragic imperial oblivion, his unwillingness to manage his own intrinsic and familiar wealth even while he desires more."

139. Ibid.

The Growing Ambitions of an Amateur Book Builder

It may be that Thornton himself added at least some of these deceptively simple drawings before his death in the 1460s or 1470s,[140] but whether we can be certain of that or not, it is important to acknowledge that they were added and not an original part of the *Alliterative Morte*, which begins, as I said above, on folio 53r in a new quire. The drawings (along with personal family records, weather prognostications, and a *Lamentatio Peccatoris* [*Lamentation of a Sinner*]) are filler items, taking up space left after Thornton placed a new romance—the *Prose Life of Alexander*—at the head of his collection. Short items frequently fill the spaces left at the end of quires and booklets in Thornton's MSS (like the charms against toothache that follow the *Perceval* romance in Lincoln: see fig. 13), presumably for the doublefold reason that paper, economical as it was, was best not wasted, and exemplars (or other sources) once discovered often had to be recorded immediately, before the opportunity had passed. Uneven availability of exemplars combined with the practical exigencies of bookmaking must have influenced the contents and shape of Thornton's homespun volumes more often than we can retrace today, but one instance of reshaping what he had already copied in order to accommodate efficiently and economically texts he was newly acquiring is worth a careful look before I turn back to that new *Alexander* romance he added to the front of the Lincoln MS.

In quire I we find three short filler items tucked in after the romance of *Eglamour*. This in itself is unremarkable, and the *De Miraculo Beate Marie* (*On a Miracle of St. Mary*), *Lyarde*, and *Thomas of Ersseldoune* all share enough with the romances to fit fairly well within the collection. What is unusual, however, is that they do not appear at the end of the quire, but in its middle, or rather on the folios just to the left of its center and immediately before the *Awntyrs of Arthur* that start midquire (on fol. 154r, fig. 10). This odd situation appears to have been the result of Thornton's refolding and restructuring a gathering that had started earlier in the project with the *Awntyrs*, a text likely copied around the same time as the *Alliterative Morte*.[141] The *Awntyrs* now fill the second half of the quire, but the inner bi-folium the romance begins on is a little grubby, and both that and the finely executed and elaborately colored capital **I** that opens the *Awntyrs* suggest that it once lay on the outside rather than the inside of the gathering. What seems to have happened is this: Thornton was copying *Eglamour* into what eventually became quire H, but he ran out of room so decided to use the folios remaining in quire I, where the *Awntyrs* were copied earlier. To do so he had to refold I, turning its outer bifolium in as one might fold back the covers of a book upon themselves to loosen its binding. What were once outside faces thus meet in the center, the empty second half of the gathering becomes the first half, and that is where Thornton finishes *Eglamour* and adds the three filler items before the *Awntyrs*' luxurious opening, now buried in the middle of the quire. It is a simple and clever solution to the difficulties associated with constructing a book both economically and gradually, without constant access to a large supplying library, and Thornton resorted to such bookmaking practices frequently. He refolds in the London volume as well, and in both manuscripts he also adds extra folios to quires in progress by folding batches of new paper stock into their centers, a practical and cost-effective technique for accommodating unexpected (or unexpectedly long) texts within a given section of his growing library.[142]

Thornton's addition of the *Prose Alexander* to the front of his romance anthology, however, was neither practical nor thrifty, but like a grand facade in a new style added to an older church, it reveals a touch of the flamboyant that seems in keeping with Thornton's scribal character. Thornton's relationship with bookmaking was neither short nor understated but a long and intimate romance, and he seems to have flaunted his production and possession of texts by signing his name to them again and again (see "Thornton Names in the Lincoln and London Manuscripts"). He flaunts his piety, an equally fashionable possession among the gentry and aristocracy of his time, more often still by recording his personal prayers with yet greater frequency.[143] And it is likely that he intended to flaunt his wealth and literary sophistication as well by adding, perhaps as he fiddled with the final structure his booklets would take, a new text not just to the opening of

140. The ink of some of the drawings on fol. 52v is, however, very similar to that used for some of the sixteenth-century material on the preceding folios, suggesting the work of later readers: see Thompson 1987, 3n13. The giant's face, however, particularly his enlarged mouth and teeth (signs, perhaps, of his unruly appetites), resembles the tiny faces tucked into capitals within the *Morte* on fols. 53r (fig. 15) and 66r, where the subject depicted is more likely King Arthur than his monstrous foe. The implication is that the artist of some of the informal drawings and that of the *Morte*'s decorated initials might have been one and the same person, making the scribe Thornton a likely candidate.

141. See Thompson 1983 for a detailed explanation of the production of Lincoln's quire I.

142. See Thompson 1987, 35–55, for an exhaustive analysis of the compilation procedures of the London volume; refolding and the folding in of additional folios (actually another quire) is discussed on 38–40. See also Hanna 1984 on the addition of extra folios to quires in both Lincoln and London.

143. A few of these are transcribed along with Thornton's name in "Thornton Names in the Lincoln and London Manuscripts" and see figs. 15, 16, 17, and 29a and b. He uses "Amen" especially frequently (by itself, sometimes several times in a row, and with his explicits, name, and other prayers) and constantly alters his wording, but a characteristic scribal tag is *R Thornton dictus qui scripsit sit benedictus Amen* (as on fols. 98v and 213r of Lincoln, and fol. 66r of London).

Thornton Names in the Lincoln and London Manuscripts

Unless otherwise indicated, all names are in the hand of the main scribe, Robert Thornton. I have included notes and prayers if they clearly accompany a name and are written in the same hand. Conjectures regarding the identification of hands are marked with a query (?).

Lincoln, Cathedral Library, MS 91

North Yorkshire, between the 1420s and 1460s

23v: thorn-ton rebus of a vine sprouting from a barrel (fig. 27)
 (illustrator's hand; drawn within a capital **A** in the *Life of Alexander*)

49v: Isto die nat*us* ffuit ^sancta maria cruce d*omini* n*ostri* Ihe*su* Cris*ti*^ Robert*us*
 Thornton in Ridayll' anno d*omini* m*illesimo* cccc liij (fig. 28)
 (hand of the scribe? or the scribe's son? recording the birth of the scribe's grandson; two rough
 and abandoned attempts to copy the record appear beneath it)

49v: Wylli*am* thorntson ar[*miger*]o this Boke
 (hand of the scribe's son? or perhaps great-grandson? attempting a display script) (fig.28)

53r: **Espoyez]**
 Tho[r]nton y*n*gli*sh*] En espyrance may [any additional text lost to damage] (fig. 15)
 (red display script at the bottom of the first folio of the *Alliterative Morte Arthure*)

75v: Edward Thornton
 (hand of the scribe's great-great-grandson?; upside down in the *Alliterative Morte*)

93v: Robart Thornton (fig. 18)
 (illustrator's hand; in a scroll held by a bird beside a capital **K** in the *Alliterative Morte*)

98v: Here endes Morte Arthure writen*e* by Robert' of. | Thornton*e* (fig. 17)
 (scribal hand?)

98v: ⌢⌒⌣ R Thornton dictus q*ui* scripsit sit b*e*n*edictus* Ame*n* (fig. 17)
 (in display script; between the *Alliterative Morte* and *Octavian*; a rough attempt to copy the name
 appears immediately below it)

129vb: Explicit Vita s*an*c*t*i C*r*is*t*ofori Thornton [name very faint]

135va: Ellenor Thorn*ton*
 (hand of a sixteenth-century family member; in *Sir Degrevaunt*)

137rb: Edward' thor[*n*]ton . . .
 (hand of the scribe's great-great-grandson?; in *Sir Degrevaunt*)

144vb: Wylli*am* thorn[*ton*] . . .
 (hand of one of several sixteenth-century William Thorntons; upside down in *Sir Eglamour*)

176ra: Explicit ^quod Robe*r*t Thorntone^ S*i*r Percevell' De Gales Here
 endys þe Romance of S*i*r Percevell' of Gales Cosyn*e*
 to kyng Arthoure ⌒⌒⌒ ⌒⌒ ⌒⌒⌒ ⌒⌒ ⌒⌒⌒ (fig. 13)
 (some display script)

194r: edward' thornton (fig. 29b)
 (hand of the scribe's great-great-grandson?; beneath works by Richard Rolle)

211v: Explicit Tractatus Explicit ~~Amen Thorntone Amen~~
 (at the end of a *Hymn to Jesus*)

213r: R Thornt*e* dictus qui scripsit sit benedictus Amen
 (at the end of a meditation and prayer on the cross)

265r: Dorythy Thornton
 (hand of a seventeenth-century family member; sideways in the Latin Psalter)

266r: Dorythy Thornton
 (hand of a seventeenth-century family member; sideways in the Latin Psalter)

278v: Thornton*e* Misereatur mei dei [*sic*]
 Miserere mei deus
 (begins in display script; among Prayers and Anthems)

London, British Library, MS Add. 31042

North Yorkshire, between the 1420s and 1460s

50r: Amen Amen' p*er* charite
 And louynge to god þ*er*fore gyfe we
 R Thorntone (fig. 21)
 (name in display script; the letters *horn* in name later rubbed and both *T* and *t* altered, perhaps to
 S and *s*; at the end of the *Northern Passion*)

66r: Amen' Amen' Amen
 Explicit la sege de Ierusalem'
 R Thornton dictus q*ui* scripsit sit ben*e*dictus Amen'
 (name later altered, the *T* possibly to a *C* or *S*, *or* likely to *ff*, and *t* to an *s*)

his romance collection in the Lincoln volume but also to the front of the London volume. In Lincoln the *Alliterative Morte* has yielded pride of place to the unique Middle English prose *Life of Alexander*, maybe because Thornton wished to set an urbane, international tone for his romance section by highlighting a popular continental hero and his exotic Eastern adventures, instead of the more insular and traditional Arthur. In addition, Alexander (as Aristotle's student) became known as the philosopher king, his life and deeds had more basis in historical fact than Arthur's, and English prose was in Thornton's day seen as a more serious and fashionable medium than verse (particularly provincial alliterative verse), so it is entirely possible that Thornton was revealing here his intellectual pretensions as well as his social ones.

A similar pattern occurs in the London MS. There it is the *Northern Passion,* written on the same paper stock as the beginning sections of the *Alliterative Morte* and the *Awntyrs of Arthur,* that seems to have been copied first and lavished with the decorative attention befitting the opening of a section on sacred or Christian history, as opposed to the secular if fanciful history presented by the Arthurian and other romances.[144] Thornton began the *Passion* with a finely decorated capital low on the page, leaving a fourteen-line space across the top of both columns, presumably for an elaborate illustration, perhaps of the crucifixion, but just possibly of the angel's annunciation to Mary that renders the crucifixion significant and marks the beginning of Christ's role in human salvation (see fol. 33r; fig. 20).[145] Such an illustration was never executed, however; instead,

144. After the *Passion* Thornton copied the first three of London's four crusading romances (see "Middle English Romances in the Auchinleck, Thornton, and Findern Manuscripts").

145. Though difficult to make out, the faded guide word in the right side of the space may be *Annunciacio.*

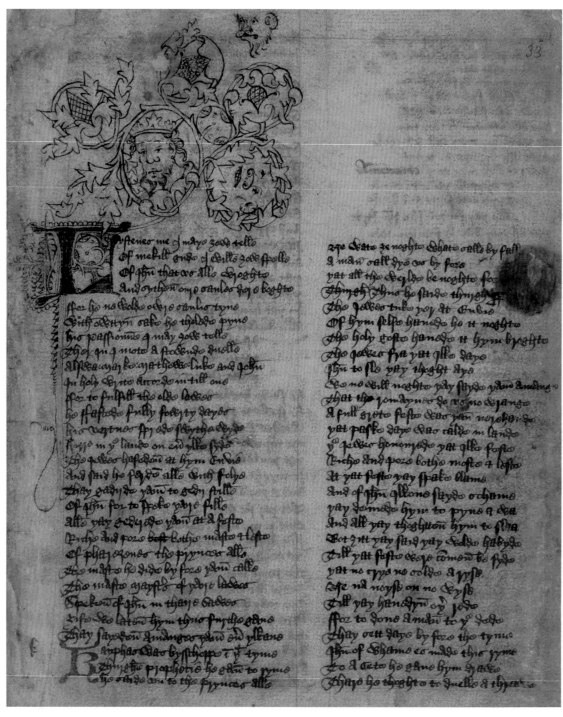

20. Thornton left room for a large, perhaps professional illustration to open the *Northern Passion* but ended up with an ink drawing, likely his own, that fills only half the space. London, British Library, MS Add. 31042, fol. 33r.

from the capital **L** in the left column there springs a heavy, twisting vine with the face of a crowned king depicted as the flower in one of its loops. A beast's head appears in another loop, while a second beastly head hovers just above the vine, both of these very similar to the head that sprouts from the initial **I** on folio 50r where the *Siege of Jerusalem* begins (fig. 21).[146] The image above the *Passion* could be said to highlight the role of Christ as king of kings (a role Thornton would no doubt have considered important given the interest with lordship and authority

suggested by the contents of the Lincoln volume), and we might then see the beast as a representation of the devil Christ does battle with in his crucifixion. Yet the drawing simply does not fit the space left for it, filling only a single column's width. Potentially sophisticated, then, in literary

146. Features of fol. 50r's beast head (its sharp ears, for example) resemble figures in the margins of the *Alliterative Morte* (a mouse-like creature with elongated ears at the bottom of fol. 72v, for instance) and connects the illustration of London to that of Lincoln.

21. Atop the initial **I** opening the *Siege of Jerusalem* is a beast like those on fol.33r; the scribe's name beneath the *Northern Passion* is partially defaced. London, British Library, MS Add. 31042, fol. 50r.

terms and skilfully executed as far as pen work goes, the illustration, like the page, stands out as unprofessional and unfinished—the text doesn't even bear a title—and it is likely that the drawing represents a compromise adopted by Thornton himself (certainly the ink of drawing and text are similar) when he realized that his grander plans for the opening folio of London would not be achieved.

As it turned out, folio 33r did not even become the opening page of the London MS, which does not begin with the *Northern Passion* and the Christian romances that follow it. Like the *Alliterative Morte* in Lincoln, the *Northern Passion* yields its position to another text, this time extracts from the *Cursor Mundi* (*Course of the World*), a long and encyclopedic compilation of biblical and historical events that suits the context of Thornton's sacred history booklet well. Here the way in which Thornton makes the transi-

tion from the opening *Cursor* to the *Passion* is particularly interesting. Thornton's first added extract brings the narrative up to the crucifixion, but at that point he adapts the narrative intrusion found in northern copies of the *Cursor* to suit his particular purposes, claiming (on fol. 32rb) that he will go on to Christ's passion by beginning "Anothir boke" (line 5), presumably the *Northern Passion* that starts on folio 33r since he never does include the *Cursor*'s report of the event.[147] Thornton did not, however, go directly on to his new "boke," perhaps partially because his

147. Thompson 1987, 49, suggests the dissatisfying nature of the *Cursor*'s passion narrative as a possible explanation and discusses the manuscript evidence. The fact that Thornton already owned a superior version of the passion was no doubt paramount.

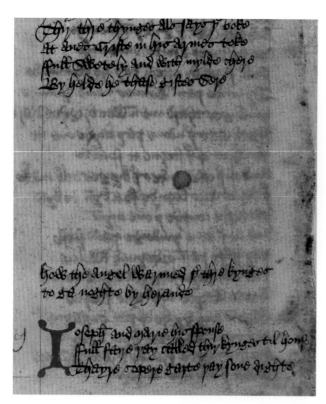

22. In the extracts from the *Cursor Mundi* added to the front of the London MS, Thornton left spaces for a (professional?) cycle of single-column miniatures. London, British Library, MS Add. 31042, fol. 8vb (detail).

quire (B) was not yet quite full. Instead, he filled the folio and a half that remained between the end of the *Cursor* extract and the already written *Northern Passion* first with a rather characteristic prayer for God's grace in completing his scribal duties and a plea for his readers' prayers, then with another fragment of the *Cursor*—the *Discourse between Christ and Man* (lines 17111ff.) that should, by rights, appear after the crucifixion, not before it.[148] It is unlikely to be a mistake: Thornton seems aware of his rearrangement of the narrative, and after the explicit to the *Discourse* explains himself to his reader on folio 32vb, in Latin this time and in a somewhat unusual way:

> Et Sic procedend*um* ad passion*em*
> d*omi*ni n*ost*ri Ih*es*u Crist*i* que incipit in folio
> p*ro*xim*o* sequent*e* sec*und*um ffantasiam scriptoris

> [And so one should proceed to the passion of our Lord
> Jesus Christ which begins
> on the next folio following according to the fantasy of
> the scribe].

That Thornton wanted his audience to read on into the *Northern Passion* is clearer than exactly what he meant by his scribal *fantasia*—some sort of humble *apologia*, most obviously, for indulging his whims as copyist and editor. Yet in both late medieval literary theory and scholastic psychology the Latin *fantasia* (*fantasie* in the vernacular) referred to a human faculty, the bodily wit that worked to "forge and compowne, *or to sette to gedir in seemyng*" things of different kinds.[149] Emphasizing his role as the forger and compiler, as well as the scribe, just as he is in the process of combining texts in new ways to give his own collection on sacred history something of a facelift may suggest personal intentions not quite so humble but very much in keeping with the illustrative plans for both the *Cursor* and the *Prose Alexander*. Unfortunately the beginnings of both of Thornton's new opening texts have been lost (just possibly because they were removed for their tempting illustrations), so we have no way of knowing what they may have looked like save by judging in relation to the sections of text we do have. By that measure, they must have been Thornton's most lavish efforts yet, since in no other part of either Thornton MS do we find the scribe leaving spaces within (rather than simply before) a text to accommodate a cycle of illustrations as he does in his new additions. Above nine of nineteen chapters in the *Cursor* Thornton leaves single-column spaces for illustrations that would likely have reflected the following chapters' contents (as on fol. 8vb, fig. 22), and in the surviving part of *Alexander* he leaves ten spaces of a similar size, occasionally indicating the topic to be illustrated by notes in the margins as though he were planning on another individual, perhaps a professional artist, completing the illustrations for him (as on fol. 7r, fig. 23).

If so, then Thornton was indeed intending to invest a good deal more in these new openings than he had in every other part of his scribal project, even the *Alliterative Morte* which received only small historiated initials, not full miniatures. Thornton did not manage to achieve his grandiose goals for these opening pieces, however, whether because the project proved too financially challenging or an appropriate artist too difficult to track down, and so the spaces remain in the Thornton MSS to this day. All save one, that is: on folio 6r of the Lincoln volume a decorated capital **Q** far larger than any of the others in the *Prose Alexander* has been used to fill one of the spaces, resulting in the spelling "**Q**When" for the word "When" that opens the following section (fig. 24).[150] This *littera notabilior* would seem to be a compromise adopted by

148. Line numbers are from Morris 1874–93. Johnston 2009, 143–44, points out that Thornton copied only the sections of the *Cursor Mundi* that were written in rhyming couplets, a meter also used in the *Northern Passion*, giving the two texts the appearance of "companion pieces."

149. As Thompson 1987, 52, discusses.
150. The spelling "QWhen" for modern "When" is not unprededented elsewhere in the manuscript (an example appears on fol. 57v), and see also "**Q**wen" at the second red capital on fol. 53r (fig. 15).

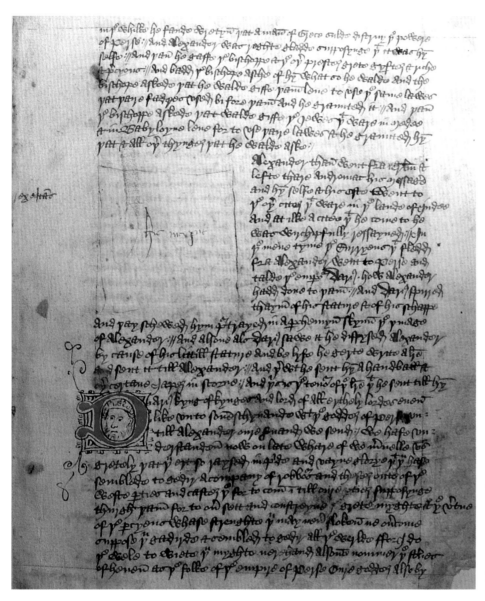

23. In the *Life of Alexander*, Thornton again left spaces for illustrations, and in this example indicated the image content with the words "rex equi*tans*" (the king rides) in the left margin. Lincoln, Cathedral Library, MS 91, fol. 7r.

Thornton once it was clear that the original plans could or would not be achieved, yet it is an experiment taken no further in the manuscript. All of the other *Alexander* capitals are of a more usual size and placement, yet they include the majority of Lincoln's most elaborate and most exquisitely executed capitals (see fig. 25).[151] It may be that we can attribute even these highly accomplished initials to Thornton, though he might have been shy of tackling full miniatures and shy also of the funds to hire another

to do so. Not only do they share features with the less lavish but more abundant initials found throughout the volume and completed over many years, but Thornton played a role in decorating both his manuscripts as their rubricator[152] that extended at times to the simpler initials often executed in the same red ink, and may well have extended to the more elaborate capitals as well (see fig. 26). If Thornton did act as an illustrator in his household books, then it may be to him that we should attribute the

151. Fredell 1994 labels these colorful and elaborate capitals Style 2. There are only five of them by Fredell's reckoning— the first three in *Alexander* (fols. 19r, 19v, and 27r: fig. 25), and the other two opening verse romances (*Ysumbras* at fol. 109r and the *Awntyrs* at fol. 154r: fig. 10)—though several other capitals in the manuscript share features with them, and the bicolored initial on fol. 163v of London (fig. 26) shares the red-and-green combination seen in figs. 10 and 25. The **Q** on fol. 6r, however, is in Fredell's Style 1, the most common style of initials in Lincoln.

152. See Thompson 1987, 56–57. The incipit headings for both the *Vita Sancti Christofori* in Lincoln (fol. 122vb) and the *Romance of the Childhood of Jesus Christ* in London (fol. 163va; fig. 26) are written in Thornton's hand and the rubricator's red ink; in the second example the capital **A** opening the text is also partially executed in the same red ink. Other instances in Lincoln are written partially in red, like the title for the *Alliterative Morte Arthure* at the top of fol. 53r (fig. 15), and see also the red initials and rubrication in fig. 29a and b.

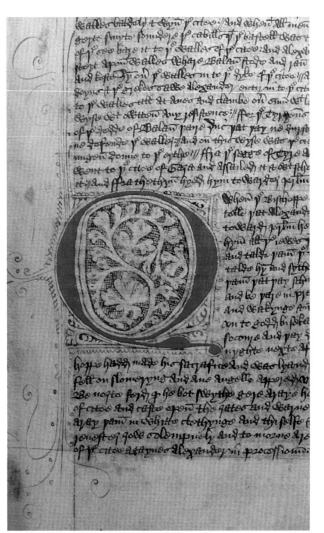

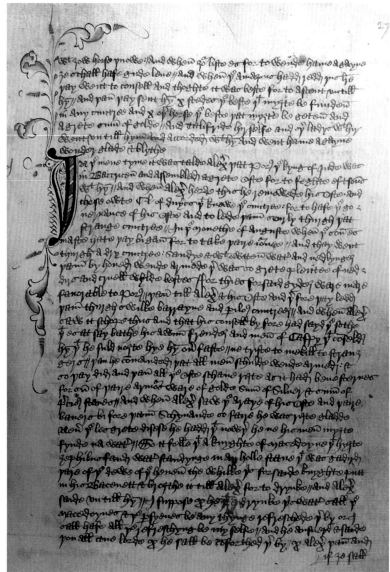

24. The enormous decorated initial **Q** in the *Life of Alexander* is a creative use of space very likely
originally left blank for a professional miniature that was never executed. Lincoln, Cathedral Library,
MS 91, fol. 6r (detail).

25. The fine initial **I** on fol.27r is one of a group of Lincoln capitals that are particularly accomplished
in both artistic design and use of color. Lincoln, Cathedral Library, MS 91, fol. 27r.

personalization of his lavish new *Alexander* romance with
a rebus of the Thornton name drawn in the form of a
"thorn" sprouting from a barrel or "tun" within the capital
A on folio 23v (fig. 27).[153]

Romances for (and from) Family and Friends

The specially designed Thornton initials in both the *Allit-
erative Morte* and the *Prose Alexander* link not only the scribe
but also his family with these two romance texts—both
extant only in the Lincoln MS and both anonymous—
and these personalizations are far from the only reasons
to think Thornton's scribal work directed primarily at his
own family. Certainly his lavish new plans for the opening

of both manuscripts may have been intended to impress
others who encountered the books, but they could as eas-
ily have been visible signs of wealth and prestige intended
for the enjoyment (both artistic and social) of those proud
family members who had achieved it. Family names appear
several times in the Lincoln volume (see "Thornton Names
in the Lincoln and London Manuscripts" for a transcrip-
tion of them), which gives every impression of a book well
used, carefully maintained, even treasured for generations

153. See the very similar rebus of an Augustinian canon in the
BL MS Harley 7333 *Canterbury Tales*: ch. 6, sec. II and figs. 12a and
13 there.

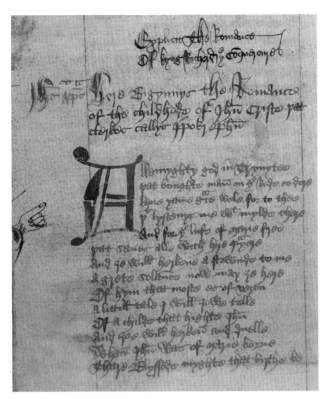

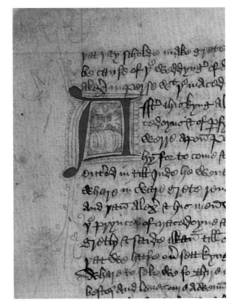

27. The Thornton name is incorporated in the *Life of Alexander* as a rebus within an initial **A**, with the "Thorn" sprouting from a barrel or tun ("ton"). Lincoln, Cathedral Library, MS 91, fol. 23v (detail).

26. The English incipit and bicolored capital **A** for the *Childhood of Jesus Christ* feature the same red ink, almost certainly from Thornton's own pen. London, British Library, MS Add. 31042, fol. 163va (detail).

in the Thornton household.[154] Family pride seems central to the records found on folio 49v, where both the birth in 1453 of Thornton's grandson, who shared the name Robert, and the ownership of "this boke" by William Thornton armiger (bearer of arms), the scribe's son or great grandson are recorded (fig. 28). The name William Thornton (probably a later family member: at least seven Thorntons bore the name between c. 1450 and 1600) appears again, upside down on a damaged folio of *Sir Eglamour* (fol. 144vb), and that of Dorothy Thornton is written twice up the side of the Latin Psalter (fols. 265r and 266r). Ellenor Thornton's name appears in *Sir Degrevant* (fol. 135va), as does that of Edward Thornton (fol. 137rb), very likely the earliest known, our scribe's great-great- grandson who was born sometime before 1545 and died after 1586. The same name (though not certainly in the same hand) appears in two other places in the manuscript as well: upside down in the left margin of the *Alliterative Morte Arthure* (fol. 75v), and beneath the works of Richard Rolle (fol. 194r; fig. 29b).

Across the page from the latter the same hand seems to copy the beginning of the Latin hymn ascribed to Ambrose that starts three lines above—"I*hesu* no*st*ra redempcio Amor" (fig. 29a)—and in a slightly rougher form, make the repeated attempts at an English line beginning "In the nam of god" that run along both bottom margins of the previous opening (Rolle's *Oleum Effusum*, fols. 192v–193r; figs. 30a and b). Immediately below the text on folio 192v appears a different hand as well. Both earlier (s.xv) and far more accomplished, it appears to be Thornton's own hand. It uses the rubricator's ink to repeat the penultimate Latin line of the text above—a line also written in red ink— and may well have been setting up something of a writing model to guide the work of young or other learning members of the family, much as the line of Ambrose's hymn guided Edward's efforts on the following folio (fig. 29a).

Now we cannot know how old Edward may have been when he wrote in the Lincoln MS, but both his interest in romance (*Degrevant*, the *Alliterative Morte,* and the *Awntyrs*

154. Until the seventeenth century, when Thomas Comber (dead 1699) married Alice Thornton and either sold or gave the book to Lincoln Cathedral (where it was by 1793). The sewing holes found along tears in several of Lincoln's folios (23, 42, and 154–59: see, for example, fig. 10) indicate hand-stitched repairs exceptional in cheaper paper volumes. The London MS, on the other hand, had passed to the book-collecting Yorkshire

Nettletons by the sixteenth century (Nettleton names appear on fols. 49r and 139v), and the only Thornton name in it is the scribe's, twice (on fols. 50r and 66r: see fig. 21 and "Thornton Names in the Lincoln and London Manuscripts"), both times defaced, either by a later reader or a family member before the book was sold.

28. Pen and writing trials, scribbles, a birth record for Thornton's grandson, also named Robert (top), and the ownership inscription of his son or great-grandson William (bottom). Lincoln, Cathedral Library, MS 91, fol. 49v.

of Arthur, where the "nam of god" line appears again)[155] and his presumably educational use of the book suggest that he may well have read the manuscript as a boy or young man. He could have been, then, just the sort of reader whose attention Thornton hoped to engage by calling the *Childhood of Jesus Christ* a "**Romance**," pointing to it with a marginal hand, writing its title in red ink, and adorning it with the only bicolored initial in the whole of the London volume (see fig. 26).[156] Other marginalia in Lincoln indicates similar educational use: in the *Mirror of St. Edmund*,

for instance, we find a disorganized array of letter trials (fol. 205r),[157] two roughshod attempts in bottom margins at copying the writing above (fols. 201r and 205v, in a hand rather like Edward's), and one instance of a much more accomplished hand (very like Thornton's own again) copying over half of the final line directly below it (fol. 203r). The *Mirror* is also among those texts for which Thornton included what look like catchwords at the bottom of some folios (204v and 205v), likely to prevent beginning readers from losing the narrative thread at page changes,[158]

155. In the same hand at the bottom of fol. 155v. A similar line appears on fol. 218r in John Gaytrygge's *Sermon* or *Lay Folks' Catechism*.

156. Green ink alternates with the more common red in only two brief sections of London: fols. 104v–120r and 144v–166v.

157. Writing trials, both less and more formal, are found elsewhere in Lincoln: examples include the scribbles on fol. 191v and the neat double columns of practice alphabets on fol. 277r. See also fig. 28.

158. See Hardman 2004, 58, for a discussion of similar aids for novice readers and the suggestion that "such textual signs might serve to identify manuscript books specifically prepared for use by a beginning reader." In the Lincoln MS these aids are written under the text at the bottom of pages much like catchwords to indicate the first words of the following quire, but they often appear when no new quire follows. They are found on almost every page of the *Prose Alexander* (see fig. 25 for an example) and sporadically elsewhere in Lincoln, with significant clusters from fol. 219v on.

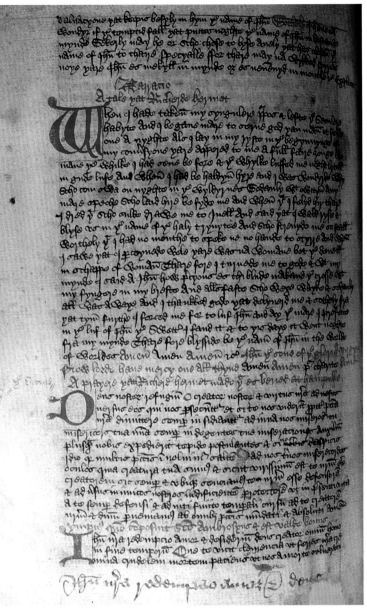

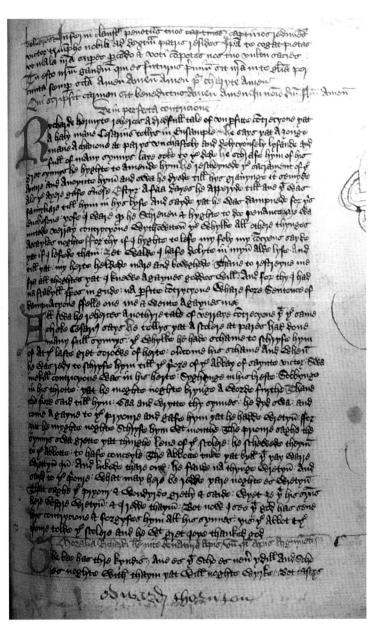

29a and b. Across the bottom, a writing trial and the name "edward' thornton" (s.xvi); in the text, thirteen instances of the scribe's "Amen," many of them in the rubricator's ink. Lincoln, Cathedral Library, MS 91, fols. 193v–194r.

30a and b. Writing exercises (s.xv and s.xvi) along the bottom of Rolle's *Oleum Effusum*, including a line by the rubricator, most likely Thornton himself. Lincoln, Cathedral Library, MS 91, fols. 192v–193r (details).

as well as titles appropriate for readers of limited or only English literacy. For English texts in both his manuscripts, he generally gives English titles (examples appear in figs. 10, 15, 16, 17, and 26), but he also frequently provides English translations and interpretations of Latin titles and subtitles, as well as key Latin quotations, even when what they translate seems obvious. For the *Siege of Jerusalem* in the London volume, for instance, he partially translates the long Latin title (see fig. 21), and for the *Song of Wisdom* in the same book he adds his own assessment to his translation, turning the *Cantus Cuiusdam Sapientis* (*Song of a Certain Wise One/Wisdom*) into "A louely Song of Wysdome" (see fig. 11). And for the opening of Edmund's *Mirror* in the Lincoln volume he Englishes not just the title but the key opening quotation as well—"Seese ȝowre callynge" (fol. 197r, line 5).

Didactic clarity appears to have been central to Thornton's scribal practice,[159] and simple learning seems central to his collection as a whole. His devotional works include a good deal of Latin writing and a few mystical and contemplative texts for exercising a more serious kind of spirituality, likely his own, but basic Christian works, such as hymns and prayers, treatises on the commandments and the sacraments, expositions of virtues and vices, confession and prayer, are more numerous and would have served to teach primary Christian tenets to the young or uneducated, much as similar texts in the Auchinleck MS must have done. The annotations Thornton adds to the texts he copied, whether from his exemplars or his own imagination, tell a similar story. In Lincoln's unique and striking *Reuelation Shown to a Holy Woman*, Thornton's few notes point to the efficacy of prayers and masses, not to the disturbing vision of hell's punishments or any of the text's intriguing visionary qualities, save in the explicit where it is called a "tractatus de visione" (fol. 258r). In the most heavily annotated text in the devotional unit of Lincoln—the *Abbey of the Holy Ghost*, called *Religio Sancti Spiritus* and *Religio Munda* at the top of folio 271r, no doubt to reflect its aim of allowing those who could not physically pursue a life of religion an experience of "gostely" or spiritual "religeon of þe herte" (fol. 271r, lines 5 and 7)— the focus of the marginalia is upon the basic concepts essential to the comprehension and practice of the Christian faith. The notes tend to be single words in both Latin (*consciencia, humilitas, caritas, paupertas, misericordia, contemplacio, paciencia, oratio, confessio, jubilacio, largitas, sapiencia*) and English (wysedome, charite, sobyrnes, mercy, curtasye, honeste, deuocioun, meditacioun, contemplacioun). While

Thornton does include meditation and contemplation, his annotations seem far from theological or mystical in intent, yet with such concise marginal guides at hand, even new readers could easily find exemplary passages defining and elaborating various key principles of devotion, doctrine, and appropriate social and moral behavior.

Appropriate social and moral behavior seems key as well to some of the marginal illustrations that highlight the *Alliterative Morte Arthure*. Take, for example, the depiction of fish, which (as I mentioned above in the context of MS Ashmole 61) were medieval symbols for reading and memorizing. Fish are used in the *Morte* to mark two key passages in an episode that sees Sir Priamus, an heir of the great Alexander, suffer defeat at the hands of Sir Gawain and shift his loyalties from the duke of Lorraine to King Arthur.[160] The first instance features two tiny fish lying belly to belly within a capital **S** on folio 80r, where Priamus and his arms are first described and the conflict with Gawain begins (lines 2525ff; fig. 31a). The images are so small and seemingly insignificant that the reader easily passes them by without notice, until two much larger fish appear in the margin of fol. 84r (fig. 31b), securely fastened, snout and tail, to the capital **T** opening Priamus's public abandonment of the duke's party to join the Round Table (lines 2916ff). No doubt there is something here of the Christian metaphor of fishing for men and souls, with Arthur the successful gatherer of knights in shimmering armor. Yet I wonder, too, if the process of shifting military allegiance from one overlord to another that is described here as Priamus seizes his banner, brings his loyal men with him, and carefully explains his actions as just and logical might have struck a chord in the turbulent struggles for personal loyalties and advantages so prevalent in the fifteenth century. In such a period of "unprecedented political crisis,"[161] even a relatively minor gentleman like Robert Thornton could be caught in the storm. We know, for instance, that between June 1453 and May 1454 he was discharged from his position as tax collector when the king, or rather Richard Neville, the new chancellor, since the king had experienced a mental breakdown in August 1453, was "moved by certain sinister informations" against Thornton, perhaps because of some involvement by Thornton on Henry Percy's side in the violent rivalry that had recently come to a head in the north between the Neville and Percy families.[162] Whatever the cause, he also managed to work his way back into favor and reappointment in 1454 and must have been a stranger neither to the type of careful political dance Priamus succeeds at in the

159. Carlson 2007–8 discusses how Thornton copies and alters his texts to eliminate the possibility of narrative ambiguity and clarify syntactic transitions like dialogue indicators, prioritizing morality and didactic potential over style and poetics.

160. Fish also appear in Lincoln on fol. 57r at line 337 of the *Morte* where two tiny fish fill an initial **S**, and on fol. 225v in

Hilton's *Mixed Life*, where a rough drawing of what appears to be the front half of a fish appears in an initial **H**.

161. Radulescu 2003, 1, speaking of the years 1440–71.

162. See Keiser 1979, 163, and Johnston 2007, 309, and forthcoming, ch. 6.

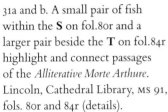

31a and b. A small pair of fish within the **S** on fol.8or and a larger pair beside the **T** on fol.84r highlight and connect passages of the *Alliterative Morte Arthure*. Lincoln, Cathedral Library, MS 91, fols. 8or and 84r (details).

Alliterative Morte nor to the necessity of sharing such a social model with future generations to ensure the continuing success of his family.

There is in the decorated capitals of the *Alliterative Morte*, then, much as there is in many aspects of Thornton's scribal work, something of the teacher, and the family of such a literate, aspiring gentleman would no doubt serve as his front-row students. But it is entirely possible — indeed, virtually necessary — that farther-flung members of Thornton's Yorkshire community also enjoyed access to the texts he gathered and copied. The library Thornton amasses is most impressive, in the wide range both of its contents and their origins: secular and monastic works, basic homely doctrine and mystical visions, verse and prose romances from north and south, provincial texts like the *Alliterative Morte* and Rolle's Yorkshire works, as well as courtly or urbane ones. No one source could have provided all his exemplars, but a local network of literate and devout book lovers might well have been able to ex-

tend its reach far and wide, even at times over social and monastic boundaries. We know that Thornton's name appears in the witness lists of several deeds, quitclaims, and charters, demonstrating not only his efforts to improve the modest means of his own family but his connections of various kinds with a number of prestigious families and higher officials, both secular and ecclesiastical, in his locality and beyond. With such individuals he could well have shared books and booklets for reading and copying, perhaps offering his own scribal contributions to such an exchange network as much as benefiting from the texts gathered and owned by others.[163] A manuscript network of this sort helps to explain why Thornton would have so frequently and so carefully signed his work, and also why the outer bifolia of his individual booklets and sections are often so worn and grubby: they may well have circulated individually out in the neighborhood and beyond, as well as within his household while the collection was still growing and developing.[164] In such a social con-

163. Such a manuscript network is suggested in Yorkshire as early as the first half of the twelfth century by Geoffrey Gaimar, who claims in his *L'Estoire des Engleis* that he "translated" the text for Dame Custance, who borrowed (or rather had her husband borrow) a copy of what is almost certainly Geoffrey of Monmouth's *Historia Regis Anglie* from the North Yorkshire Lord of Helmsley, Walter Espec, who got his copy from King Henry I's illegitimate son, Robert of Gloucester, to whom some copies of the text were dedicated: see lines 6430ff. in Bell 1960. As Hanna 1987b, 61, argues, Thornton's tendency not to convert texts into his own Yorkshire dialect as he copied, combined with the fact that most

of the texts in his manuscripts do not seem to show signs of other dialects, implies that Thornton obtained his exemplars "locally, written in a dialect homogeneous with his own."

164. In Lincoln, for instance, the dirtiest and most worn openings occur at the shift between the *Alexander* booklet and the *Alliterative Morte* (fols. 52v–53r: figs. 19 and 15); the romance anthology and the *Previte* (178v–179r: fig. 16); and the devotional section and the final booklet containing the *Liber de Diversis Medicinis* (279v–280r). Wear and tear elsewhere in the volume suggests smaller units may have circulated separately as well.

text the opening of the well-worn *Morte Arthure* (a text grubby throughout) with its Thornton family motto in "**ynglish**" and its prominent scribal prayer, both recorded in bright red ink, makes perfect sense, as does the double identification of its scribe at the end (see figs. 15 and 17, and "Thornton Names in the Lincoln and London Manuscripts"). Such a precious part of a treasured family library might be willingly lent, but its owner would want to ensure that both booklet and the gratitude of its borrower returned to the right household.

The last of the texts Thornton includes in his Lincoln volume—the encyclopedic collection of diverse medical recipes (*Liber de Diversis Medicinis*) that appears in the book's largest quire (Q)—provides us with some intriguing evidence of the sort of book-lending network I am positing here. It is difficult to say exactly when the *Liber* was copied in relation to the other texts of Lincoln, so apart it seems from the rest of the contents, sporting not even the most basic of the rubrication provided for them. Very possibly it was a late addition to the volume's plan even if it was copied early on, and it may have been included in the family volume because it had already proven its usefulness in the household in booklet form. It bears a particularly local flavor, representing Thornton's dialect more consistently than other texts in the Lincoln volume,[165] and obtaining some of its recipes from nearby Yorkshire sources, among them the rector of Oswaldkirk. Yet it was also derived from an exemplar used again in 1528–29 for the greater part of a similar medical collection found in Oxford, Bodleian Library, MS Rawlinson A.393.[166] The scribe there (who identifies himself as John Reed, parson in Leicestershire and vicar in Derbyshire) makes frequent references to both the rector and the Pickering family of Oswaldkirk—a family with whom Thornton was associated nearly a century earlier. In the 1440s Thornton was given land by Sir Richard Pickering, who also named him as one of his executors, and both Robert and his brother received bequests in Pickering's will. The implication is that the medical recipes copied by both Thornton and the scribe Reed were based on a collection owned by the Pickering family—gathered, used, enhanced, and treasured through the generations in their household perhaps—which matches well the complicated and costly nature of some of the recipes, like the one attributed to a Sir Apilton, who may have been one of the physicians of John of Gaunt, a nobleman associated with court poets and an owner of Pickering Castle in his day.[167] MS Rawlinson A.393 also holds special interest for us because it was associated with and presumably owned

by the Findern family (whose romance manuscript is discussed in the final section of this chapter) shortly after its production. A sixteenth-century hand that is not John Reed's records (on fol. 89v) three recipes headed "Probatum est Per me ipsum georgeum ffindurne," who was dead by 1540. The script is decorative in the title, more cursive for the rest, and likely the product of George's own hand, so it may be that George (or another Findern) had the medical collection made for his family from an exemplar borrowed (perhaps at a few or many removes) from the Pickering family.

That family is also of particular interest for another reason. Whatever the exact dynamics of the book-exchange network Thornton used to gather his wide-ranging collection, it must certainly have included monastic readers and libraries. Monasteries were enormous repositories of spiritual and historical writings, if not always romances, and there were many such houses in late medieval Yorkshire. The Cistercians at nearby Rievaulx (where Aelred's novices knew their Arthurian tales) had an impressive Latin collection by the fifteenth century, and in the same period the Carthusians at Mount Grace were deeply involved in the dissemination of devotional, visionary, and contemplative works in the vernacular as well as Latin (see ch. 6, sec. IV). At houses like these Thornton might well have borrowed or accessed exemplars, but a number of his texts suggest a religious community of a different sort. Some of the pieces he copied for his family seem to speak directly to women, using the feminine pronoun, including "woman" along with "man," and in more than one place addressing sisters (i.e., of a convent), as in the *Abbey of the Holy Ghost* Thornton so carefully annotated (in line 2 of folio 271r, for example: "A. dere brethir and systirs"). What this suggests is that Thornton used as exemplars (either by choice or of necessity) texts either written or adapted for female readers, particularly female readers of religious leanings.[168] Perhaps that is why Thornton's two-volume library shares so much spiritual writing— works by Rolle, Walter Hilton's *Mixed Life,* the *Mirror of St. Edmund,* and the *Abbey of the Holy Ghost,* as well as the *Song How Mercy Passes All Things* and an overall emphasis on Marian devotion and the childhood of Christ—with the enormous Vernon MS, which was most likely made for a community of women religious.[169] But the Vernon MS was produced in the West Midlands, and it stretches logic to think Thornton acquired his exemplars from so far south. A religious community like the house of Benedictine women at Nun Monkton in Yorkshire, however,

165. Hamel 1983, 124.

166. See Keiser 1980, 445.

167. Stern 1976, 214n88.

168. Thornton's adapting the texts for women himself is less likely, though certainly not impossible.

169. On Rolle's works in the Lincoln volume, see Hanna 2007, xxxvi–xxxix, liv–lxi, and 1–30, and Ogilvie-Thomson 1988, xlvii. On monastic readers of Rolle and Hilton, see ch. 6, sec. IV, and on the contents and possible religious contexts of Vernon, see ch. 6, sec. I.

where we know the nuns owned books in the fifteenth century,[170] might well have met some of Thornton's needs. Hardly surprising, then, is the discovery that Sir Richard's sister Joan Pickering was a nun at that house by 1433,[171] precisely when Thornton was working on his romance

and pious booklets and would have been as eager to get his hands on the texts she and her "systirs" were reading, as he no doubt was to call upon the presumably more secular library of the Pickering knight who later trusted him as an executor for his estate.

III. Courting Romance in the Provinces: The Findern Manuscript

Thornton's collection of romances and pious works teach us that manuscripts and the texts within them could pass easily over what we might think of as geographical, social, and religious boundaries in the late Middle Ages. In the manuscript that will draw our attention for the rest of this chapter, religious boundaries may seem far from relevant, but provincial location, social prestige, literary good taste, and creative ability are central, and boundaries are crossed freely enough to suggest their creation more a result of modern perceptions of the past than of medieval society itself. The Findern collection (CUL MS Ff.1.6) is an entirely different kind of romance manuscript. Among its many English texts we find only one whole romance (see "Middle English Romances in the Auchinleck, Thornton, and Findern Manuscripts"), the tale of *Sir Degrevant* also included in Thornton's collection, which makes Findern unlike both Auchinleck and the Lincoln Thornton with their numerous romances. It is also unlike the London Thornton, the massive Vernon collection, and many other extant romance manuscripts that tend to combine only a few or even one romance with a number of pious works.[172] The Findern volume appears instead to have been organized almost exclusively around the theme of love, particularly courtly love, which is explored and debated, celebrated and criticized in texts that include a selection of unique local lyrics along with works by the courtly poets Chaucer, Gower, and Richard Roos. Despite these somewhat pretentious contents, there was virtually no attempt like Thornton's or consistent strategy like the Auchinleck compiler's to decorate the Findern MS, which is an extremely plain paper codex of modest proportions.[173] Unlike the Thornton MSS with their amateur hand working in its various manifestations over many years, or Auchinleck with its six professional scribes copying with much greater haste, Findern bears the hands of more than forty different scribes, both professional and amateur, accomplished and informal, contributing long and short stints

to the volume for over a hundred years between c. 1446 and 1550.[174] Some of these scribes are named in the manuscript, though most are not; a couple are almost certainly women—the scribes of *Sir Degrevant*, in fact—and more may well be. The names of scribes and other late medieval individuals found throughout the manuscript open its folios to a Derbyshire gentry community of men and especially women who appear to have conspired to compile a remarkable love anthology.

None of the scribes of Findern's literary pieces sign the name Findern, however, so "the Findern MS"—the sobriquet assigned for decades now to CUL MS Ff.1.6[175]—is in fact something of a misnomer, and the association between the book and the Derbyshire family of that name is a good deal more tenuous than that between the Yorkshire Thorntons and the volumes their *pater familias* made for them. The Findern family from the South Derbyshire town of the same name was certainly by the fifteenth century (if not before) the kind of wealthy, learned, and ambitious family who would have found the use and ownership of books attainable and desirable.[176] Already in 1292 they were respectable enough for Edward I to stay with them, and their fortunes and status improved through the fourteenth century, reaching its peak of prosperity and prominence in John II, head of the family from c. 1390 until 1420. John II was a shrewd lawyer with influential associates, and he managed to expand the Findern estates markedly through marriage and more complicated forms of acquisition until his lands stretched an impressively wide crescent over the region to the southwest of Derby. He lived too early to be directly associated with the Findern MS, however, and the sixteenth-century records that link the book to the Findern family—a fragment of accounts with a "rekenyng' betwne Iohn wylsu*n and* mes*ter* fynderne" (fol. 59v), and an inventory of the "percellys off clothys at fyndyrn*e*," along with "napre" and "vessell'" (fol. 70r)—are too late to be connected with the beginnings of the manuscript (see figs. 32a and b).[177] The Master Findern referred to on folio 59v was probably the George

170. See Bell 1995, 156–57, for the records which reveal, for instance, that the Nun Monkton women were also reading Rolle.

171. See Keiser 1983, 115.

172. See the contents lists in Guddat-Figge 1976.

173. The folios of Findern measure from 220 × 153mm. to 212 × 146mm., a good deal smaller than the Auchinleck and Thornton volumes. It also contains fewer folios, with 159 surviving and likely no more than about twenty-five more missing. See Beadle and Owen 1977, xi.

174. Harris 1983 lists and numbers forty of the scribes in her third appendix (331–33).

175. Robbins 1954 first named it.

176. On the Findern family, see especially Craven 1983, Jurkowski 1997, Jewitt 1863, and Johnston, forthcoming, ch. 5.

177. The records are dated s.xvi² by Harris 1983, 299, and c. 1550 by Robbins 1954, 620.

whose name and hand appears in MS Rawlinson A.393 (the *Liber de Diversis Medicinis*) or perhaps his son Thomas Findern, the last of the male line who died in the 1550s.

It is entirely possible, however, that John II's son Nicholas Findern, who became an esquire by the 1440s and lived until 1475, could have initiated the manuscript in the mid-fifteenth century.[178] It may be that his involvement with the book has even been recorded by the fifteenth-century scribe who calls himself "Nicholas full of love" and claims to have copied an extract from Chaucer's *Legend of Good Women* (fol. 67v: "Nomen scriptoris nicholaus plenus amoris"). Similarly, the scribe who writes "A god when" three times in association with two English lyrics (on fols. 137v and 139r) may have been a Findern with a name acquired via a family tradition reaching as far back as the Godwin de Finderne recorded c. 1100.[179] Hinting at one's identity while obscuring it could well have been a deliberate part of the literary game we will discover in the folios of Findern, but for the two scribes of *Sir Degrevant*, clear identification seems to have been the point, and in them we may be able to pin down the beginnings of both the manuscript and its Findern associations. At the end of the romance, the second of its scribes records the names "Elisabet koton" and "Elisabet frauncys," enclosing the first name in an ink box (fol. 109vb; fig. 33). Each woman was a fifteenth-century member of a gentry household very near Findern (Hamstall Ridware and Foremark respectively), and the families of both continue to be associated with the manuscript in later generations: three more instances of the Cotton name link that family with the book through the first half of the sixteenth century,[180] and since Elizabeth Francis (whose mother's name was also Elizabeth) married a John Findern, either the son or grandson of Nicholas Findern, she herself became a Findern. She may not yet have been a member of that family when she worked on *Degrevant*, for she uses her maiden name, yet in Elizabeth Francis we come as close to a Findern scribe as we ever find with certainty in the manuscript.

178. As suggested in Robbins 1954, 623. See also Johnston, forthcoming, ch. 5.

179. See Robbins 1954, 622n24. On both folios the "A god when" signature appears in a scroll, and on fol. 139r, where the name appears twice, with a rebus as well (see fig. 36b).

180. On fol. 72r "cotun" and on fol. 76r "coton" (both of those in faint dry point), and at the bottom of fol. 139v the full name "Thomas Cotun" upside down in ink.

32a and b. A connection between the Findern MS and the Derbyshire family sharing that name is indicated by a "rekenyng" and a domestic inventory. Cambridge, University Library, MS Ff.1.6, fols. 59v and 70r.

Since *Degrevant* was copied in the mid-fifteenth century, it was certainly among the earliest of the texts gathered for the manuscript,[181] so we may have in Francis or her scribal colleague the individual responsible for initiating the Findern anthology. Unless the positioning of the two names, or perhaps the box enclosing the first provides a clue, we cannot know which of the two *Degrevant*

33. Beneath *Degrevant* the second of its two scribes records their names as "Elisabet koton" and "Elisabet frauncys;" the symbols beside them are mysterious, but may refer to a third individual involved in the text's production. Cambridge, University Library, MS Ff.1.6, fol. 109vb (detail).

181. A probable date of c. 1446–61 is based upon details of the *Chronicles* that follow *Degrevant*: see Casson 1949, xii; Beadle and Owen 1977, viii; Doyle 2006, 258n2; Meale 1999, 132; Thompson 1991, 33, who extends the range to 1471; and Johnston, forthcoming, ch. 5, who dates the work of *Degrevant*'s second scribe to shortly before 1446, but the work of the first to an unspecified later time. *Degrevant* is the only text in the Findern MS copied in double columns.

34a and b. The striking visual contrast in *Degrevant* between the amateur work of Scribe 21, who finishes in quire G, and the more professional Scribe 22, who starts in quire H. Cambridge, University Library, MS Ff.1.6, fols. 99v–100r.

scribes—known as Scribes 21 and 22[182]—should be assigned which name, but it is interesting that while Scribe 22's only work in the book is the second part of *Degrevant*, which she copies into a quire (H) of paper stock not used elsewhere in the manuscript, Scribe 21 seems more connected to the rest of the book. She starts her work in a quire (G, which shares paper stock with F) already partially full, and also may have added a couple of unique lyrics to the opening folios of quire N at a later date (fols. 143v–145r), which suggests ongoing access to the collection.[183] It may be, then, that the scribe who begins the romance of *Degrevant* (on fol. 96r; front plate 9) also initiated what is now the Findern MS and continued to work on it for some time, perhaps enlisting the scribal help of many others. Yet it is Scribe 22 who lends both a Derbyshire dialect and a professional appearance to the romance, with Scribe 21's script far less accomplished—the change from her to Scribe 22 is striking (see fig. 34a and b)—and her portion of the work far shorter, filling only four folios while her more experienced colleague completes the last ten.[184] Why Scribe 21 passed the work on to Scribe 22 is uncertain, but it would seem that the two women split their exemplar from the beginning, with the greater portion going to the better scribe.[185] So their collaboration is clear, as is the copying of the *Degrevant* romance at the beginning of the Findern project, and although this sort of shared manuscript production must have happened a good deal more often in domestic collections than we will ever know, it is extremely unusual to find evidence for female bookmakers in extant Middle English manuscripts.

That "Old Dance" of Love and Literature

How, then, did these gentry women go about producing such an exceptional book? Bit by bit would seem the most obvious answer. There are, for instance, others like Scribe 22 who contributed only part of a text to the Findern

MS: Scribe 23 copied only the first part of the *Chronicles of Saints and Kings of England* (another mid-fifteenth-century product), giving way to his or her colleague midfolio (fol. 112r), and Scribe 25 copied only two three-folio stints in *La Belle Dame sans Mercy* (fols. 120r–122v and 127r–129v).[186] Others copy an entire work each, like Scribe 3 who copies the *Lover's Plaint* on folio 20r, Scribe 5 who writes out the *Book of Cupid* (fols. 22r–28r), and Scribe 8 who contributes the *Three Questions* excerpt from Gower's *Confessio Amantis* (*Confession of a Lover*, fols. 45r–51r). Still others, like Scribe 21, are involved in more than one piece. Scribe 24, for instance, finishes Scribe 23's work in the *Chronicles* (fols. 112r–113r), as well as copying the heraldic notes on European royalty that follow (fol. 113r–v), and Scribe 6 works before, between, and after Scribe 25 in *La Belle Dame* (fols. 117r–119v, 123r–126v, and 130r–134v), as well as working alone on Hoccleve's *Letter to Cupid* (fols. 71r–76v) and collaborating closely, sometimes for very short stints, with the scribe "W. Caluerley" on Chaucer's *Parliament of Fowls* (the name is found on fol. 42v). Such "thoroughly whimsical" scribal practices are also found in the excerpts from Gower's *Confessio Amantis* which immediately precede *Sir Degrevant* (fols. 81r–95r).[187] Five different scribes (Scribes 16–20) contribute to no other works than these two brief pieces, three of them taking copying stints in only one of the two excerpts (Scribes 18–20 in Item 26).

> The copying proceeded by a succession of alternations which generally do not respect even folio boundaries; in some cases the stints are as short as seven or eight lines and thoroughly unmotivated by any normal detail of production. In this case, and others which approach it, one is forced to assume highly unstructured procedures—either copying as a sort of social game, where the archetype and in-production codex were passed about in a gathering for successive additions; or copying by leaving archetype and in-production codex

182. In Harris 1983, 332. Casson 1949, xii–xv, refers to these hands as A and B, and postulates a hand C finishing *Degrevant*, but suggests that C may be a more cursive form of B.

183. Beadle and Owen 1977, xi, and Thompson 1991, 32. Harris 1983, 332, sees these lyrics as the work of a different scribe, whom she numbers 31.

184. Johnston, forthcoming, ch. 5, localizes Scribe 22's dialect "to the area of southern Derbyshire, southeastern Staffordshire, northwestern Leicestershire, or north-central Warwickshire." Scribe 22's work is among the most polished and professional in the manuscript. Not only does she produce a finer script and tidier layout than Scribe 21, but she also pricks and rules in dry point before copying her part of the text: see Beadle and Owen 1977, xvii n. 24.

185. Two scribes copying independently from a split exemplar, as Hanna 1987a, 63, suggests, seems likely given that each scribe uses a different stock of paper and demonstrates a different dialect. In addition, although Scribe 21's layout is rarely even (her very first page has far more lines in its second column than

in its first: see front plate 9), she does seem to work to squish more lines on each folio as she nears the end of her segment, as though she is aware of where the part assigned to Scribe 22 begins and wants to blend their work seamlessly. She is successful in this (Scribe 21 finishes at line 564 in Casson 1949, 37, and Scribe 22 begins at 565), but she does not meet her own expectations with precision, for the final folio of quire G in which she worked was canceled, presumably because it was unused. Johnston, forthcoming, ch. 5, argues that Scribe 22's work is what remains of a damaged copy of *Degrevant*, positing that Scribe 21 later replaces the missing folios, an intriguing theory that unfortunately removes Cotton and Francis from consideration as scribes on the basis that the earlier copyist could not possibly have named the later one as well.

186. Thompson 1991, 36n63, notes how this text, like *Degrevant*, was copied from "a dismantled exemplar."

187. Hanna 1987a, 63 and 64. The excerpts are items 25 and 26 in Beadle and Owen 1977, xxiii–xxiv.

out (on a table, say) for chance additions by any interested members of the household.[188]

This conception of manuscript production as a household or social game reveals another way in which the kind of gentry networks for literary exchange I've posited for Thornton might have contributed to the production and transmission of vernacular literature. Parallels are not unknown among extant manuscripts, but the context of the closest parallel, London, British Library, ms Add. 17492, known as the Devonshire ms, is very different.[189] A book that shares Findern's focus on the theme of love, it, too, contains many hands: at least twenty-three different scribes copy over one hundred and sixty courtly lyrics by both late medieval and early renaissance writers. The collection also sports a number of signatures, names, and identifiable hands that associate the book with the court of Henry VIII, and the names and hands of Mary Shelton, Margaret Douglas, and Mary Howard/Fitzroy in particular link the manuscript to an intimate group of female friends and royal relatives in the service of Anne Boleyn and Princess Mary in the early 1530s. Here

> the stints of copying, and the fact that the manuscript seems to have returned at intervals to Mary Shelton, who acted as a kind of overseer [along with Margaret Douglas perhaps, whose hand appears most extensively in the manuscript], suggest very forcibly that it circulated in the manner of an autograph album, and that the items copied into it were designed to have some piquant personal relevance which would be appreciated by its closely-knit group of readers and contributors.[190]

Despite being, like Findern, inexpensive and workaday in physical appearance—a common characteristic of medieval English lyric collections—the Devonshire volume appears to have been passed around among both the women and the men of an elite royal circle. In it they recorded their individual poetic contributions and communications, some of them unique and personal and heartily felt, others borrowed, or more imitative and performative, but all of them actively, many of them creatively participating in the literary and political dialogues the volume records.

Now Findern obviously presents a different sort of compilation from a different social and geographical locale, yet it, too, is the work of many scribes of varying abilities; it, too, contains a number of courtly love lyrics in English; and it, too, engages the reader in an evershifting dialogue on that old dance of love. This begins, it would seem, with the manuscript's first stages of production, and extends, with the exception of a few practical, didactic, and religious pieces, throughout the compilation. "Four large sections of the manuscript [in particular]—quires A-B-C, quires D-E, quires I-K-L-M, and quire O—consist almost entirely of texts that participate in or evoke this atmosphere of playful flirtation or debate."[191] Copied around the same time during the first, fifteenth-century layer of production (though after *Degrevant* in quires G and H) with overlapping paper stocks and shared watermarks, these sections of the manuscript suggest a coherent thematic plan on the part of Findern's compilers, as well as "an appreciation for . . . playful interaction," perhaps even a desire "to emulate the literary tastes and pastimes of courtiers" like the Ricardian noblewomen who played sophisticated and participatory readerly roles at the royal court in the fourteenth century.[192] Certainly the manuscript's compilers reveal their literary sophistication and fashionable, courtly tastes by choosing works from Chaucer, Gower, Lydgate and Hoccleve—texts sometimes dedicated to kings and princes. They also had some impressive connections, obtaining their texts from the most respectable of sources, with some of the pieces in these four sections of the manuscript derived from the family of exemplars used for an important and more professional cluster of fifteenth-century Chaucer manuscripts that, like Findern, focus on love, its pleasures and trials, its gender games and learned debates.[193]

Perhaps this connection is less surprising in a provincial manuscript bearing the name "Anne Schyrley" (above Roos's *La Belle Dame sans Mercy* on fol. 118r), who was very likely related in some way to John Shirley, the middle-class bookmaker so important in the collection, dissemination, and attribution of Chaucer's and Lydgate's works.[194] One of the unique lyrics in Findern even reveals an intimate knowledge of both these courtly authors in the same creative way the Devonshire ms does—by excerpting pieces of their writing and combining them into a new

188. Hanna 1987a, 64, and see also Harris 1983, 331–32. Instances in Findern where the hand changes but the ink does not appear to support this method of production: see, for instance, fig. 35.

189. My thanks to Johanne Paquette for her generous help with the Devonshire ms, on which see also Siemens 2009, Heale 1995, and 2004.

190. Boffey 1985, 8.

191. Doyle 2006, 233, and see the table of texts on 234–35.

192. Doyle 2006, 238–39.

193. Bod. mss Bodley 638, Fairfax 16, and Tanner 346 make up

this Oxford group of manuscripts: see Doyle 2006, 235–36, and Harris 1983, 309.

194. Though Robbins 1954, 627, thought the name on fol. 118r a scribal signature, the hands of text and name do not seem to match; he also notes that Nicholas Findern was related by marriage to a Shirley family. The fifteenth-century connection between the Francis and Shirley families is discussed by Harris 1983, 305, and the wealthy Shirley family of Brailsford near Findern is discussed by Johnston, forthcoming, ch. 5. There were at least five different Annes in the Shirley family c. s.xv⁴–s.xvi¹. On John Shirley and his manuscripts, see Connolly 1998.

35. Beneath the final lines of Chaucer's *Complaint of Venus* Scribe 11 copies and revises (in the fifth of the lines written to the right) a unique love lyric. Cambridge, University Library, MS Ff.1.6, fol. 69v.

faryd Amysse" (fols. 153v–154r) the speaker uses an identifiable Derbyshire dialect, suggesting that the poem was composed in the Derbyshire region.[197] In fact, the dialect of several of Findern's twenty-four unique, shorter lyrics, some of them added to blank folios as later filler items, is characteristic of Derbyshire,[198] indicating more extensive local authorship and the strong likelihood that the provincial compilers of Findern were also participating in the manuscript's dialogue on an authorial level, just as some of the participants in the Devonshire MS did. A few of the lyrics even give the impression of being works in progress, containing alterations that would most likely result from being "copied into the manuscript at a point where production may be seen to coincide with composition."[199] Such alterations could be dismissed as simple scribal errors and corrections, but often the changes seem driven by a desire for poetic improvement through more effective language, expression, and scansion. In the unique lyric on folio 69v, for instance, a line with a repetitive end-rhyme is replaced by the poetically superior line "y loue hym *and* no moo" (fig. 35), and in another of the unique poems ("My self walkyng all' allone" on fol. 139r; fig. 36b) a different color ink for some of the changes, which are nonetheless written by the same hand as both the original poem and other alterations suggests continued access by the scribe to a draft worked and reworked—activity, that is, normally associated with an author.[200]

The scribe here is "A god when" (Scribe 29), who signs that name twice on folio 139r, and also includes a rebus in the second instance, where the name is written in a scroll, and the scroll is held up by two fish whose noses point to a barrel above (fig. 36b). Beyond marking something worthy of notice, exactly what is intended by both words and symbol remains mysterious. The scribe may simply be signing in her or his usual way, or perhaps using a secret or code name—a playful nom de plume of sorts for the sake of Findern's literary games—and either way some allusion to the Findern ancestor Godwin may be detectable, as I mentioned before.[201] What may be another code name appears across the opening on folio 138v (fig. 36a), unless of course we are to understand a real name in the words "¶ Crocit. ⚡ dyton ⚡" written in a more decorative script

poem.[195] The composite poem known as the *Tongue* (fols. 150r–151r) is made up of three stanzas from Lydgate's *Fall of Princes*, followed by three stanzas from Chaucer's *Troilus and Criseyde*, with one unique stanza tacked onto the end.[196] This particular work was copied into the manuscript by Scribe 32, who contributes nine different pieces to the book, some of them moral and devotional, others love lyrics, with six of the total unique to the manuscript, including this one, which just may have been compiled and authored by the scribe. In the unique lyric copied by the same hand that begins "Yit wulde I nat the causer

<hr>

195. In Devonshire, passages from Chaucer, Hoccleve, and Roos are reworked into lyrics—Edwards 2007, 102–3—with those from *Troilus and Criseyde*, for example, very likely used for covert communications among the scribes. For an example of covert communications in a book shared by religious folk, see ch. 6, sec. IV and fig. 28 there.

196. See Marshall 2002, 440–41.

197. See Robbins 1954, 630n118, on the dialect. The lyric is printed as #13 in McNamer 1991.

198. This is in contrast to the southeastern London dialect of many of the major pieces in Findern. See Robbins 1954, 630, and Hanson-Smith 1979, 181. Findern's *Degrevant* contains forms from both the Southeast and Derbyshire, presumably because its two scribes or just possibly their two different exemplars came from

those regions: the work of Scribe 21 features forms that best match Central Sussex and that of Scribe 22 forms found in "an area within twenty miles or so of Findern": Johnston, forthcoming, ch. 5. Hoccleve's *Letter to Cupid* in the Findern MS also has a Derbyshire provenance: see Jurkowski 1997, 196n1.

199. Harris 1983, 308.

200. The lyric on fol. 69v is printed as #5 in McNamer 1991; that on fol. 139r, as #10. McNamer discusses the revisions in some detail, as does Harris 1983.

201. The rebus and scroll appear in the same hand on the last leaf of Bod. MS Laud misc.658, though Scribe 29 is only a reader there and not involved in copying the *Three Kings of Cologne* found in the manuscript: see Harris 1983, 303–4. The *Three Kings* also appears in the London Thornton MS.

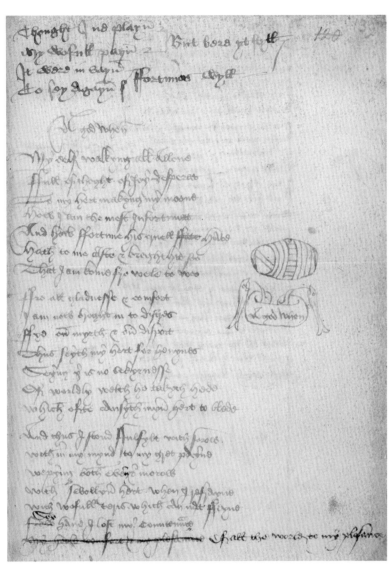

36a and b. Unique lyrics copied by Scribes 30, 4, and 29; the first signs "Crocit. dyton" with flourishes, and the third "A god when" twice, once with a rebus; the third also revises the text in darker ink. Cambridge, University Library, MS Ff.1.6, fols. 138v–139r.

but almost certainly by the same hand as the unique lyric above it. The same scribe (Scribe 30) writes "desormais" (henceforth) at the bottom of the other unique lyric in his or her hand (fol. 139v), likely as the motto of the Clifford family.[202] The motto of the Tate family who set up house close to Findern in the mid-sixteenth century ap-

pears as "theynke and thanke" at the head of *Sir Degrevant* (fol. 96r; see front plate 9),[203] and at the end of the same text (fol. 109vb) what looks to be one or two stylized and abbreviated words may record "in code" a third name beside the two scribal names (fig. 33).[204] Though it is a relatively common scribal tag, even the "full of love" designa-

202. See Elvin 1971, 42. The Cliffords were related to the Roos family and thus to the author of *La Belle Dame sans Mercy.* The same hand appears to have made a rough attempt at a musical staff and notes on fol. 139v.

203. Ibid., 199, though the Tate family are not alone in using it (see 199 and 200).

204. Perhaps with one word or part of the name running vertically on the page and the second horizontally. Johnston, forthcoming, ch. 5, believes that this name instead of that of either

Elizabeth belongs to *Degrevant*'s second scribe, and the hand and ink do indeed seem a match for both the text above and the names beside it. What the marks mean, however, remains a mystery—Casson 1949, 115n1920, reads it as "Rokeldo" with an *e* above the *R* and a *u* beneath it, but sees it as a later hand, while Robbins 1954, 626n88, transcribes it "kukesdo"—and the form and position of its letters seem deliberately cryptic, suggesting an element of play or secrecy.

37. The lyric "What so men seyn" was copied by Scribe 11, who elsewhere signs "lewestou*n*" (fols. 58v and 59r); the unique verses overturn the conventions of courtly love poetry and use layout to great effect. Cambridge, University Library, MS Ff.1.6, fol. 56r.

tion for the scribe Nicholas (Scribe 14) may play some part in the game of literary exchange, and so may the demand that Scribe 11, who signs "Quod lewestou*n*" (on fols. 58v and 59r; see also fig. 35), adds to the explicit of the *Seven Deadly Sins*—"Da michi q*uod* merui [give me what I deserve]" (fol. 58v), which might well be read with a humorous or ironic tone.

Leweston seems a straightforward surname, however, and the colophon may be a sincere plea for remuneration (perhaps by a professional scribe, since Leweston's script is indeed accomplished) or a genuinely pious sentiment. Similarly, there is little apparent reason (at least on the surface) to read the faint name of "Margery hung*er*ford" written along with the pledge "W*ith*owte variance" at the top of a unique lyric copied by Scribe 4 (fol. 20v) as anything but a genuine sentiment.[205] Yet this does not mean that Margery wasn't participating in the literary game afoot in Findern, since heartfelt sentiments would have been essential aspects of the game. The two unique lyrics added in the hand of Scribe 4 on folio 20v pick up the love debate of the nightingale and the cuckoo dramatized in the *Book of Cupid* by John Clanvowe, a poem that was part of the Findern MS much earlier though it now follows (on fols. 22r–28r) the two filler lyrics. The first lyric, "Where y haue chosyn stedefast woll' y be" (above which Margery Hungerford and her pledge appear in a different ink and hand), echoes in its vows of fidelity and service the nightingale's idealistic perspective on love; the second, "ye are to blame to sette yowr*e* hert so sor*e*," seems to respond directly to the first, taking the cuckoo's more pessimistic view of love as suffering and love-service as a hopeless effort.[206] The lyrics resolve the debate no more than the original poem did, of course. The point appears instead to have been scribal, perhaps authorial dialogue over an open-ended question of the sort very fashionable in the fourteenth and fifteenth centuries: "Is loyalty and service in love rewarded?" Margery Hungerford, however, and this is the case regardless of the relationship she bore to the poem's author or scribe, seems to have come down quite clearly on one side of the debate.

The pros and cons of love are again explored in the two unique lyrics copied into the manuscript by Leweston (Scribe 11). One speaks of enduring love surviving long absence—the same poem that contains what might be an authorial change to improve language and metre (on fol. 69v; fig. 35)—but the other presents a wittier, more cynical view of love and relations between the sexes (fol. 56r; fig. 37).[207] The speaker of that second poem—"What so

205. Margery may have been related to Margaret, Lady Hungerford and Botreaux (d. 1478), and her successor Mary Hungerford, who was connected to the Finderns through marriages and owned several Derbyshire manors, including that of Cotton: see Beadle and Owen 1977, xvi n.15, and Harris 1983, 305. Johnston, forthcoming, ch. 5, has suggested the Margery Hungerford who was married to the knight Edmund Hungerford as the most likely candidate for the person whose name appears in Findern; she lived until 1486.

206. See Doyle 2006, 239–40. The lyrics are #1 and 2 in McNamer 1991. Although the hand of the Hungerford name and that of the poem below do not match, Hungerford could nonetheless have been the author. On the one hand, Scribe 4 could have written the work out for her, while Hungerford added her name and title, or perhaps someone else knew her to be the author (or to be

Scribe 4) and wished to record it for posterity. On the other hand, Hungerford could be marking the poem as a favorite of hers, or as her contribution (authorial or otherwise) to the manuscript's love debate, but as with so many of the names and tags in Findern (and other manuscripts), we simply cannot be sure what exactly is intended.

207. The lyrics are # 5 and 4 in McNamer 1991.

men seyn"—attacks men for their falsehood and instability in love; for the way in which they "make butt game" (line 24) of emotions the female speaker seems to take far more seriously. The poet, however, one and the same with the scribe Leweston or not, appears to be doing more: "to make" in Middle English has a range of meanings, including "to compose," and the verb might have been chosen to comment on the way in which not just men but their courtly poetry tends to make little more than a game of love. The poem lays bare the manipulative nature of male poetic language, and in so doing lays out a warning to women—lays it out graphically on the page by writing each fourth line to the right (fig. 37). The first four of these lines highlighted by space tell of men's nature:

> butt varians
> ther displesauns
> and dowbilnys
> new fangell'nys.

The next four advise women readers how best to respond:

> beware for sham*e*
> and make but game
> in euyry plase
> *with*owtyn' grase.

So the male game of courtly wooing is usurped and inverted to shape a literary and social game more favorable to the needs and desires of women.

Women Romancing the Book for Women

There is considerable evidence, then, in these unique Findern lyrics to suggest something of a lighthearted literary exercise among local gentry; a shared or communal poetic effort to render in courtly (and not so courtly) ways the themes of longing or sorrow, loyalty or inconstancy in love, with each new pen and perspective imitating, adding to, or outdoing other attempts in the playful manner of the Devonshire lyrics. Yet those could possess also a personal and deadly seriousness, as the group of poems dealing with the affair between Margaret Douglas and Thomas

Howard (who ultimately lost his life because of his indiscretion) makes all too clear. And there is a seriousness also in the Findern MS—a seriouness and selectivity regarding literature, certainly, but also a seriousness of experience and expression. Even the witty literary play of the "What so men seyn" lyric addresses some very real social and emotional issues and offers practical advice as well, particularly for young women who might wish to combine social pleasures while maintaining personal honor and safety, not only from heartbreak, but from infamy and pregnancy as well—advice, that is, on how to play the courtly love game successfully themselves.

Several other texts in Findern are educational in a more traditional manner, like the *Seven Deadly Sins,* the prayers to Mary and the holy name of her son, the *Chronicles of Saints and Kings of England,* the *Seven Wise Counsels,* the *Cato Major,* the *Treatise for Launderers* and the *Pain and Sorrow of Evil Marriage.* The last two are the work of Lydgate, the first particularly addressed to women, the second to children—"[T]ake hede and lern lytull chyld" (fol. 155r, line 1)—echoing the family audiences of the Auchinleck and Thornton volumes. The extended literary debate over love might also be seen as an effective instructive tool, providing with its social education an excellent lesson in comprehension and composition, as well as rhetoric and logic. There is some evidence that young and beginning readers and writers had the Findern MS in hand—rough scribbles in many margins, for instance, as well as alphabets and pen trials in places.[208] Most striking is the upside down name of "Thomas Cotun" that appears under the motto "desormais" on folio 139v along with the grammatically questionable tag "bonos puer."[209] The fifteenth-century name "ffrances Cruker" on the blank page across from the opening of *Degrevant* (fol. 95v) may also be that of a young or learning reader, with either her piety or her scribal work (perhaps the rough salutation "ryght Worshipffull" in a different ink and probably a different hand on the same folio) praised, ironically or otherwise, via the odd assessment "potutis Inter Chyrkym," meaning something like "Frances Cruker, you could have been within the church."[210] It is difficult to be certain, of course, about what is at best

208. As on fols. 59v (fig. 32a) and 150v beneath the composite *Tongue* lyric. Rougher alphabets and trials appear along the foot of fols. 159v–160r beneath the unique *Complaint to Fortune* lyric, and on fols. 137r and 138r as well.

209. The name "Thomas" is written again right side up beneath "bonos puer," perhaps by the same hand. That young readers could and did leave such self-affirming notes in manuscripts is confirmed by an annotation left among Robert Southwell's poems in Stonyhurst, Jesuit College, MS A.v.27 (c. 1600) by the young Jeronima Waldegrave (born c. 1603). Written c. 1608–9, the poignant note claims that "iereneme walDegrave is a gooD garle BVt that noBoDi cer for her": see Brown and McDonald 1967, xxxvii–xxxviii. I am grateful to Amanda Shaw for bringing this intriguing annotation to my attention and sharing her thoughts about it.

210. Reading "potutis" as "potuistis," with a syllable eliminated as so often in medieval and poetic Latin; the plural form may be a sign of respect. "Ryght worshipfull" is a common form of address in late medieval letters, like those of the Paston family, and the scribe who wrote it also left the phrase "ryght truste and Wylbelofed" in the right margin of Hoccleve's *Letter to Cupid* (fol. 76v) and the word "ryght" beneath Anelida's complaint from Chaucer's *Anelida and Arcite* (fol. 63v), where another note in the hand that wrote "Cruker" on fol. 95v is also found, and though very difficult to make out, the name "Crvker" appears to be there, and the word "master" may be as well. The full name "ffrancIs Cruker" appears again on fol. 65v. A John Crewker was both "cousyng" to the Thomas Findern who died in 1525 and an executor of his will: see Beadle and Owen 1977, viii. Marshall 2002, 442, also attempts to transcribe these annotations, though with different results than my own at times.

a conjectural transcription of an uneven hand, but how strange and revealing a compliment it is if it does indeed read as I've suggested—just the sort of compliment one might use to inspire a young woman learning her letters.

There is much about Findern that suggests young women in particular as intended and actual readers of its texts, just as they may well have been among its compilers and scribes. It is Elisabeth Francis's maiden name that appears, for instance, at the end of *Degrevant*, which has been called "one of the most female-friendly romances in the entire Middle English corpus."[211] And female-friendly is a term one could apply to the manuscript as a whole, with much of its contents (like the unique lyrics discussed above) creating not only "a pronounced slant towards expressing the concerns of women in love" but also "a consistent interest in . . . female lament and agency," "female response to male authority," and "female intelligence."[212] There is an essential difference between the Findern anthology and that professional Oxford group of Chaucerian manuscripts to which it is related. In particular, a number of texts exploring love from the male point of view in those manuscripts are simply not included in Findern. "The *Complaint of Venus* is not accompanied by that of Mars";[213] instead Findern's folios are alive with young, intelligent, outspoken, and independent female characters. Both the formel eagle in Chaucer's *Parliament of Fowls* and the Belle Dame of Roos's poem refuse to give in to the desires of their suitors, the latter insisting in the manner of the "What so men seyn" lyric on taking courtly love as nothing more than a game. Their perspective is supported by Hoccleve's *Letter to Cupid*, an English translation of Christine de Pizan's *Epistre au Dieu d'Amors*, in which fickle courtly suitors are condemned. In the *Three Questions* excerpt from Gower's *Confessio Amantis* only the clever fourteen-year-old heroine is able to answer the riddle that saves her life, and she does not stop there: she also manipulates the king's language to earn her father a title and herself marriage to the king. Here, then, we have "a young woman with significant powers of interpretation who [like the author of the "What so men seyn" lyric] can turn men's language (though it is not strictly the language of *fin' amors*) to her own advantage."[214]

These last two works present the only instances in Findern where any sort of decorated capital has been provided to open a text.[215] At the beginning of Hoccleve's *Letter* a tiny upright fish in the hand of the scribe (Scribe 6, who copied this piece and collaborated on both *La Belle Dame* and the *Parliament of Fowls*) serves as the **I** in a two-line incipit heading (fol. 71r). Gower's *Three Questions* opens with a slightly larger and more elaborate initial **A** (fol. 45r; fig. 38a), likely also in the hand of the text's scribe (Scribe 8), who adds flourishes to the ascenders along almost every top line of the text as well (as on fol. 47v; fig. 38b). Whether Scribe 8 decorated the *Three Questions* so elaborately (for the standards of the Findern MS) simply because of his or her own idiosyncrasies or specifically to draw special attention to its young heroine and her "significant" intellectual "powers" is impossible to determine because the scribe's work appears only in this text. Space for another two-line capital opens the *Thisbe and Pyramus* excerpt from Chaucer's *Legend of Good Women* (fol. 64r), in which Thisbe demonstrates feminine powers of a different kind.[216] More than other heroines in Chaucer's collection of legends, Thisbe makes her own choices, defying her father's wishes to do so; she willingly wields her male lover's sword, speaks without being curtailed by the narrator—she, in fact, rather than her lover Pyramus, is given the last word—and is equal to Pyramus in both "passion" and "self-sacrifice."[217] This egalitarianism of the sexes is emphasized in the final lines of the legend, quoted here from Findern (fol. 67v):

> Here may ȝe seen whate louere so he be
> A woman dar and kan as wele as ~~sche~~ he
>
> *(lines 922–923).*

Women readers are thus encouraged to emulate the behavior of men, which is striking all on its own, yet the last line in Findern contains a scribal error that complicates matters. Nicholas "full of love" (Scribe 14) originally wrote the last word as "sche," an error which he then corrects with the more usual "he." But it is an interesting error that suggests how doing as Thisbe (not her lover) had done may well have been foremost in Nicholas's mind as the excerpt came to a close. With or without the error (and note that both readings remain legible), the example of Thisbe's strength and independence would have offered special encouragement to female readers: Frances Cruker, for example, whose name appears in the *Thisbe* excerpt (fol. 65v).

So there is little doubt that women readers would have found the Findern MS and its texts inspirational, and some of the manuscript's unique English lyrics may well be as

211. McNamer 2003, 207.

212. Meale 1999, 125, and Kinch 2007, 733 and 737.

213. Meale 1999, 126.

214. Doyle 2006, 256. Kiefer 2003 discusses Gower's *Confessio Amantis*, a text originally dedicated to the young Richard II, as medieval children's literature.

215. Spaces were occasionally left in Findern for *litterae notabiliores*, as by Scribe 35 who leaves room for two capitals at the beginning of the *Mischance in England* on fol. 156v, but very few were ever completed.

216. A two-line initial also seems to have been planned for the beginning of Lydgate's *Pain and Sorrow of Evil Marriage* (fol. 155r) which, as I mentioned above, was addressed especially to children.

217. The quoted words are Sheila Delany's as discussed in Doyle 2006, 254.

much the creative products as contributing aspects of that inspiration. We have already seen how the two unique lyrics Scribe 4 added to folio 20v respond to Clanvowe's *Book of Cupid,* and we have seen, too, how several of the unique Findern lyrics adopt female voices and perspectives (sometimes with the use of gender-specific pronouns),[218] record what appear to be authorial changes (in the work of Leweston and "A god when," for instance), and demonstrate Derbyshire dialect features. Taken at face value, these unique Findern lyrics seem the product of local women authors participating in literary culture as they know it; "talented amateur[s] at work" seeking "new molds for new experiences within the courtly love tradition."[219] Certainly some express the female condition with a sensitive accuracy, replacing the sexual and social powers of the unattainable lady worshipped and resented in the work of courtly male poets for what seem more genuine descriptions of lonely, virtually powerless women with little more than their steadfast affection and obedience to their marriage vows as consolation. Such scenarios match well the historical reality of gentry women, who were among the most stationary of well-to-do individuals in the late Middle Ages.[220] Of course male-authored poetry can create the illusion of female authenticity, but the kind of courtly love poetry the Findern lyrics tend to imitate and transform does not, and the Findern lyrics are far less stereotypical, more colloquial and demonstrate greater "variety and experimentation in stanza form and metre" than many other secular lyrics from the period.[221] Combined with the "remarkable 'frankness'" of these female voices, "an openness and *elan*" foreign to male depictions of women, courtly or otherwise, and much like the "heroines in the *lais* of Marie de France" whose emotions are often balanced by a keen sense of economic, social and domestic reality, these qualities do indeed make the Findern lyrics seem "sincere expressions of authentic female emotional experience."[222]

Yet it is generally assumed that Marie was writing romance fiction, not autobiographical lyrics, and while there may be—no doubt were—genuine experiences and feelings woven into any or all of the unique Findern lyrics, very likely by women authors in several cases, measur-

38a and b. The three-line initial **A** along with flourishes and faces on top-line ascenders in Gower's *Three Questions* are among the Findern MS's most lavish decoration. Cambridge, University Library, MS Ff.1.6, fols. 45r and 47v (details).

ing the personal authenticity of feelings expressed in literature often proves impossible without supporting evidence, and all the more so in a potentially playful context. Measuring the sophistication of a piece of literature does not, however, and we have already glimpsed the clever use of language and sentiment in a few of these Findern poems. Their authenticity as provincial creations does not, therefore, seem a valid reason to read these lyrics as misunderstandings of the courtly literary game of love, "provincial" in a derogatory way because they represent a "deliberate borrowing of the courtly mode by those outside the charmed circle . . . , those who have learnt the idiom of the language of love but somehow seem to be missing the meaning."[223] Recall that inside that "charmed circle," where the Devonshire MS originated, women's lyrics are read as heartfelt and autobiographical but not unsophisticated for being so—quite the opposite, in fact. So to read the women's lyrics of the "provincial" Findern MS as naïve and simple because apparently heartfelt and autobiographical before considering self-conscious literary play or deliberate reshaping of that "courtly mode" on the part of what may be sophisticated authors is both illogical and misleading. Many of the Findern lyrics are more than worthy of the courtly dialogue to which they contribute, and even the most sincere and naïve can be reflective of it in deeper ways, just as the provincial maiden Elaine of Astolat, one of Malory's most troubling minor

218. For example, in the lyric "Yit wulde I nat the causer faryd Amysse" copied by Scribe 32 in a Derbyshire dialect the speaker uses the feminine pronoun "sche" in relation to herself (fols. 153v–154r, lines 4, 12, and 13), which does not rule out a male author but does tip the scales in favor of a female one. The same is the case with the second of the unique lyrics copied by Leweston, which uses male pronouns for the beloved eight times, including "hym" in the corrected line (fol. 69v; fig. 35).

219. Hanson-Smith 1979, 182. On female authorship of many of the unique Findern lyrics, see Hanson-Smith, Doyle 2006, McNamer 1991, and Barratt 1992, 268–74; the last two print a selection of lyrics they consider to be the products of female authors.

220. In the extensive Paston letters, for instance, the men write from afar, the women from home, where most matters except their own mobility are left in their capable hands.

221. Robbins 1954, 631.

222. Hanson-Smith 1979, 186, and McNamer 1991, 280.

223. The views are those of John Stevens, discussed in McNamer 1991, 288, but "provincial" has too often been used as a dismissive tag in scholarship.

characters, is. She may well lack an understanding of the potential duplicity of the courtly language of Lancelot and thus find encouragement where he did not intend it, but her honesty, her loyalty, her frank words of love and loss strip bare the decadence and deception of Arthur's court, confirming the ideal of an entirely pure, all-consuming, unattainable love, just not for any of the courtiers of the tale.

Of course Elaine's death is also a tragic waste, and with it Malory undercuts the courtly love ideal, but so, too, does the scribe Leweston in the witty "What so men seyn" lyric with its obviously feminine point of view (fig. 37). Neither she nor the compilers of the Findern collection lacked an understanding of the potential play and duplicity of courtly language. Indeed, there is much of the kind of "sexual sparring" familiar at "mixed gatherings" of the Ricardian court[224] to be found in the Findern collection, and it is important to remember that women were neither the sole contributors nor the sole users of the book. Male scribes and readers, like Nicholas "full of love" and Thomas Cotton, left their names in Findern, and some of its unique lyrics may well have been authored by men. Many of the major texts in the manuscript were certainly written by men, with some, like those by Chaucer, more often associated with a male audience than a female one[225] and rarely combined with romance. Other texts ostensibly included for their contributions to the playful love debate may also reveal certain political associations that may have been more relevant to the men of the Findern family than the women. John II (head of the family c. 1390–1420) was a man of Lollard sympathies, supporting imprisoned Lollards and no doubt the Lollard program of disendowment as well,[226] and the Finderns were also Lancastrian sympathizers. Thus the *Book of Cupid* by the Lollard knight Clanvowe (identified as the author only here: see fol. 28r) or the English translation of *La Belle Dame sans Mercy* by the Lancastrian Roos, whose family was associated with many of the same families as the Finderns, could well have been included for political as well as literary motives. Since both authors served the royal court, both poems were probably initially intended for that courtly audience, and thus spoke its symbolic political language as well as its stylized emotional one. There can be little doubt that the men associated with the Findern MS (and very likely the women as well) would have understood that language, for they were at times deeply implicated in both local and national politics, most disastrously on May 17, 1464, when Thomas Findern was executed at Sandhill along with Thomas Roos and Robert Hungerford, all of them accused of Lancastrian allegiances.[227]

A much brighter note, though one with resonances no easier to define, is struck by an annotator of Findern's *Degrevant* romance, a tale, as we have seen, that drew the attention of both men and women in the Findern and Thornton MSS. The comment is tiny, added interlineally (almost invisibly) at the end of the first fitt by a corrector whose hand appears occasionally from the beginning of the romance (see front plate 9), but when it asks "howe say ye‧ will ye any more of hit‧" it widens the potential audience to a whole hall or chamber of listeners.[228] The note has naturally been read as an allusion to Chaucer's "Sir Thopas," where the second fitt closes by asking the audience, "If ye wol any moore of it" (VII.889). When the host of the *Canterbury Tales* stops the teller a few stanzas later, he answers that question for everyone on the pilgrimage, judging "pleynly, at a word" (VII.929), and utterly unable, it would seem, to recognize either the potential richness and humor of Geoffrey's many literary allusions to romances Chaucer knew well, or the social commentary offered by his own bourgeois words—words borrowed in places from *Guy of Warwick*.[229] It is generally a mistake, of course, to read Chaucer, the great purveyor of double meanings, "pleynly," all the more so when the tale is told by Chaucer's own tricky persona and its hero named after what the near-contemporary *Pearl* calls a "twynne-hew [two-colored]" stone.[230] The "Tale of Thopas" clearly held special value for some medieval readers, or the aristocratic patrons who commissioned and used the deluxe Ellesmere MS (San Marino, CA, Huntington Library, MS Ellesmere 26 C9) would hardly have had the tale decorated

224. Quotation from McDonald 2000, 25.

225. Though Findern is among the growing evidence for Chaucer's female readership. Doyle 2006, McDonald 2000, and Seymour 1995 and 1997 note several volumes associated with women. Koster Tarvers 1992, 318–19, discusses the striking example of Bod. MS Hatton 73, which contains works by Chaucer, Gower, and Lydgate and was passed from a "middle-class woman to royalty to gentry, documented chiefly in the women's own hands." For an example of nuns who owned Chaucer, see ch. 6, sec. II.

226. Jurkowski 1997, 202–3, and 206.

227. See Seaton 1961, 33, and Meale 1996, 129. The very same divisions and allegiances would have influenced the Thornton family in North Yorkshire, where the Yorkist Nevilles and the Lancastrian Percies were rivals, and the family of Roos held the nearby castle of Helmsley.

228. The comment appears on fol. 98va. Casson 1949, xiii, also believes the hand to be that of the corrector (D in his terminology), who works from the opening of *Degrevant* up to this point.

229. The Host's assessment that the "drasty rymyng" of "Sir Thopas" "is nat worth a toord!" (VII.930) echoes *Guy*, line 3349: "Þou nart nouʒt worþ a tord!" (Auchinleck: fol. 126va). There is also a parallel in the host's words at line VII.924: "Now swich a rym the devel I betiche!" which recalls *Guy*, line 5454: "Þe deuel biteche ich ʒou ichon" (Auchinleck: fol. 138va). The two parallels are noted by Hibbard Loomis 1962, 149.

230. Andrew and Waldron 1978, line 1013. See also the discussion in Hilmo 2004, 163.

231. As Maidie Hilmo has kindly informed me, "Sir Thopas" uses gold more heavily in its presentation than all the other tales in Ellesmere. For a discussion of Ellesmere's decoration and illustration, see ch. 5, sec. II and sec. IV.

so expensively and elaborately.[231] So while it is possible that the reader who added the "will ye any more of hit" note to *Degrevant* meant to be "scathing,"[232] it is also likely that humor was the intention: laughter at Degrevant's expense may have been one of Thornton's reasons for including *Lyarde* in his Lincoln volume,[233] so perhaps there is something of that in Findern too, maybe even a chuckle at the grassroot beginnings of a book that grew to include Chaucer himself.

Most obviously, however, the corrector's comment could have provided an opportunity for the audience to express its genuine enthusiasm, for there can be little doubt that romances generated enthusiasm from readers in the Middle Ages, some of them certainly more capable than Harry Bailly of exploring along with Chaucer and his characters the semantic possibilities of a genre once predominantly aimed (in Latin or Anglo-Norman) at aristocratic audiences that had subsequently blossomed, between Chaucer's birth and that, say, of Elizabeth Francis, to become popular reading in the English vernacular. Equally certain is the reality that romance audiences of all kinds did want more: more courageous, presumptuous heroes; more swashbuckling, romantic adventures; and more books in English. The trend has not abated despite centuries of abuse from the pens of critics, with the modern genres of fantasy and romance the most obvious descendants, and the essential structure of the popular novel still largely derived from the progressive plot of intertwined episodes, challenging hurdles and climactic arrival familiar from medieval romance.

Our romance with romance is far from over, then, and our romance with the kind of single-volume library of selected writings developed by medieval readers of the genre is no different. These engaged bookmakers were the best of wooers, spending years, if necessary, personally gathering from their social networks what they would need to succeed, spreading their folios wide for an extensive range of texts to please readers of many different ages and interests, and winning the book over to their manifold desires so completely that the anthology came to dominate the transmission of vernacular writing in late medieval England. Still today it shapes the literary canon we serve up for future generations, but with a dash of irony—we have made a tradition, after all, of selecting the texts for our own anthologies of medieval literature from these very manuscripts with only the rarest glance at what keeps them company. Yet the more inclusive eye that manuscript studies is now turning on the earliest English anthologies is reshaping literary history again, circling the quest back to the beginning in the way of the best of romances. So "Yes!" is the answer, it seems we will have "more of hit."

232. Thompson 1991, 37.
233. See Furrow 1996.

CHAPTER THREE

The Power of Images in the Auchinleck, Vernon, Pearl, and Two Piers Plowman Manuscripts

MAIDIE HILMO

Hose wole mai rede and look.

The Prick of Conscience, from the Vernon MS

I. Looking at Medieval Images

Before a medieval poem is read it is first seen as a material image on the manuscript page. Even "a capital letter represents a statement."[1] First impressions, and hence those important initial judgments, are all the more powerful if the vellum page, with its rows of hand-lettered thick and thin letter forms, are part of a larger visual program including colored and gilded ornamental capitals, embellished border elements, and, especially, illustrations. These add to the aesthetics of the page and are a testament to the importance and cost of the manuscript, and hence to its owner's taste and prestige. Iconic status is often accorded them as well. Figural illustrations are instantaneously apprehended as reflecting part of the viewer's own physical reality and so serve as a transition to the world of the text to which they provide entry or from which they emerge to provide another level of meaning. They engage the reader emotionally, set the tone, and announce the subject. Medieval reading often included looking, in a nonlinear, holistic way, at all the components of the page.

Words and images were closely associated in medieval culture as a means of apprehending truth. Medieval images were not intended to be viewed primarily as art ob-

jects in the modern sense. In early Christian times there was even a suspicion about images that were too representational or beautiful because then the minds of some might cling only to earthly things.[2] This distancing from the standards of pagan, classical art led to an artistic style that was more linear than three-dimensional, symbolic rather than merely representational. The visual as well as the verbal functioned as signifiers of meaning, often in a complementary manner.

Fueling early anxieties about images were the strictures of the Second Commandment against the making of graven images or idols in Ex. 20. 4–5 (also Lev. 26.1, and Deut. 5.8). The worship of pagan idols would indeed have posed a serious threat, as the lives of Christian martyrs gives evidence. Such stories were still popular in the late Middle Ages as seen, for example, by that of Saint Cecilia in Chaucer's tale of the Second Nun, who refuses to worship a pagan idol and so is martyred,[3] or of the sultan's Christian wife in *The King of Tars,* who pretends to do so but subsequently converts her pagan husband instead (see below). Nothing loath to encourage the destruction of pagan idols, Pope Gregory I (540–604) did

1. Havelda and Wah 2007, text fragment in a book of boxed cards. In this chapter, italic font is used to indicate ornamental initials, following usage by Michelle P. Brown 1994, throughout.

Conforming to art historical practice, boldface font is not used to indicate headings or rubrics.

2. Pseudo-Dionysius, the Areopagite (1894) 2004, ch. 2, p. 5.

3. For images of Cecilia, see Hilmo 2009, 107–35.

nevertheless allow that Christian images could serve didactically as books for the illiterate.[4] During the rise of Islam, an anti-iconic religion, Christians in the East also began to question the use of images, with the result that they were banned altogether during the periods of iconoclasm from 726–80 and 815–43. That there was also an important controversy in the West during the Carolingian period, expressive of local situations but showing awareness of the issues discussed in the East, has been argued by Thomas Noble.[5] Countering the ban in the East were such defenders of images as John of Damascus, who formulated the Incarnational argument that, because Christ became man, images of him were permissible,[6] the old law having been superseded. He also influenced later conservative writers about images in the West such as Thomas Aquinas.[7]

When image-making once more became a contentious issue in England during the latter part of the fourteenth century, John of Damascus was also quoted by Roger Dymmok, a conservative defender of images who went so far as to suggest that they are actually better than texts because they are clearer and more immediate.[8] Oxford-educated John Wyclif, however, condemned the use of rich images but allowed that they were useful for stimulating devotion; yet the sooner the sensible was left behind the better.[9] Reformers like the Lollards, for example, held that the immaterial cannot be manifested and that the only true image of God is man, who is made in his image. As one late fourteenth- or early fifteenth-century writer put it, "men shulden be more gostly and take lesse hede to siche sensible signes . . . for oure lord God dwellis by grace in gode mennus soulis, and wiþoute comparesoun bettere þan all ymagis made of man in erþe."[10] While it is all right to have a plain, unadorned crucifix to remind the illiterate of Christ's suffering, the same writer argues, it is better to give money to the poor than to adorn rich images that might be worshipped in their own right and that might "counfort men in worldly pride and vanyte and lykyng of her wombe and eʒen and oþer lustus."[11] The last of this sect's Twelve Conclusions of 1395 (a satiric work that had provoked Dymmok's response) even argued that the work of artists should be destroyed.[12] In its disparagement of colored images that look like living creatures, the *Lantern*

of Light (c. 1410) stated that fools were tricked into thinking that God's power descended into some images more than others. Many followers of Wyclif argued for the superiority of hearing (sermons) over seeing (paintings).[13]

Somewhere in the middle between the conservative and reformist approach to images is that expressed in *Dives and Pauper* (1405–10), a treatise in which Dives (cf. Luke 16.19–31), a pious layman, asks the important question: "How shulde I rede in þe book of peynture and of ymagerye?" Pauper answers by way of a long explanation about *how* to look at a crucifix: take heed of the meaning of each of Christ's wounds that he suffered for man's salvation, make an end of all one's sins, and ask for mercy, making sure to worship not the image itself but him it represents.[14]

So how does a modern reader learn a new way of seeing in order to "rede in þe book of peynture and of ymagerye?"—or more specifically, to read the illustrations in literary manuscripts? A very medieval method, but one still applicable, is described in the early eighth century by Bede who tells how Cædmon, like an animal chewing cud ("quasi mundum animal ruminando" or, in the Old English version, "swa swa clæne neten eodorcende")[15] turned the sacred stories told to him into poems. Not only is this metaphor applicable to the monastic practice of ruminating or meditating on scripture, *ruminatio* is also applicable to the way medieval images can be apprehended. The best way to understand how the images in literary manuscripts function is to look closely at them, study them, ask questions—meditate on them—and read the accompanying text with similar attention. It is also useful to become familiar with medieval art in all its forms. But first, it helps to prepare oneself by approaching illustrations with an open mind, if not with the pious attitude that might have been expected of a person in the Middle Ages.

Illustrations in literary texts deserve prolonged study and attention. They were not made in a day, so there would have been time, especially in the case of vernacular texts, for the artists to learn their content. A conscientious artist would certainly have tried to do so, and then would have adapted known iconographies to the task at hand. Sandra Hindman contends that the pictures she examines in the *Epistre* "reveal in the aggregate a heretofore unappreciated originality."[16] Too often the illustrations

4. Gregory the Great 2004, 744–47.

5. Noble 2009.

6. John of Damascus (c. 675–749), *St. John Damascene on Holy Images*, trans. Mary H. Allies, London: Thomas Baker, 1898, especially 5–6, now online at Christian Classics Ethereal Library, http://www.ccel.org/ccel/damascus/icons.i.i.html. See Barasch 1992, 211–12, and Hilmo 2004, 18–22.

7. See Aquinas 1913, 338.

8. Dymmok 1922, 182.

9. Wyclif 1922, 156–57.

10. Hudson (1978) 1997, 84.

11. Ibid., 83–84.

12. For the Twelve Conclusions of the Lollards translated into Middle English see http://www.courses.fas.harvard.edu/~chaucer/special/varia/lollards/lollconc.htm.

13. Hudson 1993, 59–61.

14. Barnum 1976, 83–87.

15. Both Old English and Latin versions of this story from Bede's *Ecclesiastical History* are available online. See Benjamin Slade, "Bede's Story of Cædmon: Text and Facing Translation," 2002–3, at http://www.heorot.dk/bede-caedmon.html.

16. Hindman 1986, 77.

in vernacular Middle English manuscripts are also "unappreciated."[17] Each new project would likely have been unique, with different placements and amounts of space available for illustrations. The making of the illustrations in most of the illustrated texts discussed here would not have been overseen by their respective authors, but these illustrations do guide the reading process according to the views and interests of their scribes, artists, and audience. Artists' manuals, such as *The Divers Arts* by Theophilus (c. 1122),[18] also make clear that the artists were professionals who had to have an intimate knowledge of the chemistry of pigments, how to prepare them, and how to apply them to different subjects. This is true even if many of the artists were not conversant in Latin. While it was handy to have access to such a manual, most artists probably did not, learning instead what was passed on from master to apprentice, from other manuscripts, and by experience.

People at all stages of the process of making images shared in their spiritual benefits, from the patrons who commissioned the works to the artists who, in using their talents, as Theophilus emphasized, participated in the "wisdom and skill" of the supreme Artificer's design.[19] Because medieval images often carried such a tremendous burden of leading the viewer beyond earthly appearances to spiritual transcendence, they should be taken seriously.

Although Gregory's dictum about pictures as books for the unlearned was frequently repeated, in effect, they served much more, as Jeffery Hamburger repeatedly asserts. In his discussion of art by and for nuns, he points out that devotional images holistically and performatively involved the whole person, "corporeal as well as spiritual, through speech, sight, and gesture."[20] He goes so far as to insist that in practice, under the influence of the mendicant orders, an increase in literacy (especially vernacular), and with the increasing emergence of women at court and in convent as an audience, images often served as a "simulacra of the divine" and were even thought to be endowed with "potency."[21] Further, he suggests that the "supposed norm" of imageless devotion, by which only the Latin literate clergy were considered to be able to reach the divine, denied legitimacy to the actual use of images by all levels of society.[22]

1. An Artist Demonstrates the Use of Images

In the early fourteenth century the devotional use of images was demonstrated visually in a French manuscript, London, British Library, MS Yates Thompson 11 (formerly Add. 39843), on folio 29r (fig. 1). In a series of four compartments set within an architectural framework that articulates the experience of enclosure,[23] a devout nun proceeds by stages from spiritual cleansing to a transcendent vision of the Trinity itself. In the first compartment at the top left, the nun is shown clasping her hands in prayer while kneeling before her confessor. An angel flies in from the left above her with a scroll that reads: "Si uis delere tua crimina dic miserere" (If you want to take away your sins say: have mercy).[24] The last word, "miserere," is a reference to Psalm 50, the fourth penitential psalm.[25] The Confessor's gesture over her indicates that he is saying the Absolution: "I absolve you in the name of the Father, and of the Son, and of the Holy Spirit. Amen." Opposite the angel and above the Confessor is the blessing hand of Christ surrounded by a cross-nimbus, showing that mercy has been granted and the penitent has been forgiven.

In the compartment on the top right, the nun now kneels before an altar surmounted by an image of the Coronation of the Virgin. Once again the nun, in the space to the left of the thin pillar, has her hands clasped in prayer in imitation, as is now obvious, of the Virgin. An angel descends from wavy clouds through the trefoil arch, suggesting that the church itself is a space that the celestial interpenetrates. The angel holds a candle, symbolizing enlightenment, a feature reinforced by the angels holding the sun and moon disks in the quatrefoils at the top.

In the compartment on the bottom left, the kneeling nun prostrates herself further. Above the altar, Christ gestures vigorously from the wavy clouds. He wears a crown of thorns, his hands show his wounds, and blood flows down from his side into the chalice. The speech scroll that extends from the clouds to her prie-dieu reads: "pro uita populi respice querita tuli" (for the life of the people, look back to the burdens I bore). Since she is not looking directly at the altar, she is remembering and meditating on the sufferings Christ endured, which the privileged viewer sees in the image. As if to emphasize the empathetic reenactment of Christ's suffering that the nun is bearing in her own flesh, internalizing it,[26] an angel holds a sword that seems about to pierce her neck. A vine branch appears to grow from the prostrate nun's hip, perhaps visualizing the words of John 15.5: "I am the

17. For a discussion of negative critical attitudes to the images in vernacular illustrated manuscripts, especially with respect to those in the *Pearl* manuscript, see Hilmo 2004, 3–7, and 139–40. For lists of previous studies, many disparaging, involving the illustrations of manuscripts discussed here and in chapter 5, see Scott 1996, 2. cat. nos. 1 (Vernon MS), 11 (Ellesmere MS), and 12 (*Pearl* MS). For discussions of the modern aesthetic expectations and problems regarding intentionality in medieval art, see Camille 1993, 43–57.

18. Theophilus (1963) 1979.

19. Ibid., 11.

20. Hamburger 1998, 19.

21. Ibid., 112.

22. Ibid., 114.

23. See Hamburger 1998, 44.

24. I thank Linda Olson for her invaluable help in transcribing and translating the scrolls.

25. As observed by Linda Olson.

26. Walter 2003, 4.

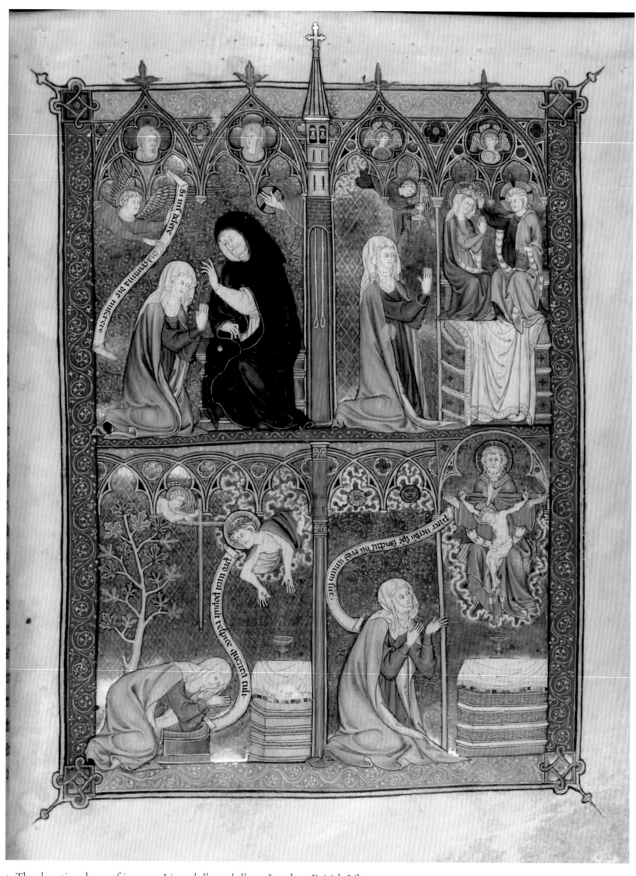

1. The devotional use of images, *Livres de l'estat de l'ame*. London, British Library,
MS Yates Thompson 11 (formerly Add. 39843), fol. 29r, c. 1300.

vine; you the branches. He that abideth in me, and I in him, the same beareth much fruit: for without me you are nothing." It is almost as if it is protecting her or as if she is symbolically about to bear fruit. Earlier in the same manuscript, as observed by Hamburger, the moment of the transubstantiation of the Host is indicated in an illustration in which these words are voiced in a scroll that Christ holds above the altar: "ego sum vitis vera" (I am the true vine).[27] The concept of Christ as the life-giving vine is reinforced by the vine scrolls in the borders of this full-page image. The vine branch is also evocative of the Tree of Life as well as of the cross itself, a parallel suggested in the image by the cross-like sword beside it.

In the compartment on the bottom right, the scroll that descends to her upper back reads "Pater uerbum spiritus sanctus hii tres unum sunt" (Father, Word, Holy Spirit, these three are one). Though still kneeling, the nun straightens up and looks directly at a celestial vision of the Trinity surrounded by heavenly clouds. The nun's hands now open up to indicate her ecstatic state. The fingers of her left hand reach across the column separating earthly and celestial reality. The Trinity is pictured in the standard Mercy Seat configuration, with the Father holding the crucified Christ while a dove represents the Holy Ghost. The focus on the Trinity, which this whole visual and verbal sequence variously reiterates, is reinforced by the rhythmical progression of the arches, the one enclosing the Trinity being raised somewhat higher than the rest in the bottom register. As if to emphasize the nun's enlightenment further, and to show that earthly reality has been transcended, the sun and moon disks are no longer held by angels but appear in the clouds above.

What is of particular interest regarding this illustration made almost a century before the image controversies flared up across the Channel is that the artist here demonstrates the stages of contemplation initiated by the use of images. This includes but also goes far beyond the conventional Gregorian view. It also shows that women were capable of understanding such complex concepts as the transubstantiation and especially, the Trinity.

2. The Illustrated English Vernacular Literary Manuscripts Introduced in This Chapter

It was a major event in literary history when the ambitiously produced Auchinleck manuscript, Edinburgh, National Library of Scotland, MS Advocates 19.2.1, with its large collection of English vernacular works, was proudly assembled and decorated as if it were as important as anything in the decorated French or Latin texts that had pre-

viously dominated manuscript production in England since the Norman Conquest. If there were earlier or other contemporary models these have, unfortunately, not survived. The Auchinleck documents the greater prominence English was being accorded as a literary language; indeed, it boldly assumes that it was just as important or even, assertively, more important than languages originating on foreign soil. It is also evidence of a wider range of functional literacy, embracing as it does the reading interests of a wealthy household around the 1330s (ch. 2, sec. I). Framed illustrations precede some of its texts, often spotlighting the heroes of the militant Christianity that characterizes many of its verse romances.

Made for a different sort of audience, likely religious rather than secular, the impressive, late-fourteenth-century Vernon manuscript, Oxford, Bodleian Library, MS Eng. Poet. a. 1, although not illustrated throughout, includes one section picturing the Gospel's birth narratives of John the Baptist and of Jesus, and another section with miniatures for *The Miracles of Our Lady*. Both of these subjects might have held a special appeal for a female audience of nuns encouraged to relive the events pictured. The more spiritually sophisticated might have unraveled the deeper levels of meaning elicited by the historiated initial of the Trinity preceding *The Prick of Conscience* later in the same manuscript. It encourages the viewer to move beyond material sight to a spiritual vision of the godhead. In manifesting the Trinity (similarly rendered as in Yates Thompson 11), however, it is also the sort of iconic representation that was derided by Wyclif.[28]

It was possibly with attention to the contemporary image controversies that the plain miniatures serving as prefaces and epilogues to the much more modest *Pearl* manuscript were made. They represent one approach to visual restraint at around the same time that the lavish Vernon manuscript was made in affirmation of a more conservative viewpoint. The *Pearl* miniatures not only serve to illustrate the individual poems, ranging from the elegiac to Old Testament to Arthurian themes, but also appear to function as an overarching visual narrative loosely but importantly unifying them. These multivalent miniatures lead the viewer to experience and understand the events as operating independently within each poem and also overall as stages of a spiritual journey whose ultimate goal is celestial, adding visually what is expressed verbally by the Parson at the end of Chaucer's *Canterbury Tales*.

About a quarter of a century after the Ellesmere MS was made (ch. 5, sec. I), the small Douce 104 manuscript of Langland's *Piers Plowman* (Oxford, Bodleian Library, MS Douce 104) demonstrates a similar interest in pictur-

27. Hamburger 1998, 44. See some of the images from this manuscript, including fol. 6v, at http://www.bl.uk/catalogues/illuminatedmanuscripts/searchMSNo.asp.

28. For the English see Aston 1984, 139: "And thus laymen depict the Trinity unfaithfully, as if God the Father was an aged *paterfamilias*, having God the Son crucified on his knees and God the Holy Spirit descending on both as a dove"; see Wyclif 1922, 156.

ing the main characters, real or allegorical, as they press closely against the text to voice or interact with it. In their intimate proximity to the words, these unframed marginal figures not only engage the text directly but also encourage in the reader, with whom they serve as an interface, a similar grappling with its concepts. The intensity of the engagement between text and image is explained by the scribe's personal involvement in making the informally executed and tinted drawings. The scribe of another contemporary *Piers Plowman* manuscript, Oxford, Corpus Christi College, MS 201, is undoubtedly also the artist who drew the heads extending from the ascenders of the letters at the tops of two of its pages, the drawing of the stork at the end, as well as the border decoration and Lombard capitals, both linked to the rubrication of the text. Evidently having had access to a good manuscript tradition, the scribe also significantly altered the text itself. This scribe-illustrator's emphasis on Conscience and sin might have been influenced by another manuscript he also worked on and illustrated with almost identical calligraphic drawings: the Ushaw *Prick of Conscience*, Durham, Ushaw College, MS 50. It is as if the words and pictures coming from the same quill unrestrainedly sprang to life during the recording of the *Piers* manuscripts. This is quite an interesting phenomenon, given on the one hand, Langland's ambivalent attitude to images, and on the other, his impassioned, lifelong reanimation of the poem into at least three separate versions, a process that might well have inspired such a Langland enthusiast to reconfigure the poem in CCCO MS 201.

Rather than providing a description of every image in all illustrated Middle English literary manuscripts, this chapter examines selected images in some of them to exemplify how each functions within its immediate textual and larger historical context. The texts examined are those most commonly taught: two major works in the alliterative tradition, the *Pearl* manuscript and two *Piers Plowman* manuscripts; the Christian romances in the Auchinleck manuscript; and religious reading in the Vernon manuscript (for Chaucer see ch. 5). The student will learn what to look for in the illustrations, how these relate not only to the text but to other decorative and scribal elements like borders, decorated capitals, and rubrication, and why their intended use by certain kinds of audience can determine the overall presentation. A number of technical factors will also be examined to show how damaged images or items painted over can be recovered, how the detection of worm holes can lead to new perceptions about such things as page alignment, and how the quality of the vellum and pigments can influence the style and reflect the status and philosophical stance of its makers and readers. It will show how the elements of medieval visual vocabulary such as gesture, scale, and color can also affect meaning. The visual adds to, complements, and sometimes changes the verbal text; it rarely literally reproduces it. Images placed before a text create certain kinds of expectation and anticipation, while those placed at the end can be particularly important in determining what the reader is to take away from the reading experience. All this can be applied, for example, to other images in these manuscripts and also to others not covered here, such as illustrated Gower and Lydgate manuscripts.

As will become evident, these illustrations were not meant to provide visual translations of the text. Rather, they remold it. What is called for to appreciate medieval art in such illustrated manuscripts is what Canadian artist Emily Carr termed "fresh seeing."[29]

II. The Auchinleck Manuscript

The making of the Auchinleck MS (NLS MS Advocates 19.2.1; c. 1327–40), raises some important questions.[30] It is a huge encyclopedic collection of forty-four works (plus thirteen lost as indicated by the numbering), including mostly pious works and romances in English when it was still in the early stages of its revival as a written language. Under what circumstances was it made and for whom? Manuscript studies often involves just such exciting detective work, as the study on the Auchinleck manuscript by Linda Olson in chapter 4 demonstrates. Based on internal and external evidence, she suggests that the project was likely undertaken for a family, including not only the adults but especially noble or upwardly mobile children, both boys and girls, for whom its various items serve exemplary functions. It has even been seen as a "women's manuscript."[31]

Coming after the reign of Edward II who was deposed in 1327 and who is satirized in the "Poem on the Evil Times of Edward II" at the end of the Auchinleck, and probably also after the seventeen-year-old King Edward III's execution of his regent Roger Mortimer in 1330,[32] this collection marks a change in national outlook. It carries with it a hope for the future by its focus on the values, drawn largely from romances set in the past, which needed to be revived in a new generation of the ruling class. These qualities are visually manifested in 5 intact

29. In an address posthumously published; see Carr 1972.

30. Online at *Auchinleck Manuscript*, ed. David Burnley and Alison Wiggins, National Library of Scotland, http://auchinleck.nls.uk/. My line references for the Auchinleck are from this site.

31. Felicity Riddy in Fellows 2008, 104.

32. Turville-Petre 1996, 108–41.

miniatures,[33] out of a possible 27 (including 13 miniatures cut out and later patched, 18 folios at the beginnings of items that could have beeen cut out for the pictures, and one on folio 256v that is damaged). Four of the miniatures are framed by a double outline filled in with color and decorative patterning, while the fifth extant miniature is a historiated initial. The small, framed miniatures are the width of one of the two columns of script and precede the text to which they are closely connected by blue Lombard capitals with red flourishing. The titles of individual works are usually rubricated, adding a further visual refinement to an expensive but not deluxe illuminated manuscript whose format is generally if not fastidiously consistent throughout.

1. *The King of Tars*

The first extant miniature in this collection deals with image issues and precedes *The King of Tars* (fig. 2). The purpose of this miniature, an appropriate choice for the artist who would naturally be concerned with matters relevant to the craft, is to show the distinction between the worship of a lifeless pagan idol, featured in the compartment on the left, and the correct worship of a crucifix, illustrated in the compartment on the right. In the latter, the addition of the kneeling woman in front of the king foreshadows the important role played by a woman in this conversion narrative. Such stories are more often the subject of early Christian saints' lives in which the worship of pagan idols was a serious challenge to the fledgling monotheistic religion. And indeed there is more than one historical layer to this story in terms of its possible origins and its contemporary relevance.

Many of the features of this particular story were to be used later by Chaucer in the "Man of Law's Tale," which he evidently borrowed from Nicholas Trevet's version of the Constance story in the Anglo-Norman *Les Cronicles* written after 1334, around the time the Auchinleck was made.[34] It may be that Chaucer was directly familiar with *The King of Tars* romance in the Auchinleck manuscript.[35]

Although the story of the battle in *The King of Tars* is evidently based on an historical account of the crusades in 1299,[36] a much earlier version of this conversion story

occurs in *Annales Eutychii*, an Arab chronicle written by the Greek Orthodox patriarch of Alexandria around 937.[37] It "preserves the earliest extant version of the conversion story which later appeared in Trevet"[38] and might have been transmitted to the West during the Crusades. Eutychius himself may have used as one of his sources a version in which the relic of the Holy Cross is referred to.[39] Some elements of the story even go back to late antiquity.[40] A medieval story close to Trevet's version is the French *La belle Héléne de Constantinople* whose title "suggests Helena the mother of Constantine,"[41] who is credited with finding the true cross around 325 A.D. This evocation of the cross, however distant from the *Tars* story, is one that was retold in the *Golden Legend*.

In view of the strong role played in *The King of Tars* by a Christian woman in the conversion of a Saracen king, it is noteworthy that Trevet's chronicle, which has as its "physical and moral center" a woman who is "literate, learned, quick-witted, resourceful, and even physically strong," was written for a royal nun, Mary of Woodstock, the sister of Edward II and the aunt of the young Edward III.[42] Trevet's Constance, the mother of the Roman emperor Maurice by the English king Alla (King Ælle of Northumbria, d. 560)[43] is connected with the English throne, as indicated in the genealogical diagrams of the family of Edward II in some of the manuscripts.[44] This explains the connection of Trevet's narrative with the family of his royal patrons. While there is not a direct connection to the royal family for the Auchinleck ms, there is a similar coalescence of language and religious issues that define the English and Christian nation in contradistinction to the Muslim world.[45]

Introducing the story in the Auchinleck ms is the rubricated title referring to the King of Tars. Below this, the miniature (fig. 2) shows a king in each of the two compartments. One would assume this to be the one identified by the title, but he is actually the pagan sultan to whom the Christian King of Tars was induced to give his daughter in marriage. On the left the crowned, curly-haired, and bearded sultan raises his hands to pray to a bestial idol, perhaps suggestive of the one hundred barking hounds the Christian lady dreams about when she arrives at his court to become his bride. The sultan himself is initially identi-

33. For further discussion of the miniatures and more references see Hilmo 2004, 112–25.

34. Possibly Trevet's story was even influenced by *The King of Tars*, according to Hornstein 1940, 354–57. See also Schlauch 1941, 155–54.

35. See Hibbard Loomis 1962, 14–33; Pearsall and Cunningham 1977, vii–xvii, esp. xi; Perryman 1980, and Akbari 2002, 118–20.

36. Perryman 1980, 42–44, 49.

37. Wynn 1982, 274.

38. Ibid., 274.

39. This includes the Persian poet Firdausī's *Shāh-nāmeh*, quoted

by Wynn 1982, 270. See also his following discussion of another Latin version of the story in the *Chronicle of Fredegar*, written around 660, and the *History of the Langobards* by Paulus Diaconus, in the 790s.

40. Correale 2005, 279–88.

41. Schlauch 1941, 156–57.

42. Rose 2001, 157–58.

43. Schlauch 1941, 158.

44. Rose 2001, 158.

45. See Akbari 2002, 114–19.

2. The difference between an idol and an icon, *The King of Tars*. Auchinleck MS, Edinburgh, National Library of Scotland, MS Advocates 19.2.1, fol. 7r, 1327–40.

fied as a heathen hound by the King of Tars. In the miniature the support and column on which this beast reclines is typical for the presentation of pagan idols.[46]

In the compartment on the right the same crowned figure is now shown correctly worshipping a Christian image: the crucifix above a draped altar. Although Christ's Passion and the Cross are mentioned in the text, such an altar with a sculpted image of the body of Christ on the Cross is not. The artist's input is evident in that the miniature required an artistic solution: the inclusion of a Christian icon to provide a visual contrast in order to differentiate the two religions. The top of the cross extends into the band of the upper border. Christ's arms are stretched on the crossbeam that aligns with the inner border, as if stretched on the frame and, by extension of the ruled lines, on the vellum on which the text is inscribed. This may be more than a careless failure to erase the ruling lines or even a self-conscious assertion of this miniature as an image by leaving traces of its making. Rather, it could also suggest an analogy: Christ stretched on the cross and parchment stretched on a frame, as expressed for example in the Vernon MS's *Testamentum Christi*.[47] Further, if the Auchinleck image is seen in Incarnational terms, it is literally linked to the life-giving Christ who was himself embodied in the flesh, unlike the useless dead pagan idol that could not animate the lump of flesh that was born to the sultan and his wife.

The *Tars* crucifix manifests the power of the true, Christian God. The gods before whom the sultan prays to bring life to their child (born without limbs or facial features) failed, so he cast them down. When he gives leave to his

wife to see if her God is a better healer, the amorphous flesh is christened and miraculously restored to life and wholeness. While the story does not mention laying the child on an altar (a church had not been built yet), the artist took the liberty of condensing the story by encapsulating its message and showing that the lump of flesh has turned into a baby (now just barely visible) on the altar just below the healing Cross.

The illustration may have been influenced by images of the "child-as-Host" motif in manuscript illustrations and vernacular literature, as Denise Despres observes.[48] In the fourteenth century anxieties about the doctrine of the transubstantiation by which the consecrated Eucharistic Host becomes the body and blood of Christ are reflected in sermons[49] even before they became major issues for later reformers. Commenting on such images as King Edward's vision of the Host turning into the Christ child in Cambridge, University Library, MS Ee.3.59, fol. 21r (fig. 3), Michael Camille observes that the "percipient at the eucharistic offering sees not an image, however, but Christ himself. The *epiphania*, the meeting of flesh and spirit in the image, was not only possible but was actually sanctioned by the experience of the mass."[50]

Very like the crowned figure of King Edward, who likewise raises his hands in prayer, the Tars sultan is shown in both compartments in his later, transformed state as a crowned Christian king, rather than initially as a turbaned figure whose "hide" was "blac *and* loþely" (928–29). This not only accords him the courtesy of appearing in his morally (and hence, visually) improved state in both compartments but fills the artistic requirement that he be

46. Camille 1995, 27.

47. The life of *Seinte Margarete* says that no deformed child will be born in a house with a copy of this work; see Williams Boyarin 2009, 87–106 for the body as parchment theme.

48. Despres 1994, 416n14.

49. Ibid., 418.

50. Camille 1995, 219. In the Queen Mary Psalter, London, British Library, MS Royal 2 B.VII, fol. 241v, 1310–20, the Christ Child is seated on the altar.

identified as the same person in both compartments to make the message immediately clear. The sultan is visually as well as spiritually converted into an acceptable image of a Western king. All hands are prominently raised in prayer in both miniatures, but those of the sultan and his wife also echo the concern with limbs in this story about the child who, upon being baptized, miraculously gains his from "ih*es*u crist þat made man" (677).

Holding front and center stage, as it were, in the compartment on the right of the Tars miniature, and in the same intermediate position between man and God as the priest in the illustration of King Edward, is the figure of the Christian wife responsible for the sultan's conversion and the transformation of the child who was formerly as "stille as ston" (639). Previously described as a typical courtly love lady with swan-white skin, she proved her mettle as a hero operating within the parameters available to a woman in her time and culture: she agrees to the marriage to keep the sultan from decimating any more of her father's Christian knights (thirty thousand of them had been killed), then agrees outwardly to do the sultan's bidding while inwardly continuing to think of Jesus. When the sultan's gods fail, she teaches him (678) that her God has the power to give life. Such a strong woman might well appeal to the female readers of the Auchinleck MS.

Indicative of the religious milieu of female viewers, this wife demonstrates the kind of affective piety women were encouraged to practice. Her emotional response to the image of the suffering, crucified Christ is given expression by her hand, for emphasis exaggeratedly larger than the king's, raised to touch the image, perceived as the living Christ. The sultan's wife is participating in the moving drama of the Crucifixion (compare the nun in fig. 1). Her maternal reach also applies to her own newly animated child, paralleling, in this iconographical context, the Eucharistic Host. Like the Ruthwell Cross's weeping Mary Magdalene whose hands are similarly enlarged to stress her emotional state,[51] she models for the viewer the appropriate response to the humanity of Christ. This sort of deep devotion and reenactment of the events of Christ's life was encouraged by the Franciscans as a means of arousing penitential remorse, conversion, and love among the laity, especially women.[52]

The miniature manifests the importance of being able to see the workings of the divine. In the text the child is given the ability to see (766), the wife wants to see her lord christened (796–97), the sultan expresses joy that he can see the child (805–6), and he therefore sees that Jesus has more might than his false gods (829–30). Prior to these miraculous events, the wife had promised her husband that she would show him that Jesus Christ could do more than his "maumettes" (717). Although the Islamic religion is anti-iconic, it was believed, incorrectly, that statues were made of Mohammed and worshipped. As Michael Camille observes, "Christians were all the more con-

3. King Edward's vision of the Host turning into the Christ child, *La estoire de Saint Aedward le Rei*. Cambridge, University Library, MS Ee.3.59, fol. 21r, mid-thirteenth century.

cerned to construct a set of images of that imageless religion in order to simulate, and stimulate, its destruction"[53] (which is what the sultan and the King of Tars eagerly set out to do following the former's conversion).

The *Tars* miniature reiterates the orthodoxy of its time for "boþe eld *and* ȝing" (1), male and female, appealing to their varying levels of understanding of the issues involved. Not only for the Sultan but for those among the Auchinleck audience whose knowledge of religion and literature was rudimentary, the Christian wife teaches the fundamental truths of the Creed, including how Jesus took flesh in Mary (846–47).

2. The *Pater Noster*

A similar level of audience for the Auchinleck is also given elementary religious instruction in the next item with an extant miniature, the *Pater Noster* on fols. 72r and 72v (fig. 4). The image of a youthful Christ with a halo (possibly with a cross-nimbus, now faded, identifying him) is attached to the *P* and inserted between the columns of text (space was not left for it by this particular scribe). The *Pater Noster* is translated into English for the "Lewede" or Latin-illiterate members of the knightly class—the ones who "gon and riden" (line 1) and should

51. Hilmo 2004, 44–45.
52. Despres 1989, 5–9.
53. Camille 1995, 150–51.

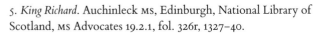

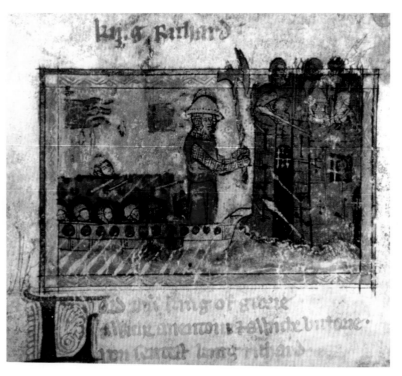

4. *The Pater Noster.* Auchinleck MS, Edinburgh, National Library of Scotland, MS Advocates 19.2.1, fol. 72r, 1327–40.

5. *King Richard.* Auchinleck MS, Edinburgh, National Library of Scotland, MS Advocates 19.2.1, fol. 326r, 1327–40.

listen and *hear* what the *Pater Noster* is (5–6). The frontally illustrated deity holds a scroll in his left hand, presumably containing the words of the adjacent prayer he himself authored (10) and then asked his apostles to teach to all mankind (14)—and that is now available to the viewing and listening audience. Just as the wife responds emotionally to Christ crucified in the *Tars* miniature, thereby inviting the viewer's "visual participation and devotional imitation"[54] (to borrow Hamburger's description of such a process), here such an audience is likewise invited to recite the *Pater Noster* before the deity who raises his hand in blessing to them. The speaker of the written text positions himself as a clerk who, with God's help, can explain all the verses of this best of all prayers.

3. King Richard, Reinbrun, and Beves: Our English Heroes and Those Saracens

The other three extant miniatures featuring English heroes of romance are also concerned with the world of the Saracens. These non-Christian "others," if pictured at all, are not dressed in Muslim garb or armor. An explanation for this curious feature might be that there was an attempt by the artist to focus on the actions of the English knights and to avoid disagreeable images of heathens (or devils, which were sometimes smudged or defaced).[55] Further

this may reflect, at a deeper level, a concern about religious contamination and cultural infection by people with whom the English heroes, especially Reinbrun and Beves, had a great deal of contact.[56] The *Tars* miniature pictures the sultan as a Western king, even before his conversion, as if he were a Christian-in-waiting. In the Auchinleck poetic version of *Beves of Hampton*, the potential fear of racial contamination is countered by presenting Josian, the Armenian Saracen bride of Beves, as a suitable female for conversion by the emphasis, for example, on her virginity and loyalty.[57] Her Armenian ancestry is of contemporary relevance since it was suggested that Armenia "should become the base for a new crusade."[58] As Rouse points out, there were anxieties about two-way conversions, especially since crusaders sometimes converted to Islam, by force or otherwise.[59] Beves's fooling of his prison guards by invoking Mohammed in order to escape can be seen somewhat in the same light as the Christian wife in *Tars* pretending to worship her husband's gods. In the story of *Reinbrun*, the child of that name is stolen by Russian merchants and sold to King Argus in Africa, then given to this king's daughter (who reads romances), and is raised and eventually knighted at the Saracen court. Here the potential for a reverse conversion is strong, but Reinbrun, who always asserts his Christianity so that his Saracen upbringing does not take hold, reverts immediately to his origi-

54. Hamburger 1998, 124.

55. As is the case in the Douce 104 manuscript on fol. 96r. See Hilmo 2004, 136–37.

56. Rouse 2008, 118.

57. Fellows 2008, 84.

58. Turville-Petre 1996, 120–21.

59. Rouse 2008, 121.

nal loyalties when he is reunited with his former guardian. Turning against the Saracen king who formerly nurtured him is obviously fully justifiable for the sake of expediency. Chivalric codes of honor and loyalty evidently did not apply to the treatment of heathens or devils. So it is perhaps not surprising that, by way of indoctrination, the focus of the extant illustrations of Auchinleck romance heroes who have contact with the world of the Saracens is placed firmly on their own Christian, English identities.

The commitment to crusading was strong around the time of the Auchinleck and later, both Edward I and Edward II having vowed to go. As Turville-Petre observes, the call for a crusade "runs right through the manuscript."[60] Richard the Lionheart, who went on the Third Crusade from 1189–92, was the crusading hero par excellence. The Auchinleck illustration (fig. 5) shows a larger than life-sized Richard standing "Wiþ his ax afor schippe" (740) as he is about to strike down the chain that the Saracens had placed around Acre to prevent ships entering the harbor to rescue the besieged, starving Christians inside.

Richard is identifiable not only by his special English axe, with its steel head weighing twenty pounds (480), shown piercing through the top border of the miniature, but also by the three leopards on his red surcoat. Richard wears chain mail and a kettle helmet, like some of his men. The large rectangular structure on his ship may be his famous wooden siege-tower, the "mate griffoun" (272, 988). Richard's victory at Acre, the high point of his crusading activities and a major source of English pride, was carefully chosen as a suitable subject for the illustration of this romance.

Just as it comes after a number of episodes involving ships in *King Richard*, so the episode chosen for the story of *Reinbrun* also comes after several battles until the one actually illustrated is reached. In this way these illustrations keep the suspense of the viewing audience high. Each time they might think they have finally reached the incident the introductory miniature illustrates only to find yet another one also fits, until finally some specific detail, like the chain around Acre, fulfils all the requirements and gives the attentive viewer the "aha" moment of recognition. This clever visual technique also gives an insight into the repetitive nature of many of the events and the episodic nature of these narratives, a feature of which the artist seems to have been aware.

In the case of *Reinbrun gij sone of warwike*, as indicated by the rubric (fig. 6; also ch. 2, sec. I and fig. 4), the largest of the miniatures still extant in the Auchinleck depicts two swordsmen in a castle setting. Since there are a number of fights in this romance, the audience's curiosity about which battle is depicted would naturally be aroused. The illustration shows Reinbrun striking the head of Haslak

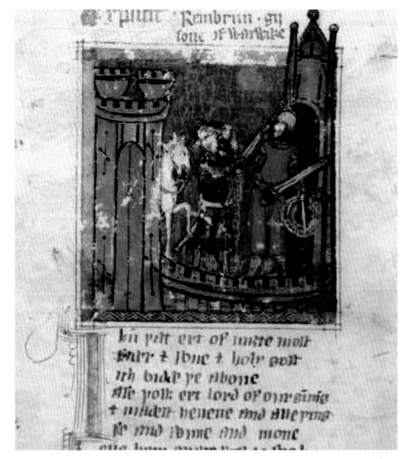

6. *Reinbrun.* Auchinleck MS, Edinburgh, National Library of Scotland, MS Advocates 19.2.1, fol. 167r, 1327–40.

(1314–15), his former tutor's grown-up son, whom he does not recognize. Haslak's red arms and his white horse (1234–35) identify him for the reader before the recognition scene between the two combatants. In the miniature a touch of comedy is added when Haslak's white horse distracts Reinbrun by giving him a kick in his behind. It is a pity that more miniatures from this manuscript do not survive to show whether the artist adds a wry humorous touch to any of the other bloodthirsty romances.

One of the most intriguing of the illustrations remaining is that of *Sir Beves of Hampton* (fig. 7; also ch. 2, sec. I and fig. 6). Unlike the other extant miniatures introducing the romances, this is the only historiated initial. One obvious reason is that there was not enough room left to include an action scene in this rectangular space, so at least a decorative *L* must have been planned by this scribe. Extending from the historiated initial is a simple double bar border down the left side of the page with an extension across the bottom. This border is a continuation of the blue and pink segments framing the letter *L* and it likewise alternates the same colors. It may be coincidental that the *L*-shaped border, the only such border in the manuscript, echoes the historiated *L* beginning the first word of the poem addressing the "Lordinges" who are the

60. Turville-Petre 1996, 121.

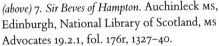

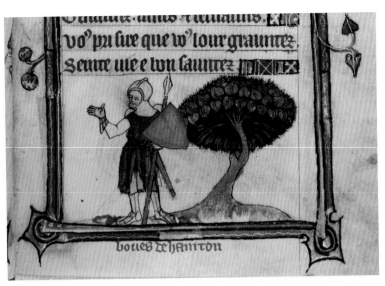

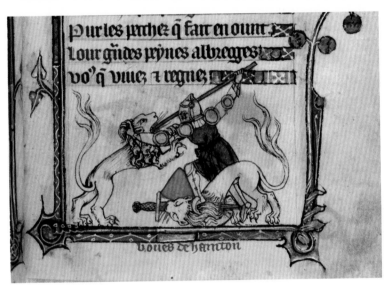

(above) 7. *Sir Beves of Hampton.* Auchinleck MS, Edinburgh, National Library of Scotland, MS Advocates 19.2.1, fol. 176r, 1327–40.

(right) 8a and b. *Bas-de-page* image of "boues de hamton." Taymouth Hours, London, British Library, MS Yates Thompson 13, fols. 10r and 12r, second quarter of the fourteenth century.

audience. Adjacent to this initial the poem itself names the knight who is the subject of the poem. It is presumably Beves who stands within the gold field inside the letter and, in a courtly pose, extends his right foot forward (cf. ch. 5, sec. III and fig. 8).

The figure inside the initial is an armed knight in surcoat and chain mail. He carries what appears to be a spear, possibly alluding to the one with which Beves smote the boar (788–89), while a sword, possibly alluding to the one Beves drew after the spear burst (790–94), can be partially seen behind him. Despite these visual references to the hero of the poem, his arms do not quite correspond to the description given. The text mentions that when he was dubbed knight he was given "a scheld gode and sur | Wiþ þre eglen of asur | Þe champe of gold ful wel idiȝt

| Wiþ fif sables of seluer briȝ" (971–73). The figure in the initial is wearing "gules on azure, i.e., red on blue" which, according to D.V. White, Rouge Croix Pursuivant, of the College of Arms in London, is "rather odd" but "not unknown."[61] He was unable to identify the arms of the figure in the historiated initial. What the shield and surcoat of the knight do have are red trilobed leaves (not exactly three blue eagles) on a blue background. It is the background of the initial, not the shield, that is gold. Sable in heraldry denotes black, but the number "five" suggests five black sables (animals).[62] Was the artist simply approximating the description, forgetting the details, being deliberately obscure because of some uncertainty regarding a possible patron, or painting a coat of arms not yet identified, possibly foreign, since Beves was dubbed by King "Ermin" of Armenia?

Among the *bas-de-page* images of romance incidents, there are three of Beves in the contemporary Taymouth Hours, London, British Library, MS Yates Thompson 13 (second quarter of the fourteenth century), which has

61. Letter dated January 19, 2000, in answer to my enquiry.
62. For links and bibliography on heraldry see http://www .medievalgenealogy.org.uk/links/herrefs.shtml.

Anglo-Norman captions.[63] One (fig. 8a; fol. 10r) shows the hero wearing a blue surcoat, although minus the details of the red trilobed leaves, and carrying a spear, as in the Auchinleck image. On the other two, the hero, similarly clad, encounters a lion who nips at his red shield (fol. 11r), and the other (fig. 8b; fol. 12r) conflates two scenes into a single illustration depicting him ramming his spear down one lion's throat while treading victoriously on another bloodied lion with a sword rammed through its mouth right through to its torso. These Taymouth images exhibit the same bloodthirsty spirit that animates the Auchinleck romance.

The Auchinleck miniature contains three features that are unusual for this manuscript: the only (extant) historiated initial, the only long border in the manuscript, and a knight with a coat of arms different from the text's description. Certainly the question of identity is crucial to this story. In looking at the features distinctive to the Auchinleck in comparison to the earlier Norman ver-sion, Jennifer Fellows notes that in the Auchinleck there is more emphasis on the hero's role as a Christian knight and on Josiane's resourcefulness.[64] The Auchinleck also intro-duces the account of his fight against the citizens of Lon-don. As Rouse suggests, this manifests an uneasiness about the cohesiveness of the English nation itself since it pits regional identities against the centralized power of King Edgar (959–75) and London, although in the Auchinleck narrative a reconciliation is subsequently effected.[65] By the "hybrid nature of his identity," as Rouse continues, the hero represents both external and internal anxieties about English identity. The Auchinleck illustration fea-turing only the hero focuses attention on him rather than on his exploits, as in the Taymouth Hours (fol. 12r). Per-haps he was meant to picture a fictive ideal rather than a "real" knight. And maybe his image models the unrealized ambitions of a patron addressed by the word "Lordinges" of which the historiated initial forms the first letter.

III. The Vernon Manuscript

Made over half a century after the Auchinleck, the Ver-non, MS Eng. Poet. a. 1 (last decade of the fourteenth cen-tury), is the largest illustrated medieval English vernac-ular manuscript, now weighing 48¾ pounds, with each vellum sheet made from a single calf-skin.[66] It origi-nally contained about 403 items (some quite short) and had about 422–26 leaves, of which 350 survive. The sec-ond of the five sections contains miniatures, and it is also this section that has a blank shield, indicating the origi-nal owner or patron was entitled to heraldic arms. It has been suggested that the Vernon MS was made for a com-munity of nuns (see also ch. 6, sec. I).[67] Certainly the ex-tensively illustrated and detailed birth miniatures for both John and Jesus would have appealed to a female audience (although today's viewer does not get a balanced impres-sion since many of the Gospel miniatures are no longer extant). While it might be argued that such a manuscript would have been too expensive for a woman to be able to afford, it might well have been associated with an aris-tocratic woman who took the veil or entered a religious community where there would have been the textual re-sources for making such a collection of religious verse and prose in the vernacular. It might even have been in the na-ture of a dowry, expected of high-born women entering convents, or given by the family or a male donor, perhaps a spiritual advisor,[68] to a woman in such a community. Women were more extensively involved as authors, read-ers, and patrons of books than was previously thought, as Carol Meale's lengthy chronological list spanning the years from 1150–1500 makes abundantly clear[69] (see also ch. 5, sec. II above regarding the Lichtenthal and Egerton Psalters). Books of Hours were lavishly illustrated produc-tions especially popular with female audiences.

The sizes of the Vernon MS, around 544 × 393 mm., the Ellesmere, at 400 × 284 mm., and even the thick Auchin-leck, at 250 × 190 mm. trimmed,[70] dictated a certain kind of reading context for these large, thick, heavy books. They could not be carried around easily for private read-ing in, say, a garden arbor. Further, their value precluded careless handling and transporting away from a reasonably secure and dedicated location. Certainly private reading for meditative purposes, especially in the case of the re-ligious works in the Vernon MS, was not precluded. Be-cause of the size and value of such manuscripts, however, it is likely that they were frequently experienced in group situations. An example of this is given by Chaucer in *Troi-*

63. Josiane (see below) is also seated between two lions (fol. 10v) and holding a lion (fol. 10v). See http://www.bl.uk/catalogues/illuminatedmanuscripts/record.asp?MSID=8148&CollID=58&NStart=13. Brantley 2002, 87, refers to these images as "pictorial quotations" from the poem.

64. Fellows 2008; see appendix on 104–8 for eight manuscript versions and 109–13 for printed texts, all between the 1330s and 1711.

65. Rouse 2008, 122–26.

66. For details and descriptions, see especially Doyle 1987 (fac-simile edition) and Pearsall 1990.

67. Blake 1990, 57–58, and Meale 1990, 132 and throughout, both in Pearsall 1990.

68. See Schleif and Schier 2009.

69. Meale 2006. I thank Kathryn Kerby-Fulton for drawing my attention to this study.

70. Doyle 1987, 1.

9. The Visitation, *La Estoire del Evangelie en englais.* Vernon MS, Oxford, Bodleian Library, MS Eng. Poet. a. 1, fol. 105r, last decade of the fourteenth century.

lus and Criseyde (83 and 103[71]) where Criseyde and her ladies, read to by a "mayden," stop reading and listening to pause over and repeat aloud the rubricated lines from the *Thebaid* describing the soothsayer's fall to hell. There are more implications to this passage than just those involving a rather high level of female literacy. Since they were so engaged just by the rubrication, one can only imagine the sort of involvement illustrations, borders, and annotations might have inspired. And that is the point about medieval reading practices. They were interactive and would often, as here, have been expansive within a group situation. As expressed in an interview with Linda Rogers concerning contemporary storytellers, Pat Carfra perceptively observed, "We respond differently in an audience than we do individually."[72] Carfra goes on to say that "every story has a lesson." In the medieval context there was certainly an emphasis on the moral of the story. Referring to hagiographic legends, Hamburger states that they "were stories to live by."[73]

A selection of images from the Vernon MS is now online[74] but the Vernon Manuscript Project will create a digital edition to be published on DVD under the direction of Wendy Scase.[75] The latter will undoubtedly create new in-

sights into every aspect of the production of the Vernon MS, but for now, it is of interest to examine a small selection of images closely.

1. The Vernon Manuscript Illustrations of *La Estoire del Evangelie en englais*

"The Story of the Gospel in English" was intended, as indicated by the fifteenth-century index, to begin with the Annunciation and end with the Last Judgment, but now only the Annunciation and the Nativity (of Christ and John the Baptist) survive.[76] Made by one artist, the extant seven framed miniatures emphasize the spiritual significance of each section into which they are inserted. The text begins with the self-confessed sinful poet hoping to gain reward from Christ through the labor of writing the gospel story in English. He connects the conceptions of John and Christ with the act of writing by his play on the concept of "dihte." At the Annunciation Gabriel "dihte" (indited) into Mary's heart the news that the Holy Ghost would "alihte" (alight/descend) into her.[77] As the Vernon

71. Unless otherwise noted, all quotations from Chaucer's works are from *Riverside Chaucer* 1987. Line numbers are indicated in parentheses in my text.

72. Rogers 2009, 17.

73. Hamburger 1998, 240.

74. http://bodley30.bodley.ox.ac.uk:8180/luna/servlet/view/search/what/MS.+Eng.+poet.+a.+1/Manuscript?q==“MS.+Eng.+poet.+a.+1”

75. http://www.birmingham.ac.uk/schools/edacs/departments/english/research/projects/vernon/index.aspx

76. Horstman (1892) 1973, 11n1.

77. Lines 125–27 in the edition by Horstman (1892) 1973. Line numbers and quotations in my text are from Horstman.

version of the *Psalterium Beatae Mariae* states, God made her the chamber "Of word þat is mad flesch" (1041–42). The conception of John is similarly described by the poet who says that the Holy Ghost "lihte" in Elizabeth and "dihte" the child in her (223–24). The word "dihte" can mean to indite, to write, to compose, and also to have sex. The implication in the poem, however, seems to be that both conceptions involved a divine source (fig. 9).

The text below the miniature of the Visitation emphasizes the intimacies of their greeting—the sweetness of their meeting, their embrace, and their kissing (167–68). Preceding the miniature the text had described how the child in Elizabeth's womb "makede gle" (160) in happy recognition of the Lord in Mary's (in the illustration the bellies of the two women touch, as if to confirm this). Elizabeth then declared that both Mary and her fruit were blessed. Despite the affectionate nature of the greeting that is so charmingly rendered, the miniature itself is formally and symmetrically, even heraldically, composed, emphasizing the significance of the event. The trees on either side enhance the theme of fruitfulness embodied in the two women and symbolically allude to the Tree of Jesse thought to prophesy the Messiah as mentioned in Isaiah 11.1: "And there shall come forth a rod out of the root of Jesse: and a flower shall rise up out of his root." In the miniature, the stem of daisy buds at the bottom right corner penetrate the border and seem to issue from the root of the tree. On the left bottom corner of the border the decorated letter þ with daisy buds attached, also incarnates the Word in the words of the poem.

2. *The Miracles of Our Lady* in the Vernon Manuscript

Out of a possible forty miniatures for *The Miracles of Our Lady* listed in the index, nine remain, the work of a second artist. As Ruth Wilson Tryon states, this is the largest collection of this genre in Middle English verse.[78] The artist of these miniatures was less interested in recording moments of sacred time, as in the case of the former artist, and more in creating a visual narrative combining several stages of the story into one miniature, while also emphasizing the more sensational aspects.[79]

The focus of these stories encouraging Marian devotion is on the sympathy and compassion of "Our Lady," especially for those who honored her image or relics or songs. As Julie Nelson Couch so aptly describes Mary's salvific role, both physically and spiritually, she "saves the population of a city, a Christian child, a harlot, a Jewish child,

a man with an amputated foot, a Christian borrower, a priest who had sex with a nun, a man with quinsy, and a sexually incontinent monk. The predominant characteristic of Mary's interventions is her deliverance of the least deserving and the most helpless: the criminal and the ignorant, sick people and children."[80] The two examples explored in this chapter demonstrate the efficacy of devotion to Our Lady for those who honor her statue.

3. The Man with the Amputated Leg Who Was Healed Again by Our Lady

This miniature (fig. 10) reconstitutes two episodes to create a dramatic visual narrative that can be understood even without the text, which I have summarized as follows:

> Among those who came to the minster with the statue of Our Lady was a man whose leg burned with such pain from his foot up to his knee that he thought he would die. He was counseled to have his leg hewn off rather than suffer so. He had this done. As he kneeled by the statue one day saying his beads, he wept and then fell asleep. It seemed to him that in a dream a fair lady took him by the knee and drew out of it a new leg. When he awoke he felt his leg whole and sound. Then all who saw this miracle honored the Lady. Therefore it is good that everyone serve Mary, the Queen of Heaven and Empress of Hell, so that we may dwell with her in joy forever.

The miniature retells this story in two registers. At the top the artist evidently took great delight in making the most of the scene by picturing a man with an axe so huge it breaks through the top border, rather like that held by King Richard in the Auchinleck miniature (fig. 5) but larger still. This artist, who liked to picture scenes of action,[81] shows the moment that the axe is held at the highest point and is about to descend on the poor man's leg. Since the bandaged leg is already bleeding profusely, it appears that at least two strokes were required to sever the leg. It is not clear who the praying lady is, possibly his wife, but in any case she manifests the piteousness of the scene.

In the second register, there is a small statue of the Virgin and Child. The sculpted Virgin holds a small flower in her hand. In the *Psalterium Beatae Mariae* by Albertus Magnus for Psalm 129.1 in the Vernon, she is hailed as the bearer of the flower that returns life to the dead.[82] That the artist added such a minute detail from another work in

78. Tryon 1923, 308.

79. See Hilmo 2004, 125–31.

80. Couch 2003, 204. For my discussions of the first and the last

of these see Hilmo 2004, 133–36, and of the Christian child see Hilmo 2009, 110–13.

81. Hilmo 2009, 110–13.

82. Horstman (1892) 1973, 94.

10. The man with the amputated leg who was healed again by Our Lady, *The Miracles of Our Lady*. Vernon MS, Oxford, Bodleian Library, MS Eng. Poet. a. 1, fol. 125v, last decade of the fourteenth century.

this volume suggests an extraordinary knowledge of the text.

The sculpted image of the Christ Child manifests his living presence in the statue by gesturing toward the sleeping man. The Virgin holds his leg and, evidently with her speaking gesture, empowered by that of her son, restores the leg verbally rather than physically, although the outcome is clearly visible, as can be seen. As pictured by this artist, it appears to be the power of the Word operating through her that effects the cure. The proximity of the statue to the scene of the action occurring while the man sleeps and the similarity, or rather, identity of the healing Virgin to her image is reminiscent of accounts by mystics who have a vision after seeing an actual image.[83] In this case, it is the viewer who can see both the image and its prototype in the dream vision of the sleeper.

4. The Priest Who Lay with a Nun

This miniature is based on the *Miracle* story, which I have summarized as follows:

There was a sinful priest who lay with a nun (6). Although he would not confess his sins, he served Our Lady daily. At last he fell sick. Our Lady wanted him

to cleanse his conscience. It came into his mind that he should find a trusty friend, a priest whom he loved, and he told him everything. He cried to God for mercy and was sorry for his sins. He asked the priest with whom he had long been friends to remember him at Mass and to pray for his soul. Then he died. The priest remembered him daily in his Mass for a year. As he was saying Mass on the anniversary of his friend's death the priest saw standing before him on the altar the fairest of ladies. She said to him that she had obtained forgiveness for his friend who was now released from his pain. She told him to look behind him. He turned, saw his deceased friend kneeling there, and then gave him the sacrament of God's body. Then he saw Our Lady come down from the altar, take his friend by the hand, and lead him out of the church. He turned back to continue saying the Mass. We should all worship her with all our might to bring us to the heavenly light. That it might be so, say an Ave to her.

The miniature itself (fig. 11) features three main episodes in two registers connected on the right side by an image of the Virgin and Child. In the upper left register it is a tonsured black monk (who may also be an ordained priest) who appears to be having his lecherous way with a nude figure on a bed. There may have been any number of reasons why the illustrator decided to portray a monk instead of a priest. It is possible that the black monk is meant to be hearing the dying man's confession, but why

83. Hamburger 1998, 118–19, gives as examples the visions of Gertrude of Helfta and Lutgard of Aywières.

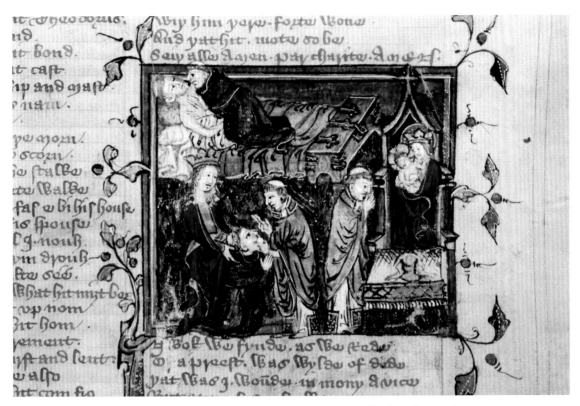

11. The priest who lay with a nun, *The Miracles of Our Lady.* Vernon MS, Oxford, Bodleian Library, MS Eng. Poet. a. 1, fol. 126r, last decade of the fourteenth century.

would he be up on the bed? If this miniature was prepared for a nunnery, it might have been too irreverent to show a priest behaving this way.[84] But why a black Benedictine monk? Olson considers the possibility that this manuscript was made for or by a Cistercian community (see the white monk pictured in the Vernon Trinity, fig. 12), a credible explanation of the provenance of this manuscript (see ch. 6). In that case, the portrayal of a black monk might indicate some rivalry between the Cistercians, who wore white habits, and Benedictines, who wore black.

In the same scene the other rather astonishing feature is that instead of a nun receiving sexual attentions there is a tonsured nude male figure! Is it the case that the artist made an error?[85] Or was it considered inappropriate to show a nun in such a compromising position if this manuscript was indeed made for such an audience? But then why specifically a nude, tonsured male reaching below the waist of the tonsured black-robed monk? There may even have been a scandal involving a homosexual liason that was still known to the producers and audience for this manuscript. If male clerics were among the intended audience, the issue of homosexuality would have been especially provoca-

tive. Could it be that the artist was remembering the text's description of the sinful priest who loved another priest—one "he louede wel" (19)—and misinterpreting it? Or was there an actual recent scandal?[86] Later, in the early fifteenth century when the index was added to this manuscript, the gender of the sexual partners in the miniature was either ignored or no longer had any salacious relevance, so the title describes the original genders and religious affiliations as indicated in the poem itself.[87] Since there was not, as in the Auchinleck miniatures, a title preceding the miniature and poem to delimit its topic, there was more room for interpretive play by the miniaturist.

Utilizing the technique employed in some of the other miniatures in which honor is paid to Our Lady by way of addressing her via her statue, as in the case of the man with the amputated leg (fig. 10), the Vernon artist portrayed a similar statue here as a pictorial solution to the text in which she is only an unseen presence in the first part of the narrative. The statue of the Virgin and Child ensconced within a church niche serves a dual purpose: she can be considered the recipient of her man's service while he was alive, and then, in the lower register, she is

84. As suggested to me by Kathryn Kerby-Fulton in an email on July 16, 2009.

85. For this view see Scott 1996, 2:19.

86. Tryon 1923, 338, observes that this Miracle was "not a very

wide-spread legend," raising the possibility that its inclusion in the Vernon was somehow relevant and timely.

87. Serjeantson 1937, 222 and 235.

a materialization of his fellow priest's vision of her on the altar.

Reading from right to left in the lower register (as one does also in the miniature of the child thrown into a privy by a Jew),[88] the priest is shown saying Mass at the altar on which there is a covered chalice, and then, as the text describes, he turns and administers the Communion Host to the deceased sinner. The latter is shown as if physically present in the body. To stress that it is Our Lady's actual presence that has emerged from the statue, she is pictured without a halo and is shown larger than life size as she presents the reformed sinner to the priest. This conflates the incidents of her getting off the altar, taking the man by the hand, and then leading him away, presumably to heaven. The artist has charmingly found an artistic solution to picturing the narrative by reducing and conflating the number of incidents, unifying them by the dual use of the statue for both registers and connecting the last two scenes by thematically aligning the Christ Child in the sculpted image with the chalice on the altar and also the Host administered to the kneeling man (cf. the *Tars* miniature, fig. 2). In both Our Lady is also closely associated with the Host. Except for the regendering of the nun and the change of religious order for the sinner, this miniature is true to the essential narrative.

In the two *Miracle* story miniatures just discussed and in, for example, the ones about the Harlot of Rome on 124v, the Merchant of Constantinople on 126r, and the Drowned Monk on 126v, the statue of the Our Lady is similarly rendered. This blond-haired Virgin, often haloed, wears a golden crown and a blue robe.[89] She always holds the Christ Child, who sometimes gestures in ways that signal his living presence in the image. This statue, from which Our Lady also often emerges to take part in the relevant scene, is always situated in a gabled niche, which in the story of the monk who had drowned, for instance, is clearly part of a church (see ch. 6, fig. 6, top right).

What all this points to is the very real possibility that there was such a statue in a church near the place where this miniaturist worked. It may have been the same, or connected with, the religious establishment for which this manuscript could have been intended. The message would have been that, although the stories took place in other times and places, the local statue of the Virgin and Child was also a miracle-working image. The Vernon miniatures would have served to channel and mold responses to such

an image and to demonstrate the value of doing so — these are literally images to endorse the use of images.[90] It might even have been part of a campaign to attract pilgrims to this statue. The text of the miracle of the man whose leg was restored by Our Lady begins with a description of the minster that was founded in her honor and in which there was a "swete ymage"[91] (33) of her to which the people of that country made pilgrimages to be healed. If something similar is advocated for the Vernon statue, then its significance and meaning expand outwards to the community and surrounding area.

Many of the *Miracle* images in the Queen Mary Psalter, for instance, also show a small statue of the Virgin and Child,[92] indicating that it was part of the illustrative tradition to render various miracles in this way, but it does allow for local application where opportunity allowed. Perhaps when the actual location where the Vernon manuscript was made is discovered, there will also be some indication of such a miracle-working statue having been in the vicinity.

5. *The Prick of Conscience* and the Image of the Trinity in the Vernon Manuscript

The first line of *The Prick of Conscience* suggests it was copied from a book, but the next line asking the audience to read and "look" particularizes the Vernon version. It begins with a historiated initial that encloses an image of the Trinity set in a rectangular frame to accommodate the praying white monk (fig. 12). The presence of this white monk in the bottom right of the panel might indicate that this manuscript was made for Cistercian monks,[93] of whom he is one, but it could also relate to such a person being a donor of the manuscript. It was common for patrons, family members or spiritual directors, to make special donations of books and images to religious houses for women ever since early medieval times when, for instance, Æthelweard made an amplified Latin translation of the Anglo-Saxon Chronicle for his relative, Mathilda, Abbess of Essen.[94] Andrea Pearson explores the ways in which continental Cistercian nuns either directly commissioned works or acquired them in the form of donations.[95] In a book made for Jacqueline de Lalaing just before she became abbess of Flines, it is the French King Louis XI and other male members of the Lalaing family who are pictured kneeling before the image of Saint Anne

88. Hilmo 2009, 111.

89. In the Miracle of the Harlot of Rome (124v), the crown is somewhat simplified, perhaps because it was finished by an assistant.

90. Cf. Hamburger 1998, 246, with reference to the images in Suso's *Exemplar*, and 134.

91. Horstman (1892) 1973, 155, l.33.

92. Fol. 204v shows the statue only; fols. 208v, 210v, 215, 217,

221v, 224, and 227 show both the statue and a large figure of the Virgin's prototype engaged in the action. See the facsimile edition by Warner (1912).

93. But see Scott 1996, 1:23, who suggests that the columbines hanging from the bottom border of the page with the Trinity panel might indicate a "Benedictine/Norwich connection."

94. Whitbread 1959, 579–81.

95. Pearson 2005, 323–63.

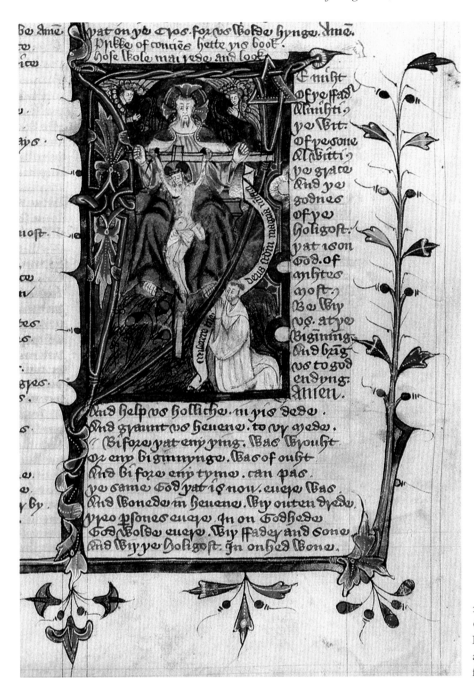

12. The Trinity, *The Prick of Conscience.* Vernon MS, Oxford, Bodleian Library, MS Eng. Poet. a. 1, fol. 265r, last decade of the fourteenth century.

teaching the Virgin to read.[96] It would appear that this image served the dual purpose of helping the future abbess to meditate on the religious scene while also reminding her to pray for her illustrious family members.

A close examination of the Vernon initial shows that the artist has graphically rendered the details of the first part of the poem. In multiple ways, the whole visual panel is focused on the Trinity (cf. fig. 1), reflecting the same multiple focus in the first part of the poem. Beside the panel, and including the historiated *Þ*, the text emphasizes the might of the Father Almighty (adjacent to the pictured head of the seated figure), the wisdom of the

Son All-wise (adjacent to the image of bleeding, crucified Christ pierced by three black spikes in his hands and feet), and the grace and the goodness of the Holy Ghost, that together are one God of greatest might. The Holy Ghost is not directly pictured, perhaps because of an awareness of Wyclif's criticism about showing it as a dove. It could also be for the artistic reason that an image of such a dove would not be in the right place if depicted adjacent to the relevant words of the text, beside Christ's body (as in the case of the figures of the Father and the Son that are placed beside the lines of text referring to each of them), instead of in the traditional iconographic position above the Father's head.

Then below the panel but still beside the descender of the *Þ* that becomes a border element, the text contin-

96. Ibid., 361–62, and fig. 11 on 342.

ues the prayer to grant us heaven, and then in the next stanza goes on to emphasize, again, the same God who existed before the Creation and is now and ever was, and who lives in heaven, three persons ever in one Godhead.[97] Then there is a third repetition of the Father, the Son, and the Holy Ghost, who always dwell in oneness. The concept of the Trinity in the historiated initial is also indicated by such visual metaphors as the spray with three buds, by the tiny black outlines delineating three plants with trefoil tops, and rather dramatically, in the gold frame adjacent to the text, by three notches. Some of the smaller decorated letters on this page have notches, but in the case of the frame there is obviously a concern to use every possible opportunity to emphasize the concept of the Trinity.

Even more dramatically, if subtly, for those seriously engaged in reading and looking, the letter thorn itself can be seen to be composed of three strands that flow together and separate only to reunite. This symbolically suggests the eternal aspect of the Trinity being part of the one godhead. While this visual abstraction as a rendition of the concept of the Trinity might seem a bit fanciful, it was a famous device also used in the illustrations of the Trinity and the patterns of history in the mystical *Figurae* of the Cistercian abbot Joachim of Fiore, who incorporated

geometric shapes, especially in configurations involving threes, to visualize symbolic concepts.[98]

The hands of the praying monk in the Vernon panel almost touch the left foot of God the Father on the other side of the letter, while the foot of the Cross within the initial touches the earth on which the monk kneels, making a nice distinction between the world of the spirit and that of the flesh while simultaneously providing for a transition between the two. The scroll originating on the side of the monk but also crossing over to be received by the Trinity contains the first words, in Latin, of the penitential Psalm 50 (cf. fig. 1).

Does this panel of the Trinity indicate that by contemplating such an image one can, like the contemporary English mystic Julian of Norwich, come to a vision in which both the human and divine natures of Christ, as well as their interpenetration and coexistence in the Trinity,[99] be apprehended? Or can it be assumed that the divine can be accessed through contemplation of both word *and* image together by a penitent assailed with the "prick" of conscience? The illustrations in the Vernon MS appeal to a fairly wide range of viewers and levels of spiritual and literary sophistication. They are suitable for a religious community and even for some outreach into the larger community (ch. 6).

IV. The *Pearl* Manuscript

What is astonishing about the *Pearl* MS, London, British Library, MS Cotton Nero A X, Art. 3, is that the twelve miniatures illustrating the exquisitely crafted poems are so plain. Traditionally these illustrations have not received much acclaim by literary critics, who have dismissed them as crude.[100] More recently art historian Kathleen Scott viewed them as the work of a professional, regionally based artist, although even she thought the artist did not did not pay much attention to the poems.[101] If these same images had been lavishly decorated, ornamented with gold leaf, painted with quality pigments, and surrounded by lavish borders, they might have been accorded greater aesthetic merit but might still not meet the expectations of those looking for a visual equivalent of the verbal text.

Although some of the poems cover biblical history,

there are no sacred images of God or the Virgin (this is also true of MS Douce 104 of *Piers Plowman*; see below). This alone gives some clue to the historical context in which they were likely added to the text, but how soon after the manuscript was made is debatable.[102] What this hesitation about the use of holy images, together with the overall plainness of execution, does reveal is that they appear to reflect a sensitivity to just the sort of image issues that were raised by reformers like the Lollards. This does not mean that the artist or the patron of the miniatures was a Lollard or a staunch reformer, but it does indicate an engagement with current discourses.

Given such a religious climate, what would have been the challenges faced by an artist instructed to illustrate the poems in this manuscript after their texts had been already written?[103] Although she did not tie the "moral" tales together into a continuum, Jennifer A. Lee saw the illus-

97. This border element is not only attached to the bottom border but is one of the three shoots, as it were, that ascend from the bottom bar border to separate or frame the three columns of text on this page.

98. See the study by Reeves and Hirsch-Reich 1972, especially 312–14 on the influence of Joachim's symbolic *figurae* on Langland's "Tree" (associated with the Trinity in the B-text, Passus 16 and in the C-text Passus 19).

99. For the observation on Julian of Norwich, see Hamburger 1998, 165. For Julian's Second Revelation, chapter 10, see the Christian Classics Ethereal Library modern translation at http://www.ccel.org/ccel/julian/revelations.iii.i.html. This is not to suggest this Vernon artist knew Julian's *Revelations of Divine Love*.

100. This still sometimes appears to be the case; see, for example, Andrew and Waldron 2007, 4. Line numbers and quotations in my text are from their edition.

101. Scott 1996, 2: 67.

102. See Hilmo 2004, 139–40, for a discussion.

103. That the miniatures were added later is apparent from the fact that some of them were clearly drawn on top of the lines ruled for text, as in the Noah image on fol. 60r, or added to the space at the end of a poem, as on the fol. 86r image of Jonah and the Whale economically added to the end of the previous poem but serving as a preface to the next (fig. 21).

trations of individual poems operating on more than one level, so that each "highlights each main character's journey to spiritual knowledge" and illuminates "part of the human soul's pilgrimage to complete faith in God."[104] Perhaps, seeing from the point of view of an artist, it is possible to go a step further.

The illustrations in the *Pearl* MS appear to have been added to the text: a bifolium of four full-page miniatures precedes *Pearl* and five fill the blank spaces between the poems (full page, except for the image of Jonah and the Whale that fills the space at the end of *Cleanness* but relates to *Patience*, the poem that follows), while the last three appear at the end of the manuscript. By their placement, the miniatures automatically serve as visual prefaces to the poems and, at the end of *Sir Gawain and the Green Knight*, as a visual epilogue. Further, the group of miniatures added to the beginning of the manuscript balances the group at the end, suggesting that the artist conceived of the collection as a whole unit, at least in overall design terms. Would such an artist, like the Ellesmere designer (ch. 5, sec. II and sec. IV), have attempted to unite the disparate poems by linking them meaningfully into a larger narrative framework? If seen from that perspective, then the choice of subjects to illustrate begins to make more sense than has been previously thought. The artist can be seen not only as rendering "the first critical judgment of these poems"[105] but as creating an overarching spiritual narrative by linking the poems collectively. This study will explore such a possibility.

The first four miniatures trace the progress of the prostrate dreamer mourning the passing of his infant daughter and then seeing her in his visionary dream as ensconced within heaven, which is illustrated as a castellated fortress he cannot himself enter. This is followed by a visual tour highlighting Old Testament events in *Cleanness* and *Patience*. Finally, the last three miniatures culminate at the entrance to Camelot, evocative in its iconographic presentation of the celestial gate, into which the hero is now welcomed.

There appears to be a transmogrification of the Gawain romance genre to allow the hero to arrive at the entrance to Camelot, an iconographic melding of British myth and the Christian vision of the New Jerusalem. The miniatures trace the steps that the artist, as one of the first readers of the poems, made in trying to co-opt them into some sort of intelligible and meaningful sequence as sacred history. As a result, the poems and miniatures to-

gether create a new narrative for subsequent audiences of this manuscript.

More information, including transcriptions and digital photographs of the *Pearl* MS, is becoming available online in the Cotton Nero A.x Project under the direction of Murray McGillivray.[106]

1. *Pearl*

The first miniature of this unbound collection is much worn. One of the four prefacing *Pearl*, it not only introduces that poem but also, in a sense, sets up the journey incorporating the rest of the poems in a kind of visionary quest. The viewer comes upon the dreamer in *Pearl* asleep on a flowery turf or arbor (38) edged at the top with stylized trees (fig. 13). Demonstrating his familiarity with the themes of Christian iconography, the artist innovatively adapted the conventional one used since Anglo-Saxon times for the sleeping Adam, as in the Cædmon manuscript (fig. 14a), or later for the same subject in James le Palmer's *Omne Bonum* (see fig. 18b, lower right, below), or that showing Augustine (with open eyes) in a garden during his sudden conversion, as painted on a fifteenth-century wooden panel on one of the Carlisle Cathedral stalls[107] (fig. 14b). Lynn Staley drew attention to the similarity of the Carlisle image to that of the dreamer.[108] Similar in conception to the scene of the dreamer is that of the author of *Le Songe du Verger*, who has fallen asleep beside a stream in a garden surrounded by trees, at the bottom of the miniature in a slightly earlier French manuscript, London, British Library, MS Royal 19 C.IV, fol. 1v, 1378.[109] This traditional Christian iconography was itself a borrowing from classical art depicting the sleeping Endymion (fig. 14c).[110]

The contour of the dreamer's body (fig. 13) parallels not only the wavy hillside above but also the prominent dark green spot below, calling attention to it. What does this "spot" contain? Is it a pond or an underground entrance? What does it signify? Since the "spot" is such an important focus of the first part of the poem, its possible meanings are as multilayered as is the visual image. It could indicate the spot where the pearl fell through the grass into the ground (10), or simply the spot on which the dreamer fell asleep (57), or the internal landscape into which he descends, or his daughter's grave. It could also indicate the spot where the seed will sprout as the dreamer tries to console himself that his buried pearl, like a seed, will

104. Lee 1977, 21 and 44.

105. Ibid., 44.

106. http://people.ucalgary.ca/~scriptor/cotton/projectnew.html

107. I thank James Armstrong, the Head Verger of Carlisle Cathedral for the photo, and also Carolyne Baines and Dr. Canon David Weston for their help. Weston's modified transcription of

text reads: "Her wepyng and walyng as he lay, sodenly a voice thus herd he say, 'Tolle lege, Tolle lege'"; see Weston 2000; also Park and Cather 2004, 214–31, and Hamer 1995.

108. Staley 2005, fig. 20.

109. See http://www.bl.uk/catalogues/illuminated manuscripts/searchMSNo.asp.

110. As observed in conversation by John Osborne.

13. The dreamer/ narrator falls asleep, *Pearl*. *Pearl* MS, London, British Library, MS Cotton Nero A X, Art. 3, fol. 41r (37r), late fourteenth century.

come to life again. This resonates with the biblical image likening the mustard seed to the kingdom of heaven in which "the least indeed of all seeds" grows up to be "greater than all herbs and becomes a tree" (Matt. 13.31–32). In this case it is the dead child who becomes a queen in heaven when the dreamer encounters her again. Later in the same chapter of Matthew (13.45–46) the "pearl of great price" links the seed and pearl images with the kingdom of heaven, the ultimate goal of the dreamer. Additionally, the image of the dark wavy spot in the miniature could anticipate the vision of the jeweled stream reflect-

ing the starry skies and beside which "stroþe-men" (marsh men) sleep (113–20), which itself is analogous to the subterranean or interior state of the dreamer transported to his vision of the New Jerusalem.[111] The touching up of the white and reddish-brown patches invite this reading. Visually, the dark spot could also be intended to prepare the viewer for the stream that prevents the dreamer's access to the Pearl Maiden in the New Jerusalem, as seen in the last two *Pearl* miniatures (figs. 17b and 19).

111. Despres 1989, 89–118.

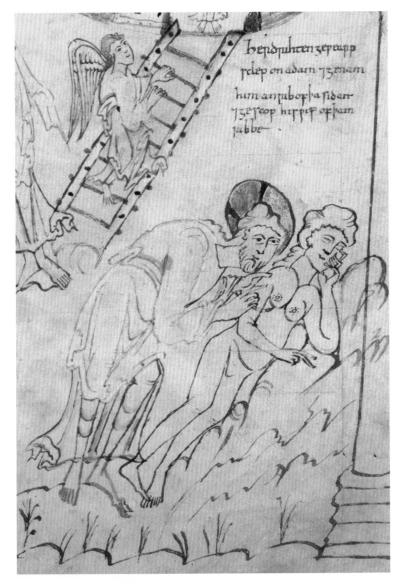

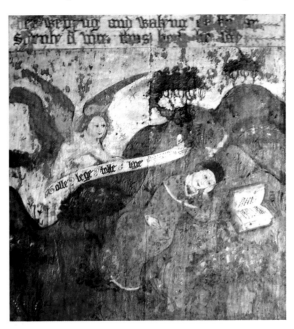

14. (a) Adam sleeping. Cædmon MS, Oxford, Bodleian Library, MS Junius 11, page 9, first half of the eleventh century (b) Conversion of Augustine. Carlisle Cathedral Stall, fifteenth century (c) Endymion Sarcophagus. New York, Metropolitan Museum of Art, third century.

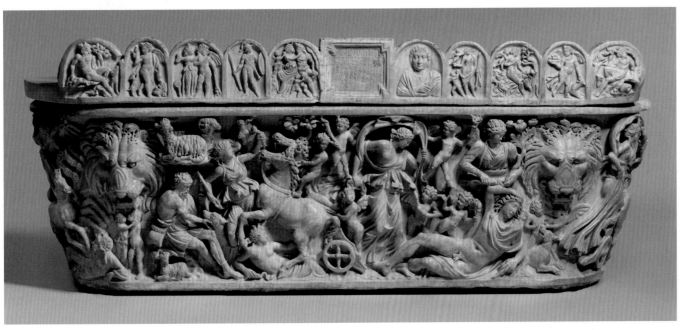

15. Under the dark spot, detail from the dreamer/narrator falls asleep, *Pearl*. *Pearl* MS, London, British Library, MS Cotton Nero A X, Art. 3, fol. 41r (37r), late fourteenth century.

The "spot," however, might not originally have been emphasized so prominently. With the application of modern technology it is now possible to recover what might have been otherwise lost to view. In this case, an appointment with Anthony Parker, the British Museum's conservation officer, led to an important discovery. Through the use of the museum's Video Spectral Comparator and an IC8 Integrator Comparator, the added dark paint layer was photographically lifted off to reveal what was actually under the wavy spot before someone, not necessarily the original artist, added the second layer of paint. What is revealed, not surprisingly, is a continuation of the flowery meadow upon which the dreamer reclines (fig. 15).

This raises some interesting questions about the several stages and artists involved in the making of the miniatures. Were the original miniatures only drawings to which someone else added color?[112] In the case of the "spot" did someone want a clearer grave site for the daughter? Were there one or two people who did the painting? In the first miniature of the sleeping dreamer, what at first seems a different color from that used for the streams and oceans in the other miniatures is accounted for by the base color of the meadow, which is a light beige, whereas the other watery areas do not appear to have had any other color underneath the water. The similarity of the pigments in these miniatures is more apparent in the original manuscript. Variations of this aquamarine color, perhaps mixed on different occasions, are also used for clothing and architectural features in some of the miniatures. In the photograph of the spot removed, even the original wavy spot

16. (a) detail of the dreamer, *Pearl*, fol. 42r (38r)
(b) detail of Jonah, *Patience*, fol. 86r (82r). *Pearl* MS, London, British Library, MS Cotton Nero A X, Art. 3, late fourteenth century.

seems a bit darker than the surrounding area. Could it be that it was decided to add an additional painterly layer to increase the prominence of this patch?

The work of this colorist is not especially careful in its execution, especially in some of the scenes involving water. This is evident in the third *Pearl* miniature in which the dreamer's finger pointing to the Pearl Maiden across the stream is painted over (fig. 16a) and in the miniature

112. Lee 1977, 19.

17. (a) The dreamer walks through a forest, *Pearl* fol. 41v (37v) (b) The dreamer points to the Pearl Maiden, *Pearl* fol. 42r (38r). *Pearl* MS, London, British Library, MS Cotton Nero A X, Art. 3, late fourteenth century.

of Jonah and the Whale in which parts of Jonah's head and the handle of the two-pronged hook seem to have been accidentally painted over as well (fig. 16b). Did yet another person add the streaky and oily-looking aquamarine color to the spot and the rivers and oceans of the other miniatures, even painting over details like pointing fingers? Future spectrographic analysis of the pigments (or some other advanced technology) might help to determine the exact nature of this added pigment.

However lacking in painterly expertise and costly pigments, the person who painted these areas clearly wanted to emphasize the thematic importance of the spot even though it was previously part of the flowery meadow and to connect it symbolically with the waters of death in the Flood scene and that of Jonah. Whether or not this critical mind thought of the other layers of meanings it would likely have evoked in subsequent viewers is not clear, but in effect, a tantalizing mystery was created around the image of the "spot."

Following that of the reclining dreamer, the second miniature (fig. 17a) depicts him walking through a transfigured forest of trees (with individual leaves rendered as if they could actually slide over each other; 75–80). In the third miniature (fig. 17b), in different clothes as if to in-

dicate a lapse of dream-time, this figure points up to the Pearl Maiden across the stream.

The landscape in all of the *Pearl* miniatures remains somewhat constant, as if one is a continuation of the other. It is the perception of the dreamer that has changed. There is the same flowery meadow with trees and, in place of the wavy dark spot, there are wavy streams in the other miniatures. Even the compositional masses are much the same on the recto and verso sides of the first three *Peal* miniatures. For example, where the hillside slopes down in the first, in the second it slopes up, and then in the third it slopes down again.

The second and the third might originally have been composed on one sheet, which in the case of the *Pearl* miniatures was then folded. This bifolium may have been added to the front of the manuscript. What is now a slight jog in the continuation of the hillside going up and then going down is explained by the fact that the bifolium was evidently cut in the middle at some point but then each leaf was not realigned properly. There are two clues that this is so. One is that there is evidence that this bifolium was expertly repaired along the spine, where there are indications of an added strip and repair, at some time in the past, as pointed out to me by Anthony Parker when he

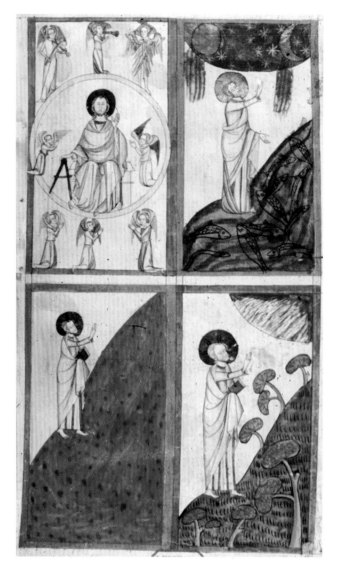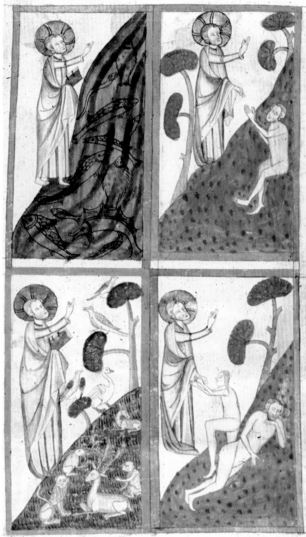

18. Creation miniatures. (a) The Creator enthroned; God creating the firmament; God creating the fruits of the earth; God creating the sun, moon, and stars, fol. 1r (b) God creating the fish; God creating the animals; creation of Adam; creation of Eve, fol. 1v. James le Palmer's encyclopedia, the *Omne Bonum*. Descriptions according to Sandler 1996, figs. 86–87. London, British Library, MS Royal 6 E VI, vol. 1, c. 1360–75.

held up a bright (pen) light along the spine. That the two leaves were not realigned properly after the edges were cut is evidenced by the worm holes, which now do not realign. This is significant. If placed in correct alignment, these holes appear to indicate that the hillside on the second and third miniatures, allowing for some cutting of the inner edges, would likely have been continuous, permitting the waters of the stream in both to flow together. Such close attention to details in the study of manuscripts can help reestablish original intentions.

In each of the last three *Pearl* miniatures the pointing dreamer clothed in red, the stylized trees, and the streaky fish-inhabited rising stream are remarkably similar to the Creation miniatures in James le Palmer's encyclopedic *Omne Bonum* (c. 1360–75; figs. 18 a and b).[113] The latter "echo the standard compositions for Old Testament themes such as the Creation."[114] What seems somewhat unrealistic to the modern eye is the rising stream in both the *Pearl* and *Omne* miniatures. Perhaps this derives from the attempt, by the *Omne* artist or his exemplars, to render a round earth, replicating the idea of the round mandorla in which the Creator sits in the first scene (possibly doubling

113. Staley 2005, 254, sees this as another indication that the Pearl artist "had connections with other artists and their sources." For James le Palmer's *Omne Bonum* (BL MS Royal 6 E VI, 192, c. 1360–75), see http://www.bl.uk/catalogues/illuminated manuscripts/Addterm.asp?ID=373&List=ScribeID&Target= results. See also Sandler 1996.

114. Sandler 1996, 1:88.

19. The Pearl Maiden
within the New
Jerusalem, *Pearl. Pearl* MS,
London, British Library,
MS Cotton Nero A X,
Art. 3, fol. 42v (38v), late
fourteenth century.

as a sign of the Omega to go with the large *A*, which itself
also doubles as a compass, that the Creator holds). It also
conforms to the semicircle of the firmament at the top of
the third scene (the compartments are read vertically from
top to bottom and then back up to the top; fig. 18a). In the
Pearl MS it is how the swelling streams are rendered in the
scenes of Noah (fol. 60r) and of Jonah (fol. 86r, fig. 21).

In the visionary sequence of the *Pearl* miniatures, the
dreamer does not wear a hat in the last three, as he did in
the first where the liripipe of his chaperon seems to have
taken on a life of its own, possibly signifying that his spirit
has taken flight.[115] Compared to that in the first miniature

where it has cuffed sleeves and is gathered at the waist, in
the last three his long red houpeland has changed style as
well, with variations in the red coloring and the style of
its sleeves. It has also lost its belt. Perhaps this indicates
his more disheveled dream state. These changes also sug-
gest time lapses and the unexplained shifts characteristic
of dreams.

Both in the poem and in the last two miniatures (figs.
17b and 19), the figure he encounters in his dream is now a

115. Gollancz (1923) 1971, 9.

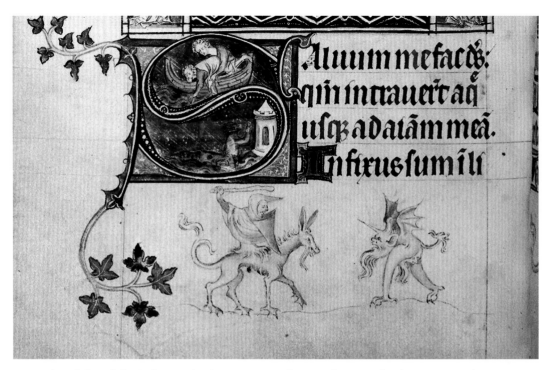

20. Jonah and the Whale, Psalm 68. The Queen Mary Psalter, London, British Library, MS Royal 2 B VII, fol. 168v, c. 1310–20.

full-grown woman. In the third miniature (fig. 17b), she is crowned and dressed in a white version of the same style of houpeland as that of the dreamer. The three pearls below her collar in the third miniature identify her as the Pearl Maiden and associate her with the Trinity. Her transformed status is further revealed in the fourth miniature where she appears as a queen within the walls of the New Jerusalem (fig. 19).[116] In her position overlooking the crenellated walls between the tower and a church-like building she can now be identified as the pearl gate of John's vision (Rev. 21.21). As a Bride of Christ, she represents all the maidens within the New Jerusalem and in herself represents the body of Christ.

The hilly mound on which the dreamer fell asleep in the first miniature is also that on which the New Jerusalem is situated in this last miniature. Unlike the poem that ends with the dreamer awakening and consoling himself by entrusting his pearl to God and by thoughts of the Eucharist, the miniature leaves him in his dream. Like a courtly lover, the Pearl Maiden is shown holding her right hand over her heart, a departure from the poem where she is not shown as so emotional. At the same time she reaches out to

the dreamer with her left hand, but this gesture may also contain something of a warning that he should not cross the stream that separates the earthly realm from the heavenly one she inhabits. While he seems less disconnected from her than previously, he is still separated by that very stream. It is populated by large sea creatures, one seemingly about to swallow a smaller, thinner one. These also inhabit the ocean in the representations of Noah on folio 60r, where a large fish is actually swallowing a smaller one, as if in anticipation of the following miniature of the whale swallowing Jonah (fig. 21), visually linking all three submarine worlds as symbolic representations of death.

2. *Patience*

Some representations of Jonah, like the one in the Queen Mary Psalter (BL MS Royal 2 B.VII, fol. 168v, c. 1310–20; fig. 20), show him not only being cast into the sea, as in the top counter space of the *S* but also about to be resurrected from the whale's belly onto dry land again, as in the bottom of this historiated initial for Psalm 68.[117] That is not the case in the *Pearl* MS.

116. In his paper "The Pearl-Poet Manuscript in York," delivered at the July 2011 conference held at York, Out of Bounds: Movement and Use of Manuscripts and Printed Books, 1350–1550, Joel Fredell drew attention to similarities of the landscapes and other feature in the *Pearl* MS illustrations to those in London, British Library, MS Harley 1808. See fols. 9v, 30v, and 45v at http://www.bl.uk/catalogues/illuminatedmanuscripts/record.asp?MSID=6645&CollID=8&NStart=1808. Fredell maintained that the

Pearl MS was produced at York in the early fifteenth century. I am grateful to Hannah Zdansky, who attended the conference, for this information.

117. Like some of the subplots involving common characters in Renaissance tragedies, the battle against the devil on the *bas-de-page* echoes, in a lower key, the significance of the story of Jonah and the Whale.

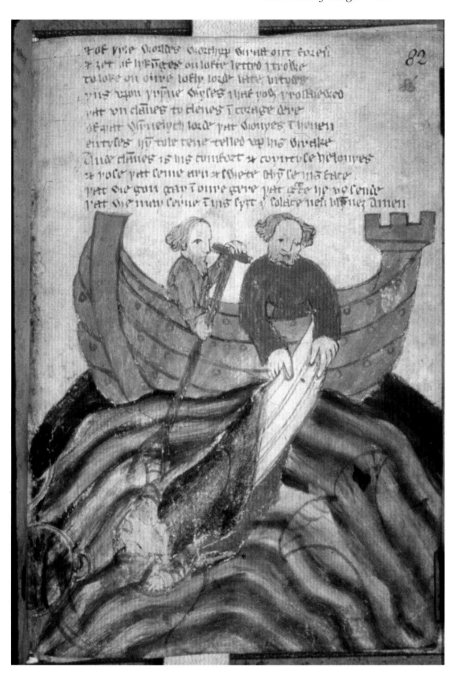

21. Jonah and the Whale, *Patience*.
Pearl MS, London, British Library,
MS Cotton Nero A X, Art. 3, fol. 86r
(82r), late fourteenth century.

The depiction of Jonah and the Whale on folio 86r (fig. 21) is placed in the empty space right below the end of *Cleanness*, the preceding poem, followed by one of Jonah preaching in Nineveh on folio 86v (fig. 24) which, in turn, faces the text of *Patience* on folio 87r. These two prefatorial miniatures to *Patience* are not only chronologically sequential but are also related typologically. Jonah was told by the Lord to go to preach in Nineveh, but the reluctant Jonah fled and found passage on a ship. A tempest arose and his shipmates cast him into the sea, where a great fish swallowed him. Jonah was in its belly three days and nights, and then he cried out to God from "the belly of hell" (Jonah 2.3), so God spoke to the fish and it vomited him out on dry land. Then the Lord again told Jonah to go preach in Nineveh, which Jonah did. In the New Testament Christ spoke of his coming death and resurrection by using the analogy from Jonah:

> For as Jonas was in the whale's belly three days and three nights: so shall the Son of man be in the heart of the earth for three days and three nights. (Matt. 12.40).

The text of *Patience* makes clear the significance of the whale's belly. It "stank as þe deuel" and "sauoured as helle" and, more specifically, that the Lord heard Jonah from "hellen wombe" (274, 275, and 306). In the visual narrative of this manuscript, the monstrous whale is the infernal counterpart of the castellated New Jerusalem pictured in *Pearl*. Even the mound of the first poem is visually echoed by the rounded mound of the watery depths in the miniature.

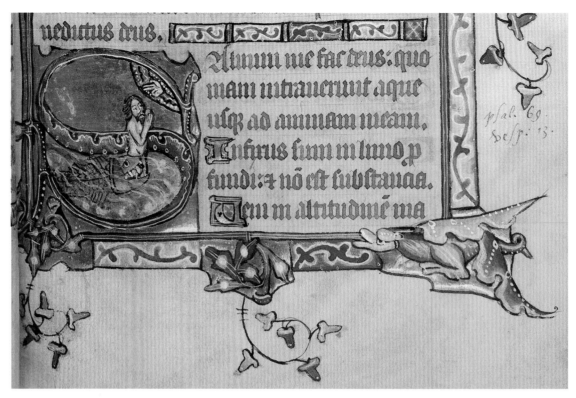

22. Jonah and the Whale, Psalm 68. Psalter, Notre Dame, IN, University of Notre Dame, Hesburgh Library, MS 65, fol. 58r, c. 1400.

Although *Patience* says that no tooth touched Jonah (252), the illustrator could not resist depicting the whale's teeth clamping Jonah's head (fig. 21). A two-pronged hook pierces the beast's nostril and jaw, a visual allusion to Job 40.19–21 about boring through the nostrils or jaw of Leviathan with a stake or hook. The identification of the Leviathan as a whale (Isaiah 27.1) was taken by commentators[118] to refer metaphorically to the devil or death, who swallowed Christ at the time of his Passion, thinking he was merely human. The hook was interpreted as a reference to Christ's concealed godhead that enabled him to deceive death (the Leviathan or whale) and so to rise again. Christ's descent into hell was also thought to have been foretold by Psalm 68.2: "I am come into the depth of the sea." This psalm was illustrated with a scene of Jonah in a contemporary English psalter now in Notre Dame, IN, University of Notre Dame, Hesburgh Library, MS 65, fol. 58r, c. 1400 (fig. 22; compare fig. 20). In the bottom of this historiated initial, the tempestuous sea is the infernal counterpart of the heavenly domain in the upper half, as indicated by the gold background and clouds from which God speaks. As if to reinforce the significance of the whale, there is a winged dragon in the bottom-right corner of the border looking up toward the scene in the

historiated initial. Typologically, the whale, the dragon, the serpent, the lion's mouth, and Leviathan were all considered manifestations of the devil and hell.[119]

Two scalloped holes at the bottom left of the image of Jonah and the Whale (fol. 86r, fig. 21) indicate that the miniature painted (not necessarily drawn) after this text was folded into booklets. An alternative explanation is that it was painted on an open sheet spread on top of the one with the text beginning *Patience* before being folded. A photograph (figs. 23a) clearly reveals that, either way, the two holes in the parchment were simply painted over onto the folio underneath this one, leaving two scalloped areas of paint at the edge of the text on the first page of *Patience* (fig. 23b). A trace of paint on fol. 85v is a further indication that the paint was still wet when the booklet was folded.

Facing the beginning of the text of *Patience* is the miniature of Jonah (fig. 24) loosening the words within him (350) and finally preaching to the Ninevites, as indicated by his gesture. The poem describes the people of Ninevh as accursed fiends engaged in villainy (82, 71). Almost Christ-like, the prophet Jonah is depicted as much larger than the people over whom he bends slightly.

This subject of Jonah preaching is not frequently pic-

examples, translations, and a discussion; see Hilmo 2004, 36–37 (and n37) and 50–54.

119. Ibid. See also "The Devil in Beast Shapes" in the index of the Vernon's *Miracles of the Virgin*; Tryon 1923, 353.

23. (a) Parchment holes on fol. 86r (82r) (b, right) the impression on fol. 87r (83r). *Patience. Pearl* MS, London, British Library, MS Cotton Nero A X, Art. 3, late fourteenth century.

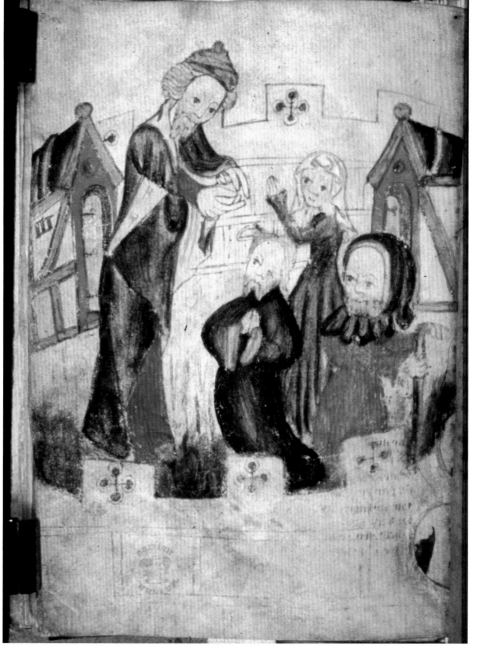

24. Jonah preaching in Ninevah, *Patience. Pearl* MS, London, British Library, MS Cotton Nero A X, Art. 3, fol. 86v (82v), late fourteenth century.

25. Harrowing of Hell. (a) Tiberius Psalter. London, British Library, MS Cotton Tiberius C.VI, fol. 14r, mid-eleventh century (b, above right) Fitzwarin Psalter. Paris, Bibliothèque Nationale MS lat. 765, fol. 15r, 1350–70 (c, left) Book of Hours. Koninklijke Bibliothek, National Library of the Netherlands, The Hague KB, 79 K 2, fol. 89v, 1430–45.

tured, but the artist appears to have adapted the iconography of the Harrowing of Hell[120] in which Adam and Eve, and often the Old Testament righteous, reach up to be saved by Christ. Hell can be represented either architecturally, cave-like or, since Anglo-Saxon times, zoomorphically, or any combination of these (figs. 25 a–c). This configuration in the miniature of Jonah preaching also gives a clue to the typological significance the artist gave to this scene. Following the Harrowing, Christ was thought to have preached to the captives in hell, an interpretation of I Peter 4.17. Augustine, referring to this scrip-

120. The belief that Christ descended into hell to rescue the righteous souls from the devil over whom he was victorious is based on such passages as Psalm 68.18; Isaiah 24.21–22; Zechariah 9.11; 2 Corinthians 2.14; Acts 2:27 and 31; Ephesians 4.8–10; and 1 Peter 4–6 and 19–20.

tural passage, thought that it applied also to the "Prisoners in the death of unbelief and wickedness,"[121] a description also applicable to the Ninevites.

Beside the man praying and the woman reaching up to Christ in the miniature of Jonah preaching is a small figure leaning on a cane or staff and looking not at Jonah but contemplatively out in the direction to the left of the viewer. Who is he? It has been suggested that he is one of the "sottez" (fools or idiots) whom, along with women and dumb beasts, the Lord does not want to strike down (509ff.).[122] He is pictured more like a squat dwarf than like the Adam- and Eve-like figures beside him. His proportions are reminiscent of the self-presentation of two fourteenth-century authors: Thomas Usk and the ever elusive Chaucer (ch. 5, sec. IV), the latter described by the Host as a "popet," one "elvyssh" in countenance (Pro-Thop 701, 703). In the miniature the squat figure wears the same red houpeland and blue chaperon with liripipe as the dreamer-narrator in the first miniature of *Pearl*, linking the two portraits even if recasting the second figure as somewhat like a dwarf. He may also be a variation of the man, frequently dressed in red and playing an attendant role in some of the other miniatures, on a spiritual journey through this manuscript. In this manuscript it also allows the artist to connect the threads of the various poems.

3. *Sir Gawain and the Green Knight*

The prefatorial miniature for this romance shows the Green Knight decapitated by Gawain at the Yuletide feast. The final three at the end of the poem sum up the main events: the Temptation of Gawain, Gawain seeking the Green Chapel and coming to a barrow, and Gawain welcomed back to Camelot. This last can also be seen to serve visually as a conclusion to the quest not only of Gawain but also, by proxy, of those of the protoganists of the preceding poems.

At the top of the first *Gawain* miniature (fig. 26), King Arthur and Queen Guinevere in the center are flanked by two men in red as they stand above a table that divides the top half from the bottom where the Green Knight, mounted on a green horse, holds up his bleeding head that has just been decapitated by Sir Gawain, also in red. There is a striking display of sharp weapons. Revealing the sacramental and sacrificial overtones of this scene, as inter-

preted by the miniaturist, are the bleeding head displayed against the altar-like table and the golden-columned vessel on the right that looks like a ciborium.

The ritualistic aspect of this scene might well be evocative of the suggestions in the poem, as observed by Francis John Ingledew, of the Circumcision, which was assimilated to the Passion in homiletic literature about the Five Wounds of Christ (one of the symbolic meanings of the Pentangle in the poem itself).[123] Since the events in the poem occur during the Yuletide, it is perhaps significant that the Feast of the Circumcision is celebrated on January 1, perhaps drawing such an association closer

Not only would such a liturgical association have been possible for this miniature but, even more obvious, are its visual correspondences to images of the head of John the Baptist. The content of the *Gawain* miniatures, especially this first one, has been compared to the painting (c. 1330) on the north wall of the chancel in the Church of St. Hubert at Idsworth, Hampshire.[124] John Fleming regards such works as "ransomed indeed from the iconoclast by their very obscurity."[125] One might add, such paintings might also have been familiar to the illustrator of Nero A X, if this person was not also himself a wall painter, since the plainness of style is not uncharacteristic of many such extant wall paintings.[126] In terms of iconography, Ann Astell sees the Gawain images as a transposition of the Idsworth scenes from the life of John the Baptist to "convey its penitential message."[127] Certainly the beheading scene of the first Gawain illustration could not but recall to a medieval English viewer this dramatic biblical story (Matt. 14), and it might well have been thought of in relation to Richard II, whose patron saint was John the Baptist.[128] Biblical correspondences, whether to the Circumcision or the beheading of John the Baptist, and possibly contemporary historical references to Richard, would have encouraged a multilayered reading of the illustration.

Following this prefatorial miniature and, in the visual epilogue, the next one of Gawain's fleshly Temptation (fol. 129r), the miniature of the hero coming to the Green Chapel at the appointed time (fig. 27) intriguingly varies the artist's evocations of infernal venues (watery or worldly) that the protagonists of the poems in the manuscript must encounter and survive. The Green Knight in the top half is an exact replica of Gawain in the prefatorial miniature, except that now he is the one holding the poll-

121. Augustine 1886, Letter CLIV.

122. Andrew and Waldron 2007, 5, following Gollancz (1923) 1971, 10.

123. Ingledew 1989, 162.

124. See the image at History of St. Hubert's Idsworth at http://www.homeshed.plus.com/bcichurches_netobjects/html/history_of_st__hubert_s_idswor.html.

125. Fleming 1981, 125.

126. See Ann Marshall's "Medieval Wall Painting in the English Parish Church," updated Dec. 18, 2009 at http://www.paintedchurch.org/. See also her version of the story of "The Legend of the Hairy Anchorite at Idsworth, Hamphire" on the same site.

127. Astell 1999, 135. But see Marshall, online as previously noted, who sees part of this as the story of John van Beverley, the "Hairy Anchorite." She notes that a confusion of Johns means that the Baptist entered the legend early.

128. Astell 1999, 136. She also points, however, to other pertinent connections between these two.

26. The Green Knight
decapitated at the Yuletide
feast, *Sir Gawain and the Green
Knight*. *Pearl* MS, London,
British Library, MS Cotton Nero
A X, Art. 3, fol. 94v (90v), late
fourteenth century.

axe. In the bottom register Gawain on his horse replicates the Green Knight on his horse in the prefatorial miniature, as if their identities had been exchanged or as if the one is a doppelgänger or dark side of the other.

Perhaps it is the visualization of the alien landscape of Wyrale that helps to explain this sea change or transformation that has taken place here. Although the illustration has faded substantially, it is still possible to glimpse one of the most eerily conceived landscapes in medieval art. There is still some suggestion of the flowery mound of the *Pearl* images, but it has undergone a disturbing metamorphosis and is reminiscent of the uncanny quality of the approach to the mere of Grendel. Once again the

viewer has been brought into an infernal region through which the hero must pass. Gawain's journey to this unearthly landscape is reminiscent of the dreamer's otherworldly journey through the transfigured forest up to the river he cannot cross, and Jonah's descent into the belly of the whale. And as Takami Matsuda has suggested concerning the poems, the vision of the afterlife is used as a narrative framework.[129] It is this concept that the artist appears to have highlighted and used as one of the devices to link the poems.

Not only is the Green Knight with his axe suggestive of

129. Matsuda 2007, 504.

27. Gawain seeks the Green Chapel and comes to a barrow, *Sir Gawain and the Green Knight*. *Pearl* MS, London, British Library, MS Cotton Nero A X, Art. 3, fol. 129v (125v), late fourteenth century.

Death, but there is also the hint of a crouching figure in a cave. The Green Chapel, following the tenor of the poem, is conceptualized as a barrow or burial mound:

> Hit hade a hole on þe ende and on ayþer syde,
> And ouergrowen with gresse in glodes aywhere,
> And al watz holȝ inwith, nobot an olde caue
> Or a creuisse of an olde cragge—he couþe hit noȝt
> deme
> With spelle.
> 'We! Lorde,' quoþ þe gentyle knyȝt,
> 'Wheþer þis be þe Grene Chapelle?
> Here myȝt aboute mydnyȝt
> Þe Dele his matynnes telle!'

[It had a hole at the end and on either side, / And (it was) overgrown with grass in bright patches every-where, / And all was hollow inside, nothing but an old cave, / Or a crevice in an old crag—he could not say it / with words. / "Lo! Lord," said the noble knight, / "Is this the Green Chapel? / Here might around midnight / The Devil recite his matins!"]

(2180–88)

Following the text, the artist has rendered this unearthly landscape so effectively that even the "grass in bright patches" is pictured. As argued by Matsuda, the text itself is reminiscent of the description of the otherworld in such works as the popular *Tractus de Pugatorio Sancti Patricii* in

28. Gawain raised up by King Arthur and welcomed to Camelot, *Sir Gawain and the Green Knight*. *Pearl* MS, London, British Library, MS Cotton Nero A X, Art. 3, fol. 130r (126r), late fourteenth century.

which Owein enters Purgatory and is met by devils. There is also the cave serving as a "trysting place for devils" in the version of Saint Patrick's Purgatory with its nine holes in Giraldus Cambrensis's *Topographia Hibernica*. Then there is the semihistorical account by the Catalan knight Ramon, who visited King Richard II on his way to Saint Patrick's Purgatory and then, on his return journey, saw the "preserved head of Gawain" at Dover.[130] As Matsuda maintains, this does not mean that the *Pearl* poet had read a specific version of such a journey, but such accounts, especially of the very popular story of the Purgatory of Saint Patrick, provide a narrative context for such episodes.[131]

In the last Gawain miniature, which also frames the collection as a whole, the hero finally arrives at his destination, in this case, Camelot (fig. 28). He is welcomed by King Arthur, Queen Guinevere, and a figure clothed in red, similar to the figures on either side of Arthur in the prefatorial miniature to the poem. What is most noteworthy is that the green baldric or girdle Gawain wears as a sign of his guilt, as mentioned in the poem, is nowhere in evidence in the miniature. Except that she wears green instead of white, this queen looks very like the crowned Pearl Maiden of the first poem. While the green gown and the gold belt might be nods to the idea of the girdle, that is clearly not the main interest of the miniaturist.

130. See Matsuda 2007, 497–505 for details.
131. Ibid., 501.

At a deeper level of meaning, here the queen has replaced the Pearl Maiden, who now offers no impediment to the quester's access. King Arthur stands like the Christ in some representations of the Harrowing of Hell. Instead of holding a resurrection banner, the king's left hand is raised in greeting. With his right hand he welcomes and raises the smaller figure of Gawain, who kneels like another Adam in the Harrowing illustrations (cf. figs. 25 a–c),[132] or like a knight at a knighting ceremony (except that Gawain is already a knight). The arched entrance to the court of Arthur calls to mind the New Jerusalem pictured in the last *Pearl* miniature (cf. the arched doorway of the pavilion from which God speaks in fig. 20). Such entrance points are charged metaphors in medieval art and architecture as "intersections of inner and outer," infernal or sacred space.[133]

By various intervisual references, the miniaturist has transformed the poem's romance setting so that the secular court can also be read spiritually with reference to the heavenly one. The ending of the poem hints at such a larger, eschatological framework. It proceeds from secular history to salvation history—from the time of the Passion, when the Lord wore a "croun of þorne," to fulfillment in the future when he is asked to "bryng vus to His blysse." Like the *Omne Bonum* artists who gave coherence to many of its texts by illustrating the overall theme,[134] the *Pearl* artist's miniatures visualize events in such a way as to imply that they are part of a larger scheme. Dream visions, biblical journeys, and romance quests are but figurations for the journey to our ultimate celestial destination. Further study of this manuscript's miniatures might well lead to the discovery of additional motifs that not only reflect contemporary issues but also fit within such a larger pictorial program.

V. Two *Piers Plowman* Manuscripts and the Ushaw *Prick of Conscience*

Although there are just over fifty *Piers Plowman* manuscripts, very few contain illustrations.[135] Of these, the only two that begin with historiated initials are Oxford, Corpus Christi College, MS 201 and Oxford, Bodleian Library, MS Douce 104. CCCO MS 201 includes heads extending from the ascenders at the tops of two folios, their meaning illuminated by comparison with similar heads in *The Prick of Conscience*, Durham, Ushaw College, MS 50, copied by the same scribe. MS Douce 104 (see also front plate 8) has an extensive cycle of some seventy-two marginal illustrations, the majority of which are figural and interact dynamically with the text, a feature enhanced because of their placement in the adjacent margins.[136] By their position and manner, the Douce images modify, shift, limit, displace, and even undermine the meaning of some lines, while calling special attention to others by highlighting them. The Douce cycle has been extensively studied by scholars of literature and art history, aided by the facsimile edition by Derek Pearsall and Kathleen Scott.[137] The Douce manuscript also contains an elaborate and inventive cycle of marginal annotation (ch. 4, below), making the manuscript an attractive site for the study of "production team rivalry" between the scribe-illustrator and the annotator-corrector.

Since other parts of the present book deal with Douce 104 more extensively, and since the CCCO MS 201 illustrations have been largely neglected, and form a more manageable example, this section will deal especially with some of the issues surrounding the presentation of the elusive author in each of these two manuscripts. Like those in the *Pearl* manuscript, these *Piers* illustrations are not the sort that might be found in large deluxe manuscripts. They are mostly if not all scribal, as will become evident. This lack of ostentatious illustration is not surprising in view of Langland's disapproval of rich images, as evident especially in the B-text.[138] There in Passus 3.47–75 Mede consents to decorate her Friar Confessor's church with paintings and (donor) portraits, but such "gravynge" in windows is condemned by God as an act of pride and pomp (64–66). Langland does not condemn stained glass windows as such but does condemn the ostentatious show of donor pride. In Passus B 5.226–27 it is Covetousness who says he and his wife will go on pilgrimage to Walsingham and to the Rood at Bromholm.[139] The Priory of

132. See Grabar 1966, 126. on its iconographic origins in representations of the victorious Roman emperor, raising up and liberating kneeling figures saved from tyranny. Christians used "the same formula for images of Christ descending into hell." The Pearl miniaturist adapted this iconography for both the image of Jonah preaching to the Ninevites and that of Arthur lifting up and welcoming Gawain to Camelot.

133. See Camille 1993, 45 and 48. *Gesta* 39.1 (2000) is devoted largely to articles on the importance and significance of portals.

134. Sandler 1996, 1:85.

135. Not discussed here are London, British Library, MS Cotton Caligula A.XI, which has marginal drawings in profile, but see also Kerby-Fulton 2000a, 112, for comments on these and on San Marino, CA, Huntington Library, MS HM 128, which has three marginal drawings. Added in the mid- to late-fifteenth century

at the front of Cambridge, Trinity College MS R.3.14 is a tinted drawing of a plowman with two oxen and an assistant with a prod; see The *Piers Plowman* Electronic Archive at http://www3 .isrl.illinois.edu/~unsworth/cyber-mla.2002/SNAG-0018.jpg. For other minor representations, see Scott 1992, xxvii, n1.

136. See especially Kerby-Fulton and Despres 1999 and Hilmo 1997, 13–48.

137. Pearsall and Scott 1992.

138. Unless otherwise indicated, line numbers and quotations from the B-text are from Schmidt (1978) 1987.

139. For its history see Galbi 2003, IV.A, at http://www .galbithink.org/sense-s5.htm.

Bromholm was a pilgrimage destination because it was said to contain a relic of the true cross that, from surviving representations of it, was covered with gold or silver-gilt.[140] In Passus 15.81a Langland quotes the Latin version of Psalm 96.7 asking that those who adore graven images be confounded. It is true that this is a passage about idolatry and does not condemn the appropriate use of images by orthodox Christians who adore the prototype of the image and not the image itself. After all, when the dreamer awakes on Easter morning he invites his family to creep to the cross on their knees and kiss it (Passus 18.431).[141] Langland also incorporates into his poem visual iconography from illustrated pastoral manuals and meditational texts,[142] as well as from conventional medieval illustrations of the Harrowing of Hell and Passion. The illustrations in CCCO MS 201 and MS Douce 104 are almost part of the text, sometimes even merging with it, one symbol system extending another.

1. Animating the Letter and Visually Authorizing the Text in the CCCO MS 201 and the MS Douce 104 manuscripts of *Piers Plowman*

When vernacular texts in the fourteenth and fifteenth centuries began to take on sufficient importance to acquire decoration and illustrations, they inevitably developed the ornamental and illustrative vocabulary of religious texts. Scriptural texts in early Hiberno-Saxon manuscripts were elaborately ornamented with decorated letters that carried with them something of the sacred mystique associated with the creative Word of John 1.1. The empowering Word was expressed by shape-shifting plant, animal, or human forms visually "animating" the letter, as suggested by Laura Kendrick.[143] The Creator's authorial function was further conveyed by portraits of the seated evangelists busily recording his words. It is not surprising, therefore, that the first extant portrait of a vernacular author, albeit a priest, Laȝamon, was likewise shown seated within a historiated initial at the beginning of the *Brut* in London, British Library, MS Cotton Caligula A, made in the second half of the thirteenth century.[144]

By the fifteenth century not only was Chaucer frequently portrayed (see ch. 5), but other important authors of English texts were also depicted. This created something of a challenge in the case of the unknown identity of

the author of *Piers Plowman*. His description of himself as "Longe Wille" was taken to be "the historical entity called William Langland, but it could also be a pseudonym, a reference to an errant will"[145] or some similar abstraction. The two *Piers* manuscripts discussed here are the only ones that have a figure of the dreamer-narrator who appears to perform an authorial and authorizing function, somewhat similar in effect to that of the dreamer illustrated in the *Pearl* manuscript. The portrayal of a dreamer at the beginning of a work is suitable for signaling an interior journey to spiritual enlightenment.[146]

The only extant instance of the B-text with a historiated initial, CCCO MS 201 (fig. 29 a), begins not with the usual *I* or *Y* but an *A* for "Al in . . ." The portrait within the historiated initial makes it clear that the portrait itself is to be identified as the dreamer, who says, like John in the Apocalypse, " I beheld . . ." and "I seyȝ . . ." (F1.12 and 13).[147] Within this eleven-line-high letter the figure of the narrator (F1.9–10) inclines his head in the Endymion pose, although here he is seated, if not on a broad bank (F1.7), at least on a dark-green mound, perhaps suggestive of the wilderness of his dream (F1.11). The closed eyes of this bearded figure imply that the text that follows is the record of a sleeping dream (F1.9–10). He wears large "three-fingered laborer's gloves, indicating that the illustrator has conflated the dreamer and plowman."[148] In MS Douce 104, Piers Plowman is actually depicted with similar gloves (see fig. 32). Interestingly, the text of CCCO MS 201 omits the line "In habite as an heremite vnholy of werkes."[149] Indeed, this figure is not poorly clothed in a hermit's russet, perhaps to convey a higher worldly station, one worthy of a different kind of respect. He is, like the MS Douce 104 illustration of Piers, "a strikingly authoritative peasant."[150] The cowl and leggings of the CCCO MS 201 figure are color coordinated with the gloves. His buttoned coat and his rounded hat with a wide brim are of the same reddish pink as the surround of the initial and the border rather than simply "russet."[151] He appears on a gold background, suggestive of another dimension that fits in with the world of his dream. The initial itself is enhanced with gold decorative elements, including gold balls with squiggles and gold leaves at the top left.

His boots, which seem to have longish pointed toes, dangle above what at first appears to be a footstool (fig.

140. Wormald 1937, 31.

141. As pointed out by Kerby-Fulton in Kerby-Fulton and Despres 1999, 30.

142. See the discussions by Kerby-Fulton and Despres 1999, 20–25, and 120–21.

143. Kendrick 1999, throughout and especially 177.

144. Hilmo 2004, 102–12, fig. 30.

145. Bale 2008, 923; see also Benson 2001, 83–99. See Schmidt's B-text (1978) 1987, 15.152, and Adams et al. 1999 for F11.166.

146. Despres in Kerby-Fulton and Despres 1999, 122–25.

147. All line references from CCCO MS 201 are from the *Piers Plowman Electronic Archive*, vol. 1: Adams et al. 1999.

148. Ibid., note 2 for F1.1.

149. Ibid., note 4 for F1.2.

150. Kerby-Fulton and Despres 1999, 44.

151. Adams et al. 1999. Note 487 regarding "**&** y Rob*er*t in russet / g*an* rome a-bowhte" (F6.3) states that "The reading 'y Robert' is unique to F. **Bx** reads *yrobed*."

29. (a) The dreamer/narrator (detail), *Piers Plowman*. Oxford, Corpus Christi College, MS 201, fol. 1r, first quarter of the fifteenth century (b) Itinerary from London to Chambéry, Matthew Paris's *Book of Additions*. London, British Library, MS Cotton Nero D I, fol. 183v, 1250 (c) "A tour on a tuft / tryally y-tymbryd" (detail), *Piers Plowman*. Oxford, Corpus Christi College, MS 201, fol. 1r, first quarter of the fifteenth century (d) Little Malvern Priory Church in Worcestershire, England, from the twelfth century, with later restorations.

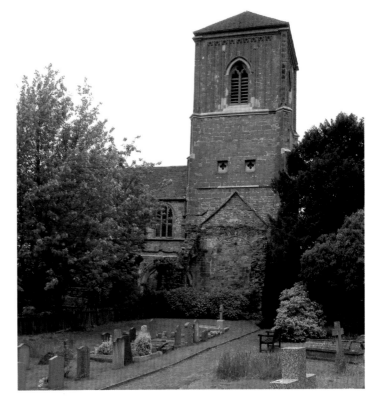

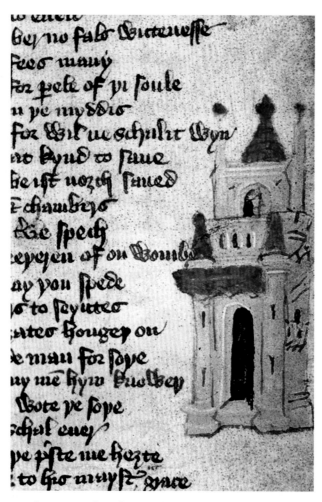

30. The Manor of Truth, *Piers Plowman*. Oxford, Bodleian Library, MS Douce 104, fol. 34r, 1427.

29c) but is rather more like a castle (with an arcaded gate at the far end) or a four square Norman tower, perhaps one like that of Little Malvern Priory (fig. 29d, before restoration and a new roof) if seen from the surrounding Malvern Hills. It appears to indicate the tower or "tour' on a tuft / tryally ytymbryd" he sees in his dream (F1.13), mentioned two lines below the historiated initial. The image is reminiscent of some of the abbreviated drawings of towers, castles, and cities in the maps of Matthew Paris that are signifiers of meaning more than realistic architectural features. See, for example, those in Matthew's map from London to Chambéry (fig. 29b).[152] Michael Gaudio refers to Hugh of St. Victor's directions for interpreting *mappae-mundi* that progress "from geographical description to his-

tory and ultimately to the contemplation of spiritual unity beyond history."[153] With respect to Matthew Paris, he observes that the itineraries should be understood "as two aspects of a single historical project uniting a spatial world of places and a temporal world of events, both oriented toward an earthly, and ultimately heavenly, Jerusalem."[154]

In CCCO MS 201, this feature has been described as "an image of a walled city beneath his feet.[155] Its meaning is made more explicit in the C-text by the description that it is the Tower of Truth (Pro 15).[156] In the MS Douce 104 version of the C-text, the Manor of Truth is pictured in the margin of Passus 7.232ff. (fig. 30). All of these variant architectural images are fairly standardized depictions of both earthly[157] and celestial structures. Just as the abbreviated images in Matthew Paris are not exact replicas of actual buildings and cities, so in CCCO MS 201 and MS Douce 104 they are not literal renderings of specific structures. In his discussion of representations of medieval cities, Robert D. Russell observes that their purpose was "more symbolic than topographical" and that the "standard image settled on was compact and self-contained but still possessed all the necessary parts of a city, most particularly the walls with their towers and gates."[158] By the Carolingian period, he continues, the conventions were extended to include the heavenly Jerusalem, with artists picking and choosing the most important visual elements from the basic "urban ideogram."[159] He astutely suggests that the heavenly Jerusalem of *Apocalypse* 21 was often interpreted according to "the fourfold medieval hermeneutic of a literal, an allegorical, an anagogical, and a tropological meaning." Accordingly Jerusalem could be 1) the Jewish capital; 2) the Church or Ecclesia; 3) the heavenly Jerusalem; or 4) the human soul.[160]

As part of the opening visual statement in CCCO MS 201, this compact image is the only main attribute, excluding his clothing, that helps to distinguish the figure who has been constructed to serve an authorizing function. It is evocative of the tower above the deep dale and the field of folk described in the following lines, allowing it to be seen as either the earthly and/or heavenly "tour" of his dream. The medieval tower visually encapsulated in the historiated initial and described in the text as situated in the east high against the sun at the beginning of the poem (F1.12) takes on a fuller spiritual signification in Passus 5, where it is described as a court clear as the sun (F5.596). Both in the poem and in the illustration it is a polyvalent image. It can function loosely as an earthly tower or as one also

152. See also the abbreviated signs for places in the early fifteenth-century map of England and Ireland in BL MS Harley 1808, fol. 9v. This is online at http://www.bl.uk/catalogues/illuminatedmanuscripts/ILLUMIN.ASP?Size=mid&IllID=19679

153. Gaudio 2000, 50.

154. Ibid., 53.

155. Adams et al 1999 n2.

156. Pearsall (1978) 1982, 28nn14–18. All line numbers from the C-text, unless otherwise noted, are from this edition.

157. Kerby-Fulton and Despres 1999, 55–56.

158. Russell 1994, 146.

159. Ibid., 147–48.

160. Ibid., 149.

indicating the Lord's footstool (cf. Isaiah 66.1; see also my discussion, below, of the Ushaw historiated initial); an inner spiritual "castle of the soul"[161] or the heavenly court. Allowing for maximum interpretive play, Langland did not tie his tower or manor or castle or court to any one specific meaning nor, perhaps, should the viewer for this richly invested "ideogram" in both CCCO MS 201 and MS Douce 104.

While the CCCO MS 201 historiated initial democratically formulates the dreamer as a laborer who is favored with visionary experiences, the MS Douce 104 version is rather more complex in its presentation (fig. 31). Since this image on the first folio is now dark due to wear (lightened in this reproduction for greater clarity), it is even more difficult to recover the concept that informs the portrait. He is tightly enclosed within the initial *Y* at the beginning of the poem. He appears to have a gray beard and, possibly, light brown hair. His open eyes look toward the text. He wears a beige cowl and what appears to be a long gray gown not incompatible with the rough garments a hermit might be presumed to wear (2–3).

It is what he is holding that is open to conjecture. It has been suggested that it might be an agricultural implement,[162] possibly connecting him with similar laborers illustrated in this manuscript, including the digger with a shovel (fol. 39r) or Piers Plowman or Activa Vita with a plow stick (figs. 32 and 33), both the shovel and plow having penitential associations in medieval symbolism.[163] The iconography of his pose, with his left arm raised toward his head, associates him with still other characters, including Sloth (fol. 31r), Elde (fol. 55r), and Imaginatif (fol. 63r).[164] Certainly there is considerable ambivalence in the stance and presentation of the figure within the historiated initial. His position as a dreamer whose visionary experiences are recorded in the following text also associates him with characters like the scribe (11.161, fig. 34), who is positioned, as Kerby-Fulton has argued, beside a passage signaling "the beginning anew of Will's vision."[165] This multireferential figure could be intended as a visual pun on "scriptura," which means "writing" in Latin, or it could refer to a scribe ("scriptor" in Latin), or more particularly to Will himself writing.[166] Is it a writing implement that the figure on the first folio of MS Douce 104 holds?

The object the figure holds in the historiated *Y* on the first folio does not, however, conform exactly either to

31. The dreamer/narrator (Will?), *Piers Plowman*. Oxford, Bodleian Library, MS Douce 104, fol. 1r, 1427.

161. See Pearsall (1978) 1982, 141n232.

162. Scott 1992, xxxviii.

163. Kerby-Fulton and Despres 1999, 131–33.

164. Ibid. See also 154–63. Dare one add the Sleeping Bishop on fol. 44r?

165. Kerby-Fulton and Despres 1999, 53–54. That the scribe is Will, see 160–61.

166. Ibid., 223n58. I am grateful to Kathryn Kerby-Fulton for these observations.

32. Piers Plowman, *Piers Plowman*. Oxford, Bodleian Library, MS Douce 104, fol. 35r, 1427.

33. Activa Vita, *Piers Plowman*. Oxford, Bodleian Library, MS Douce 104, fol. 69r, 1427.

34. Scribe (Will?) Writing, *Piers Plowman*. Oxford, Bodleian Library, MS Douce 104, fol. 52v, 1427.

a plow stick or a writing implement. It extends from his knee or at least as far as his hip, continues past his waist where he reaches to hold part of it with his right hand, up past his shoulders (his left arm seems to reach across it at that point) and then it also extends farther over across the text on the right. Significantly, it is a gold instrument of some kind, according it a very special kind of importance since the use of gold is rare in this manuscript. Could it be that there is some suggestion here of the dreamer in the guise of a minstrel (1.35)? Along with other such characters as hermits, whose moral status is blurred, as Pearsall notes, they represent one of "Langland's persistent preoccupations" in that he saw his own life as a mirror of such roles.[167] Activa Vita identifies himself as a minstrel in the passage adjacent to the illustration in MS Douce 104 (15.190–202; fig. 33), while 9.126–40 associates minstrels with poor beggars and hermits. It may be that there is an attempt in the historiated initial to emphasize the positive aspect by presenting the dreamer as one of God's minstrels, analogous also to David pictured harping, whether at the beginning of the Psalms as in Notre Dame, MS 65, fol. 7r, (fig. 35a) or in other contexts such as in the *bas-de-page* of the Taymouth Hours, London, British Library, MS

167. Pearsall (1978) 1982, 29n35.

Yates Thompson 13, fol. 30r, (second quarter of the four-teenth century; fig. 35b). In the former, David's harp is gold (though now much flaked off), while in the latter, the harpist has his left arm and hand up above the harp, which is what the Douce figure could also conceivably be doing. The condition of the Douce historiated initial does not make it clear what medieval instrument he might be playing, if indeed that is what it is meant to suggest. The harp-like shape of the *Y* itself might well have brought to mind a harp. Despite the ambivalence Langland might have had to singers and musicians (in the B-text he is more positive about minstrels), as a poet he was not totally di-vorced from his fellow artisans, nor was the (Anglo-Irish) scribe-illustrator of the MS Douce 104 manuscript.

Other possibilities include a scrip (a bag) or a pilgrim's staff like Patience on folio 70r. What is clear is that consid-erable thought was given to the composite characteristics that shape this authorizing figure in the historiated initial. Manifesting the elusive fourteenth-century poet in one or more of his narratorial guises certainly presented an artis-tic challenge. Perhaps the elusivenes of the object held by the Douce dreamer on this worn folio is an inducement for scholars to explore further the chameleon-like charac-ters who voice the text and may or may not be Langland.

The MS Douce 104 illustrations show the remarkably close engagement with the text that only a scribe-illus-trator, who in this case is also at least one of the rubrica-tors[168] (but not the annotator), would likely make. The ink of the underlined Latin quotation is the same as that used to outline the main features of the portraits of Will Writing and of Piers Plowman (figs. 34 and 32). In the case of Activa Vita, the red that highlights his lips is the same as the red underlining his name, which overlaps his neck, drawing the connection even closer, as if he is indeed say-ing: "my name is actiua vita" (fig. 32), an appellation that could well apply to the busy scribe-illlustrator-rubricator of this manuscript.

2. The Roles of the Scribe in the Decorative Scheme of the CCCO MS 201 *Piers Plowman* and the Ushaw *Prick of Conscience*

The scribe of the idiosyncratic CCCO MS 201 manu-script of *Piers Plowman* exhibits a similar intimate involve-ment in its entire presentation, including dramatically alternate versions of the text.[169] It is instructive to com-pare the illustrations and decorative scheme in this manu-script to a fragment of *The Prick of Conscience* in Durham, Ushaw College, MS 50, copied by the same scribe, as iden-tified by A. I. Doyle[170] He noticed that there are similari-ties between the two manuscripts in the cadels (the large

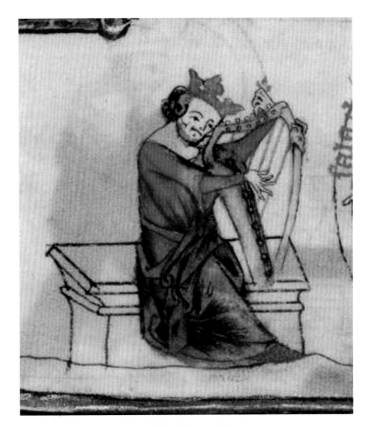

35. David playing the harp. (a) Psalm 1. Psalter. Notre Dame, IN, University of Notre Dame, Hesburgh Library, MS 65, fol. 7r, c. 1400 (b) Taymouth Hours. London, British Library, MS Yates Thompson 13, fol. 30r, second quarter of the fourteenth century.

168. For example, on fol. 23v, for the annotations in red for the "cronicil" (5.178) and "bibel" (5.169). I thank Kathryn Kerby-Fulton for this observation.

169. See Kerby-Fulton 2000, 103–129.

170. Doyle 2000, 46. See also Kerby-Fulton 2000, 109, who sees Chancery Clerk features in the hand of this scribe.

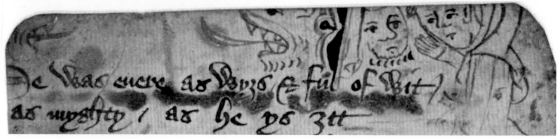

36. Heads extending from ascenders. (a–b) *The Prick of Conscience*. Durham, Ushaw College, MS 50, fols. 1r and 1v, first quarter of the fifteenth century (c–d) *Piers Plowman*. Oxford, Corpus Christi College, MS 201, fols. 11r and 76v, first quarter of the fifteenth century.

calligraphic ascenders with heads), both "clearly by the same talented hand," the ones in Ushaw likely made by the scribe.[171] An examination of these will tilt the likelihood toward greater certainty not only that the same scribe made these drawings but also that they are meaningful in relation to issues of conscience. Secondly, the framing elements in both will be examined with a view to determining if these are also by the scribe. Thirdly, the stork, at the end of CCCO MS 201, identified by Doyle as by the same hand as the drawings above the ascenders, will be

seen as an expression of the scribe-illustrator's reaction at having completed the task. Finally, the historiated initials of both will be considered.

Even a cursory glance at the calligraphic drawings extending from the ascenders at the tops of a couple of folios in both manuscripts convincingly indicates that the drawings were made by the same hand and that this hand is the scribe's (figs. 36 a–d). On the first folio of Ushaw, for instance, the oblique angle of the *D* in the middle of the rubricated but oxidized "Incipit pr*o*logus De Stimul*o* Consciencie" becomes one side of a small, tilted three-quarter profile head. The thickness of the straight line of the ascender, correct for a quill held in position for such

171. Doyle 2000, 46.

an oblique line, and its extension into the portrait head, indicate that this confidently executed stroke was part of one continuous movement. Further, the serif of the *S* of "Stimulo" curves up to form the line of the cuff of the figure above. The color and width of stroke also form the outline of the rest of the head itself. The same principle applies to the ascenders and heads at the top of the verso page, except that in this instance they are in the same ink as the main text. In CCCO MS 201, to take but one example, the ascenders of "cacchepol" (officer) on fol. 76v (fig. 36d) extend to become part of the decorative structure that separates the profile heads. In both manuscripts the characteristic solid infilling of most of the ascenders reveals the same cavalier level of execution.

In both manuscripts there is also a sense of opposition between the heads that appear on either side of these thickened ascenders, some of which have plant-like patterns between them in CCCO MS 201. Sometimes the heads confront each other. Are these mere doodles or does an overall motif inform them? There are basically two types of heads: a normal human head on the one hand and either a head with a deformed nose or a leonine head on the other. Once this Janus-like antithesis has been identified, it is easy to see how they can relate to the topic, especially, of *The Prick of Conscience*.

In the Ushaw prologue the narrator says he will explain what conscience is—a theme that the drawings emerging from the ascenders amplify. The figure on the top right of folio 1r (fig. 36a) has his hands raised, possibly to explain something to the talking head facing him or to the innocent-looking face attached to the *D*. On folio 1v, a figure wearing a cowl also raises his hand and appears to be speaking into the ear of the figure, possibly a woman[172] wearing a pleated wimple, who is seriously considering his good advice. Guidance is often portrayed in art by such a configuration, whether it is one of the evangelist symbols transmitting what to write,[173] or a dove inspiring David.[174] On the other side of this figure is a leonine head with sharp teeth and a flaming tongue facing away toward a similar head on the left (now partly cropped).[175]

This scenario suggests that the figure in the middle is listening to the advice, or prick, of conscience, the de-monic force of evil turning away in defeat in the other direction to face its mate in evil. The leonine heads in both manuscripts refer to the mouth of hell and the devil, an iconography that derives from Anglo-Saxon art and became popularized throughout medieval Christendom (see figs. 25 a–c). What these images in Ushaw and CCCO MS 201 visualize in an abbreviated form is a psychomachia (conflict between the virtues and vices) in which the role of Conscience is seen as a key player.

Similar configurations showing a figure in the middle flanked by good and evil forces have a long iconographic tradition, stretching from Anglo-Saxon times, as indicated in the middle register of a Last Judgment scene in the New Minster Liber Vitae, London, British Library, MS Stowe 944, fol. 7r to the later fifteenth century, as depicted in the Seven Ages of Man scenes in the London, British Library, MS Add. 37049, fols. 28v–29r. In the former, St. Peter with his key reaches over a small figure in the middle to strike the head of a devil on the other side, both vying for possession of the contested soul.[176] In the latter, and even more like the heads in Ushaw and CCCO MS 201, are the heads in BL MS Add. 37049 (fig. 37). Whether portrayed as heads or full-length figures and whether at the tops of sections of text or in the margins, each set of figures shows "man" from infancy to old age flanked by an angel or a devil, usually both, as they try to influence his moral choices.[177] In the end, as demonstrated in the last scene, the good angel draws out and receives the soul of the dying man, while the devil, all his labor having been in vain, turns to the audience as if "to confirm the 'ugly chere' of the inhabitants of hell."[178]

In CCCO MS 201, at the top of folio 11r (fig. 36c), Conscience is accused by Lady Mede (opposed to Conscience in much of the drama)[179] of giving bad counsel to the king. The heads of the ascenders show the forces of good, represented by the figure with the curly hair, back-ended against those of evil, represented by the savage demonic head with downturned eyes (as in Ushaw 1v; fig. 36b). At the top of folio 76r (fig. 36d) in CCCO MS 201, the scribe-illustrator has used to good effect the opportunity to cover an erasure[180] by showing a similar curly-haired figure surrounded and opposed by evil forces above the line beginning with the rubricated "Crucifige" (Crucify him!) in a

172. Ibid.

173. See, for example, the angel facing Matthew in the Hours of Catherine of Valois (Henry V's wife), London, British Library, MS Add. 65100, fol. 21v, c. 1420–22; in Scott 1996, illus. 287 in vol. 1.

174. See the Beatus page of the St. Albans Psalter, second quarter of the twelfth century, at http://www.abdn.ac.uk/stalban spsalter/english/commentary/page072.shtml.

175. See the demon encouraging Herod and one of the swordsman in a scene of Massacre of the Innocents in the Queen Mary Psalter in BL MS Royal 2 B. VII, fol. 132r at http://www.bl.uk/catalogues/illuminatedmanuscripts/results.asp.

176. London, British Library, MS Stowe 944, fol. 7r at http://www.bl.uk/catalogues/illuminatedmanuscripts/ILLUMIN .ASP?Size=mid&IllID=5353.

177. On fol. 47v, Pride is flanked by two bestial-headed devils trying to gain his attention; see http://en.wikipedia.org/wiki/File:British_Library_Additional_37049_47v_Pride.png.

178. Brantley 2007, 280; also 278–80.

179. See Kerby-Fulton 2000, 111, who observes that this scribe embroidered the role of the civil servants who surround Mede.

180. Adams et al 1999, n1549.

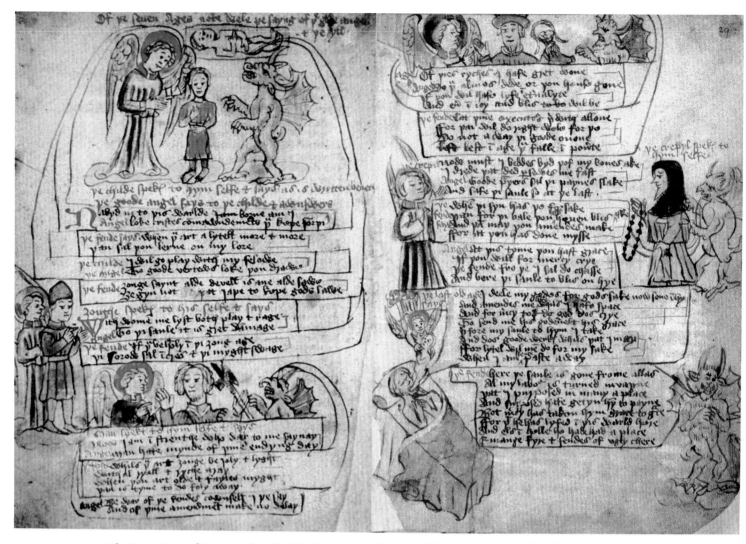

37. The Seven Ages of Man. London, British Library, MS Add. 37049, fols. 28v–29r, mid- to late fifteenth century.

visionary passage dealing with the events leading to the crucifixion and the battle between life and death.

That the fine distinctions concerning the topic of Conscience versus Mede had a particular interest for the scribe-illustrator is apparent also in the addition of a Lombard capital *T* in red with green semiabstract vegetal ornament and green flourishings extending outside along the margin of 11r at F4.216 (fig. 38). It does not occur at a Passus division.

In this passage Conscience explains that there are two different kinds of meed or payment; only the one that is payment for workers is legitimate, as opposed to that gained by usurers. The red ink of the initial is the same as that used for the highlighting at the bottom of the ascenders at the top of the page, the underlining and infilling of special letters and words in the text, the paraph signs along the margin (where green is used for alternate ones), and the rubricated Latin passages throughout the manuscript (identified by Doyle as by the scribe of the text).[181] Given the intimate connection and coordination of all these, there is no reason to suppose that, along with

the red outlining of the calligraphic drawings at the tops of the pages, they are not by the same person.

Other Lombard capitals, apart from those at the beginning of each Passus, occur only at passages relating to Conscience and the deadly sins. Specifically, these are at F4.158 where Mede mourns and complains to the king about Conscience (in the passage just preceding the one mentioned above); at F4.345 where the king orders Mede and Conscience to be reconciled, although Conscience will have none of it; at F5.62, where Repentance makes Will weep; at F5.135 where Wrath begins to awake and there is a blank space for a three-line letter *T*[182]; at F5.188 where Covetousness speaks; at F5.308 where Gluttony begins to speak; at F5.394 where Sloth arrives all slimy-eyed and beslobbered and there is a space for such a letter; while at F7.146 Wit, not surprisingly, becomes confused

181. Doyle 2000, 46, and Kerby-Fulton 2000, 110.

182. Adams et al 1999, n260 indicates that a guide letter *T* appears.

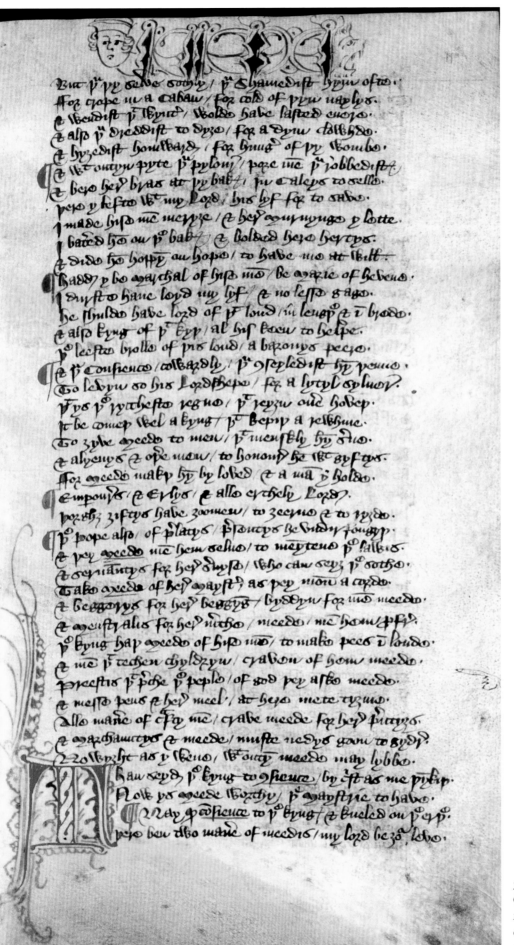

38. *Piers Plowman*. Oxford,
Corpus Christi College,
MS 201, fol. 11r, first
quarter of the fifteenth
century.

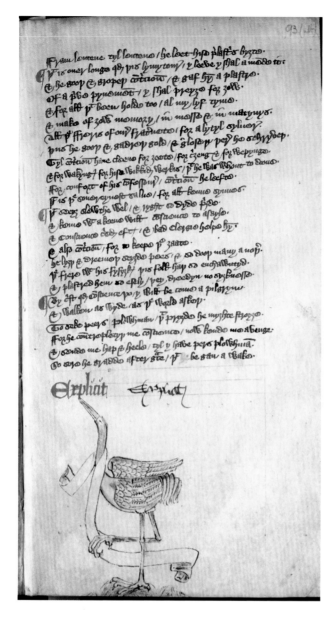

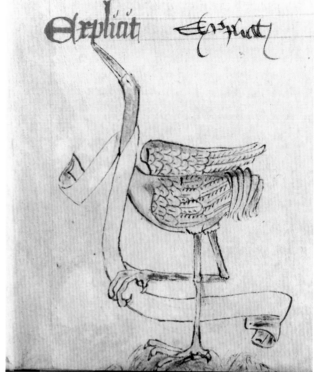

39a and b. Visual colophon of stork (with detail), *Piers Plowman*. Oxford, Corpus Christi College, MS 201, fol. 93r, first quarter of the fifteenth century.

concerning the distinctions between Dowel and Dobet. What all these extra Lombard capitals, some with flourishings and some not, show is that the scribe-illustrator called special attention to Conscience and those sins that were probably troublesome to him personally. Of course the Seven Deadly Sins are the most universally noted parts of *Piers* manuscripts. Given also the similarity of the cadels in both this manuscript and the Ushaw *Prick of Conscience*, it seems likely that the scribe made CCCO MS 201 after the latter, which deals specifically with such issues.

The emotional connection of this scribe-illustrator-rubricator with his work is delightfully evident in the visual colophon at the end, expressing triumphant enthusi-

asm at having "delivered" the poem (figs. 39 a–b). A stork, correctly identified by Doyle,[183] looks at and nips the descender of the *p* of the rubricated "Explicit." In his joy, as if shouting, "I'm finished! I'm finished!" he evidently felt compelled to repeat this word, first written in the main ink and then again when he went back to add the red highlighting to the letters and paraph markers on this page. The stork has a long unfurled scroll, likely symbolic of the long poem just completed ("explicit" literally means "unfolded"),[184] wrapped around its neck and grasped by the well-articulated talons on its right foot. The scroll might have been intended to have a message, especially if it was meant for a patron who, for some reason, did not materialize. The tinted washes on its body are mixes of the rubricating red and the brown (here in two shades) of the ink of the text. It will be remembered that the rubricating red and the dark brown ink are also the colors used for the drawn heads of the ascenders at the beginning of the manuscript.

There remains but to consider the borders and historiated initials at the beginnings of the Ushaw and CCCO MS 201 manuscripts (figs. 40 and 41a and b). Was the scribe-

183. Doyle 2000, 46, and Scott 1992, xxvi n 1. But see Adams et al. 1999, n1788 regarding suggestions that it was made later and is a pelican, emblem of Corpus Christi College. A pelican, how-

ever, has a pouch attached to its lower beak and has short legs and webbed feet.

184. See Brown 1994, III.1, at http://web.ceu.hu/medstud/manual/MMM/frame12.html.

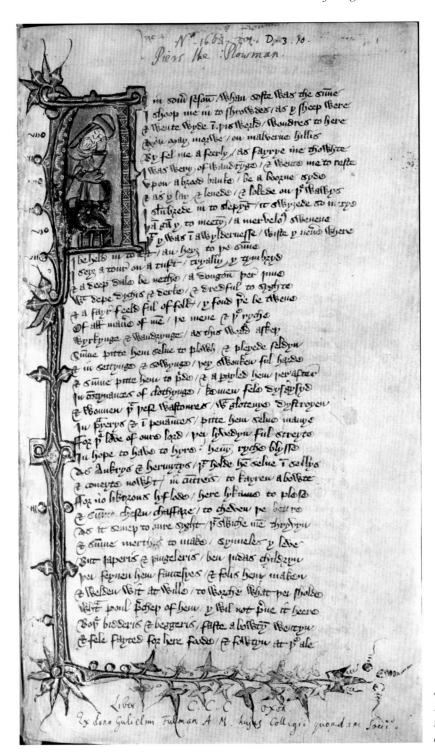

40. The dreamer/narrator (Will?), *Piers Plowman*. Oxford, Corpus Christi College, MS 201, fol. 1r, first quarter of the fifteenth century.

illustrator-rubricator of CCCO MS 201 also the illustrator of the historiated initials and the borders of both manuscripts? Care was taken to enhance the decorative elements of the first folio of the Ushaw fragment. But is this difference between the two historiated initials due to a different purpose, the Ushaw one upgraded to accord with its subject and audience, rather than because Ushaw employed a different artist for the historiated initial and border? Doyle noted the similarities between the trefoils along the bottom bar of the L-shaped border in both manuscripts.[185] While it is difficult to tell, due to its frag-

mentary condition, what is depicted at the top left corner and the bottom junction of the L-shaped border that descends from the historiated initial in the Ushaw scheme, it would appear that there are vegetal medallions with long, pointed leaves or petals similar to those in CCCO MS 201. Within the historiated initial of the deity in Ushaw, the red pigment of the bleeding wounds of the risen Christ is the same as the red of the "Incipit" and of the more in-

185. Doyle 2000, 46.

formally drawn faces and ascenders at the top of the folio. Did the scribe-illustrator just add the wounds to the image of Christ made by another artist? Or is the difference due to the historiated initial and the border being made with more care and diligence as a separate exercise?

Consider the decorative vocabulary of the main elements. The overall shape and architecture of the *A* of the historiated initial in Ushaw is similar to that in CCCO MS 201. It has a bar across the top, the left side is curved and has a decorative descender, and the bar across the letter forms a floor at the bottom. All of the Lombard *A* forms in this manuscript (and there are some twelve of them) are similar in structure, such as the *A* at the beginning of Passus 12, fol. 68r (fig. 42). There the letter, now infilled with a freestyle egg-and-dart motif of alternating round and pointed shapes in blue, an additional color acquired further on in the execution of this manuscript, has a blue descender surrounded by red flourishings that, in this case as in some others, descends to form a border along the left margin. The red is the same as that of the rubrication, paraph markers, and picked-out letters along the left margin of the text. Near the bottom of the red flourishing are two cross-hatched *X* shapes with a parallel horizontal bar between them. This is essentially the main decorative infill repeated along the right side of the historiated initial at the beginning of the *Piers* manuscript, suggesting that such elements, along with irregular wiggly lines, scallops, and dots, were part of the decorative vocabulary of this *Piers* scribe-illustrator-rubricator.

As for content of the historiated initials at the beginning of both manuscripts, there are also similarities. Both figures are displayed against a gold background and have gold ornamentation in the borders. Both the figures within are seated and have an object at their feet. In the case of Ushaw, this appears to be a tripartite globe, which not only represents the earth that is the Lord's footstool (Isaiah 66.1) but is also associated with the Trinity, the subject of the beginning of *The Prick of Conscience*, and illustrated in the MS Douce 104 *Piers* (Passus 19.112) as a globe held by a hand at the start of a passage explaining the Trinity. The hands of the figures in both CCCO MS 201 and Ushaw are emphasized and there is heavy outlining of much of the rest of the figure in each. It is true that the execution of the face in Ushaw is of a finer order and made with additional tools, but that could be explained by this artist using a model of the deity from another manuscript rather than simply drawing him freely in an informal manner similar to the *Piers* head or the faces at the ascenders of both manuscripts. This is, after all, an image of

41a and b. *The Prick of Conscience*. Durham, Ushaw College, MS 50, top and bottom fragments of fol. 1r, first quarter of the fifteenth century.

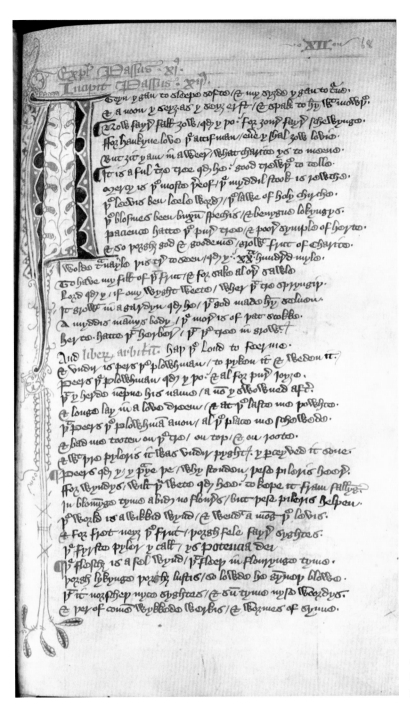

42. Lombard capital, *Piers Plowman*. Oxford,
Corpus Christi College, MS 201, fol. 68r, first
quarter of the fifteenth century.

the supreme Author and the subject of the first part of the
poem, so additional care would naturally be given to it.
There is nothing particularly difficult in the execution of
the deity's face. While it is not possible to maintain with
absolute certainty that the historiated initial on the first
folio of Ushaw was made by the same scribe-illustrator-
rubricator who likely executed all of CCCO MS 201, it
seems reasonable to suppose that this is the case.

Many of the issues considered here in relation to the
execution of these manuscripts might well be further re-
solved by the application of advanced technology to clar-
ify further what is now obscured by damage and wear
and to determine whether or not the same pigments were
used in some of the elements under consideration. This

preliminary examination demonstrates how a close and
serious study of decorative details can lead to a greater
understanding of how each manuscript was read and un-
derstood by the scribes, especially, as in this case, those
who likely had exchequer or chancery training in which
marginal illustrations were used.[186] In such informal
rather than deluxe manuscripts it is not surprising that the
scribes personalized their work and played multiple roles
as rubricators and illustrators. After all, the art of calligra-
phy was not as distant from that of illustrators in medieval
times as was the case in later periods when texts were me-

186. Kerby-Fulton 2000, 108 and 118.

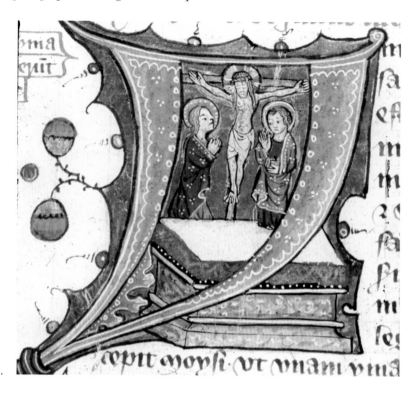

43. "Ymagines," James le Palmer's encyclopedia, the *Omne Bonum*. London, British Library, MS Royal 6 E VII, Part 2, vol. 2, fol. 531r, c. 1360–75.

chanically printed while paintings, especially in oil, were completely separate entities requiring different media, materials, skills, and personnel. In these *Piers* manuscripts the roles of reader, editor, rubricator, artist of Lombard capitals, decorative borders, and calligraphic illustrations could still be undertaken by a scribe, not only literate in Latin and English, but also competent in preparing the pigments for all these.

VI. Conclusion

Today's reader is not completely at a loss when trying to regain a sense of how medieval images functioned. The visual lesson set forth in BL MS Yates Thompson 11 (fig. 1) demonstrates the use of images for contemplative purposes, starting with mental and spiritual preparation, emotional engagement, and finally spiritual vision, in which what is seen is manifested in the relevant visual image; each, in effect, proving the truth of the other.

In England the issue of images was also undertaken at the end of the encyclopedic *Omne Bonum* (fig. 43). It was an experienced and very Latin-literate artist who made the historiated initial *Y* for "Ymagines," the word for "images." The brief instruction to the illustrator, on the left, reads: "'Fia*nt* ymagi*nes* sup*er* / altare"[187] (Make images above an altar). The main text gives a conventional medieval justification for holy images: "Ymaginum causa in ecclesia dei est perpetua ut in eis habeatur memoria dei & sanctorum, & ideo faciende & observande" (Images have an everlasting reason for being in the Church of God for in them we have the memorials [commemorations] of God and the saints, and so they are to be made and looked at). This artist has subtly extended the function of images beyond merely the commemorative.

Within or behind the *Y* initial, the image could be just that—a sculpted or painted *image* of the scene of the Crucifixion, or it could be the actual scene of the Crucifixion[188] to which the contemplative reader has been granted a mystical glimpse or, on multiple levels, both. The crucified Christ and the Virgin Mary are represented behind the altar while John stands on the altar, which itself spans both the sacred space within the initial and the viewer's reality outside it. This particular image seems to allude to the transitional function of religious images (and perhaps the "letter" of the text) as a conduit to the divine itself. Of course, the extension of the altar beyond the space of the initial was also a practical solution to filling the blank rectangular space left for the illustrator by the scribe. The former, nevertheless, utilized the space meaningfully.

Within this initial the cross (like the crown of thorns) is green, an allusion to the Tree of Life. The haloes of

187. Transcription at http://www.bl.uk/catalogues/illuminated manuscripts/ILLUMIN.ASP?Size=mid&IllID=32171. See also Sandler 1996, 245 for this and also for the Latin text and transla-tion beside the image. For a further discussion of *Omne* images see Sandler 1996, 76–107.

188. See Sandler 1996, 245.

the three blond figures suggest a hierarchy of holiness. Emotional involvement is solicited by the blood flowing freely from the crown of thorns, the nails, and the gash in Christ's side (below his breast).[189] A model of piety, the Virgin, with her hands clasped in prayer, looks directly at her son, whose head is turned in her direction. John, a witness to the Crucifixion to which he calls attention, represents the intellectual response, as indicated by the text he holds for readers of the future to whom his distant gaze appears to be directed.

What is exciting about the illustrated vernacular English manuscripts examined in this chapter is that the techniques for extended looking at religious images are also applicable, even if mystical knowledge is not always the aim. None of them have strayed far from some sort of spiritual application. The Auchinleck MS begins with an image dealing with an ineffective pagan idol in contrast to the efficacious crucifix representing the living God who can turn a lifeless lump of matter into a living child. It continues to include images of the heroes of a militant Christianity as models for a new generation of Christian knights. The Vernon MS deals directly with Incarnational issues and the power of images. It also contains an image of the Trinity for *The Prick of Conscience* and, in this case, a monk engaged in contemplation. With intervisual references to conventional religious iconographies, the plain miniatures of the *Pearl* MS can be seen to place the disparate poems into a larger spiritual framework that connects and transforms them into a meaningful whole. The scribes of the two *Piers Plowman* manuscripts and *The Prick of Conscience* fragment demonstrate how completely they became involved in their subject, to the extent that they expanded their role to visual commentary and interpretation. Although their illustrations were not always "peynted parentrelynarie" (painted between the lines; B 11.305; compare those inserted between items in the Auchinleck and Vernon MSS), they actually created the text anew for subsequent readers.

189. An allusion to the concept of Jesus himself as Mother? See Bynum (1982) 1984 and for quotations from Julian of Norwich on this, see http://www.gloriana.nu/mother.htm.

Professional Readers at Work

Annotators, Editors and Correctors in
Middle English Literary Texts

KATHRYN KERBY-FULTON

Sometimes the notes are ferocious,
Skirmishes against the author
Raging along the borders of every page
In tiny black script.
If I could just get my hands on you,
Kierkegaard, or Conor Cruise O'Brien,
They seem to say,
I would bolt the door and beat some logic into your head.
.

Students are more modest
Needing to leave only their splayed footprints
Along the shore of the page.
One scrawls "Metaphor" next to a stanza of Eliot's.
Another notes the presence of "Irony"
Fifty times outside the paragraphs of A Modest Proposal.

.
And if you have managed to graduate from college
Without ever having written "Man vs. Nature"
In a margin, perhaps now
Is the time to take a step forward.
.

Even Irish monks in their cold scriptoria
Jotted along the borders of the Gospels
Brief asides about the pains of copying,
A bird singing near their window,
Or the sunlight that illuminated the page—
Anonymous men catching a ride into the future
On a vessel more lasting than themselves.

Billy Collins, "Marginalia"[1]

WHEN WE THINK of reader annotation today, we, like American poet Billy Collins, are most likely to think of colorful comments scribbled in library books, or our own "finding notes" in modern reading editions. This kind of annotation occurs in Middle English texts, too, but much medieval notation also served the purpose of conferring authority on the text, citing sources (like the modern footnote) or guiding the reader through a maze of speakers—often a judgment call, since medieval manuscripts had no speaker quotation marks, at least in our sense.[2] Marginalia could also be used to guide the reader in memorization (mnemonic devices), to summarize narrative, or to enhance meditation and prayer. Even this does not exhaust the range of medieval marginalia,

1. Http://www.poemhunter.com/poem/marginalia/.

I would like to thank Derek Pearsall for his close and careful reading of this chapter; Stephen Partridge for his extensive advice on the Chaucer glosses, and for kindly sharing his edition; Alastair Minnis for advice on the Gower section; Nicole Eddy most heartily for her research assistance and careful proofreading for this chapter, and Sarach Baechle and Melinda Dille Nielsen for help with particular points.

2. See ch. 1, sec. IV; and fig. 1, below, on the use of rubrication and hierarchy of scripts as methods for distinguishing quotations from authoritative sources, such as the Bible; see ch. 1, sec. II, p. 54, for an attempt to mark speaker names marginally. On medieval punctuation systems, see Parkes 1978.

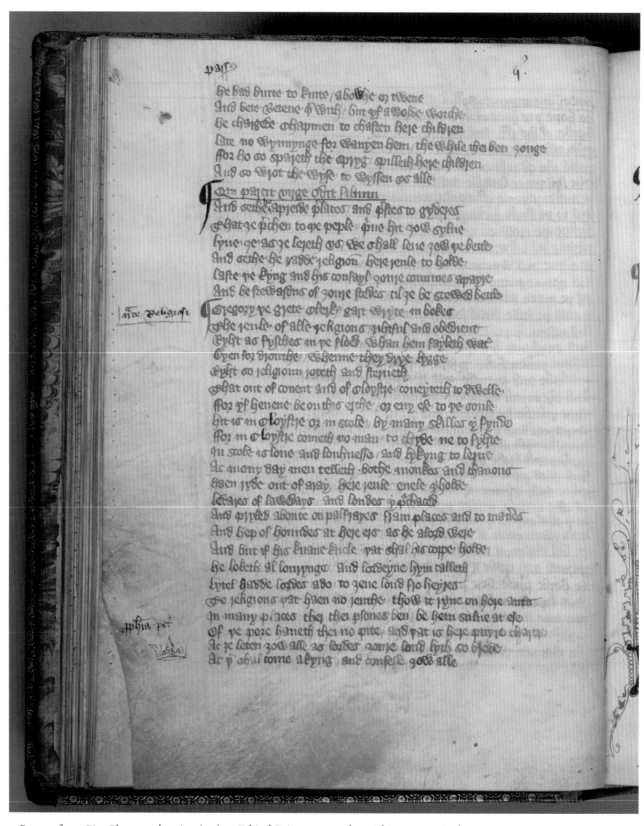

1. Passage from *Piers Plowman*, showing (top) an Ethical Pointer note, admonishing monastic clergy who leave the cloister, marked with L-shaped brackets: "⌐*notate* Religiosi" (C.V.146). Beneath, an annotation reads "*prophecia petri*" (C.V.165), wrongly attributing the prophecy that a future king will disendow the monasteries (C.V.168) to Piers, plus a pictograph drawing of a crown of the type used in filing Exchequer documents. Here it suggests ominously that the monasteries will soon be the king's property. The annotator writes in a documentary hand. San Marino, CA, Huntington Library, MS HM 143, fol. 22v.

which could register dissent (for instance, on issues of heresy or politics) or speak back to the text on gender issues or in debate on any subject.[3] The scribes or professional readers who created this kind of marginal notation could have been of sufficiently high stature in their day that they are not even Collins's "anonymous men" to us. Among scribe-annotators with recognizable names are John Shirley (who created a marginal persona to shout down to Lydgate's antifeminism) and John Cok (who marked moments of pathos and emotion in the texts he copied).[4] Some annotators had more famous names, like John Gower, Nicholas Love, John Capgrave, Thomas Hoccleve—and probably, as we'll see, Geoffrey Chaucer.[5] Annotators also created marginal pictorial or categorizing symbols learned in university and civil service training, "pictographs" that fall under the radar screen of art historians but which play a role alongside verbal annotations in showing us that medieval reading was far from linear (fig. 1).[6]

This wide range of marginalia can be found in Middle English literary manuscripts, and one of the most important things this chapter will do is restore a sense of the rich, multivalent reading experience in medieval books. None of our major writers likely expected his or her texts to be read on the naked page. Thus, the annotation of Chaucer's, Gower's, and Hoccleve's works all reveal an early pattern of manuscript apparatus created to provide a learned framework of source attributions and commentary for vernacular poetry—perhaps partly influenced by the emerging humanist fashions of Petrarch, Boccaccio, or Dante but also by learned tradition generally. We know that Gower created and supervised the production of a (deliberately?) difficult Latin apparatus and marginalia for the *Confessio Amantis*, perhaps to offset the vernacularity of his Middle English text, and that Hoccleve did the same for his *Regiment of Princes*.[7] Scholars have wondered if Chaucer did the same, because some sets of marginal glosses in the *Canterbury Tales* (for example, in several early copies of the "Marriage Group" tales) are so sophisticated as to be attributable to the master himself. The annotation of *Piers Plowman* presents a different set of problems: largely in Middle English and often aimed at distinguishing subgenres, themes, and characters, it more resembles notes in the less learned segments of the *Canterbury Tales*, and Chaucer's *Troilus* (a work found twice in company

with Langland's poem).[8] In both these major poets, patterns of annotation emphasize issues of authorship, narrative, genre, dream experience, or polemic. Marginalia in the manuscripts of Margery Kempe and Julian of Norwich show contemplative professional readers at work: in the sole surviving Kempe manuscript (London, British Library, MS Add. 61823), the largest supply of notes serves to detail a professional's opinion on the validity of Margery's visions, her knowledge of other visionary authorities, and the historicity of her account. They also supply mnemonic and meditative aids to the reader. In Julian's Short Text (London, British Library, MS Add. 37790), a much simpler set of markers (not all entered at once) succeeds in highlighting the crucial moments of Julian's thought and unique doctrine—they create, in effect, a tiny reader's digest of this first version of her *Revelations*. We have no way of knowing whether Julian herself could have contributed to this, but as Michael Sargent has shown of her contemporary and fellow religious writer, Nicholas Love, even *nota* marks can be authorial.[9]

This chapter will introduce the remarkable range of extant marginal supply across the manuscripts of these major writers and the views of modern scholars on the problems they pose, and it will also offer new approaches to each. It will look at other dimensions of manuscript preparation, especially correction (often the annotator's job) and editorial intervention in Kempe. As we saw in chapter 1, beginning especially in the thirteenth century and steadily evolving up to and throughout the early era of print, medieval manuscripts could be given ever more elaborate systems of *ordinatio*.[10] It appears that many of the professional readers who supervised book production often encountered Middle English exemplars they felt had an insufficient reading apparatus (a technical term preferred by some scholars to cover all aspects of *ordinatio*, including annotation).[11] Throughout the period, tables of contents, rubricated chapter descriptions, decorated or historiated initials, pictorial cycles, running heads, marginal notes, physical finding devices (like tabs), and indices could be added to elaborate the reading apparatus of a book.[12] The first part of this chapter will deal with the wide variety of marginal notation we find in Middle English manuscripts and its role in reader guidance.

3. See for instance Baswell 1992 and sec. I below.

4. For Shirley see ch. 6, sec. II, below, and Veeman 2010; for Cok, see Kerby-Fulton and Despres 1999, 70–75; and Eddy, forthcoming.

5. On glosses to Gower see section I below; for Love, see n9 below; for Capgrave, see Lucas 1969; and for Hoccleve, n7 below.

6. See Kerby-Fulton and Justice 1998.

7. See Pearsall 1989 and Blyth 1999. Blyth transcribes and translates all of Hoccleve's Latin marginalia.

8. In Huntington HM 143 and in Huntington HM 114. See ch. 1, sec. IV. See also Middleton 1982, and Benson and Windeatt 1990.

9. Sargent 2005, 50.

10. Parkes 1976.

11. See the discussion of this controversy in Partridge 1996, par. 17.

12. In addition to instances in the previous chapters, see Clemens and Graham 2007, chs. 2 and 3, for general introduction and helpful color plates.

I. Categories of Marginalia: The Annotating and Glossing of Chaucer

Though it is not always easy to match up medieval literary theory (usually based on Latin texts) with medieval marginal practice in vernacular writing,[13] four umbrella categories of marginalia can be discerned by the modern reader: Narrative Reading Aids, including grammatical, lexical, and source glossing, and notes marking topics, speakers, and narrative summaries; Ethical Pointers, including, exhortations, precepts, and prayers; Polemical Responses, including political, religious, or social comment; and Literary Responses, including genre-related markers, rhetorical labels, and comments on authorship.[14]

Some examples will help. We begin with Chaucer, and we will look at some annotations to three of the *Canterbury Tales*: the "Nun's Priest's Tale," for the wide variety of note types it attracted; the "Wife of Bath's Tale," for the stable cycle of sophisticated Latin glosses on women and marriage that appears in the most authoritative manuscripts, perhaps originating with Chaucer himself; and the "Prioress's Tale," for the light that the marginal notes can shed on the long-standing controversy over the story's sources and anti-Jewish sentiment. As we will see, the kinds of marginalia that travel with particular *Tales* are partially determined by the genre of the tale, and by the genetic or family groupings—as designated by modern editors—into which manuscripts fall in the Chaucerian textual tradition. In the case of manuscripts El, Hg, Ch, Dd, and Bo², the original annotator in question may sometimes even be Chaucer himself,[15] and this raises striking questions we will explore in more detail below, especially in relation to the source glosses of El in the "Wife of Bath's Tale."

1. An Overview of Annotation Types:
The Case of "The Nun's Priest's Tale"

For the purpose of illustrating types, however, it can be useful to take a single tale, and survey the supply across the entire genetic range of manuscripts. Here, selected from the superb complete transcription and collation made by Stephen Partridge, are examples demonstrating each of the main kinds of marginalia in "Nun's Priest's Tale" manuscripts.[16] The "Nun's Priest's Tale," often thought Chau-

cer's most accomplished, well-rounded tale, lives up to its reputation in the catholicity of its notes. They suggest to us, for instance, that early annotators were gripped by the same kinds of social, gender, and political issues as we are today. But the notes also give evidence of medieval reading practices. This, too, emerges in the notes, alongside literary concerns with voicing, satire, sourcing, and allusion.

We begin by looking at sample Narrative Reading Aids. Oddly, even this most common category of notes offers news about medieval reading practices. The Speaker Identification note at line 3445 (table 1) shows agreement in three authoritative manuscripts (Ch, El, Hg) in identifying the historical person referred to at the end of the poem as the Archbishop of Canterbury, who in Chaucer's time would have been William Courtney. New Criticism always poured scorn on such attempts at historicization in twentieth-century scholarship, but can such an identification just be dismissed in manuscripts of good textual authority? (Two of the three here, Hg and El, were likely written by Chaucer's own scribe.) The persistence of such identifications in, for instance, Chaucer's more personal lyric poetry,[17] tells us something about early reader expec-

A NOTE ON CITATION METHODOLOGY IN THIS CHAPTER

For those readers new to manuscript studies, normally, one would cite not only the note but the main text it accompanies directly from the manuscript. This is because the same passage may read differently in one manuscript than another. In this chapter, text and note segments from Langland, Kempe, and Julian are presented directly from the manuscripts in question. Chaucer manuscripts, however, present a different set of problems, since the same marginal note often appears in several manuscripts, as Stephen Partridge's complete critical edition of *Canterbury Tales* marginalia (1992) makes clear. In the charts below, therefore, multiple transcriptions are neither practical nor desirable, since the text accompanying these notes is quite stable. So here each reading for the main text has been checked against the complete list of variants for the tale in the variorum edition (Pearsall, 1984) and cited from the *Riverside Chaucer*. In the discussion of the "Wife of Bath's Prologue" and "Prioress's Tale" next, passages are cited from the manuscript indicated.

13. On the Latin tradition, see Copeland 1991, 82–90, especially on *enarratio* and the relation between marginal commentary and interlinear glossing in Latin exegesis (also discussed below).

14. For these categories, see Kerby-Fulton and Despres 1999, ch. 3, especially 76ff., with extensive examples from two manuscripts of *Piers Plowman*, Huntington HM 143 and Douce 104. Grindley developed a closely related schema. Different systems of classification and subclassification exist in modern scholarship largely because the study of marginalia is still in its infancy (2001).

15. See the textual arguments put forward for these manuscripts in Partridge 1993. The shelfmarks for the manuscript sigla used here and throughout this book are standard and can be found

in *Riverside Chaucer*, 1118–19, listed in alphabetical order and in the "Index of Manuscripts and Incunabula" below.

16. These annotations are cited from an updated version (kindly supplied to me by the author), Stephen Partridge, from his unpublished 1992 thesis, pp. VII-5 to VII-7, by line number, as are the identifications of sources, where applicable. I would like to express my gratitude to Stephen Partridge for sharing his critical edition of the glosses with me and his updates. As will appear in the notes below, I am indebted much to his work.

17. See the similar particularizing glosses to "Lenvoy de Chaucer a Scogan" cited in *Riverside Chaucer*, 1087, note to line 43.

TYPE OF NOTE: NARRATIVE READING AIDS	LOCATION OF ANNOTATED PASSAGE IN *RIVERSIDE CHAUCER*	TEXT OF NOTE, MANUSCRIPT SOURCE, AND EXPLANATION OF PLACEMENT	ANNOTATED PASSAGE FROM TEXT OF "NUN'S PRIEST'S TALE"
		TABLE 1	
TOPIC	VII.2898	"Dreem" (Dd), where Chauntecleer begins to narrate his dream of the fox	"Me mette how that I romed up and doun / Withinne our yeerd, wheer as I saugh a beest"
SOURCE GLOSS	VII.2940	"Caton Sompnia ne cures" (Se), from the *Dicta Catonis*, II.3, which reads "Somnia ne cures, nam fallunt plurima [Do not care for dreams, for dreams deceive many]"; beside Pertelote's advice on dreams[1]	"Lo Catoun, which that was so wys a man, / Seyde he nat thus, 'Ne do no fors of dremes'?"
GRAMMATICAL GLOSS	VII.2786	"id quod" (Dd), anticipating difficulty with Middle English syntax, here clarified by Latin translation	*Written above* "That þat," meaning "that which" in the line " . . . no remedie / It is for to biwaille ne compleyne / That that is doon"[2]
LEXICAL GLOSS	VII.3002	". *id est* . dremed"(El), a translation to a word more common in London dialect	*Written above* "mette"
SPEAKER IDENTIFICATION	VII.3445	"Dominus Archiepiscopus Cantuariensis" (Ch, El[3], Hg, Py), apparently identifying the reference to "my lord" as the Archbishop of Canterbury, mentioned in the Nun's Priest's final benediction (William Courtney at the time)	"As seith my lord, so make us alle goode men, / And brynge us to his heighe blisse! Amen."
NARRATIVE SUMMARY	VII.3378	"thaffray of the widowe *and* of hir doughtres after the Fox" (Se), beside the chase episode	"And syen the fox toward the grove gon . . ."

1. Pertelote quotes only the first half. As the *Riverside Chaucer* 1987, 937n2940 mentions, this gloss is not in El or Hg. Cato is also identified as the source in Ht and He.

2. This is the line as given in the *Riverside*, which has orthographical differences from Dd here.

3. El actually reads "*scilicet dominus* archie*piscopus* Cantuarien*sis*," "namely, the Lord Archbishop of Canterbury" (at the time, William Courtney). See the *Riverside Chaucer* 1987, 941n3445. Dd reads "Cantuariensis."

TYPE OF NOTE: LITERARY RESPONSES	LOCATION OF ANNOTATED PASSAGE IN *RIVERSIDE CHAUCER*	TEXT OF NOTE, MANUSCRIPT SOURCE, AND EXPLANATION OF PLACEMENT	ANNOTATED PASSAGE FROM TEXT OF "NUN'S PRIEST'S TALE"
		TABLE 2	
GENRE	VII.2984	"fabula" (Fi) "Naracio" (Gg),[1] at the beginning of the story of the two pilgrims; several MSS also here identify the source of the tale as "Tullius" (Ad[1], Cn, Dd, En[3], Ln, Ma)	"Oon of the gretteste auctour that men rede / Seith thus: that whilom two felawes wente / On pilgrimage . . ."
RHETORICAL DEVICES	VII.3215	"Reductio" (Ad[1], En[3]), beside the narrator's mock-epic comment that the fox's imminent attack has been foreseen by Providence	"A col-fox, ful of sly iniquitee, / That in the grove hadde woned yeres three, / By heigh ymaginacioun forncast . . ."
AUTHORIAL VOICE ATTRIBUTION	VII.3050	"Auctor" (El), identifying the narrator's interjection, here understood as the author's	"O blisful God, that art so just and trewe, / Lo, how that thou biwreyest mordre alway!"

1. Wheatley 1996, 121ff.

tations of realism and historicity (even where the identifications are wrong).

Just as striking is the implication of the note on the common grammatical problem in Middle English of interpreting a "that that" construction (in Dd's Latin gloss "id quod" is supplied at VII.2786 (table 1), written in the same hand as the main text).[18] This last is significant because it implies an audience more used to reading *Latin* than Middle English—which still had to make its way in Chaucer's lifetime. So much for the supposed comfort of the vernacular.

Equally revealing is the Literary Responses category (table 2). The Genre note above at VII.2984 jives well with (as Edward Wheatley has shown) learned traditions of reading fables as *narratio* and *enarratio*—that is, telling the story itself and then interpreting it, initially via paraphrase.[19] Stunning to the modern reader, however, is the Authorial Voice Attribution note at VII.3050 in El, identifying the voice of the supposed "Auctor."[20] Intriguingly in El—given all its clout with modern scholars—the *auctor* is often conflated with the narrator wherever a vocative (or an apostrophe, rhetorically speaking) appears, as here where the Nun's Priest launches into an apostrophe: "O blissful God." Another such "Auctor" designation in El appears, for instance, in the "Man of Law's Tale" beside a similar apostrophe, "O sodeyne wo," along with a Latin gloss from Innocent III's *De Miseria Condicionis Humane*, (one of many glosses from Innocent that led scholars back to the version Chaucer himself used).[21] There "Auctor" is invoked where the narrator reflects in *De Miseria*-style on how sorrow comes on the heels of worldly joy. Nothing here, or in the Nun's Priest's passage above, or in several such instances, would suggest the voice of the *auctor*

to us today. This in itself speaks volumes about medieval literary theory of narrative voicing, and asks us seriously to question whether the ideas on "persona" originating in New Criticism can be easily applied to medieval texts.

Polemical Responses in Chaucer's *Tales* can cover a range of social, religious, political, or gender controversies. Two instances of the latter can be seen in table 3.

Something these examples teach us is that the attitudes of annotators, even in polemical matters, can be enigmatic: does the Nl annotator at VII.3270 (table 3) really agree with Physiologus about female power or is he just having a good laugh? Are annotators even always male (a question that becomes more important in gender polemics)?[22] Most importantly, the bilingual nature of many note-text relations (especially in polemical comment) adds further complexity to the question of audience literacy and response, and it suggests not only multilayered reading but multitiered audiences. Only in conjunction with the text it highlights does the function of a note become clear—annotations were never meant to be read apart from their texts (a real temptation when using modern lists of them), nor, in the case of original annotation, vice versa.[23]

Although all four categories are derived from evidence both in medieval literary theory and rhetoric, and also from the kinds of rubricator markings to distinguish annotation types, the most well-researched of these areas relates to the final category of Ethical Pointers. These notes especially mirror aspects of exegetical and scholastic traditions, and, I would suggest, they go some way toward further illuminating what we today call medieval literary theory. The work of Alastair Minnis and others has es-

TABLE 3			
TYPE OF NOTE: POLEMICAL RESPONSES	LOCATION OF ANNOTATED PASSAGE IN *RIVERSIDE CHAUCER*	TEXT OF NOTE, MANUSCRIPT SOURCE, AND EXPLANATION OF PLACEMENT	ANNOTATED PASSAGE FROM TEXT OF "NUN'S PRIEST'S TALE"
GENDER	VII.3270	"Mulier h*abet* potestat[em] v[iri]" (Nl), fleshing out Chaucer's laconic reference to Physiologus's bestiary and the view that the sweet voice of mermaids leads sailors to destruction	"and Chauntecleer so free / Soong murier than the mermayde in the see / (For Phisiologus seith sikerly / How that they syngen wel and myrily)."
POLITICAL	VII.3326	"contra adulatores" (Ne), beside the narrator's comment on the fox's flattery of Chauntecleer	"Allas, ye lordes, many a fals flatour / Is in youre courtes, and many a losengeour . . ."

18. Partridge 1992, 3:5, notes that Dd's glosses often resemble Hg's.

19. Wheatley 1996, 121ff.

20. See Kerby-Fulton 1997, and for parallel instances in Chaucer, see Benson and Windeatt 1990 and Zieman, forthcoming; for instances in *Piers Plowman* marginalia, see below.

21. Fol. 60r; this page is visible online at the Huntington Li-

brary Manuscript Catalogue; see Partridge 1992 II-6 for the gloss and II-1 on Chaucer's manuscript of the *De Miseria*.

22. David Benson comments on the enigma of annotator attitudes (1997, 22–23). For a female annotator at work, see Kerby-Fulton 2003.

23. Even a simple nota can have a rich meaning in context; see the examples in Julian's Short Text below.

tablished that many medieval ideas of literary genre de-
rive from the study of the Bible, itself a wide collection of
genres. Medieval theologians had identified several bibli-
cal literary *modi*,[24] many of which we can see reflected in
the types of annotations found even in vernacular texts.[25]
The five below stem from Alexander of Hales:

1. preceptive mode (*modus praeceptivus*), a teaching
 or commanding style, found in the texts of the
 Pentateuch;
2. historical and exemplifying modes (*modus historicus* and
 exemplificativus), found in the historical books of the
 Old Testament;
3. exhorting mode (*modus exhortivus*), a preaching or
 urging style, found in the sapiential books of the Old
 Testament;
4. revelatory mode (*modus revelativus*), found in the
 prophetic books;
5. orative mode (*modus orativus*), a prayerful or
 beseeching style, found especially in the Psalter.

Compare these (e.g., 1, 3, and 5) with some typical Ethi-
cal Pointers in the "Nun's Priest's Tale" in table 4:

So also, the tale's famous *exempla* (which would count as
modus exemplificativus, 2) and the revelatory moment (*mo-
dus revelativus*, 4) are also much highlighted: for example,
"here may ye se that dremes ben to drede" (beside line
3063 in Se), and in other manuscripts explicitly using the
word *exemplum* ("Aliud exemplum de sompnijs" in Ad[1] and
En[3]). The Precept note in table 4, giving the Latin para-
phrase for Romans 15:4, highlights a passage also promi-
nently used in Chaucer's "Retraction" (X.1083). This we
might expect, but the orative mode highlighted here at
3342 (table 4) is a prayer to Venus—these categories were
versatile, even daring.[26]

The study of how such annotations relate to medieval
theories of reading is in its infancy.[27] Still less studied is
the contribution of marginal notation to our understand-
ing of how readers actually used the page. For instance,
in some manuscripts, differences in annotation types are
distinguished by physical markings, especially in certain
highly developed cycles of marginalia. So, for instance,
in a *Piers Plowman* C-text (Huntington HM 143), L-shaped
brackets designate Ethical Pointers (fig. 1, highlighting an
admonition to monks: "⌐n*ota*te Religiosi"), but where Po-

TABLE 4			
TYPE OF NOTE: ETHICAL POINTERS	LOCATION OF ANNOTATED PASSAGE IN *RIVERSIDE CHAUCER*	TEXT OF NOTE, MANUSCRIPT SOURCE, AND EXPLANATION OF PLACEMENT	ANNOTATED PASSAGE FROM TEXT OF "NUN'S PRIEST'S TALE"
EXHORTATION (*modus exhortivus*)	VII.3402	"nota" (Me), beside the Nun's Priest's exhortation to beware the instability of Fortune, at the denouement	"Now, goode men, I prey yow herkneth alle: / Lo, how Fortune turneth sodeynly / The hope and pryde eek of hir enemy!"
PRAYER (*modus orativus*)	VII.3342	"Venus godes of plesaunce" (Se)	"O Venus, that art goddesse of plesaunce, / Syn that thy servant was this Chauntecleer, . . . / Why woldestow suffre hym on thy day to dye?"
PRECEPT (*modus praeceptivus*)	VII.3440	"Quocum*que* scri*p*ta sunt ad n*ost*ram doctrinam scri*p*ta sunt Vt *per* consolaci*on*em scripturar*um* spem habeam*us* [For what things soever were written were written for our instruction, that through the consolation of the scriptures we might have hope]," (Ht) a Latin paraphrase of Romans 15:4, the source for the Nun's Priest's final "moral."	"Taketh the moralite, goode men. / For Seint Paul seith that al that writen is, / To oure doctrine it is ywrite, ywis; / Taketh the fruyt, and lat the chaf be stille"

24. Also useful, especially for *Piers Plowman*, is the disputative
mode (*modus disputativus*), dialectic, or disputation style found
in Job and the Apostle Paul, according to Thomas Aquinas, who
sought to emphasize the relations between rational science and
affective wisdom. Alexander's and Thomas's categories are de-
scribed in Minnis 1988, 124–28, citing *Summa Alexandri*, i, 10, for
these five.

25. For this connection see Kerby-Fulton and Despres 1999,
76ff.

26. Nicole Eddy suggests that desire to mark prayers may be
in part due to the tradition of marginal annotation in liturgical
and prayer texts, where *oratio* and *responsio* markers in the margins
show call-and-response format (private communication).

27. See Kerby-Fulton and Despres 1999, 76ff., and also Baswell
1992 and Minnis 2008, 172ff., for a bibliography.

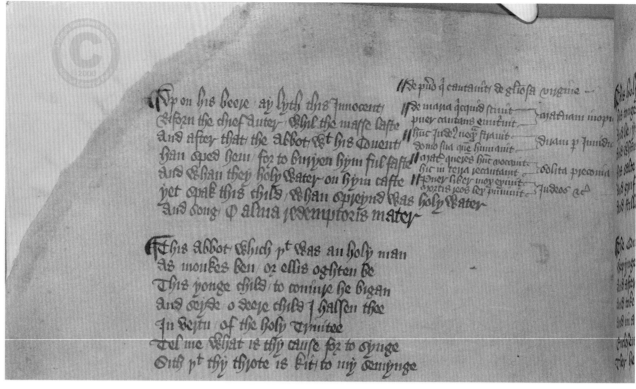

2. Detail from "The Prioress's Tale," in the Hengwrt *Canterbury Tales*. In the right-hand margin is a source gloss to line 635 from John of Garland's *Miracula Beatae Virginis*, one of the many analogues for Chaucer's tale, though not a source. Aberystwyth, National Library of Wales, MS Peniarth 392D, fol. 212v.

lemical Responses such as remarks made against the friars and prophecies (as in fig. 1) are given there is no such mark. Narrative Reading Aids, however, in HM 143 are carefully distinguished by a system of parallel slashes,[28] just as they are in the Hengwrt *Canterbury Tales* (fig. 2). These different signs suggest a set of distinctions in the annotator's mind or in the scribe's. Parallel slashes are common signals left for rubricators,[29] who normally came along after the scribe and even after the annotator-corrector to do highlighting, underlining, initials, or other decorative work (in HM 143, the note rubrication was left undone). In Hengrwt the scribe (Pinkhurst) also used the left and right margins to distinguish what Doyle and Parkes called "headings" showing subordinate topics in the text (i.e., a Topic Narrative Reading Aid) from Source glosses, that is, the authoritative-looking "Latin apparatus of citations and quotations from sources in the right-hand margin"[30] (see fig. 2). The fact that the extensive glossing of learned authorities in Hengwrt is always placed in the right hand margin is reminiscent of the authoritative position of the right side in medieval art. Whatever the origin, both of these cases suggest a hierarchy of annotation types in the

mind of the scribes. These priorities will give us insight into the role of the glosses in Chaucer's "Wife of Bath's Tale" and other key tales, our next concern.

2a. Glosses to the "Wife of Bath's Prologue"

It is necessary first to distinguish further between a gloss and an annotation. The term "annotation" is broad and covers the range of marginalia we have just discussed, usually to help orient the reader in various ways. A gloss, as the instances of grammatical, lexical, and source glossing we saw in the "Nun's Priest's Tale" indicated, usually carries supplementary explanatory material accompanying a word or passage. As Rita Copeland explains, the word *gloss*, according to Isidore of Seville, meant translation from one language to another: "Glossa Graeca *interpretatione* linguae sortitur nomen ('Gloss' gets its name in Greek from linguistic *explanation*)."[31] The later fortunes of "*interpretatio* as commentary or explanation are to be bound inextricably with the idea of interlingual translation," as Copeland goes on to explain, even as its definition became broader and broader. In the later Middle Ages, the rela-

29. For example, in Hengwrt, where Scribe B used the lines to indicate paraphs in the text and at the beginnings of the glosses.
30. Doyle and Parkes 1978, 163–201, discussing plates 55 and 56.
31. Copeland 1991, 89–90; my emphasis.

tionship between a Latin gloss and a vernacular text becomes especially complex, as the roles of glosses multiply, and even simple source glossing could be used strategically to nuance, or at least to allow for multiple readings. So, for instance, in relation to the Wife's troublesome fourth husband, the El glossator at line 460 glosses her story of Metellius, who struck his spouse and killed her simply because she drank wine, giving the location in Valerius Maximus's *Facta et dicta memorabilia*, and the actual quotation:

Valeri*us* . lib*ro* . 6° . *capitulo*. 3° . / Metellius ǀ vx*or*em suam / eo q*uod* vinu*m* bibisset ǀ fuste *per*cussam int*er*emit / [Valerius book 6. Chapter 3. / Metellius killed his own wife whom he had struck with his staff because she had drunk wine].	Metellius / the foule cherl the swyn That with a staf / birafte his wyf hir lyf' ffor she drank wyn / thogh I hadde been his wyf He sholde nat' han daunted me fro drynke (El, fol. 67v)[1]

1. III.460–63. Citations here and below from the El glosses to the Wife of Bath are from the color facsimile by Woodward and Stevens 1995, checked against Partridge 1992, III-2 to III-19; they are keyed to the *Riverside Chaucer*.

Even though the Latin just repeats the information in the Middle English (just adding precise references), it does not denounce the story but casts it in a sober tone that sits antagonistically against the Wife's defiance, in a more authoritative language, moreover, little known to many medieval women. El, however, was intended for a noble, likely aristocratic family (see ch. 5 on the evidence of its illustrations), where women might well have read some Latin. Certainly, reading this passage (and many more we will look at) without the gloss is a different experience from reading with it.

While glosses can be composed by authors themselves (raising a key question, as we will see, in Chaucer studies), annotations are usually offered by a scribe or reader, although annotative commentary by an author is not unheard of and can be even mischievously offered (as in John Capgrave's marginalia).[32] Roughly speaking, portions of early authoritative texts of the *Canterbury Tales* seem more often to have been glossed (perhaps only later did some tales acquire layers of reader annotations), but copies of *Piers Plowman* tend not to be glossed but rather annotated. This suggests something about the somewhat distinctive audiences for both poems; more uncertainly, it may suggest something about their respective authors (or their earliest scribes) and the public they anticipated for their works. This distinction between a work's audience (the group of readers and listeners it actually reached) and its

public (the group the author imagined or hoped it would reach) is an important and useful one developed by Anne Middleton in her classic study of the "Audience and Public of *Piers Plowman*" (Middleton 1982). Though this has not yet been done, the overlapping of the audiences for both poems can be traced to some extent in the similarities of marginal accretion in both transmission histories. But the extant vernacular accretions of each may not fully represent the top tier of the audiences they reached, or even the public each author imagined.

The majority of the surviving glosses to the *Tales* are—surprisingly for Chaucer's reputation as the Father of English Literature—in Latin; the most important and recurring of them form an apparatus that makes the *Tales* appear more humanist or classical in nature, even tales (like the Wife of Bath's or Merchant's or Franklin's) where we might not expect such treatment. So, while no one is surprised to see the heavy and learned glossing of the "Clerk's Tale" (which Chaucer translated from Petrarch's Latin) or of the "Parson's Tale" (not really a tale after all but a treatise on the vices and virtues), the heavy Latinizing of the margins in the "Marriage Group" tales mentioned above—two in the romance genre and one a fabliau—does require some explanation. The most glossed portions of these tales are the debate or polemical portions: where, for instance, the Wife preaches her philosophy of marriage, often citing Scripture; where January and his friends debate the joys of marriage; or where Dorigen fortifies herself with a catalogue of classical heroines who preferred death to dishonor. These glosses, like most in the *Tales*, are often source glosses, or at least ostensibly so. But are some of these "source glosses" a pretence for subtle commentary? The extensive Latinate glosses in portions of the "Marriage Group" tales, and their accuracy as source materials suggest that some very early glossator (was it Chaucer himself?) was enormously engaged with these tales and with the project of authorizing them, often "ambiguating" them, and perhaps even in some places heightening irony. Moreover, the very kinds of questions that grip modern readers, about the "feminism" of the "Wife of Bath's Prologue," the misogyny of the "Merchant's Tale," or the spousal abusiveness of the "Clerk's Tale," are indeed the subjects heavily glossed in these tales.

Let's first look at the earliest sets of glosses supplied to the "Prologue" of Chaucer's "Wife of Bath's Tale," one of the most delightfully controversial of the *Tales*: the glosses were copied by Scribe B (or Adam Pinkhurst) in more cramped fashion into Hengwrt and later in a preplanned fashion into Ellesmere (compare figs. 2 and 3). Doyle and Parkes 1978 established that when Scribe B copied Hengwrt, he apparently did not plan ahead for the inclusion of the glosses.[33] This suggests either that some-

32. Capgrave used a special, ambiguous scribal mark to highlight passages of political significance he wanted his powerful patrons to notice. See Lucas 1969.

33. Note the slightly different view in Partridge 1993.

one supplied him with a new exemplar midway through the process or that he initially thought to avoid copying the glosses (these, of course, are extra work for a scribe, work often left unfinished, even when started). Or, as Stephen Partridge has suggested, perhaps he was trying to get his glosses as close as possible to the verses they support, making his own selection. Indeed, glosses in learned Latin texts are often written around the main text in just such a squeezed manner.[34] If Scribe B is Adam Pinkhurst, Chaucer's own scribe,[35] Chaucer himself may have been the source of the missing glosses, or perhaps just of raw material for the glosses, and if so, this would authorize Hg's glosses, just like it has Hg's main text, as a snapshot of the *Tales* before they were complete. Scribe B did plan for the glosses in Ellesmere by ruling for them—and there are very few Hg glosses, as Partridge shows, not in El (some of the few there are, in the "Prioress's Tale," we will look at below). Another set of manuscripts share Vulgate glosses for the "Wife of Bath's Prologue," including CCCO MS 198 (Cp), which as we saw in chapter 1, was copied extremely early by Scribe D. While several of the Vulgate glosses appear in many manuscripts, they are not in Hg or El.[36] But if any glosses have a chance of being both authorial and also maturely considered, it is the ones that made it into El: not only do they appear in the most authoritative manuscripts generally, but more importantly, their level of sophistication is striking.[37]

Although they do not go so far as to name Chaucer as the glossator of El, in the new *Sources and Analogues of the Canterbury Tales*, Ralph Hanna and Traugott Lawler use the El glosses as the most reliable of manuscript guides in determining the actual sources of the "Wife of Bath's Tale":

> We have tried to honor the Ellesmere glossator in what we print. More than half of his glosses are to lines 1–183 [of the Prologue] and are taken from Jerome's *Adversus Jovinianum*; most are biblical verses, but they are cited because Jerome cites them. The glossator was quite thorough.[38]

Jerome's petulant and often cruel arguments against marriage become, in Chaucer's hands, the Wife's uproarious impromptu sermon on men and married life. Twenty-one out of the first twenty-six glosses in the El "Wife of Bath's Prologue" cite Jerome's *Adversus Jovinianum*, or the biblical

quotes that form the substance of Jerome's argument. The "Prologue," however, has none of the sneering, sardonic quality of Jerome's polemic; rather, as Hanna and Lawler say, of all Chaucer's prologues, it is most steeped in a literary tradition that was "always allied with satire and it certainly had its comic manifestations, most notably in the *Roman de la Rose*."[39] The El glosses, in fact, represent every major known source for the "Prologue," comprising, for instance, the standard sources for medieval antimatrimonial collections of the very kind the Wife's fifth husband, Jankyn, reads aloud to her so irritatingly:

> He hadde a book that gladly, nyght and day,
> For his desport he wolde rede alway;
> He cleped it Valerie and Theofraste,
> At which book he lough alwey ful faste.
> And eek ther was somtyme a clerk at Rome,
> A cardinal, that highte Seint Jerome,
> That made a book agayn Jovinian.
> (Riverside Chaucer *1987, III.669-75*)

In addition to Jerome's *Against Jovinian*, the reading matter the Wife lists here that makes her so indignant is Theophrastus's *Liber de Nuptiis (The Book of Marriage)* and Walter Map's *Dissuasio Valerii ad Rufinum (Valerius's Dissuasion of Rufinus from Marriage)*. This bibliographical scene famously ends with the Wife's tearing of the book ("Al sodeynly thre leves have I plyght," III.790), her reception history of just deserts, making the El glosses themselves pretty important in the literary interplay leading to this moment of reckoning. The El glosses quote these works and also quote some of Chaucer's more obscure sources, including sayings by Ptolemy and astrological material from "Almansor" and "Hermes."[40] Given what we know of Chaucer's passion for astrology evident in what some scholars believe to be the only extant sample of Chaucer's handwriting (in the *Equatorie of the Planets*),[41] they add weight to an already hefty bunch of learned glosses. The question for Chaucer scholars then is, would an independent scribe or editor have arrived at the correct identification of all these source glosses unaided? Not easily.

If this identification seems more than coincidental, it is, however, the subtle literary quality of how the glosses interact with the text in El that lends further support to the case for their being Chaucer's. Some of the glosses, of

34. See Clemens and Graham 2007, plates 3–13 and 3–16, for instances in the Latin tradition of this kind of glossing.

35. Mooney 2006. See ch. 1, sec. iv, and page 81 on the identification and any scholarly dissent.

36. For example, the quote from Matthew 19:21 in Cp glossing the Wife's discourse on Christ's instructions for living "parfitly" (III.108); see Partridge 1992, III-7.

37. Partridge 1993.

38. Hanna and Lawler 2005, 352.

39. Ibid.

40. See ibid., 379–87, for the pertinent texts of these, along with the Aesop's fable "Romulus" that the Wife cites in her provocative quotation "Quis hanc imaginem pinxit?" (383). Hanna and Lawler also print analogues from Matheolus, *Lamentationes*, and Eustache Deshchamps's *Le Miroir de Mariage*, altogether an impressive set of intertextual possibilities for the Wife's performance (387–403).

41. The manuscript is Cambridge, Peterhouse 75.i, fol. 71v. For a plate, see Roberts 2005, no. 38, and her list of scholarship on the *Equatorie*.

course, would be easy enough for any literate person to supply, like the Latin Pauline text at line 52, "Melius est nubere q*ua*m vri" (El, fol. 63v, from I Corinthians 7:9), which simply sources the Wife's quotation from Paul "Bet is to be wedded than to brynne" (III.52). But even such quotes are cited because they appear in Jerome's complex argumentation (in this case from *Adversus Jovianian* I.9), which Chaucer is following in detail as he writes. This means that even simple glosses carry with them a complex web of association. So, where the wife says gleefully that God "bad vs for to wexe and multiplye," Chaucer is in fact evoking not only the famous injunction to Adam and Eve in Genesis but, given its narrative context in what I call the Jerome sequence, he evokes Jerome's harsh words as well, given in table 5 below.

This is the fourth El gloss to the "Wife of Bath's Prologue," of which, again, the first 21 out of 26 are all citations from Jerome, a staggering statistic. The reader who knew Jerome's *Adversus* would have watched the first 379 lines of the Wife's monologue unfold virtually as a commentary on that text—and not one, on the whole, Jerome would have enjoyed. Even though the gloss is the essence of simplicity, when the reader hears the Wife's rollicking new interpretation of the Genesis injunction, what sort of response are we to imagine that the glossator had in mind? Is the reader simply to weigh the Wife's cheerful view that this allows her to multiply husbands against the orthodox understanding of the literal level, that is, that God is commanding Adam and Eve to procreate, which the Wife shows no signs of doing) and laugh? Or is the Latinate reader expected to do more: to remember Jerome's menacing words that plants needed first "to grow" (*crescere*), so that they could then be cut off (*ut esset quod postea posset excidi*)—a vicious metaphor in a sexual context, suggesting marriage as emasculation? And was the reader to remem-

ber, too, and take to heart that marriage only "fills earth" (*terram replent*), not heaven? How much was the knowing reader to call to mind? Probably a good deal. Even these simple glosses, then, support the associations of the Wife with earthiness and the body—and, by implication, salvational failure, a failure not implied by St. Paul, the ostensible source of the quote, but by the zealotry of Jerome. This is the kind of choice these glosses repeatedly force the reader to make.

There are multiple instances in the El source glosses to the Jerome sequence of the "Prologue" that supply a quote for what might appear to be an affirmative allusion from Jerome himself, but which actually trigger large, complex sections of *Adversus*, unflattering to the Wife's views.[42] One such deception is the third gloss, which appears where the Wife is puzzled about how many husbands the Samaritan woman Christ counseled might be allowed to have. Since the run-up to the glossed verse is necessary for context, I have underlined the verse beside which the gloss appears in table 6 below.

The gloss, by itself, seems supportive of the Wife's argument that there is "no definite number" of wives, because according to Paul, "those who have wives should be just as those who don't." But in fact that is not exactly the spirit of what Paul said, as any educated person would have known: Paul was saying that since "time is short, for the rest, let those who have wives be as though they had none; and those who mourn, as they did not mourn, etc. [Tempus breve est; reliquum est, ut et qui habent uxores, tanquam non habentes sint; et qui flent, tanquam non flentes, etc.]" (I Cor. 7:29–30). The larger context is the imminent coming of the End, and Paul is encouraging (though not commanding) celibacy, so the gloss is very cunningly chosen. It is as cunning, and as open to unstable reading, as the Wife's own interpretation of Christ's advice to the Samar-

TABLE 5		
"WIFE OF BATH'S PROLOGUE"	EL GLOSS	PASSAGE FROM JEROME'S *Adversus Jovinianum*
But wel I woot' expres withoute lye God bad vs / for to <u>wexe and multiplye</u> That gentil text' kan I understonde (El, fol. 63r; III.27–29)	Crescite *et* multiplicamini (El, fol. 63r; III.28, from Genesis 1:28, but in fact cited from Jerome, I.16)	"Quod autem ait, 'Crescite et multiplicamini, et replete terram' (Gen. 1.28), necesse fuit prius plantare silvam et crescere, ut esset quod <u>postea posset excidi</u>. Simulque consideranda vis verbi, 'replete terram.' Nuptiae terram replent, virginitas paradisum. [As for the command 'Increase and multiply, and fill the earth,' it was necessary first for matter to be planted and grow so that there would be something to be cut off later. And let's think about what 'fill the earth' means. Marriage fills earth, virginity heaven]." (Jerome I.16, Hanna and Lawler 2005, 363, line 56ff.).

42. The Wife's Prologue perhaps reflects the complexity of attitudes toward women in the rising bureaucratic classes (of which Chaucer and Hoccleve are excellent examples). Of course, Jerome is often outrageous himself, making him the ideal source. For an overview of the critical problems the Wife poses, see *Riverside Chaucer* 1987, 864–65.

	TABLE 6	
"WIFE OF BATH'S PROLOGUE"	EL GLOSS	PASSAGE FROM JEROME
Herkne eek / which a sharp*e* word for the nones Biside a welle / Ih*es*us god and man Spak / in repreeue of the Samaritan Thou hast yhad / fyue housbondes quod he And that man / the which *þat* hath now thee Is noght' thyn housbonde / thus seyde he c*er*teyn What that he mente therby / I kan nat seyn But *þat* I axe / why that the fifthe man Was noon housbonde to the samaritan <u>How manye / myghte she haue in mariage</u> <u>Yet herde I neuere tellen in myn age</u> <u>Vpon this nombre diffinicio*un*...</u> But of no nombre / mencio*un* made he Of bigamye / or of Octogamye Why sholde men / speke of it vileynye" (El, fols. 63r–63v; III.14–25 and 32–24)	<u>Non est vxor*um* numerum</u> diffinitu*m* (El, fol. 63r)[1] [There is no definite number of wives] quia *secundum* Paulu*m* / Qui h*a*b*e*nt vx*ore*s sic sint tanq*ua*m non habentes [Because according to Paul those who have wives should be like those who do not have]. (Jerome I.21 (15) and I.17 (13), citing 1 Cor 7:29)	"Nec enim consequens esset ut Apostolus . . . cum habentibus quoque uxores praeceperit ut sic sint quasi non habentes (cf. I Cor. 7.29), et ob hanc causam <u>non esse uxorum numerum definitum</u>: quia post baptisma Christi, etiam si tertia et quarta uxor fuerit, quasi prima reputetur. . . . Non damno digamos, immo nec trigamos, et, si dici potest, octogamos: plus aliquid inferam, etiam scortatorem recipio poenitentem . . . [Since Paul has urged those who have wives to be like those who don't . . . and the reason there is no definite number of wives one can have is that if a man gets married after he is converted (*literally*, after the baptism of Christ), even if it's his third or fourth wife, she is considered to be his first. . . . I don't condemn bigamists, trigamists, or, if I may say, octagamists. I will say further that I will welcome any whorechaser as long as he repents]." (Jerome I.15, Hanna and Lawler 2005, 363, line 48ff.)

1. Partridge's critical edition of the glosses here rightly reads "numerum diffinitum" instead of the grammatically correct nominative "numerus diffinitus." As Nicole Eddy helpfully observes, "this is further proof that the glossator is sitting there with Jerome in front of him, and just copies the form right out of Jerome, where it is accusative!"

itan woman in a common-law relationship: amusingly, the Wife is so bourgeois she cannot imagine living unmarried with a man, and therefore she does not even get the force of Christ's comment, imagining he meant that the Samaritan's last husband (the fifth) was one too many! What the glossator is doing here—and a very Chaucerian move it is—is multiplying comically innocent misreadings of authoritative texts. But the key words, the Wife's "nombre diffinicioun," the glossator's "num*er*um diffinitu*m* " (as Eddy notes, copied ungrammatically straight out of Jerome), and Jerome's "numerum definitum," link the context from which the gloss comes ultimately to Jerome's, providing a horrible source for the idea that "there is no definite number": the reason Jerome gives is that it makes no matter how many times a man marries because "I will . . . welcome any *whorechaser* who repents" (*etiam scortatorem recipio poenitentem*). Jerome, then, regards *any* man who remarries as a "whorechaser (scortatorem)." To go from the playfulness, and here even innocence of the Wife, to the cheerful ambivalence of the gloss to the crass vulgarity of Jerome is a downward spiral into black sarcasm, but this is not a journey every medieval reader could make (perhaps fortunately). And here we come to an important aspect of these Latin glosses and the text they accompany: that they are written for *tiers* of learnedness, and for the learned, they offer tiers of philosophical choice. Here we have at least three, if not four, different tiers of literacy

in operation: (1) English comprehension alone; (2) basic Latin literacy to construe the gloss; (3) knowing or being able to check the larger context of the biblical allusion ("secundum Paulum"); (4) knowing Jerome's sneering disquisition on the "numerum definitum" question.[43] And as for tiers of philosophical choice, if a medieval reader or hearer, however learned, had wanted to stop at the first or second tier, who could blame him or her?

It is for such different types of readers—those, for instance, who just wanted a good-natured romp, or those who saw St. Paul's glass as half full rather than half empty, or even for those with a penchant to be scandalized—for whom certain of the glosses were designed. A fun example is one of the few in the first 379 lines in which a Pauline quote is not filtered through Jerome, though it has to run the gauntlet of a clutch of Jerome quotations all copied at once in the margin on folio 64v of El (see fig. 3), among which it sticks out as the Latin for the Wife's translation at that line (transcribed in table 7).

Read on its own, the I Cor. 7:4 gloss (underlined in second column below) sweetly supports the Wife's conveniently truncated version of Paul's injunction on the marriage debt—with no "etcetera" such as often accompanies Latin biblical quotation in medieval texts to re-

43. For a sophisticated treatment of literacy issues in late medieval England, see Zieman 2008.

	TABLE 7	
EL GLOSS	"WIFE OF BATH'S PROLOGUE"	FULL CONTEXT OF FOURTH GLOSS (ONLY) IN ST. PAUL
¶Qui vxorem habet et debitor dicitur et esse in prepucio et seruus vxoris et quod malorum seruorum est alligatus [He who has a wife is said to be a debtor and to be uncircumcised, and a servant of his wife, and like a bad servant he is bound] (Jerome I.15) ¶Et iterum seruus vxoris es / noli propter hoc habere tristiciam [Again you are the slave of a wife, but do not on this account grieve] (Jerome I.13) ¶Item si acceperis vxorem non peccasti tribulacionem tamen carnis habebunt huiusmodi et cetera [Again, if you marry, you have not sinned, but [such as do] shall have tribulation in the flesh, etc.] (Jerome I.16, citing 1 Cor. 7:28) ¶Item vir corporis sui non habet potestatem / set vxor [Again, a man does not have power over his own body, but his wife (does)] (I Cor. 7:4) ¶Item viri diligite vxores vestras [Again, husbands, love your wives]" (Jerome I.16, citing Colossians 3:19) (El, fol. 68v)	Which shal be / bothe my dettour / and my thral And haue / his tribulacioun withal Vpon his flessh / whil I am his wyf I haue the power / durynge al my lyf Vpon his propre body / and noght he Righte thus / the Apostel / tolde it vnto me And bad oure housbondes / for to loue vs weel Al this sentence / me liketh euery deel (El, fol. 64v; III.155–62)	Uxori vir debitum reddat, similiter autem et uxor viro. Mulier sui corporis potestatem non habet, sed vir; similiter autem et vir sui corporis potestatem non habet, sed mulier. Nolite fraudare invicem, nisi forte ex consensu ad tempus. [The man owes his wife the debt, but similarly also the wife owes the man. The woman does not have power over her body, but the man (does); but however the man does not have power over his body, but the woman (does). Defraud not each other, unless out of consent for a time]" (I Cor. 7:3–5).

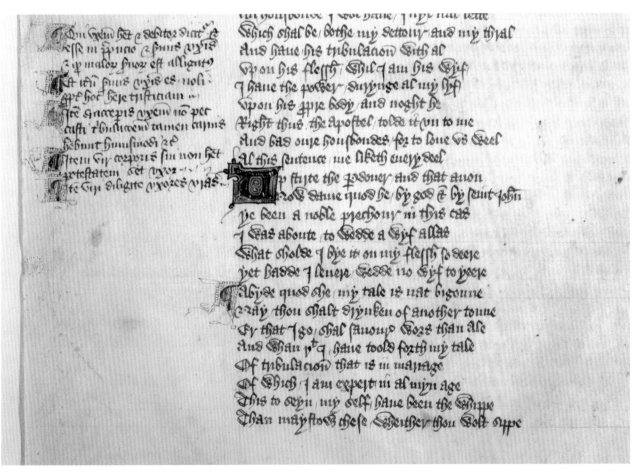

3. Detail from the "Wife of Bath's Prologue," in the Ellesmere *Canterbury Tales*. A heavy group of glosses, transcribed in the chart above, surrounds some of the Wife of Bath's more outrageous claims (III.155–62). San Marino, CA, Huntington Library, MS EL 26 C 9, fol. 64v.

mind the reader to fill in the second half of the quotation mentally. (Interestingly an "etc." does appear here in other manuscripts, like Tc², but not El).[44] This glossator enjoys playing the would-be biblical innocent alongside the Wife with this gloss, and the next ("Item viri diligite vxores vestras" from Jerome I.16, citing Colossians 3:19) also sweetly confirms the Wife's philogynist position. On one kind of reading then, so what if the quote is sawn in half, and every Tier 3 and Tier 4 reader knows it? Even Tier 3 and 4 readers are allowed to have fun or wish the world different. On another reading, to get to the I Cor. 7:4 gloss, the Wife's table-turning declaration, one has to slog through a whack of previous glosses from Jerome that promise slavery and tribulation to husbands (the subject, indeed, of the Wife's previous lines: "An housbonde I wol have . . . / Which shal be bothe my dettour and my thral" (154–55). Reading these glosses, then, in El at least, and some of its genetic family (Ra1, Tc²) is a complex experience. Other manuscripts (such as Ne and En3) have only the positively sawn-off gloss.[45] Some manuscripts have nothing in the margins in these stretches.

So even relatively simple glosses, even ones that appear to confirm the text (and may), come with a lot of baggage, and one can already see how slippery the label "source gloss" is in Chaucerian glossing. These glosses have been read as moralizing correctives to the Wife's apparent flippancy (by Graham Caie), and as feminist defense (by Susan Schibanoff).[46] Both are plausible readings—like Chaucer's tale itself, the glosses are capable of multiple interpretations and additional readings are equally plausible, especially given that the glosses are in Latin, glossing, in all cases, vernacular lines. Often, I would suggest, they function both to assure that "correct" reading is accessible, and to ensure that a playful or ambiguous layer of reading is possible: the effect of the Latin gloss can range from serious to humorous to sardonic to ironic to allegorical, even sexually suggestive.

To use a better-studied analogy, these Latin glosses, then, often function much the way the Latin quotations *within Piers Plowman* do—that is, they function diversely to (quietly) authorize or undermine or complicate or multiply voicing in the poem, as Langland scholars have long recognized.[47] This is a way of writing for multiple levels of audience at once.

2b. A Note on Comparing Glosses in Chaucer's and Gower's Texts

One might think more readily of an analogy to Gower rather than Langland, but on closer inspection, even though Gower, too, writes for a tiered audience linguistically, the El glosses of the *Canterbury Tales* do not function as Gower's do—however much they look like them. Scholars generally agree that it was Gower himself who created the Latin apparatus to the *Confessio Amantis* but that, as Derek Pearsall writes, "they are of a completely different kind [from those in Chaucer]. . . . Gower's Latin apparatus, by contrast, contributes to a systemic programme, carefully integrated with the English text."[48] Briefly, *Confessio* glosses tend to do one of the following: simply supply the Latin source for a quotation (e.g., Prol. 152), or summarize information in the English text (as formulaic Narrative Reading Aids, often beginning with "Hic declarat," e.g., Prol. 34, or "De statu," e.g., Prol. 94). Gower's glosses can also augment the English text: "De statu cleri" (Prol. 194) names the antipope of the Great Schism, embellishing the generalities on the state of the clergy in the English text.[49] But broadly speaking, *ambiguation* in Gower's glossing is rare; one tends to know where the glossator stands on issues. A fourth kind of gloss in Gower seeks overtly to challenge or displace the text with another, usually moralized reading. For instance, as Minnis notes, "When Genius . . . recommends *fin' amors* as a secure and proper channel for desire . . . , we find in the margin a Latin comment to the effect that this is not true in itself, but is rather what lovers believe: 'Non quia sic se habet veritas, set opinio Amantum'" (4.1451).[50]

The El glosses do not direct interpretive traffic like this. Their relationship to the text of the "Prologue" is never directly framed for us by a gloss narrator, who, as Kurt Olsson says of Gower's glosses, is always "impatient" to "simplify" the relationship between poet and lover: as in the gloss to 1.59, where the author postures "quasi in persona aliorum [as it were in the person of other people] . . . fingens se auctor esse Amantem [feigning himself, the author, to be (the) lover]."[51] In the El Wife of Bath glosses the relation of text and Latin quotation can be interpretively authorizing, but it is always oblique. Exactly the same method is used by Langland as El's glossator uses.[52]

44. Recorded in Partridge 1992, III-8, for these lines.

45. Ibid.

46. Caie 1976; Schibanoff (1988) 1998.

47. Pearsall 2008, 11, and scholarship cited there; Kerby-Fulton 2006, 380–82, for a few examples.

48. Pearsall 1990, 15.

49. Peck and Galloway provide helpful translations and commentary on the glosses (2006).

50. Minnis 1992, 175, my emphasis; see also see Minnis 2008, 17n3.

51. Olsson 1992, 39.

52. This is not the place to discuss Langland's methods, but the fluidity between text and margin is a key point in medieval book production. In the copying and recopying of texts in medieval manuscripts generally, it is not uncommon for material that started as glosses to move in from the margins to the text, or vice versa, especially when we are dealing with Latin and vernacular; see Irvine 1992. See the discussion below of the MS Oriel College 79, Oxford *Piers Plowman* text.

Gower's method, as Rita Copeland has shown more broadly, is one of textual displacement, a standard feature of learned glossing traditions. In her study of Latin exegetical practice and rhetorical commentary, she writes:

> Latin exegetical practice in the Middle Ages . . . works to displace the original text, materially by paraphrase, and conceptually by reconstituting the argumentative structure of the text. . . . Latin commentary substitutes itself for the text in question, inserting itself into the *auctoritas* of that text, hence appropriating [it].[53]

This goal, to displace the text, most often first by paraphrase and then by reconstituting the argument, is a very different kind of reading from our own (still) New Criticism–inflected treatments of the text as sacrosanct. Chaucer, however, uses these learned traditions very differently, as we know from examining his poetry itself. Chaucer, as Edward Wheatley has shown, integrated learned glosses into his poetry. In grammar schools, schoolmasters often taught their Latin texts by introducing the marginal apparatus (especially plot and topic summaries) to a literary story or poem first, and then working through, or better, inwards on the page, to the primary text, with its greater linguistic difficulties and rhetorical sophistication. This is how the Latin text of even a simple fable like the one the Nun's Priest tells would be taught to boys,[54] and many of the digressions on dreams, theological points (like predestination), biblical and historical *exempla*, and so forth that we find in Chaucer's rendition would appear in the marginal commentary of a school text containing the fable. As Wheatley has suggested, Chaucer's own reconstruction of the fable brilliantly folds all this material into the main text.

While it is clear, then, that Chaucer knew exactly how to use this sort of marginal material, he did not choose to create such displacing glosses for the "Wife of Bath's Prologue" (nor, so far as we can tell, his other *Tales*), as Gower did for his. Rather, if he authored glosses like we find in the El "Wife of Bath's Prologue," his purpose was subtle and even playful. Chaucer, oddly enough, is not yet fully credited with, nor indeed, even imagined as having done the type of complex interlinguistic dance Langland did, because of the relative neglect of the glosses, and also because of questions of authorial attribution.

3. The Problem of Authorial Attribution in the Glosses and a Case from the Hengwrt "Prioress's Tale"

Although scholars have yet to determine whether this stable, early group of glosses[55] to the *Canterbury Tales* can be securely attributed to Chaucer himself, scholarship on individual tales points in that direction. In a succinct overview of past scholarship on this problem, Partridge lists the following evidence:

> Dempster 1943 showed that the glosses to "The Clerk's Tale" and its text suggest, in their shared variants from the standard text of Petrarch's version of the story, that both glosses and text were drawn from the same manuscript; thus it is at least highly probable that Chaucer himself is responsible for the glosses. Lewis assembled evidence of a very similar kind for some of the "Man of Law's Tale" glosses by collating the glosses, and Chaucer's text, against all the surviving MSS of Innocent III's *De Miseria* (1978, 32–9). Brennan 1973 adduced evidence that Chaucer was responsible for a long gloss in the "Prioress's Tale" simply by showing that both text and gloss were drawn not from the text's apparent source in Revelations, but from Jerome's summarizing allusion to Revelations in his *Adversus Jovinianum*. Finally, most relevant to the Wife of Bath's Prologue is Pratt's study of Chaucer's indebtedness to the *Communiloquium* of John of Wales, or to a similar compilation intended as an aid to preachers (1966).[56]

Partridge goes on to suggest various qualifications to these studies, but he concludes with this very powerful argument:

> Even when we take such qualifications into account, however, these four studies assemble a formidable body of evidence that the person or persons responsible for the source glosses found in the earliest MSS, and in widely disparate parts of the *Tales*, *had unusual access to Chaucer's own library*, as well as unusual sensitivity to where Chaucer was drawing on a source different from one either named in or most obviously indicated by the text of the *Tales*. Without a manuscript in Chaucer's own hand or one we can be sure he supervised, final proof is impossible.[57]

53. Copeland 1991, 103.

54. Wheatley 1996, which also cites extensive scholarship on these modes of pedagogy, including Copeland 1991, esp. ch. 3.

55. This stable, early group of glosses sometimes even occurs in manuscripts that editors regard as genetically independent of one another (that is, not deriving from the same textual family). This means that a stable group of glosses to certain tales existed early enough to have been disseminated across family groups. As we saw in ch. 1, no copy of the *Canterbury Tales* survives with an authorial imprimatur (unlike, for instance, the holographs of

Hoccleve), though good cases for authorial proximity to Scribe B, at least, can be made for those he copied, and perhaps a few other witnesses: Partridge makes a strong case, for instance, for Ch's tradition, despite its chronological lateness (see Partridge 1993, esp. 88–89).

56. Partridge 1996, par. 22. I would like to thank Stephen Partridge most warmly for his generosity and advice. For the studies mentioned by Partridge in this paragraph, see "References Cited."

57. Ibid., par. 23; my emphasis.

Stephen Partridge wrote these conclusions in 1996, before Linne Mooney's discovery of the name of Scribe B, Adam Pinkhurst, a discovery that at least suggests (for many who accept the identification) the possibility that the Hg manuscript was supervised by Chaucer in some way or that the project of making it was known to him.[58] This makes the Hg glosses, too, crucial for literary interpretation, alongside El's—indeed, these tales should not be read without them. The "Explanatory Notes" in the *Riverside Chaucer* often make reference to Latin glosses, but not comprehensively and usually without saying how many other manuscripts contain the gloss or where differences arise.[59] In other words, the glosses are not yet fully integrated into modern Chaucer study and scholarship—an exciting task beyond the scope of this chapter but full of both promise and difficulty.

One brief example of difficulty is heightened by Pinkhurst's identification: why, then, do some glosses appear in Hengrwt but not in El? The Latin gloss in Hengwrt to line 635 of Chaucer's "Prioress's Tale" (fol. 212v, fig. 2) is lifted from John of Garland's *Miracula Beatae Virginis*, one of the many analogues for Chaucer's tale. Though not considered by modern scholars to be a direct source for Chaucer, the John of Garland verses appear in the margin of Hg at the miraculous climax of Chaucer's story, when the murdered child lies before the high altar as the abbot performs the funeral mass: "Vp on his beere / ay lyth this Innocent.'" In Hg, and several other manuscripts (but not El), there is a marginal heading at this point (VII.635, "de puero qui cantauit de gloriosa virgine [concerning the boy who sung about the glorious Virgin]"), but only in Hg, Ch and Dd, do the John of Garland verses appear:

de maria quicquid sciuit	
puer cantans enutriuit	} Maternam inopi[am][60]
hunc Iudeus nequam strauit	
domo sua quem humauit	} Diram per Inuidi[am]
Mater querens hunc vocauit	
hic in terra recantauit	} Solita preconia
Puer liber mox exiuit[61]	
Mortis reos lex puniuit	} Iudeos *etcetera*.[62]

[Whatever the singing boy knew from (or about) Mary, he nourished her [i.e., his mother's] maternal need. The worthless Jew laid him low, buried him at his home, through dire envy. The lamenting mother called him; [from] in the ground, he sung back the accustomed praises. The free boy left [or rose up] soon; the law punished the Jews answerable for death, etc.]

(VII.635)

The heading note and the gloss are squeezed into Hg in the inner margin on folio 212v—that is, on the right hand side, like all Latin source glosses in the Hg marginal system. Carleton Brown, on whose study of the sources and analogues for the "Prioress's Tale" all modern studies rely, categorized the Garland version as a Group A version—one in which, importantly, the boy is dug up alive and unharmed (indeed, in some Group A versions the Jew is even converted, though in others he is simply punished).[63] The Group A version texts are—at least in relation to the child—those with the happy endings. Group C version texts are much more elaborately miraculous, tragic, and, unfortunately, negative in tone toward the Jews; it is from a Group C type that Chaucer drew his own "Prioress's Tale." The Hg gloss is striking, then, because it showcases the possibility of the Group A ending, that is, that the boy survived: *exiuit* usually means "he left," and can also mean "rose up."[64] One of the functions of traditional learned glossing is the supplying of alternative endings,[65] and perhaps Chaucer (or perhaps Adam Pinkhurst) was experimenting early on with providing just such an apparatus for the tale. Here, however, the alternative ending has a way of casting a very different light on the role of the Jews in the poem. Group A texts have no funeral mass scene, so the gloss is placed at the very point at which John of Garland's tale diverges from Chaucer's. To a knowing reader (that knowing reader we met so often in the glosses to the "Wife of Bath's Tale" and "Prologue") it is a clear reminder that the tale could end more happily. The reader would have been free to take the gloss not only as an alternative but also as a subtle corrective—and a more authoritative one. This makes the possibility that Chaucer himself added it to the Hg package quite intriguing. Other scenarios are possible, of course: Brennan argued that the gloss arrived as a remnant of Chaucer's "working memoranda."[66] The fact that the gloss did *not* make it to El, however, is most significant: this further isolates Chaucer's dark rendering of the tale and of the Jews. If only we knew his own final wishes on this and on so much more.

58. Discussed above in ch. 1, 81ff.

59. Boenig and Taylor offer a very helpful student edition of the *Tales* with translations, though not the Latin text, of the El glosses (2008).

60. The late-thirteenth-century copy of this John of Garland poem in ms Royal 8.C.IV (fol. 21r) has interlinear marginal glosses to clarify its obscurities. My translation reflects information in the Royal glosses, transcribed in Brown 1910, 7. Above this line the gloss reads "s. ne deperiret inopia" to make clear that the boy supported his mother by singing songs of the Virgin, a detail made more explicit in other versions. I thank Linda Olson and John Van Engen for helpful advice on this translation.

61. The interlinear gloss in the Royal ms reads "sed plage apparuerunt," that is, "though scars were visible." Note that, with almost humorous precision, the "et cetera" at the end even fits the metrics.

62. The text in Royal reads "Iudeos in anglia."

63. For the information in this paragraph, see Brown 1941, 454ff.

64. Normally in the latter case a transitive verb, see Latham 1965.

65. I am grateful to Alastair Minnis for his advice about this.

66. Brennan discusses the other four glosses from Hg not in El, which Brennan argues was in Chaucer's working memoranda for a planned revision of the tale to further emphasize the theme of virginity (1973).

II. The Annotations in Manuscripts of Langland's *Piers Plowman*

There is a real difference in character between most of the annotations that survive in extant *Piers Plowman* manuscripts, and the Latin source glosses we just have seen in several of the *Canterbury Tales*. The notes in *Piers* manuscripts look more like those we have seen in the "Nun's Priest's Tale," often with Langland's poem, however, pressed into further service as mnemonic devices, or aids to meditation, as well as reading aids. Indeed, in the margins of Langland's poetry we see almost anything but source glossing, which is surprisingly rare in the *Piers* corpus. What we do see in the teeming margins of *Piers* manuscripts, however, is evidence of passionate and diverse contemporary reception of his poetry, marked by a heavy degree of reader participation (both professional and casual). This participatory activity is cousin to the avid scribal participation within the text itself that has made *Piers Plowman* one of the top challenges in the entire history of English editing and ed-

itorial theory.[67] One vivid example, emblematic of this sea of scribal enthusiasm for social authorship, appears in Bod. MS Digby 102, where a corrector has added alliterative lines (shared uniquely with four other C manuscripts) to Imaginatif's discourse on the salvation of non-Christians, thereby interpolating further heartfelt concern that pagans (for him, Job and Aristotle) should also be among the saved (see fig. 4a).[68]

The chaos of its textual diversity and its marginal supply is further evidence that the poem was a blockbuster from the late fourteenth century on into the Reformation. Since its B-text annotations are, with a few key exceptions, often terse and uninformative, we will begin with the strongest case for the study of marginal supply in *Piers Plowman*: the C annotations. Those we examine will all be from the most authoritative genetic family of C-text manuscripts, known to scholars as the "i" group.[69]

4a. Passage from *Piers Plowman*. An interpolation into the text has been added after C.XIV.193, elaborating on the salvation of the "pagans" Aristotle and Job, beginning "Job was a paynym ꝛ *and* plesede god at prys /" and concluding wistfully: "That he is saf as was Iob ꝛ y can not wete þe soþe /." Note the corrector's sign inserted in the main text (six lines up from the bottom), the rubricated metrical punctuation (because the main text is written in prose to economize), and the different rubrication ink for the interpolation, suggesting it was added after the manuscript was finished. The annotation, in the hand of the later annotator (Y2) reads: "no*ta* of Salamon *and* oder." Oxford, Bodleian Library, MS Digby 102, fol. 53v, bottom of page.

67. See Finn 2003; and ch. 1, 65, above.

68. Russell and Kane 1997, 16, on entries by this correcting hand, and 185, for the entire passage, added after XIV.193; on the four other manuscripts, one of which includes the Z-text, see Horobin 2010, "The Scribe of Bodleian Library, MS Digby 102 and the Circulation of the C Text of *Piers Plowman*," 108. For a plau-

sible identification of the main scribe as likely Robert Lynford, whose hand appears in early fifteenth-century documents for the Brewer's Guild, see Horobin 2010, "The Scribe of Bodleian Library, MS Digby 102," 94.

69. Hanna 1993, 40–41.

4b. Passage from the end of Lady Mede's Westminster episode, *Piers Plowman*, showing Y2 at work. The annotations read: "reson chaunceler to the kyng *and* concyens be Iuges in *courtes*" (IV.184) and "vnsittyng sufferaunce" (IV.189), the latter condemning tolerance of impropriety. Below, Passus V opens with the "autobiographical" passage. Oxford, Bodleian Library, MS Digby 102, fol. 11v, lower half, Y2 annotations c. 1500.

We will look first at some early C-texts that have full cycles of original marginalia: Huntington HM 143 (X), written in the last quarter of the fourteenth century in Langland's dialect (southwest Worcestershire) but likely copied in London (a manuscript we met earlier in ch. 1, fig. 15);[70] and Bod. Douce 104 (D), dated 1427 and written in Hiberno-English, likely in the Dublin-Pale region of Ireland (see front plate 8). Both annotation cycles exemplify highly engaged readings of the poem by annotators with quite different literary sensibilities. These two are among the most important extant copies of the poem: X is the base manuscript used for all modern scholarly editions of the C-text (see ch. 1, sec. IV), and D contains

the only pictorial cycle known to have survived in any *Piers* manuscript (see ch. 3, sec. V). In addition, we will look further at Digby 102 (Y), also written in Southwest Worcestershire dialect but during the first quarter of the fifteenth century and entirely in prose, to economize on space (just as D economized on its space for pictures).[71] The manuscript also contains an important set of political poems dated between 1400 and 1421.[72] Digby 102 contains 97 original notes, entered at the time the manuscript was written (annotator Y1, fig. 5), and a further 381 added some 75 years later in a very late fifteenth-century or very early Tudor Secretary hand (Y2, see figs. 4a and b).

All three early cycles were the product of profes-

70. For a transcription of the marginalia, see Grindley 2001, and on the manuscript see Grindley 1992; on its London provenance, see Horobin and Mooney 2004.

71. See Schaap 2001; and front plate 8 above.

72. Barr 2009.

sional reader-annotators working as part of the production team, but each of the three cycles is quite different in tone and agenda. X's annotator shows most interest in following the narrative of the poem, D's annotator is most interested in following the allegory, and Y's annotators (both) are most moved by the political and legal issues. All the annotators—like most who marked the margins of *Piers*—are also interested in ethics, ecclesiastical polemic, and prophecy (the largest stable categories of *Piers* annotation everywhere).

The rich supplies of X and D are both unusually literary in perspective but wholly different. Unlike D's annotator, who tends to want to distill the allegory, what sets X's apart is that he follows Will, the narrator of the poem, like a faithful terrier, highlighting the action of the narrative itself—not always an easy task in a poem with more talk than action. To modern eyes, annotating a storyline does not seem so unusual, but his focus on the narrative marks him as a very particular kind of medieval reader, one who is willing to treat *Piers Plowman*, a vernacular poem, with something of the dignity that a schoolmaster would treat a Latin set text, particularly a *fabula* of any sort. This tells us something crucial about the early reception of Langland's poem (X might even have been made during his lifetime, or at least shortly thereafter): that is, the poem was seen as difficult enough to require a key to maneuver.

In the previous section we saw that a schoolmaster's marginal apparatus taught students to track narrative and many of the complex digressions of a text like the Nun's Priest's, on predestination, historical exempla, and the like.[73] The same could be said of Langland's poem—a much more complex narrative—which also takes up many of these same topics and freights its action with similar learned digressions. If the X annotator (hereafter Xa) emphasizes the narrative structure in his key, the D annotator (Da) is more likely to be absorbed by the digressions themselves and is impatient (to use Olsson's word of Gower's gloss narrator) to strip away the narrative as quickly as possible and get to the moral. To use a modern analogy, Da is rather like a mathematics teacher who is able to skip some of the steps and arrive more quickly at an answer, confident that his class is advanced enough to keep up with him. Da, in his approach to Langland's allegory, was assuming just such an advanced class.[74] Medieval readers like Da were often counseled to pay more attention to the "kernel" (the moral teachings) than the "chaff"—as the Nun's Priest himself finally admits, exchanging his raconteur's hat for his preacher's cap at the very end of his tale: "Taketh the fruyt, and lat the chaf be stille" (VII.3443).

Since the clerically trained of all sorts form by far the largest known audience for *Piers Plowman*, we could expect this widely accepted form of reading to prevail in *Piers* marginalia, and often it does—but not solely.

1. Annotators of the C-Text of *Piers Plowman* and Their Handling of Major Cruxes

If we were to combine the X and D readings into one conglomerate reading, we would have, perhaps, the winner of the supper Harry Bailey promises the tale tellers at the beginning of the "General Prologue" to the *Canterbury Tales*, with Harry's "best sentence" and "moost solaas" (I.798). If we were to add Y's marginalia into the mix, we would have legal and political commentary. Taking all three together we would also have evidence of the influence of English manuscript production in civil service or civic secretariat circles and/or by legal scribes who worked either in government offices like Chaucer himself did or in legal settings such as Langland must have (judging by his extensive legal vocabulary). These circles, as scholarship is increasingly showing, were always pushing English literary texts in new directions.[75]

So keen is Xa to tell Will's story that we can get a blow-by-blow description of even small events in the poem such as Will's meeting with the two friars, which is annotated in true Aristotelian fashion, with beginning, middle, and end. It is also capable of *displacing* the text itself, schoolmaster style:

C.X.5 (44r) // hyer will*e* | so3te dowel | *and* mete wy*t* | ii freris

.17 (44v) // lo what a frer*e* sayde | of dowel

.30 // n*ota* how þe ry3twise | falleþ vii syþis in | þe day *and* 3i[t] standith | safly

.56 (45r) // hyer*e* dep*ar*tid will*e* | *and* þe frer*is*

But Xa's sense of humor surfaces here as well (something he shares with Da and also sometimes Y's annotators), in this tongue-in-cheek summary note in which Will "sought Dowell" but (instead) "met with two friars" (X.5). Judging by the amount of antifraternalism he indulged elsewhere in his marginalia, this is unlikely to be straight, but it certainly is deadpan. Fig. 6a shows Da's note going straight to the "kernal," entirely skipping the storyline and the friars, further displacing the text; it also shows the equally ambivalent response of the D illustrator (who is not Da) to the scene, caricaturing the friar's face but also using real silver to mark the Franciscan cord of poverty around his waist (the friar's leanness being tes-

73. See Wheatley 1996.

74. This would be consistent with what we know of the audience for which Douce 104 was created. See Kerby-Fulton and Despres 1999.

75. D and X are among the manuscripts of *Piers Plowman* produced in civil service milieus (see Kerby-Fulton and Despres 1999). For Y's connections with the legal world, see Schaap 2001. See also Mooney 2007 and 2008.

timony to his sterling adherence to this vow). Note that the D illustrator made the friar stand literally on the word "stond," the key moral image of the exemplum—this kind of pun was considered optimal for mnemonic devices.[76]

Xa, in choosing to focus so clearly on the narrative trajectory of *Piers*, also reflects another distinctive type of medieval reading, that is, reading for emotional events. Perhaps the Jane Austen of *Piers* annotators, with his attention to subtle emotional nuance, even a conversational moment can be an event for him:

C.XIII.213 (61r) // hyer caw3te | will colour[77]

[where Will blushes upon being rebuked by Imaginatif, having been ejected from his dream for challenging Reason's reasonableness]

Emotion in the later Middle Ages would have been associated with a tradition of affectivity, whether in devotional writing ("affective piety") or in some specific kinds of romance: one of Xa's contemporaries, John Cok, also enjoyed highlighting emotional moments in devotional texts.[78] X's cycle then represents a distinctive type of medieval sensibility—not one, interestingly, much represented in *Piers Plowman* itself (where Xa had to work to find it), and hardly noticed in D or Y.

In emotionally charged moments of Will's personal experience,[79] Xa highlights Will's role for the reader as a "participatory" I-speaker, confirming what modern scholars have long thought a key function of dream-vision narrators, as Paul Piehler theorized years ago.[80] Will's moods and sufferings—and also, we might note, Lady Mede's (e.g., "// hyere muornede [sic] mede | for *con*cience acusede her*e*," III.215, fol. 13v; "// hyer*e* murned mede | for sche was clepid hore [called a whore]," IV.160, fol. 20r)—are carefully recorded and form the backbone of the X cycle. Not so, interestingly, Piers's own emotional responses, which are entirely ignored: he is clearly too remote a figure, too godlike, perhaps, for this humanized emotional treatment, even though, as hero, he experiences several emotions in the poem, such as anger, uncertainty, and pain. Xa is not alone in this view of Piers. Many other annotators confirm this sense of his divine role, too: typical, for instance is the dignified "grace is *with* perse the ploughman" (XXI.211, fol. 88r) of Y2 (Y's later annotator). In X, Langland's dramatic allegories (to use Elizabeth Salter's helpful term for allegorical characters so realistic

that all they need is a human name),[81] but only the dramatic ones, such as Mede, Glutton, Wit, and Will himself, live and breath for the annotator. His enjoyment or empathy is palpable, like the episode in which Glutton vomits up a "soup" ("caudel") as Clement tries to lift him from a drunken swoon:

C.VI.412 (29r) // Glotou*n* cowede a caudel | in cleme*ntis* lappe

The line is textually gleaned,[82] but the annotator could simply have delivered an exhortation against drinking or, like the majority of B-text annotators, identified the passage only as "Gula [Gluttony]," one of the seven deadly sins.[83] Instead, he lifts out the unforgettable word "caudel" and delivers both Harry Bailey–style "sentence" and "solaas" (*Tales*, I.798)—and an unforgettable mnemonic device.

What lives for Da is allegory of all kinds, such as embryonic allegory:[84]

C.XII.19 (55v) n*ota* de wower*e*

[when Will finds that a friar will not hear his confession unless he has money and accuses him of being like a wealth-motivated suitor]

or

C.XV.56 (67r) n*ota* de sowr lof

[at the Feast of Patience, when Will and Patience are seated at a side table and given only a "sour loaf" of bread, and told to do penance: "Agite penitenciam"]

and figural allegory:

C.XX.21 (92r) n*ota* how ih*esus* schal jowst i*n* persis armo*ur*

[at the allegory of the Crucifixion]

and diagrammatic allegory:

C.XVIII.86 (83v) n*ota* de wedlok woddowot [widowhood] *and* maydenot [maidenhood]

[using only words with Anglo-Saxon roots rather than any of the Latinate words in Langland's text ("Matrimonye" [86], "Virginite" [89]), in the allegory of the Tree of Charity].

76. Kerby-Fulton and Depres 1999, 10.

77. Grindley misnumbers this note.

78. On Cok as a scribe of religious texts, including an excerpt from *Piers*, see Kerby-Fulton and Despres 1999, 70–75; for Cok's notes to romances, where didacticism is the key focus, see Eddy, forthcoming.

79. See, for example, the notes at C.I.69, IX.167 and XX.4; all the notes in X are transcribed in Grindley 2001.

80. Piehler 1971, 9.

81. Salter and Pearsall 1967, 10ff.

82. The label is from Grindley 2001 and distinguishes those annotations that draw their substance from the text being annotated and those notes freely composed.

83. For the many, many B-text notes on this passage that say only "Gula" or the English equivalent, usually at B.V.297 as part of the Seven Deadly Sins cycle, see the listings under that verse in Benson and Blanchfield 1997.

84. This enormously helpful term is from Pearsall 1994a, 16.

These few examples from D's cycle could be multiplied to take in every kind of allegory in Salter's taxonomy, not simply the dramatic allegory noticed in X.[85]

Both the fifteenth-century Y annotators, more than either of the other two, are more literal readers. But the main interest of both the earlier (Y1) and later (Y2) annotators is polemical, political and legal, perhaps in keeping with the political nature of the lyric poetry also found in Digby 102. A few examples will give the flavour of Y2's interests and love of specialist terminology:

C.III.113 (3v) vsurers *and* regrato*u*rz be not
 enf*r*aunchised

[beside a passage decrying how usurers and fraudulent retailers are enfranchised as free men of the city through bribery, despite city ordinances]

C.III.179 (4v) mede copith [robes] the com*m*issary

[referring to Lady Mede's plenteous bribery of the commissary-general, a clerical official who presided over the bishop's court and was often bribed by fornicators][86]

Y2 was always intrigued by Westminster, and in fig. 4b we see his hand at characteristic work on the annotations from the end of the Lady Mede episode, here the king's appointment of Reason as chancellor of the Exchequer (184), and Reason's denunciation of "vnsittyng sufferaunce" (tolerance of improprieties, 189) at court. Y1, writing circa 1425 (fig. 5), though more terse, also likes to highlight legal genres and terms:

C.IV.45 (9v) |. **billa**

[referring to a parliamentary petition, where Peace presents a petition against Wrong]

or

C.XXII.137 (94r) |**Arches**

[referring to the havoc Antichrist wreaks in the Court of Arches, the Archbishop's court].[87]

He has a system of brackets, circles, or *punctus* points to distinguish certain notes (the latter evident in fig. 5, discussed below). Whoever Y1 and Y2 were, they were following Langland's critique of the courts, parliament, politics, and church in minute detail. Although very different readers, together the annotators of the three manuscripts and D's illustrator exemplify highlighting strategies to satisfy the three most crucial audiences for the poem: literary, theological, and bureaucratic—a combination uniquely typical of the writing office and civil service milieu.

We come now to the treatment of two major critical cruxes in the C-text: first, whether or not we hear authorial voicing in the so-called "autobiographical" passage (C.V.1ff.), and, second, whether Langland's long new addition on beggars ("lollars") and the "deserving" poor (C.IX.83ff.) also reflects in any way his attitude toward the Lollard movement (as inspired by Wycliffite writings) in the C revision. These passages evolved in many ways from two famous passages he had ripped out of the B-text, the Tearing of the Pardon and Imaginatif's chastising of Will for writing poetry. As we will see, the new passages in C were much more popular with annotators than their B-text counterparts. These are cruxes for which the three C annotation cycles (and, below, sample B cycles) can serve as a litmus test for differing early responses.

With respect to the "autobiographical passage," Xa is especially noteworthy as he never swerves from a sense of Will's agency, not even here. He treats the narrator consistently as Will, that is, *actor* not *auctor*—a dilemma for annotators of both Langland and Chaucer.[88] Here is how differently the annotators regard C.V's "autobiographicality" (table 8):

TABLE 8		
Xa (c. 1400)	Da (c. 1427)	Y1 (c. 1500)
at C.V.8 // hyer concience ǀ *and* raysou*n* aratyd ǀ wille for his lol ǀ ly*n*ge (20v)	at C.V.9 I had noo wyll to do gode (21r)	at C.V.16 idelnes (12r)
·35 // hyer wille answered ǀ to rayson (21r)	·61 no*ta* de clerkys (22r)	
·104 // hyer wente wille ǀ to churche *and* ful a ǀ ȝen a sclepe (22r)	·78 houu pore gentill ǀ beþ refusit (22r)	·111 prayers *and* penaunce is god labo*u*r (13r)

85. For a full discussion of this annotator, see Kerby-Fulton and Despres 1999, ch. 3 and 181–191.

86. See Pearsall 1994a, note to C.II.190.

87. See Schaap 2001, 97, on the different bracket systems.

88. For several instances of annotations attempting to distinguish "actor" from "auctor" in *Troilus* annotations, see Benson and Windeatt 1990. See Kerby-Fulton 1997 on the medieval literary theory.

Y2 is most uncompromising, entirely discarding Will as the "chaff" (the story) for the "fruit" (the moral)—Chaucer's Parson would be proud of this reading. Xa regards the "I" speaker, significantly, as just Will's character. But Da, who normally pays no attention to the narrator, preferring instead to follow the allegorical threads of the poem, opts suddenly for the pronoun "I" ("I had noo wyll to do gode"), the only use of "I" in his entire cycle of 257 annotations.[89] This looks like recognition of a shift in narratorial voicing, such as many modern critics have heard here, coupled with a delightful pun on Will's name (Da loves to pun, a mnemonic technique throughout the manuscript). Da also fearlessly responds to the most virulent political segments here, highlighting the poet's screed against bondsmen, bastards, and beggar children becoming clerics (C.V.61ff.) and highlighting the suffering of "pore gentill" folk who are bypassed for knighthoods and bishoprics now that anyone can buy or bribe his way into them (C.V.78). By contrast, Xa carefully avoids all the controversial political and social ramifications of the passage, which has been widely read as Langland's response to the Rising of 1381, a controversial subject, and shifts to the safer verb "lolly*nge*" to describe Will, whom Langland had portrayed as "yclothed as a lollare" (C.V.2), though "lytel" regarded "amonges lollares of Londone" (C.V.3, 4) because he makes poetry at their expense. Xa is apparently reluctant to use "lollere" for his narrator/protagonist, Will, though in C.IX he willingly uses this label for other groups (see next table).

The Passus IX segment on begging, "lollars," and just alms-giving was very popular, as we saw in ch. 1; in the Ilchester manuscript, which is quite early, it is even pushed up to the front of the poem (see ch. 1, fig. 17). Sandwiched between the description of the Pardon from Truth, and

Piers's argument with the priest, it was also an object of fascination to all the early annotators (and the D illustrator). Table 9 below gives the entire and massive response to the new passage by the three annotators and D illlustrator.

There is no clear evidence anywhere here of awareness of heresy. Anne Hudson has shown that the term "Lollar(d)" for followers of Wyclif was not reliably in use much before 1388 and only slowly gained ground in the 1390s.[90] Xa, perhaps working in the 1390s (certainly c. 1400) does not use the label to mean heretics and Da refuses to use the word at all. Only Y1 noticed Langland's unique and enigmatic attempt to define the word *lollar*, perhaps against rising appropriation of it in anti-Wycliffite circles (line 213),[91] but his *nota* there does not tell us what he recognized, and the other two annotators do not find the attempt either interesting or recognizable.[92] The hot topic for all of them is not heresy, it is begging. Xa and Da are moved by the plight of poor cottagers at C.IX.71ff., one of Langland's most poignant new segments, on the struggles of destitute, apparently single mothers of whom he says that it is "reuthe . . . to rede or in ryme shewe / The wo of this wommen þat wonyeth in cotes" (IX.83–84). Da highlights these self-consciously poetic lines, though we have to be careful of assuming concern for gender issues, because the main text in D actually masculinizes the women, rendering the standard reading "wommen" as "wonnyng men," even though the key activities of the passage, spinning and infant care, are uniquely female at this time.[93] All three annotators show empathy for the "lunatic lollars," Langland's new segment urging charity and prophetic abilities for the mentally and psychologically disabled wanderers. D here has a moving illustration of one such "lollar" dressed like a biblical apostle (fig. 6b), paralleling

5. Detail of a note to *Piers Plowman*, C.IX.106, in the hand of the early annotator, Y1, working at the time the manuscript was made. The note reads ". Lollard*es* ." and the passage, part of Langland's new segment on beggars in C.IX, describes the suffering of the mentally and psychologically disabled "lunatyk lollares." Oxford, Bodleian Library, MS Digby 102, fol. 31v, c. 1425.

89. See Kerby-Fulton and Despres 1999, ch. 3, on the characteristics of Da. In their variants to this line, Russell and Kane mistook this for a correction.

90. Hudson 2003.

91. See Schaap 2001 for the full transcription, but Y2 (c. 1500) writes "lollard*es*" at IX.217, fol. 33r where Langland explicitly attributes spiritual "lameness" to lollars.

92. On these and other relevant *Piers* annotations, see Scase 1989, 155–60; see Kerby-Fulton 2006 on the lack of interest in Lollardy in many quarters c. 1400.

93. This kind of "universalizing" is typical in D. See Kerby-Fulton and Despres 1999.

TABLE 9		
Xa (c. 1400)	**Da (c. 1427)**	**Y1 (s. xv¹)**
	C.IX.83 (41v) "*n*ota de woo of pore ǀ pepill þat wo*n*nyth ǀ *in* por howsyn *and* haþ ǀ childyr" *beside the woes of poor cottagers*	
C.IX.92 (40v) "ǀcoterelis feste" *beside a list of low quality food that would be a feast for poor cottagers*		
.106 "ǀLunatyk lollar*es*"	.106 (42r) IMAGE OF "LUNATIC LOLLAR" (**fig. 6b**) *dressed as biblical apostle*	C.IX.106 (31v) "Lollard*es*" (*see* **fig. 5**), *beside the definition of the "lunatyk lollares," who lack wit, but travel like Peter and Paul, sometimes prophesying* .127a (32r) "*n*ota" *beside* "Si quis videtur sapiens, fiet stultus vt sit sapiens/ If anyone thinks he is wise, let him become a fool that he may be wise" (1 Cor. 3:18)
.140 (41r) "ǀpropur*e* lollar*es*" *i.e., the lazy beggers*		
	.166 (42v) "*n*ota de beger*s* þat hath lem*m*onys" *i.e., have lovers*	
.170 "// byhold hyer ǀ of lollar*en* childr*e*" *i.e, children whose limbs are broken by their parents to enhance begging*		
	.175 (43r) IMAGE OF BLIND MAN	
.204 (42r) "// *n*otate ʒe lewede ǀ ermytes" *i.e., former workmen who impersonate friars in order to beg*	.204 (43v) "*n*ota de hermytes þat ǀ wo*n*yth by þe hey ǀ wey"	
		.213 (33r) "*n*ota" (*circled*), *beside Langland's definition of a "lollar" as one who is "lame" in body or, like false hermits, lame in belief* "the lawe of holy churche"
	.223 (43v) "*n*ota de lewyt men ǀ *and* lordis" *exhorting both to be faithful*	
.247 "// hyer*e* mette ǀ wille wy*t* lollar*es* ǀ to þe mete ward" *beside the poet's comment that he often meets false hermits begging at noon*	.247 (44r) IMAGE OF FALSE FRIAR	.249 (33v) "*n*ota", *beside imposters posing as friars*
.263 "ǀ*n*otate ep*iscopi*" *beside a complex allegory of shepherd's salve for wounded sheep now being "supersedeas," a writ often obtained by bribing a summoner*	.265 (44r) "*n*ota de molle ǀ pastore". *i.e., "under a weak shepherd" [the wolf befouls the wool]* .265 (44r) IMAGE OF SLEEPING BISHOP AND WOLF STEALING SHEEP	

Y1's note (fig. 5); he was also highlighting the association between their sufferings and St. Paul's "fools for Christ" (in the Latin at IX.127a) on the next page. Xa contrasts these lunatics to what he calls "propur*e* lollar*es*" ("true lollars," that is, corrupt beggars) suggesting that Langland's attempt to reclaim the word by using it for the psychologically disabled he sees as figural but not real.

All these C-text annotators saw that the passage dealt with the major social and ecclesiastical problems of their moment, far outweighing, for instance, the impact of the B-text Pardon Tearing episode, which is hardly noticed by annotators (see below), and which in effect it replaces. As we will see shortly, Langland's move to replace the B-text Pardon Tearing scene with this new long, often poignant passage on deserving and undeserving beggars was a more popular move than the Tearing had been.

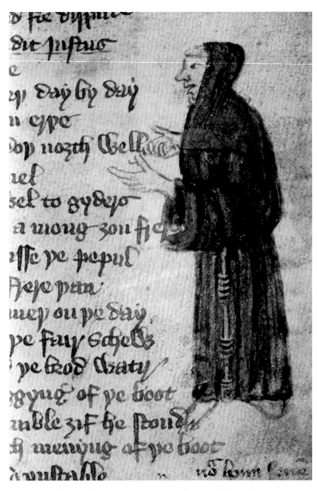

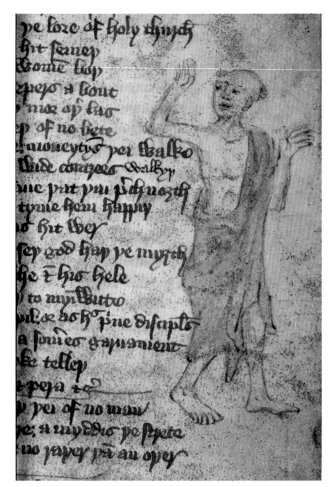

6a. Detail from the passage in *Piers Plowman* about the Franciscan Friar encountered during Will's search for Dowell. The annotation below (partly cropped and very rubbed in the MS) is from his exemplum and reads in full: "no*ta* houu [seue*n*] syþ[ys in] þe de[y] synny[*s*] þe [ryt]fol" (C.X.37). Only the first three words are visible here. Oxford, Bodleian Library, MS Douce 104, fol. 46r.

6b. Image of the "lunatic lollar" from *Piers Plowman* (C.IX.106), sanctified by the illustrator, who portrays him (unlike other figures in the cycle) in gold-dusted biblical garb. Also evident is the hand of the annotator, here acting as corrector, adding the word "walkyþ" below the main text's "walke." Oxford, Bodleian Library, MS Douce 104, fol. 42r.

2. The Annotations of the B-Text of *Piers Plowman* and Langland's Revisions

The B-text's marginal annotations are the only ones that have been fully transcribed in published form, and in his introduction to his transcription, C. David Benson records his disappointment in their quality:

> Unlike proper medieval glosses, they do not analyze, comment on, or elucidate the text at any length. [They] . . . are almost always brief and often not more than a single word—*nota*. Nothing suggests that any note in the B-MSS necessarily derives from the author of *Piers Plowman,* nor is there any evidence that a standard scheme of annotation was ever developed. . . . Except for the Latin names of the Deadly Sins in Passus 5, few notes are found in more than one manuscript. Each scribe apparently produced his own . . . , with the exception of two groups of closely affiliated MSS.[94]

One group shares no more than a single note,[95] but the second group, O (Oxford, Oriel College, MS 79) and C2 (Cambridge, University Library, Ll.iv.14), shares a large number of verbatim notes; these two, along with Bm (London, British Library, MS Add. 10574), which has a couple of unique notes on the "author," and a manuscript genetically related to it, C (Cambridge, University Library, Dd.i.17), provide us with our best windows on memorable B-text annotation. One further bright spot is the somewhat later set of B-text annotations in M (London, British Library, MS Add. 35287), an unusually intelligent and creative supply, but the notes are in many dif-

94. Benson and Blanchfield 1997, 20.

95. Bm (BL MS Add. 10574), Bo (Bodley 814), and Cot (Cotton Caligula A.xi); Bo has a note at its Prol.56, also found in Bm; Cot has a note at VI.86, also found in Bm (Benson and Blanchfield 1997, 20). The three manuscripts have long been identified as textually related.

ferent hands, most quite late.[96] So for our purpose here, to understand audience response to passages Langland revised out, O, C2, C, and Bm, whose main texts are all genetically related and contain early notes, are most useful.[97]

The major themes that Benson identifies as being staples of the early B-text annotators are fairly simply listed: the Seven Sins, prophecies, clerical reform, the friars, and a handful of notes trying to identify the poem's author—whom they did not necessarily distinguish from the narrator, Will.[98] Typical of this is the note in O at B.XV.152: "longe | wille," not echoed in the notes of O's fraternal

twin, C2, but in the later marginal supply of C2, a mid-sixteenth-century hand writes "Longe will" at this well-known line: "'I have lyved in londe,' quod I, 'my name is Longe Wille.'" One of the very few notes longer than a single word in the B-text portion of Bm[99] also occurs at this line: "Nome*n* auctor*is* | [h]ui*us* lib[r]i e*st* Lo*n*ge wille" (The name of the author of this book is Long Will, B.XV.152, 62v),[100] and another similar Latin note appears at the very opening of B.XV where the dreamer is awake, and wandering in a semi-mad and antisocial state (fig. 7; table 10):

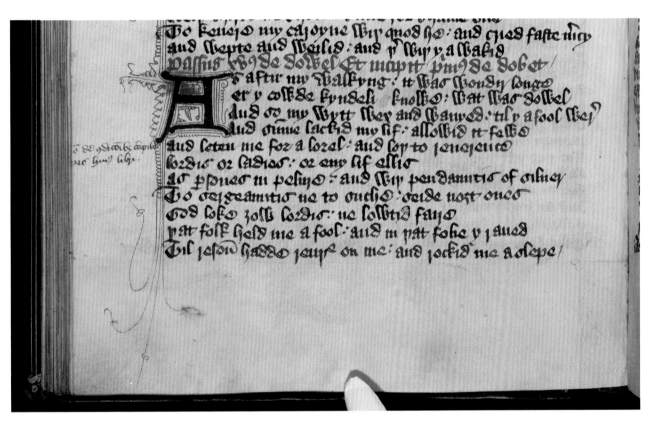

7. Detail of a note to *Piers Plowman*, B.XV.3, showing a partially cropped marginal annotation that reads: "[n]*ota* de *condicionibus* compila | [to]ris hui*us* libri" (Note the condition of the compiler of this book). London, British Library, MS Add.10574, fol. 60v.

TABLE 10	
[n]*ota* de *condicionibus* compila \| [to]ris hui*us* libri [Note the condition of the compiler of this book]	And so my wytt wex and wanyed : til y a fool wer*e* And su*m*me lackid my lif : allowid it fewe And leten me for a lorel : and lo þ to reuerence Lordis or ladies : or eny lif ellis ~ Þat folk held me a fool : and in þat folie y raued (Bm [BL, MS Add. 10574], fol. 60v; B.XV.3–6, 10)

96. Simon Horobin has recently found Adam Pinkhurst's hand there active as a corrector in M; see Horobin 2009b.

97. Recorded here in the order they appear in the apparatus of Kane and Donaldson 1975; see Hanna 1993, 39–40.

98. Benson 1997, 21–24.

99. The manuscript is only a B-text from Passus III to the end. Bm (BL MS Add. 10574) is one of the manuscripts designated by Fisher as being in a Chancery hand. See Fisher 1988, 268–69, and Kerby-Fulton 2000a.

100. Here and in the next note, page cropping interferes with the text.

Here the annotator calls the narrator a "compiler"—which is what Chaucer is called in the explicit of the Ellesmere MS: "Heere is ended the book of the tales of Caunterbury, compiled by Geffrey Chaucer, of whos soule Jhesu Crist have mercy. Amen."[101] The term *compilator* (compiler), which has a very specific meaning in the Middle Ages, as Alastair Minnis has shown, is perhaps more understandable in relation to Chaucer, since the *Tales* are a collection of discreet units originally by other authors, adapted, and gathered together with framing material written by Chaucer (virtually the medieval definition of *compilatio*). The use of this descriptor for the author of *Piers Plowman*, however, raises interesting questions about how a contemporary saw the poem structurally. As a compilation of dreams? Of voices? Of dialogues?[102] Of doctrine? And equally intriguing is his assumption that Will's state of madness describes the real-life "conditions" of the compiler. We can scoff at this as naïve reading of persona, but in a period when Hoccleve can describe himself in his poetry as suffering from madness and actually mean what he says (as we now know from documentary evidence), what does this assumption on the part of the annotator really mean?[103] While it is clear from the annotator's tone that he did not know Langland personally and may well be a flat reader of fiction, it is also equally clear that the distinctions between author and persona are lost on him and many others (we saw the same in annotations to Chaucer, above). This, in itself, should give us pause about how this distinction worked for medieval authors—or how they, in turn, exploited its ambiguity.

B-text notes are not usually so fulsome as the C-text ones; in fact this distinction can be seen *in parvo* by a swift glance at Benson's listing of the Bm annotations, because the notes in the C-text portion of Bm (Prologue and first two passus) are in full sentences or phrases like those we saw in C-text manuscripts earlier, while the B-text portion is annotated with single words and manicules, the only exceptions being the two unusual Latin notes on the author just mentioned. Clearly there was a different

annotation style for B-texts and C-texts, suggesting that scribes imitated the notes of earlier copies, even where they didn't copy them. B annotations—oddly, considering the modern reputation of the two texts—are usually, with a few exceptions, far less literary in quality than their C-text cousins. B notes are less likely to trace the course of the narrative,[104] and most surprising of all, they take little account of the things that modern scholars find so crucial about B: especially the Tearing of the Pardon episode, and the dialogue in which Imaginatif chides Will about writing poetry, but also the overarching literary narrative tracing Will's personal growth (or not), and even the supposed climax of the poem in the Crucifixion and the Harrowing of Hell. Study of the B notes really underlines how differently medieval and modern readers could think. That said, the B notes do show different kinds of annotators at work, and there is a discernable difference between what an apparently learned cleric (as in O)[105] or a civil service annotator (as in C2 or Bm)[106] might choose to highlight, as compared to what a convent annotator highlighting C (CUL Dd.i.17), likely a York Austin friar,[107] might select for notice (see also ch. 6, sec. I, below).

O and C2 share the only substantive body of notes to recur in two B-text manuscripts. At times, C2 follows O closely, even slavishly, even sharing notes with O that are lexical glosses, despite the fact that the manuscripts were written in different dialects. O has by far the largest supply, and its main text was written perhaps a quarter of a century before C2. Whatever the textual explanation for their partly shared supply, C2 shares a staggering sixty-five annotations, verbatim, with O. The notes, however, are often so terse as to seem like merely telegraphic-style topic headings and are unlikely to have descended from anything authorial.

Both annotators, for instance, mark the passus about Piers's Pardon from Truth (Passus VII), but neither takes the slightest interest in the Tearing of the Pardon (B.VII. 115–38), as one can see just from checking the line numbers below:

101. See *Riverside Chaucer* 1987, 328; for an image of this colophon, see Petti 1977, plate 3. On concepts of *compilatio*, see Parkes 1976 and Minnis 2008; on Chaucer more specifically, Minnis 1988, ch. 5.

102. As Hanna points out, four early London B manuscripts (Cambridge, Trinity College, B.15.17 [W], BL MS Add. 35287 [M], Bod. MS Laud misc. 581 [L], Cambridge, Newnham College, MS 4 [Y]) share a colophon that identifies the poem as "dialogus Petri Plowman." See Hanna 2005, 246–47, and 258ff.

103. See Burrow 1983, and for the newest documentary evidence of Hoccleve's illness, see Mooney 2007, 313ff.

104. In addition to the C-texts we just examined (X, D, and Y), see also Bod. Digby 145 (Kerby-Fulton 2003). All have good examples of elaborate annotation cycles, exceeding any B notes in detail.

105. Judging from the presence of Latin poetry in part I of the manuscript, the part containing *Piers*. On fol. 88v, though in a different fifteenth-century *Anglicana* hand from the *Piers* text, A. I. Doyle identified the texts of the "Latin and Greek refrain of the Improperia with an English version" (cited in Kane and Donaldson 1975, 11–12).

106. The scribe of Bm has civil service training (see n. 99 above). The scribe of C2 has also been identified by Fisher as having had Chancery training. The contents, which include the single extant copy of *Richard the Redeless*, point to a civil service and/or political milieu.

107. Benson and Blanchfield 1997, 33–34, list the evidence for this provenance among the York Austin friars as arrived at by Doyle and Hanna. For a recent study of Dd.i.17, see Kerby-Fulton 2006, Case Study 1.

TABLE 11	
O	C2
30r / B.VII.18 Marchauntis	34r / B.VII.18 March[a]undis
30r / .26 how þu schalt do ǀ þin almes	34r / .26 How þu shalt do ǀ þin almes
30v / .72 catoun of ǀ almes dedis	35r / .72 Caton of ǀ almes dedis
30v / .83 Of falcse beggeris	35r / .83 ffalse beggers
31r / .99 [in red] þe pardoun ǀ of peris ǀ Plowman	——
32r / .192 Of pardoun[1]	36v / .192 of pardon

1. On 32r, above the note at B.VII.192, these unfinished words appear: "now haþ þe p . . ." The note is not an annotation (these are normally underlined), and the unfinished word is unlikely to be "pardon," since it is not a "*par*" abbreviation.

Not only are the notes verbatim (here and often elsewhere in these two manuscripts), allowing for minor differences in orthography (and the rubricator's insertion of an extra note in red ink at 99 in O), but more strikingly, if one compares the line numbers, it is immediately clear that the copyist is following the exact placement of each note in his exemplar as well. Even though the notes themselves are not barnburners, they do tell us something interesting about manuscript production, namely that annotations like these were not spontaneous, that copyists worked from exemplars or lists—and sometimes that copyists erred. A note misplaced, for instance, in the Douce 104 *Piers Plowman* (D), shows that the annotator was copying his notes and mistook one line on the subject of David for another.[108] These, then, are not the more personal notes of an annotator like John Shirley, the avid scribe and coterie bookman who signed his annotations and wrote jesting allusions to Chaucer in the margins, such as "Be pees or I wil rende this leef out of *your* booke."[109] O and C2 share mostly exhortative Ethical Pointers and workaday summaries that serve a Topic function.

In terms of content, what is interesting about this list of all the notes in Passus VII is not what is in it but what is *not*. In chart form like this, one can see that neither annotator notices any prominent aspect of the Pardon (not its origin from Truth, its contents, or the main estates it covers) nor the Tearing (lines 119–43), nor Piers's conversion to the contemplative life, nor any aspect of his argument with the priest. What is noted is all quite conventional,[110] and only the last note highlights a colorful line (where

the dreamer sets the value of pardons "at one pies hele" [at the value of a pie crust]" (B.VII.200). The O and C2 annotators, then, seem not to have shared much with modern readers of Passus VII, unless perhaps doubt about the value of official pardons. But if we are looking for direction on how to read a crux like the Tearing, or, in a later passus, a literary episode like Will's famous confrontation with Imaginatif over meddling in poetry (which neither annotator notices), we are going to be disappointed. Nearly the only B annotator who expressed definitive interest in the Tearing scene is the (probably) Austin friar scribe[111] of the B-text with the editorial sigil C (that is, CUL Dd.i.17), and he was interested only in Piers's renunciation of his sowing and decision to live by prayer alone (B.VII.118). Even so, his only comment was a *nota*.

Even the B manuscript with the most interesting, lengthy, and complex marginal supply, M, done in multiple, mostly late hands, is relatively unresponsive on these two episodes. There is a small rubricator's mark such as the late annotators (sixteenth century) often used in front of other notes beside line B.VII.119, where Piers vows not to be so concerned about food hereafter, but no note was ever written. More definitive is the treatment of the Imaginatif passage on poetry at the opening of XII. Here a fifteenth-century cursive annotating hand writes "Emendemus dum temporem habemus" (Let us amend ourselves while we have time), which simply translates into Latin and shifts into the first person plural Imaginatif's line: "Amende thee while thow might: thow hast been warned ofte" (B.XII.10).[112] If anything, this looks like the annota-

108. For images of the misplaced note, see Kerby-Fulton and Despres 1999, fig. 39.

109. As Veeman shows, he is impersonating the Wife of Bath here (2010). The transcribed quote comes from Harley 2251, fol. 142r. See Edwards 1972 for a complete transcription.

110. The notes highlight these topics: the merchants in the "margin" of Piers's document (B.VII.18); how the merchants are to give alms, extrapolated to include the reader (B.VII.26 "how þou . . ."); a rudimentary source gloss, naming Cato, who is already

named in the text (B.VII.72); a judgmental label on "false beggeris" (B.VII.83); and two notes highlighting belated issues the pardon raises: which of the poor are included, and the question of official pardons (B.VII.192).

111. See n. 107 above.

112. The annotation is not among those entered when M was first made; these have an L-shaped bracket, like those in HM 143 (X) discussed above.

tor wholly agreed with Imaginatif that Will is wasting his time writing poetry! We might have expected something more sympathetic from the annotators of M, who often provide Narrative Summaries in Latin, and who also like to point out some of Langland's livelier colloquialisms (e.g., "No*tabile* off | malkyns mayden | hed" at B.I.183), and who could enter into the allegory enough to write, for instance, beside the assertion of B.XX.321 that Piers "hath power over alle" the compelling note: "*id est* papa" (that is, pope). But even these annotators did not deliver on the Tearing or back up modern views on Imaginatif's altercation with Will over writing poetry.

These episodes were both cut from the text when Langland revised B to make the C-text, and the passages he replaced them with (or reworked them into) both get much more notice from his early audience, as we saw, than their B counterparts did. This tells us something new about Langland's revision process we may not have understood before: he was revising for *his* audience, not for us.

In fact, other major topics that get short shrift may surprise the modern reader, and were probably not taken up for very different reasons—because they were already too familiar to the clerically or semiclerically trained annotators who most often worked on this text, and their prospective audiences.[113] So, for instance, the annotators of O and C2 also jump completely over the Tree of Charity passage, the narrative of Abraham, Moses, and the Good Samaritan, the Crucifixion, and most of the Harrowing of Hell (in O the jump is from B.XV.550 to B.XVIII.125; C2's jump is almost the same), resuming where "veritas" (Truth) appears, introducing the first of the four daughters of God, Truth. The daughters are nearly his only interest

(Langland, of course, was progressive in his privileging of Mercy),[114] and he marks them as a scheme of four (medieval annotators loved numbered schemata and diagrammatic allegory: seven sins, four daughters, and so forth). How might we explain this lack of interest (repeated in other B annotators) in what we might feel is the poem's climax? Should this also make us rethink? For O, the climax of the poem is not Passus XVIII but the final passus, XX, with the coming of Antichrist, and the heightened role of the friars.[115] Moreover, this response can be paralleled in many annotators (in those manuscripts of the C-text we have already met, for instance, D and Y have enormous supply in the final passus), so it is far from unusual.

As we are beginning to see, medieval readers, especially professional ones, did not necessarily read as we do. They made assumptions about what their audiences would or should want to know or read; they might highlight narrative, allegorical, political, or other kinds of content. Whatever they thought of the abilities of the reader or patron for whom they annotated, they were themselves a great deal more learned than their notes usually show. We know this because once in a while a rare learned gloss appears in the margins of *Piers Plowman*. In the case of O, it is in the same hand as the simpler notes: a long, Chaucerian-style gloss from Jerome on the End Times suddenly appears in O at B.XX.53, in the same hand but in a different ink from the simpler ones.[116] It was, then, an afterthought, and quite uncharacteristic. But it supplies a valuable piece of evidence that the normally telegraphic, vernacular annotators of the B-text tradition were neither monolingual nor unlearned—nor did they expect all their readers to be.

III. Annotations and Corrections in the *Book of Margery Kempe*: Cruxes, Controversies, and Solutions

For yet another kind of approach to annotation of vernacular books, we turn to a Carthusian annotator's massive marginal response to the *Book of Margery Kempe* in BL MS Add. 61823, the only surviving manuscript. This now well-known work, likely the first autobiography in English, written or dictated by a larger-than-life woman of supposedly minimal literacy—mysticism's Wife of Bath—remains a scholarly puzzle. Endless ink has been spilled over the oddities of this work: Margery's perpetual search-

ings for visionary validation, the attacks on her orthodoxy and her antisocial loud fits of crying, all dramatized with liberal slices of fifteenth-century middle class life.[117] To this day, modern critics still disagree about major subjects: What caused the fits of crying that made her so unpopular? How much control did Margery herself exert as an author? What did religious professionals think of her and was gender an issue? The largest cycle of marginalia in our sole surviving manuscript deserves a chance to weigh in.

113. On audience literacy issues, see Middleton 1982 and Zieman 2008.

114. See Pearsall's note. O has one other note, at 76v / B.XVIII.300 "Of a dreem," which marks the place where the Devil tries to warn Pilate's wife in a dream and thus to throw the Crucifixion off course. O especially highlights novel theological items.

115. Whether or not these final passus were even originally part of the B-text has been questioned by Warner 2011, ch. 4.

116. See Scase 1989, 116–17, but the gloss was provoked, I believe, not by polemics but by a misreading of the word "leute" for "lent."

117. For a good discussion, based on internal evidence, of the role of Kempe's scribe and amanuensis, see the exchange between Nicholas Watson and Felicity Riddy in Olson and Kerby-Fulton 2005, 395–434 and 435–44; for a brief, illuminating reading of the annotations, especially in relation to Richard Methley, see Lochrie 1991, 206–12.

1. The Red Ink Annotator as Corrector

The main annotator of this cycle, known to scholarship as the Red Ink annotator (hereafter RIa), was working in the early sixteenth century in the Carthusian priory of Mount Grace in Yorkshire, before the Dissolution. Scholars agree that he was responsible for the marginal annotations in red, although the attribution to him of one minor set of simple red *n* (or perhaps open-topped *a*?) marks is somewhat less certain (see fig. 8b and the appendix to this section). Even this set of marks is also likely his, but we will never know for sure, and they are not critical to understanding his oeuvre either way.[118] Scholarship further agrees that he was by far the most prolific annotator in the manuscript, in any color of ink, and also final arbiter of the entire marginal supply, often boxing or highlighting in red earlier entries. Paleographical and dialect evidence suggests that he was also the corrector: as Meech first noted, both corrections and annotations in red show dialectal spellings originating "north of the Humber" (Meech and Allen 1940, xliii), and in contrast to the main text's dialect, which is consistent with Margery's native area of Lynn in East Anglia circa 1440. And RIa's large hand is always unmistakable in his discursive notes, which is the category of his work that will concern us here.

Though working much later, RIa is interested, among other things, in establishing and even correcting the historical facts of the biography (e.g., he adds "of lyn" in the margin of fol. 3v [note to 6:26] to clarify Margery's

husband's town of origin, Lynn). He was rubricating (or heightening or finishing rubrication?) as well as annotating and even correcting in red rubricating ink, which in places has the almost comical effect of a college student's highlighting pen rather than the subtlety scribes normally sought in canceling a mistake.[119] If one looks through the manuscript, these corrections cannot help but jump off the page, and they form a distinctive pattern. So, for instance, despite having an affective bent to his piety, the annotator does not seem to be entirely happy about Margery's handling of what Barbara Newman calls the "scripted vision" genre—the kind of "vision," that is, arising from prepared meditations on the life of Christ.[120] Or, to put it another way, he does not like departures from "the script" (something he shares with the anonymous Carthusian author of the *Mirror for Devout People*)—distrusting the leaps of *ymaginacyonys* possible in scripted vision.[121] He will strike through sections in which Margery, for instance, sees herself helping to care for Christ as a child:

~~*and* holpyn to kepyn hym in hys childhod *and so forth in to þe tyme of hys deth*~~

(98v; 203:11; see fig. 8a)

or where she has a vision that a man cuts Christ's body with a dagger:

~~And þan cam on *with* a baselard knyfe to hire syghte / *and* kytt þat precyows body al on long in þe brest~~

(100v; 208:8–10);

8a. Detail from *The Book of Margery Kempe* (203:11), showing the red ink corrector's dramatic habit of strike-through correction in red, here indicating his disapproval of one of Margery's imagined meditations. The crossed *d* in the margin (abbreviating "deleatur") marks the intended deletion. London, British Library, MS Add. 61823, fol. 98v.

118. Please see "Appendix on the Red Ink Annotator" at the end of this section that deals with the puzzle presented by the multiple colours of red ink in the marginalia, as noted in Fredell 2009. The marginal annotations and corrections in red ink have been fully transcribed by Parsons 2001. Citations give the folio number in BL MS Add. 61823, and the page and line number in the printed edition are from Meech and Allen 1940.

119. A similar system of correction appears in Bodley 505, also a Carthusian manuscript.

120. Newman 2005.

121. See Johnson 1999b, 73ff.

8b. Passage from *The Book of Margery Kempe*, showing the varying rubrication colors and layers of annotation that make detecting RIa's work complex. Acting as a corrector, he added the word "gostly" to "dawnsyn ^gostly^" to prevent a more worldly reading (52:29). A discursive note by RIa (with his usual horizontal-tailed trefoil) appears where Christ tells her that she is a singular lover of Christ ("singularis *Christi* amatrix"). Further below, the marginal "no*ta*" by RIa appears where Christ promises she will dwell with him in heaven. It is difficult to account for all the varying rubrication colors and highlighting devices that can be seen on this page (see appendix to this section), but it is very clear that the red ink was not all applied at the same time. This, however, does not necessarily mean multiple hands at work for each new application. London, British Library, MS Add. 61823, fol. 26r.

or where he finds her diction too worldly (e.g., at 49v; 101:14), and makes her verb "to sportyn" into "to refresse," apparently a more seemly descriptor for saints relaxing in heaven. We see him inserting the adverb "gostly" to describe activities that sound too exuberant in some secular way. For instance, at folio 26r (52:29), he makes "dancing" more spiritual by adding the word "gostly" ("dawnsyn ^gostly^," see fig. 8b) or at folio 43r (87:14), even God the Father's hands cannot be trusted if literal: "þe fadyr*e* toke hir*e* be þe hand ^gostle^"! Or, we could note his deletion of "abedyn" in the description of demonic sexual thoughts or temptations at folio 70v (145:22): "cursyd mend*ys* ~~abedyn w*yth* hir*e*~~ wer*e* delectablyl to hir*e* ageyn hir*e* wille."

When one studies the corrections alone, one gets the sense of a prudish monk, but his annotations tell a far more interesting story—and, unlike anything we have seen so far in this chapter, a much more personal one.

2. The Red Ink Annotator as Professional Reader

RIa eagerly followed visionary issues and genres. His supplementary *ordinatio* in red, for instance, on folio 9v marks off as a "visio" (18:8) an early vision validated by an anchorite who tells Margery that she is now "sowkyn" at the breast of Christ—using "visio" in its technical, Macrobian sense. But he is not naïve. He repeatedly marks the

margin with the word "dyscrescio*n*" (fol. 13r), following nearly every attempt at visionary validation or probation Margery makes. In fact, *discretio*—the discretion or testing of spirits to distinguish a true visionary from a false—is one of the key things that interests him, even in the passage where Margery negotiates chaste marriage with her husband. This well-known episode is a modern anthology favorite, with its irresistible exchange in which Margery's husband asks her whether she would have sex with him again if a man threatened to slay him instead, whereupon she remains unmoved, and he ruefully retorts that she is "no good wyfe" (11:24). But however fascinating to us, none of their marital dialogue in this episode interests the RIa, only their vows of chastity. Thus, he writes "vow" (fol. 12r; 23:36) where Margery is asking for the vow of chastity; his large capitulum-style *n*, if indeed it is his, on folio 13r (25:11) appears beside the idea of giving up on Friday fasts (which, Christ affirms, had been a bargaining chip). Most movingly, he highlights the sentence delivering John Kempe's chivalric vow "**Than** seyd hir*e* husband . . . As fre mot ʒo*ur* body ben to God as it hath ben to me." Here the annotator (in the same red ink as "vow" above) also writes "grace" (fol. 13r; 25:12)—meaning the grace of God, of course, but also a gesture toward the gracefulness of John Kempe's words (spoken prose worthy of the mature Malory and a rarity in *The Book of Margery Kempe*).

We can learn much from this annotator about what we are supposed to follow, what we should pass over in silence, and what we should memorize. So, for instance, in chapter 13, where Margery is called a heretic and threatened with burning in Canterbury, fearing for her life, the annotator is silent. His (if it is his) large capitulum-style *n* appears (fol. 14r; 28:2) when issues of discretion arise (a monk asks whether she has the Holy Ghost or the devil, highlighted by a red paraph in the text). He rounds off chapter 13—a chapter modern scholars mainly read for issues of heresy—with one of his many validating assertions about Margery's wisdom: "R Medlay . v . [i.e., vicar] was wo*nt* so to say" (fol. 14v; 29:17) beside the comment that it was a wonder Margery's eyes and heart could endure the "ardour" of her passion. The reference is to Richard Methley, the distinguished Carthusian translator into Latin of Marguerite Porete's *Mirror of Simple Souls*, as well as the *Cloud of Unknowing*, a member of the annotator's own house.[122] Throughout the annotations, Methley is paired with another historical person, "prior Norton": for example, on folio 33v (68:31), "so fa RM | *and* f Norto*n* | of Wakenes *and* | of þe passyon."[123] The subject here is Margery's loud crying (the previous note on the same

page was "no*ta* de clamor*e*" supplied in brown ink, likely by the main scribe, Salthows, with his signature trefoil, but boxed in red by RIa). As Kelly Parsons shows in her introductory essay to the transcription of these marginal annotations, the notes about these two men are in the past tense, which perhaps signifies that they are dead and that the annotations were done between 1528 and 1539 (the date of the Dissolution).[124]

The annotator, then, is someone who reads the *Book of Margery Kempe* to understand the religious experiences of his companions of recent memory. The note "So dyd p*r*ior Norto*n* i*n* hys excesse" (51v; 105:20) appears immediately following "no*ta* de colore" (51v; 105:17), a reference in the text to Margery's physically turning blue and gray, the color of lead, during a crying fit, prompting some around her to wonder whether she had epilepsy. These were matters for professional *discretio* (discretion of spirits), or even *probatio* (testing of the spirits), and they were very "scientifically" understood among religious professionals.[125] On folio 85r (174:19) we have, yet again, a reference to Methley when Margery is roaring away in the text: "father M . | was wont | so to doo." Taking these passages together, we have the annotator's professional investigative interest in the symptoms of her religious crying. This is not to downplay his spiritual empathy (a trait in evidence elsewhere), but with respect to her crying, the annotator's job is virtually a scientific investigation—and not unlike the legalism invoked by some inquisitors on validation issues, except that religious science is more the methodology here, not canon law. At folio 33v (68:31) he is interested in the physical symptom of "Wakenes" (weakness) that accompanied Methley's and Norton's bouts of devotion, similar to that accompanying Margery's. Like his interest in the gray-blue leaden color she turns, this is forensic spirituality—of which there are parallels in Julian's own famous visions of Christ's body (also highlighted in the Amherst MS by a Carthusian annotator, as we will see below).[126] Our annotator puts Margery on par with Methley and Norton, which is certainly a compliment to her. But the "So dyd p*r*ior Norto*n* i*n* hys excesse" (51v; 105:20) is also a telling marker of his opinion about such religious experience: the word "excess/us" in Late Medieval British Latin can refer to "excess, outrage, transgression" and, in collocation with "mentis," can mean "trance, or ecstasy."[127] Given the dual meaning, it is hard to know for certain whether he means "so did Prior Norton in his ecstasy" or simply "excessiveness"—or both. But since the note is in English, rather than Latin, and since in the *Book of Margery Kempe* itself, the word "excess" in English is only used

122. On Methley, see the notes to chapter 13 in Meech and Allen 1940, and Parsons 2001, 151ff.

123. On Norton, see Parsons 2001, 151ff.

124. Ibid., 154.

125. See Newman 2005.

126. See Kerby-Fulton 2006, ch. 8.

127. See Latham 1965, definition of "Excess/us" for these meanings. I thank Barbara Newman for advice about this.

in a negative sense, some ambiguity remains. But his dis-approval, if such it is, is slight and certainly not gender specific.

Far from being a record of dull didacticism, these annotations have a purpose and a goal: they are research into the true nature of visionary experience. The annotator is an expert. He notes not only Methley but Julian: at folio 21r (42:9), he writes "dame Ielian" to highlight Kempe's encounter with the older visionary even though he is not in the habit of naming the various historical persons Margery meets. In his marginal annotations, he cites only author- or text-based visionaries by name: Richard Rolle, Marie d'Oignies, Bridget of Sweden, Methley, and Norton (who in fact wrote three apt treatises: *Devota lamentatio*, *Musica monachorum*, and *Thesaurus cordium amantium*).[128] This strongly suggests that the annotator knew that Julian was an author, not just an historical person of note. He was himself almost certainly part of a Mount Grace circle of living devotional writers that would have included William Melton (chancellor of York and author of prefaces to Norton's works and a treatise against Luther) and the Mount Grace visionary, Robert Fletcher.[129]

Among the related concerns that stir his investigation is the question of Margery's loud crying. The annotator ransacks the *Book of Margery Kempe* for evidence of what exactly causes her crying and traces of *discretio* in relation to it;[130] in fact, he thinks he has found the explanation at folio 92v (190:28) where he writes "racio hic | ponitur quare | sic plorans clamauit" (here is placed [or proposed] the reason [or cause] why she cried out wailing in this way), where Margery beholds the crying and swooning of Mary at the time of Christ's Crucifixion. His sudden use of the word "racio" (perhaps even legal language here, *racio* [or *ratio*] meaning a cause or plea) is striking in this context. On the same page he writes, just below, "trew it is blyssyd lord"—a heartfelt ejaculation conveying palpable relief, perhaps, that there is a reason for all this (191:3).

He also addresses religious doubt itself in the deluge of annotations that accompany chapters 57–59, where Margery fights her losing battle with Christ over her fervent wish for universal salvation. No less than twenty annotations are lavished on folios 68v–71r, and, switching almost entirely into Latin, they follow Margery's bid to save everyone, the Lord's gift of vision to her about who is saved and who is damned ("nota de revelacionibus," fol.

70r; 144:7), and the withdrawal of this gift because Margery refuses to think the damned are damned. "Nota / eius dubitacionem" (fol. 70r; 144:25), he writes, as Margery is taught an especially hard lesson: that if she is really going to doubt that God is the origin of these visions of the damned, then she must learn what visions from a demonic source, described by RIa on the next page as "fantyses" (fol. 70v; 145:24), are really like. The annotator follows this in excruciating detail, ending by translating the final lesson from the text's Middle English into marginal Latin, as a way of fixing it even more firmly into the professional mind. He is not so much interested—as we are today—in Margery's bid for universal salvation (of which he says only "nota charitatem eius" [note her charity], fol. 68v; 141:13), but in what she learns about visionary experience. For him this is "How to Tell a True Vision from a False Vision 101," a crash course taught by God. The Red Ink Annotator is sitting in the front row, taking notes. He is supportive of her authorship, he delineates her types of vision, as we saw earlier; and her prayer types (e.g., "mentall praer" at fol. 105r; 216:23). He also tracks her miracles; for instance, he circles in red Salthows's "nota mirabile quod sequitur" ("take note of the miracle which follows," fol. 40v; 82:20) when through prayer a German priest is able to understand her English. Altogether, he is intent on highlighting each gift of grace she is given. But he follows it all like an investigator sifting evidence, even correcting her when she gets her geography wrong: "syon" the margin says at folio 119r (245:31), when Margery mistakenly speaks of having obtained her pardon at Sheen ("Schene"). The seriousness with which the annotator works is one of—if there may be such a thing—hopeful skepticism: a mix of joyful participation, polite silences, and professional diagnosis. The wonderful thing about this annotator's work is that never do we find misogyny in it. For this, I think, we can forgive him any other failing, including his sometimes heavy-handed correction techniques.

Appendix on the Red Ink Annotator and Previous Annotators in BL MS Add. 61823

Parsons's 2001 study carefully distinguished the annotations and corrections in brown and black ink by previous hands.[131] Fredell has usefully built on Parsons's work by connecting the brown-ink annotator's corpus with the original scribe of the main text, noting his consistent use of a vertical-tailed trefoil (visible in fig. 8b, line 17, of the

128. Sharpe notes that Norton's treatises were edited after his death by a Carthusian colleague, "the visionary of Mount Grace, Robert Fletcher" (d. 1554), who persuaded William Melton (d. 1528) "to contribute prefaces for publication" (1997, 287).

129. William Melton may refer to the friar who is against Margery (see Windeatt 2000, 323n2), or it may refer to the William Melton who was a colleague of Norton's and wrote prefaces for his works, who died in 1528 as chancellor of York. See Sharpe 1997, 788.

130. Such as, for instance, at fol. 88r.

131. Not all scholarship since has been equally careful in following the distinctions in her "Editorial Procedures" (Parsons 2001,164–65) about how she designates different inks and hands at work, with some resulting confusions; see Fredell 's 2009 study with some confusion about both her analysis and Kerby-Fulton's (in Kerby-Fulton and Hilmo 2001, 8–9).

present book, different from RIa's horizontal-tailed trefoil shown in the margin, fig. 8b as well).[132] This earlier main text scribe signs himself as "Salthows" on the last folio, decorating his signature with his personal trefoil.

From my own study of the manuscript, I would add to Fredell's observations that Salthows was also likely the first rubricator, though RIa would later add or finish or enhance rubrication.[133] For instance, on folio 120r, Salthows's trefoil in brown ink is followed by the word "A-m-e-n" in red, with each letter separated by his trefoil. Moreover, on folio 9r Salthows's vertical trefoil appears, unusually, in red, too, so either Salthows was rubricating at the time, or RIa was later imitating Salthows.[134] The variety of styles of capitulum marks in red throughout the manuscript may also suggest more than one rubricating hand over time, as Fredell argues. But Fredell's second main contention, that RIa was not the scribe of the largish *n* marks throughout the manuscript is questionable. Up till now we have thought of these as *n* marks but they have the same flourished arc as the open-topped *a* abbreviation in RIa's own *nota* (visible in top margin of fig. 8b), making it most likely that RIa himself did these marks in an earlier run through the manuscript. In other words, they may be a "nota" form of capitulum mark (an open-topped *a* is a common form for such marks in Middle English manuscripts). A capitulum mark is generally used to suggest a new topic and emphasis, and likely both intentions are present here. Fre-

dell rightly notes that these marks precede RIa's discursive notes in time (some are later written over by RIa), but since we already know RIa made multiple passes through the manuscript, providing new layers of *ordinatio*, annotation, and correction in red ink, they were more likely part of an earlier campaign to supplement *ordinatio*. These large *n* marks usually coincide with paraphs or red-splashed letters in the Kempe text.

Another clue appears on folio 3r beside the date "m^lo. cccc.xxxvj" where Salthows's trefoil occurs in his brown ink, after which RIa's horizontal-tailed trefoil appears in red, below a large red *n* mark in the same red ink as RIa's. Moreover, annotating in red was not so widespread that following Fredell's theory, one would have to posit different annotators a hundred years apart independently choosing to do this. The different ink colors are worthy of attention, but rubrication colors often vary in tone across texts (e.g., in Douce 104's *Piers*), owing to the need for new batches of ink, and scribe-annotators, especially in monastic settings like the Carthusian one here, return over the same pages repeatedly across the years, not always maintaining exactly the same script.[135] Fredell does not deal with the corrector's work in red ink, which might have changed his views. Whether RIa or another scribe created these marks, however, does not greatly alter RIa's oeuvre, which otherwise remains exactly as Parsons laid it out.

IV. The Quiet Connoisseur: The First Annotator(s) of Julian of Norwich's *Revelations* in the Amherst Manuscript (London, British Library, MS Add. 37790)

The handful of marginal comments written by the very first annotator(s) of the only extant copy of Julian's Short Text of her *Revelations*[136] are so minute as to be virtually unnoticeable—and, indeed, unnoticed they have mostly remained by modern scholarship.[137] If Kempe's account

of visionary struggles attracted, as we just saw, a kind of exhaustive latter-day forensic campaign to uncover the truth about the source of her religious experience, Julian's text attracted, not surprisingly, the opposite: an early, discreet set of *nota* marks, most likely written by one early

132. In Fig. 8b in the margin above, a red *n* (or an open-top *a* denoting a capitulum mark?) highlights where Margery has been despised for Christ's love, may well have been done by RIa: compare the flourished *a* abbreviation for the n*ota* below, definitely in his hand; he has added a C-shaped paraph resembling a square bracket to the line the paraph accompanies (second line from top), further evidence that the marginal mark was intended as a capitulum mark. Inserted in very dark red, also in RIa's hand, is the interlinear annotation "deo gr*acias* i*n* et*ernum*" (thanks to God eternally), just after the vertical-tailed trefoil in brown ink by Salthows, the original scribe. The same color of red is used for the three-line Lombard capital **T**, perhaps suggesting that RIa supplemented the capitals and certain interlinear notes or other elements of *ordinatio* in one campaign (similar matches appear elsewhere)? If so, he later returned to write his marginal comments, or sometimes to box them, in a lighter orange-red ink. A marginal *n* or open-top *a* much further below was added initially without the bracket (and it corresponds to another C-shaped paraph in the text), and later bracketed, probably at the same time the marginal note above was boxed.

133. See fig. 8b and previous note.

134. For strong evidence of later scribal imitation of John Shirley's style and marks, see Veeman 2010.

135. See Kerby-Fulton in Kerby-Fulton and Hilmo 2001, 8. For stunning documentary evidence of a scribe's hand changing over time, see Revard 2000.

136. The word "revelatiou*n*" is the one used throughout the Short Text by Julian herself to describe each of her revelations (e.g., fol. 99v; iv.37ff.), so I use the title *Revelations* here; Watson and Jenkins 2006 adopt instead the later scribal heading as a title (discussed below).

137. See Cré 2006, 281–98, and appendix 4. This annotator may be also an early corrector. The main corrector's hand Colledge and Walsh thought "remarkably like that of the [main] scribe, and probably formed by the same writing master" (1978, 1:2). The annotation supply is far too tiny for real comparative letterform analysis, so, like Cré's identifications, mine are offered with that caveat. All citations to the printed text are to Colledge and Walsh.

connoisseur (at most, two) of contemplative theology, apparently at work alongside the scribe of the text. The fact that one batch of the annotator's ink looks like the brown ink used for the quire signatures has not previously been noticed and suggests that he is part of the production team. This annotator is looking for advanced insight into the great problems of salvation and mysticism—and he finds it.

Cré identifies him as Reader 7, and separates the notes into hands 7a and 7b to take account of slight differences in ink and level of script formality. It is hard to be sure, given the tiny supply of letter forms, whether this is one man returning back over the text at another time with different ink and pen (remembering that the cut of a pen affects a hand, too), or two very similar scribes working at roughly the same time, but I, too, will refer to him as one person, as does Cré. There are eight simple forms of *nota,* including one manicule.[138] His notations were done in two different stints, using two different colors of ink. In dark brown ink also used for the quire signatures he made notes on folios 99r, 102v, 108v (see fig. 9a), 111r, and 114r. At another time, and in a just slightly more cursive hand, he apparently made notes in black ink on folios 102r and 102v, and on folio 109v he drew a manicule. What is further suggestive of his early role in the text's production is that the main scribe of the Short Text, likely when he was rubricating, also supplied a *nota* in red on 108v (fig. 9a), and apparently underlined *our* annotator's note on that page in red, as well as the one on 111r, further suggesting that our annotator was part of the original production team and worked ahead of the scribe in annotating.

This extraordinary manuscript, known as the Amherst manuscript, is a large anthology containing copies of mostly mystical and contemplative treatises, several written either by or for women.[139] In fact, it was built up in three booklets, each starting with three major texts copied by the same scribe: Rolle's *Fire of Love,* Julian's Short Text, and Porete's *Mirror of Simple Souls,* with all other texts providing filler.[140] Whether the Amherst manuscript itself reached a mixed audience has been the subject of debate, but evidence is now growing for fifteenth-century Carthusian outreach to lay patrons and associates of both sexes in their vernacular book production.[141] The Amherst manuscript is striking, moreover, because of the number of its texts overtly attributed to female authors (Julian and

Birgitta of Sweden), dedicated to women (like Rolle's *Fire of Love,* for Margaret Heslington), or written entirely in female allegorical figures and pronouns (like Marguerite Porete's *Mirror,* copied in Amherst without author attribution). The manuscript (s.xv. med.) preserves the Short Text, which opens, here at least, with an editorial heading (see fig. 9b) declaring that it is "Avisioun" (a vision) shown to a "deuoute woman" named Julian, a recluse at Norwich who "ʒitt ys onn lyfe" in 1413 ("CCCC xiijº."). We know this heading (likely a rubric in an earlier copy) was composed by a scribe or editor, not by the author: Julian would not refer to *herself* as a "deuoute woman," given the universal decorum demanded by the medieval modesty *topos.* As one can see in fig. 9b the scribe who provided the colored initials made many mistakes, including the first initial of the book, **T**, into which an **h** had to be crammed later (a mistake for **Þ**, now, some fifty years later, partially fallen out of use?).[142] Although the Julian text itself contains no sensational marginalia by the most famous Amherst annotator, James Grenehalgh (a Carthusian apparently transferred from Sheen to discourage "textual intimacies" with a Syon nun; see ch. 6, sec. IV),[143] the modest, anonymous mid-fifteenth-century marginal notes to the Short Text are fascinating in a different way. They form what I described at the beginning of this chapter as a tiny "reader's digest" of Julian's more daring or original thought in her first version of the *Revelations.*

The gender of the original annotator (who may or may not be different from the writer of the Amherst notes) is likely male, but we cannot know for certain; none of the *notae* highlight tell-tale gendered passages or issues (such as, for instance, Julian's *apologia* for teaching as a woman or her devotion to the young Mary of the St. Anne "Trinity"), but we would be wrong to assume that only women could note such passages—or that only men would ignore them.[144] The passages that are noted, however, do frequently have inclusive language (often, for instance, "mann and womann," 108v; fig. 9b), and, though relatively few in number, they are spread across the entire text, indicating careful, potentially inclusive reading, and highlighting some of the most important parts of the work. So subtle a reader of Julian was the mind picking these passages.

These notations are set out in table 12 below, beside transcriptions from the Amherst text of Julian, with underlining indicating what is underlined in the manuscript:[145]

138. Cré does not treat nonverbal notes and so does not list the manicule, nor does she note that the brown ink used in these notes also did the quire signatures.

139. See Colledge and Walsh 1978, 1:3–5 for contents.

140. Cré 2006, 21.

141. See Parsons 2001; Cré 2000; Brantley 2007, 45; Dutton 2008; Paquette 2009.

142. See Colledge and Walsh 1978, 1:1, on guide-letter practice in monastic scriptoria.

143. Cré notes only fols. 110v and 112v (2006, 338).

144. See Kerby-Fulton 2003 for examples of female annotation of a broad range of topics having little or nothing to do with gender.

145. I thank Sarah Dawson for sharing her transcriptions with me while I was preparing mine. Several punctuation details rendered here are only visible in the original manuscript; line numbers correspond with Colledge and Walsh 1978, not the manuscript itself.

	TABLE 12	
nota [dark brown ink]	. god schewyd it vnto me als litille as it hadde beene a hasylle notte . Me thought it myght hafe fallene for litille . / In this blyssede revelacioun god schewyd me thre noughtes of whilke nouȝttes this is the fyrste that was schewyd me of this nedes ilke man *and* woman to hafe knawynge that desyres to lyeve contemplatyfelye that hym lyke to nouȝt alle thynge that es made forto hafe the love of god that es vnmade . / *fol. 99v, corresponding to line 37ff., ch. iv, in Colledge and Walsh 1978 (CW)*	
nota bene [black ink]	And this ranne so plenteuouslye to my syght that me thought ȝyf itt hadde bene so in kynde for þat tyme itt schulde hafe made the bedde alle on blode *and* hafe passede ouer abowte . / God has made waterse plenteuouse in erthe to oure servyce and to owre bodylye eese . for tendyr love that he has to vs . / Botte ȝit lykes hym bettyr that we take fullye his blessede blode to wasche vs with of synne . for thare ys no lykoure that es made that hym lykes so welle to gyffe vs for it is so plenteuouse and of oure kynde *fol. 102r, cf. line 17ff., ch. viii, in CW*	
nota [brown ink]	. aftyr this oure lorde sayde . I thanke the of thy servyce *and* of thy trauayle *and namly* in þi ȝough . *fol. 102v, cf. line 53, end of ch. viii, in CW*	
nota [in red ink, by Amherst scribe] fig. 9b	for as it was be	Fore schewed to me That I schulde synne : ryghtso was the comforth schewed to me Sekernesse of kepynge for alle myne evencristen ^what may make me mare to luff myne euencristen^ than to see in god that he loues alle that schalle be safe as it ware alle a saulle . And in ilke saule that schalle be sayfe is a goodely wille that neuer assentyd to synne na neuer schalle . *fols. 108r–108v. cf. line 5ff., ch. xvii, in CW*
nota [brown ink, underlined in red] FIG. 9B	Also god schewed me that syn is na schame bot wirschippe to mann for in this sight mynn vnderstandynge was lyfted vp into hevene . and thann comm verrayly to my mynde . David . Peter *and* Paule Thomas of Inde and the Maudelaynn howe thaye er knawenn in the kyrke of erth with thare synnes to thayre wirschippe . And it is to thamm no schame that thay hafe synned . na mare it is in the blysse of heven . for thare the takenynge of synne is tourned into wirschippe . Right so oure lorde god schewed me thamm in ensampille of alle othere that schalle cum thedyr . Synn is the scharpyste scourge that any chosene saule maye be bette with . whilke scourge it alle for bettes mann *and* womann and alle forbrekes thamm and noghteȝ hym selfe in thare awne syght sa fare forthe that hym thynke that he is noght worthy bot as it ware to synke into helle . *fol. 108v, cf. line 17ff., ch. xvii, in CW*	
[manicule in black ink]	I Am grownde of thy besekynge first it is my wille that þou hafe it *and* syne I make the to will it *and* syne I make the to beseke it *and* ȝif þou beseke howe schulde it than be that þou schulde nought hafe thy besekynge *fol. 109v, cf. line 20ff., ch. xix, in CW [subsequently repeated and underlined again on the same folio]*	
nota bene [brown ink underlined in red]	for alle þis \| [fol.111r] lyfe in this langoure that we hafe here is bot a poynte . And whenn we ere takene sodaynly oute of payne into blysse it schalle be nouȝt and þerfore sayde oure lorde . / Whate schulde it than greve the to . Suffere a while . senn it is my wille *and* my wyrschippe it is goddys wille that we take his behestys and his confortynges als largelye and als myghtelye as we maye take thame and also he wille þat we take oure abydynge and oure desese als lyghtelye as we may take thamm and sette thamm atte nought for the lyghtelyere we take thamm . the lesse price we sette be thamm for luff the lesse payne salle we hafe in the felynge of tham And the mare thanke we schalle hafe for thamm . In this blyssed revelacioun . I was trewly taught that whate mann or womann wilfully . cheses god in his lyfe he may be sekere that he is chosene . Kepe this treulye . for sothly it is godys wille that we be als sekere in tryste of the blys in heuene whiles we ere here as we schulde be in sekernesse whenn we ere thare . *fols. 110v–111r, cf. line 23ff., ch. xx, in CW*	
nota [brown ink]	. for many menn and womenn leues that god is alle myghty *and* may do alle and that he is alle wisdome and can do alle . Botte that he is alle love *and wille* do alle, þar thay stynte . And this vnknawynge it is that most lettis goddes luffers . for whenn thay begynn to hate synne and to Amende thamm by the ordynnaunce of holye kyrke . ȝit þere dwelles a drede that styrres thamm to behaldynge of thamm selfe and of þer synnes before done . And this drede þay take for a mekenesse . bot this is a fowlle blyndehede and a waykenesse and we cann it nouȝt dispyse . *fol. 114r, cf. line 19, ch. xxiv, in CW*	

What one can immediately see about these passages is that they contain a system of *nota* marks and of underlining (sometimes in red),[146] which pick out striking passages. I will treat first as a group all those notes written in brown and black ink, and then return to the note written in red (by the Amherst scribe), and the passage marked only by a manicule (black). The first *nota* (fol. 99v) highlights the hazelnut passage, one of the most justly famous in this text. But it highlights, again, as the Nun's Priest would put it, the "fruit" of the passage, not the "chaff" (the image), and in so doing points up Julian's move from the nut ("notte") to the first of three "noughtes" for contemplatives—a pun

146. Underlining without marginal notation also occurs at many points, e.g., fol. 111r.

9a. Passage from Julian of Norwich's *Revelations*, showing two *nota* marks: one in red (by the Amherst scribe) and one in dark brown by the same hand that supplied other early *nota* marks and also the quire signatures. In the top margin, a correction has been inserted to the end of the second line; in the bottom side margin, a later annotator (s.xvi) traces the stages of confession ("contretyoun," "confessyoun," "penaunce,") and adds "þe gostly father". London, British Library, MS Add. 37790 (Amherst MS), fol. 108v.

9b. The opening of Julian of Norwich's *Revelations*. Note the errors made by the rubricator, in supplying a **T** for his exemplar's **Þ** (forcing him to put an **H** inside the **T**) and mistakenly an **S** below instead of an **I**. London, British Library, MS Add. 37790 (Amherst MS), fol. 97r.

of the very type that annotators were trained to look for as mnemonic devices.[147] In Augustine's visionary hierarchy, a tier two image (the product of "imaginative" vision) becomes a tier three imageless vision ("intellectual vision"),[148] as Julian moves us from what is "made" to what is "vnmade." The note, then, in true connoisseur fashion, notes the "higher" theological moment. These are not notes for novices.

The next *nota* passage (a "nota bene" on fol. 102r) occurs during Julian's account of her near-death vision and highlights the remarkable scene when Christ's blood seems to her to run so plentifully that, she comments, if it had been happening in reality ("in kynde"), it would have overflown the bed on which she lies. These are concrete images, but, again, it is the "fruit" the annotator goes for, highlighting Julian's teaching that Christ prefers to wash us in his blood than in the water he—equally plenteously—created for "erthe." This little passage uses the word "plenteuouslye" three times: of Christ's blood in Julian's vision, of God's gift of water, and finally, of the availability of the gift of Christ's blood, which is also of our "kynde" (nature), a concept also used three times in the same short space.

Equally remarkable is the brown ink *nota* appearing overleaf (102v), which picks out, eagle-eyed, a fleeting personal, even *autobiographical* moment for Julian, in which the Lord explicitly thanks her for her "servyce" and her "trauayle"—but most especially ("namly") for giving these

in "þi ȝough [youth]." Is it the "trauayle" that grips him, or her endurance since youth, or the ever present desire in annotators to glean authorial information?

The next *nota* in dark ink (again brown, fol. 108v, fig. 9b) highlights a daring passage, best compared to the one on the same topic that closed (and perhaps broke) Langland's A-text (XI.265–end): the list of famous sinners (David, Peter, Paul, Thomas of India, and Mary Magdalene) who now enjoy heavenly bliss. For Julian, unlike Langland or at least his narrator, whom this distresses, the sins of these saints are paradoxically precious commodities, and proof of salvation despite failings.[149] The passage goes even further, however, and in a striking parallel with Marguerite Porete's daring theology (which is also in the Amherst manuscript), insists that it is "no schame" to these sinners to have sinned.[150] These sinners are shown in "ensampill*e*" (a key word in the passage) of all to come after, no less, but most heavily underlined (in red) and noted marginally is the idea that sin is the sharpest scourge that any "<u>chosen*e* saule</u>" may be beaten with: it "forbrekes" (breaks utterly) any "man*n* & woman*n*," nullifies (again the word "noghteȝ") the self "in thar*e* awne syght." This annotator especially loves to trace Julian's use of concepts of "noughting" (making into nothing, annihilating), a major and complex concept in mystical language, which the annotator understands well. He also noted it in Amherst's copy of Porete's *Mirror* (fol. 171v), where it looms even larger.[151]

147. See Despres, in Kerby-Fulton and Despres 1999, 143–44.

148. On Augustine's three levels of vision, as articulated in his *De Genesi ad litteram*, see Kerby-Fulton 2006, 21–22.

149. Colledge and Walsh mention parallels in the *Chastising of God's Children* and in Kempe's *Book* (1978, 1:255n19).

150. See Kerby-Fulton 2006, ch. 8, on parallels between Porete and Julian, including this one.

151. See Riehle 1981, 64–65, 74, 105, and 188, for its usage in Middle English and Continental parallels.

The next note (fol. 111r), another *nota bene*, again highlights the intellectual "fruit" rather than the key image of yet another famous passage: Julian sees that all we suffer in this life is "bot a poynte" and promises that when we are suddenly taken out of pain and into blisse "it schall be nouȝt." Therefore, she urges patience in suffering and detachment from suffering, all in a long passage marked with underlining, but the *nota bene* occurs at the moment of real spiritual payoff: "In this blyssed revelacioun . I was trewly taught that whate mann or wommann wilfully . cheses god in his lyfe he may be sekere that he is chosene . Kepe this treulye." In this quotation, I have retained the manuscript's punctuation, which surely indicates where the emphasis should fall in reading or performance of this all-important sentence. There, once again in gender-inclusive language, is the promise that any man or woman who willfully chooses God may be secure in the knowledge of being chosen. This is an enormous claim and promise. Colledge and Walsh go to great lengths to show the orthodoxy of this kind of thought and cite a parallel passage in Latin by William of St. Thierry (the theologian, by the way, perhaps most influential on the more daring Porete).[152] The annotating scribe knew it was extraordinary and clearly approved of it.

The last dark ink *nota* (fol. 114r) also marks a sophisticated, gender-inclusive passage that is reminiscent of the theology and even the tone of Porete, with her trademark defiant privileging of love above all else. In three perfectly parallel clauses, Julian lays out how many men and women believe that God is almighty, and all wise, "Botte that he is alle love . . . þar thay stynte [stop]." She immediately goes on to speak of another thing that "most lettis [hinders]" believers from realizing their potential, and that is that just when they begin to "Amende thamm" (the word is capitalized), they are gripped by a sense of their own sin, and this, she says they "take for a mekenesse," but it is instead a foul blindness and a weakness—harsh language for Julian. Although this does not match more notorious Free Spirit–style impatience with penance and other practices (such as one can find even in Amherst's own text of Porete), it is nonetheless on the same spectrum. This kind of discussion marks Julian's text as aimed at advanced readers only (in fact, Julian's Long Text, like Porete's, travels with a warning against too general a dissemination).[153]

Our annotations in the dark inks, then, for all their marginal simplicity, preserve a sophisticated selection of passages from Julian's text, so very unlike the patterns more usually found in annotating original or radical thinkers in the Middle Ages, where an annotator will scour the text for conventional wisdom and unchallenging ideas, passing over uncomfortable ideas in silence.[154] Not so this annotator, nor the Amherst scribe[155] (now the rubricator) who noted the passage on folio 108v (fig. 9a), stressing that in every soul that shall be saved there is "a goodely wille that neuer assentyd to synne na neuer schalle." Though there are theological precedents for this kind of idea (Colledge and Walsh again cite William of St. Thierry, the orthodox Cistercian mystic), this is a bold theology, especially for a female vernacular writer. The manicule, written in his colleague's—our annotator's—black ink (109v), also picks up a similar, reader-empowering theme with yet another key word in advanced mysticism, "grownde": "I Am grownde [ground, foundation] of thy besekynge [asking, beseeching],"[156] along with the promise that, since God is (in scholastic terms) the "efficient cause" of the asking, he will deliver.

Together these notes foreground passages of sophisticated, often Continental-style, mystical language and daring theology, paralleled elsewhere in Amherst. Though one might expect otherwise of a largely vernacular collection, full of texts by and for women, Amherst was neither for novices nor for the theologically faint of heart. This, too, should make us revise some of our expectations for the readership of women's writing in English.

This overview of marginalia in Chaucer, Langland, Julian, and Margery Kempe can only scratch the surface of the immense range of medieval reception. What the study of marginalia can do is remind us that late medieval art, like all art, was viewed through multiple lenses and indeed a whole prism of interpretations. Interpretation is generated through the eye of the beholder (never had authors fewer means of authorial control than in a manuscript culture), and one never knows which color on the spectrum the beholder might choose. But the more representatives of each interpretation we get, the closer we are to seeing medieval writings again with less of our own refraction and more as they appeared to early readers and authors.

152. Colledge and Walsh 1978, 1:254n9, and introduction, 117–18.

153. See Kerby-Fulton 2006, 297–98, for the warning and discussion.

154. For some examples in Hildegard of Bingen manuscripts, see Kerby-Fulton 2000b; in Joachite manuscripts, Kerby-Fulton 2006, ch. 2.

155. Cré lists this as his only note in the Julian text (2006, 337), but the theme of powerful assurance is also highlighted with red underlining near a red corrector's mark on fol. 111r saying that God wills us to know that our enemy's power is "is lokenn" in the hands of a Friend, which allows us to set temporal troubles "atte nouȝt."

156. On "grounde" as a key but complex concept in mysticism, see Riehle 1981, 85, 88, 156, 159, 161, 195, and 213.

CHAPTER FIVE

Illuminating *Chaucer's* Canterbury Tales
Portraits of the Author and
Selected Pilgrim Authors

MAIDIE HILMO

"Frend, what is thy name?
Artow come hider to han fame?"
"Nay, for sothe, frend," quod y;
"I cam noght hyder, graunt mercy,
For no such cause, by my hed!
Sufficeth me, as I were ded,
That no wight have my name in honde."

House of Fame, ll. 1871-77

I. Introduction

Reflecting Chaucer's awareness that posthumous fame means relinquishing control over one's literary oeuvre, the poet-dreamer in his *House of Fame* exclaims that he wants no one to have his "name in honde" when he is dead.[1] In "Chaucers Wordes unto Adam, His Owne Scriveyn," Chaucer's meticulous scraping and rubbing of the vellum to correct the mistakes made by his scribe indicate his own attempt to control the transmission of his works for contemporary readers and for posterity. Chaucer tries to ensure that if this scribe happens to have occasion to make more copies of both the *Boethius* and *Troilus and Criseyde*,[2] he will be less negligent and hasty (Adam 2). The very fact that he went to the expense of hiring a scribe to write out his works in formal script on vellum implies that Chaucer wanted a permanent record of them for posterity, one he could regulate.

When Chaucer died in 1400, was there even an author's copy of the *Canterbury Tales* that could be copied, licitly or otherwise?[3] It appears that Chaucer's tales were not immediately assembled into one long continuous series in a single manuscript book but circulated individually or as groups in unbound pamphlets,[4] probably among contemporaries such as Gower, Strode, and other members of a literate reading circle. This state of incompletion opened up the field for later editors to add spurious tales to the *Canterbury* collection. It also presented challenges to manuscript designers and illustrators to contrive ways to make the tales appear to be a unified collection.

1. Unless otherwise indicated, all quotations from Chaucer's works are from the *Riverside Chaucer* 1987. Line numbers are enclosed in parentheses in my text. Abbreviations follow *Riverside* usage. In this chapter, italic font is used to indicate ornamental initials, following the usage by Michelle P. Brown 1994, throughout. Conforming to art historical practice, boldface font is not used to indicated headings or rubrics.

2. There is a possibility that these manuscripts survive; see Mooney 2006, 97–138, at 103n23 and 113; and Stubbs 2002, 161–68.

3. For possible evidence before 1400, see ch. 1.

4. See ch. 4 on some romance manuscripts that also circulated in small booklets.

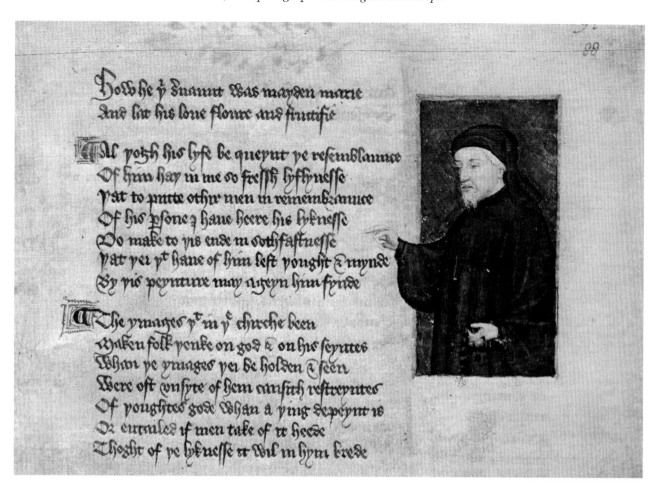

1. Portrait of Geoffrey Chaucer, Thomas Hoccleve's *Regiment of Princes*.
London, British Library, MS Harley 4866, fol. 88r, 1411–12.

It is after Chaucer's death that things would have changed dramatically. In an age without copyright laws was it open season for copyists? When Chaucer died, what happened to his *Canterbury Tales*, either in the form of circulating booklets or as a preliminary assemblage in a single manuscript? Was there a clamor to copy Chaucer or was the demand created? And if so, by whom? What role did the scribes, decorators, and illustrators play in shaping the image of this author and presenting his works to the audience that mattered?

One major piece of the puzzle appeared to fall into place recently when Linne Mooney identified Chaucer's scribe.[5] In a busy intersection of London when she was returning from the Guildhall Library back to the Mercers' Hall archives, she realized that scribe who had signed his name in the Scrivener's Company oath in the former was one and the same person as the Hengwrt-Ellesmere scribe who wrote in an account book in the latter and that, thinking of the Adam of Chaucer's little poem, she "stopped still" and "the penny dropped"—Chaucer's scribe was a real person: Adam Pinkhurst![6]

The identification of the Adam of Chaucer's poem with the historical Adam Pinkhurst is persuasive not only for paleographical reasons but because the time and place

seem to fit so well. The identity of the scribe employed by Chaucer is of great importance because Adam Pinkhurst might indeed be the scribe who wrote two of the earliest manuscripts of the *Canterbury Tales* around the time of Chaucer's death: the Hengwrt MS, Aberystwyth, National Library of Wales, Peniarth MS 392D (*olim* Hengwrt MS 154) and then the Ellesmere MS, San Marino, CA, Huntington Library, MS Ellesmere 26 C 9. The scribe of the Ellesmere MS was also one of the scribes of the Trinity Gower, identified by Doyle and Parkes as Scribe B.[7] It is appealing to think that the Adam Chaucer refers to is Adam Pinkhurst and he in turn is also Scribe B because it gives more authority to the Hengwrt and Ellesmere MSS. This would link both directly to Chaucer himself. The differences between those two manuscripts indicate that this scribe did not have possession of a single complete copy of the *Canterbury Tales* at the time of Chaucer's death, one that he could use as an exemplar. Jane Roberts, however, challenges the identification of Adam Pinkhurst as Chau-

5. See Mooney 2006, 97–138, and see also ch. 1.
6. Mary Robertson at http://www.huntington.org/uploaded Files/Files/PDFs/S06frontiers.pdf.
7. Doyle and Parkes 1978.

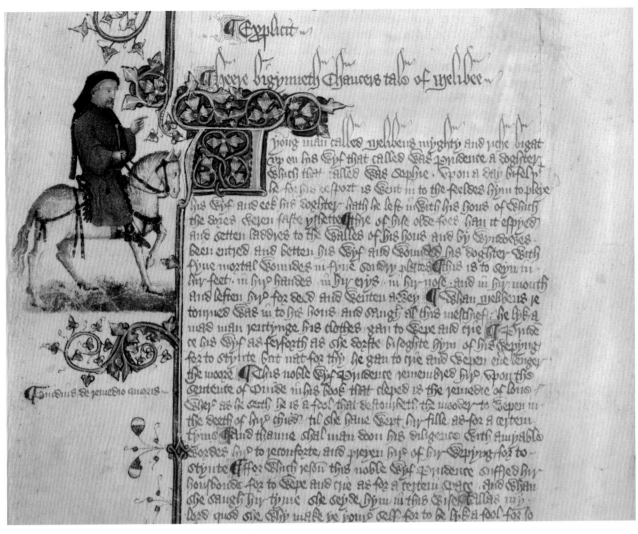

2. Portrait of Geoffrey Chaucer, *The Canterbury Tales*. San Marino, CA,
Huntington Library, MS Ellesmere 26 C9, fol. 153v, 1400–10.

cer's scribe Adam[8] (see also Kathryn Kerby-Fulton in ch. 1 overview and sec. V), so for now it remains a tempting possibility rather than a certainty.

While the identity of Scribe B/Adam Pinkhurst cannot be resolved with certainty at this time, a related question that presents itself is who gave literary editorial direction and helped in the overall arrangement and artistic design of the Ellesmere, the first extant illustrated manuscript of the *Canterbury Tales*? One strong possibility is some contribution by the poet Thomas Hoccleve, who worked with Scribe B/Adam Pinkhurst as Scribe E on the Trinity Gower.[9] Hoccleve may also have been Scribe F, one of the five supplementary scribes who not only worked on the Hengwrt MS in that capacity but also in an edito-

rial and poetic one, adding from a few words to a line here and there where there were lacunae or blank spaces left by supplementary Scribe A.[10] In his *Regiment of Princes*, London, British Library, MS Harley 4866, fol. 88r, composed in 1411–12 for Prince Henry (the future Henry V), Hoccleve not only positioned himself as heir to Chaucer but also included a portrait of him in the margin to show how "father" Chaucer looked (fig. 1). This portrait is remarkably similar to the portrait of Chaucer in the Ellesmere MS on folio 153v (fig. 2).[11] As Derek Pearsall argues, the *Regiment* portrait served an iconic function effecting the laureation of Chaucer as poet,[12] a function that it also served, as will become apparent shortly, in an earlier manifestation in the Ellesmere MS. Was it also Hoccleve—poet and scribe,

8. "On Giving Scribe B a name and a clutch of London manuscripts written c. 1400," forthcoming in *Medium Ævum*.

9. Cambridge, Trinity College, MS R.3.2 (581). For the identification of Hoccleve as Scribe E see Doyle and Parkes 1978, 182.

10. Mosser 2000 at http://www.canterburytalesproject.org/pubs/HGMsDesc.html#N5. See also Stubbs 2000 "Hands" at

http://www.sd-editions.com/hengwrt/home.html. See also ch. 1, sec. V.

11. For images from the Ellesmere facsimile see http://sunsite3.berkeley.edu/hehweb/EL26C9.html.

12. Pearsall 1994b, 399–406.

3. Adam Pinkhurst's oath (detail), Scriveners' Company Common Paper. London, Metropolitan Archives, CLC/L/SC/A/005/MS05370, page 56.

4. The B-text of *Piers Plowman*. Cambridge, Trinity College Library, MS B.15.17, fol. 1r, 1390s (?).

commissioner of the *Regiment* portrait, and coworker with professional illuminators—who solicited the involvement of the artists of the Ellesmere MS in that project? In the case of the lavish Litlyngton Missal, it was the scribe Thomas Preston who evidently subcontracted its illumination to individual artists.[13]

Yet the historical Adam Pinkhurst himself appears to have had artistic inclinations, as seen in the singularly large flamboyant flourishing of his name in the margin of his written oath in the Scriveners' Company Common Paper (fig. 3).[14] If he is Scribe B, he may have worked on other literary manuscripts with artistic elements, possibly including the B-text of *Piers Plowman* in Cambridge, Trinity College Library, MS B.15.17 (fig. 4), which Mooney positions chronologically as having been made before the Hengwrt MS. In MS B.15.17 there is an elaborately decorated initial *I* forming part of the double bar border of the first folio.[15] A close look at the border of this *Piers Plowman*

13. Backhouse 1999, 6–9. The Litlynton or Westminster Missal, Westminster Abbey, MS 37, was commissioned in 1383–84 by Nicholas Litlynton, abbot of the Benedictine house at Westminster. Thomas Preston was hired to write the text, which took two years. For a fascinating account of the costs of the materials involved, see Backhouse's study.

14. While deluxe manuscripts would have been made by professionals such as scribes, rubricators, illustrators, and border artists, it seems likely that there could sometimes have been some overlap in function. Many of the illustrations shown at the end of the first three volumes of Scott 2000, 2001, and 2002 could have been made by artistic scribes, especially in cases where illustrated objects or diagrams occur in irregular spaces surrounded by and inscribed with text. The artistic skills and the materials used by both scribes and artists are much the same. They obviously worked in close proximity and would often have known each other.

15. Mooney 2006, 113–14.

manuscript shows affinities with that of the Hengwrt MS (fig. 5), as in the case of the details of the vegetal flourish curling around and descending from the border at the bottom of the page in each of these manuscripts. Margaret Rickert noted the stylistic similarities of the borders of the Hengwrt and Ellesmere MSS.[16]

While it is unlikely that Adam Pinkhurst engaged in anything more than pen-flourished initials in any of his works, it may be that he, assuming he was Scribe B, was instrumental in soliciting the talents of the border artists of the Hengwrt and Ellesmere MSS. Like Scribe D who also worked on the Trinity Gower (see ch. 1, overview), Scribe B might well have been involved in organizing and directing illustrators in the promotion of an English author.[17] If the Scribe B/Adam Pinkhurst identification holds, this would have made him not only Chaucer's "own" scribe during the poet's life but also the one who undoubtedly played an important and influential role in the enterprise that helped to ensure Chaucer's posthumous fame—who better?

What emerges from this discussion is that there seems to have been a loosely associated group of scribes and illuminators in London who variously worked together on a number of literary projects promoting vernacular literature. The situation concerning authentic copies highlights the conditions relating to the production of a literary work and calls attention to an evolving conception of authorship in fifteenth-century medieval manuscript culture that was collaborative and open-ended. Just as in the twentieth century it took a whole studio to produce a movie "star," in the fifteenth century it took the combined ardor of patrons, readers, scribes, and artists to help build up the idea of an individual "author." In the fluid process of manuscript production it was possible to change the import of a work in a number of ways. This was less possible in the age of print once standardized multiple copies indelibly set texts that could not all be recalled once they had been sold to anonymous buyers.

In the early fifteenth century it appears to have been in the interests of the scribes and artists to be associated with literary figures they helped to lionize and whose works they were employed in presenting to wealthy bureaucratic, aristocratic, and even royal readers, although this would still have been a niche market. As professionals, the scribes involved likely welcomed the change from such dreary routine activities as keeping records and would have enjoyed being involved in new projects promoting vernacular English literature. Illuminators, whether they specialized in figural, decorative letter, or border art, likewise would have been keen on the creative challenges of adapting traditional iconographies and techniques associated with Latin and French authors to contemporary native English authors.

As will become evident in the rest of this chapter, the Hengwrt and Ellesmere MSS helped establish two similar but distinctive decorative traditions for the rest of the illustrated *Canterbury Tales* manuscripts in the fifteenth century and even for the early illustrated printed editions. These *Canterbury Tales* manuscripts proved the success of their decorative schemes that, while building on those of late fourteenth-century manuscripts (see examples in ch. 3), were both inventive in conception and yet inscribed English literature into the mainstream of other illuminated texts.

The production of meaning is in a constant state of flux, as these *Canterbury Tales* manuscripts demonstrate. What did Chaucer intend, and even if it were possible to recapture that, could even he have intended the same thing between the conception of a work, its revisions, and its formal inscription by scribes and artists, assuming he actually saw or had a hand in any of the *Canterbury Tales* manuscripts that are now extant? The earliest readers would have been those scribes and artists who made the manuscripts, whether during his lifetime or afterwards, and they undoubtedly understood his work in different ways and tried to convey their understanding accordingly. Even then, would any two people viewing an illustration see exactly the same thing, even if they had a similar social background and education, and were of the same age and gender? This reading process, with all its variables, would naturally be repeated and over and over again as each new manuscript was made, looked at, and read. Meaning also changes over time. Is this not also true for the professional interpreters of literary endeavors, the scholars who edited printed editions of the *Canterbury Tales* and those who subsequently attempted to interpret the text accordingly?

Most recently the study of manuscripts has focused attention on particular manuscripts and the wealth of enriching detail that each uniquely provides as a holistic entity, including its annotations and, in the case of more lavish ones, its ornamentation and illustration. Michael Camille observed that for the medieval viewer the activity of vision was "understood not as a passive process but as an active one involving the body and the whole person."[18] This is what the study of manuscripts in facsimile helps to recover. The accessibility of colored facsimiles on the Internet has accelerated this study so that individual versions of the text can be seen in their entirety. This has made it possible to study the texts in the context of their ornamental vocabulary and illustrative accompaniment. Editions of Chaucer without all this have proved useful, but the text was divorced from all the additional material that an educated medieval reader, for instance, would have taken for granted as a conveyer of meaning. It is true that footnotes in scholarly printed editions are

16. Rickert 1940, 1:567.
17. Kerby-Fulton and Justice 2001, 217–37.
18. Camille 2000, 202.

helpful, but the reading experience is not the same. Even illustrated editions of the *Canterbury Tales* tended to place the illustrations almost anywhere except where they actually occur in particular manuscripts, especially in the case of the Ellesmere illustrations that have been the ones most commonly reproduced. It is not surprising, therefore, that the function of the illustrations was sometimes not the primary consideration in the attempts (a) to determine which artists illustrated which images, (b) to judge their artistic merit, (c) to categorize them according to stylistic considerations, or (4) to assay their apparent fidelity to the text or lack of it. Nevertheless, a number of studies do examine the diverse ways in which they contribute to a larger appreciation of the text and its author.[19]

What this chapter does is to try to discover the function of the illustrations as reading and viewing guides for particular audiences. It provides an interpretive approach that attempts to encourage today's reader to see afresh the visual matter in the manuscripts under discussion (cf. ch. 3, sec. I). The focus is on the ways in which Chaucer is portrayed and in which the text is presented either as a literary garden over which his authorial control is established or as an ongoing open-ended pilgrimage in which authorship of the tales told en route is dispersed and the final destination is likewise without boundary.

A full study of the emergence of author portraiture during the late medieval period is not possible here, but some of the discussions in chapter 3 help to contextualize a growing interest in portraying literary authors whose status both endorses and is endorsed by the inclusion of their images along with their texts.[20]

The purpose here is not to cement a particular interpretation as the right one but to show how the portraits and framing elements in *Canterbury Tales* manuscripts can be seen to operate. Viewers will likely agree in many cases, even see more than is brought to attention here, and sometimes disagree entirely as other observations seem more apt. That is all to the good if it encourages readers to attend closely to the visual elements and perhaps to see Chaucer's magnum opus in a way that illuminates the present as well as the past. Otherwise why read and look at old works?

II. The Decoration and Borders of the Hengwrt and Ellesmere Manuscripts

All the elements that make up the material presentation of richly illuminated *Canterbury Tales* manuscripts serve to shape the text and its reception. The border decoration, especially of the Ellesmere, has been described and usefully compared to the borders made by the artists of other manuscripts, as indicated especially in the important pioneering work by Margaret Rickert[21] and later on by Kathleen Scott.[22] While including some of these observations, the present study goes further in exploring the functions of the borders and interconnected decorative and illustrative features that appear to encourage distinctive readings of Chaucer's text in the century following his demise. Interestingly, in tracing the development of the borders in relation to illustrations, it would appear that two distinctive if related illustrative traditions began to emerge from the border schemes of the two principal manuscripts written by Scribe B/Adam Pinkhurst, the Hengwrt and the Ellesmere MSS.

The border ornamentation of lavishly decorated *Canterbury Tales* manuscripts attracts and captures attention, cultivates the kinds of readers being solicited, and flatters their status. At another level, readers are offered direct and indirect visual cues that can be seen as assisting while directing their understanding of the text. They are subtly guided to identify their interests with those of Chaucer, whose work is advanced as being eminently suitable for their attention and endorsement. In turn, owning this kind of Chaucer manuscript underscores their own status as discriminatory and perspicacious readers, supporters of the best in national culture. This sets a trend popularizing a vernacular English poet whose work can be further individualized for specific patrons and used as a model for future literary endeavors. Once this process is set in motion, everyone involved benefits: not only the aristocratic leaders of taste whose patronage is solicited and their wealthy followers who must likewise own lavish Chaucer manuscripts but also the professional scribes and illustrators of Chaucer, other writers following in the footsteps of a

19. For a historical perspective and a selection of studies of Chaucer portraits and related topics see especially Spielmann 1900; Piper 1924, 241–56; Rickert 1940, 1:561–605; Galway 1949, 160–177; Trapp 1959, 227–55; Kellog 1960, 119–20; Schulz 1966; Thorpe 1978; Pearsall 1977a, 338–350; Pearsall 1977b, 69–74; Kelliher 1977, 197; Gombrich 1979, 471–83; Salter and Pearsall 1980, 100–23; Stevens 1981–82, 113–33; Seymour 1982, 618–23; Christianson 1989, 207–218; Hanna 1990, 1–15; Botvinick 1992, 1–18; Pearsall 1992, 285–305; Grabar 1992; Wright 1992, 190–201; Pearsall 1994b, 386–410; Scott 1995, 87–119; Gaylord 1995, 112–42; Emmerson 1995, 143–70; Bowden 1995, 171–204; Scott 1996 (see catalogue entries for specific manuscripts); Klages 1997; Hilmo 2001, 14–71; Knapp 2001; Olson 2003, 1–35; Hardman 2003, 37–72; Carlson 2003, 73–119; Rosenblum and Finley 2003, 140–57; Hilmo 2004, 5–7 and 138–99; A. Gillespie 2006; Hilmo 2007, 71–105; Bale 2008, 918–34; Hilmo 2009, 107–35.

20. See also examples of the iconography of presentation portraits in the British Library's MS Arundel 38, fol. 37r, in ch. X and BL MS Harley 2278, fol. 6r in ch. 6, sec. III, fig. 17.

21. Rickert 1940, 1:561–605.

22. Scott 1995, 87–119, and see 113n1 for a summary of studies on the borders; see also Hilmo 2004, 164–67.

writer they helped to promote, even the "corrective" imitators of Chaucer;[23] in fact, a whole cultural movement promoting English vernacular literature is set in motion.[24] Chaucer must be portrayed in a suitable fashion and his work carefully and selectively tweaked to highlight those features that will successfully navigate the political and religious pitfalls of the early fifteenth century. All it needs is to get started.

It is instructive, therefore, to look at the development of the principal framing elements in the first pages in the Hengwrt (fig. 5) and the Ellesmere (fig. 6) MSS before proceeding to see how these two appear to have led to distinguishable border designs that influenced successive copies. Each has a double bar border, on all sides in the former and along the left margin in the latter. One bar is burnished gold leaf and the second is painted with either blue or rose pink in alternating segments. Each border contains vegetal segments and interlaced knots of various kinds, although these are in greater profusion in the Ellesmere. The principal difference is that the first folio of the Hengwrt has a full, four-sided bar border enclosing the text on all sides, while the Ellesmere has a demi-vinet border[25] that is open on the right side. The three sides of this demi-vinet border consist of a vertical double bar on the left with horizontal branching sprays across the top and bottom that terminate in curling elements. The four-sided and three-sided borders both extend from the enlarged initial beginning the text.

The Ellesmere was the first extant manuscript to include figural illustrations of all the narrating pilgrims in the tales section, establishing one pattern for illustrated manuscripts with pilgrim portraits. The Hengwrt, with its four-sided bar border on the first folio, led the way for those later illustrated manuscripts that acquired an author portrait within the historiated initial that begins the text, an amplification of the decorated initial in the Hengwrt.

The initial letters that begin the text of the *Canterbury Tales* in both the Hengwrt and Ellesmere are remarkably similar. They are each about six lines of their respective texts in height. The letter *W* is formed by two intersecting *V* shapes. Strikingly, in each case, the left *V* is blue and the right one pink. These features alone suggest some continuity of design between these two manuscripts written by Scribe B/Adam Pinkhurst.

Of course, the Ellesmere gives an impression of less looseness, with more compactness and precision to create a greater elegance of presentation. The thirty-two lines of the first folio of the Hengwrt are not subdivided by smaller decorated capitals to mark text divisions as in the Ellesmere, which has forty-eight lines on this folio. The

Ellesmere has a couple of two-line-high decorated capitals in the introductory portion: first to separate the general setting from the specific time and place locating the narrator, and then to feature his statement of purpose. The third one that introduces the Knight is not two but three lines high, elevating the Knight's status in a way that sets the trend for privileging aristocratic values in the Ellesmere MS. Marking the beginning of the narrator's description of the highest ranking pilgrim, the marginal annotation also calls special attention to the Knight. It is evident from a quick comparison of the first folio of the Hengwrt and the Ellesmere that the apparatus of the second is more advanced in its inclusion of decorated letters that organize the text.

In both manuscripts the large *W* beginning the text is appended to the bar border, sharing with it some of the burnished gold that glitters on the page. This initial serves pictorially as part of the ornamental trellis framework surrounding the field of the text and phonetically as the first letter of that narrative text. One consequence of that transitional function is that it calls special attention and attaches importance to the idea of the "word" in a way familiar to medieval readers of religious texts such as bibles, gospel books, psalters, and books of hours. These were usually in Latin and so the "Word" may not always have been understood by lay readers, but the visual symbol would nevertheless have carried a special and often mystical sense of the sacred. In the case of the first *Canterbury Tales* manuscripts, as in some of the *Piers Plowman* manuscripts, it transfers a heightened sense of value from religious texts to a literary work in the vernacular. It is a strategy that elevates and authorizes this particular text to endorse its doctrinal correctness for its intended high-born readers. Compared to the Ellesmere, there is little so elaborate in decoration and so consistently well-organized in overall design in fourteenth-century illustrated English literary manuscripts (see ch. 3 for more details on some of these manuscripts). It is noteworthy that two of the Ellesmere border artists have been identified as two of those who also worked on a large hours and psalter, Oxford, Bodleian Library, MS Hatton 4.[26] It seems obvious that the designer of the layout of the Ellesmere, who may even have been one of the border artists, deliberately wanted to produce an effect very similar to the Hatton Hours and Psalter, even if not to that particular manuscript.

Of the seventy-one borders in the Ellesmere MS (what is left of the Hengwrt manuscript has no more borders), sixteen embellish the Parson's discourse, reinforcing the religious association of such borders. On the last page, a

23. On the theory of "corrective imitation" and some examples with reference to those coming after Chaucer, see Johnson 1999a, 65.

24. As mentioned to me by Kathryn Kerby-Futon, an argument

could be made that this process started with William Langland's *Piers Plowman* manuscripts.

25. See Margaret Rickert 1940, 1:562.

26. Scott 1995, 87–119, figs. 23–26.

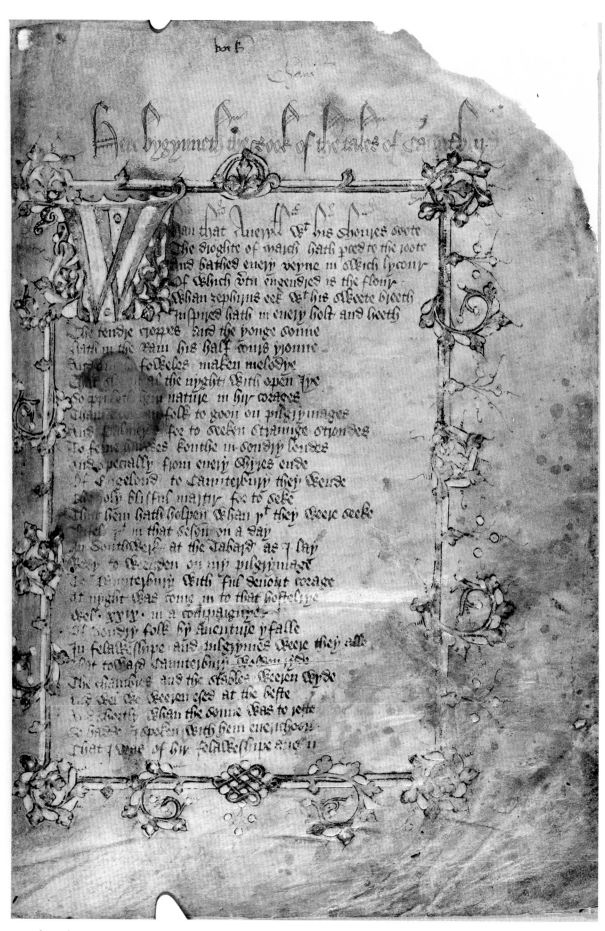

5. Geoffrey Chaucer, *The Canterbury Tales*. Aberystwyth, National Library of Wales, Peniarth MS 392D (*olim* Hengwrt MS 154), fol. 2r, c.1400.

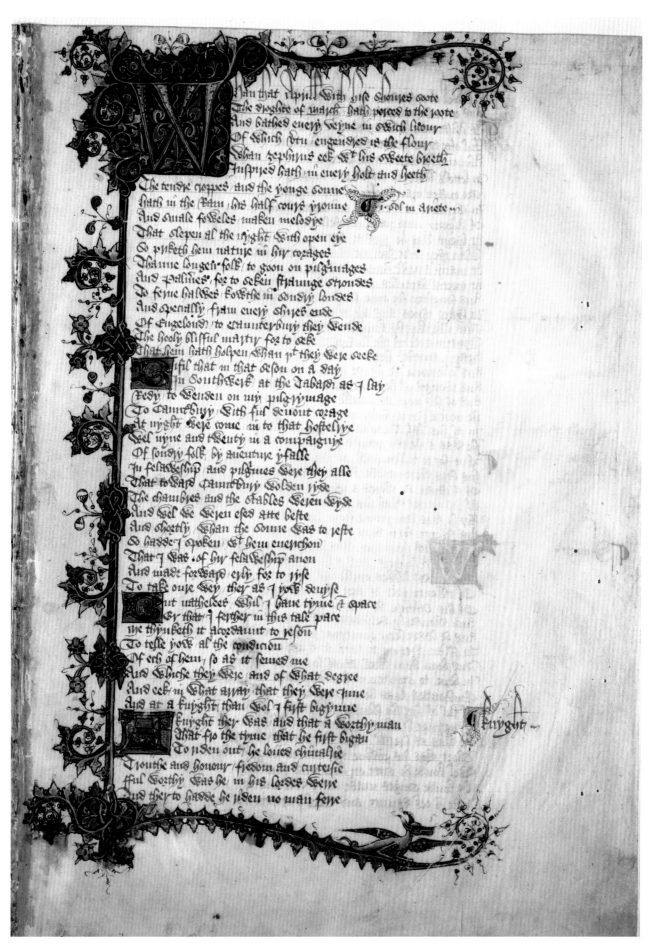

6. Geoffrey Chaucer, *The Canterbury Tales*. San Marino, CA, Huntington Library,
MS Ellesmere 26 C9, fol. 1r, c. 1400–10.

special flourish extends from the three-sided demi-vinet border to the marginal annotation calling attention to fruit of penance which, as defined in the adjacent text, is heaven. The ornamental borders and initials make of this text a kind of paradisal garden by analogy with religious texts similarly framed and introduced. The use of burnished gold in the borders and the first ornamental initials literally and figuratively illuminates the text in the Hengwrt and Ellesmere MSS to enhance their perceived value.

III. The Historiated Initial with an Author Portrait: A Further Development of the Hengwrt Tradition

The three extant illustrated *Canterbury Tales* manuscripts that have taken the concept of an enclosed garden, suggested by the four-sided bar border, a step further by including a portrait of Chaucer within the first letter are London, British Library, MS Lansdowne 851, c. 1407–10[27] (1413–22 on the British Library site)[28]; Oxford, Bodleian Library, MS Bodley 686, c. 1430–40[29]; and Tokyo, MS Takamiya 24 (formerly Devonshire), c. 1450–60. Each portrait reinforces the allusion to biblical and religious authors similarly placed at the beginnings of their texts and so functions to elevate the vernacular literary author and his text (see also the portraits in two *Piers Plowman* manuscripts; ch. 3, sec. V). Yet each of these illustrations characterizes Chaucer in a slightly different way according to changing perceptions and historical circumstances.

Important work has been done on the illustrated portraits in these manuscripts by Phillipa Hardman.[30] The following sections examine these Chaucer portraits in relation to the visual rhetoric provided by the closed borders of which they are a part. Seen within such a framework it is interesting to note the subtle differences in the way Chaucer was viewed over the better part of the fifteenth century in what would appear to have developed into one sort of ongoing tradition of Chaucer portraiture.

1. BL MS Lansdowne 851, c. 1407–10

In BL MS Lansdowne 851, fol. 2r (fig. 7), the interlocking *U* shapes forming the introductory letter *W* slide almost together to create a single large inner space big enough for the inclusion of the figure in the middle. Here Chaucer has the appearance of a civil servant[31] of respectable means (coincidentally, it is a documentary hand that copied this manuscript; see ch. 1, sec. V). Mature but not old, Chaucer has a full head of brown hair cut short in the early fifteenth-century fashion, and he sports a small, pointed, gray beard. He wears a gray houpeland with baggy sleeves gathered at the wrists. There is the suggestion of a modestly thin white fur trim at the neckline and hemline. The overall conservative look is modified by his red hose, possibly anticipating the spirit of lustiness that also informs the Wife of Bath in her narrative. It is an astute rendering of a multifaceted Chaucer. It has been suggested that this portrait is by a prominent artist of the time, Herman Scheere.[32]

Although he appears to wear a pen case on a cord around his neck Chaucer is not shown writing but holding an open book in the direction of the text he is facing. There is writing in this middle-sized book, indicating that it is a finished work, the authentic, completed, correct copy of the *Canterbury Tales* endorsed by the author who holds it with both hands. The historiated initial, with its enclosed portrait, also forms the first letter of the following *Canterbury Tales*. Chaucer presents the text and is shown to be within it. His is the mind that created it. The figure of the author preceding his text visually reflects the Middle English definition of a border or "bordure" as signifying both a storyteller and a frame.[33]

There appears to be a dynamic interplay of the two-dimensional and three-dimensional on this page. The figure of the author is shown in a three-quarter profile as he stands on a tiled floor with a rudimentary perspective that likewise suggests depth. Behind him, however, there is a green background with thin, yellow double outlines that follow the interior shape of the letter. While this background suggests the world of spring described in the adjoining text, it also forms a flat patterned surface, inviting a more abstract understanding of the significance of the pictured author, elevating while distancing him from the perishable world. This flat plane also provides a transition from the three-dimensional figure of Chaucer to the ornamentation of the initial letter and the border to which it is attached. In a calligraphic style reminiscent of the ascenders of Scribe B/Adam Pinkhurst (though not exclusive to him since this is characteristic of legal hands; see ch. 1, sec. II), five of the ascenders of the letters in the first line of text hook into the top border, touch it, or aspire to reach it, providing another sort of transition from text

27. Date suggested by Scott 1996, 2:87.

28. See http://www.bl.uk/catalogues/illuminatedmanuscripts/searchMsNo.asp.

29. As dated by Scott 1996, 2:141, and Hardman 2003, 44.

30. Hardman 2003, 37–72.

31. The Lansdowne scribe's hand is, coincidentally, that of a civil servant, as mentioned to me in conversation by Kathryn Kerby-Fulton.

32. Scott 1996, 2:111.

33. Kendrick 1999, 217–23.

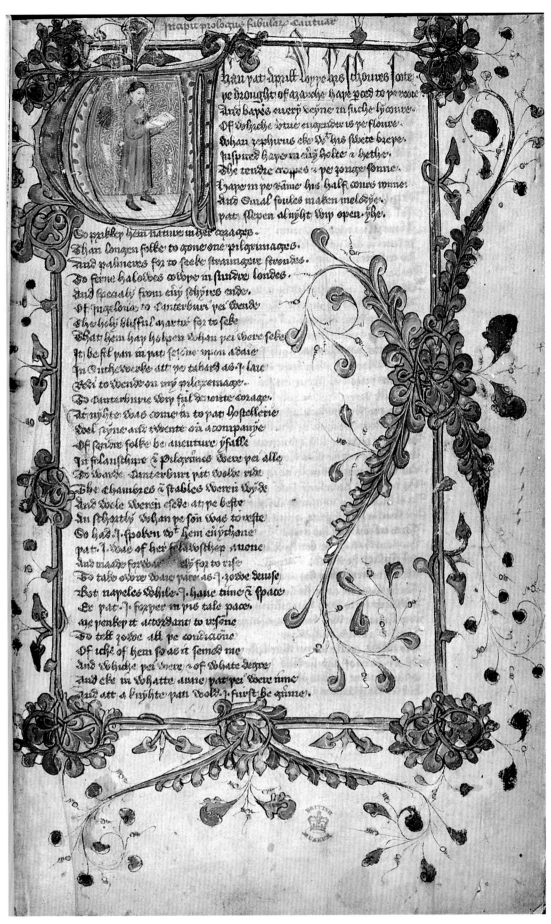

7. Portrait of Geoffrey Chaucer, *The Canterbury Tales*. London, British Library,
MS Lansdowne 851, fol. 2r, c. 1407–10 (1414–22 on the British Library website).

[255]

to border. Exuberantly unrestrained ornamental sprays are appended to the right border and also descend from the border at the bottom. The enclosing border elements create, if not a paradisal garden, at least a kind of aristocratic *locus amoenus* or a rhetorical garden of verse. The double bar border with its floriated sprays serves as a kind of laureation of the poet framed within the historiated initial and at the same time allows the reader entry into the world described by the text.

2. Bod. MS Bodley 686, c. 1430–40

Following the same basic design pattern as that of the first page of the *Canterbury Tales* in the Lansdowne manuscript is Bod. MS Bodley 686, c. 1430–40, fol. 1r (fig. 8). The opening text is likewise enclosed within an ornamental four-sided bar border with an appended historiated initial featuring a portrait of Chaucer. The border has grown wider with fine filigree work and has acquired cameo-like bosses at the four corners. There are scrolls encircling and entwining the colored bars of the left and right borders. According to Hardman: "The left-hand scroll reads: ': / : pences d / : de mai : / : pences / de m/ || Jhc / merci :/ : ladi : / help:' and the right-hand scroll reads: 'in god is : / : al : mi truste / : in god : || As fortune / : faulit : As fort / : faulit :'."[34] While they endorse the text with a religious sentiment, these two scrolls also impart a sense of antiquity to the genealogy of the original owner or owners (especially if this was a wedding gift; see below) whose mottoes they may be.[35] In this portrayal, Chaucer appears to be acquiring a stronger historical role as the time-honored author whose work is possibly meant to help legitimize such a family by association in a process of mutual inscription of status.

Unlike the image of the gray-clad Chaucer in the Lansdowne manuscript, this one shows a blond Chaucer clothed in a short, blue, pleated cloak cinched at the waist and trimmed with rich brown fur at the collar, cuffs, and hem. The color scheme is similar to that first initiated in the Hengwrt MS: pink, blue, and burnished gold (here with added colors). Chaucer's clothes are colored to match the blue and pink colors of the border ornamentation. The Lansdowne Chaucer's red hose has turned pink, showing off his legs (one points to the blue cord that entwines the framing letter and descends to become a bar of

(facing) 8. Portrait of Geoffrey Chaucer, *The Canterbury Tales*. Oxford, Bodleian Library, MS Bodley 686, fol. 1r, 1430–40.

the border (compare the courtly pose of Beves, ch. 3, sec. II, fig. 7). The color coordination and linking of elements indicate that a single artist likely painted the border, the historiated initial, and the portrait.

This accomplished artist evidently also had a playful streak. This is suggested by the vegetal border decoration that includes not only acanthus foliage but also features a Lords-and-Ladies floral spray entwining the left border midway down, right beside the lines that introduce Chaucer and the pilgrims gathered at Southwark. This plant motif, with a spike or spadix projecting from a cowl surrounded by leaves, is suggestively erotic in a manuscript closely contemporary with Bodley 686, one assumed to be Chaucer's translation of *The Romance of the Rose*, Glasgow, University Library, MS Hunter 409, c. 1440, fol. 57v (fig. 9).[36] There this plant appears prominently four times along the border and once within the decorated letter referring to the God of Love. Its flowering spadix pierces through the bottom of the letter to touch the narrator's self-referential "I." That the suggestiveness of the Lords-and-Ladies plant (Arum maculatum) was not lost on this illuminator is evident from one of its more common alternative English names—and there are over a hundred, many also salacious[37]—"cuckoo pintle." This derives from association with the cuckoo, which first appears in spring, and from Old English "pintel" meaning, as Bosworth and Toller modestly phrase it, a "membrum virile," a definition that continued into Middle English usage.[38] A closer look at the Bodley borders reveals that there seem to be some two dozen Lords-and-Ladies plants of various sizes, including the large one in the spray appended to the left border and numerous minute ones scattered around in the borders. Within the top right segment and in the spray appended to the right border appear to be the female forms that have acquired the ripened berries of autumn. The viewer's gaze can follow the progress of fruitfulness around the borders. Further, the sense of progression in time can be seen as an anticipation of the pilgrimage itself and the transformation of the goal to produce spiritual fruit, as indicated at the end of the "Parson's Tale."

The colors of the flower and fruit may also explain a

34. Hardman 2003, 44.

35. Ibid., 44 and 68n25; Scott 1996, 2:215.

36. This manuscript has been digitized, with images and transcription, at http://www.memss.arts.gla.ac.uk/html/samples.htm. Click on "Page Index" and then "57v." See also Thorp 1987, 89.

37. Prime 1960, 216–17. Similar plants were popular in English borders from around 1420–25 until 1455—see Scott 2002, 12, 46, 54, and 120–21 for a discussion and examples. She refers to this plant under the umbrella term "aroid." The flowers in Hunter 409

and in Bodley 686 are, however, clearly identifiable as a specific species. Their erotic suggestiveness in these 2 manuscripts is clear from the context.

38. See http://en.wikipedia.org/wiki/Arum_maculatum. The updated Anglo-Saxon Dictionary by Joseph Bosworth and T. Northcote Toller in now online at http://www.ling.upenn.edu/~kurisuto/germanic/oe_bosworthtoller_about.html. The Middle English Dictionary, online at http://quod.lib.umich.edu/m/med/, defines it simply as "penis."

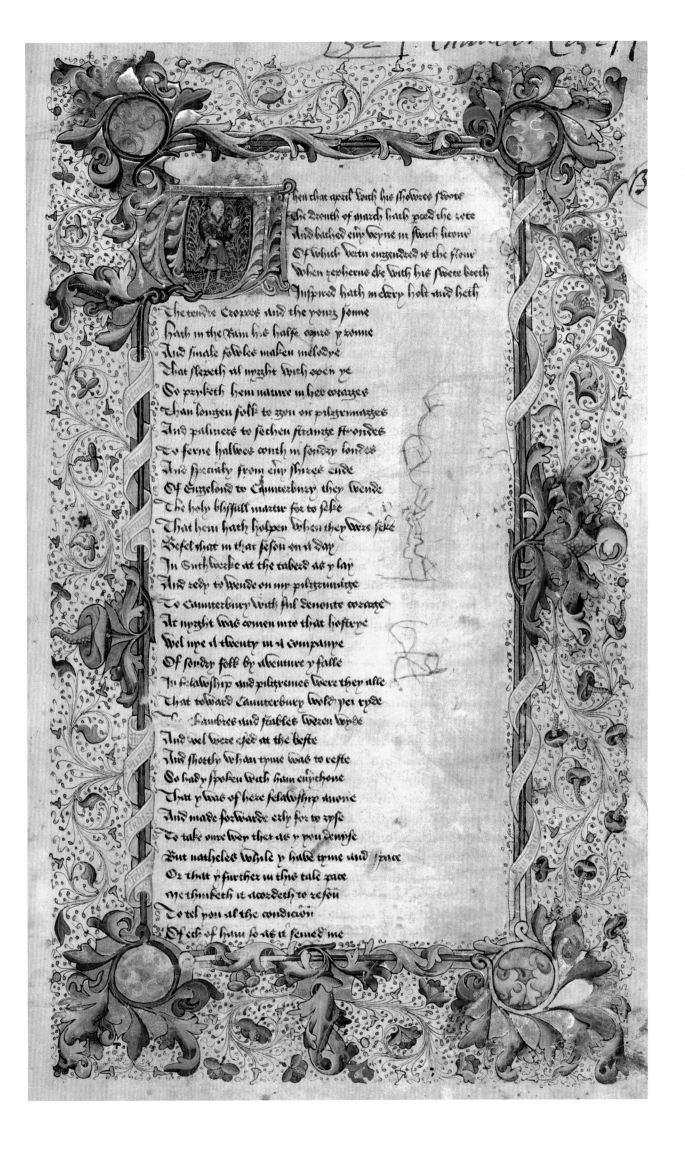

When that april with his showres swote
The drouth of march hath perced the rote
And bathed euery veyne in swich licour
Of which vertu engendred is the flour
When zepherus eke with his swete breth
Inspired hath in euery holt and heth

The tendre croppes and the yong sonne
Hath in the Ram his halfe cours y ronne
And smale foules maken melodye
That slepeth al nyght with open ye
So pryketh hem nature in her corages
Than longen folk to goon on pilgrimages
And palmeres to sechen straunge strondes
To ferne halwes couth in sondry londes
And specially from euery shires ende
Of Engelond to Caunterbury they wende
The holy blisfull martir for to seke
That hem hath holpen when they were seke
Befel that in that seson on a day
In Southwerke at the tabard as y lay
And redy to wende on my pilgrimage
To Caunterbury with ful deuoute corage
At nyght was comen into that hostelrye
Wel nyne and twenty in a companye
Of sondry folk by aventure y falle
In felawship and pilgremes were they alle
That toward Caunterbury wolde þei ryde
The chambres and stables weren wyde
And wel were esed at the beste
And shortly when tyme was to reste
So had y spoken with hem euychone
That y was of here felawship anone
And made forwarde erly for to ryse
To take oure wey ther as y you deuyse
But natheles while y haue tyme and space
Or that y further in this tale pace
Me thinketh it acordeth to resou
To tel you al the condiciou
Of ech of hem so as it semed me

feature of the portrait of Chaucer within the historiated initial: the large orange-red tubular hat which he holds below his waist and which otherwise would have no place as a major feature of an author portrait. Could the hood be an intertexual allusion to the "Game in myn hood" as described by Pandarus (*Troilus and Criseyde* 2.1110)? Michael Camille gives a contemporary artistic example of the medieval symbolism often associated with the hood in his discussion of the embroidery on a purse depicting a woman pulling a man's hood.[39] In the case of the Bodley page, the large hood held by the figure resonates with the ornamentation of the Lords-and-Ladies plants scattered around the border to reinforce and emphasize the fecund energies of spring and its generational possibilities. It is likely that the visually literate medieval viewer, able to decode the mutual reflexivity of the framing portrait and the decorative imagery of the border, would see

in this page a playfully rendered love garden[40] inhabited by Chaucer as the poet of love, perhaps also recalling the popular *Romance of the Rose* that he translated. This enclosed love garden thus serves as a kind of portal into the literary garden that follows. The decorative apparatus introducing the *Canterbury Tales* in the Bodley manuscript is in the lighthearted spirit of youthfulness and fun consonant with the opening words of the poem.

It is tempting to speculate about the intended owners of this manuscript. Not only the richness of the manuscript but, on this folio, the combination of French and English on the border scrolls suggest an aristocratic family, or at least one from the upper gentry aspiring to such a status. Given the subtlety, decorum, and lightness of touch with which it is executed, as well as the ornamental and textual enrichment of the borders, could it be that this manuscript was perhaps intended to inspire the right sort of ambience for a recently married couple—especially if a fruitful outcome was important and desirable? In the bottom left scroll, the prayerful request to Christ for mercy and to Our Lady for help situates such a desire for offspring within a marital and religious context. If that is the case, then the references to God and fortune in the scrolls on the right, while they might seem to pull in opposite directions, add a philosophical note of acceptance in the spirit of "whatever will be, will be."

The use of images that extol and encourage fertility is not an unprecedented role for medieval manuscript art. In societies where lineage is everything, the production of an heir is of primary importance. This is exemplified in Chaucer's "Clerk's Tale" (137). The lavish Bible made for Wenceslas IV of Bohemia (whose sister Anne was the first wife of England's Richard II) contains numerous figures of buxom bath maidens, symbolic objects, plants, and animals associated with fertility in order to rehearse a "plea for potency" for this childless emperor.[41] As early as the Old English Caedmon manuscript (Oxford, Bodleian Library, MS Junius 11) and as late as the Lichtenthal Psalter (likely ordered to be made by Joan Fitzalan for her young daughter, Mary de Bohun, married at around eleven years

9. Geoffrey Chaucer's translation of *The Romance of the Rose*. Glasgow, University of Glasgow, Hunterian Library, MS Hunter 409, fol. 57v, c. 1440.

39. Camille 1998, 63–65. Camille quotes the passage in Chaucer's *Troilus*. See his fig. 37: "Game with a hood. *Aumonière* made in Paris c. 1340. Hamburg, Museum für Kunst und Gwerbe." See also Camille's fig. 52 of a *Roman de la Rose* illustration in Biblioteca Apostolica Vaticana, MS Urb. 376, fol. 51v, c. 1280. It combines monetary and erotic symbolism by depicting a lady feeling her lover's long purse, which is also positioned below the waist as in the Bodley portrait. For other variant associations of "hood," including love games and "manhood," see Smith 1983, 7 and 9; and Hodges 2001, 230–31 and n22.

40. Camille 1998, 78–79. Camille discusses "the imaginary space for love" created by "flowery borders and lush vines" in manuscripts. He associates the space with the time: spring.

41. Ibid., 86–87. The Bible is Vienna, Österreichische National-bibliothek, Cod. 338, c. 1390.

of age to the future Henry IV), there are numerous images of childbirth and women holding babies. Urging that the source of power for aristocratic women is in the production of a male heir, such illustrations encourage them in their primary duty. For the noble young owners of the Lichtenthal Psalter, which highlights "marital fruitfulness," it is probable that "'reading' the images . . . was as much a part of their education as reading and reciting the words of the sacred text."[42] Sometimes this might be brought about in a playful way, as in some of the erotic images added to the Egerton Psalter for the young Mary de Bohun, whose family badge is the swan that informs many of these illustrations. As Denise Despres astutely observes, the image depicting a "naked young courtier who straddles the historiated 'D' of Psalm 60 (folio 41r), his erect phallus a spray of foliage, his bare feet resting upon a white swan, holding forth a large, jeweled ring" undoubtedly relates to sexual union.[43] If the Bodley manuscript was meant as a bridal gift, comparable in intent to one of the two de Bohun Psalter-Hours just mentioned,[44] it is interesting to note that instead of celebrating a marital union and encouraging a successful issue through an illustrative program in a religious manuscript book, this fifteenth-century work now employs vernacular literature as the medium for commemorating an alliance and carrying a message.

In the evocatively erotic but tasteful and delicate artwork of the border and initial of the Bodley *Canterbury Tales*, it appears that the imagery functions metaphorically, in this case, of human as well as vegetal generation, thereby altering the reading and application of Chaucer's text in a particular if subtle manner. It is a good example of a visual "bourde."[45] The "game" in the portrayed author's hood is both visual, inviting the viewer to identify and connect the motifs on the page, and also textual, introducing the storytelling contest that unifies the *Canterbury Tales*.

3. Tokyo, MS Takamiya 24 (formerly Devonshire), c. 1450–60

The third extant manuscript in the four-sided bar border tradition including an author portrait within the introductory historiated initial is MS Takamiya 24, fol. 1r (figs. 10 and 11). It has a much more densely embellished border but still employs pink and blue pigments, a standard feature of lavish *Canterbury Tales* manuscripts by this time, along with an abundance of burnished gold everywhere. The luxuriously lush border dominates the page to

create an impression of great splendor. The large historiated initial with its portrait of the English poet is superimposed on the border itself, which surrounds it and extends into the text space. In a further interplay of the visual and the verbal, the elongated first four words form part of the top border, equal in width to the other three sides. The frame has appropriated the text and author while the text in turn has taken to itself a framing function. In this process of mutual transformation, the visual elements of the page have become a major feature, participating in, even dominating, the authorial role. Taken together, the sumptuous ornate border and the author incorporated in the initial are presented as a great treasure, an artifact of English tradition and cultural excellence.

Chaucer wears a long, fur-trimmed, red houpeland with a purse hanging from his belt, enhancing the impression of richness. Marking his increasingly heightened status in the literary milieu of the fifteenth century and paralleling the rise of the Chaucer family, he looks more like a wealthy magnate or nobleman than a poet. While the earlier decorated manuscripts with their lavish vegetal borders serve to provide a kind of posthumous visual laureation of this author and his works, MS Takamiya 24 ennobles him as well. This appears to anticipate Caxton's description of him as "that noble & grete philosopher Gefferey chaucer the whiche for his ornate wrytyng in our tongue maye wel haue the name of a laureate poete / For to fore that he by hys labour embelysshyd / ornated / and made faire our englisshe."[46] From this estimation of him, it would appear that the resplendently decorated and finely executed pages of such fifteenth-century manuscripts were effective in their visual inscription and promotion of this "noble" author whose works took on the attributes of their presentation and could be seen in this light, thereby reinforcing contemporary literary estimates of their value. The visual embellishments are the equivalent of the verbal rhetoric that contemporary audiences appear to have valued as a mark of literary excellence, English now being promoted as being just as capable of producing it as the more traditional Latin. Readers in the twenty-first century, however, might not necessarily think of Chaucer's work as ornately embellished, although the *Pearl* poem might be considered along those lines (yet the illustrative program of that manuscript does not include ornamental borders; see ch. 3, sec. IV).

Unlike the previous Chaucer portraits considered so far, this one shows him seated, and unlike many biblical au-

42. Sandler 2004, 142. This psalter is Baden-Baden, Lichtenthal Abbey, Archiv MS 2, c. 1380–94.

43. Despres, unpublished essay by permission of the author. This Psalter-Hours is London, British Library, MS Egerton 3277, begun c. 1361 and completed in the 1380s.

44. See also Caviness 1993, 333–62.

45. A "bawdy story" or a "joke, jest, witty remark" as defined

by the Middle English Dictionary; see online at http://quod.lib.umich.edu/m/med/lookup.html. Here the "bordure" or border, including the historiated initial, conveys the titillating jest.

46. From Caxton's "Prohemye" to the second edition. See both first and second facsimile editions at http://www.bl.uk/treasures/caxton/homepage.html. For a slightly modernized version with punctuation, see Blake 1973, 61.

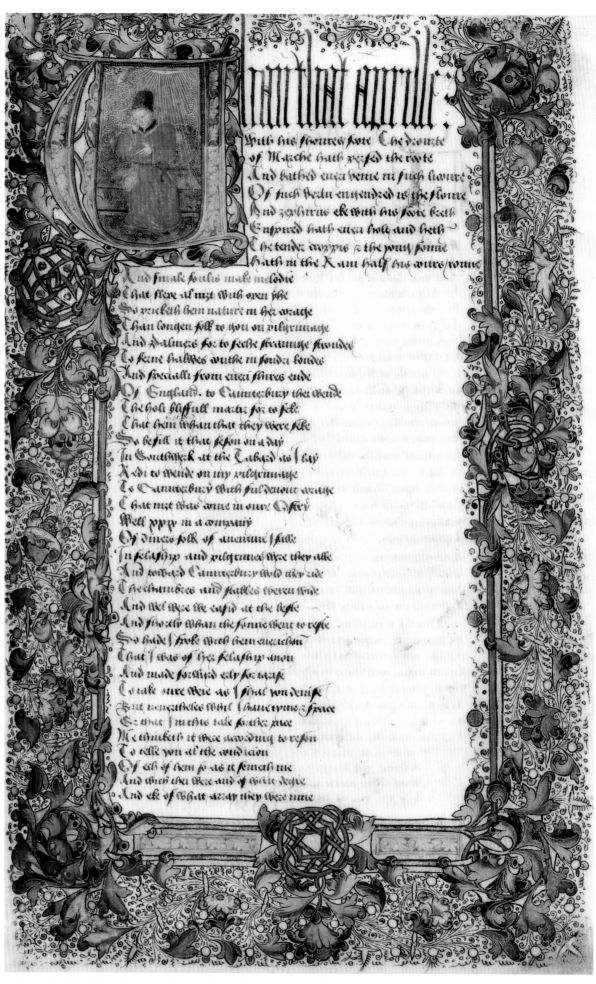

10. Portrait of Geoffrey Chaucer, *The Canterbury Tales*. Tokyo, MS Takamiya 24, fol. 1r, c. 1450–60.

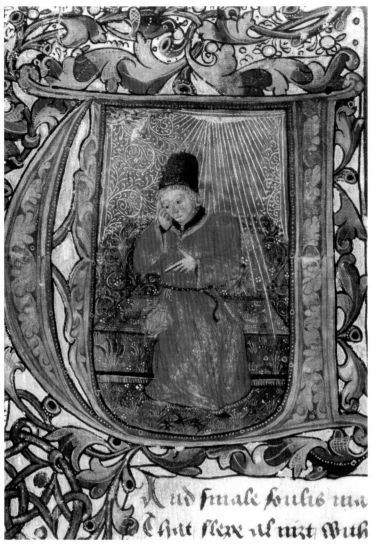

☞ The assemble of foules.

☞ Here foloweth the assemble of foules verap plea-
faunt and compendyous to rede or here compyled by
the prcclared and famous clerke Geffrap Chaucer.

11. Portrait of Geoffrey Chaucer (detail), *The Canterbury Tales*. Tokyo, MS Takamiya 24, fol. 1r, c. 1450–60.

12. Portrait of Geoffrey Chaucer, *The assemble of foules*. Printed in London by Wynken de Worde, 1530, STC (2nd ed.) / 5092. San Marino, CA, Huntington Library, MS 31325, title page.

thors portrayed in religious manuscripts, he is not engaged in the act of writing. Rather, he seems to be deep in contemplation, with his right hand held to his bowed head. This gesture reflects the long-established iconography of the dreaming Endymion in classical art, appropriated in early Christian art for such religious uses as the portrayal of the dreaming Adam from whose rib Eve is created, or later, of such dreamers as the narrators of the *Pearl* poem and *Piers Plowman* (see ch. 3, sec. IV and sec. V).[47] Moreover it has been adapted for use in manuscript portraits of patristic scholars such as Jerome in his study.[48] The same pose would be used to represent Chaucer as a "fa-

mous clerke" in a woodcut at the beginning of Wynken de Worde's 1530 publication of *The assemble of foules* (fig. 12).[49]

In the fragmentary Oxford, Bodleian Library, MS Rawlinson Poet. 223, a seated figure is depicted within the historiated *A* beginning the "moral tale of Melibe and Prudence" (fig. 13). The positioning of a pilgrim author portrait within a historiated initial attached to a modified demi-vinet border at the beginning of his tale is something of a hybrid in terms of the pattern of illustration discussed so far. Such a portrait is more common at the beginning of *Canterbury Tales* manuscripts, as in MS Takamiya 24, while equestrian portraits of the pilgrim authors

47. It is at http://image.ox.ac.uk/show?collection=corpus&manuscript=ms201.

48. A. Gillespie 2006, 123.

49. Ibid., 123 and n55, fig. 15. See also the Huntington Library copy at the EEBO site (by subscription): http://eebo.chadwyck.com.ezproxy.library.uvic.ca/home. This woodcut has been used

for at least fourteen different sorts of publications, as indicated in Hodnett 1973, 267, no. 926, and fig. 82. An almost identical copy of this cut was used for six different books, as indicated by Hodnett, no. 927, fig. 83. The first English use occurred around 1517. This reuse demonstrates how the meaning of the cut can be determined by its context in a reflexive manner.

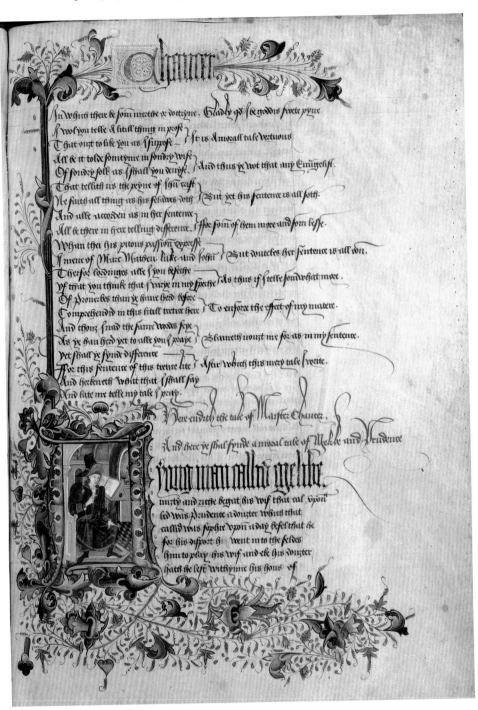

13. Portrait of Geoffrey Chaucer/"Melibe," *The Canterbury Tales*. Oxford, Bodleian Library, MS Rawlinson Poet. 223, fol. 183r, c. 1450–60.

are more common in those manuscripts with illustrations preceding the tales, as in the Ellesmere MS. Since MS Rawlinson Poet. 223 was written by the scribe who also wrote MS Takamiya 24 around the same date, it is not surprising that there are similarities in the portraits of the seated figures (and in the components of the borders),[50] possibly under the influence and direction of this scribe. In this case, the figure points to the text that the historiated ini-

tial *A* begins. Behind his left shoulder an open book on a typical medieval writing desk with a slanted top suggests that he is the author, or at least, narrator of the tale his speaking gesture indicates. Although the title of the tale does not identify Chaucer as the speaker and while there is almost certainly some conflation with the "Melibe" of the title in such details as the richly attired robe he wears, it is unlikely to be that character since the title specifies both him *and* Prudence. Furthermore, Chaucer had asked, in the last line of his response to the Host, just above, to be allowed to "telle" a moral tale in prose as he had promised (mentioned a few lines earlier). The following tale is indeed in prose. The only other extant illustration in this

50. For a fuller description of this portrait, and of the other surviving portraits of the Friar preceding his "Prolog," see Hardman 2003, 47–50.

manuscript characterizes the Friar by picturing him in his pulpit at the beginning of his "Prolog" on fol. 142r, so it seems plausible that the design scheme was to picture the pilgrim authors. In the case of the "moral tale of Melibe and Prudence" the portrait is consonant with the notion of an author as a scholar in his well-appointed study, similar to some Gower portraits.[51] Since the first folio of this version of Chaucer's *Canterbury Tales* has been lost,[52] it is not known if there was a portrait of Chaucer at the beginning. The seated figure in Rawlison is most likely Chaucer, given also that his portrait is similarly placed in the Ellesmere MS (fig. 2). Even Oxford, Corpus Christi College, MS 198, fol. 217v, which contains no portraits, has its most elaborate border at the beginning of this tale, referred to as "Chauceres tale." The attribution to Chaucer is prominently embedded within the top border of the Rawlinson MS.

In MS Takamiya 24 the study has been replaced by the outdoor setting and the scholar by the poet. Sitting alone on a turf bench, feet on a flower-studded grassy patch, Chaucer is surrounded by what may be intended as a rose arbor.[53] This is reminiscent of images of the Virgin seated within an enclosing arbor as in London, British Library, MS Add. 31835, fol. 27r, Amiens, 1430s (fig. 14). In MS Takamiya 24 the enclosing garden is not a visual metaphor of the Virgin as the earthly habitation and "erbor swete" of the incarnate Lord,[54] or of paradise, but of a literary garden. Derek Pearsall suggests that the setting might be an allusion to the poet's self-representation in *The Legend of Good Women*.[55] There Chaucer describes "a litel herber that I have, / That benched was on turves fressh ygrave" (F 203–4).

That the portrait still retains something of its historical precedents in religious author portraits[56] is seen by the divine rays that shine down on Chaucer, illuminating his efforts. While Chaucer does include some religious tales, like that of Saint Cecilia as told by the Second Nun, that is not the focus here. A further clue is given in the blue raindrops[57] falling from the wavy blue cloud at the top left and which, together with the sun, relate directly to the first nine lines of the poem beside the historiated initial. The raindrops and rays of sunshine that nourish the growth of the natural world in the springtime are, on one level, directly translated from the poem.

There is, however, a second, figurative level by which this scene can be understood. What is brilliantly config-

14. Virgin and Child in an arbor. London, British Library, MS Add. 31835, fol. 27r, Amiens, 1430s.

ured within the historiated initial is visualized with great economy: it is the author who is in the process of being inspired to write his masterpiece as he is illuminated by the divine rays and as his imagination is refreshed by the rain. Golden rays now illuminate the inspired poet rather than just the holy figures of religious art. The author is infused with divine rays, but there is no image of God above the clouds, nor a hand of God descending from the clouds to direct human affairs. It is not the Divine Author

51. Kerby-Fulton and Justice 2001, 217–37. Hardman 2003, 49, observes that "Melibeus . . . notably neglects the teachings of books and authorities." Although it may be a "generic 'author' image," as she suggests, the viewer will tend to derive meaning from its context. On the false etymology of "Melibeus" see *Riverside* 1987, 924n967.

52. Hardman 2003, 47.

53. Ibid., 45.

54. Lydgate 1966, l. 285.

55. Pearsall 1992, 291.

56. See Glasgow, University Library, MS Hunter 475 (V.7.2), fol. 274v, eleventh to late twelfth century, depicting the hand of God speaking to Saint John, who in turn directs his hand, from which rays descend, to his disciple Prochoros, busily writing the *Acta Joannis*. See http://special.lib.gla.ac.uk/exhibns/treasures/subject.html.

57. Hardman 2003, 45.

but the human author who, albeit divinely inspired, is featured. Such light imagery is consonant with the language used in humanist and Renaissance circles to refer to great authors.[58]

In MS Takamiya Chaucer is shown in the process of artistic creation as he envisions his *Canterbury Tales*, not an otherworldly message of salvation. Wide-eyed and unfocused as he looks off into the distance, and divorced from the natural world of everyday, he sits alone in an arbor, verbalizing the text as it comes to him. His pointing finger is a speaking gesture, indicating that he is hearing its rhythms as he vocalizes them.[59] There is, however, no scribe in this little scene. The purse at his waist, on this level of interpretation, is a visual trope indicating his "treasure of memory"[60] from which he will draw in order to transform the tales he has heard or read about. It is also possible that the object hanging from his belt is a girdle book. Whether it is a purse or a girdle book, it indicates the high value placed on literary creation, a value that is enhanced by the visual richness of the decorative features of the page: this book and its author are treasures.

By now, in England, artistic genius has acquired value. This conception of inspiration anticipates early Renaissance thinking in which the inspired literary artist is raised to new heights, receiving the sort of veneration formerly accorded to saints. Earlier in Italy portraits of its literary giants who heralded the Renaissance had already been popular for some time. The portrait by Giotto (1267–1337) of his friend Dante, who had been dead over a dozen years, appears to show the vernacular poet still earlier as he had appeared when younger.[61] Some later portraits in this iconographic tradition crown Dante with laurel.[62] While some portraits of Petrarch also acquired laurel wreaths,[63] there is a late fourteenth-century Italian portrait of this poet seated in a garden at the front of a small wicker structure as shown within the historiated initial in London, British Library, MS Harley 3454, fol. 1r.[64] Petrarch has an open book in his hands and another beside him, but as in the Takamiya Chaucer, he gazes off into the

distance beyond the left margin, perhaps also musing on his own composition, the *Opuscula vari*, which follows. In the second half of the fifteenth century in England, it is Chaucer who has reached these new heights in the literary stratosphere, Chaucer who is the great national poet who has been much emulated but not surpassed. That is what is presented in the Takamiya portrait: Chaucer is illuminated by divine inspiration and his work is materially illuminated on the page.

It brings to a culmination an interest in the creative process evident not only in Chaucer's work but also as revealed in the *Troilus and Criseyde* frontispiece (fig. 15). As an idealized youthful bearded Chaucer tells the story of Troy he is envisioning in his mind's eye, the royal listeners surrounding him can see the story unfolding in theirs, while at the same time the procession of what appear to be the characters of Chaucer's story of Troy are figured in the background at the top of the picture.[65] The green color of the trees at Chaucer's back is repeated in the same color tipping the rocky ledge separating the two realities and the greenery of the imagined scene above, visually linking them. The double border consisting of a framed inner border and an outer one with spray work enhances the fantasy. Because it is the imaginative act that binds all together there is no need for Chaucer to be pictured as reading from his book. In an appropriation of religious iconography, it is now the poet, not the preacher, who is seen standing in a pulpit and gesturing with one hand to his audience, as Pearsall has observed.[66] Since the text follows the frontispiece, there is also no need for labeling the Troy scene above, as there is in the *Très Riches Heures* January illustration (fig. 16) where the Duc de Berry is featured in a feast scene below a tapestry in which the Trojan subject is identified by inscriptions. This full-page *Troilus* miniature depicts that magical and timeless moment when imaginative creation, author, and audience are one, and the viewer is given a privileged glimpse of all three before embarking on a reading of the story as it unfolds.

The four-sided bar borders of the *Canterbury Tales* in the

58. See A. Gillespie 2006, 118–26. She quotes the paratext to Rastell's 1525 printing of the *Parliament of Fowls* in which he praises the "noble man" Chaucer and associates his works with the "risyng of firy phebus bryght" (A1r–v).

59. Hardman suggests that the pointing gesture might indicate that he is dictating a composition (2003, 46).

60. Hardman 2003, 46 and 69n29, referring to Carruthers 1990, 34–35, 39, and 251.

61. Mather 1912, 118. Giotto's Dante appears as one of the crowd in Paradise, but he is suitably grave, as befits the author of the *Inferno*. See http://www.paradoxplace.com/Perspectives/Italian%20Images/Single%20frames/Portraits/Dante_Alighieri.htm. But see Gombrich 1979, 471–83, who questions the identification.

62. For instance, that by Raphael (1483–1520). For this and

similar images, see the website in the previous note. See also A. Gillespie 2006, 13; she observes that the canonical place of the *Commedia* was asserted in late medieval Italian manuscripts by "depicting a laurel-wreathed Dante."

63. For thumbnails of Petrarch see http://www.google.ca/images?hl=en&sugexp=evnsp&xhr=t&q=Portraits+of+Petrarch&cp=21&um=1&ie=UTF-8&source=univ&ei=UTNTTd7SLYHEsAPd9sjIBg&sa=X&oi=image_result_group&ct=title&resnum=1&sqi=2&ved=0CCwQsAQwAA&biw=1006&bih=882.

64. See http://www.bl.uk/catalogues/illuminatedmanuscripts/searchMsNo.asp.

65. See especially Salter and Pearsall 1980, 100–23 and Scott 1996, 2:183–84.

66. Pearsall 1977, 70–71.

15. Geoffrey Chaucer, *Troilus and Criseyde* frontispiece. Cambridge, Corpus Christi College, MS 61, fol. 1v, c. 1415–25.

16. New Year's celebration at the court of John, Duc de Berry, with Troy scene above, in the calendar scene for January, *Très Riches Heures*. Chantilly, Musée Condé, MS 65, fol. 1v, 1410–16.

Hengwrt tradition discussed so far likewise serve as visual prefaces or gateways to the literary experience that is about to begin. They establish control over the text they enclose[67] and, in the works discussed, intimate that a garden of verse is about to be entered.[68] These borders help to elevate and illuminate Chaucer's fiction, placing it in the same ranks as important texts with the same basic color and design scheme during this period (cf. the border of *The Prick of Conscience* in Chicago, IL, Newberry Library MS 32.9, fol. 2r, where the decorative elements of the closed four-sided bar border reinforce the concept of the eternal Trinity; front plate 3).[69] In each of the three *Canterbury Tales* manuscripts with a historiated initial, the author is introduced within the first letter of the first word as he himself introduces his text. Whether middle-aged or young, whether like a Westminster clerk, a fashionable courtier, or an inspired nobleman, he directs the way the tales are to be understood and what level of audience is meant to be attracted. The historiated initials serve as a point of transition between the text, of which they form the first letter, and the border. The traditional English border, as Scott observes, developed historically from the first letter and so is connected with the text metaphorically as an enhancement.[70] This close connection in design can be seen especially in the Hengwrt MS itself and in the Lansdowne and Bodley *Canterbury Tales* manuscripts. In the case of the Bodley manuscript, the metaphoric connection of the Lords-and-Ladies plant motif dramatically reinforces the significance of the author's hat and so plays on the generative forces of spring mentioned in the opening lines. In the Takamiya MS, the historiated initial is placed within the lush vegetation of the border. There the flowery surround of the poet, and the rain and the rays descending on him from above, not only echo the beginning of the poem but also depict the poet in the process of being inspired. To enjoy the full significance of such elements, the viewer needs to replicate the medieval way of looking, taking the time to tease out the meaning conveyed by the interconnected visual and verbal clues. Even in the period before print, the image of the author was, to borrow a phrase from Alexandra Gillespie, "open to 'creative regeneration.'"[71] In these manuscripts, the vegetal ornamentation of the frame and the historiated initial also function visually as a kind of laureation of the father of English poetry, while visually inscribing his poetry as ornate. As the only figural portrait in these *Canterbury Tales* manuscripts in the four-sided border tradition, the author serves to introduce the whole of the *Canterbury Tales*, including the "General Prologue" and the individual tales, over which his authorial role is thereby established.

67. Cf. Scott 2002, 8–9.

68. For a delightful illustration of a garden of verse see the mid fifteenth-century French translation by Laurens de Premierfait of Boccaccio's *Decameron* in which Boccaccio appears outside an enclosed garden within which a laurel-wreathed poet recites to a courtly audience. See Oxford, Bodleian Library, MS 213, fol. 1r at http://bodley30.bodley.ox.ac.uk:8180/luna/servlet/detail/ODLodl~1~1~40814~116745:Decameron-?sort=Shelfmark,Folio_Page&qvq=q:213;sort:Shelfmark,Folio_Page;lc:ODLodl~1~1&mi=184&trs=188. Compare the *Troilus and Criseyde* frontispiece, just discussed, and Salter and Pearsall 1980, 155–16.

69. See also the plates in Scott 2002 showing numerous examples for religious, didactic, legal, historical, and scientific works, many of them in Latin.

70. Scott 2002, 9.

71. See also A. Gillespie 2006, 10 and throughout.

IV. The Ellesmere Traditions: Illustrated Pilgrim Authors

The Ellesmere MS, however, subtly deflects the attribution of Chaucer as sole author of the *Canterbury Tales* by illustrating the twenty-three pilgrim "authors" who tell stories. This may also have been wise strategically if this manuscript was made during a particularly fraught time politically and ecclesiastically.[72] The Ellesmere design featuring the pilgrims buttresses the pilgrim Chaucer's claim in the "General Prologue" (as it is now commonly known) that he is only repeating what these several pilgrims themselves said, and excuses him from responsibility for any content that might prove offensive to his audience. Significantly, the illustrated pilgrim narrators are not portrayed adjacent to the "General Prologue" descriptions of them, as one might expect, nor at the beginnings of their prologues, but only at the beginnings of their respective tales. This close proximity to their tales stresses that the individual pilgrims, visually materialized, are the real "authors." The portraits are placed to the left of the border on the verso folios (except for the Miller)[73] and detached from it and adjacent to the lines they resonate with on the recto folios. The narrators interact closely with the stories they tell, influencing and being influenced by them. Chaucer himself is portrayed only at the beginning of his prose tale (fig. 2), coloring the viewer's impression of him. He is visually associated with that tale, rather than with the complete *Canterbury Tales* as in the development of the Hengwrt four-sided border tradition that places his portrait within the historiated initial at the beginning of the entire work.

In both groups of manuscripts, the illustrative program serves as a unifying device, in the first case highlighting Chaucer as the author of the entire work, and in the second connecting all the tales by emphasizing them as fabrications of the pilgrim authors on their journey to Canterbury. If the subjects of their narratives were illustrated, then there would be less of a sense of cohesiveness to the collection since not all the stories fit into a single thematic or generic whole. Found in connection with the figural illustrations at the beginnings of the tales and often marking important divisions in the narratives, the sequence of demi-vinet borders throughout the Ellesmere MS also creates a visual rhythm and sense of continuity (this is also true of the demi-vinets on subsequent folios of Lansdowne 851 and Bodley 686). The journeys of the viewer and the "authors" are joined in a parallel movement toward the goal. By the end of the experience, the last border is, however, still open-ended, allowing a further movement beyond the manuscript for a transformation from a geographical to a spiritual destination as the final "fruit" to be gained from the pilgrimage. It also allows readers to take the pilgrimage into their own lives.

Whether the pilgrims approach the text from the left or the right, they enter from undefined space outside the manuscript. Just as the pilgrims gather at the Southwark Inn from different geographical, social, and personal spaces, with their real character and background unremarked except as they choose to present themselves to the pilgrim Chaucer or as they reveal themselves in their prologues and tales, their histories are largely unknown. They are visually introduced without any setting (except for grassy turfs added to the portraits by the second artist).[74] The open-ended borders with unframed pilgrim portraits invite the viewer to speculate further on their identities and to fill the negative but active white spaces of the vellum pages and beyond.

The reader can begin to reconstruct the identity of each pilgrim and the meaning of the text by connecting the illustration with a number of elements on the page that interact with it. To assist in the process, the visual semantics of the first illustrated page of each tale includes the elaborate border ornamentation, large decorated capitals, often smaller capitals, and, frequently, textual marginalia. Many of the pilgrims are illustrated with attributes that help to identify and highlight some essential aspect of their personalities, tales, or a/vocations.[75]

In such cases, the reader's own visual and verbal literacy, as well as social and personal background, are also important constituents of the interpretive process. Since each

72. See Hilmo 2004, 160–63.

73. See the Miller on fol. 34v (online, as previously noted). The artist's model for a figure with bagpipes might have faced left or the Miller was meant to be shown satirically as a buffoon (GP 560) by imitating the placement of the Knight. It could also have been a mistaken placement corrected in subsequent portraits.

74. For analyses and classification of which illustrations might have been made by which artists see, for instance, Rickert 1940, 596–602; Emmerson 1995, 151–56; and Scott 1996, 2:40–43, cat. no. 43.

75. For example, the Ellesmere Miller carries a bagpipe (fol. 34v). In other versions he carries a practice chanter, as in the Oxford fragments; see Hardman 2003, 58–59, and fig. 1; and in Caxton, see online. For images of practice chanters, used for learning to play the bagpipes or practice while travelling, see http://www.tartantown.com/practice_chanters.html. I am grateful to Joan Lewis for the identification of the chanter and to David Hart for his learned discussion about these instruments.

In medieval fashion, the Ellesmere Clerk, to give another example, carries books under his arm (fol. 88r). Adamnan, in his life of the sixth century St. Columba, tells a story about a youth drowned while he had "a number of books packed up in a leathern satchel under his arm." See Adamnan 1874, bk. II, ch. VIII, online at http://www.fordham.edu/halsall/basis/columba-e.html. Caxton's Clerk, on the other hand, carries a bow and arrows, a visual metaphor in portraits of John Gower as a satirist aiming his arrows at the world; Hilmo 2007, 71–105.

manuscript is a distinctive production often meant for a specific reader or readers, at least in social status if not in actual identity, the reading process is governed not only by the author's text as shaped by the manuscript's professional planners, scribes, and artists but also by the intended or actual audience. Further, an accretion of meaning is built up each time the reader comes again to the text, having the additional benefit of knowing how the text proceeds and the added life experiences acquired in the interim.

The emphasis here will be not only on the lavish Ellesmere MS,[76] which appears to have set the precedent for portraying mounted pilgrim narrators, rather than episodes from their tales, but also on a manuscript made within the next quarter century and on the first illustrated printed edition. Specifically, these are the fragmentary Cambridge, University Library, MS Gg.4.27, c. 1420–30, which has nine illustrations,[77] and Caxton's first illustrated printed edition of 1483, which contains twenty-six woodcuts, including one of the pilgrims feasting. There are spaces in London, British Library, MS Harley 1758, c. 1450–60, but whether or not these were intended for illustrations is controversial.[78] The so-called Oxford fragments[79] are not dealt with here because the few remaining illustrations are not of the pilgrims selected for special attention in this study.

A discussion of all the pilgrim portraits in the earliest illustrated books of the *Canterbury Tales* would take too much space. To see how figural illustrations can affect and be affected by the pilgrims' narratives as executed by different artists at different times for changing audiences, it is useful to look in detail at a few specific portraits to see how they varied. Chosen because they exemplify some of the main issues concerning authorship and audience, the pilgrim portraits selected for examination from the Ellesmere MS, MS Gg.4.27, and Caxton's second printed edition include the Knight and his son the Squire, the Wife of Bath, the Manciple, and Chaucer. This is by no means an exhaustive list of pilgrim illustrations that reflect either Chaucer's exploration of these issues or those of his presenters in the fifteenth century.

It becomes clear that, just as in the manuscripts that begin with historiated initial portraits of Chaucer, the illustrated pilgrim portraits in the Ellesmere tradition are each unique in presentation. Then, in the age of print, some standardization begins to appear in each edition, with only minor variations apparent in subsequent editions by those early sixteenth-century publishers who used or copied the work of the Caxton block cutter. Modern critics such as Benson who argued that it is the tale, not the teller,[80] that is important have obviously relied on more recent printed editions in which only the text is featured. Late medieval manuscripts, with all the paraphernalia of the *ordinatio* of the page, like decoration and annotations, offer a more diverse and multileveled reading experience. In the case of *Canterbury Tales* manuscripts that include illustrations of the pilgrim authors as well, the artistic designers took full advantage of the opportunity to manipulate the way each tale was to be understood by casting it as the imaginative product of a particular pilgrim author who is vividly portrayed before each tale to color its reception by a select audience. While Caxton did not include annotations, he did add more reading aids to his second edition of 1483, most notably the woodcuts of the pilgrims. Neither he nor the manuscript designers he tried to emulate emphasized the thematic content of the tales except as they reflected or were projections of the pilgrim authors (or in particular instances, gave a nod to the chief patrons). It is only recently, with the possibilities offered by the computer, that the reading experience has once again become diverse, as the various Chaucer sites offer attractive visual and textual features, including panels along the borders and ever proliferating links to yet more information.[81]

1. The Knight

According it great importance, the Knight's portrait is the first figural illustration to appear in the Ellesmere MS (fig. 17). Like the others in this manuscript, it is an equestrian portrait, and as such it initiates and reinforces the illusion that the pilgrims are indeed on the road to Canter-

76. See Hilmo 2004, 160–99 for discussions of the Monk, the Pardoner, the Parson, the Franklin, the Prioress, the Merchant, the Miller, the Cook, and the Summoner. For a study of the Prioress, the Second Nun, and the Nun's Priest, see Hilmo 2009.

77. The six pilgrims are the Reeve, the Cook, the Wife of Bath, the Pardoner, the Monk, the Manciple, and, uniquely in fifteenth-century *Canterbury Tales* manuscripts, the Virtues and Vices, including the pairs Envy and Charity, Gluttony and Abstinence, and Lechery and Chastity. This fragmentary East Anglian manuscript also contains other works including John Lydgate's *Temple of Glass*. For a description see Scott 1996, 2:143–47, cat. no. 43.

78. In his review of the Ellesmere Chaucer, Partridge 1997, 885–90, suggests that they did. Hardman 2003, 60, however, points out that it has been overlooked that these spaces occur after the ends of the previous tales and before the beginnings of the prologues of the following tales. Complicating the issue is that Harley

1758 contains both a full border on the first folio and three-sided borders as at the beginning of the "Merchant's Tale." The first folio in Harley 1758 can be viewed at http://www.imagesonline.bl.uk/results.asp.

79. They are in two locations: the John Rylands University Library of Manchester, UK, for English MS 63 and the Rosenbach Museum and Library, Philadelphia, PA, for MS 1084/2. The three extant illustrations are the Miller, the Cook, and the Man of Law, all enclosed in plain rectangular frames. See Hardman 2003, 58–60, and figs. 2–4.

80. Benson 2003, 21–33.

81. Links to ten such Chaucer sites, including the Harvard Chaucer page, can be found at http://www.unc.edu/depts/chaucer/chpages.htm. See also http://special.lib.gla.ac.uk/exhibns/chaucer/index.html.

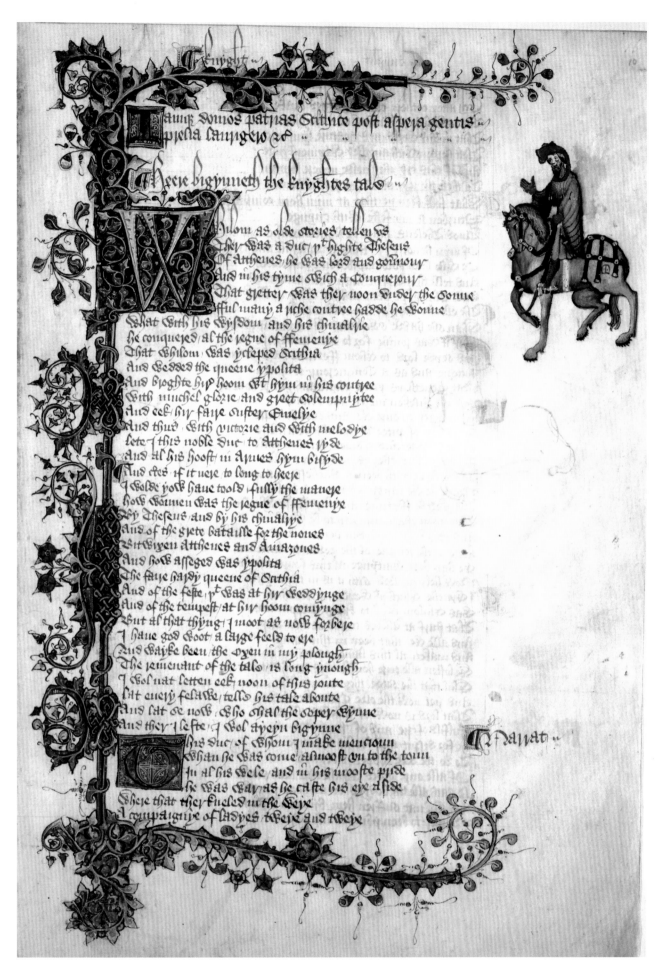

17. The Knight, Geoffrey Chaucer's *Canterbury Tales*. San Marino, CA,
Huntington Library, MS Ellesmere 26 C 9, fol. 10r, c. 1400–10.

bury. As each pilgrim tells a story, more distance appears to have been covered, increasing the sense of movement in space and time as they progress toward their ultimate destination. Portraying the pilgrims as riders is a scheme that was to be used repeatedly in subsequent *Canterbury Tales* illustrations featuring the pilgrim authors.

And like the others in the Ellesmere, the Knight's portrait does not appear within a historiated initial, as did the author portraits in manuscripts in the four-sided border tradition. The decorated initial *W* at the top of the page, however, does parallel in size and look the only other decorated initial as large, that beginning the *Canterbury Tales* (fig. 6). The addition of the portrait privileges the tale section over the "General Prologue" in the decorative hierarchy of the manuscript's design.

What is striking about the Knight's appearance is that he is not accoutred as a knight in shining armor. He is not dressed in rusty or bloodied chain mail as he proceeds on his way to make his religious observances at Canterbury immediately on his return from his latest campaign against the enemies of Christendom. Rather, he wears an elegantly paneled, high-necked, gray houpeland with a scalloped hem at knee length, along with a rust-brown chaperon on his head color-coordinated to match his fingerless mittens, scabbard, and fashionable arming points on his chest. Not only are the last two items tipped with gold, but his rowel spurs are the only ones in this manuscript hand-painted with gold.[82] The long points on his shoes indicate high status. The serviceable unadorned horse of the "General Prologue" has been turned into the finest of specimens with an abundance of gold bosses, hinges, and tips on his harness. His bearing is not "as meeke as is a mayde" (GP 69) but instead proud and straight. Was the artist ignorant of the "General Prologue" description or is there some other purpose to this transformation of horse and rider?

The illustrated Ellesmere Knight plays several roles. The figure's sweeping gesture can be read as that of the author and master of ceremonies, greeting and welcoming the reading and viewing audience to this text, indeed, to the entire collection of stories. However, as the first author portrayed in the manuscript, this fictional author also appears to displace Chaucer, who is not pictured until later in the manuscript.

Secondly, given the placement, look, and disposition of the pictured figure, he also takes on some of the attributes of Theseus, with whom the tale begins. The Latin

inscription by Statius at the top of the page mentioning the return of Theseus also serves as a kind of title to the page. It would be natural to identify the figure as Theseus, mentioned in the adjoining vernacular text as the "duc." In contrast, for example, to that of the Manciple's horse, whose head is jerked away from the text (fig. 28a), this illustrated horse gazes at this first sentence, as if calling attention to the identity of his rider.[83] By his gesture, it would appear as if the rider is halting his troops, offstage, and greeting the people of Athens to whom he is returning. The two decorated letters farther down the page also refer to Theseus, who could indeed be the subject of this page, both in the visual design and in the text.

Thirdly, and for similar reasons involving the higher status the illustration accords him, this lordly figure serves as the person with whom the aristocratic patron or intended owner can identify. In this guise, he invites the audience to join him in the spacious and well-appointed aristocratic pleasure garden that the demi-vinet border implies. Indeed, attempts have been made to identify him with a specific historical figure.[84] This tale can be seen as a model reaffirming correct behavior for rulers and those espousing a chivalric code of ethics.

Finally, however, this figure is the pilgrim Knight, as indicated by the title. He has taken on some of the attributes of the main character of the tale he has chosen, no doubt partly because it reflects some aspect of his chivalric persona. As the Knight, he has been given the privilege of telling the first tale. The fact that the lot has fallen to him simply validates the basis of the medieval hierarchical system understood to be divinely sanctioned, at least by the class for whom this manuscript was made.

What the visual departures from the detailed descriptions of the pilgrims of the "General Prologue" demonstrate is not that the artists had no clue about what the text said, but that such a text was considered malleable by the designers and artists. An aristocratic audience needed to be encouraged to find something interesting, edifying, and entertaining in a work in the formerly degraded English vernacular. Above all, it needed to have its own social prejudices reaffirmed. In such a case, the manuscript's designers, conscious of the requirements of the financial sponsor underwriting the cost of this work, walked a fine line and would not have undertaken the enormous expense of making such a manuscript book without having planned every aspect of its production carefully. Materially and artistically, it is an object of great price that any member of the nobility would treasure.

Unfortunately there are no other extant illustrations

82. There are four other portraits with details painted in gold: the Wife of Bath's gold belt, Chaucer's pen case, the decoration on the Monk's hounds, and the Miller's thumb. As opposed to the burnished gold leaf in the border decoration, gold paint was made by adding a binder to finely ground gold dust. For instructions from the medieval period see Theophilus (1963) 1979, 34–37. See also Viñas and Farrell 1999, 26.

83. See also the discussion in Hilmo 2009, 117, suggesting that the Ellesmere horses are personalized.

84. See Jones 1994 and, by the same author et al. 2003. He suggests that the portrait of Chaucer's Knight is based on mercenaries like John Hawkwood. See Hilmo 2004, 172.

of the Knight until William Caxton had woodcuts made of him and the other pilgrims for his second printed edition of the *Canterbury Tales* in 1483. This illustration of the Knight *does* look like a knight in shining armor (fig. 18). In the same year Caxton's block cutter depicted similar armor for the knight in the *Game and Playe of the Chesse* but with the visor on his helmet closed, unlike that of the *Canterbury Tales* Knight.[85] Wynken de Worde's 1498 printed edition of the *Canterbury Tales* used the Caxton woodcut from the *Game and Playe of the Chesse* for Chaucer's Knight, making him even more a generic knight since his face is not visible. What accounts for this difference in conception between the time of the Ellesmere rendition and that of Caxton? In the interim, many changes had taken place.

The introduction of print technology into England revolutionized the way texts were made, even while there were also continuities with the past in its early stages. Caxton's typefaces for vernacular books were intended to look like hand-lettered calligraphic script, even to the point of appearing somewhat antiquated. As in the case of manuscripts, spaces were left for the later addition of ornamental capitals introducing and separating sections. In this case, hand-painted red Lombard capitals helped to soften the regimentation of regular type. Caxton's decision to add woodcuts to his second edition of the *Canterbury Tales* proved useful not only because they serve as finding aids and interpretive guides but also because they relieve the tedium and somniferous effect of rows of dense, heavy black type. In his second edition Caxton also reduced the size of the black type, added such features, prominent in the Ellesmere design, as running titles at the tops of the pages and more spaces, the latter especially noticeable in the separation of stanzas for those tales with rhyme royal stanzas.

Both the woodcut illustrations and the main text are now in black and provide a contrast to the bright white paper surface. The colorful floriated borders of illuminated manuscripts suggestive of aristocratic pleasure gardens, rhetorical gardens of verse, or paradisal gardens are gone. There is, however, some attempt to represent the third dimension in the *Canterbury Tales* woodcuts by the layering of planes, the size reduction of the distance vista, and the shading. And even more realistically, the respective proportions of rider and horse are more accurate. If anything, it is a more modern aesthetic.

There were also historical differences in the technology of warfare that are reflected in the woodcuts. For instance, the Caxton block cutter updated the verbal portrait of Chaucer's Knight to accord with actual advances in armor as the fifteenth century progressed. Metal armor be-

18. The Knight, Geoffrey Chaucer's *Canterbury Tales*. Printed in Westminster by William Caxton, 1483, STC (2nd ed.) 5083. London, British Library, G.11586, sig. a3v (fol. 3v).

came more prevalent, largely replacing the chain mail and the "gypon" mentioned by Chaucer. The Caxton Knight sports a metal helmet with a plume and—all in metal—a visor that can be lowered in battle, a bevor to protect his neck and chin, a pauldron at his shoulders, a breastplate, couters at his elbows, gauntlets for his hands, tassets at the tops of his thighs, cuisses on his thighs, poleyns with side wings on his knees, greaves for the fronts of his legs below the knees, and sabatons for his feet. What remains of the Ellesmere Knight are his rowel spurs and the long points on his toes. Unlike the Ellesmere Knight, he does actually have a weapon, a long black sword. It appears that the Caxton carver was showing off his knowledge of contemporary armor while at the same time making the Knight relevant to the viewer of 1483.

85. See book IV, ch. 5, at Gutenberg: http://www.gutenberg.org/files/10672/10672-h/10672-h.htm#bk4ch5. This is a later copy with incorrect attribution.

This woodcut image depicting Chaucer's Knight is placed both preceding his verbal portrait in the "General Prologue" (here called simply "Prologue") and again preceding his tale. This is the advantage of the use of moveable woodcuts in the age of moveable type.[86] This dual use of the illustrative woodcuts in Caxton's *Canterbury Tales* also balances the "General Prologue" and the tales section, according them equal literary weight. Because the Knight once again comes first, even in the "General Prologue," his portrait carries added weight and performs similar functions to those of the Ellesmere Knight: he temporarily assumes an authorial role and welcomes the reader to the pilgrimage.

As seen in this woodcut, the Knight is shown in a minimalist setting consisting of uneven terrain with a single rock in the foreground. The Caxton woodcuts are somewhat emblematic in nature. In this case the Knight, equipped with armor befitting his times, reinforces Caxton's moral appeal to current rulers for a return to the chivalric virtues that informed previous ages. In Caxton's epilogue to the *Order of Chivalry* (c. 1484), for instance, he says that this book is requisite to "noble gentylmen" and then ends boldly by saying that he presents this book to King Richard III and the young lords, knights, and gentlemen so that "the noble ordre of chyvalrye be herafter better used and honoured than hit hath ben in late dayes passed."[87] This gives something of the political climate in which Caxton continued to work and adds a slight edge to the woodcut portrayal of the Knight. In the year that Caxton published the second edition of the *Canterbury Tales*, Richard III usurped the throne.

In addition to a nostalgic longing for the chivalric values that were imagined to have informed the past, there is also a fanciful element now, as seen in the addition of a plume on the Knight's helmet. This might also call up, for its contemporary audience, the image of a bygone era, inviting them to see Chaucer's work in that light. In speaking of an even more beplumed and decorated knight in William Thynne's 1532 edition of the *Canterbury Tales*, Betsy Bowden says that this kind of "artful stylization" marks "what is now termed medievalism, a romanticized idealization of the nation's past."[88]

2. The Squire

Since there are no hand-painted portraits of the pilgrims in the "General Prologue" section of the Ellesmere MS, that of the Squire does not follow his father's. Instead, he appears prominently in the middle of the book at the

(facing) 19. The Squire, Geoffrey Chaucer's *Canterbury Tales*. San Marino, CA, Huntington Library, MS Ellesmere 26 C9, fol. 115v, 1400–1410.

(above) 20. The Squire (detail), Geoffrey Chaucer's *Canterbury Tales*. San Marino, CA, Huntington Library, MS Ellesmere 26 C9, fol. 115v, 1400–1410.

top of the page beginning his tale on folio 115v (fig. 19). The Squire approaches the border from the left, as do the other pilgrims depicted on the verso folios. The floriated spray descending from the decorated initial serves as a ground line for the Squire. The initial itself breaks up the bars of the border, of which it is also part, and rather like a door, permits entry to the text. This Squire is all courtesy, the two lines at the top of the text vocalizing his polite self-deprecation as he asks to be excused if he speaks amiss, which his self-referential gesture reinforces. Like the Franklin, whose gesture in the Ellesmere portrayal also indicates that he is protesting his skill,[89] his modest little speech is actually a sign of rhetorical finesse. The Squire's innocent and deferential gaze reinforces the "General Prologue" portrait describing his courtesy.

86. Driver 2004, 47 and 75.

87. As quoted by Blake 1973, 111–12. Caxton's preface to *Le Morte d'Arthur* (1485) reflects his ongoing concern with this subject, saying that he "sette it in enprynte to the entente that noble men may see and lerne the noble actes of chyvalrye, the jentyl and

vertuous dedes that somme knyghtes used in tho dayes by whyche they came to honour" (7).

88. Bowden 1995, 178, fig. 42.

89. Hilmo 2001, 15–16, and 2004, 180–81.

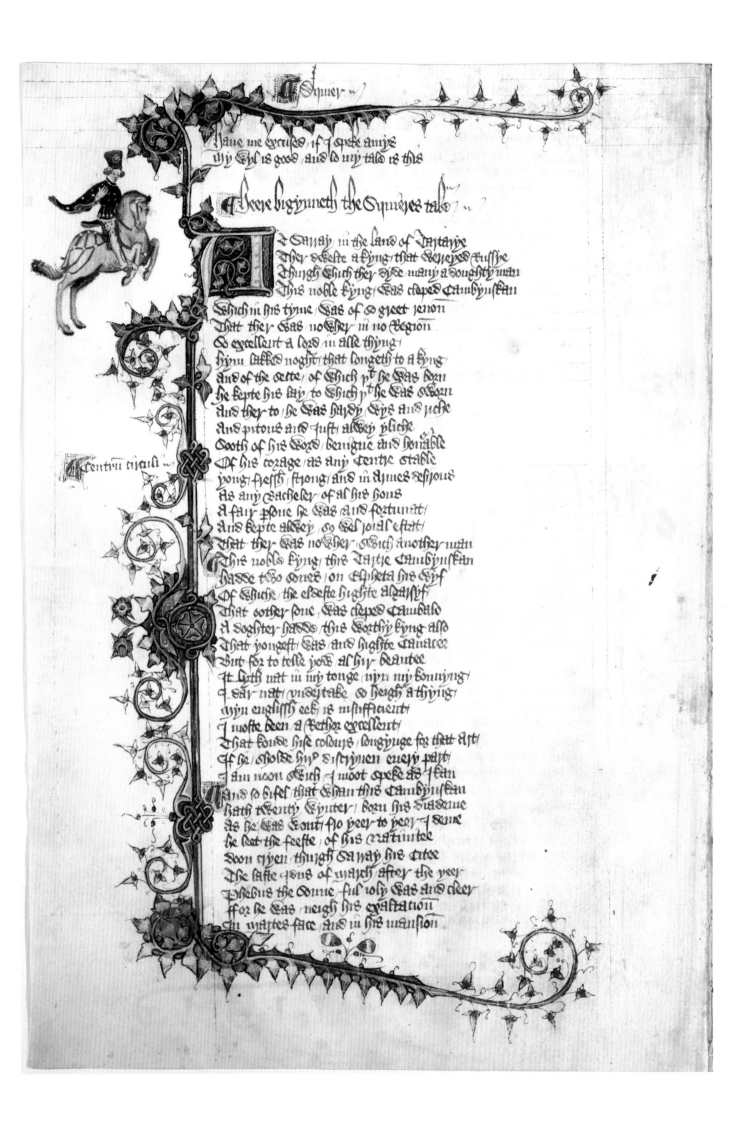

¶ Squyer·

Haue me excused / if I speke amys
my wyl is good / and lo my tale is this

¶ Heere bigynneth the Squyeres tale ·

At Sarray / in the land of Tartarye
Ther dwelte a kyng / that werreyed Russhe
Thurgh which ther dyde many a doughty man
This noble kyng / was cleped Cambyuskan

Which in his tyme / was of so greet renoun
That ther was nowher / in no Region
So excellent a lord / in alle thyng
hym lakked noght / that longeth to a kyng
And of the secte / of which pt he was born
he kepte his lay / to which pt he was sworn
And ther to / he was hardy / wys and riche
And pitous and iust / alwey yliche
Sooth of his word / benigne and honurable
Of his corage / as any centre stable
yong / fressh / strong / and in Armes desirous
As any Bacheler / of al his hous
A fair persone he was and fortunat/
And kepte alwey / so wel roial estat/
That ther was nowher / swich another man
This noble kyng / this Tartre Cambyuskan
hadde two sones / on Elpheta his wyf
Of whiche / the eldeste highte Algarsyf
That oother sone / was cleped Cambalo
A doghter hadde / this worthy kyng also
That yongest was / and highte Canacee
But for to telle yow / al hir beautee
It lith nat in my tonge / nyn my konnyng
I dar nat vndertake / so heigh a thyng
myn english eek / is insufficient/
It moste been / a Rethor excellent/
That koude hise colours / longynge for that Art/
If he sholde hir discryuen euery part/
I am noon swich / I moot speke as I kan

¶ And so bifel that whan this Cambyuskan
hath twenty wynter / born his diademe
As he was wont / fro yeer to yeer/ I deme
he leet the feeste / of his natiuitee
Doon cryen / thurgh Sarray his Citee
The laste Idus of March / after the yeer
Phebus the sonne / ful ioly was and cleer
ffor he was / neigh his exaltation
In Martes face / and in his mansion

Just as his youthfulness in every detail of dress and behavior is described verbally, so the Ellesmere portrait depicts him as the virtual embodiment of springtime (fig. 20). Echoing the text, his short gown is sprinkled with embroidered white and red flowers, very like a meadow. Everything about him seems about to take off, from his flowing sleeves to his horse with his swinging tail and the upward thrust of his stance. The Squire's light brown hair is curled, as mentioned in the "General Prologue" and as typified in the medieval iconography of youth.[90]

As does his father's visual portrait in the Ellesmere, this one raises the status of the Squire even more obviously. The Squire is shown with extremely long points on his shoes (no longer clearly visible because the paint has flaked off). In a fashion introduced into England by Richard II, he wears clapper bells suspended from his belt. Both they and his rowel spurs are painted white, likely meant to suggest silver. Since the Squire's portrait is placed near the beginning of his tale, which mentions the royal King Cambyuskan (i.e., Genghis Khan), it is perhaps not surprising that the Squire's status is identified with his fictional character.

His powerful horse can also be accounted for as a reference pointing to the magic flying horse in his story. This gives added resonance to the swinging tail and saddle straps of the horse, now seen as ready to ascend in flight. Such details would be accorded particular importance upon rereading the tale, while the large size of this horse, proportionally larger in relation to rider than that of any other in the Ellesmere, would prepare the first-time reader for the account of the special horse in the tale.

The ring he wears, causing a bulge under his white glove, can be accounted for as another link to his story, which mentions a magic ring given to the king's daughter. This magic ring allows Canace to understand the language of birds. As a signifier of speech, the ring highlights the self-presentation of the Squire as being skilled in the art of rhetoric.

The way the Squire wears this ring, high up on his ring finger, is one of three very suggestive clues that may reveal the identity of the person the designers of the Ellesmere had in mind as the principal recipient of this manuscript. First, a panel portrait of the young Henry V depicts him wearing a ring in the same high position on his ring finger.[91] (And as for rhetorical skill, there appears to have been substance to Shakespeare's portrait of Henry V, act IV.3, as an inspiring orator when he gave his Saint Crispin's Day speech.)[92] Secondly, corroborating evidence pointing to Henry V is the white badge appearing on the illustrated figure's high hat. Its shape is suggestive of the device of the white swan of Mary de Bohun, Henry IV's first wife and mother of Henry V, which was subsequently associated with these rulers.[93] And thirdly, seen to be quite out of the league of someone with the status of Chaucer's Squire in the text is the ermine this illustrated figure wears on his leggings (compare the ermine lining of Henry's garment as shown in the cover image from BL MS Arundel 38).[94] Based on this internal evidence within the Ellesmere—and there is no external evidence in the early fifteenth century—all this points to the possibility that the portrait was intended to allude to the young Prince Henry. This raises the intriguing possibility that the other figure most notably elevated in the illustrations, that of the Knight, the Squire's father, might indeed be intended as a flattering reference to Henry IV. In the absence of a dedication or other mark of its earliest owner or patron, the Ellesmere could well have been a gift meant for the young Prince Henry, although the identity of the donor remains speculative.

The Squire in Caxton, pictured before the description of him in the "General Prologue" and again before his tale (fig. 21), sports a plume like the one worn by the Knight in the woodcut. Instead of gracing a helmet, it adds a fanciful element to his Robin Hood style of hunting hat. As befitting a son of the Knight, the Squire's stance, like that

90. See the pictures of "youth" in depictions of the Ages of Man, for example in the De Lisle Psalter, London, British Library, MS Arundel 83, c. 1308–10, fol. 126v. See online at http://www.bl.uk/catalogues/illuminatedmanuscripts/results.asp. Compare also literary descriptions as related in Mann 1973, 115–20.

91. See Hilmo 2001, fig. 10, or Hilmo 2004, fig. 69; or view at http://media-2.web.britannica.com/eb-media/38/1238-004.jpg.

92. See Mogens Herman Hansen, "The Little Grey Horse—Henry V's Speech at Agincourt and the Battle Exhortation in Ancient Historiography," *Histos* 2 (1998): 46–63, nn. 8–16, at http://www.dur.ac.uk/Classics/histos/1998/hansen.html.

93. Mary's son, "King Henry V added the de Bohun swan to that of the Royal Standard in her honour," as observed by Pete Bown, "A History of the Bown Name," http://www.empusa.co.uk/home/history.htm. The last two images on this site show, respectively, the swan in Henry V's Royal Standard and Mary de Bohun's swan seal. The curved neck of the swan creates a circular hole within the seal impression like that of the badge on the

Ellesmere Squire's hat. The same white swan badge is directly associated with the personal arms of the Prince of Wales (the future Henry V), as depicted right above the portrait and personal arms of John Siferwas, the Dominican artist of the Sherborne Missal (London, British Library, MS Add. 74236, p. 81), made between 1400 and 1405, about the same time as the Ellesmere. This image can also be seen at http://www.bl.uk/collections/treasures/sherborne/sherborne_broadband.htm. Turn the pages until you get to their page 10, and then select the magnifying glass and drag it over the initial for a close-up to use this new "Turning the Pages" technology used by the British Library for special manuscripts.) For a discussion of the Missal, see Backhouse 1999, 7. Henry V had a white swan on his flag in the Battle of Agincourt when he defeated the French, according to Price 1994, 97.

94. Phillips 2007, 26, observes that "even wealthy knights must generally refrain from wearing cloth of gold, purple silks, sables and ermines, gemstones or pearls."

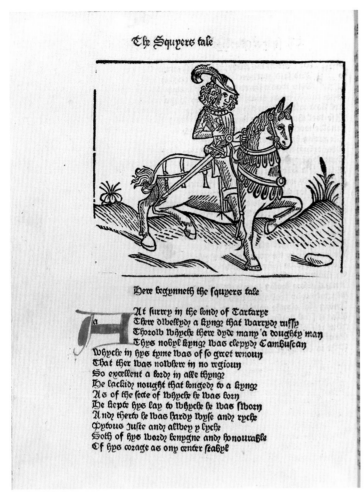

21. The Squire, Geoffrey Chaucer's *Canterbury Tales*. Printed in Westminster by William Caxton, 1483, STC (2nd ed.) 5083. London, British Library, G.11586, sig. n8v (fol. 104v).

22. The Squire, Geoffrey Chaucer's *Canterbury Tales*. Printed in London by Richard Pynson, 1526, STC 5086. Glasgow, University of Glasgow, Hunterian Library, Bv.2.6, title page.

of his horse, is deferential. The long points on his fashionable high leather boots indicate high status. The only accoutrement suggesting military skill is the sword hanging at his side, echoing his father's solid black one, but here he is not gripping it as does his father. Rather it is more of an accessory and seems to indicate that he had been in active service (GP 85), underlining the approaching manhood of the curly-haired youth familiar from the Ages of Man iconography. Like its rider's long curly hair, the horse's mane is curly (and its tail bound up), increasing the fanciful element. As in the case of the other pilgrims,[95] with the exception of the Knight and the Knight's Yeoman, he wears a rosary, in this case, loosely around his neck, rather like a chain of office.

He does not have flowers embroidered on his short jacket but, subtly calling attention to it, he delicately holds the single stem of a five-petaled white flower between his thumb and forefinger, almost as if it were a scepter. This could simply be a visual synecdoche by which one flower is intended to represent all the flowers embroidered on his short gown, as described by Chaucer (GP 89–90)—it being difficult to render much detail in such a woodcut. At another level, however, it might well be a visual reference to the white rose of York, possibly with reference to young Edward V, whose reign lasted only a few months before he and his brother disappeared after being sent to the Tower in 1483, the same year Caxton printed the illustrated *Canterbury Tales.*

The Squire is the first illustrated pilgrim the viewer encounters in Richard Pynson's 1526 edition of the *Canterbury Tales* (fig. 22). He now appears as the center of interest on the full title page. Previously Caxton, following

95. The fact that the pilgrims wear or hold rosaries is likely a contemporary feature reflecting the use of the rosary that was much in vogue in the late fifteenth century (although the developing use of the rosary had begun centuries earlier). It also adds a religious note to the portraits and provides a sense of unity of purpose since they are all on a pilgrimage. Earlier in the fifteenth century the Hoccleve Chaucer portrait also includes a rosary, its red and black beads linking it with the colors of the pen case and strap around Chaucer's neck (fig. 1).

manuscript usage, did not use title pages for his printed books, but these were to become standard features in the development of printed books. They serve an advertising function to entice the customer to buy the book. In this case, the Squire seems to have stepped out of a chivalric romance. Even his rather splendid, curly-maned horse has acquired plumes and additional decorative saddle trappings. The portrait is surrounded by an outer border made up of an assembly of four separate strips of ornamental woodcuts (Caxton had adopted such reusable border units in some of his later printed books). The religious motifs of the bottom border suggest the whole is grounded in Christian values, which, together with the chivalric element suggested by the portrait of the Squire, would have been intended to appeal to a more broadly based audience looking for an idealized and romanticized medievalism.

3. The Wife of Bath

In the Ellesmere MS the illustrated Wife of Bath is raised to a status higher than indicated in Chaucer's text (figs. 23 and 24). Her sleeves are trimmed with fur and she wears a gold belt. Other than the Knight's horse and the Monk's, hers is the only one that has gold bosses. And like the Knight's, only her horse is fitted with gold stirrups. As shown by the placement of her portrait at the beginning of her tale, the Wife of Bath not only introduces her tale but takes on some of the characteristics of the Elf Queen she describes in the adjacent text. The portrait manifests her own unfulfilled aspirations and embodies the subject of her tale in a kind of symbiosis of narrator and text. In this composite role she allows a high-born female reader to identify with her, just as lordly readers could identify with the Knight or the Squire.

She is delineated in a finer mode than the descriptions of her. Her hat is merely a sensible traveling hat not as large as a "bokeler" (GP 471), while her coverchiefs do not appear to weigh ten pounds. The Ellesmere designer did not approve of, or thought his aristocratic audience would not approve of, some of Chaucer's franker characterizations — the Wife of Bath's overt sexuality, for instance, is downplayed by not displaying lascivious gap-teeth or her scarlet red hose. Her foot-mantle, a garment that slips over her feet and comes up to and largely covers her hips (not large hips, as previously thought),[96] allows her to ride comfortably astride her elegant horse.

Not all her lively character traits are eliminated, as hinted by the riding crop. It reminds the reader that she herself has "been the whippe" (WBTPro 175) suffered by her three elderly husbands, the only allusion to her own

96. Beidler 2000, 388–97.
97. See Scott 1996, 2:143–47, cat. no.32.

(facing) 23. The Wife of Bath, Geoffrey Chaucer's *Canterbury Tales*. San Marino, CA, Huntington Library, MS Ellesmere 26 C9, fol. 72r, c. 1400–10.

(below) 24. The Wife of Bath (detail), Geoffrey Chaucer's *Canterbury Tales*. San Marino, CA, Huntington Library, MS Ellesmere 26 C 9, fol. 72r, c. 1400–10.

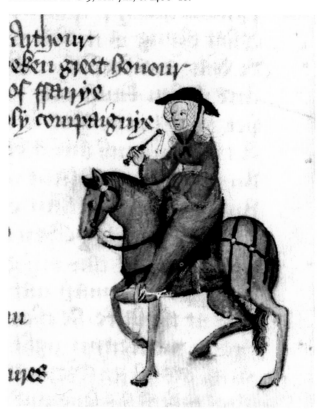

autobiographical prologue in this portrait, indicating that the artist was likely familiar with that text. The whip or crop is not unusual in size or usage. Her expression is not so much bold as determined, and her complexion rosy rather than red. Overall, her portrait elevates her status and emphasizes the tale affirming noble values rather than the more bourgeois concerns of the "General Prologue" description or even those conveyed in the prologue to her tale.

A different kind of portrayal of the Wife of Bath can be seen in a manuscript made around the same time as the Oxford, Bodleian Library, MS Douce 104 *Piers Plowman* (ch. 5, sec. V): Cambridge, University Library, MS Gg.4.27, c. 1420–30, a fragmentary East Anglian collection including also John Lydgate's *Temple of Glass* and other works[97] (fig. 25). Only nine illustrations survive: six pilgrims preceding their tales and, unusually, three sets of Virtues and their corresponding Vices to illustrate the Parson's description of the seven deadly sins and their remedies. Unlike the one in the Ellesmere, this illustrated Wife of Bath most certainly does have large head gear, with pleated coverchiefs surmounted by a mass of folded and twisted red fabric. Phillipa Hardman notes that this "head-dress

Quod this Somonour and I bishrewe me
But if I telle tales two or thre
Of freres er I come to Sydyngborne
That I shal make thyn herte for to morne
For wel I woot thy pacience is gon
Oure hooste cride pees and that anon
And seyde lat the womman telle hir tale
Ye fare as folk that dronken were of ale
Do dame telle forth youre tale and that is best
Al redy sir quod she right as yow lest
If I haue licence of this worthy frere
Yis dame quod he tel forth and I wol heere

Heere endeth the Wyf of Bathe hir prologe and
bigynneth hir tale

In tholde dayes of kyng Arthour
Of which that Britons speken greet honour
Al was this land fulfild of fairye
The Elf queene with hir ioly compaignye
Daunced ful ofte in many a grene mede
This was the olde opinion as I rede
I speke of manye hundred yeres ago
But now kan no man se none elues mo
For now the grete charitee and prayeres
Of lymytours and othere holy freres
That serchen euery lond and euery streem
As thikke as motes in the sonne beem
Blessynge halles chambres kichenes boures
Citees burghes castels hye toures
Thropes bernes shipnes dayeryes
This maketh that ther been no fairyes
For ther as wont to walken was an Elf
Ther walketh now the lymytour hym self
In vndermeles and in morwenynges
And seyth his matyns and his holy thynges
As he gooth in his lymytacioun
Wommen may go saufly vp and doun
In euery bussh or vnder euery tree
Ther is noon oother Incubus but he
And he ne wol doon hem but dishonour
And so bifel that this kyng Arthour
Hadde in hous a lusty Bacheler
That on a day cam rydynge fro Ryuer
And happed that allone as he was born
He saugh a mayde walkynge hym biforn

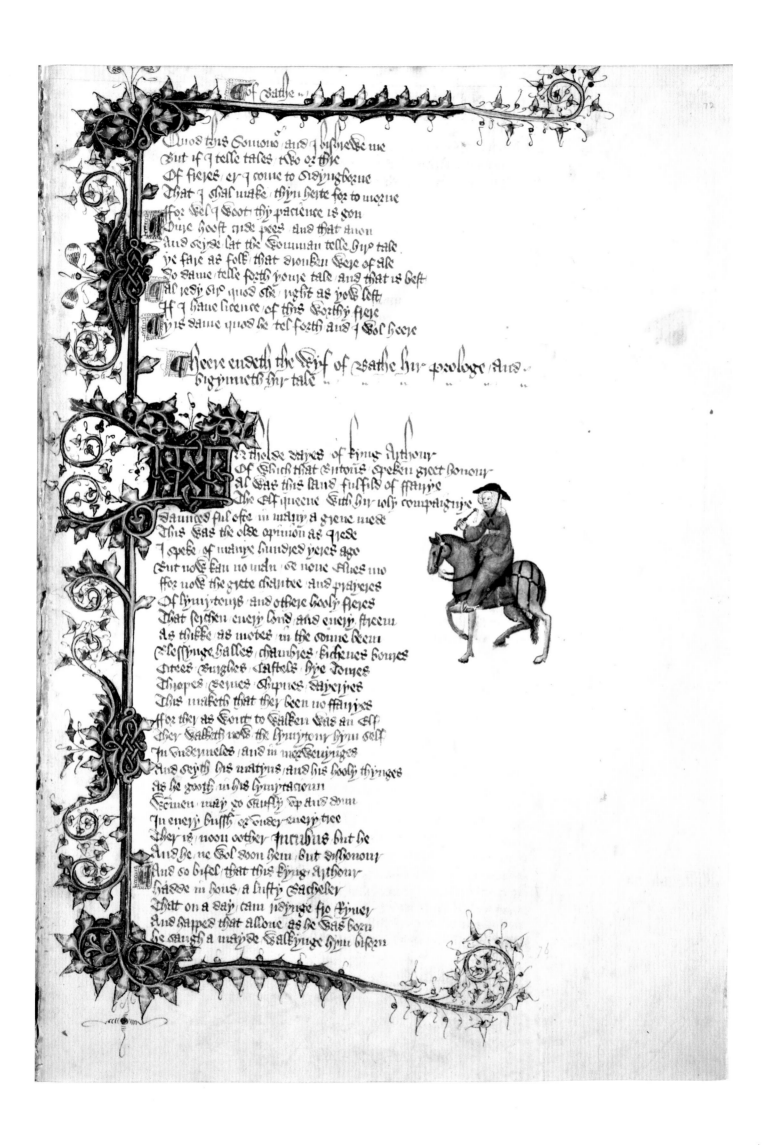

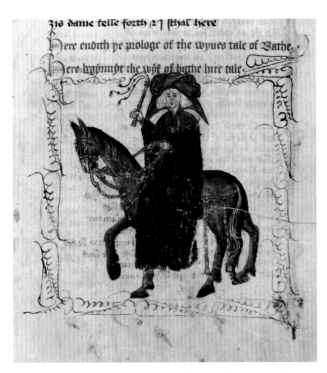

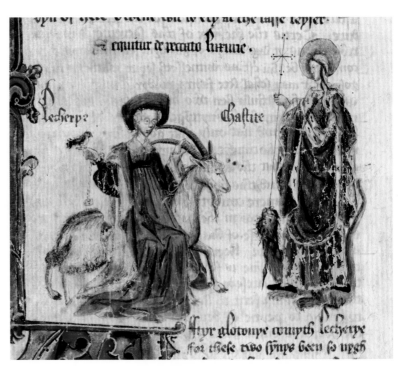

25. The Wife of Bath, Geoffrey Chaucer's *Canterbury Tales*. Cambridge, University Library, MS Gg.4.27, fol. 222r, c. 1420–30.

26. Lechery and Chastity, Geoffrey Chaucer's *Canterbury Tales*. Cambridge, University Library, MS Gg.4.27, fol. 433r, c. 1420–30.

was apparently designed to be even larger: faint preliminary drawing is visible to the right of the Wife's hood and to the left of the horse's head."[98] Her long blue cloak comes up to her shoulder, perhaps a variant of the Ellesmere Wife's foot mantle. We do not know if she wears red hose, but, also by way of displacement, her horse, which she rides sidesaddle, does have red trappings. In her left hand she holds the red rein close to her chest, a detail that, as Hardman continues, indicates that she has succeeded in getting "the bridel in myn hond" (ProWB 813).

Held prominently in her right hand is a riding crop, which, compared with the Ellesmere version, is longer, has an extra tail and added knots (the illustrated Cook on folio 192r in this manuscript carries an even longer riding crop, but it has only two tails). It also fills in the space that was originally intended to accommodate a larger headdress, indicating that the interpretive satriric thrust about women's large headdresses was toned down slightly. Instead, the designer particularized the Wife's attempt to invert the usual authoritative hierarchy of gender relations, described in extreme form by the Clerk in his tale. Here the elongated and more heavily loaded whip emphasizes the Wife's attempt to gain sovereignty. Hardman aptly sums up the portrait as expressing her "complex femininity."[99]

Like the other pilgrims in this manuscript, the Wife is enclosed in a light pen-work border consisting of a pattern of graduated scalloped lines. The darker ones at the top right were added later to fill the space, perhaps because the rubrication, indicating the beginning of her tale, left a small space there. The rubrication, as is evident from the Manciple's portrait where it surrounds the head, hands, and horse (see fig. 28b), was added after the illustration.

In MS Gg.4.27 the illustrations of the Virtues and Vices are not enclosed by pen-work borders, but they are labeled. Lechery carries a sparrow and rides sidesaddle on a goat, both creatures symbolically associated with this vice (fig. 26). Her left hand suggestively grasps the goat's horn. Lechery's counterpart, Chastity, is represented in the same illustration as a tall, elegant, haloed woman with a red ermine-trimmed outer garment. She carries a thin cross that pierces the head of the lion she is simultaneously trampling underfoot. She also tramples underfoot a dragon whose tail snakes up her left side. These are the beasts of Psalm 90.13, representing, in the case where a female tramples them, lust. This iconography goes back at least as far as Aldhelm (639–709), who wrote *De laude virginitatis* for the nuns of Barking. The trampling or defeat of the Vices is also familiar from the numerous illustrations of the Virtues and Vices in the manuscripts of Prudentius's *Psychomachia* in Carolingian and Anglo-Saxon works. In Gg.4.27 they represent the evil forces of lust over which Virginity has triumphed.

98. Hardman 2003, 55–56 and 70n47.
99. Ibid., 56.

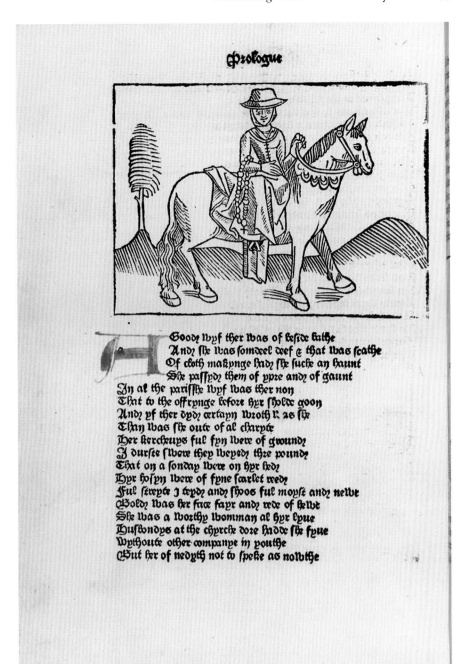

27. The Wife of Bath, Geoffrey Chaucer's *Canterbury Tales*. Printed in Westminster by William Caxton, 1483, STC (2nd ed.) 5083. London, British Library, G.11586, sig. b5v (fol. 13v).

It is interesting to view the portrait of the Wife of Bath in relation to this female pair of Lechery and Chastity. (In the contemporary Douce 104 manuscript of *Piers Plowman*,[100] Lechery is illustrated on folio 26v as a male figure.) The reader of MS Gg.4.27 might well connect these two contrasting figures of Lechery and Chastity with the Wife of Bath's discussion of the respective values of marriage versus virginity. In this manuscript, the painted red lips of Lechery correspond to those of the Wife of Bath, visually reinforcing the connection. Perhaps the illustrated Virtues and Vices were intended by the designers of MS Gg.4.27 to provide a moral context for the illustration of

the pilgrims as seen within the larger scheme of Christian salvation that the Parson presents. If so, these illustrations serve a corrective function in this presentation of Chaucer's work for a more puritanically minded audience.

Since there are no other extant illustrations of the Wife of Bath until Caxton and his second printing of the *Tales*, the woodcut he had made of her must be considered next. It can be seen that special thought was given to the Wife of Bath's portrait (fig. 27). Unlike the second placement of the woodcuts of the other pilgrims, which precede their tales, not their prologues, hers appears, instead, before her prologue. In this edition, her intriguing personality has overtaken the narrative she tells! As revealed by her portrait, the block cutter was obviously familiar with the details of her self-presentation. It must surely have

100. See my discussion of this manuscript in ch. 3.

been Caxton, however, who made the decision about the second placement of her portrait—an indication that he thought her more fascinating than her tale, and that the reader would agree.

As if to emphasize her unique position further, she is also the only pilgrim portrayed directly facing the viewer. Her own gaze is somewhat ambiguous as she appears to look down on the viewer to whom she presents herself. Is she looking over the audience for a sixth husband? Her hint of a smile might imply this to be the case. Her large right hand rests somewhat suggestively on her belly, while her left hand lightly holds the frilly reins of her pleasant-looking horse. Her coverchief is modest and her hat the same kind of sensible traveling hat worn by the Ellesmere Wife. Her figure is slim, neat, and elegant and, once again, not very bourgeois. Her dress is fashionable, with a scarf tucked into her buttoned front, but there is nothing excessive about it. Her large rosary with its wooden beads is draped over her right arm, rather like an accessory to her attire.

Apart from her obvious feminine qualities, there is also something philosophical, almost meditative, about her. She might well be looking back over her life, ahead to the tale, and perhaps even further beyond. Whether it was a happy accident or done on purpose, her slightly divided, bemused gaze adds an element of inscrutability. She is clearly a woman of many parts and of some depth. She does not carry a riding crop, suggesting that sovereignty over the opposite gender is not her main issue after all. Her frontal position and gaze invite viewers to the "game," however they might choose to define it.

4. The Manciple and Chaucer

While fifteenth-century visual portrayals of the Wife of Bath vary, those of the Manciple are remarkably consistent in their emphasis. In Chaucer's text, the Manciple, like the Wife of Bath, is a concise and able storyteller, although the Friar would silence her (ProFrT 1274–77). The "Manciple's Tale" also raises speech issues in relation to who should say what and to whom, and whether self-imposed silence might not be better than telling the truth. His tale is about language, how it can be manipulated, and its social dimensions.

This Manciple, a buyer of provisions for a law school, is a sort of middle management official. The "General Prologue" makes clear that his masters, the law students, are training to be stewards of rent and land for English lords, but they might well follow his example because his accounts are in excellent shape: he is a real financial wizard. He "sette hir aller cappe" (GP 586), which might be translated literally as "set the cap for all of them," that is, made a fool of or deceived them all. In various ways the Manciple illustrations in Ellesmere, Gg.4.27, and Caxton all call attention to the metaphor of the slang expression visually by making much of his hat (figs. 28 a–d). In the two manuscript illustrations it is color coordinated with the rest of his attire. In the Ellesmere he has a richly lined, wide-sleeved houpeland, allowing for the possibility that he does stash away some wealth.

Concerning him and the issue of the worthiness of the English language, Chaucer says, rather satirically, it shows God's grace that such a "lewed" man can surpass the wisdom of a heap of learned men (GP 574–75). This raises the issue of learning, especially since, in his tale, he says he is "noght textueel" and will "noght telle of textes" (235–36)—yet he does just that, since his fable is based on Ovid and he quotes Cato and the scriptures. Of course the fable could have been widely available through oral traditions, biblical quotations would have been heard in sermons, and Cato was taught to schoolboys. In his tale, he apologizes for using the term "lemman," which is a "knavysshe" word for lover (204–5). Pearsall suggests he is a kind of "greasy middleman for some of Chaucer's own concerns" about language.[101]

At the beginning of the "Manciple's Tale," Phoebus (Apollo), the god of rhetoric, slays the serpent Python with his bow. It is also the weapon Phoebus, in his jealous rage, uses to slay his unfaithful wife. Then, symbolically by means of rhetoric, he silences the truth about her actions that would make him look bad. (The wife in this story is never given voice so her point of view is unremarked.) Further, this tale explains why the white crow became black and lost his singing voice: because Phoebus punished him as a traitor for being the (truthful) messenger that the god was being cuckolded.

It is the moral of that story that is featured in all the Manciple illustrations. The way the Manciple treats his horse visualizes the moral. In all of the illustrations the horse's expression is similar, as well as the rider's way of holding the reins tight. Betsy Bowden has called attention to the Urry copper engraving of 1721 (fig. 28d). The artist shows the Manciple's harshness toward his horse, as "indicated by the two chains holding firm the long curb-arms of the bit, so that slight pressure on the reins drives a spoon or disc—possibly spiked—hard against the animal's palate."[102] In response, the horse "arches its neck and tries to prance sideways . . . its mouth open to evade pain from the bit. The later artist recognized in his prototype [MS Gg.4.27] . . . tack that was still used." Nonetheless, Bowden continues, "he declined to copy the anger of the fifteenth-century horse, which plasters its ears flat and glares backward at a pretentious rider forced to resort to the extra-powerful curb reins." Even the horse in the Ellesmere and in Caxton turns back in anger. The rein is pulled back in each case.

101. Pearsall 1992, 238.
102. Bowden 1995, 185.

28. The Manciple, Geoffrey Chaucer's *Canterbury Tales.*
(a) San Marino, CA, Huntington Library, MS Ellesmere 26 C9,
fol. 203r, c. 1400–14
(b) CUL MS Gg.4.27, fol. 395r, 1420–30
(c) Printed in Westminster by William Caxton, 1483, STC (2nd ed.)
5083. London, British Library, G.11586, sig. f5v (fol. 273v)
(d) Edited by John Urry, copper engraving, 1721, Notre Dame, IN,
University of Notre Dame, Hesburgh Library, ESTC T106027,
page 174.

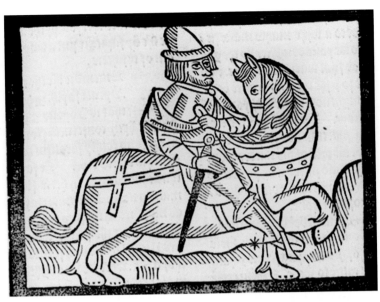

29. Portrait of Geoffrey Chaucer, Geoffrey Chaucer's *Canterbury Tales*. Printed in London by Richard Pynson, 1492, STC 5084. Glasgow, University of Glasgow, Hunterian Library, Bv.2.12, fol. a1r.

Where did this detail come from, since there doesn't appear to be anything in the *Canterbury Tales* to give this characterization? The saying that one should keep a tight rein on one's tongue[103] is from James 1.26: "If anyone consider himself religious and yet does not keep a tight rein on his tongue, he deceives himself and his religion is worthless" (not bridling his tongue: Douai).[104] *That* is the moral of the fable of the crow—he should have kept his mouth shut! He didn't bridle or keep a tight rein on his tongue when he volunteered the information to Phoebus about his wife's infidelity. All the artists, evidently following the Ellesmere example, appear to have been familiar enough with the biblical metaphor, probably often quoted, to utilize it as a way of visualizing the moral. The portrayal suggests sophisticated epitomizing that foreshadows Renaissance emblem books.

That the artists knew the actual text of the *Canterbury Tales* is reinforced by the inclusion, in three of the portraits, of the gourd, mentioned not in the "General Prologue" but in the "Manciple's Prologue." There he offers a gourd of wine to the Cook to make peace with him after

having accused him of being stinking drunk. At this the drunken Cook falls off his horse, but upon being offered wine, is happy.

To conclude his tale, the Manciple reiterates the point his dame taught him in a way that may have had a certain relevance to Chaucer's own situation as an author in fraught political times:

> "be war, and be noon auctour newe
> Of tidynges, wheither they been false or trewe."
> *(359-60)*

Following the lines from the *House of Fame* quoted at the beginning of this chapter, Chaucer implies that what he feels or thinks he will keep to himself and suffer the consequences. What can be known of him afterward can be ascertained from his art, made to the best of his ability (1877-82).

Perhaps Chaucer had reason to keep his thoughts to himself (and to heed the advice he attributes to the Manciple's mother), especially among the "hye" (361) of the land, who themselves, as history proved, came and went. What is more than curious is that in the 1492 edition of Richard Pynson, the woodcut based on the model for Caxton's Manciple (but not used for the Manciple in Pynson)[105] *is* used for a rather grim Chaucer, who pulls the reigns tight so that the annoyed horse has to turn his head back (fig. 29). This would seem to indicate that these illustrations were understood figuratively in the ongoing visual conversation about speech issues and authorship.

5. Chaucer

It is interesting to see how the visual portrait in the Ellesmere depicts Chaucer—not as directly responsible for the content of all the tales whose authorship is dispersed among the various pilgrim narrators visually staged before the relevant tales but primarily as the narrator of "Chaucers tale of Melibee" (fig. 2). The Ellesmere colophon, however, states that the tales were "compiled" by Chaucer. Because he is portrayed next to a prose text, he is not presented here primarily as a poet but rather as a wise philosopher of mature years, indicated by his gray hair and hoary beard. It is the idea of his authority that is featured as it is in some of the portraits of an aged Gower, as Gaylord argues.[106] Chaucer's sober, dark-colored houpeland and hood, its liripipe hanging down the back, reinforce the visual statement about who he is.

His belt, worn below his paunch, and the strap around

103. The idea is expanded in the "Franklin's Tale" when Dorigen agrees to become Arveragus's wife since he offers her "so large a reyne" (755). Unfortunately for Dorigen, she does not exercise the discipline herself when, in a careless moment, she pledges to become Aurelius's "love" if he can remove the black rocks that she finds so depressing (990).

104. See *Holy Bible* 1914, 329. The Latin Vulgate uses the verb "refreno" (to rein back, hold in): "si quis autem putat se religiosum esse non refrenans linguam suam sed seducens cor suum huius vana est religio"; see *Biblia Sacra* 1994, 1860.

105. It is not used for the Manciple in Pynson. In the "General Prologue" the woodcut of the Squire, with added chevron cuts in the border, is also used for the Manciple. Preceding the latter's tale, however, is the woodcut used for the Pardoner in the "General Prologue."

106. Gaylord 1995, 134-38.

the pen case hanging from his neck add color to an otherwise grave appearance. What stands out most dramatically can be seen in the original manuscript better than in a copy: his pen case is hand-painted in gold, identifying him as a writer. This object, his somber expression, and his *declamatio* gesture[107] all associate him with or point to the adjoining text. Specifically, the hand-painted gold of the pen case links him directly with all the burnished gold leaf in the bar border, in the background of the decorated letter beginning the tale, and in many of the text's paraph markers.

The decorated letter *A* has received special attention from the artistic designer. The underdrawing of the left vertical stroke shows that the actual letter was moved right slightly so that the horse's head, which seems to have butted the letter over, would not actually touch the letter. Probably because the letter was moved over, causing a slight revision of the original plan, the bar border descending from the decorated letter was moved over as well. This occurs on only one other folio in this manuscript: in the depiction of the Prioress,[108] which is the illustration preceding that of Chaucer in the Ellesmere.

Chaucer's finger points to the crown of the letter *A*. According to the "General Prologue" (160–62), a "crowned A" is engraved on the Prioress's brooch. The decorated letter *A* on the Chaucer folio is surmounted not by an actual golden crown but by an elaborately extended spray of vegetal ornamentation that could be also be construed as a garland, which is another medieval definition of "coroun."[109] No other tale beginning with a decorated *A* in the Ellesmere has such a crown.[110] The ornamentation of the garlanded letter helps visually to reinforce Chaucer's reputation for rhetorical finesse.[111] The Latin words on the Prioress's brooch, "Amor vincit Omnia" (GP 162), can be ambiguously interpreted as a reference to courtly or divine love. Given the other correspondences between the two portraits in question, the Latin marginal annotation "Ouidius de remedio amoris" on the Chaucer folio amounts to an intertextual reference on the same theme. It refers to advice from Ovid's *Remedy of Love* in the adjacent text remembered by Prudence, who consequently waits for her husband to grieve his loss before cautioning restraint and patience, qualities desirable in rulers. Of

course, by happy coincidence, Chaucer's fame as a poet of love, primarily courtly but also divine love (as described by his contemporaries Eustace Deschamps, Thomas Usk, John Gower, and Thomas Hoccleve),[112] is also summoned up by association in the marginal annotation that, in effect, serves as a kind of inscription for the portrait.

All the visual features on this folio—the serious and pious Chaucer featured in the portrait itself, allusions to him as the poet of love, the ornamental aspects of the border and decorated letter corresponding to his fame for rhetorical finesse—combine to characterize Chaucer as a multifaceted presence. To the overall complex characterization must also be added such details as the horse's wide-eyed, somewhat guileless expression as he gazes at the letter *A* that introduces the beginning of the tale. In the Ellesmere MS, as in many fifteenth-century illustrations of the pilgrims (and indeed in Chaucer's text itself), the horses are often seen to reflect some aspect of their riders.[113] This one reminds the viewer of yet another side to Chaucer, the ingenuous narrator not only of the "General Prologue," willing to take the pilgrims at their own word, but also of his poetic account of "Thopas." Chaucer is indeed "twin-hued" like the "topaz" stone[114] described in the contemporary *Pearl* poem (1013). In an age in which word play, and here pictorial play as well, was popular, the design encourages some of the associations, just mentioned, to be teased out of the visual syntax of this and related pages. It requires a lingering and careful "reading," and even several rereadings, to gain a full appreciation of what is conveyed about Chaucer in this momentous and historically important portrayal.

The Ellesmere portrait itself, likely the first surviving portrait of the poet, has close descendants in the rest of the fifteenth century and well beyond. A mirror image occurs in some of Hoccleve's *Regiment of Princes* manuscripts, including the earliest intact portrait in BL MS Harley 4866, made around 1412 [?] (fig. 1), possibly as a presentation copy for Prince Henry who had commissioned the poem.[115] It occurs in the margin beside the passage in which Hoccleve says that "to putte othir men in remembraunce" of him, "I haue heere his lyknesse / Do make . . . in sothfastnesse." Chaucer's pointing hand extends out of the panel to point to the word "sothfastnesse," as if to

107. As Voaden 1996, 10 and n33 observes, this pointing finger was used "to indicate visually the presence of an authoritative speaking voice."

108. For the illustration on fol. 148v see the Ellesmere site or, together with a discussion of the illustration of the Prioress at the beginning of her tale, see Hilmo 2009.

109. *Riverside Chaucer* 1987, 1232.

110. A crowned letter *A* was a decorative motif associated with Richard II's wife, Queen Anne; see the *Riverside Chaucer* 1987, 1026n171. Chaucer describes Criseyde who stood "in beautee first" just "as oure firste letter is now an A" (Tr, I.171–72). Lowes 1908, 288 and 299, sees the word "now" as a contemporary allusion to

Queen Anne. The concept of the primacy of *A* in the alphabet, in religious symbolism (Rev. 1.8; 21.6; and 22.13), and in Chaucer's time, in relation specifically to Queen Anne, could also be applied to the outstanding qualities of people such as Criseyde.

111. See Hilmo 2001, 15–16, or 2004, 165–66; and also Lerer 1993, 22–56, at 24, 48–49, and 239.

112. For details see Brewer 1966, 242–44.

113. Piper 1924, 246, and Hilmo 2009, 117.

114. This quality of the topaz stone was mentioned to me by Leonard A. Woods.

115. For commentary and images, see Pearsall 1994b, 386–410 and especially 399–408. See also Knapp 2001, 107–58.

emphasize the fidelity of the image to the original. The end of his rosary also extends down below the panel, as if to indicate the relevance of the portrait to the following stanza drawing the connection of this image to those of God and the saints. The close similarity of this portrait to the Ellesmere version, the hand holding the reins now replaced by one holding a rosary, implies that Hoccleve might well have been involved in the production of the Ellesmere manuscript. Both images may derive from a panel portrait that was the model. The portrait of Henry in MS Arundel 38 (cover image) might also have been derived from a panel portrait. In any case, it is not impossible that a panel portrait, or even the Harley version, was derived from a manuscript source, possibly even one predating the Ellesmere portrait.

It could even have been a portrait in which the author is shown standing,[116] since the Ellesmere figure is sitting in the saddle with straight legs (like some of the other riders in this and other manuscripts of the period). The apparent disproportion between the upper and lower body might be the result of trying to adjust a standing portrait to an equestrian one. It can also be understood in terms of the Host's description of him, at the beginning of the "Prologue to Sir Thopas," as a small, plump "popet," one "elvyssh" in countenance, who is always staring on the ground (ProThop 701, 703, and 697). Speaking of himself metaphorically as an intellectual dwarf or half a man, the writer Thomas Usk challenges the reader not to laugh in scorn to hear him.[117] Caxton, in his *Mirrour of the World*, repeats the idea that Virgil was "a man of lytil stature . . . and wente his heede hanging down and beholdyng the ground."[118] Hoccleve says that Chaucer wrote many lines in honor of Virgil.[119] Perhaps Chaucer's self-construction simply followed what appears to have been a tradition of authors and artists (see also ch. 3, sec. IV, fig. 24) who strategically assumed such a modest, small, unthreatening stance.

It appears there were at least two distinct manuscript traditions for the illustration of Chaucer, reflecting different priorities in the marketing of this author by those who had his "name in honde" in the decades after his death: the one presenting him as a mature, wise philosopher and the other showcasing him as a younger man in a correspondingly spring-like setting that also echoes the first words of the *Canterbury Tales* (where the latter sort of image usu-

ally occurs). Of course, there were some that utilized elements from both, such as MS Takamiya 24, which displays a young, inspired philosopher-poet in an enclosed spring-like arbor. All in different but related ways achieve an unofficial laureation of the poet and his work.

By the 1480's Caxton had begun to use prefaces at the beginnings of his printed books. Like current publishers' advertisements, they served to market the books that now no longer had a press run of one, as did manuscripts. They also functioned as an interface between the text and the reader. In his "Prohemye" to the second edition of the *Canterbury Tales*, Caxton begins by situating Chaucer among the great writers of the past and praising him for his "ornate" writing in English. Previous books in this "rude" tongue ought not to be compared to "hys beauteuous volumes / and aournate writynges." It would appear, from the repetition of "ornate" and the reference to the beautiful volumes, that the earlier illuminated manuscripts of Chaucer's works contributed to the perception of Chaucer's writings as ornate also. Sumptuously decorated manuscripts effectively aestheticized Chaucer's text in the eyes of fifteenth-century beholders. This is proof indeed of the successful marketing strategy by the early designers of Chaucer manuscripts and the look that helped promote other vernacular poetry in the early fifteenth century, as Kathryn Kerby-Fulton and Steven Justice have observed.[120]

Caxton then goes on to describe the tales of Canterbury in which are to be found "many a noble hystorye / of euery astate and degre" including the "tales whyche ben of noblesse / wysedom / gentylesse / Myrthe / and also of veray holynesse and vertue." He assures the reader that he has "dylygently ouersen" the printing of the book. In the woodcut made by Caxton's block cutter, the poet himself is portrayed as a stylish well-to-do merchant or noble gentleman (fig. 30). His expression is serious, but the attributes of his writing life are gone. There are no pen cases and no books. Instead, he has a sword and wears a cape and high leather boots with pointed toes. Middle-aged in appearance, he has a beard and wears his hair at neck length, with curls at the bottom edges. His short jacket with an edging at the hems, possibly fur, is gathered at the waist to produce three scalloped pleats on the side. Rather like the Squire's, his rosary is worn around his neck.

116. There may have been a tradition of portraiture showing the Italian poet laureates in such standing poses on which the frescoes by Andrea del Castagno (1421–57) are based; see his portraits of Dante, Boccaccio, and Petrarch, each holding a book as he stands within his own framed space, at http://www.paradoxplace.com/Perspectives/Italian%20Images/Montages/Art/Andrea%20del%20Castagno.htm. There may well have been a panel portrait of Chaucer on which such renditions as occur in the historiated initials are based. Such a Chaucer portrait could have

been in imitation of one of the Italian laureate poets, assuming Castegno's versions had such antecedents.

117. Usk, "The Testament," ll. 66–67, p. 31. Cf. Virgil's reproach to Dante; see *Riverside* 917, note to 696–97.

118. Caxton 1913, 160. See also Kellogg 1960, 119–20.

119. Hoccleve 1999, ll. 4985–87; see also http://www.lib.rochester.edu/camelot/Teams/hoccfrm.htm.

120. Kerby-Fulton and Justice 2001, 223.

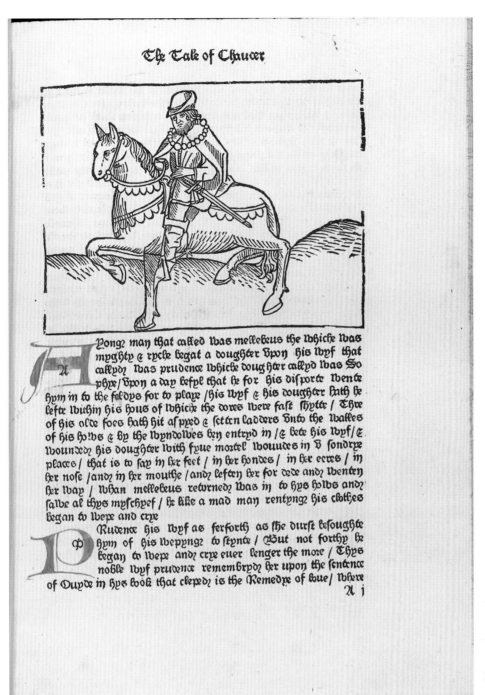

The Tale of Chaucer

A yong man that called was mellebeus the whiche was myghty & ryche begat a doughter upon his wyf that callyd was prudence whiche doughter callyd was So phye / upon a day befyl that he for his disporte wente hym in to the feldys for to playe / his wyf & his doughter hath he lefte within his hous of whiche the dores were fast shytte / Thre of his olde foes hath hit aspyed & setten laddres unto the walles of his hous & by the wyndowes ben entryd in /& bete his wyf & wounded his doughter with fyue mortel wouudes in v sondry places / that is to say in her feet / in her hondes / in her eeres / in her nose /and in her mouthe /and leften her for dede and wenten her way / whan mellebeus retorned was in to hys hous and saw al thys myschyef / he lyke a mad man rentynge his clothes began to wepe and crye

Prudence his wyf as ferforth as she durst besoughte hym of his wepynge to stynte / But not forthy he began to wepe and crye euer lenger the more / Thys noble wyf prudence remembryd her upon the sentence of Ouyde in hys book that clepyd is the Remedye of loue / where

A i

30. Portrait of Chaucer, Geoffrey Chaucer's *Canterbury Tales*. Printed in Westminster by William Caxton, 1483, STC (2nd ed.) 5083; London, British Library, G.11586, sig. a1r (fol. 229r).

This Chaucer wears the style of hat with upturned sides and pointed front sported by the Ellesmere Merchant. It was to become especially fashionable in the second part of the fifteenth century, as Irish Brooke observes, "for some fifty years at least a Flanderish beaver hat was a necessary item in every well-dressed man's wardrobe."[121] A number of the male pilgrims in the Caxton woodcuts wear such hats, including the Manciple (fig. 28c), and the Merchant, who wears a less stylish version. The Caxton Squire wears a similar one too, but with the addition of a feather.

The woodcut of Chaucer is not included in Caxton's version of the "General Prologue" but it is used twice, once before the "Ryme of Sir Topas" and again before the "Tale of Melibee," here called the "Tale of Chaucer." What is unusual and occurs nowhere else in this edition is that there is a blank space at the end of the Thopas story, which Caxton would usually have filled with the woodcut of the next tale. Nor does he begin on the next side, which is left entirely blank, but places both the woodcut and the beginning of the actual tale on the page facing the blank one. Of course, there it begins a new signature, but still it is odd. The woodcuts indicate it is the same Chaucer that tells both tales, but there was evidently a desire to

121. Brooke 1939, 74.

31. The Merchant (Rook), Geoffrey Chaucer's *Canterbury Tales*. Printed in Westminster
by Wynken de Worde, 1498, STC 5085; London, British Library G.11587, sig. a2r.

emphasize the prose tale in a special way.[122] Where space
was left for them, as in the British Library copy, there are
thirty-one large, hand-painted red Lombard initials scat-
tered throughout the "Tale of Chaucer." Not counting the
one beginning the Parson's "Prologue," the "Tale of the
Parson" merits only eleven large initials, with space left
for a *T* never added to the beginning of the second part.
The tale by the Knight received nineteen. The "Ryme of
Sir Topas" has only one at the beginning, one at the sec-
ond fitt, and one where the Host interrupts. Clearly the
very moral prose tale was considered a selling feature of
this book and indicates its popularity in the fifteenth cen-
tury. Many modern editions omit it and provide only a
very brief summary instead, testament to very different
promotions for very different audiences. Of course, it is
to be remembered that the second edition was printed in
1483, so this "Tale of Chaucer," which urges reason and

prudence rather than violence, might well have been in-
tended as a guide for the young king, or, more pointedly,
for the usurper, who "disappeared" him.

By the time of Wynken de Worde's printed edition of
1498[123] — he acquired Caxton's woodcuts after the latter's
death — this woodcut of Chaucer was used three times:
just before the beginning of the "General Prologue" ("Pro-
logus"), before Chaucer's prose tale, and again near the end
of the book, between the words "Here endeth the Person
his tale" and "Here taketh the maker of this boke his leue."
It is the addition of this woodcut to the beginning of the
"General Prologue" ("Prologus") and again after the last
tale that re-inscribes and reinforces Chaucer's authorship
of the whole of the *Canterbury Tales* and visually supports
the enthusiastic praise of his writerly skills in the "Prohe-
mium" (a copy of Caxton's, whose "soule," as de Worde
adds, has "heuen won").

122. It is also possible, as Linda Olson has suggested to me,
that Caxton hoped to find more of this text and left a blank
space for it.

123. The British Library copy can be found on Early English
Books Online or EEBO. For Wynken de Worde's 1498 edition click
on "Search," and then in "Bibliographic Number" type: "STC and
5085" to shorten your search.

Wynken de Worde visually prefaces the "Prohemium" itself with a woodcut (fig. 31) he also used for the Merchant before his tale, although not before the description of the Merchant in the "General Prologue" ("Prologus"), which does not contain all the pilgrim woodcuts. His woodcut of the Merchant happens to be the one Caxton had previously used for the Rook in the second edition of the *Game and Playe of the Chesse*.[124] What Wynken de Worde has done is to begin the book with a simple title page, *The boke of Chaucer named Caunterbury tales*. Then, opposite a blank page, the "Prohemium" is illustrated by the portrait also used for the Merchant. After that, there is a portrait of Chaucer looking like a contemporary wealthy merchant or noble gentleman at the top of the first page just under the title "Prologus" and before the main text.

As Martha Driver points out concerning Wynken de Worde's "thoughtful pictorial methodology" and his pioneering of the title page in England: "His use of pictures signals a new way of thinking about the book, the possibilities of the printed page, and the function of illustration—both as a way of increasing the impact of text upon the reader, and as a means of selling books and developing a recognizable 'image' for the printer himself."[125] It would be difficult not to see the first woodcuts of the Merchant (Rook) and of a fashionably dapper Chaucer as a reflection of the sort of customer he hoped to attract for his printed edition.

Another instance of Wynken de Worde's flexible reuse of a woodcut to shift meaning according to context and to add or reinforce meaning is strikingly evident in his repetition of Caxton's woodcut of the pilgrims feasting. Caxton had placed this cut, the first illustration to date of all the pilgrims gathered together as a group, just before the description of all the pilgrims at the Tabard seated at supper (GP 747–50; fig. 32). That this was a deliberate choice is indicated by the empty space left at the end of the preceding page (c3v), which was not quite large enough to accommodate the cut. Wynken de Worde exploited the full possibilities of this cut, using it three times (just as he did the Chaucer portrait), in this case, by placing it before the descriptions of the individual pilgrims (GP 43), before the description of the supper (as Caxton had done)—and finally on a separate page at the very end of the book.[126] There it provides a visual conclusion for the open-ended text, suggesting that the goal has indeed been reached, that a supper has been provided at all their cost to the pilgrim who told the best tale. It is a brilliant unifying device that brings the enterprise full circle, ending the pilgrimage with a feast just as it began with one. Further, and most importantly, this woodcut is also suggestive of the heavenly feast that will be their real reward. That he meant it to signify the heavenly feast is evident in de Worde's reuse of the same woodcut for his edition, printed within a couple of years of his *Canterbury Tales*, of Lydgate's *Assembly of the Gods* (STC 17006) to represent the Feast of the Immortals.[127] The strategic placement of this woodcut marking the end of the text serves as a late fifteenth-century visual extension and completion of Chaucer's fragmentary work. In this instance, it is not the scribe or the artist per se who has reconfigured Chaucer's work but the publisher who creatively used the new technology to create a new text for a new market. Woodcuts might initially have been reused by Wynken de Worde for practical economic reasons but, under the direction of this enterprising printer who quickly understood their potential, they became a creative means of visually reframing the narrative, both in parts and for the whole of his *boke of Chaucer named Caunterbury tales*.

V. Conclusion

Just how extraordinary the ongoing fifteenth-century conversation was concerning the portrayal of the pilgrim authors of the *Canterbury Tales* rather than the subjects of their tales can be seen in relation to fourteenth-century illustrated English vernacular texts, including the Auchinleck MS (where highlights from selected works are featured), the Vernon MS (where the subject is illustrated, as in the case of the analogue to the "Prioress's Tale"), and the *Pearl* MS (where the artist tried to establish a continuity between the poems by creating a loose visual narrative).

124. See Blake 1973, 88. The British Library copy can be found on EEBO ("STC and 4921"). By using Caxton's woodcut of the Rook for the Merchant, Wynken de Worde also alleviated some of the burden carried by Caxton's use of a single woodcut for the Merchant, the Franklin, and the Summoner.

125. Driver 2004, 77.

126. This does not appear in the EEBO copy but does appear on the microfilm copy; see STC 5085. See also the reference to it in Carlson 2003, 114, where he indicates De Worde's repeats (his designation for this woodcut is 20C).

127. Moran (1960) 2003, 31, points out the use of the Caxton woodcut of the seated pilgrims at the beginning and end of Lydgate's text (the only woodcuts used in this edition apart from the publisher's device), caustically referring to the figures as "most ungodlike." Its reuse in the *Assembly of the Gods* does, however, demonstrate not only that Wynken de Worde tried to get as much mileage as he could out of the woodcuts he had but also that he was able to transfer the meaningful associations that accrued to this illustration at the end of the *Canterbury Tales* to another work referring to a heavenly feast. Not only is it an economic use of a resource, it is a clever intervisual reference. Moran dates the *Assembly of the Gods* to 1498, while the EEBO site ventures "ca. 1500," a date repeated by Driver 2004, 35.

32. Pilgrims feasting, Geoffrey
Chaucer's *Canterbury Tales.*
Printed in Westminster by
William Caxton, 1483, STC
(2nd ed.) 5083. British Library,
G.11586, sig. c4r (fol. 20r).

By the end of the fourteenth century and in the fifteenth century, a new interest developed in portraying the English authors themselves, rather than just scenes from their texts, although this usage continued also. Chaucer's contemporary, John Gower, was depicted, for example, in his role as a moral satirist aiming his arrow at the world in the *Vox Clamantis*, as seen in San Marino, CA, Huntington Library, MS HM 150, c. 1392–99, fol. 13v.[128] Thomas Hoccleve

may be the person shown in a presentation miniature in BL MS Arundel 38 (cover image)[129] and John Lydgate in one of *The Siege of Thebes* manuscripts with a presentation miniature in Bod. MS Digby 232, 1420–22 (?) fol. 1r. In these three cases, the social and political roles of authors are presented. This fascination with the varieties of authorial stances is also probed in the beginning historiated initial and many of the marginal illustrations of William Lang-

128. See Hilmo 2007, 78–80, and 100, fig. 6. The image is also available at http://sunsite.berkeley.edu/hehweb/HM150.html.

129. That it is likely to be Hoccleve rather than Mowbray (see ch. 1, sec. VI) is suggested by the later *Regiment* presentation

portrait clearly depicting Hoccleve in London, British Library, MS Royal 17 D.vii, fol. 40r (online). Both may be part of a tradition showing the author at this point in illustrated manuscripts of the *Regiment.*

land's *Piers Plowman* in Bod. MS Douce 104, 1427,[130] and in the historiated initial in CCCO MS 201 (see ch. 3, sec. IV).

The conversation about authorship is particularly noteworthy in the various manuscript portraits of Chaucer himself, whether in the full-border tradition in which he is portrayed as author within the historiated initial at the beginning of the tales or in the Ellesmere tradition in which he is shown primarily as the author of his prose tale. In Caxton's edition the woodcut of Chaucer is placed before both of the pilgrim Chaucer's tales, thereby visually expanding his fictional authorial role. Wynken de Worde realized the full potential of movable woodcuts by sandwiching the entire text of the *Canterbury Tales* between enclosing portraits of Chaucer at either end of the actual tales to emphasize his authorship of the whole and—in a clever move paralleling Chaucer's strategy in the text—to present him also within his fiction as the pilgrim author of his prose tale.

While not all the artists of the illustrated *Canterbury Tales* in the fifteenth century would have known all Chaucer and pilgrim portraits made by their predecessors, it appears that they were aware of adding their contribution to the tradition, further inscribing it as *the* way to conceptualize this author for their time and audience. None of the images in the manuscripts is a direct copy of any of the others, but it is apparent that, depending on the degree of similarities, the illustrators must have had the opportunity of looking closely at one or more of the earlier illustrated manuscripts, possibly knew someone else who was doing the illustrations for one or, and this is less likely in view of the congruence of details, had a description of such an enterprise given to them by someone such as their supervisor or patron. In the last instance, however, it might have led to an arrangement whereby an earlier manuscript was made available for viewing. All this, of course, implies not only that the artists were literate in the vernacular—for otherwise how would they have known which pilgrim they were looking at?—but that they knew the text, had a remarkable visual memory, and possibly made notes (just as a student in manuscript studies might do during a privileged viewing of an original). In her study of the Sarajevo Haggadah and its relation to other fourteenth-century Spanish haggadot, Katrin Kogman-Appel concludes that the artists relied on their memories of images in other versions to account for the similar but not identical renditions, a process she refers to as "formal congruence."[131]

That there was an evolving sense of Chaucer portraiture is apparent in the congruence of such frequently repeated details as Chaucer's pointing finger or his pen case, a book, a purse, a hat, or a rosary. He could be pictured riding en route to Canterbury, standing or sitting in his study, or enclosed within an arbor. He could be soberly robed in a scholarly-looking gown, belted or unbelted, or fitted out in fur-trimmed clothes, or even fashionable riding boots and beaver hat. He could be young, mature, or old, and innocent, contemplative, or wise in countenance. Always there was some ingredient that harkened back and drew a connection to one or more of the earlier portraits. Of course there were a number of variations in the shared elements of that conversation. And always he precedes or inhabits his text, whether conceived as the whole of the tales or only those ascribed to his pilgrim persona.

The conversation on authorship in which the *Canterbury Tales* illustrators participated, and so helped to foreground, effectively enhanced the status of the author over his narratives. His raised social status is shown by the richer clothing he wears in the later manuscripts. The fifteenth-century conversation that visually formulated Chaucer was always one that was intended to appeal to the upper echelons of society and articulated as it defined their cultural codes.

On the material page and so in memory, the author of the *Canterbury Tales* had become an icon that each illustrator redefined. While in the "General Prologue" Chaucer distances himself from the other pilgrim authors, he is, ipso facto, also their author. Are they all different parts of his character and concerns, as suggested in the Manciple/Chaucer woodcut, or are they merely imaginings he has created? Who was Chaucer really and why was he important? In attempting to answer such questions, those who had Chaucer's "name in honde" marked the beginnings of a literary industry that showcased his authorial presence.

In his "Prologue," Chaucer's Clerk laments that death has slain "Frаunceys Petrak, the lauriat poete . . . whos rethorike sweete / Enlumyned al Ytaille of poetrie" (ClTPro 31–38). While Chaucer was never made poet laureate (a position not yet official in England), his successors recognized him as such. As John Lydgate says of him, Chaucer was "worthy the laurer to have" for he "founde the flourys first of rethoryk / Our rude speche only to enlumyne."[132] As Chaucer did the vernacular, so the writers and artists who followed him "illuminated" the poet on vellum and on paper for their own times and audiences.

130. See Kerby-Fulton and Despres 1999.

131. See Kogman-Appel 2006, especially 51–54. One implication of this is that the artists did not necessarily rely on detailed instructions to the illustrator or model books.

132. Lydgate 1966, lines 3–9.

CHAPTER SIX

"Swete Cordyall" of "Lytterature"
Some Middle English Manuscripts
from the Cloister

LINDA OLSON

For if heuene be on þis erþe, and ese to any soule,
It is in cloistre or in scole, by manye skiles I fynde.
For in cloistre comeþ no man to carpe ne to fiʒte,
But al is buxomnesse þere and bokes, to rede and to lerne.

*I*DEALIZED AS SUCH A PORTRAIT of monastic intel-
lectual life might seem, there is a good deal more
than nostalgic sentiment behind William Langland's
words in *Piers Plowman*.[1] Historical records make it clear
that peaceful isolation from the world and its conflicts did
not always prevail in medieval English cloisters—quite
the contrary, in fact. As Langland suggests (B:V.135–81)
in his portrayal of Wrath ("som tyme a frere" himself)
among monks and especially nuns, monastic orders were,
at times, entirely caught up in the personal, economic, po-
litical and intellectual struggles of the Middle Ages. Fur-
thermore, surviving catalogues of monastic libraries dem-
onstrate that far from all religious communities had grand
collections of "bokes," with nunneries in particular often
possessing little more than the basic biblical and liturgical
texts necessary for the *opus Dei* (the divine office or "work
of God" around which monastic life revolves).[2] Yet for the
most part monasteries must indeed have been among the
finest of places "to rede and to lerne" in late medieval Eng-
land, and for precisely the reasons Langland prioritizes:
books in numbers and of a variety modern readers might
find surprising, and for the most part the intellectual peace

to savor them. Centers of education as well as devotion,
medieval religious houses needed books and lodged (often
trained) those with the skills to make them. As perpetual
communities that included members more involved with
texts than most medieval people, they (or at least the most
wealthy and happily situated of them) were able to gather
and preserve books over centuries in a way that few medi-
eval individuals, even individual families, could.

Although monastic life may seem to some so heavily
conscripted as to deny virtually all freedoms, relative to
the medieval alternatives, cloister walls offered not just
access to books and the leisure to learn but a wide range
of challenging career opportunities—infirmarian, cellarer,
precentor (in charge of song) and scribe, to name only a
few possibilities—as well as physical safety from two great
killers of the time: war for men and childbirth for women.
In addition, and despite an ascetic rule that forbade per-
sonal ownership of any and all property, monks and nuns
could and did own their own books—lots of books that
frequently ended up in the libraries of their monastic com-
munities at their deaths.[3] They also copied manuscripts (an
activity thought to enflame the desire for spiritual things)[4]

1. X.305–8 in Kane and Donaldson 1975, used for B-text
quotations.

2. On the books of medieval nuns, see especially Bell 1995.

3. See, for instance, the long list of donors, many of them mo-
nastic, in Ker 1964, 225–321.

4. As the Carthusian customary makes clear: see Cannon 1999,
319.

1. A *Rule* of Benedict (s.x ex., likely from Bury St. Edmunds) in which each Latin chapter (beginning at "**DE . . .**" in the rubric here) is followed by an Old English translation (at "**Ð**"). Oxford, Corpus Christi College, MS 197, fol. 59v.

and wrote their own books, sometimes for their communities, sometimes for individual patrons of religious aspirations, and sometimes (no doubt more often than we will ever know) against the wishes of their monastic superiors.[5] The cloister was at times so safe an intellectual environment that nonreligious authors whose writings offended authorities in the world could and did seek friendlier reception for their thoughts, as well as refuge for body and soul, in the cloister.[6] Suspect books that could earn their lay owners death—English versions of biblical texts in the fifteenth century, for instance, and even a text as incendiary to church officials as the French *Mirouer des Simples Âmes* (*Mirror of Simple Souls*) for which Marguerite Porete was martyred in the fourteenth century—could be read and studied, copied and translated without repercussions behind the monastic walls of England.

There was truth, then, in Langland's assessment of monastic libraries as elevated just a little above the conflicts so prevalent among the folk of the English fields. Elevated they were, too, by language, since in most religious houses through much of the Middle Ages the freedom "to rede and to lerne" took place almost exclusively in Latin. Latin was the language of the church and thus the language in which both classical and Christian learning reached England in the early Middle Ages. It was also the basis of the much grander post-Conquest monastic collections that predictably included biblical texts and their exegesis, liturgical and hagiographical writings, patristic and later theological treatises, collections of prophecy as well as grammar, but also classical and contemporary poetry, epics and romances, histories both ancient and recent, handbooks of medicine and cosmology, encyclopedic and bibliographical compendia, contemplative and mystical writings, and works of guidance both sacred and secular. Benedictines, Augustinians, Cistercians, Carthusians, even mixed houses of men and women like the Gilbertines and outreach orders like the friars whose mission involved directly educating the laity were shored up by predominantly Latin book collections.

Only a few older houses (Durham, Winchester, Worcester and Christ Church Canterbury, for instance) retained beyond the Conquest a fair smattering of the Old English manuscripts used to ensure that less-educated monks were able to read essential documents, like the *Rule* they lived by (see fig. 1). By the fourteenth century, however, the English chronicle tradition begun in Anglo-Saxon re-emerges in the Middle English chronicles of Robert of Gloucester (c. 1300), who may have been a Benedictine of St. Peter's, Gloucester, and Robert Mannyng (c. 1338), a Gilbertine monk at Sempringham.[7] As the fifteenth century came to a close, a few male communities—the Carthusians at London, Sheen, and Mount Grace, for instance—had gathered a respectable selection of Middle English spiritual texts. Yet the most significant post-Conquest demand for vernacular writing appears to have arisen in female monastic houses, very likely because late medieval women, who had no access to university training, tended to be less educated and Latin literate than men. Thus many Latin texts were translated and many new English works composed especially or at least initially for religious women by men (like the Carthusians) steeped in the monastic tradition of Latinate learning preserved in their own cloisters.

5. In Guibert of Nogent's autobiographical *Monodiae* (c. 1115), his abbot's disapproval of his Genesis commentary inspires him to pursue his writing "in secret": see Benton 1964, 91.

6. For example, the beguine Mechtild of Magdeburg's *Flowing Light of the Godhead* met with such opposition that her spiritual advisor urged her to enter the convent of Helfta, where her writing was admired and fostered: see Finnegan 1991, 14.

7. See Cannon 1999, 330.

I. Nourishing the Spirit of Religious Women: Vernacular Texts and Manuscripts

Yet not all English nuns needed male counterparts to produce vernacular texts for them. There were Latin literate women to be found in many convents, and some of them chose to express themselves as authors in vernacular languages. In the second half of the twelfth century, for instance, Clemence, a Benedictine nun of Barking, produced a subtle and sophisticated *Vita* of Saint Catherine of Alexandria in Anglo-Norman, and she may also have been responsible for the life of Edward the Confessor penned in the same language by a nun of the same house.[8] With their positive portrayals of learned women, both texts must have met an enthusiastic audience at Barking, and they were read by other nuns as well: both of them appear, for instance, in a fourteenth-century collection of saints' lives in French that belonged to the Augustinian canonesses of Campsey.[9] The nuns of both communities owned other works in French as well as English, including at Barking a fifteenth-century English charter "longynge to the office | off the Celeresse of þe Monestary" (London, British Library, MS Cotton Julius D VIII, fol. 40r) that is so specific and unusual as to suggest that the cellaress herself, or one of her more learned colleagues, either wrote the text or translated it from an earlier French or Latin version, it, too, almost certainly the product of a Barking hand (see fig. 2).[10] In 1237 a pro-Scottish Cluniac nun of Delapré (near Northampton) wrote a politically charged

2. The opening page of the English "Charthe" (s.xv) "longynge to the office" and outlining the duties of the "Celeresse" at the abbey of Barking. London, British Library, MS Cotton Julius D VIII, fol. 40r.

8. See MacBain 1958 and Wogan-Browne 1996.

9. BL MS Add. 70513: see Bell 1995, 124–25.

10. See Bell 1995, 109–10, who discusses the connection to Barking.

3. A Brigittine *Rule* (s.xv) from Syon copied by the Carthusian scribe William Darker, who also added the rubrication and maybe the initial **I**. Cambridge, University Library, MS Ff.6.33, fol. 40v.

Anglo-Norman chronicle that she partly translated from a Latin text by a Benedictine monk of Croyland (William of Ramsey) and partly composed herself.[11] Eleanor Hull (c. 1394–1460), a noble widow associated with the Abbey of St. Albans who lived at the Benedictine priories of Sopwell and Cannington, translated both the *Meditations upon the Seven Days of the Week* and the *Seven Psalms* from French texts herself, even though the second included extensive scriptural exegesis, a genre generally considered in her day "the exclusive preserve of university-educated male clerics."[12]

Yet the need to read and understand religious texts including the Bible was familiar to monastic women, and the Benedictine nun who translated a French copy of the *Rule* into English for her community (possibly the alien priory of Lyminster) early in the fifteenth century acted within a long tradition of interpretive work to ensure that the "soules" of nuns who did not know French would not "falle *in* the deueles net."[13] She also included a final note about herself, presumably "the wrytere, that this wrot, and togedere the *lettres* schet," and about "the lady that this dede make," suggesting that between them they filled the roles of patron, translator, and scribe. Both women were nuns, "ibounde" and "harde yknet" to "this rule," and their bookish interests appear to have been shared by others in their community. Tacked onto the end of this *Rule* are a number of specific instructions about the treatment of manuscripts that informs "younge ladies" of the community to take good care of the books distributed to them each year, and especially not to "kitte out of no book leef ne quaier, neyther write therinne." Every librarian's nightmare perhaps, but it would seem that the nuns of this community were so enthusiastic about their reading that they eagerly annotated, corrected, and even kept for themselves "those texts which most engaged them."[14]

It may be easy to imagine such interested if unruly female readers picking up authorial pens, yet in our present state of knowledge there are many more extant medieval texts, English or otherwise, written by men than by women. Of the five other Middle English versions of Benedict's *Rule*, for instance, three were certainly and the other two most likely penned by men.[15] The *Rule* of Augustine used by the Syon nuns was translated for them by Richard Whytford, a Carthusian of that house in the early sixteenth century, who included a commentary (from Hugh of Saint-Victor) and both translated and composed other works to assist the nuns in the contemplative life.[16] The Brigittine *Rule* was also available to the Syon nuns in English—both it and the Augustinian *Rule* are translated in Cambridge, University Library, MS Ff.6.33 (see fig. 3), a fifteenth-century volume belonging either to the sisters' or the brothers' library at Syon but certainly copied by William Darker, a Carthusian monk of Sheen (c. 1481–1513) whose distinctive hand appears in two other English manuscripts associated with the women of Syon.[17] And both the *Orchard of Syon* (an English translation of the Latin version of Catherine of Siena's *Dialogo*) and the *Mirror of Our Lady* (written by a monk of Syon and owned by a nun of that house)[18] were prepared in the fifteenth century specifically for the nuns of Syon, the latter offering

11. The text now exists in a transcription (s.xvii) by William Dugdale: see Denholme-Young 1929–31.

12. The quotation is from Barratt 1992, 219.

13. The book is Library of Congress, MS 4; quotations are from the transcription in Krochalis 1986, 22.

14. As Koster Tarvers 1992, 310, points out.

15. See the discussion in Krochalis 1986, 30–33.

16. See Bell 1995, 74.

17. These are Glasgow, University Library, Hunterian, MS Mus.136 (T.6.18) copied in 1502 for Elizabeth Gibbs, abbess of Syon (1497–1518), and London, Lambeth Palace, MS 546 which may have belonged to the Syon sister Elizabeth Woodford. On all three manuscripts, see Bell 1995, 186, 191–92, and 201–2; on other manuscripts copied by Darker, see Parkes 1969, 8.

18. See Aberdeen, University Library, MS 134 + Bod. MS Rawlinson C.941 (s.xv ex) in Bell 1995, 175–76. The nun was Elizabeth Monton and the scribe, Robert Taylor, both of them at Syon in the early sixteenth century.

4. This opening of Rolle's *Form of Living* (s.xv[2]) identifies the author and one of his female religious readers, "Marg*aretam* de Kyrkby." Warminster, Wiltshire, Marquess of Bath, Longleat House, MS 29, fol. 30r.

detailed—even exhaustive—English guidance for every aspect of the nuns' daily services.

The Syon community, founded by Henry VI in 1415, seems to have been the most generously endowed of English convents when it came to vernacular literature, but there were other houses of women for whom English texts were custom-made by men. Before 1401 the *Chastising of God's Children* was prepared for the nuns of Barking, likely by a Carthusian,[19] and a Carthusian (perhaps of Sheen) was also responsible for the meditative compilation known as the *Speculum Devotorum* written for a "gostly syster" (of what order remains uncertain) between c. 1420 and 1440.[20] The Carthusian order was clearly dominant in the production of late medieval English texts for religious women, but they, too, were not alone. The *Scale of Perfection* was written for an unnamed "gostli sustir in ihesu crist" by Walter Hilton (died 1396), a solitary originally trained as a lawyer who became an Augustinian canon at Thurgarton Priory (and to whom the anonymous *Chastising* was in fact ascribed in manuscripts associated with Sheen and Syon).[21] The unique surviving copy (London, British Library, MS Arundel 327) of the *Legends of Holy Women* penned by the Augustinian friar Osbern Bokenham for a number of patrons, several of them women, bears a colophon stating that it was copied in 1447 in Cam-

19. See Kerby-Fulton 2006, 263, 288, and 474n87.

20. See Voaden 1996, 55.

21. Cannon 1999, 336, and Kerby-Fulton 2006, 267.

bridge for a "Frere Thomas Burgh" who gave the book to a "holy place of nunnys," very likely the Franciscan nuns of Denny near Cambridge.[22] And in the 1340s before any of these men were writing, the Yorkshire mystic and hermit Richard Rolle was producing his English works—the *Ego Dormio* (*I Sleep*), *Commandment*, *Form of Living,* and *English Psalter*—for nuns and anchoresses, one of whom, Margaret Kirkeby, we know by name (see fig. 4).[23]

The earliest of all English works of formal religious guidance was the *Ancrene Wisse,* which was originally composed c. 1225 (very likely by an Augustinian canon or Dominican friar) as a rule of both the inner and outer life for three young noblewomen, biological sisters who had chosen a reclusive ascetic life over wealth and marriage, and just may have had some say in what sort of rule they received.[24] Within a few decades it had been revised for a much larger group of twenty or more recluses. We can see this revision in progress in the very early London, British Library, MS Cotton Cleopatra C VI (probably copied in the 1230s), which sports marginal corrections and revisions by a second though nearly contemporary scribe (1240s or perhaps 1250s); he added his part to the quires before the book was first bound and his work suggests he may well have been the original author of the *Ancrene Wisse* (see fig. 5).[25] Many of these revisions were incorporated (and further edited) a few decades later in the longer version of the *Ancrene Wisse* found in Cambridge, Corpus Christi College, MS 402 (1270s or early 1280s).[26] Later still in the century, MS Cotton Cleopatra C VI found its way into the hands of Matilda de Clare, the Countess of Gloucester, who gave it to the house of Augustinian canonesses she founded in the older establishment at Canonsleigh in 1284.[27] A Latin version, possibly translated by Simon of Ghent, bishop of Salisbury (1297–1315), may have been directed especially at the Cistercian nuns

of Tarrant,[28] and sections of the text were certainly used by nuns of Syon in a printed edition (c. 1493) retranslated from the later of two French versions.[29]

Yet female religious were not the only ones to make use of this text of guidance: Simon's Latin translation reveals an interest in both male and female religious readers, and one copy of the French version was associated with the Benedictine monk of Norwich, Geoffrey of Wroxham (died 1322).[30] The richly annotated MS Cotton Cleopatra C VI also found its way to Norwich Cathedral and was owned there by the sixteenth-century canon and antiquarian Robert Talbot, while London, British Library, MS Cotton Nero A XIV containing the original version of the *Ancrene Wisse* can be associated with two Benedictine houses of monks,[31] and the revised version in CCCC MS 402 was given by John Purcel near the end of the thirteenth century to the Augustinian (Victorine) canons at Wigmore.[32] In addition, modifications for male religious have been detected in two English versions of the text,[33] and as the examples of Matilda de Clare, Robert Talbot, and John Purcel demonstrate, secular clergy and even lay folk made use of what is ostensibly a text for the religious life. In one manuscript (Cambridge, Magdalene College, MS Pepys 2498) we even find what has been called a Lollard (or Wycliffite) version of the text entitled "Þis good book Recluse" in which a general audience of both sexes is offered "a rule for all Christians" and the active life rather than the contemplative is celebrated.[34] The lesson for us here is that a practical and dynamic guide to the religious life like the *Ancrene Wisse* got around and was soon adopted and adapted by readers far removed from its original audience. The situation is much the same with the writings of Hilton and Rolle, which are found in the manuscripts of both monastic and lay folk (like the gentleman Robert Thornton: see ch. 2, sec. II).

22. Doyle 1958, 236n8. Quotations are from Serjeantson (1938) 1971, 289. Edwards 1994 discusses the scribes and production of the manuscript at both Cambridge and Clare, Bokenham's home monastery.

23. See Watson 1991, 275–76; Baker 2007, 426; and Hanna 2004, 20. Margaret appears to have been a Cistercian nun of Hampole (from 1343 on) until being enclosed as a recluse in 1348.

24. The original text can be found in BL MS Cotton Nero A XIV (s.xiii², probably the 1240s): see Day and Herbert 1952. On *Ancrene Wisse* and the Augustinians, see Dobson 1976; Millett 1992 discusses other possibilities.

25. The main scribe is A and the near-contemporary revising scribe/author B in Dobson 1972, xlvi ff., but the more recent description in Millett, Dobson, and Dance 2005 names them C and C² (xiii–xiv).

26. See Millett, Dobson, and Dance 2005, and Dobson 1972, ix.

27. See Bell 1995, 126. A third scribe—D in Dobson 1972, and C³ in Millett, Dobson, and Dance 2005—may have added his (or her) revisions to the text shortly after it arrived at Canonsleigh, using another *Ancrene Wisse* manuscript as a guide (Dobson 1972, cxlvii), but see also Millett, Dobson, and Dance 2005, xiv.

28. Dobson 1972, clxxi–clxxii, and Millett, Dobson, and Dance 2005, xvii–xviii

29. Göttingen U.L. 4° Theol. Mor. 138/53 Incun., where the text is called the *Tretyse of Love*: see Bell 1995, 187.

30. See Millett, Dobson, and Dance 2005, xviii and xxiv–xxv.

31. Worcester Cathedral and Winchcombe Abbey: see Millett, Dobson, and Dance 2005, xix–xx.

32. Purcel was a Shropshire landowner who made the gift at the request of the community's precentor, Walter of Ludlow, according to the *ex libris* inscription on fol. 1r: see Millett, Dobson, and Dance 2005, xi.

33. In BL MS Cotton Titus D XVIII and Cambridge, Gonville and Caius College, MS 234/120; both make considerable use of masculine pronouns and other adjustments for male readers: see Millett, Dobson, and Dance 2005, xvi and xxiv.

34. The book likely dates to c. 1365–75 (though some would have it later), so *Lollard* may not be the right term, but the manuscript does contain a number of biblical translations and commentaries in English: see Millett, Dobson, and Dance 2005, xx–xxi. Hanna 2000b, 31, associates the manuscript with the Augustinians of Waltham.

5. This early (likely 1230s) copy of the *Ancrene Wisse* includes corrections, revisions, and additions (1240s or 1250s) that may be authorial. London, British Library, MS Cotton Cleopatra C VI, fol. 194r.

The Vernon Manuscript: A Library *in Magno*
for Monastic Women?

All three—the *Ancrene Wisse*, Hilton's *Scale of Perfection*,
and Rolle's English writings—are found in the largest of
all Middle English books, the late-fourteenth-century
Vernon MS (Oxford, Bodleian Library, MS Eng. Poet. a.1).
And all three were initially intended as practical guidance
for an audience of religious women, as was the book's
opening piece—a Middle English version of the Latin rule
for recluses (*De Institutione Inclusarum*) originally written
in the twelfth century by the Cistercian monk Aelred of
Rievaulx for his sister, a nun.[35] This translation, identified
in a rubric (fol. iii verso a) as the work of an otherwise
unknown Thomas N., appears just after the manuscript's
table of contents and in the same early fifteenth-century
hand (that of Scribe A).[36] It does not appear in the con-
tents list, however, suggesting that it, too, was intended to
serve as introductory material—material that supports the
idea (shared by many readers of the manuscript) that this
massive book was designed for a female religious audi-
ence.[37] Its library-sized collection of 403 religious, moral,
and literary works packed tidily into 350 surviving folios
would undoubtedly have provided a wide and appropri-
ate range of reading for monastic women. Its physical size
(544 x 393 mm.) renders it much too large (and much too
heavy at over fifty pounds!) to have been used anywhere
but on a lectern, where a small group of nuns (and many
English nunneries were small) could have enjoyed Ver-
non's lavish decoration and illustration as well as its finely
executed script. Since the manuscript also features texts
punctuated for reading aloud,[38] we might imagine it situ-
ated in a monastic refectory as well, where saints' lives and
other fortifying works like those found in Vernon would
be read at meal times.

Of course, much about Vernon also makes it a deluxe
book fit to grace a noble or royal chamber, but that does
not rule out a monastic environment. The highest aris-
tocracy often dedicated their daughters to the church,
and some provided generous patronage to accompany
them. Several English houses of nuns were so endowed,
and an order like that of Fontevraud, where aristocratic
women were particularly prominent and noble daugh-
ters of the region received instruction alongside novices
and nuns,[39] would have created an environment perfectly
suited to all the Vernon MS had to offer for the education
of both religious and lay women. No doubt that is why
Ian Doyle suggested an original home at Nuneaton,[40] a
house of Fontevraud in Warwickshire still thriving in the
later fourteenth century, where we know that at least one
other manuscript—the trilingual Nuneaton Book—found
a home with the learned prioress Margaret Sylemon and
"her students" in the late fourteenth century.[41]

As appealing and appropriate as such a connection may
seem, solid evidence linking the Vernon MS to any par-
ticular owner, monastic or otherwise, is entirely lacking.
We do, however, have clues that suggest where the book
might have been produced. The dialect of its scribes, for
one, and that of its sister volume the Simeon MS (London,
British Library, MS Add. 22283), a book sharing many of
the same texts in similar groups and made simultaneously
in the same place, has been localized to the West Mid-
lands.[42] Within this area, monastic production seems vir-
tually certain, for while we have seen surprising provin-
cial access to texts among fifteenth-century households in
Yorkshire and Derbyshire (ch. 2, sec. II and sec. III), it re-
mains difficult to imagine any Midlands setting other than
a religious house for such "an exceptional enterprise of
book-production"—an enterprise that must have required
dozens of exemplars and at least four years' labor for Ver-
non's main scribe (Scribe B) who also contributed to the
Simeon MS.[43] A Cistercian house is suggested by texts like
the translation of Aelred's *De Institutione*, the life of Ber-
nard, Abbot of Clairvaux, tacked onto Vernon's *South Eng-
lish Legendary* (fol. 93vc)—the only known copy of that
popular text that includes this life[44]—and the *Miracles of
Our Lady* (indeed the whole of Vernon's second part with
its focus on Mary), to whom all Cistercian houses were

35. The Vernon version is the earlier of two ME versions: it
dates to the late fourteenth century, while the second version
(found in Bod. MS Bodley 423) dates to the mid-fifteenth: see
Ayto and Barratt 1984, xiii. For the original Latin, see Hoste and
Talbot 1971.

36. For the table of contents, see Serjeantson 1937.

37. As Doyle 1987, 14, argues, "an amply-grounded presump-
tion, in England and throughout Europe at this time in the later
middle ages, would be that any collection of vernacular religious
literature of comparable scope was most probably made for nuns
or other devout women." Doyle also discusses the two scribes
of Vernon (5–6). See ch. 3, sec. III on the special appeal some of
Vernon's illustrations might have held for women readers. Unfor-
tunately the new *Facsimile Edition of the Vernon Manuscript* edited by
Wendy Scase is not yet available to consult on this and other issues
concerning Vernon.

38. See Hussey 1990, 73.

39. See Kerr 1999, v and 126.

40. Doyle 1987, 15, where he also mentions Westwood, a much
smaller Fontevraud house.

41. Cambridge, Fitzwilliam Museum, MS McClean 123 (s.xiii⁴),
predominantly in French and Latin, was owned first by the Nu-
neaton nun Alicia Scheynton (s.xiii⁴–s.xiv¹); Margaret Sylemon
was prioress c. 1367–c. 1386: see Bell 1995, 158, and Kerr 1999,
125–26.

42. On dialect, see Doyle 1987, 11, and Ayto and Barratt 1984,
xvii. The locale may be pinpointed more precisely to North
Worcestershire or Warwickshire. On the relationship between
Vernon and Simeon, see Doyle 1990a and Sajavaara 1967.

43. Doyle 1987, 1 and 6. Vernon and Simeon sometimes share
one or even two exemplars for a given text, as is the case with *The
Prick of Conscience*: see Lewis 1981, 259–60, and Blake 1990, 47.

44. Scudder Baugh 1956, 39.

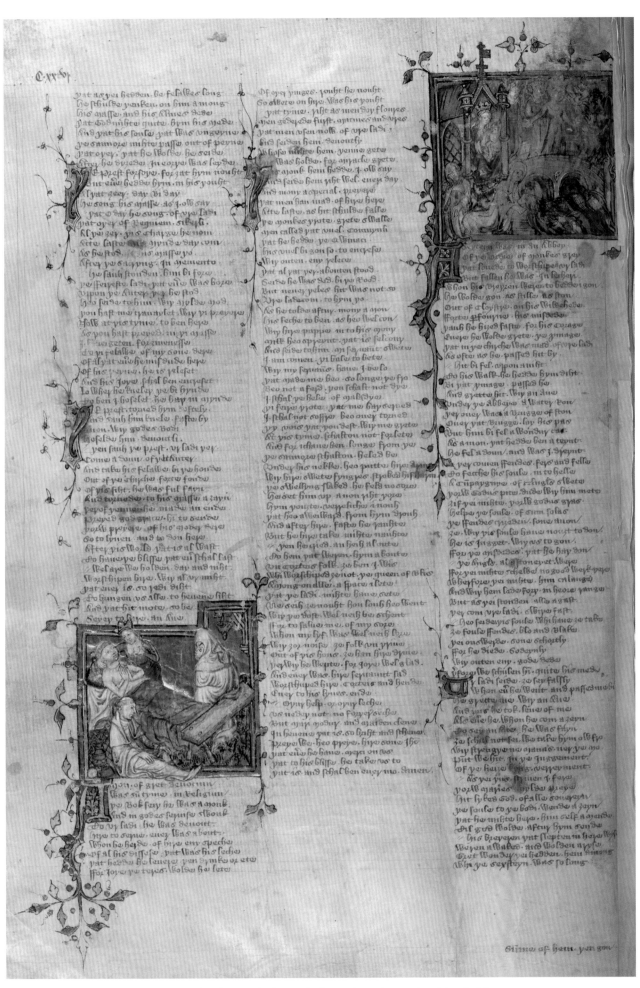

6. The fine miniatures in Vernon's *Miracles of Our Lady* feature both monks and Mary in white clothing reminiscent of undyed Cistercian robes. Oxford, Bodleian Library, MS Eng. Poet. a. 1, fol. 126v.

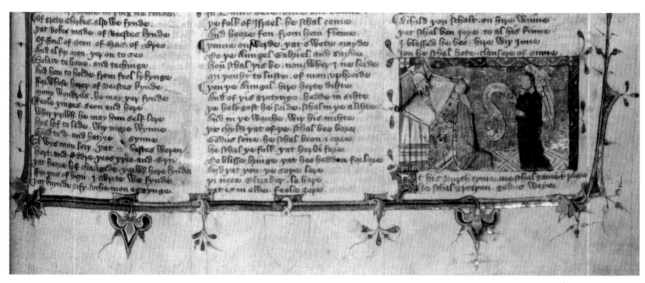

7. The first folio of *La Estoire del Evangelie* features the outline of a shield (bottom center) likely intended
for a patron's or reader's arms. Oxford, Bodleian Library, MS Eng. Poet. a. 1, fol. 105r (detail).

dedicated. The *Miracles* also make up one of only four texts
in the Vernon MS to have received illustrations (as opposed
to border and other decoration),[45] with the white-cowled
monks who feature in some of its miniatures supporting
a Cistercian influence on the book (see the examples on
fol. 126v; fig. 6). Since the Cistercians stood out for the
undyed (hence white) wool of their robes, the prominent
depiction (on fol. 124rb) of the Virgin's white tunic (with
her wearing it on fol. 126vc; fig. 6) might also suggest a
pro-Cistercian bias in Vernon (or at least in its *Miracles*),
as indeed may the fact that the fornicating monk on fol.
126rc is portrayed as a black (or Benedictine) monk. The
same bias is suggested by the devout white monk who
kneels before the Mercy Seat (in which the Father holds
the crucified Son) in the historiated Þ that opens Vernon's
Prick of Conscience (fol. 265rc).

So some sort of Cistercian involvement in the pro-
duction of Vernon seems highly probable, and Bordes-
ley Abbey, near the Worcestershire–Warwickshire bor-
der, has been a well-accepted possibility.[46] It lay within
the right dialectal region, and further links between Ver-
non and the Cistercian abbey at Bordesley are established
via other manuscripts, like the books given to Bordesley
by Guy de Beauchamp in 1305, which might have whetted

the monks' appetites for romance and certainly included
a French text of *Joseph of Arimathea* that could have pro-
vided the original for the unique English version of that
romance found in Vernon.[47] London, British Library, MS
Add. 37787, a collection of English and Latin made some-
time shortly after 1388 for, and perhaps by, John North-
wood, a monk of Bordesley, shares no less than fourteen
English items with Vernon.[48] And the scribe (Scribe A)
who added the table of contents and Aelred translation to
the front of Vernon, as well as rubrics in places and likely
the red folio numbers throughout (as in the top left corner
of figs. 6 and 8), also copied the chronicle and cartulary of
Bordesley's daughter house, Stoneleigh, up to 1393, then
augmented it with documents as late as 1411.[49]

The only true deterrent to associating Vernon with
Cistercian production is economic: Bordesley was far
from a wealthy house, and for a smaller community like
Stoneleigh, Vernon and Simeon together would have cost
half its annual income.[50] The problem is eliminated, how-
ever, if we imagine a wealthy patron from outside the
community, perhaps one whose arms would have filled
the outline of a small shield that dangles from the bot-
tom of the border decoration at the opening of the manu-
script's second section (see fol. 105rb; fig. 7). So ambitious

45. The four illustrated texts in Vernon are *La Estoire del Evan-
gelie*, *The Prick of Conscience*, the *Pater Noster* page, and the *Miracles*,
of which only nine of the forty-one listed in Vernon's table of
contents have survived: see the stubs where folios have been cut
away at the top right of fig. 6, and see also see Meale 1990, 117. On
Vernon's illustrations, see ch. 3, sec. III and Hilmo 2004, 126ff.

46. See, for instance, Doyle 1987, 14–15, and Hussey 1990, 63.

47. See Blaess 1975, 513.

48. For all but one of those pieces, Vernon and BL MS Add.

37787 share the same textual tradition: see Scudder Baugh 1956,
37–39.

49. See Doyle 1987, 5–6 and 12–13 on Scribe A. For the main
hand of Vernon, Scribe B, Doyle suggests "a monastic context"
(12). The addition of Vernon's table of contents, folio numbers,
and rubrics suggests a supervisory role for Scribe A.

50. As Doyle 1987, 14 and 15 points out, the cost of mak-
ing these two expensive vellum manuscripts would have been
between £65 and £85, and Stoneleigh Abbey, even in 1535, had an
annual income of only £151.

is the decorative scheme of Vernon's part 2 (the only section of the manuscript to sport full miniatures) that it could well have been intended as the opening of the volume, and it may also have been the first part of the book produced, when the support of a patron as generous as that enjoyed by the original recluses addressed in the *Ancrene Wisse* was readily available.[51] Yet the shield was left blank, perhaps due to a lack or reduction of finances that also resulted in the less ambitious decorative scheme found in other parts of Vernon.[52] It may be that some noble patron who subsequently withdrew support or ran low on funds had commissioned a monastic scriptorium to produce a book planned as a lavish gift to the community where his or her daughter was accepted for instruction or as a novice. Such generous bequests from the laity were a significant source of books for monastic libraries, yet even so the Vernon MS would have been an exceptional gift, one that could have improved the quality and range of education received by everyone in the community. For Vernon gathers texts that we find spread among smaller books belonging to medieval monastic women and compiles them into an enormous single-volume library of religious, moral, and literary works in both poetry and prose—a library not *in parvo*, then, but *in magno*.[53]

In the first (up to fol. 104v) of Vernon's distinct if unequal parts,[54] the reader's frame of reference is established by hagiography and Old Testament history. The beautifully illustrated part 2 presents the *Story of the Gospel* (*La Estoire del Evangelie*) in English (with a French description) along with a large collection of poetic Marian material, both historical and devotional in nature. The contents of part 3 (beginning at fol. 147r) are more diverse and difficult to categorize beyond their didactic emphasis on instilling basic morals, behaviors, and tenets of the Christian faith. It begins with the *Northern Homily Cycle*, a monastic composition that contains much of the same kind of material as part 1 but is interesting because it represents a Midlands expansion of the text found only in Vernon and Simeon.[55] Among debate and advisory literature are two different poetic versions of the *Mirror of Saint Edmund*, which also appears in its original prose form in part 4 of Vernon. In part 3 we also find *The Prick of Conscience* with its historiated opening initial, two of Vernon's three ro-

mances, *Robert of Sicily* and *The King of Tars*,[56] and a couple of allegorical pieces: Robert Grosseteste's *Castle of Love*, which is an English version of the original *Chasteau d'Amour* found among other places in Prioress Sylemon's Nuneaton Book; and the *Charter of Christ*, which makes of Christ's body a charter of inheritance to believers. Finally, the poem *Susannah* stands out in part 3 for its alliterative style and vigor, and while its tale of female virtue recalls the *King of Tars* romance, its poetic and linguistic sophistication looks ahead to the works in part 4.

Part 4 (starting at fol. 319r) presents the most intellectually challenging pieces in the Vernon MS and is also marked by a change from a three-column layout to a two-column one, and from poetry to what was considered the newer and more serious medium of prose, with only a few exceptions at the end of the section.[57] The opening text is the English version of the *Stimulus Amoris* known as the *Pricking of Love*, which sets the affective devotional tone of part 4. In some manuscripts, though not in Vernon, the work is ascribed to Hilton, and more of that author's English works appear in a cluster further on in the section—the first book of the *Scale of Perfection*, the *Mixed Life*, and two psalm expositions. There is a cluster of Rolle's works as well, consisting of the *Commandment* (a text of basic teaching on love) addressed to a Cistercian nun of Hampole, the *Form of Living* written for the recluse Margaret Kirkeby and containing a detailed account of mystical and contemplative experience (see fig. 4), and the *Ego Dormio*, "a brief epistolary homily on the stages of spiritual perfection" or "þre degrees of loue" which appears to have been composed for a recluse or nun.[58] Along with the *Ancrene Wisse* (and one of its companion texts, the *Talking of the Love of God*), these choices on the part of the Vernon compiler enhance the sense that the book (or at the very least its fourth part) was intended for a female religious audience, and Aelred's text for his sister may well have been added to the front of the manuscript with this section especially in mind.

Yet neither the argument for female readers nor that for a religious audience can be completely conclusive, and for several reasons. Hilton's *Scale* that generally addresses a spiritual sister widens that to "Gostly Broþer. or Suster" in Vernon (fol. 343va), as in other manuscripts, much as we have seen the *Ancrene Wisse* applied to men; the *Form of Confession* also in part 4 is the only prose text shared

51. The *Ancrene Wisse* in MS Cotton Nero A XIV makes it clear that the three original recluses have all their needs provided: see Millett, Dobson, and Dance 2005, 73n4, who quote the passage in relation to the later extended version. On part 2 as the first and most ambitious part of Vernon (or perhaps a separate volume), see Doyle 1987, 8. Although the opening initial has been cut from the first folio of part 2, it was larger (12 lines) than that opening part 1 (7 lines), and perhaps historiated as well.

52. And in the (possibly unfinished) Simeon MS, which contains no illustration for *The Prick of Conscience* to match Vernon's historiated Ð even though the text in both appears to have derived from the same exemplars.

53. For the contents of Vernon, see especially Guddat-Figge 1976, 269–79, and Blake 1990. For household libraries *in parvo*, see ch. 2.

54. This count does not include the table of contents and the English Aelred in Scribe A's hand.

55. Blake 1990, 53.

56. The second appears in the Auchinleck MS as well (see ch. 2, sec. I).

57. On the contents of part 4, see Hussey 1990.

58. Quoting Watson 1991, 226. See also Hussey 1990, 69.

8. Vernon's A-text of the alliterative poem *Piers Plowman* begins (without a title) halfway down column b
("**IN. A. somer sesun.**"), under the prose of *Adam and Eve*. Oxford, Bodleian Library, MS Eng. Poet. a. 1, fol. 394v.

by Vernon and the Cistercian John Northwood's MS Add. 37787; and other texts in the manuscript's fourth section appear also in Thornton's Lincoln, Cathedral Library, MS 91 (the *Mixed Life,* the prose *Mirror of Edmund,* and the *Abbey of the Holy Ghost,* for instance).[59] *Piers Plowman* was also read, and read widely, by men—often religious men—as well as women,[60] and it, too, appears in part 4 of Vernon (in an early but fragmentary copy of the A-text), marking the end of Vernon's prose pieces (you can see the switch on fol. 394v in fig. 8), although the verse lines of the *Joseph of Arimathea* romance that follows are written out like prose. Part 4 of Vernon might not have been designed for the loftiest or most mystical of intellectual and spiritual aspirations—there are no Latin works and students of the manuscript seem in agreement that a text of high mysticism, like the *Cloud of Unknowing* with its *via negativa,* would not have been included even had it been available to Vernon's compiler. Yet part 4 nonetheless raises the readerly bar, and renders the drop back to the short but attractive devotional and advisory lyrics in part 5 of the manuscript all the more striking. Though the scribe returns to the manuscript's original three-column format, it has been suggested that Vernon's last section, much shorter than the others, may have been added as an afterthought.[61]

The variety of texts and forms combined in Vernon would be very difficult to characterize had the table of contents added to the front of the collection not already named the book "salus | anime" or "in englyhs tonge Sowlehele" (fol. i ra). The primary meaning here must be the health of the soul in a Christian context, with the title promising the improvement in faith, devotion, obedience, meditation, and charity urged by so many of Vernon's texts. Yet the challenging and accomplished alliterative poems *Susannah* and *Piers Plowman,* lengthy religious guides like Hilton's writings, and moral romances such as *Robert of Sicily, The King of Tars,* and *Joseph of Arimathea* suggest there may be another dimension to the Vernon's concept of "soul's health." They introduce the possibility that the Vernon collection was compiled not just on the basis of what might be called a comprehensive archival approach to textual culture often found in medieval monastic environments—an approach, that is, born of a desire to preserve all writings of spiritual, historical, and educational interest—but also with a selective eye alert to literary and intellectual excellence, perhaps even entertainment value.[62] Could, then, the health of the soul highlighted by the Vernon table of contents also encompass the benefits of reading primarily for literary and intellectual pleasure? Acknowledge a more complex awareness of the "swete cordyall" provided by "lytterature?"[63] We may never know the intentions of Vernon's makers any more than we can identify those makers with certainty, but the possibility of readers as literary as they were spiritual need not cast doubt on a monastic context for Vernon's production or reception despite the persistent trend of modern scholarship to separate the "religious" from the "literary." Many medieval English books unapologetically combine the two, after all, and many medieval English monasteries owned vernacular manuscripts containing major literary and secular works. Studying these books widens our perspective to the range of English reading and readerly intentions actually found within cloister walls, and reveals how religious owners and makers of manuscripts were well aware of the manifold excellences of literature's "cordyall" and responded to them in a variety of unique ways.

II. Monastic Manuscripts of Chaucer: Literary Excellence under Religious Rule

Although we do not find in Vernon the author considered *the* Middle English poet of excellence, we can associate manuscripts of Geoffrey Chaucer's works with Benedictines, Augustinians (both canons and friars), Carthusians (who were given the *Boece* by an Augustinian friar),[64] and the nuns of Syon. While the *Boece,* Chaucer's English translation of Boethius's *Consolation of Philosophy,* fits rather neatly into modern preconceptions of appropriate reading for those living under a monastic rule, some of the other texts we can place in the hands of religious readers may not. Chaucer's *Treatise on the Astrolabe,* for instance, was written for his ten-year-old son "Lyte Lowys"[65] and

59. Some texts shared by Vernon and Lincoln are derived from similar exemplars, like those used for Hilton's writings by Thornton and the compilers of Vernon and Simeon: see Keiser 1984a, 106–7, and ch. 2, sec. II.

60. On Langland's women readers, see Kerby-Fulton 2003.

61. Blake 1990, 56.

62. See the discussion of these two attitudes in Cannon 1999, who mentions Vernon as the product of a traditional monastic view that renders "all English writing . . . equally valuable" and sees John Lydgate (a Benedictine monk) as pivotal in the late-fourteenth-century transition from this inclusive archival attitude to a selective one based on a "criterion of 'excellence'" (341).

Vernon and other manuscripts suggest the distinction was far from clear.

63. Quoting Henry Bradshaw's *Life of St. Werburge* (2, ll. 15 and 21) from Cannon 1999, 346.

64. The manuscript is Bod. MS Bodley 797, part 3, and the donor was Master Dr. John Bury, Augustinian professor in sacred theology (front pastedown), who was provincial of the order in England from 1459, and by 1460 resident at Clare, the first house of friar hermits in England; he gave the manuscript to the Carthusians of Sheen: see Seymour 1995, 51.

65. Line 1 of the prologue in the *Riverside Chaucer* 1987, the source of all line numbers for Chaucer, but see also ll, 41–42, where "every discret persone" who might read or hear it is considered.

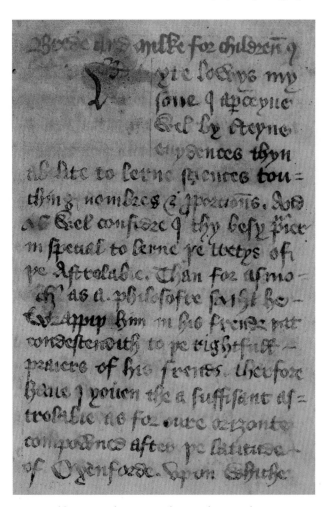

9. Owned by a Benedictine monk named More, this copy of Chaucer's *Treatise on the Astrolabe* for his son bears the title **"Brede and Milke for childrene."** Oxford, Bodleian Library, ms Bodley 619, fol. 1r.

might thus be considered a text for children rather than the sophisticated Latinate readers found in male monastic houses; and as a treatise on astronomy, it could be considered an exploration of the very sort of learning that monks should not—were even forbidden to—pursue. Yet the long tradition of monastic historical writing reveals a keen, sometimes overly enthusiastic, interest in astronomical events and signs,[66] and most monasteries (like the houses of Fontevraud mentioned above) were educational institutions as well as religious cloisters, with some male orders establishing collegial houses so that their members could benefit from a *studium generale* like Oxford. Thus astronomy and cosmology became hot topics in the fifteenth-century monasteries as well as the universities, a trend which no doubt contributed to the survival of more manuscripts of the *Astrolabe* than of any other work by Chaucer except the *Canterbury Tales*.[67] A significant number of these can be linked to certain or possible monastic homes.

Setting aside manuscripts of no more than probable monastic provenance,[68] we have three extant copies of the *Astrolabe* linked firmly to Benedictine readers or copyists: Oxford, Bodleian Library, ms Bodley 68, part 1, copied possibly in Lincolnshire between 1400 and 1425; ms Bodley 619, written in the South East Midlands, possibly London, likely in the third quarter of the fifteenth century; and ms Ashmole 393, part 1, made probably in 1453 at Christ Church Cathedral, Canterbury, ms Bodley 68 contains (on fol. ii recto) an early inscription placing it at the Benedictine priory at Coldingham and St. Abb's, Berwickshire,[69] and ms Bodley 619 sports an early sixteenth-century inscription associating it with a monk named More, either Thomas More of the Worcester priory who owned two other manuscripts, or more likely a monk of Great Malvern priory, who may have been the Oxford scholar Christopher Aldewyn, alias More.[70] Both are relatively small booklets made up of little else but the *Astrolabe*, and though they have potential connections with Oxford University, both also assign Chaucer's text the title **"Brede and Milke for childrene"** (ms Bodley 619, fol. 1r; fig. 9).[71] ms Ashmole 393, part 1, does not use that title for its extracts from the *Astrolabe*, but it, too, is associated with both a Benedictine house and Oxford, since one

66. John of Worcester's Latin *Chronicle* (1067–1141) provides an excellent example of excessive astronomical enthusiasm, reporting phenomena far more elaborate than contemporary records of the same events: see McGurk 1998.

67. See Laird 1999, 157. For descriptions of the *Astrolabe* manuscripts, see Seymour 1995, 101–30.

68. These include four fifteenth-century volumes: bl ms Egerton 2622, probably from a religious house, maybe a university convent; Cambridge, St. John's College, ms E.2 (105), likely written in a monastic house and associated with a William Gray, perhaps a fifteenth-century Bishop of Lincoln or Ely; Aberdeen, University Library, ms 123, possibly an Augustinian manuscript, maybe from Warrington; and since the scribe of Bod. ms Ashmole 360, part 5, signs his name as "pekeryng ffr Iohn" (fol. 124r), he was presumably a *frater* or brother of some order, though the early history of the manuscript is otherwise unknown: Seymour 1995, 115ff.

69. Among other early inscriptions in the manuscript is that of the scribe John Enderby of Louth (fol. ii verso), who may have been a Cistercian of Louth Park in Lincolnshire: see Seymour 1995, 123, and Horobin 2009a, 121.

70. The inscription on fol. 69v reads "Constat More de Mychelmalvarn Monoch." See Seymour 1995, 107.

71. Aberdeen ms 123 features the same title, as does Bod. ms E Museo 54, while Bod. ms Rawlinson D.3 lays the text out in a spacious, well-rubricated way suitable for young readers, and cul ms Dd.3.53 contains the name of the late-sixteenth-century schoolmaster Richard Mulcaster. Orme 2001, 278 and 362n18, suggests that the title may indicate the text was found suitable for teaching not just astronomy but reading, and notes how ms Bodley 619 in particular sports contents and layout well suited to young readers. Another copy called "Milk et breed" belonged to the Thurgarton Augustinian canons. See Webber and Watson 1998, 419, and Horobin 2009a, 121.

10. The scribe John "Neuton" dates ("die 25 Octobris 1459") and places ("Rhodo") his work; the book contains Chaucer's *Parliament of Fowls* and was associated with two Syon nuns. Oxford, Bodleian Library, MS Laud. Misc. 416, fol. 226v (detail).

of its scribes was Henry Cranebrook, a monk of Christ Church who studied at Canterbury College Oxford in 1443 and has been associated with other manuscripts.[72] Unexpected as it might seem, then, the little cosmological treatise Chaucer addressed to his young son appears to have found within the learned and powerful Benedictine order a ready home in the hands not only of children and beginners but advanced scholars as well.

Unexpected, too, might be the idea that Chaucer's *Parliament of Fowls*, a courtly love debate, could be considered monastic reading. Yet two copies are linked to religious communities: one to the Augustinian canons of Leicester and the other to the Brigittine nuns of Syon, with whose book I will begin. Oxford, Bodleian Library, MS Laud. Misc. 416 is a paper manuscript dated by the second of its three scribes, John Neuton, who notes that he completes his copy of the English version of Vegetius's *De Re Militari* on October 25, 1459 (fol. 226v; fig. 10). As a military treatise addressed to Sir Thomas Berkeley and designed for "lusty" knights and warriors, this is a text more likely to turn up in a noble household than a royal convent, and that may well be where it was produced, since the scribe also claims to have "Script*us* Rhodo," which might be read "written at la Rode," the manor house (at Selling, Kent) of John Tiptoft, earl of Worcester.[73] Other contents also suggest a domestic or household book: the *Instructions to his Son* by Peter Idley, which includes teaching on the Ten Commandments and Seven Sins similar to those found in the Auchinleck MS (Edinburgh, National Library of Scot-

land, MS Advocates 19.2.1) and Oxford, Bodleian Library, MS Ashmole 61; the *Cursor Mundi* that Thornton added to his London volume (London, British Library, MS. Add. 31042); and the works of John Lydgate, an author copied by both Thornton and the scribes of the Findern MS (Cambridge, University Library, MS Ff.1.6), the last of which also contains the *Parliament of Fowls* (see ch. 2). Still, there is good reason to think monastic scribes were involved in the book's production: not only is the John Neuton who signed MS Laud. Misc 416 referred to elsewhere in the book as "brother John," but he appears to be one and the same with the John Nuton who signed a register of Battle Abbey, where he was a Benedictine monk from 1463 until becoming prior of that abbey's cell at Exeter.[74] Both he and a (probable) kinsman Roger Newton, very likely the first of the book's scribes whose similar script and language suggest shared training, were paid for their work on MS Laud. Misc. 416, but since Roger received much less per folio than John, he could well have been a member of the Tiptoft household. The third scribe, who worked on the manuscript at a slightly later date, was responsible for the *Parliament of Fowls* (now fragmentary) as well as the Lydgate pieces but unfortunately remains unnamed.

So it is highly unlikely that MS Laud. Misc. 416 was either made for or first owned by the two nuns of Syon—Anne Colville and Clemencia Thraseborough—whose names appear on its end pastedown.[75] Both were at Syon in 1518 and both died in the 1530s, so would have been very young (if born at all) when the book was begun, and it is probable that the manuscript was given to the Syon community, perhaps to one of the named nuns in particular, sometime after the death of John Tiptoft, who was

72. As Seymour 1995, 130, notes, he signs "Henricus Grustorrens" and "h c alias grustorrentem": fol. 44r–v.

73. See fig. 10 and Seymour 1995, 26, and for other suggestions Bell 1995, 195, and de Hamel 1991, 81 and 141n77. As Seymour also notes (130), the monk Henry Cranebrook who worked on MS Ashmole 393, part 1 (containing Chaucer's *Astrolabe*) corresponded with Earl Tiptoft.

74. John is given the title "fr" for *frater* on fol. 70r; the Battle Abbey register is found in BL MS Harley 3586, where Nuton's signature appears on fol. 13r. On both, see Seymour 1995, 26.

75. See Bell 1995, 195, on their association with the manuscript.

executed in 1471. Though we cannot be sure which nun (if either) might have received the gift, Colville's name is written above Thraseborough's, whose name appears only in the context of a prayer request, and Colville was also associated with a copy of Hilton's *Treatise of Eight Chapters* (see sec. IV). Colville may well have been, then, the first or primary Syon owner. Of course the strong arguments against the dangers of carnal love presented by Hilton's treatise (and many other texts owned by the Syon nuns) are a world apart from the courtly debate of the *Parliament of Fowls*,[76] so we are left with a question. How might Sisters Anne and Clemencia have read Chaucer's text?

Assuming them to be women of the nobility or gentry — one of Colville's signatures in her Hilton volume suggests as much by featuring a "D." for "Domina" or "Dame," that is "Lady," before her name (fol. 39v) — we might find no conflict at all. But I suspect they would have been encouraged to read the *Parliament* in the moralizing way the *Disce Mori* (*Learn to Die*) advised Syon nuns to read *Troilus and Criseyde*.[77] The *Disce* sees the descent into physical, worldly love — and as fornication outside of matrimony that of Troilus and Criseyde was among the worst kinds of worldly love — as a source of grief, vice, and madness, as well as one of the greatest dangers facing religious women vowed to chastity. Yet the opening of Troilus's *Canticus* about the ambiguities of love as the greatest of both pleasures and pains is nonetheless quoted, and the reader is informed that more can be learned about this "sweet poison" in Chaucer's tale:

> Of which poison if ye lust more to rede,
> Seeþ þe storie of Troilus, Creseide and Dyomede.[78]

Certainly the author seeks to "arm the reader" heavily enough that the text of *Troilus and Criseyde* becomes no more than "instructive," a lesson in distinguishing "true from false, good from evil, vice from virtue," an intention that reveals something of the medieval "analogy between literary and sexual seduction" and the more general "anxiety" about "medieval reading" and its potential dangers.[79] Despite the dangers, however, he tells the Sister Alice he addresses to consult Chaucer's poem, suggesting that to him — and perhaps to the donor of MS Laud. Misc. 416 as

well — even morally suspect texts were acceptable within cloister walls, and the nuns of Syon were in any case possessed of enough intellectual and spiritual discernment to determine through their own reading experience what was good for them and what was not. Besides, whether the love-debate of the *Parliament* distracted the soul with inappropriate sensations or not, the poem ends with the formel eagle rejecting all lovers, which is precisely the choice the monastic vows taken by Colville and Thraseborough demanded of them.

Collecting and Correcting Chaucer: Augustinian Manuscripts of the *Canterbury Tales*

With the second monastic copy of the *Parliament of Fowls*, we are looking at a very different sort of manuscript and a medieval home not among nuns but the Augustinian canons of St. Mary de Pratis, Leicester. London, British Library, MS Harley 7333, written in the second half of the fifteenth century, most likely around 1460, is an exceptionally large volume made up of seven separate booklets and containing an extensive anthology of predominantly English works (see "The Contents of London, British Library, MS Harley 7333"), many of them by Chaucer, making it the largest surviving manuscript collection of his writing (both in physical size and number of texts).[80] The *Parliament* is accompanied by the *Canterbury Tales*, the *Complaint of Mars, Anelida and Arcite, Lack of Steadfastness, Gentilesse, Truth, Complaint to His Purse,* and the attributed *Complaint d'Amours*, suggesting an effort on the part of MS Harley 7333's compiler to gather into a single volume a wide selection of works by one author (rather than by genre, say, as in the case of Thornton's romance collection: see ch. 2, sec. II).

Such a project recalls the collecting work of the London bookman John Shirley, and in fact some sections of MS Harley 7333, including the early part of the *Canterbury Tales*, derive from at least one Shirley exemplar and bear his characteristically chatty and "clergial" headings and annotations (see fol. 37r for the heading to the *Canterbury Tales*; fig. 11).[81] Were it not for this manuscript, we would not know that Shirley had copied or annotated the *Can-*

76. More in keeping with "appropriate" reading for nuns would be Chaucer's "Parson's Tale" found in a manuscript that addresses its Rolle works to a woman recluse: see sec. IV, fig. 4, and Ogilvie-Thomson 1988, xxvii. For Colville's Hilton, see Bell 1995, 190.

77. The treatise was addressed to "Suster dame Alice," and may have been compiled at Syon, where Dorothy Slyght owned a copy in Oxford, Jesus College, MS 39: see Patterson 1987, 118, and Bell 1995, 196–97 and 199, the last on another manuscript owned by Slyght.

78. Quoted from Patterson 1987, 127; the *Troilus* stanza is I.400–406 in *Riverside Chaucer* 1987.

79. Quotations from Patterson 1987, 153, 145, 152, and 144, respectively.

80. As Shonk 1998, 81, points out. At 450 x 330 mm. MS Harley

7333 is larger than Auchinleck (discussed in ch. 2, sec. I) but smaller than Vernon, and with 211 folios it is thinner than both. See Seymour 1995, 22, and Shonk 1998, 81, for the date, though Kline 1999, 118, suggests 1425–75.

81. Shonk 1998, 89, claims that MS Harley 7333 "shows evidence of perhaps four different exemplars behind its version of the *Tales*" alone, with only the first being Shirleian, but also argues against monastic production. On the Shirley headings and notes throughout the manuscript, see Connolly 1998, 173–75, who suggests that many of the contents in booklets 3 and 5 "seem to derive from Shirley's texts," perhaps from more than one exemplar. For a new study and complete transcription of Shirley's headnotes in the manuscript, see Veeman 2010. The term "clergial" comes from Hanna 2000b, 34.

The Contents of London, British Library, MS Harley 7333

First Booklet

 fol. 1r: *Brut*

Second Booklet

 fol. 25r: *Cato Minor* and *Major* (Burgh in Latin
 and English)
 30v: *Against Fortune* (Lydgate)
 31r: *Henry VI Pedigree* and *Roundel on
 Coronation* (Lydgate)

Third Booklet

 fol. 33r: *Guy of Warwick* (Lydgate)
 36r: *Evidens to Beware: Old Man's Counsel*
 (Sellyng)
 36v: *Balade: Mon cuer chante* (Charles d'Orleans
 in French)
 37r: *Canterbury Tales* (Chaucer)

Fourth Booklet

 fol. 120r: *Confessio Amantis* (Gower) with *Proverbs*
 (Impingham)
 129v: *Parliament of Fowls* (Chaucer) with
 extract from *Life of Our Lady* (Lydgate)
 132v: *Complaint of Mars* (Chaucer)

Fifth Booklet

 fol. 134r: *Anelida and Arcite* (Chaucer)
 135r: *Complaint against Hope*
 136r: *Complaint d'Amours* (Chaucer?)
 136r: *Lives of Saints Edmund and Fremund*
 (Lydgate)
 147r: *Complaint of Christ* (Lydgate)
 147v: *Lack of Steadfastness, Gentilesse, Truth* and
 Complaint to His Purse (Chaucer)
 148r: *Balades* (Halsham, borrowing from
 Lydgate)
 148r: *Verses* (in Latin) with an extract from
 Pilgrimage of the Soul (in English)

Sixth Booklet

 fol. 149r: *Verses on English Kings* (Lydgate)
 149v: *Christmas Game* (Burgh)
 150r: *Gesta Romanorum* (or *Deeds of the Romans*)

Seventh Booklet

 fol. 204r: *Regiment of Princes* (Hoccleve)

More detailed accounts of the contents can be
found in Seymour 1995, 21–22, and Kline 1999,
133–38.

terbury Tales at all, since the text does "not appear in any of Shirley's existing anthologies or in other volumes derived from his work."[82] Now Shirley was not among the scribes of MS Harley 7333, but he was indeed connected with the Augustinian canons—he rented shops and a tenement from the Augustinian priory of St. Bartholomew (and the associated hospital), owned and perhaps engaged the work of the Augustinian scribe John Cok of that same house, whom he named as an executor in his will, and even requested burial "withyn the chapell of our Lady in the chirch of Seynt Bartelmew hospitall of London"— and that association might well account for the presence of Shirley-influenced texts in an Augustinian house as closely linked to London as Leicester Abbey was in the fifteenth century.[83]

There has been considerable debate as to the number of scribes involved in the production of MS Harley 7333—anywhere from three to nine or more scribal hands have been detected in the book—and some difference of opinion as well about their status, professional or monastic.[84] Only one scribe signs a name to the work: on fol. 122ra we find the words "**Quod Impingham**" in the large and formal script used for headings by one of the book's main copyists, but no connection has yet been made between that name and the Leicester Augustinians. The "doctor peni" who is said in the bottom margin of

82. Connolly 1998, 174.

83. Despite the abbey's physical distance from the capital. See Griffiths 1992, 90–91; Hanna 2000b, 33–34; and Connolly 1998, 175, who transcribes Shirley's will in her second appendix, from which I have quoted (204).

84. Manly and Rickert 1940a, 209, list "six to nine or more hands," while Kline 1999, 118, claims the manuscript was copied by eight scribes, and Shonk 1998, 84–85, detects the work of only three. Shonk also argues for professional if rural production, while Manley and Rickert and Kline present the case for the manuscript being copied and compiled in a monastic scriptorium, where the large number of exemplars it uses might be readily available.

11. The largest extant manuscript anthology of Chaucer features a long Shirlean heading (top left) for the *Canterbury Tales* and is linked to Leicester's Augustinian canons. London, British Library, MS Harley 7333, fol. 37r.

fol. 150r to have "writ this booke" can be linked to the abbey, however, since a John Peny (LL.D. of Oxford) was a canon of Leicester by 1480, prior of the house by 1493, and abbot in 1496, but the hand recording his involvement dates to the early sixteenth century and is unlike that of any of the manuscript's scribes. This doesn't necessarily mean that Peni wasn't among those scribes, but that the attribution to him is considerably later and thus uncertain.

With a third name found in MS Harley 7333, we are on more stable ground, specifically with identifying one of the manuscript's rubricators and correctors. On fol. 41rb, the name "¶ **Stoughton**" appears in the red ink of the rubricator who also underlines and highlights key words, headings, and marginal notes, makes corrections to the text, and leaves a number of intriguing drawings in the manuscript (see examples in figs. 11, 12a and b, and 13).[85] William Stoughton (or Stockton) was the cellarer of Leicester Abbey in the later fifteenth century, and he leaves his name in the manuscript three more times (in red ink on fols. 32vb and 45vb, and black on fol. 189ra), but in these instances the name takes the graphic form of a rebus consisting of a tree "stock" growing from a barrel or "tun," and twice accompanied by fish drawn in the same color as the rebus (figs. 12a and 13).[86] Clearly Stoughton wished to make his family symbol memorable to readers, and perhaps barrel, stock, and fish were meant to provide a clue to Stoughton's monastic position (as keeper of the cellar) as well as his personal identity.

It is true that such markers of identity might have been used by Stoughton to acknowledge scribal responsibility, but it is odd, then, that the same scribe did not copy all of the folios on which the forms of Stoughton's name appear. Alternatively, he could have been recording ownership of the book or perhaps personal involvement with its contents, a possibility supported by the location of his signatures. The red name "Stoughton" appears, for instance, at the point in the "General Prologue" where the Host opens his proposal for a tale-telling game with the words "Ye gon to Cavntirbury god yow spede" (fol. 41rb; I.769). Perhaps Stoughton meant to memorialize his own participation (vicarious or actual) in the pilgrimage to Canterbury,[87] a possibility lent some credence by the rebus on fol. 45vb beside a passage of the "Knight's Tale" which describes Arcite's journey into town (fig. 12a; I.1628ff). Cellarers were among the few members of monastic communities whose position would have necessitated travel, not for the battle equipment Arcite obtains of course but for provisions and other practical reasons.

So there may have been a strong personal element to Stoughton's involvement with the manuscript, yet his activities—rubricating, highlighting, underlining, correcting, perhaps decorating—give the distinct impression that he was also preparing the text for readers beyond himself, presumably the brothers of his community, and acknowledging his own role in the telling (or retelling) of the *Tales* as he did. At times it seems inescapable that he intended what might seem informal or personal drawings for future readers as well as himself: some of his striking and richly varying depictions of fish present fine examples, acting as hooks in the mind's eye of both reader and rubricator, lest essential Christian principles be forgotten. Honoring one's parents, for instance, is the theme of the tale from the *Gesta Romanorum* (*Deeds of the Romans*) and its "**Moralitee**" (or Christian moral) which are highlighted (in black instead of red ink) by three of Stoughton's fish—they appear along with his rebus and an early form of the Stockton family arms on fol. 189r (fig. 13).[88] Even Stoughton's most casual seeming doodles—the rubricated fish and faces, for instance, that emerge almost organically from scribal letters and loops, sometimes without any obvious didactic or personal purpose associated with the text (see figs. 12a and b, and fols. 43vb, 44ra, and 205r)—indicate a professional reader. It seems their author was comfortable with books, accustomed to wielding a pen and brightening a page, and perhaps a little bored of clarifying for others a poem he knows well.

The blend of professional and personal seems particularly appropriate for a monastic bookmaker who was both working for and a brother of the community that owned MS Harley 7333, and several other members of Stoughton's house may also have contributed to its production, some of them in far more invasive ways. The manuscript's *Canterbury Tales* contain textual variants occurring in no other surviving copies, and we see considerable evidence of scribal editing and rewriting in an effort to clean up certain aspects of Chaucer's text.[89] The interference is intermittent and ranges from the extreme decision to omit a tale altogether, to the relatively minor alteration of a single word, yet either can produce significant results in ideological terms. The "Shipman's Tale," for instance, was simply not copied, possibly because it was not available but perhaps because its tale of a monk's involvement in monetary

85. My thanks to Kathryn Kerby-Fulton for sharing her thoughts on the marginalia of the Stoughton rubricator.

86. The "stock-ton" rebus recalls Thornton's in the Lincoln *Prose Alexander*, in which a thorn grows from a barrel. The scribe who signs "A god when" also draws fish along with a barrel in the Findern MS. For both and other fish in romance manuscripts, see ch. 2 and figs. 7a and b, 27, 31a and b, and 36b there.

87. On the other hand, the rubricator may be recording his own journey to Stoughton, one of the granges of Leicester Abbey, in which case the word could refer to the place only and not Leicester's cellarer at all.

88. Manly and Rickert 1940a, 214, describe the arms as "a saltire between four door staples." Perhaps the three fish are intended to represent the father, mother, and son who appear in the tale.

89. See Kline 1999, 117, who discusses MS Harley 7333's "unique pattern of ideological editing" in detail. As Shonk 1998, 81, points out, the "corrupt" nature of the manuscript's *Tales* strips them of authority in textual and literary terms, leaving them virtually neglected by scholarship.

12a and b. The work (in red) of the Augustinian rubricator and corrector William Stoughton, whose rebus (bottom right of fol. 45v) is a "stock" growing from a "tun." London, British Library, MS Harley 7333, fols. 45v–46r.

and sexual exchange was deemed inappropriate and a poor role model for Augustinian readers. The end of the "Pardoner's Tale" is similarly omitted from the manuscript, so that the Pardoner's words end (at VI.918 on fol. 97rb) with the claim that Christ's pardon is best for all, "I wolle yow not disseyve," while the questionable attempts to sell relics and pardons, along with the Host's angry and colorful response (VI.919–68), are eliminated. Dorigen's contemplation of suicide in the "Franklin's Tale" is also omitted (V.1422–27 are missing from fol. 85vb), and it may be that the "Wife of Bath's Prologue" and "Tale" suffered censorship as well, but in this instance after the copying was completed, since an entire quire is missing after fol. 72. While

this results in the loss of the end of the "Merchant's Tale" (from IV.2119 on, avoiding May's adultery in the garden) and the beginning of the "Friar's Tale" (up to III.1376), only the "Wife of Bath's Prologue" and "Tale" are entirely removed. Perhaps the exuberant sexual and interpretive freedom of the Wife was considered so offensive to some member of the Leicester house that it was removed from the manuscript much as she had herself torn a "leef" from Jankyn's "book of wikked wyves" (III.667 and 685). However the quire was lost, it rendered the canons of Leicester as deaf to Chaucer's ironic and multilayered exploration of gender relations and learned traditions as the Wife herself grew to Jankyn's misogynism.

Smaller changes unique to the *Canterbury Tales* in MS Harley 7333 suggest a similar desire to keep certain topics and issues out of the Leicester library. Mentions of the devil or fiend, for instance, are altered or omitted in more than once place, and behind some changes there seems a clear understanding and deliberate suppression of "Chaucer's intended criticisms of the church."[90] An effort to cast a kindly light on the Augustinian order is also apparent, making the Leicester canons who likely served as some if not all of the book's scribes the most probable editors.[91] A simple change in the "Miller's Tale" presents a perfect example: a "cloisterer" (at I.3661), meaning any monk, is replaced in MS Harley 7333 with "a Chanoune cloysterere" (fol. 56va), firmly connecting the only "cleric in the tale

90. Kline 1999, 118.

91. Harley 7333's main scribe (Scribe 1), who contributed the largest portions to the manuscript, may have been particularly responsible for the changes, though the work of Scribe 2 in Shonk 1998 reveals something of a supervisory role, and that of Scribe 3

in Kline 1999 the most active editing of Chaucer's text. As Owen 1991, 69–70, points out, the production of MS Harley 7333 was something of a "group effort" in which "no single man's taste dominates."

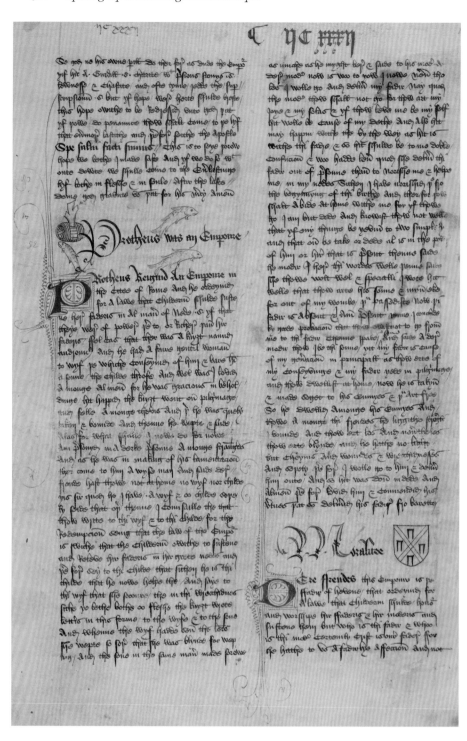

13. In the *Gesta Romanorum* the Stoughton rubricator draws (in black ink) his rebus with three fish (left column) and a shield bearing an early form of the Stockton arms (right column). London, British Library, MS Harley 7333, fol. 189r.

without some moral defect" with the canons regular.[92] In the "Canon's Yeoman's Prologue," the Yeoman's negative comments about his master are removed (VIII.704–9 at fol. 89vb), so that the Canon is no longer cursed to "sorwe," "shame" and "the foule feend," or accused of introducing his Yeoman to the science of alchemy, though none of the alchemical experiments the Canon wanted him to maintain silence about are eliminated from the tale itself. Such editorial choices suggest that the Augustinian canons of Leicester had no desire to suppress information on a suspect science like alchemy but only hints of their own involvement in it, a particularly revealing position given that in 1440 (only a couple of decades before MS

Harley 7333 is definitely in progress) John Sadyngton, abbot of the Leicester canons since 1420, was accused during an episcopal visitation of practicing sorcery (a common charge against practitioners of alchemy).[93]

More extensive alterations occur in the somewhat crude "Reeve's Tale." On the simplest level, offensive vocabulary is removed: occurrences of the overtly sexual and potentially violent verb "swyve," for instance, are replaced with the softer terms "dight" (at I.4178; fol. 59ra) and "Pleyed'" (at I.4266; fol. 59rb). The genealogical struc-

92. Quotation from Kline 1999, 125.
93. As Kline 1999, 129, points out.

ture of the Miller's family is changed as well. His Wife is no longer the daughter of the town parson (I.3943) but of the "Swonneherde," who gives "yron" as well as "brasse" along with his daughter in MS Harley 7333 (I.3944), and she is fostered not in a "nonnerye," as most manuscripts would have it (I.3946), but in a "dayrye" (fol. 57vb).[94] The changes not only wipe the slate clean for the church, since medieval parsons should not have been siring daughters, but imply less social discernment on the part of Miller, whose desire for a well-bred bride is satisfied in the canons' manuscript by a dairy maid. Further alterations mean that it is the Miller himself who wishes to marry his daughter well and pass his property on to her, rather than the parson planning to bestow his wealth (church property, that is) on his granddaughter (at I.3977ff; fol. 58ra). Having so eliminated the problem of a parson depriving the church in favor of his illegitimate progeny, the editor of MS Harley 7333 can hardly leave intact Chaucer's deeply ironic explanation of the parson's self-condemning reasoning:

> For hooly chirches good moot been despended
> On hooly chirches blood, that is descended
> Therfore he wolde his hooly blood honoure,
> Though that he hooly chirche sholde devoure
>
> *(I.3983–3986)*

He completely rewrites these lines to read:

> ffor wel egoten goode most been despendid
> In worthi bloode wher it is descendid
> Þerfore he wole his oune bloode honour*e*
> Þoughe þ*at* men þerof speke harome *and* loure
>
> *(fol. 58ra)*

Admittedly there is an effort to retain the rhyme and meter adopted by the poet, and even a nod in the direction of Chaucer's cutting insight—the definition of "worthi bloode" is left up to the reader, after all. Yet readerly anxiety has blown both poetic wit and literary excellence to the wind here, suggesting that even the careful, prescriptive compiler of the *Disce Mori* may have had more confidence in the ethical reading skills of the women of Syon than the cautious producers of MS Harley 7333 had in the literary and social discernment of the canons of Leicester.

Not that any anxiety over the questionable nature of Chaucer's *Canterbury Tales* as appropriate reading material for cloistered religious folk prevented his texts from being disseminated by the Augustinian canons, who were active in producing and reading Middle English texts of various kinds and can be associated with others copies of

14. The Augustinian scribe William "Cotson'" records his name and the date 1490 between two hagiographical *Canterbury Tales*. Manchester, Chetham's Library, MS 6709, fol. 173r.

Chaucer's magnum opus.[95] The *Tales* in London, British Library, MS Add. 5140 (late fifteenth century), for instance, belonged to Henry Dene, prior of the Llanthony Augustinians and later archbishop of Canterbury (1500–1503).[96] Here Chaucer's work is given the Latin rubrics (incipits and explicits) we might expect of a monastic manuscript, and while the "Wife of Bath's Prologue" and "Tale" are included, they are subjected to a generous helping of Latin glosses that condemn her creative and experiential reading of learned authorities and do their best to silence her more contentious arguments.[97] Safer still is the late-fifteenth-

94. Though as Kline 1999, 125, argues, the second reference to the "nonnerie" (I.3968) is left unaltered, presumably because it refers specifically to the Miller's wife's education rather than the whole of her upbringing.

95. On the associations between Augustinian canons and Middle English literature, see Hanna 2000b.

96. What appear to be his arms as archbishop are recorded on fol. 1r of the manuscript: see Seymour 1997, 97, and Manly and Rickert 1940a, 32–33.

97. See Schibanoff (1988) 1998 for a discussion of the marginalia in BL MS Egerton 2864, which shares both a scribe with MS Add. 5140 and Latin glosses—thirty-eight side notes and rubrics for the Wife's five husbands by the reckoning of Seymour 1997, 94 and 113.

century presentation of excerpts from Chaucer's *Tales* in Manchester, Chetham's Library, MS 6709, where only the hagiographical tales of the Prioress and Second Nun are included by the scribe William Cotson—likely an Augustinian canon of Dunstable—among a larger collection of saints' lives that combines Chaucer's writing with Lydgate's (see fig. 14).[98] Again in San Marino, CA, Huntington Library, MS HM 144 (after 1482, perhaps c. 1500) two of Chaucer's *Tales*—the "Tale of Melibee" and the "Monk's Tale"—were copied among a larger collection of moral, religious, historical, and poetic texts in English which may have been compiled by an Augustinian, since we know that an early owner had access to another manuscript from the priory of canons at Bisham Montague.[99] If so, he was an Augustinian who felt as free to edit the texts he copied

as did the canons who participated in the production of MS Harley 7333: here even the serious prose "Tale of Melibee" assigned to Chaucer's own literary persona is manipulated, resulting in a "very free version with many minor omissions, expansions, paraphrases, and small Latin translations of ME phrases."[100] So while the surviving manuscripts of the *Canterbury Tales* leave no doubt that the Augustinian canons were particularly active readers and producers—even exceptional anthologizers—of Chaucer's work, they also demonstrate how that "laureal and moste famous" (MS Harley 7333, fol. 37ra; fig. 11) of all Middle English literary writers could be excerpted and reshaped by members of a religious order to reflect and support a view of the world very unlike Chaucer's own.

III. Lots of Lydgate and a Little Hoccleve: Chaucer's Successors in Monastic Hands

In some monastic collections the views presented in Chaucer's writing may not even have been recognized as uniquely his or as independent of the work of other authors. One of the most interesting things about the two *Canterbury Tales* included in Huntington MS HM 144, for instance, is that their scribe appears either to have had no knowledge of Chaucer's authorship, or to have suppressed that knowledge by calling the "Tale of Melibee" simply *Prouerbis* (fol. 81r) while the "Monk's Tale" is entitled *The falle of Princis* (fol. 100r).[101] Given those headings, which together foreshadow Wynkyn de Worde's *Prouerbes of Lydgate vpon the fall of prynces* (c. 1515),[102] and their context in a collection including half a dozen Lydgate works, Chaucer's tales might easily have been misunderstood as the writing of that prolific Benedictine author from the Abbey of Bury St. Edmunds. The same potential exists in the case of Chetham's MS 6709, where Chaucer's two saints' lives are surrounded by those of Lydgate (*Life of Our Lady, Margaret, George,* and *Edmund and Fremund*), whom Cotson names in the manuscript (on fol. 287v, for instance) and gives credit for his work, while his famous predecessor receives no such recognition. Together these two manuscripts reveal a tendency among medieval readers to align the writing of Chaucer and Lydgate, making the latter "the equal of Chaucer," even acknowledging him to have a "broader appeal" in a way modern readers, as happy for the most

part to put Lydgate's poetry down as to pick Chaucer's up, find difficult to comprehend.[103] For us, Chaucer is and has always been the priority, yet both Huntington MS HM 144 and Chetham's MS 6709 make Lydgate more central, quietly tucking Chaucer's pieces in under his successor's rubric.

The trend works the other way around in some cases, of course, with Lydgate's *Siege of Thebes,* for instance, included in some manuscripts as a final Canterbury tale. The Augustinian prior and archbishop Henry Dene would have read his Chaucer and Lydgate so blended in BL MS Add. 5140, where the *Siege* follows immediately upon the end of the "Parson's Tale" and is called in Latin "the last of the fables of Canterbury" (fol. 359v). The scholarly incipit here makes it clear, however, that the *Siege of Thebes* was the product of the monk Lydgate on the journey home from Canterbury, while the explicit for the "Parson's Tale" defines it as the "last of the tales Chaucer composed" (fol. 359v). Together, they clarify for the reader (though in something of a fictional context, to be sure) that Lydgate was responsible for the smaller amount of text in a way the Huntington and Chetham's manuscripts do not do for his predecessor. Since Lydgate admired and emulated Chaucer, whom he calls in his prologue to the *Thebes* the "Floure of Poetes thorghout al breteyne,"[104] and also very deliberately wrote himself into the *Canterbury Tales,* even

98. Cotson signs the MS in several places, and as Manly and Rickert 1940a, 83–84, point out, a nineteenth-century copy of an earlier inscription suggests his link to the Augustinian priory at Dunstable. Manly and Rickert also consider the volume "a religious 'library' compiled by an amateur," with the most likely candidate Cotson himself. The two Chaucer tales were copied from William Caxton's 1484 printed edition of the *Tales.*

99. A parchment reinforcing strip found in MS HM 144 contains a list of canons professed at Bisham Montague: see the Huntington's online description of the manuscript at http://sunsite3 .berkeley.edu/hehweb/HM144.html.

100. Seymour 1995, 152.

101. Only a later sixteenth-century title identifies the first as "Chawsers talle of melebe" (fol. 81r).

102. See Seymour 1995, 152.

103. Quotations from Edwards 1981, 22. Although this may have been the case with monastic readers in particular, who in principle shared both ethics and lifestyle with Lydgate, manuscripts of lay and unknown provenance also combine Chaucer with Lydgate: in the Findern MS associated especially with gentry women, for instance, a unique lyric called the *Tongue* blends lines from both poets (see ch. 2, sec. III).

104. Erdmann 1911, l. 40.

having the Host request his story, he would no doubt have been pleased by the close association of his own writing with Chaucer's and flattered by the careful preservation of his authorial identity despite the connection. Given Lydgate's willingness to adapt his pen to any enthusiastic (and generally paying) audience, he may also have been pleased by the way in which his works were tucked into virtually every kind of medieval English manuscript.[105] "His audience encompassed the nobility, bourgeoisie, religious institutions and individual clerics—in fact a full spectrum of potential fifteenth-century readership."[106] Thus we can find his *Fall of Princes* associated with the Derbyshire gentry women responsible for the Findern MS (ch. 2, sec. III) but also with the male Benedictines of Battle Abbey (London, British Library, MS Sloane 4031, c. 1470).[107]

It is this latter sort of manuscript that particularly concerns us here, however, and such books are far from difficult to find since Lydgate was not only copied and read in English monasteries but carefully selected, collected, excerpted, interpolated, identified, illustrated, and anthologized, especially (as we shall see) among members of his own Benedictine house at Bury. Often Lydgate is represented in monastic books by only a single short piece or two in a much larger compilation or miscellany. This is the case, for instance, with his *Calendar* of saints included among "dyuers deuowte tretis" in Oxford, Bodleian Library, MS Douce 322, which was given (most probably in the late 1470s) to "dame pernelle wrattisley," a Dominican nun of Dartford.[108] It is also the case with the Winchester anthology (late fifteenth century) owned by John Buryton, sacrist of St. Swithun's Benedictine Priory, and containing among its large collection of Latin and English texts Lydgate's version of the *Secrets of Old Philosophers*.[109] London, British Library, MS Arundel 396, which belonged to Catherine Babington, the subprioress of the Campsey Augustinian canonesses in 1492,[110] contains Lydgate's writing on the Mass, as does London, Lambeth Palace, MS 344 (s.xv ex.), which may have been owned by the Augustinian canons at Notley.[111] The last, however, includes other Lydgate poems as well, like the popular *Life of Our Lady*, a text found also in London, Society of Antiquaries, MS 134 (s.xv²), perhaps from the Halesowen Premonstratensian Abbey.[112]

Some of the most interesting and complicated of the monastic collections containing Lydgate are those (like MS HM 144 and Chetham's MS 6709) in which his writing is gathered together with Chaucer's. Lydgate's *Siege of Thebes* and *Secrets of Old Philosophers* keep company, for instance, with Chaucer's *Parliament of Fowls* in the manuscript associated with the Syon nuns Colville and Thraseborough (Bod. MS Laud. Misc. 416). The Augustinian scribe Cotson

15. Associated with the Augustinians of Bisham Montague, this manuscript gathers stanzas from four different Lydgate poems onto a single page. San Marino, CA, Huntington Library, MS HM 144, fol. 145v.

ment for literary services'"—from the abbot of St. Albans for his *Life of St. Alban* (343). For manuscripts containing Lydgate's works, see Pearsall 1997, 68–84.

106. Edwards 1981, 22. Lydgate's works are found, for instance, in manuscripts associated with the gentry families of Findern and Thornton (ch. 2, sec. II and sec. III).

107. Ker 1964, 8. Beyond the Findern MS itself, Bod. MS Digby 230 contains evidence linking Lydgate's *Fall of Princes* to Findern women: see Harris 1983, 300.

108. Fol. i recto. "Wylliam Baron Esquyer" was the donor. The inscription claims that Pernelle was his niece, but it is more likely she was his granddaughter: see Bell 1995, 133.

109. BL MS Add. 60577, in which Buryton signs his name as "Bury" followed by a rebus of a tun (on fol. 1r, for instance); he may have bought the book from another St. Swithun's monk named John Brynstane: see Wilson and Fenlon 1981, 10–12 and 22. The manuscript also contains a selection of stanzas from Lydgate beginning "Lyfte vp the eeyes of your aduertence" (24).

110. Babyngton left the book to her community: see Bell 1995, 124.

111. See Ker 1964, 140.

112. See ibid., 95, but as Seymour 1974, 286–87, observes, the connection to the abbey is made via an eighteenth-century note.

105. On Lydgate's impressive list of wealthy, noble, and monastic patrons, both male and female, see Edwards 1981, 21, and 1994, 167n49, and Cannon 1999, 342, who points out that Lydgate is the first English "writer for whom there is a record of a 'specific pay-

combined four of Lydgate's hagiographical texts (including the *Life of Our Lady*) with two *Canterbury Tales*, virtually subsuming Chaucer in what might seem a straightforward compilation of Lydgate *vitae*.[113] And the possibly Augustinian collection in Huntington MS HM 144 scatters its short Lydgate pieces among William Lichfield, John Trevisa, Benet Burgh, the *Gospel of Nicodemus*, the *Stations of Jerusalem* (which here contains verses from the *Life of Our Lady*), and two of Chaucer's tales ("Melibee" and the "Monk's Tale"), with some of the Lydgate pieces represented by no more than a single stanza each. Such is the case on fol. 145v, where four stanzas are copied from four different Lydgate poems—*Horse, Sheep and Goose*; *Pageant of Knowledge*; *Tied with a Line*; and *Court of Sapience*—with the first three presented as though they were part of a single work (fig. 15).[114] The second and third of the four stanzas are copied (with some variations) as "balades" by "Halsam" in MS Harley 7333 (fol. 148ra), where a single stanza of the *Life of Our Lady* is also added to the end of Chaucer's *Parliament of Fowls* (fol. 132vb).[115] But MS Harley 7333 boasts a wider selection of Lydgate works—the lament *Against Fortune*, the *Pedigree* and *Roundel of Henry VI*, the romance of *Guy of Warwick*, the *Lives of Sts. Edmund and Fremund*, the *Complaint of Christ* and the *Verses on English Kings*—to match its Chaucer anthology.

That enormous Augustinian collection doesn't stop there, however (see "The Contents of London, British Library, MS Harley 7333"). MS Harley 7333 also contains the English *Brut* and *Gesta Romanorum*, extracts from John Gower's *Confessio Amantis* and a number of other short pieces, a few of them in Latin and French, and at its very end, Thomas Hoccleve's *Regiment of Princes*, a well-organized "handbook to the princely virtues" that suits the political bent of the collection, if not the monastic calling of its makers.[116] Extant today in forty-three manuscripts, the *Regiment* appears to have been the most popular of Hoccleve's works, as well as the only one to find its way into medieval cloisters.[117] Three other copies can be associated with religious houses, all of them containing Lydgate works as well: the Premonstratensian LSA MS 134 includes the *Regiment* along with the *Life of Our Lady*; London, British Library, MS Add. 18632—a fifteenth-century book given to the Benedictine prioress and convent of Amesbury by the priest Richard Wygyngton in 1508[118]—pairs it with the *Siege of Thebes*; and another Brit-

16. The final *envoi* for Amesbury's copy of the *Regiment of Princes* is decorated with display script rubrics, an ornate initial **O**, and a portrait of Hoccleve at his desk. London, British Library, MS Add. 18632, fol. 99r.

113. Beginning with the *Life of Our Lady*, followed by the two Chaucer tales (of the Prioress and Second Nun), then Lydgate's *Life of Margaret* and his versions of the *Lives* of the English saints George, and finally Edmund and Fremund: see Seymour 1995, 148.

114. See items 18–21 in the manuscript's online description: http://sunsite3.berkeley.edu/hehweb/HM144.html, and Bühler 1940 for detailed discussion.

115. See Bühler 1940, 568, and Seymour 1995, 21.

116. Quotation from Seymour 1981, xxviii. Like other manuscript copies of the *Regiment*, MS Harley 7333's was provided with

Latin glosses in red ink to guide the reader and identify important sources and authorities.

117. The count of *Regiment* manuscripts is from Seymour 1974, 255, who points out that twenty-five of the forty-three copies appear alone in their manuscripts, an interesting fact given that all four of the monastic manuscripts containing the poem combine it with other works, two of them (MS Harley 7333 and LSA MS 134) in especially large, coucher-style volumes. Seymour 1981, xxx, also notes that Lydgate's literary output was more than ten times that of Hoccleve.

118. See fol. 99v, and Bell 1995, 103–4.

ish Library MS, Harley 116, which looks very much like it was produced by a Carthusian house in the fifteenth century, places it at the head of a varied collection including a few Lydgate pieces, like the *Dietary* which survives in more manuscripts than any other work by Lydgate.[119] While none of the monastic *Regiment* manuscripts seem quite luxurious enough for the royal prince, soon to be Henry V, whom Hoccleve addresses in the text, both LSA MS 134 and BL MS Add. 18632 sport gilded and tinted initials along with some fine border work, and the latter even features an author portrait of Hoccleve, "the compiler," at his desk (fol. 99r; fig. 16).[120] Lydgate was not granted the same special attention in BL MS Add. 18632, but his *Siege of Thebes* (like his *Life of Our Lady* in LSA MS 134) did receive decorative initials and borders.[121]

Although many of the monastic manuscripts in which we find Lydgate's writing are plain and workaday (figs. 14 and 15 provide good examples), his texts were among the most lavishly illustrated of Middle English works. The most deluxe of monastic Lydgate manuscripts appears to have originated in the Benedictine Abbey of Bury St. Edmunds, where Lydgate spent the majority of his life.[122] From there, we believe, came the spectacular *Lives of Sts. Edmund and Fremund* found in London, British Library, MS Harley 2278, a book very likely produced under the watchful eyes of the author. Both the work and the manuscript were written in the months (or years) following the visit of the twelve-year-old Henry VI to the wealthy abbey for Christmas and Easter in 1433–34. Perhaps the boy-king, who was admitted to the fraternity of the monastery before his departure, revealed a special interest in the abbey's patron saint Edmund, once a king of England himself, or it may be that Bury's abbot, William Curteys, simply wished to foster such an interest.[123] Either way, it was the abbot who initiated the project as a gift for the young king, and spared no expense in making MS Harley 2278 one

of the most sumptuous and richly illustrated of all surviving medieval English nonliturgical books.[124] It sports about 120 miniatures in as many folios, and was clearly designed to tell not only the saints' *Lives* in visual terms, but the book's life as well, with several illustrations featuring the Bury community, two depicting the young Henry VI, and two offering portraits of Lydgate himself, while both the abbey and royal arms are presented as well (see fig. 17).[125]

No other extant manuscript of the text boasts so many miniatures or such elaborate and costly decoration, but MS Harley 2278 did become a model for later copies of *Edmund and Fremund*.[126] These copies are among a group of manuscripts dedicated almost exclusively to the works of Lydgate and produced in the vicinity of Bury St. Edmunds in the 1460s, when Lydgate (who died in 1449) had been gone for over a decade.[127] One primary scribe—named the "Edmund-Fremund scribe" for his multiple copies of the *Lives*—links the manuscripts of this cluster.[128] Among these manuscripts is London, British Library, MS Harley 2255 (c. 1460–c. 1470), a carefully copied anthology of forty-five different Lydgate pieces, both minor poems and excerpts, that features in its opening initial (fol. 1r) a small version of the Bury St. Edmund's arms found in MS Harley 2278.[129] It is likely, therefore, that MS Harley 2255 was made (possibly along with other Edmund-Fremund scribe manuscripts) for, by, or at (perhaps all three at once) Lydgate's abbey, where the monks might well have made special efforts to produce and retain their own copies of their homegrown author's works. In both the work of the Edmund-Fremund scribe and the lavish folios of MS Harley 2278 we can glimpse a thriving, even grand, tradition of English literary production based upon Lydgate's writing and promoted by the Benedictines of his own community—a tradition that must have contributed to Lydgate's wide popularity among lay as well as monastic readers.

119. MS Harley 116 seems a religious compilation and contains *De fundatione domus Carthusium* in Latin verse: Seymour 1974, 266. Edwards 1981, 15, counts the extant *Dietary* manuscripts at fifty-five.

120. MS Add. 18632 (fols. 2 and 101) also contains fragments of the household accounts of Elizabeth de Burgh, countess of Ulster, for the years 1356–59, including records of payments to Chaucer when he was a page in her household. For Hoccleve as a scribe, see ch. 1, sec. VI, and on author portraits, see ch. 5, especially sec. III.

121. Seymour 1981, 275 and 286.

122. In over sixty years as a monk, Lydgate was formally resident at Bury St. Edmunds for more than fifty of them; he served as prior of the house at Hatfield for almost a decade. See the table of dates in Pearsall 1997, 50–52.

123. On the details and context of MS Harley 2278's production and its illustrations in particular, see Scott 1996, II:225–29. Color images of many folios are available in the British Library's online catalogue at http://www.bl.uk/catalogues/illuminated manuscripts/welcome.htm.

124. Lydgate's *Life of St. Alban* may have been similar, since the amount Lydgate received from the abbot of St. Alban's "was enough for a handsome copy, illustrated like those of the Bury

saints": Doyle 1989, 118. As Pearsall 1997, 51, notes, Lydgate was freed of his obedience at Hatfield to return to Bury on April 8, 1434, and it may be that his return was related to the manuscript project for the young king; he began to receive a royal annuity in 1439.

125. Both king and author appear in fol. 6r's miniature, with the royal arms and badge (spotted antelope) illustrated in the initial **T** below (fig. 17). Each is also depicted praying before St. Edmund's shrine: the author on fol. 9r, and the king on fol. 4v. The Bury arms (*azure* with three golden crowns) appear as a full-page miniature on fol. 3v.

126. Scott 1982, 357–60, discusses the relationship between MS Harley 2278 and later copies of the *Lives*; see also Edwards 1981, 17.

127. On the localization of these manuscripts, their main scribe, and their illustrations, see Scott 1982, and Edwards 1981, 16–19. Beyond Lydgate, only Hoccleve's *Regiment of Princes* appears in these manuscripts. As Doyle 1989, 117, observes, the dedication in some later copies of the *Lives* is altered to Edward IV.

128. As do illustrative and decorative schemes, discussed by Scott 1982, who gives the scribe this title.

129. Scott 1982, 343n33 suggests that MS Harley 2255 features the hand of the Edmund-Fremund scribe from fol. 117ff. but notes that Jeremy Griffiths believed the entire manuscript in one hand.

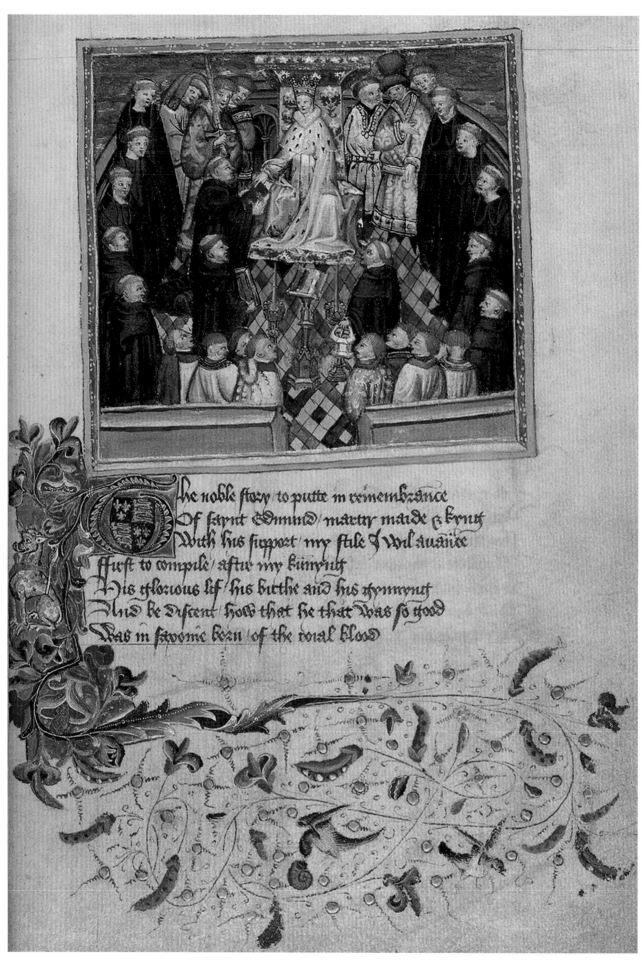

The noble story / to putte in remembrance
Of seynt Edmund / martyr mayde & kyng
With his support / my stile I wil avaunce
ffirst to compile / aftir my kunnyng
His glorious lif / his birthe and his gynnyng
And be disscent / how that he that was so good
Was in sothme born / of the roial blood

17. Lydgate's *Lives of Sts. Edmund and Fremund* made at Bury St. Edmund's for Henry VI includes a presentation scene, with the royal arms and badge below. London, British Library, MS Harley 2278, fol. 6r.

IV. "Sadde Mete" for Mind and Soul: Contemplative and Visionary Texts in the Cloister

Lydgate was something of a literary star, then, shining most agreeably on all quarters from the security of a powerful and wealthy monastery, but not all authors whose writing graced the book cupboards of medieval English monasteries enjoyed such safety and prestige. The French theologian Marguerite Porete, who found protection among no religious order, is a striking example. Her *Mirouer des Simples Âmes* challenged the ecclesiastical and political status quo with its open dismissal of the rituals and sacraments of the church, and in 1310 Porete lost her life at the stake for her zealous circulation of her book.[130] We might expect to find such a heretical text debated among scholars at Oxford, if in England at all,[131] but instead her highly mystical, deeply philosophical, and richly allegorical dialogue was read and disseminated among some of England's most conservative monks, the Carthusians. The Carthusians were a singularly isolated (each monk had his own cell) and contemplative order dedicated to individual union with God, but they were also dedicated to the production of books, which served as a substitute for the preaching their solitary lifestyle forbade.[132] Through the efforts of their learned members Porete's *Mirouer* appears to have entered England and received not only translation into English but also revision, commentary, and retranslation into Latin.[133] All three extant manuscripts of the Middle English *Mirror of Simple Souls* translated by the somewhat mysterious M.N. can be associated with the Carthusians—Cambridge, St. John's College, ms 71 with the London Charterhouse, Oxford, Bodleian Library, ms Bodley 505 with Edmund Storoure, prior of that same house from 1469 to 1477, and London, British Library, ms Add. 37790 with James Grenehalgh, the corrector and annotator of several Carthusian

manuscripts who appears to have worked in up to five English charterhouses in the first decades of the sixteenth century.[134] In the last of these manuscripts, known also as the Amherst ms, the *Mirror* is set among a predominantly English collection of texts that demonstrates well the kind of contemplative and revelatory literature that late medieval Carthusians were reading, translating, copying, and passing along to others.

Vernacular Texts for the Contemplative Connoisseur: The Amherst Manuscript

Written by one scribe (presumably with the initials I. S.) in a clear and tidy *Anglicana formata* of the mid-fifteenth century (see fig. 18), the Amherst ms gives every indication of thoughtful organization around the theme of contemplation and can be neatly divided into three logical sections.[135] The first (fols. 1r–96v) opens with Middle English translations of Rolle's *Emendatio Vitae* and *Incendium Amoris* (*Mending of Life* and *Fire of Love*) made in 1434 and 1435 by the prior of the Lincoln Carmelites, Richard Misyn, to which is added the Pseudo-Bernardine *Golden Epistle*, also in English. At the head of the second section (fols. 97r–136v) is the only extant copy of the shorter and presumably earlier version of Julian of Norwich's *Showings*, which is followed by the Middle English translation (likely by a Carthusian via a Latin intermediary) of Jan van Ruysbroec's *Vanden Blinckenden Steen* known as the *Treatise of Perfection of the Sons of God*,[136] fragments of two of Rolle's English epistles (the *Ego Dormio* and the *Form of Living*), and a fragment of Heinrich Suso's *Horologium Sapientiae* (*Clock of Wisdom*), again in Middle English. The third (fols. 137r–237r) begins with M. N.'s *Mirror of Simple Souls*, after which appears a Latin compilation on contemplation drawn primarily from the Pseudo-Augustinian *Liber Soliloquiorum Animae ad Deum* (*Book of the Soul's Soliloquies to God*), two short tracts in English on contemplation and the contemplative life, and a Middle English translation of a brief extract from Birgitta of Sweden's *Revelations*. With the Misyn translations of Rolle, Julian's *Showyngs,* and M. N.'s English of Porete forming the skeleton of the book—each of them appearing as the main text in one of the manuscript's three parts—there is a progression in the complexity of Amherst's texts: "the most systematically

130. A brief summary of Porete's double-edged relationship with authority in relation to her book, which was first condemned and burned long before she was, can be found in O'Sullivan 2006, 146–47. For an English translation of the *Mirouer*, see Colledge, Marler, and Grant 1999.

131. For evidence of debate among Paris theologians, see Kerby-Fulton 2006.

132. "Because we cannot by mouth, let us preach the word of God with hands" was a frequently repeated Carthusian dictum originating in the Carthusian *Consuetudines*: see the Latin in Gillespie 1999, 248.

133. See Doiron 1968, and Colledge and Guarnieri 1968. The Middle English translation was made (probably in s.xiv ex.) by an M. N., who was very likely a Carthusian, and the Latin (from the Middle English) in the later fifteenth or early sixteenth century by Richard Methley, who was certainly a monk of the Mt. Grace charterhouse.

134. See Doiron 1968, 244. Sargent 1976, 238, notes that Storoure wrote ms Bodley 505. A professed monk of Sheen's charterhouse, Grenehalgh was a guest at the Coventry house after 1507, and perhaps also at London and Mt. Grace, then died at the Hull charterhouse in May 1530: see Sargent 1984, 1:79–84.

135. ms Add. 37790's contents are listed in Colledge and Walsh 1978, 1:3–5, and Cré 2006, 17–18, who also notes the manuscript's three sections (21). The initials I. S. appear on fols. 1r, 96v, 225r (fig. 18) and 226r (twice), but no connection with an individual scribe (Carthusian or otherwise) has yet been established.

136. Ruysbroec's text entered England in a Latin translation from which the English version was made: see Sargent 1984, 1:22–23.

didactic" of them, the *Mending of Life*, comes first, and "the most speculative," the *Mirror*, as well as the manuscript's only Latin text, are included in the last section.[137] The progression of Amherst's contents from spiritual "mylke" to the "sadde mete . . . of hye contemplacion" thus echoes and enhances the natural progression of contemplation, from its preparatory practices and lifestyle, to the loftiest and most mystical union with the divine that is its ultimate goal.[138] So reading, too, is progressive here, with Julian's revelatory experience (in part 2) and Porete's allegorical dialogue (in part 3) requiring considerable reflection and interpretation on both literary and theological levels compared to Rolle's more straightforward treatises.[139]

Careful interpretation, particularly the need to understand the text in "gostely" ways—biting on "þe bitter | barke of the notte," as it were, to arrive at "þe | swete kernelle" (fol. 143r)—is precisely what M. N. focuses on in his translation of Porete's *Mirror*, or more accurately in his second effort to get his translation right. He tells us in his prologue that he originally translated the text from French to English "many ʒeeris goone," but that "some wordes þerof | hafe bene mystaken" (fol. 137r) and thus require the clarification he gives certain passages by writing "mo wordes þerto in maner of glose" (fol. 138r). He distinguishes these glosses, which appear not in the margins but within the text itself, by acknowledging them in scholarly fashion with the addition of his initials in red ink: the first ("**M**") appearing at the beginning and the last ("**N**") at the end of each addition (see fig. 19). Several of these glosses may have been inspired (or necessitated) by his knowledge of the striking similarity between Porete's ideas and a number of those condemned as extreme free spiritist propositions by the Council of Vienne (1311–12).[140] If so, M. N. had good reason for the "grete drede" he felt as he attempted to render a text of such "hye devyne maters" so "my | stely . . . spoken" both safe and profitable for "deuout Saules"; and in such a case, even his authorial humility—he says he lacks the strong "white" teeth needed "to byte of this brede"—might be taken at face value (fol. 137r). He makes something of a disclaimer as well, warning his readers of the dangers of taking the book "oþerwise than it is mente" (fol. 137r), and praying in his epilogue that God will inspire his readers to understand "in the same holy wise; as it is deuoutly ymente" (fol. 225v). And just to be sure, he explains that the *Mirror* is fit reading only for advanced "sau | les that bene disposid to . . . hie felyngis" (fol. 138r), suggesting that accurate reading and contemplative success are intimately entwined. Often "the notte and the kernelle" lie "withynne | the schelle vnbrokunne," but for true contemplatives this only deepens their experience of divine love and blesses them with "more clere insiʒt" into divine matters (fol. 138r).

Thus careful meditative reading is encouraged and rewarded, and M. N. is more than worthy of his "mede"

18. Amidst prayers and advice at the end of Porete's *Mirror of Simple Souls* appear the initials of both translator (M. N. in the lower right margin) and scribe (**S** wrapped around **I** four lines up from the bottom). London, British Library, MS Add. 37790, fol. 225r.

137. Cré 2000, 50.

138. See V. Gillespie 2006, 134, for the quotation from Nicholas Love's *Mirror of Christ*, where he offers his audience of "symple vndirstondyng" the "mylke" of lighter doctrine rather than the "sadde mete of grete clargye and of hye contemplacion."

139. As Cré 2000, 53–57, explains in some detail.

140. On the connection between M. N.'s glosses and several of the extreme propositions the Council of Vienne's *Ad Nostrum* bull claims were held by free spirit adherents, see especially Kerby-Fulton 2006, 272–96. See also Cré 2006, 180–90, who argues that M. N. considered the text orthodox.

19. In Porete's *Mirror* the translator's comments are enclosed with "**M.**" and "**N.**" in red; the Carthusian corrector Grenehalgh adds a missing line in brown ink at the top left. London, British Library, MS Add. 37790, fol. 143v.

when he tackles such tricky aspects of Porete's *Mirror* as the scene where the personified Soul takes leave of the virtues by informing his reader in a long comment that a soul enjoying the height of contemplative union has already reached the "swete kernelle" of God's love and can thus dispense with the surrounding shell of vices resisted and virtues embraced (fol. 143r). To say that M. N. introduces some clever sidestepping into his "gloses" would be an understatement, yet clarification does seem his primary intention, and the same is the case when Grenehalgh takes his correcting pen to that same long gloss. In MS Add. 37790 M. N.'s concluding line—"And þus it is mened | þat þis saule takeþ | leeue of *v*ertues"—was originally missing but was added by Grenehalgh (fol. 143v; fig. 19), who also corrects Porete's own text in a few places, as well as the manuscript's English copy of Rolle's *Fire of Love*.[141]

Grenehalgh's critical attention to Amherst is indicative of another, imminently practical way in which the English Carthusians were concerned with getting the text just right, and when it came to contemplative works, it seems the corrector and annotator Grenehalgh was their peripatetic expert. His hand has been detected at work in over a dozen books, both manuscripts and incunabula, containing works in both Latin and English, to which he added marginalia in both languages as well.[142] The texts he an-

141. Grenehalgh is one of eight different annotators in MS Add. 37790: their notes are transcribed in Cré 2006, 321–42, where Grenehalgh is Annotator 6 (338–39). For a discussion of the earliest annotator(s) of Julian's short text, see ch. 4, sec. IV.

142. A list of these manuscripts can be found in Sargent 1984, 1:74.

notated and corrected, often comparing readings between manuscripts, even between English and Latin versions of the same text, include (among others) the works not only of Porete and Rolle (*Emendatio Vitae* and *Contra Amatores Mundi* [*Against Lovers of the World*], as well as *Incendium Amoris*) but Suso, Hilton (*Scale of Perfection* and *Mixed Life*) and the anonymous author of the *Cloud of Unknowing*. In several he has left his monogram "IG" (as he does on fol. 33r of Amherst), but while some of these books may have been his personal possessions—the printed version of Hilton in Philadelphia, PA, Rosenbach Museum and Library, Incun. 494H (discussed below), for instance—in most cases he appears to have labored over communal books in an effort to establish standard versions of the contemplative texts so dear to the solitary Carthusian lifestyle.[143]

So we need look no further than one of the English charterhouses—perhaps Beauvale, the house closest to the southwest Lincolnshire dialect of Amherst; or Hull, in the northeast region where the manuscript's exemplars originated and Grenehalgh ended his career; or perhaps even Sheen, where Grenehalgh was professed before the end of the fifteenth century and many other Carthusian books originated[144]—to find a suitable medieval home and audience for this connoisseur's anthology of contemplation. Yet there are compelling reasons to think MS Add. 37790 something of a women's book as well. Both Rolle's *Ego Dormio* and *Form of Living* were written for women, and while his *Incendium Amoris* was not, Misyn translated the text at a woman's request—"**Sistyr Margarete**" is addressed in the heading in Amherst (fol. 18v), and "do*mi*ne Margarete. | heslyngtou*n* recluse" in its explicit (fol. 95r).[145] In addition, both Julian's *Showyngs* and the fragment from Birgitta are acknowledged in the manuscript as women's works. Porete, however, is not identified (not in any of the manuscripts of the *Mirror* in any language), and M. N., apparently unaware (or perhaps all too aware)

of Porete's fate, seems (or prefers) to consider his author a man despite the text's decidedly feminine approach.[146] The same apparent ignorance occurs with the Middle English translator of the *Liber Spiritualis Gratiae*, containing the revelations of Mechtild of Hackeborn, perhaps because its author—Gertrude the Great, Mechtild's fellow nun at Helfta in the later thirteenth century—refers to herself as "illa persona," rendering her gender undetectable.[147]

Like the *Mirror*, Mechtild's *Liber* appears to have come to England through Carthusian efforts, and the fifteenth-century *Book of Ghostly Grace* was translated from it likely by a Carthusian monk who found himself compelled to comment very carefully on questionable aspects of the text before him much as M. N. had.[148] Both extant manuscripts of the Middle English text reveal Carthusian connections: Oxford, Bodleian Library, MS Bodley 220 was copied, likely in the second quarter of the fifteenth century, by a scribe who signs his name "Wellys I." and was probably one and the same with the Carthusian John Wells, a monk as much on the move among English charterhouses as Grenehalgh was to be in the next century;[149] and London, British Library, MS Egerton 2006 was written in a mid-fifteenth century hand so similar to that of Amherst that if the same scribe did not copy both manuscripts, the two books were at the very least produced in the same scriptorium (see fig. 20).[150] We know that MS Egerton 2006 belonged to Richard III and his wife Anne Warwick (married 1471 and deceased 1485), which means that like Lydgate's *Lives* in MS Harley 2278 it was very likely made for royalty by a monastic order.[151] It also means that Mechtild's *Book* was accessible to lay women, notably to those women associated with Anne at the royal court, which may account for some of the female names recorded in MS Egerton 2006 between the fifteenth and the seventeenth centuries.[152] Other manuscript evidence corroborates: Richard's mother Cecily, Duchess of York,

143. In BL MS Royal 5.A.v, for instance, Grenehalgh's name appears on fol. 47r and his "IG" monogram eight times on fols. 20r, 45v, 51r, 51v, 53r, 53v, 55v, and 57r, but we know that the manuscript was given to the Coventry Charterhouse by Robert Odyham (prior c. 1457–68) long before Grenehalgh arrived there in 1507–8: see Sargent 1984, 1:148–56, and Ker 1964, 249. Although the Rosenbach Hilton has traditionally been given the number H491 in scholarship, Karen Schoenewaldt of the Rosenbach Foundation has informed me that the correct accession number is in fact 494H. See the examples of Grenehalgh's monogram in figs. 23, 25, 26, and 27.

144. See Cré 2006, 56–57, and Colledge and Walsh 1978, 1:3. The Beauvale option might expand the list of charterhouses Grenehalgh visited, but Carthusian books could also be sent or taken from house to house.

145. Misyn appears to have translated both the *Emendatio Vitae* and *Incendium Amoris* for Margaret Heslington, a recluse at York: see Doyle 1998, 126.

146. See Cré 2000, 51–52.

147. See Barratt 1992, 49–50, who suggests that Gertrude's

learned and accomplished Latin might also have marked her as a male author.

148. For example, a discussion of infant baptism and salvation prompted the translator's warning to "beware . . . , for clerkes holdene the contrarye opynyon" and "the furste wrytere" must have "mysunderestode": Barratt 1992, 59, ll, 193–96. Both Halligan 1979, 47–59, and Voaden 1996, 66, discuss the central role of the Carthusians in disseminating the *Book of Ghostly Grace*.

149. See Halligan 1979, 2. First entering the records in 1425, Wells certainly spent time at London, Hull, Mt. Grace, Hinton (where his death was recorded 1445) and perhaps one other English charterhouse.

150. See Cré 2006, 50. Halligan 1979, 22, offers the "cautious suggestion" that MS Egerton 2006 "might have been written in the Carthusian house in Axholme, located in Lincolnshire near the Yorkshire border." Fol. 18v of MS Add. 37790 sports a puzzle initial very similar to those on fols. 1r (fig. 20) and 20v of MS Egerton 2006.

151. See Halligan 1979, 4, and Cré 2006, 50; the first notes that the book likely belonged to Anne (n. 7), and the second that Richard read it too.

152. See Halligan 1979, 4, and Voaden 1996, 54n14.

owned a copy of the *Book*, which she gave in 1495 to her granddaughter Brigitte, a nun of Dartford,[153] and another copy was given earlier in the century to Joan Courtenay, perhaps a nun, by the laywoman Alianora Roos, whose burial at Mt. Grace suggests a Carthusian connection that might explain her early possession of the text.[154]

It is clear, then, that the vernacular of Mechtild's revelations—like that of Birgitta's and Catherine of Siena's—traveled rather easily from the closed cells of Carthusian monks to lay readers, even lay women, perhaps partially due to the later medieval tendency for the English charterhouses to provide "some form of pastoral care for [their] lay patrons as well as the wider lay community" despite the fact that their constitutions and statutes discouraged such activities.[155] For Porete's *Mirror*, however, there is no evidence either for or against female or lay readership in England,[156] and while the postmedieval copies of the longer version of Julian's *Showyngs* suggest preservation through the exiled nuns of Syon, the short text survives only in MS Add. 37790. So although women, particularly religious women like those at Syon for whom Carthusian scribes and authors frequently labored over devotional and contemplative literature in the vernacular, could have had access to Amherst—could even have been the intended readers and thus also the recipients of a great compliment to their intellectual and spiritual accomplishments[157]—a primarily male Carthusian audience remains the most probable. Yet in that rests a still greater compliment to the female authors included in the anthology, for they are measured here (even if one of them anonymously) against the contemplative writings of Augustine, Suso, and Rolle, and as both literature and theology their work proves more than equal to the challenge.

The Known and the Unknown: Manuscripts of Richard Rolle and the Anonymous *Cloud* Author

If the Carthusians who were copying and reading female contemplative authors as innovative and sophisticated as Julian and Porete did, for the most part, keep them safely within their order, their policy appears to have been quite the opposite with works by the Yorkshire hermit Rolle, whose writings in both Latin and English were, much like the work of Lydgate, widely circulated. There are nearly five hundred extant manuscripts of varying medieval origins and provenances containing one or more pieces by Rolle, an extraordinary number that makes him one of the most popular authors in the fifteenth century and undoubtedly the "most popular of the 'mystics' at the time."[158] Known by name in the Middle Ages, even in

20. Likely copied by the scribe of BL MS Add. 37790, Mechtild's *Book of Ghostly Grace* with its fine puzzle initials belonged to Anne of Warwick and her husband Richard III. London, British Library, MS Egerton 2006, fol. 1r.

153. See Voaden 1996, 67, who also discusses the excerpt of Mechtild's *Book* found in Downside Abbey, MS 26542, which belonged to a nun of Dartford who bequeathed it to two of her sisters (62).

154. Voaden 1996, 67, where she notes that Roos's will, dating to 1438, is "the earliest known record" of Mechtild's English *Book*.

155. Cré 2006, 43 and 45; financial necessity almost certainly contributed to the change in policy.

156. Though there is the sense that M. N. is responding to and anticipating a wider audience as he undertakes his second translation: see Cré 2006, 38–40.

157. Cré 2006, 31, suggests the possibility of MS Add. 37790 finding readers at Syon.

158. Quotation from Watson 1999, 542, who records the number of manuscripts on 547. Baker 2007, 425, notes that medieval wills indicate Rolle along with Hilton as the most popular of medieval authors in the fifteenth century.

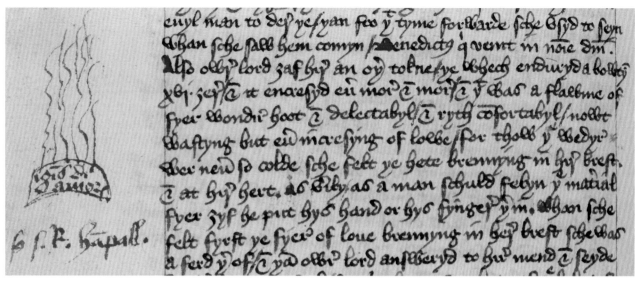

21. The red-ink Mt. Grace annotator links the "fire of divine love" ("**ignis diuini | amoris**"
enclosed in the curved box) described in Kempe's *Book* to the mystic Rolle ("**R. hampall.**").
London, British Library, MS Add. 61823, fol. 43v (detail).

association with many works he did not write, Rolle (dead by 1349) has been called the "first real 'author'" of Middle English and the "true father of English literature."[159] His works of guidance, devotion, and contemplative experience appealed to an extremely broad national readership, both lay and monastic, male and female, with women particularly active consumers of his English epistles and the translations made from his Latin writings, like those in the Amherst MS.[160]

As its initial position in that manuscript would suggest, the *Emendatio Vitae* was his most popular piece, extant in over 100 manuscripts, and receiving the compliment of seven different independent translations into English, including the one by Misyn found in Amherst.[161] Though we know of only Misyn's translation of the longer and more contemplative *Incendium Amoris*, we know, too, that the laywoman Margery Kempe had heard the text and was profoundly influenced by Rolle's descriptions of spiritual fire, experiencing her own versions of *fervor, dulcor et canor* (heat, sweetness and song), a fact the red-ink Carthusian annotator of the sole extant manuscript of her *Book* considered worthy of notice (London, British Library, MS Add. 61823; see fig. 21).[162] Read devoutly, even a single chapter of the *Incendium* in Latin could win a forty-day indulgence for Christopher Braystanes, a Benedictine monk of York who died (1474–1475) as a Carthusian of Beauvale, the charterhouse to which he gave the work.[163] The implication is that Rolle's writing was enormously important to the Carthusians, and there is plenty of evidence that they played an essential role in copying, editing, and disseminating the hermit of Hampole, with the nearby house at Mt. Grace and the important community at Sheen particularly active.[164] At the latter we can even situate two copies (one of them annotated by Grenehalgh) of an intriguing Rolle compilation entitled *De Excellentia Contemplationis* (*On the Excellence of Contemplation*), a long Latin

159. Hanna 2004, 19, and Alford 1984, 40 (quoting Carl Horstman), where a list of references to manuscripts and editions of Rolle's prose writing is included (51ff.).

160. Bell 1995, for instance, lists eight different women's religious houses that owned extant manuscripts containing English works either by Rolle or attributed to Rolle (see 226–27). Only Syon is recorded as possessing Rolle's works in Latin (241) but in two fifteenth-century manuscripts (ECC MS 35 and BL MS Add. 24661) that are perhaps better or at least primarily associated with Grenehalgh and the Carthusians. Bell tentatively assigns both manuscripts to Syon because of Sewell's monogram and name (178–79 and 187–88). Ker 1964, however, tentatively assigns MS Add. 24661 to Syon (185) and ECC MS 35 more certainly to Sheen (178).

161. See Watson 1989, 124, and Alford 1984, 45, who notes that the English translations appear in sixteen different manuscripts.

162. The annotations were added at Mt. Grace Charterhouse probably between c. 1528 and c. 1539: see especially Parsons 2001, and ch. 4, sec. III above. When Kempe describes (ch. 35) the "fyere of loue brennyng in here brest," the annotator uses Latin, a line drawing, and Rolle's name to highlight and authorize her experience (fol. 43v; fig. 21): see Meech and Allen 1940, 88. The red-ink annotator also adds Rolle's name when Kempe claims to have heard the *Incendium* (fol. 19v; ch. 17): Meech and Allen 1940, 39.

163. CUL MS Mm.5.37, a Carthusian MS which contains the *Incendium*, the *Oleum Effusum* and the *Emendatio Vitae*; the indulgence appears in red ink on fol. 2r, and the later biographical notice of Braystanes as a Carthusian of Beauvale, on fol. 2v: see Sargent 1976, 232–233.

164. Alford 1984, 48, notes the Carthusians, the Syon community, and the Hampole nuns as primary promoters and disseminators of Rolle's writings.

work which seems to represent a Carthusian attempt to construct an acceptable (that is, carefully edited) version of Rolle's collected writings.[165]

While the Carthusians were exceptionally busy collecting and correcting him, they did not have the market cornered on him. The Cistercian nuns of his local Hampole owned Rolle's own copy of his *Psalter* and were almost certainly the initial recipients of his English epistles, while the section of Warminster, Wiltshire, Marquess of Bath, Longleat House, MS 29 containing several of Rolle's works (including the *Form of Living, Ego Dormio,* and *Commandment*) may have descended from "an autograph collection made for" the Hampole nun turned recluse Margaret Kirkeby, whose name appears twice in conjunction with his writing (on fols. 3or and 58v; fig. 4).[166] Also Cistercian, or very possibly so, is the lavish Vernon MS which, along with its sister-book the Simeon MS, contains all three of Rolle's English epistles for women, as well as a number of his lyrics, while the closely associated BL MS Add. 37787 belonging to the Bordesley Cistercian monk Northwood features several of the same lyrics. Beyond the Cistercians, the Syon Brigittines were advised by their *Mirror of Our Lady* to read Rolle's *Psalter*, and in Bod. MS Douce 322, amidst "dyuers deuowte tretis" beginning with Lydgate's *Calendar,* Wrattisley, the Dominican nun of Dartford, could have read Misyn's English version of the *Mending of Life,* as well as a *Petty Job* attributed to Rolle.[167] The *Form of Living* was owned by Sibilla de Felton, the learned abbess of the Barking Benedictines from 1393 until 1419.[168] A fragment of the *Form* along with the *Commandment* and two texts attributed to Rolle belonged to a nun of Shaftesbury's Benedictine abbey, and the same community's steward gave the nuns the *Virtue of the Holy Name of Jesus,* a portion of Rolle's commentary on the Song of Songs that proved popular and circulated separately.[169]

Naturally, with all of this popularity and exposure Rolle did not escape criticism. He was, after all, unconventional in adhering to no formal religious order and cutting edge

in bringing contemplative writing to the English vernacular. As I mentioned above, the Carthusians who raised his banner highest also worked in the *De Excellentia* compilation to iron potential problems from the fabric of Rolle's writings, and so it is not entirely surprising that it was among the Carthusians that criticism arose. Although we lack the accusatory text itself, we know from the defense offered by Rolle's disciple, the hermit Thomas Basset, that it was aimed by a Carthusian at Rolle's willingness to grant the individual power over his or her own spiritual attainment, make "men judges of themselves" and deceive them with his mystical feelings and his books.[170] Rolle was well-defended by Bassett, but the writings of the second generation English mystics, Hilton, and the *Cloud* author—writings which also found a welcome home among the Carthusians—nonetheless seem designed to a significant degree by the need to define the difference between their new contemplative approaches and the work of their innovative predecessor.

In the *Cloud of Unknowing* (written c. 1370s–80s), for instance, the danger of mystical feelings as potentially physical as Rolle's fire of love, especially when combined with the personal freedom to judge one's own experience, is spelled out in some detail by the anonymous author, who may well have been a Carthusian himself.[171] Always mindful of the "ʒong disciple" for whom he writes—indeed of any "ʒong man or a womman, newe set to þe scole of deuocion"—he explains how easy it is to be misled either into striving physically to the point of exhaustion for a spiritual warmth that never comes, or into believing that "fleschly chaufyng" in the body is the divine "fiir of loue" Rolle describes.[172] The "deuil haþ his contemplatyues" (86, l. 19), the reader is warned, but as a true believer in contemplative experience, the *Cloud* author never directly criticizes Rolle. Instead he seems inspired by Rolle's experiences to write texts like the *Cloud,* the *Book of Privy Counselling,* and the *Epistle on the Discretion of Stirrings* as cautionary guidance for the next generation of contem-

165. The two Sheen manuscripts are Douai MS 396 and BL MS Add. 24661, the last containing Grenehalgh's marginalia and a "much-altered version" of the *Incendium Amoris*; a third MS of the *Excellentia,* BL MS Egerton 671, was partially copied by the hand of MS Add. 24661, so may also be from Sheen: see Sargent 1984, 1:37–38.

166. Quotation from Ogilvie-Thomson 1988, xv. Rolle's own copy of his English *Psalter* was given to the Hampole nuns by Robert Est of York: see Bell 1995, 141.

167. See Krug 2002, 186, and Bell 1995, 132–33.

168. The book is Beeleigh Abbey, MS C. Foyle, early fifteenth century: see Bell 1995, 107–8 and 226, and Ogilvie-Thomson 1988, xl, where a summary description of many manuscripts containing Rolle's texts is provided (xxxvi–xlix). The abbess owned other manuscripts in English, French, and Latin: see Bell 111 and 115–16.

169. The manuscripts (both s.xv) are CUL MS Ii.6.40 (in which the two attributed works are a *Pater Noster* and a *Speculum* of St. Edmund) and BL MS Add. 11748. The nun who owned the first was

Joanne Mouresleygh, recorded as a nun of Shaftesbury in 1441 and 1460; the steward who gave the second was the wealthy Dorset landowner William Carent (c. 1396–1476): see Bell 1995, 164–65, and Ogilvie-Thomson 1988, xliii. The *Virtue* or *Oleum Effusum* is also found in Thornton's Lincoln MS (ch. 2, sec. II), reminding us of the large audience for Rolle among the devout gentry and nobility of England.

170. See the *Defensorium contra Oblectratores,* extant only in Uppsala Universitetsbiblioteket MS C.621 (c. 1400), which probably came to the Brigittine motherhouse in Vadstena via Syon: Sargent 1981, 182ff., and 184 for the quotation.

171. On Carthusian authorship of the *Cloud,* see especially Kocijančič-Pokorn 1995; see Minnis 1984, 62, for other suggestions.

172. Quotations from Hodgson 1944, 85, ll. 9 and 15–16, and 86, ll. 6 and 13, but see the whole of ch. 45; all references are to this edition.

platives, who should properly interpret both what they read and what they feel, and if necessary curtail their own supernatural experiences. Although the *Cloud* author addresses women as well as men, and his message would no doubt have been considered particularly pertinent to women in the Middle Ages, I know of no manuscript of the *Cloud* itself with a medieval provenance connecting it with a religious (or any other) woman, which doesn't mean women didn't consume the text as well as men, but that they've left us no bread crumbs to follow.

Three of the extant *Cloud* manuscripts (there are more than a dozen altogether) can be linked with certainty to the Carthusians, however: the late fifteenth-century London, British Library, MS Harley 2373 containing all but one of the *Cloud* author's corpus (the *Dionese* is missing) was annotated by Grenehalgh at Mt. Grace (see fig. 22); Oxford, Bodleian Library, MS Douce 262 (fifteenth and sixteenth centuries) featuring the *Cloud* copied by William Tregooze and the *Privy Counselling* by Andrew Boorde, both of them monks of the London Charterhouse (see fig. 23); and Parkminster, St. Hugh's Charterhouse, MS D.176 (early sixteenth century), where the *Cloud* and *Privy Counselling* were copied by William Exmewe, one of the monks executed at Tyburn at the dissolution of the London Charterhouse in 1535.[173] As with Porete's *Mirror*, the Carthusians weren't just reading and reproducing the *Cloud* in English but translating it into Latin and making very sure that their perception of the author's meaning came through clearly in either language. Richard Methley, for instance, a monk of the Mt. Grace Charterhouse, translated both the *Mirror* and the *Cloud* into Latin and also provided glosses for each text.[174] And Grenehalgh provided hundreds of corrections, spelling alterations, and comments in Latin for the English *Cloud* in MS Douce 262 (see fig. 23), revealing how he compared the Douce text with what may have been a master copy of sorts at the London Charterhouse, and perhaps thereby created the corrected exemplar for the Parkminster *Cloud*; similarly in MS Harley 2373 he annotated the *Privy Counselling*, correcting it against a manuscript at Mt. Grace (see fig. 22).[175]

In MS Douce 262 Grenehalgh did something else as well: he attributed the *Cloud of Unknowing* to Hilton, a claim discounted in modern scholarship, and one that may well have surprised Hilton more than anyone, engaged as he was in rewriting both Rolle and the *Cloud* author in important ways.[176] Mistaken though it may be, Grenehalgh's attribution demonstrates how two contemplative authors whose mystical thought and methodology are today judged so very different could be considered one and the same by a late medieval reader who knew their writing well—a professional reader, in fact, who corrected and commented extensively on the texts of both. Perhaps Grenehalgh's error arose because the two authors frequently address the same issues despite the Pseudo-Dionysian approach of one and the Augustinian methods of the other.[177] Whatever the reason for his claim, however, given the popularity of Hilton among not only the Carthusians but the Brigittines of Syon and many other devout folk, religious and otherwise, it could only have increased the circulation possibilities of the *Cloud*.

Reading it Right: Living with the Contemplative Writings of Walter Hilton

As a matter of fact, the only extant text very probably by the *Cloud* author that can be linked to a woman owner—the *Treatise of Discretion of Spirits*—traveled with Hilton's *Treatise of Eight Chapters*, and belonged to Colville, the nun of Syon who also owned the work of Chaucer, Lydgate, and other authors in Bod. MS Laud. Misc. 416.[178] Women were a natural audience for Hilton because he initially wrote his *Scale of Perfection* (the first book of which was completed by the mid-1380s) for a "gostli sustir in ihesu crist," and although we do not know exactly who that woman was, the Syon sisters (and their supporters) seem to have been eager readers of his careful and detailed guide to the many stages of the contemplative life.[179] The two books of the *Scale* in London, British Library, MS Harley 2387 were given to Syon's nuns by the recluse Margery Pensax, who entered the house shortly after its founda-

173. On Carthusian manuscripts of the *Cloud* author, see Hodgson 1944, ix–xix, and Sargent 1984, 1:51–53 and 224–47. Two more fifteenth-century manuscripts—CUL MS Kk.6.26 containing all seven of the *Cloud* author's certain works, and TCD MS 122, containing the *Cloud* and *Privy Counselling* combination may also be Carthusian products, while the informal Carthusian commonplace book of English and Latin passages bound into Westminster Cathedral, Diocesan Archives, MS H.38, with its *terminus post quem* of 1393, preserves what is probably the earliest extant extract from the *Cloud*, ch. 65 on imagination (Hodgson 1944, 117–18): see Horrall 1990, especially 217.

174. Both translations are found in the late fifteenth-century PCC MS 221 (copied by the Carthusian scribe Darker and annotated by Grenehalgh); in the case of the *Mirror* Methley deletes M. N.'s glosses and adds his own: see Sargent 1984, 1:36 and 50–51, Hodgson 1944, xiv–xv, and Colledge and Guarnieri 1968, 373–82.

175. Hussey 1989, 121, counts Grenehalgh's annotations in MS Douce 262's *Cloud* at about 550. On Grenehalgh's work in manuscripts Douce 262 and Harley 2373, see Sargent 1984, 1:224–47; and for the relationship between MS Douce 262, the Parkminster MS, and a London master copy, 245–46.

176. For Grenehalgh's notes on Hilton and the *Cloud*, see Sargent 1984, 1:235–37. Watson 1999, 552 and 555–56, and Baker 2007, 428–29, discuss Hilton's literary dialogue with both Rolle and the *Cloud*; to the latter in particular Hilton responds in Book II of the *Scale*, written in the 1390s.

177. See Baker 2007, 428.

178. The book is BL MS Harley 993 (s.xv), where Colville's name appears three times (once on fly-leaf ii and twice on fol. 39v): see Bell 1995, 190, and Hodgson 1944, lxxvii.

179. The *Cloud* author, in sharp contrast, focuses on the top stages of the mystical life. A list of manuscripts of Hilton's *Scale* appears in Minnis 1984, 75–76.

22. Grenehalgh compared this *Book of Privy Counselling* with an earlier copy at Mt. Grace, carefully marking in the margin material lacking in that "vet*eri* libro" (top line of the annotation). London, British Library, MS Harley 2373, fol. 70v (detail).

23. Grenehalgh finishes his textual work on the *Cloud* by noting himself (".IG.") above the explicit and below it, the scribe William "Tregooz," a monk of London's charterhouse. Oxford, Bodleian Library, MS Douce 262, fol. 118v.

tion in 1415,[180] while those in Oxford, All Souls College, MS 25 were donated in the next century by Rose Pachet, a professed nun of Syon by 1518, and prioress of the restored community in 1557.[181] Both books of the *Scale* along with the *Mixed Life* are included in Wynkyn de Worde's 1494 printed edition (Rosenbach Incun. 494H), which belonged to the Syon nun Joanna Sewell (presumably via the gift of Grenehalgh) at the time of her profession in 1500,[182] and the same edition was owned by Katherine Palmer, who led a group of nuns to the continent after the suppression of Syon and ultimately became their abbess.[183] Although de Worde's print of the *Scale* with the *Mixed Life* as a third book appears to have been commissioned for Lady Margaret Beaufort, mother of Henry VII, and her courtly crowd, it clearly appealed to monastic women as well, with Hilton's texts passing easily between readers both aristocratic and religious, as the copy of the *Mixed Life* given in 1495 by Cecily, Duchess of York to her granddaughter, Anne de la Pole, prioress of Syon, demonstrates.[184]

Beyond the gates of Syon was an equally zealous audience of religious women. Pensax, for instance, was already following a solitary ascetic life long before she brought her copy of the *Scale* to Syon. Longleat MS 29 includes the *Mixed Life* with its Rolle collection, and the Vernon MS (like the Simeon), with its Cistercian associations and probable female recipients, contains the *Mixed Life* and Book I of the *Scale* (with Book II likely not yet available when it was produced), while London, British Library, MS Add. 11748 given to the Shaftesbury Benedictines by their steward includes Books I and II of the *Scale*—both of those manuscripts combining Hilton with Rolle as well. The two books of the *Scale* were also owned by Elizabeth

Willowby, the Augustinian canoness of Campsey who appears to have given Cambridge, Corpus Christi College, MS 268 (s.xv) to her community,[185] and by Elizabeth Horwood, the abbess of the Franciscan minoresses at Aldgate in London who intended London, British Library, MS Harley 2397 (also s.xv) to stay among her spiritual daughters.[186] Horwood's manuscript, like de Worde's 1494 print in Rosenbach Incun. 494H, contains the *Mixed Life* as well, a text that also belonged to Alice Braintwath, the prioress of Dartford's Dominican nuns in the 1460s and 1470s.[187]

For Hilton, then, as for Rolle, religious women were a primary audience, which isn't to say that religious men were not. In 1546, for instance, the Cluniac monk Anthony Bolney, who was subprior of the Lewes house, received Katherine Palmer's 1494 printed edition of the *Scale* and the *Mixed Life*, and both the Coventry Benedictines and the Cambridge Carmelites owned manuscripts containing Hilton pieces.[188] A Latin translation of the *Scale* made before 1400 was the work of the Carmelite Thomas Fishlake and copied by the Syon brother Clement Maidstone for presentation to the Brigittine motherhouse in Vadstena.[189] And there may be in San Marino, CA, Huntington Library, MS HM 112 and the two British Library manuscripts once bound with it into a single volume a hint of circulation among Hilton's fellow Augustinians as well.[190] The composite volume contains both Book I of the *Scale* and the *Treatise of Eight Chapters*, and was commissioned by John Pery, a canon of the Augustinian Priory at Aldgate, London, who made his presence felt in more than one place in the book (see figs. 24a and b).[191] Particularly interesting about this composite volume is the fact that the scribe most closely associated with Pery has been tentatively identified as the Carthusian monk of

180. Pensax was an anchoress at St. Botolph's, Bishopsgate in London by 1399 and still in 1413; the gift is recorded in a fifteenth-century inscription on fol. 130v of the MS: see Bell 1995, 190.

181. See Bell 1995, 196, who notes that her name appears on fol. 135r.

182. Sewell's monogram appears several times in the book, always in Grenehalgh's hand, which assumes an elaborate display script for the "**IS**" on fols. 5r and 135v, and the combined ·:·**IGS**·:· monogram on fol. 4v, where he also records her ownership: see figs. 26–29.

183. The book is now CUL Incun. 3.J.1.2. 3545: see Bell 1995, 183.

184. See Sargent 1976, 237, and 1984, 2:355–56, and Bell 1995, 209.

185. The recipients have been trimmed from the inscription (s.xv ex.) recording Willowby's gift on fol. 169v, but Willowby (who disappears from the records after 1532) owned a second book (an untraced print by de Worde) that was given to a fellow canoness named Catherine Symonde, who was asked to pass it along to another Campsey canoness: see Bell 1995, 123 and 125–26.

186. They were urged to pray for "þe sowles off hyr*e* ffad*er* | *and* her*e* moder*e*" and a master Robert Alderton, who may have been her teacher or confessor (fol. 94v). The inscription dates to the fifteenth century, and Horwood was successor to a Christina who was abbess in 1455: see Bell 1995, 149.

187. BL MS Harley 2254 (c. 1400); the ownership inscription (s.xv ex.) appears on fol. i verso along with the names of two other women, Elizabeth Rede and Joanna Newmarch, presumably nuns of Dartford: see Bell 1995, 131. The manuscript also contains the *Pricking of Love* sometimes ascribed to Hilton.

188. In Bod. MS Digby 115 and York Minster, MS xvi.K.5: see Ker 1964, 54 and 24.

189. Fishlake's translation is sometimes called *De Nobilitate Animae*, and the manuscript copied at Syon is Uppsala, University, MS C.159: see Sargent 1984, 1:47, and Lagorio 1981, 138. Unlike their female colleagues, the Syon brethren seem to have read their Hilton primarily in Latin rather than English: see Gillespie and Doyle 2001, 779.

190. Huntington MS HM 112, containing the *Scale*, was originally the middle section of a three-part book; the first part is now BL MS Add. 10052 and the third part is BL MS Add. 10053, which includes the *Treatise of Eight Chapters*. See the online description of MS HM 112 at: http://sunsite3.berkeley.edu/hehweb/HM112.html.

191. On fol. 78v of Huntington MS HM 112 Pery added his scribal-style "q*uod* I pery" to the *Scale*'s explicit (fig. 24a). In BL MS Add. 10053 "q*uod* I Pery" appears in the same hand and similar ink on fol. 29r, and as "**Ioha*nn*is pery**" in red ink on fol. 83r, where he is identified as a canon of Aldgate and the maker of the book (fig. 24b).

24a and b. The Augustinian canon John Pery (his name appears at the bottom of both pages) may have had the prolific Carthusian scribe Dodesham copy his Hilton. San Marino, CA, Huntington Library, MS HM 112, fol. 78v, and London, British Library, MS Add. 10053, fol. 83r.

Witham and Sheen, Stephen Dodesham (died 1482), "one of the most prolific medieval English scribes yet recognized" who seems to have enjoyed a secular career making manuscripts before doing the same in monastic life.[192] The association of an Augustinian volume with the Carthusians and one of their busiest scribes heralds a host of manuscript evidence indicating that the charterhouses would have been the places to go for the best copies of Hilton's popular *Scale*, even if you happened to be a member of his own order.[193]

Extant Hilton manuscripts associated with the Carthusians are manifold. Two fifteenth-century copies of both books of the *Scale* belonged to the London Charterhouse: Cambridge, University Library, MS Ee.4.30 and London, British Library, MS Harley 6579, the second a carefully made master copy of sorts in which several contempo-

192. Quotation from Doyle 1990b, 14, and on Dodesham and his manuscripts, see also Edwards 1991 and Doyle 1997, where features of Dodesham's widely varying scripts are discussed and a list of the many manuscripts he worked on is included (115). The shifting nature of Dodesham's hand caused Doyle 1990b, 15, to wonder if "his *oeuvre* was in reality that of a whole school or scriptorium of scribes." On the attribution of Huntington MS HM 112 and BL MS Add. 10053 to Dodesham, see Fletcher 1985. Horobin 2009a, 116–21, argues that Dodesham was also responsible for

the copy of Chaucer's *Astrolabe* found in Bod. MS Bodley 619 (see fig. 9).

193. As Doyle 1989, 113, notes, "there is a want of positive evidence that Hilton's own order," generally quite involved in the production and transmission of Middle English writing, "did much towards the early diffusion of his writings"—a striking contrast to the Benedictines' support of Lydgate's work or the Carthusians' support of the *Cloud* author, if indeed he was of that order.

25. At the end of Hilton's *Scale* Grenehalgh records the names of author, scribe ("Benet") and corrector ("Grene | halgh" and "IAG"), and dates his work to 1499. Cambridge, Trinity College, MS B.15.18, fol. 115r.

(facing) 26. Packed with critical, didactic, and personal annotations, the 1494 Wynkyn de Worde print of Hilton that Grenehalgh shared with Sewell bears the names and monograms of both. Philadelphia, PA, Rosenbach Museum and Library, Incun. 494H, front pastedown.

rary hands have inserted corrections, provided alternate readings, and added missing passages to provide the fullest and most meaningful version possible.[194] Another *Scale*, this time in Fishlake's Latin, may have come from the London house, or perhaps from Sheen, a charterhouse to which several other extant Latin copies are connected.[195] Certainly produced at Sheen were Book I of the *Scale* in the Tokyo, Takamiya 3 (formerly Luttrell Wynne) MS and Books I and II in Cambridge, Trinity College, MS B.15.18: both manuscripts were copied by Robert Benet, procurator of the house, and the text in TCC MS B.15.18 was annotated by Grenehalgh (see fig. 25).[196] Also annotated by

Grenehalgh were the two *Scale* books in the Duke of Devonshire, Chatsworth MS of Hilton,[197] and most extensively of all, the de Worde 1494 printed edition of the *Scale* and *Mixed Life* in Sewell's Rosenbach Incun. 494H.

The monumental efforts made by the Carthusian scribes and correctors to get the complete text of Hilton just right is nowhere clearer than in Rosenbach Incun. 494H. Grenehalgh's annotations reveal that he compared this printed *Scale* to four or more manuscripts: to the English in TCC MS B.15.18 and if not CUL MS Ee.4.30, then a version very like it; to the Latin in London, British Library, MS Harley 6576; and to the text in at least one other

194. See Sargent 1984, 1:45 and 2:294–95, and Hussey 1989, 119.

195. See Sargent 1976, 228, and 1984, 2:324, on Taunton, MS Heneage 3083, from the London house, a book that also contains Rolle's *Incendium Amoris* and *Emendatio Vitae*. The Sheen manuscripts include BL MS Harley 6576, annotated by Grenehalgh at Sheen; Bod. MS Bodley Lat.th.e.26, copied by John Feriby of Sheen; and SJCO MS 77, copied by John Dygoun, an Oxford-

trained lawyer who became the fifth recluse of Sheen in 1435. On these manuscripts, see Sargent 1984, 1:44 and 47 and 2:323–25, and 1983, 189–90 and 215–16, as well as Hanna and Griffiths 2002, 100–105.

196. See Sargent 1984, 1:44–45 and 2: 340–45. Benet was dead by 1517/18.

197. Sargent 1984, 1:44 and 73.

This boke is diligently corrected oute of Laten

Laus deo

Hampole

Liber Cartus: Schene Jhu Bethlee

Greuehalgh Monke profess

unidentified (likely lost) MS.[198] TCC MS B.15.18 and MS Harley 6576 both contain alternate readings and additions in Grenehalgh's hand from the de Worde print, while the majority of what amounts to hundreds of textual annotations in the printed version derive in turn from those two books, with about a third of them in Latin, just as we might expect after reading Incun. 494H's front paste-down, where Grenehalgh reports that the text was "diligently corrected oute of Laten'" (fig. 26). While Grenehalgh's detailed comparison of multiple copies is often apparent in his critical marginalia (see fig. 22), the correction and annotation of Rosenbach Incun. 494H is exceptional even by his generous and exacting standards, and whether the book was initially his personal possession or belonged to the Sheen charterhouse, it seems to have become his own "master-text of the Scale, into which he entered corrections from all other sources."[199] It is hardly unexpected that a former schoolmaster[200] and active professional reader for a bookmaking order who worked on so many Hilton manuscripts would create such a useful tool of his trade, but what does seem surprising is that he would give this precious volume away, apparently long before his career was over.

Yet that is precisely what he seems to have done, recording the nun Sewell as the owner along with the date of her profession at Syon—April 28, 1500—in a way which has suggested to readers that he gave her the book on that occasion,[201] or perhaps presented her with a community book he had made very much his own (see fig. 27). If we compare the book's two ownership inscriptions, Sewell's is the better claim: Grenehalgh's name on the front paste-down appears only after the assignment of the book to the Sheen Carthusians and more in the way of a scribe or corrector than an owner—"Q*uod* **G**renehalgh' Monke Profess*us*"—but on fol. 4v we are explicitly told that the "boke belongith to Dame Ihone Sewell'," sister at Syon (figs. 26 and 27). Even in that clearest record of her possession, however, Grenehalgh blends his own name with hers in a combined ·:·**IGS**·:· monogram with flourishes, and while her individual ·:**IS**:· monogram does appear across the opening on fol. 5r (as in several other places in the book) and is even expanded into her whole name on fol. 135v (fig. 29), Grenehalgh was himself responsible for all

the names and monograms. He worked on the book long before her profession at Syon: the date 1497 appears in his hand in the bottom right corner of the front paste-down (fig. 26), and a signed note at the end of the *Scale* Book II (fol. 134v) reports that Grenehalgh completed his editing work on that text on the Carthusian feast of the relics in November 1499, precisely when he claims to have finished his work on the *Scale* in TCC MS B.15.18, suggesting that he compared, corrected and annotated the two books together at Sheen (see fig. 25).[202] Also referring to November of 1499 is the note on fol. 126r of Incun. 494H invoking the prayers of St. Leonard on his feast, while the virtually indecipherable annotation written among the large printed letters of "AMEN" at the bottom of fol. 59r is dated to 1500, the year of Sewell's profession, and includes her monogram.[203] Even after Grenehalgh may have formally passed the book on to Sewell, he kept annotating it: he returned, for instance, to fol. 134v and added a reference in 1501 to the May feast of St. Helen and the finding of the cross, and along the very bottom of fol. 30r he wrote a barely legible annotation that includes the monogram "IS" and a date in February 1501 (fig. 28).[204]

We might most accurately think of Rosenbach 494H as a shared book, then, with Grenehalgh using it as a practical tool for what became a productive career as a professional Carthusian reader and editor but also sharing it with Sewell at Syon, which is where the manuscript seems to have stayed.[205] Perhaps sharing Hilton was simply an extension of his professional life, since it is generally believed that Grenehalgh found himself in the role of Sewell's spiritual guide, though Carthusian monks were, for the most part, not even permitted to speak to women.[206] Certainly there is evidence of the teacher-pupil relationship in Grenehalgh's annotations for Rosenbach 494H, nowhere more obviously than when they feature Sewell's monogram or name. Among the chapter summaries for Book I of the *Scale*, for instance, Grenehalgh draws attention to Hilton's discussion of "how a man shall see the grounde of synne wythin hymselfe" by marking the spot with a decorative trefoil and attracting Sewell's eye with a pun on her name that also guides her reading: "Se wele fro this | to þe end' of the | first boke. *and* begy*n* | at such a signe."[207] He again adopts the distinctive tone of a teacher—"þ*u* shalt

198. Sargent 1984, 2:330–359 discusses Grenehalgh's work in Rosenbach Incun. 494H and MSS TCC B.15.18 and Harley 6576 in detail. See also Hussey 1989, 121.

199. Sargent 1984, 2:330.

200. The first record of Grenehalgh (1488) is as *magister scholarum* of Wells Cathedral, a position which would have put him in charge of more than fifty students: see Sargent 1984, 1:76–78.

201. About Sewell we know only what we learn from Grenehalgh's annotations and that she died July 2, 1532, and was buried near the chapel screen at Syon: see Sargent 1984, 1:106n76.

202. On fol. 134v of Incun. 494H Grenehalgh also notes that he completed the task between 4:00 and 5:00 in the afternoon: see Sargent 1984, 1:199.

203. See Sargent 1984, 1:85, 86, 183 and 191.

204. See Sargent 1984, 1:199–200 and 181. The purpose of these annotations remains uncertain.

205. Sargent 1983, 207.

206. Sargent 1984, 1:90–92, where he also discusses the equally strict Syon regulations about contact with the opposite sex.

207. On fol. 3r for ch. 52; no corresponding trefoil appears in the main text: see Sargent 1984, 1:89.

Capitula prime partis

How a man shall be shapen to the ymage of Jhesu/and Jhe
su shapen in hym / Capitm lxxxii.
The cause why this boke was made: And how she sholde ha
ue her in reding therof that was made to. Capitm lxxxiii

Here endeth the chapytours of the fyrst book·
And after foloweth the fyrste parte of this present vo ·
lume/

This boke belongeth to Dame Jhone Sewell
Syster in Syon professed The yere
off oure Saluacion A thousand fyfe hundreth

IGS

In die Sancti Vitalis Martiris xxviij Aprilis

27. Before Hilton's *Scale* Grenehalgh records Sewell's ownership of the book, notes the date of her Syon profession, and merges their initials ·:·**IGS**·:·. Philadelphia, PA, Rosenbach Museum and Library, Incun. 494H, fol. 4v.

28. Written in tiny script and nestled at the bottom of the folio, this annotation seems to be a private message discussing a Valentine's meeting between Grenehalgh and Sewell. Philadelphia, PA, Rosenbach Museum and Library, Incun. 494H, fol. 30r (detail).

vnderstond*e* . . ."—for a long gloss on the active and contemplative lives that appears above the decorative ·:**IS**:· on fol. 5r.

Grenehalgh's guidance of Sewell begins as early as the front pastedown, which features among its various notes and quotations in both English and Latin two marked with the "IS" monogram (fig. 26). One quotes the Pauline notion of being crucified to the world—"Michi mundus *cr*ucifixus est et ego mu*n*do"—and refers Sewell to II.27 of the *Scale* for an "exposiciou*n*" of this principle so central to monastic life.[208] The other reads:

The eye of þ*e* hert is calde þ*e* Inner ^eye^. What þ*e* | openyng of it is. What it betokniþ. *and* þ*e* ve*r*tues þ*at* comme*ne* þ*er*by. See in | the second' boke þ*e* xl chappetir ·:**IS**:·

If we turn to that the fortieth chapter (fol. 120r), we find in Grenehalgh's hand the Latin note "Q*uid* sit int*er*ior oculus | diffinitiue" beside Hilton's explanation of the many won-

208. The quotation is from Galatians 6:14 and is the motto of modern Syon, though we do not know if it was used in the Middle Ages as well: see Sargent 1984, 1:88.

In deſpiſyng of pᵉffered onʳ ghoſtlÿ enmye ſaÿ yⁱˢ ħimns

O tortuoſe ſerpens qui mille per meandros fraudesꝫ
fleꝺuoſas agitas quieta corda⁖ Diſtede. ꝯc hic eſt.
hic eſt ꝯc. liqueſte⸱ ſignū T⸱ quod ipe noſti damnat
tuam cateruam⸱ T⸱ Crux pellit oīe crimen⸱ fugi
unt ⊞ crūcē tenebre⸱ tali dicata ſignō mens fluctuare
neſtit. Diſtede 4 ꝯ do vt 16 a foꝉ

Agaynſt vayne dꝛemoꝛ oꝛ fantaſioꝛ ſai yⁱˢ vꝵ

Pail. O. pꝛul vagantū portenta ſomnioꝛum ⁚
procul eſto ꝑnicaci preſtigiatoꝛ haſtu⸱ Diſtede ꝛc

Sanctus Saluator

Maria · Johanna · Birgitta

Sewell ⁚7

Sᶜͭꜱ Auguſtinus.

Vallata
Oicaꝫ⹃ Stipata ſeu⟶ Non timebia⟶ A ſagitta pambulante in die⸱ a negocio
cū mata⟶ pambulante in tenebris⸱ Ab incurſu et ꝛc
A timoꝛ noctis demonio midiano⸱ Sꝫ cadent a laīe tuo

Ad te autem ⸱ꝑ⸱ non appropinquabit ⟶ Quod preſtare dignetuꝝ
Jeſus⸱ xꝓus⸱ Dominꝰ nꝛ AMEn

derful states and feelings that come with the opening of the "ghostly eye," including the "entre of con|templacyon." Grenehalgh assumes that entering such a contemplative state is a goal he shares with Sewell, and when Hilton discusses the spiritual discernment of those "chosen soules" for whom the inner eye is opened (ch. 45, fol. 132v), the double monogram ("IGS") appears again along with the simple words "spes nostra" (our hope). At the end of the *Scale* he implies her achievement of this elevated spiritual state by placing her name and monogram alone within inner walls at what must be Syon and continues his guidance with prayers and advice, mostly in Latin, appropriate to the reclusive or contemplative life (see fig. 29). These notes and others suggest not only that Grenehalgh assumed Sewell familiar enough with books and proficient enough in Latin to negotiate cross-references and mixed annotations (and this is the case whether he added the Latin before or after intending the book for her), but also that he used Hilton's text for both himself and his student, just as he prepared it for members of his extended Carthusian community, as the serious guide to sincere devotion and contemplative life Hilton had intended.

In a climate of strict segregation between the sexes (at least in theory), a book like Rosenbach Incun. 494H, passed through the kind of privacy grills or turning windows used to permit communication while preserving enclosure in medieval monasteries, might well have allowed detailed instruction between teacher and student that could otherwise not have taken place.[209] Of course, it could have allowed other kinds of communication as well, and though it proves impossible at times to separate the professional from the personal in relationships based on spiritual direction and friendship between vowed religious, some of Grenehalgh's annotations for Sewell may well go beyond the role of guidance. That note dating to

1501 and written almost off the bottom edge of fol. 30r in such tiny letters that one hardly even notices it while leafing through the book serves as a perfect example (fig. 28). It seems to describe a meeting between Grenehalgh and Sewell (who is identified by her monogram) on February 13, the vigil of St. Valentine's day, 1500 for them, 1501 in our own calendar, when they were able to talk together ("colloquebar" perhaps "in carne") only after considerable "difficulty" ("post difficultatem").[210] The monastic rules that forbade any direct contact between Syon nuns and Carthusian monks could well have constituted that difficulty, and provided, too, the need for the secrecy that both position and script size (not to mention abbreviation) facilitate on fol. 30r. Other notes in 494H might similarly have recorded or set the times for such clandestine meetings: the discrete mention of the 1501 feast of the finding of the cross on fol. 134v, and the tiny cursive words oddly situated between the letters of "AMEN" at the end of the first book of the *Scale* on fol. 59r, where the date 1500 and both Sewell's monogram and Grenehalgh's Christian name—"Iacobus Professus"—are included, seem promising candidates.[211] If these unique annotations were indeed intended in this way, then the sharing of Hilton's *Scale* by Sewell and Grenehalgh hints at a relationship that extended beyond the dynamics of mentor and pupil, and contributed to Grenehalgh's peripatetic future in the Carthusian order.[212] Such an intriguing and personal use of this early printed book in the cloister also reveals just how much about the complexities of medieval reading experiences can be missed by the student of the twenty-first century who encounters Hilton (one of those authors generally considered too dry and alien by current standards to be entirely teachable) only in the pristine medium of modern print.

V. Taking it to the Streets: Middle English Drama from the Cloister

The leap from monastic contemplative writings to the often comedic, sometimes lowbrow texts of late medieval drama may seem an enormous one, but in actuality the Middle English plays afforded one of the greatest potential connections between layfolk of all social levels, both men and women, adults and children, and the theology developed in medieval English cloisters. Universal salva-

tion history, affective devotion, biblical exegesis, hagiography, allegorical dramatization of internal conflict and progress—all and more familiar from monastic writing are found also in the mysteries, miracles, and moralities. The Franciscan mission to take the Bible to the streets through vernacular preaching and instruction has been singled out as particularly influential,[213] but it seems that no one reli-

209. Sargent 1984, 1:92n47, mentions privacy grilles at Syon for conversing without violating enclosure. Through these or some kind of turning window, books might have been passed between the nuns and the Syon brethren (or Carthusian monks) much like they were between the nuns and canons of Gilbertine houses: see Golding 1995, 180.

210. See Sargent 1984, 1:86 and 181, where he attempts a transcription of this difficult annotation; my own differs in places.

211. Sargent 1984 attempts a transcription of the glosses on fol. 59r as well (1:183). Grenehalgh uses capitalization in the word

"re|formAtA" here directly beside the "IS" monogram in a way that suggests some now irretrievable significance that might also be attached to similar capitalization on fol. 135v (fig. 29).

212. For some reason never specified in the records Grenehalgh was removed from his charterhouse at Sheen in 1507 or 1508 to become a guest in the house at Coventry; he was still considered a guest when he died at the Hull charterhouse in 1530: see Sargent 1984, 1:79–80.

213. In Jeffrey 1975, for instance.

gious order was exclusively involved with the plays. Certainly the Franciscans played their part: Wyclif and his followers emphasized the role of the gray friars in promoting and performing drama "in Englisch tunge" in their condemnations of both plays and friars, and the Coventry *Annals* for 1492 note how the "King came to see the playes acted by the Grey Friars."[214] Perhaps motivated by the same sort of information, Robert Cotton's librarian Richard James left a seventeenth-century note on the flyleaf of the N. Town play manuscript (London, British Library, MS Cotton Vespasian D VIII) linking it to the "Fr*atres* mendicantes." The inscription is generally discounted by modern scholarship, but it may be that James was aware of a traditional association now otherwise lost to us.[215] The Master Thomas Bynham who was paid for "making and composing the banns" announcing the Beverley Corpus Christi play in 1423 may have been a Franciscan as well, but his designation as a "Friar Preacher" is more likely to suggest a brother of Dominican affiliations.[216] Dominicans are recorded as the instigators of a fifteenth-century production in Exeter,[217] and one study of the morality play *Mankind* has suggested as a likely author Nicholas Meryll, the prior of the Cambridge Dominicans who transferred to Lynn around 1460 and might well have written the play for a feast in the priory refectory.[218]

So the new fraternal orders must have had a significant influence on vernacular drama, but so, too, did the more traditional religious orders, and here the manuscript evidence is plentiful. The earliest copy of a morality play known to modern scholarship—the fragmentary and now lost *Pride of Life*—was squeezed into crowded columns on the verso of account rolls dating to 1337–46 and belonging to the Augustinian canons of Holy Trinity Priory, Dublin.[219] The play was recorded most likely by the canons themselves about a century later—early to mid-fifteenth century—but it may have been composed in Ireland as early as the mid-fourteenth century and represents another early example of Augustinian involvement in vernacular literature.[220] Two more fragments—both also connected to texts of a more practical or economic sort—hail from Benedictine houses. A neatly laid out prologue to a lost miracle play about Mary and a poor knight was added by an early-fifteenth-century hand to the back of a fourteenth-century notice of appropriation belonging to Durham Cathedral Priory (see fig. 30).[221] Likely one of the monks themselves copied the piece, and the same is probably the case with a fourteenth-century fragment of a king's pomping speech (perhaps Herod's) in both Anglo-Norman and English, to the back of which was added Latin accounts of 1370 concerning the manor of Rickinghall, a possession of the abbey of Bury St. Edmunds at the time.[222] It may be that Benedictine monks were also associated with the Chester Mystery Cycle, for while two different attributions to monks have now been for the most part discredited, a tradition of Benedictine authorship is nonetheless indicated, and the earlier of the attributions—that to the St. Werburgh's monk Henry Francis made in the proclamation of the town clerk in 1531/32—is far from impossible.[223] Finally, the Carthusians we have seen so deeply involved in the transmission of contemplative texts in the vernacular also seem to have found English drama of interest, as indicated by the plays in Oxford, Bodleian Library, MS E Museo 160.

MS E Museo 160 is a unique blend of chronicle and prayer, drama and romance dating to the first quarter of the sixteenth century and composed, it would seem, in the very process of copying by a Carthusian monk of Yorkshire.[224] The chronicle that fills most of the volume sweeps from

214. The first quoted from Wyclif's *De Officio Pastorali* and the second from the Coventry *Annals* for 1492, both in Jeffrey 1975, 38.

215. James's inscription also makes an interesting link between the plays in MS Cotton Vespasian D VIII and Coventry ("vulg*aro* dicitur | hic liber Ludus Coventri*ae*"), though this is now considered an error that was repeated in scholarship for decades: see Spector 1991, xiii–xv and notes.

216. See Briscoe 1989, 153 and 170n1.

217. Briscoe 1989, 153.

218. Marshall 1997, 197–200, discusses Meryll and the possibility of Dominican authorship, and also mentions the characterization of Mercy in the play as a Dominican friar.

219. The roll was formerly number 235 in the Christ Church collection of the Public Record Office in Dublin but was lost in a 1922 explosion; we now know the text only from an 1891 edition and reproduction: see Waterhouse and Davis 1970, lxxxv–vi, and plate III (facing 91).

220. See King 2008, 255–56, Hanna 2000b, 35–36, and Waterhouse and Davis 1970, c.

221. Durham, Dean and Chapter, MS 1.2 Arch. Dunelm. 60, on which see Waterhouse and Davis 1970, cxv–cxviii, and Wright 1983.

222. BL Add. Roll 63481 B: see Waterhouse and Davis 1970, cxiv–cxv.

223. Francis is recorded as a monk of St. Werburgh's in Chester in 1377, 1379, and 1382. The second attribution is to Ranulf Higden, the well-known author of the universal Latin history known as the *Polychronicon* who became a monk of Werburgh's in 1299 and died 1364/5; the attribution was made c. 1619 by a Chester antiquarian and smacks of reformation propaganda in its descriptions of Higden's intentions. The Chester Cycle survives in five manuscripts (and three more of a single play or less), with the earliest dating to the last decade of the sixteenth century. See Lumiansky and Mills 1973, vii, and 1983, 166–68, 213–17, and 285.

224. See the description of the manuscript and its texts in Baker, Murphy, and Hall 1982, lxxiv–xcix, and Baker and Murphy 1976a, xiv–xvi. The scribe lists Carthusian priors, makes it clear that he shares their religious affiliation, and even claims that Jesus loves Carthusians more than others. Since the dialect of the manuscript is northeastern, probably southern Yorkshire, and there are also references linking the chronicle to Yorkshire, the scribe may have been a member of the Axholme, Beauvale, Hull, or Mt. Grace Charterhouse. Only fols. 136v–139r containing the *Fifteen Articles of the Passion* are in a different hand.

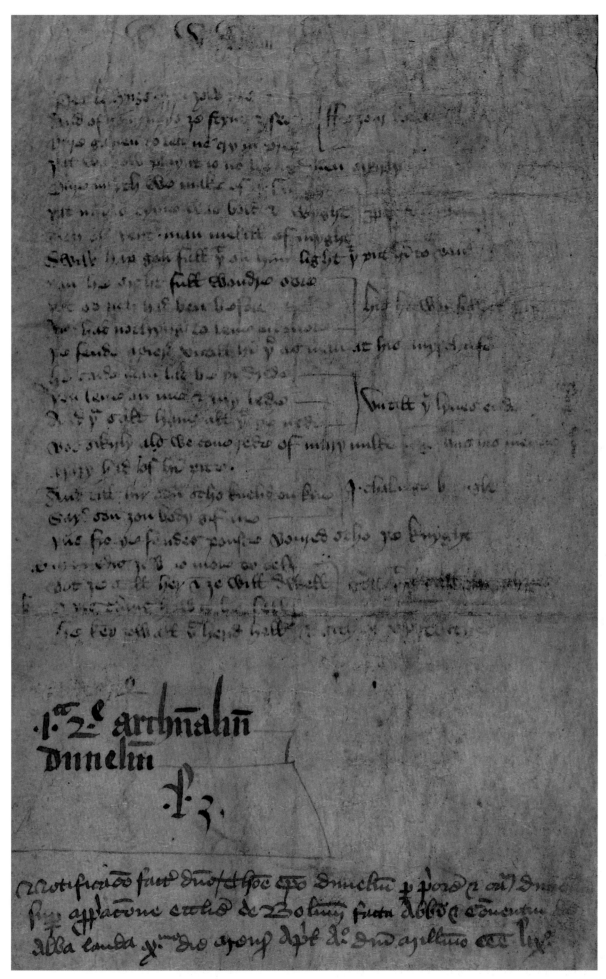

30. Both a northeasterly dialect and a 1359 "Notificacio" place this prologue to a lost Mary play at Durham's Benedictine Priory. Durham, Dean and Chapter, MS 1.2 Arch. Dunelm. 60.

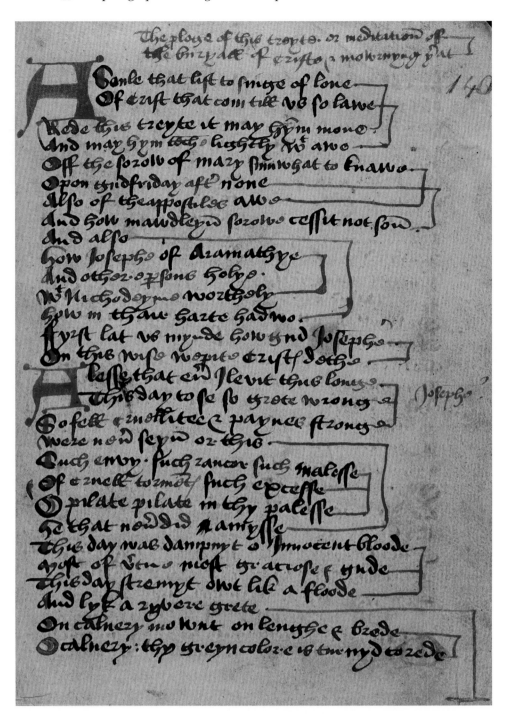

31a and b. At the beginning of *Christ's Burial*, we see a Carthusian playwright in action, transforming his **"meditatiou*n*"** (top of fol. 140r) into **"a play to be played"** (bottom of fol. 140v). Oxford, Bodleian Library, MS E Museo 160, fol. 140r–v.

Old Testament patriarchs through New Testament saints to contemporary complaints, and the two plays included by the scribe-author—*Christ's Burial* and *Christ's Resurrection* (fols. 140r–172r)—work within this overall structure of salvation history. Yet meditative prayer permeates the book as well, becoming a narrative technique in itself, and the monk's "original purpose" in the two plays he wrote around 1520 appears to have been the composition of "a verse meditation on the burial and resurrection."[225] His manuscript project underwent various changes as it proceeded, however, and among these developments was the transformation of this meditation designed for readers into twin "meditational dramas" that enact that reflective experience and could well have been performed, in the author's priory perhaps, or the hall of a local gentleman, or the streets of a nearby Yorkshire community.[226] The scribal heading in red above *Christ's Burial* (fol. 140r) calls the text a **"treyte. or meditaciou*n*,"** but into the bottom margin

225. Quotation is from Baker, Murphy, and Hall 1982, lxxxv. Brantley 2007, 294, notes that the "history is really a series of prayers."

226. See Baker, Murphy, and Hall 1982, lxxxv–lxxxviii, who discuss the changes that made a play of a meditation.

over the page (fol. 140v) is squeezed a note (also scribal and also in red) that identifies it and the *Resurrection* as "**a play to be played' on p**art **on gudfrid[**ay**] | after none and þe other p**art **vpon Est**er **day after | the resurrectioun**" (figs. 31a and b). The note also informs us (piecemeal, unfortunately, due to a tear) that the "**begyηnynge**" part of the text contains "**certen lynes**" which should "**not be said if it be plaied**."

There are about two dozen of these simple narrative tags rendered redundant by the anticipation of real players and their actions, and thus crossed through with the same red ink, which is also used for more ordinary corrections, for bracketing verses and underlining parts in the way of a rubricator, and for adding speakers' names in the margins (see figs. 31b and 32a). The way in which the scribe places speakers' names also reveals the in-progress nature of his play text: they are tucked into the margins of the early pages of the *Burial* (running up to fol. 147r, just like the deletion of narrative devices), and though this arrangement is not unusual in medieval English drama manuscripts (see figs. 33a and 34b, and front plate 10), space was not left for the apparatus in MS E Museo 160, with the result being a crowded

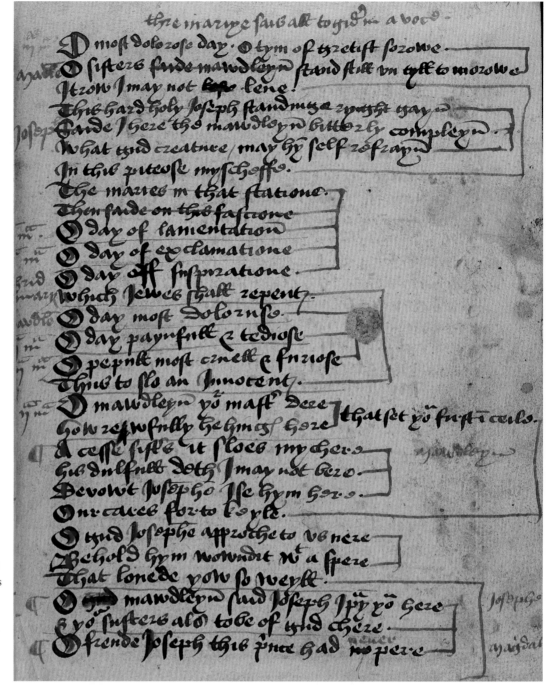

32a and b. The scribe-author rubricates, corrects, and edits his plays for performance, cutting redundant lines and rearranging speakers' names. Oxford, Bodleian Library, MS E Museo 160, fols. 141r and 151v.

page (like fol. 141r; fig. 32a). In the second half of the *Burial* and all of the *Resurrection* this layout has been abandoned (as are the narrative tags, eliminating the need for further excision), and the names along with other directions are centered on the page above the lines to which they apply, giving a tidy appearance that suggests how the playwright "is no longer of two minds about what he is doing" (see, for example, fol. 151v; fig. 32b).[227] The "generic fluidity" this

Carthusian scribe and author demonstrated in the process of composing and recording his meditative plays reveals how easily medieval drama could sprout from the fertile folios of the monastic contemplative life.[228]

Compiling a Dramatic Cycle: The N. Town Plays

We are given by MS E Museo 160 a unique glimpse of Carthusian drama in the making, emerging as it does here from the inclusive momentum of salvation history and the affective engagement of devotional meditation. Yet MS E Museo 160 is not alone among Middle English play manuscripts in prioritizing salvation history or revealing

227. Ibid., lxxxvi.

228. The quotation is from Brantley 2007, 298, who also discusses what the manuscript might reveal about the way in which medieval authors developed their plays.

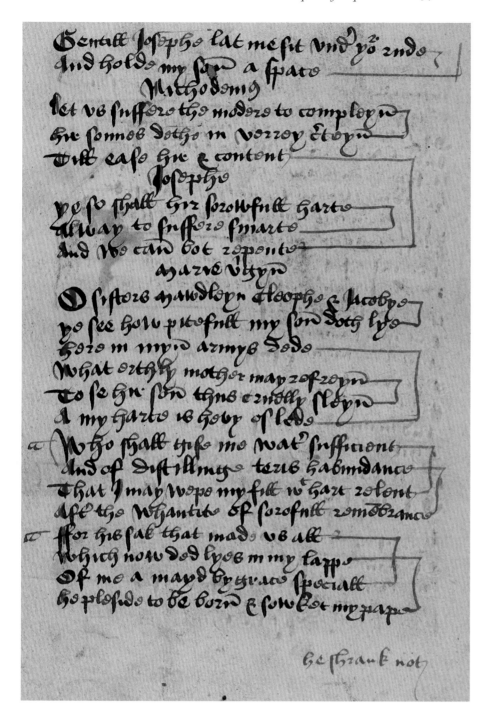

a dramatic work in progress or creating for the reader a monkish milieu. The N. Town MS (Cotton Vespasian D VIII, already mentioned for its possible links with the Franciscans) presents a large compilation of plays within a creation-to-judgment framework familiar from other cycle plays but one that has been inflated with additions by a scribe-compiler working most likely from rough play texts in the third quarter of the fifteenth century.[229] Instead of the chronicle format adopted by the Carthusian scribe-author of MS E Museo 160, MS Cotton Vespasian D VIII makes drama the focus, with more than forty plays providing the fullest possible version of Christian history. The main scribe-compiler (Scribe A) begins with a cy-

cle of plays and the proclamation that precedes them, but he then uses a different exemplar to blend in a number of Marian plays (at times literally laying stanzas from this new exemplar side by side with those from the original cycle), a little later adds in a Purification play (with the date 1468 at its end), still later amalgamates a Passion play

229. On the manuscript, its scribes, and plays, see Meredith 1991, and the introductions in Spector 1991, and Meredith and Kahrl 1977. The main scribe-compiler (Scribe A in Spector 1991, xxii) is one of four scribal and revising hands at work in the manuscript; he seems to have rubricated the entire volume, and the date 1468 written on fol. 100v appears to be his work as well.

33a and b. The scribe-compiler provides detailed instructions (bottom left) for a shorter, alternate ending to the N. Town *Visitation* play that can be used "si placet" of fol. 73v (if it pleases) by skipping from the red-dotted cross two-thirds of the way down fol. 73v to the same at the bottom of that folio, then up to the red-bracketed word Co*n*templacio at the right side of fol. 74r. London, British Library, MS Cotton Vespasian D VIII, fols. 73v–74r.

in two parts that he may have copied sometime earlier, and finally incorporates an Assumption of Mary play in an entirely different hand that he then rubricates to match the rest of the volume.[230] So all-pervasive is his archival desire to include all he can that any literary sensitivity he may have felt toward his material becomes overwhelmed: he merges texts awkwardly at times, provides an odd alternate ending for Mary's visit to Elizabeth, and sacrifices dramatic integrity, even "narrative coherence" in favor of "expansion and inclusiveness" (see figs. 33a and b).[231]

Unfortunately, we know neither the origin nor the precise audience (intended or actual) for the N. Town plays,

230. See the discussion of the process in Meredith 1991, and the summary in Fletcher 2008, 189–93; on the Marian part of the compilation in particular, see Fletcher 1982. The scribe-compiler's work patterns suggest that he had a number of play booklets available to him; some he used for exemplars, and some he actually incorporated into his larger play book.

231. Quotation from Fletcher 2008, 197, and see also 193–98. For the two possible endings for the Mary play, see figs. 33a and b, and Fletcher 1982, 472.

which are so called because the end of their long proclamation reads "A Sunday next yf þat we may | At vi of þe belle we gynne oure play | In. N. town" (fol. 9v), with the N usually read as *Nomen,* the Latin word for "name," and the implication being that those proclaiming the coming festivities were to provide the name of whatever town they were planning to perform in. This does suggest, however, that the original cycle used by the compiler was mobile, traveling perhaps with a troupe of actors to different venues, and the reshaping work of the manuscript's revisers also indicates some use of the volume for performance, though in parts only rather than the whole of the cycle, as though the expansive approach of the manuscript's compiler was lost on later users.[232] Since we know that the main scribe's dialect is East Anglian, specifically from the neighborhood of East Harling in south central Norfolk, it is a distinct possibility that those plays taken on the road were performed in the "villages around the Norfolk and Suffolk border in the late fifteenth and early sixteenth centuries."[233] Yet the N. Town plays are not simply entertainments for peasants and townsfolk but learned, often Latinate texts that make extensive and sophisticated use of theological and liturgical sources (for both the plays themselves and the glosses found on a number of folios), as well as methodology generally applied to sermons and exegesis; not only marginal genealogies but the careful scribal distinction of passages blended together from different plays indicate a scholarly mindset, while access to the range of different play texts necessary for the compilation suggests the presence of a significant dramatic center.[234]

Such qualities have contributed to the understanding that N. Town's scribe-compiler had benefitted from monastic training—the narrator figure Contemplacio, for instance, is particularly monkish, in both his contemplative outlook and his insistence on the mediating role of monastic life between the divine and the community[235]— and ought to be situated at one of the religious houses that appear to have participated in what has come to be known as the East Anglian dramatic tradition.[236] The Cluniac (Benedictine) priory at Thetford is a likely possibility: not only is it located within a few miles of the main scribe's dialect area, but it was dedicated to the Virgin Mary as we would expect of a house connected to the N. Town collection with its Marian focus, and one of its surviving registers (Cambridge, University Library, MS Add. 6969) records numerous payments from the late fifteenth century through the mid-sixteenth to visiting players and local parishes and villages (including East Harling) in connection with plays, games and interludes.[237] It is clear from these records that the majority of these dramatic entertainments took place within the priory itself, sometimes with the "assistance of the convent" ("cum auxilio" or "cum adiutorio conventus"), though precisely what sort of assistance—scribal, authorial, performative, financial?—we cannot be sure.[238] Among plays supported in surrounding villages, however, we should perhaps include the extant *Play of the Sacrament* (found in Dublin, Trinity College, MS F.4.20), since its banns proclaim its performance in Croxton, closer still to Thetford Priory, which made payments at least twice to the guild of Croxton, perhaps in conjunction with the play.[239] The N. Town plays might have been similarly sponsored, the original cycle of plays with its proclamation traveling through the area, those of more complicated staging requirements remaining closer to home, and perhaps a monk of Thetford priory conscientiously gathering, copying, and restructuring the available play texts of the region.

The Croxton *Sacrament* has also been linked to the grander Abbey of Bury St. Edmunds, however, and so, too, has the N. Town manuscript, two of whose scribes reveal Bury features in their language.[240] As a major economic, political, ecclesiastical, and literary center, where Lydgate and his manuscripts thrived, Bury fits perfectly. The Rickinghall play fragment is linked to Bury's abbey, and the abbey's library included classical play texts by the twelfth century, when the abbot prohibited any further

232. On the revisers' hands, see Spector 1991, xxiii–xxv, and Meredith and Kahrl 1977, xxiv. Meredith 1991, 124, notes that the manuscript was mined as "a kind of theatrical quarry" by later readers.

233. Quotation from Fletcher 2008, 187. On the dialect of the main and other scribes, see Spector 1991, xxix–xxxviii.

234. On the marginalia in the N. Town MS, see Meredith and Kahrl 1977, xxii–xxv, and Fletcher 1981, who argues that the glosses and genealogies are the product of the scribe-compiler. When blending stanzas from his Marian plays exemplar into those from his original cycle, the scribe-compiler distinguishes the two via the red paraphs that mark each stanza: the lobe of the paraph is empty if the stanza is derived from the original cycle but bears a single red dot if the stanza has been taken from the Marian plays: see fig. 33b, Meredith and Kahrl 1977, xvii, and Fletcher 2008, 189.

235. See McMurray Gibson 1989, 130, who calls this character of Contemplacio "the most extraordinary expositor figure in medieval drama."

236. See, for instance, Coldeway 2008, and the map and list of play manuscripts copied by Norfolk scribes in Beadle 1991, 101 and 107.

237. See the discussion and the transcribed list of payments in Beadle 1978, and see also Sugano 1994.

238. Quoting from Beadle 1978, 6 and 8.

239. The payments are recorded in 1506–7 and 1524–25, on which see Wasson 1997, 31, where the appropriateness of the play for the green in front of the church of Croxton is discussed. See also Waterhouse and Davis 1970, lxx–lxxxv, on this unique play.

240. Scribe A, the main scribe-compiler, and Scribe D, responsible for the *Assumption* used by A: see Spector 1991, xxxviii. On the links to Bury, see also Wasson 1997, 31, and McMurray Gibson 1981 and 1989, especially 125ff.

"spectacula" in the abbey church yard due to a Christmas day brawl associated with them.[241] Though we cannot be sure of the nature of these "spectacula," we do know that Corpus Christi pageants were played in Bury from the fourteenth through the sixteenth centuries by both religious guilds linked to the abbey and lay guilds; one of the latter was responsible in the late fifteenth and early sixteenth centuries for performing a now lost play of St. Edmund in the refectory of the abbey on St. Edmund's night.[242] Players of various sorts frequented the prior's hall in the sixteenth century, and no doubt a century earlier the monks were already enjoying (perhaps as early critics) the pageants, royal entries, and mummings that their star author, Lydgate, was writing for royals, middle class merchants, and people in the street alike.[243] Some show striking resemblances to the mystery cycles, and Lydgate's devotional Marian lyrics, like his *Life of Our Lady* ("the most ambitious, certainly the longest . . . *vita* and hymn of praise to the Virgin in the English language" and one we have already seen in the hands of religious folk), share much in common with the Marian plays so central to the N. Town collection.[244] Far removed from the "Madonna of Franciscan simplicity who inhabits the York, Towneley and Chester cycles," the Mary of both Lydgate's lyrics and the N. Town plays is a "mystical Virgin," a Mary "who is paradoxically both handmaiden and exalted queen."[245] It is not improbable, then, that Lydgate played some part in initiating, organizing, even authoring parts of the N. Town compilation, particularly in the final years of his life. His (and his abbot's) motives in so doing would have included the most obvious—the instruction of Christian souls in the abbey's care—but since dramatic entertainments were a sure way to bring money to a busy town like Bury, where

the abbey controlled the market, the intended goals could also have included resolving two enormous expenses: from 1430 on a fallen west tower had to be replaced, and more extensive reconstruction was needed after a disastrous fire was started by men working on the tower in 1465, just three years before the only certain date we have for the N. Town MS.[246]

Drama at Bury St. Edmunds: The Macro and Digby Plays

So the evidence surrounding MS Cotton Vespasian D VIII seems to indicate some meaningful connection to the abbey of Bury St. Edmunds that proves notoriously difficult to pin down. The link is reinforced, however, by two additional East Anglian play manuscripts with more certain Bury provenances. The first, Washington, DC, Folger Shakespeare Library, MS V.a.354, known as the Macro MS, is one of the most important Middle English play manuscripts, yet its three morality plays are rarely if ever taught (or even mentioned) alongside *Everyman* in surveys of medieval literature. The *Castle of Perseverance* (written and copied s.xv in.), *Wisdom* and *Mankind* (both written and copied s.xv ex.) appear alone in the manuscript and in their correct chronological order.[247] Yet as their confused foliation indicates, they were not always arranged so.[248] In the Middle Ages, the three plays appear to have existed as three separate manuscripts, or more accurately perhaps as three playbooks, since each provides evidence of at least intended performance in the form of stage directions.[249] Two of these were originally owned by a monk named Hyngham whose ownership inscription in a different manuscript (a copy of John Walton's translation of

241. On the plays of Plautus and Terence in the Bury library, which "was exceptionally rich in classical texts," see Thomson 1972, 633, and the discussion below. On the brawl and the meaning of "spectacula," see McMurray Gibson 1989, 114 and 205n30, and Lancashire 1984, 92, entry 422.

242. For the Corpus plays, see the entries in Lancashire 1984, 92. The information on the lost play of St. Edmund comes from two wills, both bequeathing valuable clothing or costumes to the play itself, with one calling it "Seynt Edmunds pley in the Frayter," the other making the gift "to the gylde of Seynt John Baptyst in Bury," a lay confraternity, "and also for the revell on Seynt Edmund's nyght": quoting from McMurray Gibson 1989, 115; see also Beadle 1995, 337n56.

243. On entertainments in the prior's hall, see Lancashire 1984, 92, entry 425. Other evidence of players paid by and associated with the abbey is discussed in McMurray Gibson 1989, 124, including a 1520 note of payment to "men who came with a camel, by the prior's order." On Lydgate's public dramatic works, see Nolan 2005, Schirmer 1952, 100–108, 136–43, and 242–45, and Pearsall 1970, 183–88, who notes how the surviving mummings written between 1424 and 1430 are found in manuscripts associated with Shirley (184). Lydgate was still writing dramatic pageants in his old age in 1445, when he wrote the royal entry for Margaret of

Anjou, Henry VI's new queen: see McMurray Gibson 1981, 82–84. See also fig. 15 for a stanza from Lydgate's *Pageant of Knowledge*.

244. See the discussion in McMurray Gibson 1981, 81–90, with the quotation from 72. A parish church situated within the Bury abbey enclosure and dedicated to the assumption of the Virgin suggests a perfect locale for the performance of the Marian centered N. Town plays: see McMurray Gibson 1981, 70.

245. McMurray Gibson 1981, 86, who discusses other parallels between Lydgate's works and the Marian plays, and argues for the possibility of Lydgate's involvement with the N. Town plays.

246. All discussed by McMurray Gibson 1981, 75–76, and 1989, 125–26, where she notes that the fire also necessitated the rebuilding of the Lady Chapel in the 1460s, another expense that corresponds with the N. Town plays.

247. Assuming *Mankind* was copied after *Wisdom*: see Beadle 1995, 329–30. On the Macro MS and its plays, see Eccles 1969, Bevington 1972, Riggio 1998, and *Folger Shakespeare Library, MS V.a.354*, as well as Beadle 1984 and 1995, and Griffiths 1995.

248. Bevington 1972, xvii, describes the different arrangements in which the three plays have been bound together over the years.

249. In the case of *Wisdom*, the stage directions are particularly elaborate and also include cuts, making it highly likely that it was actually performed: see Baker 1986, 83, and for similar stage directions in the Bod. MS Digby 133 *Wisdom*, see fig. 37b.

34a and b. The Bury monk Hyngham copied *Wisdom* (left) and most of *Mankind* (right), recording his unique ownership inscription "sup*er omn*ia" at the end of both, as in *Wisdom* here (bottom of fol. 121r). Washington, DC, Folger Shakespeare Library, MS V.a.354, fols. 121r and 128v.

Boethius's *Consolation of Philosophy*) confirms his identity as Thomas Hyngham, a monk of Bury St. Edmunds.[250] The less conventional inscription of ownership shared by *Wisdom* and *Mankind* (fols. 121r and 134r) calls (in Latin) upon the playbooks themselves to proclaim their owner: "O book, if anyone should by chance ask to whom you belong, you will say 'I belong above all to Hyngham the monk'" (fol. 121r; fig. 34a).[251] Simply by writing this, of course, he has made the books do his bidding, and in a

250. The manuscript is Oslo and London, Schøyen Collection, MS 615, where the inscription appears on fol. iii verso: see plate 54 in Beadle 1995 and plate 2 in Griffiths 1995; Hyngham's identity is discussed in both. Hyngham may also have owned the earlier *Castle* playbook, but we have no solid evidence of that; the John Adams whose name is written on fol. 158v of the *Castle* may be the "Adames of Bury" who produced a Christmas "interlude" in 1572 at Hengrave Hall, which is only three miles from Bury: see McMurray Gibson 1989, 112–13.

251. The Latin reads "O liber si q*uis* cui co*n*stas forte q*ue*retur | hyngh*am* q*ue* monacho dices sup*er omn*ia | Consto."

rather informative way: the lack of a Christian name, for instance, might suggest that Hyngham anticipated the circulation of the plays among local Bury people who would know who the monk Hyngham was, while the qualification "above all" hints at other users who might have believed themselves deserving of some ownership rights.[252]

Their reasons might not have been as compelling as Hyngham's, however, since it is clear that he himself copied all of *Wisdom* and the majority of *Mankind* (a different hand finishes the second play on fols. 132v–134r).[253] The hand of all three of his inscriptions looks especially like that of *Wisdom*, yet "the range of letter forms" they use is "closer to that found in" *Mankind*, and though the format and script of *Mankind* are a good deal more cramped than the same in *Wisdom*, we nonetheless have in *Mankind* the work of the same scribe, writing more hastily (or with a less steady hand perhaps) and at a different time (see fig. 34b).[254] Exhibiting both "a distinctly individual realization" of "fifteenth-century cursive script" (see front plate 10) and an economy that left no room for rubrication or anything remotely luxurious, both playbooks give the impression of being amateur productions for personal use.[255] Are we to assume, then, that like the Franciscans condemned by the Wycliffites, Thomas Hyngham acted in such plays himself? Possibly—both manuscripts are entirely suitable for performance (as is the *Castle of Perseverance* playbook, which even includes an annotated stage design on fol. 191v), and the Bury monks might well have helped with dramatic entertainments much as the Thetford ones did.[256] But Hyngham could also have been the author producing a script or perhaps a director of sorts organizing both texts and players, who may well have been those other users his inscriptions point toward. We may even have clues about who such players might have been, since several names do appear in the three playbooks, particularly in sixteenth-century hands, and some of these have been traced to Bury

and its vicinity.[257] Some of these annotators also seem to have contributed to the distinctively playful marginalia found in *Wisdom* (which sports the greatest number of names)—marginalia suggesting that "prankish scribes or young scholars were devising messages and even indecencies to one another under the cover of a secret code," or rather codes, since more than one is used.[258]

On the back of *Wisdom*'s final folio, for instance, sixteenth-century notes demonstrate five different ciphers with the name Rainold Wodles and carefully explain one of those codes, named "grew" or "grw" (for "Greek" apparently), which replaces each vowel with the following letter of the alphabet (with **k** for **i** and **y**, **x** for **u** and **v**, and **xx** for **w**; fig. 35).[259] That same code is used in the first half of the sixteenth century by a Robert Oliver when he claims possession of *Wisdom* (fol. 119v), and he uses the last of the five as well to write his name at the bottom of fol. 101r.[260] There is also frequent mirror writing and backwriting, some of it justified by content—like "Evank scranim sik" for "kis min arcs knavE" on fol. 114v (front plate 10)—and even some drawings of a courtier, a couple of odd little faces, and a number of dragons on the originally blank page following the opening of *Wisdom*, all of which could be the scribblings of young readers or players (fol. 98v; fig. 36a). Bits of verse also appear, including a fragment of a ballad on the three Marys (fols. 111v–112r), and the interesting "Wythe hufa | Wythe huffa w*ythe* huffa w*ythe* huffa onys agen' | A gallant glorius" written upside down on fol. 117r, perhaps as some kind of writing exercise, since the script is rather decorative. Though *Mankind* does not sport any playful ciphers, it, too, shows signs of educational use in the epistolary opening written perhaps for practice at the top of fol. 127v, and particularly in the school exercises written upside down in both English and Latin on fol. 134v and signed by a John who seems to have recorded his name elsewhere in the manuscript as

252. See also Beadle 1995, 331.

253. Eccles 1969, xxvii, and discussed in detail by Beadle 1995.

254. Quotation from Beadle 1995, 331. Notice, for instance, how the three place names ending with "ham" in lines 13, 17, and 19 of fol. 128v of Macro are abbreviated with a superscript "a" exactly as Hyngham's name is in his ownership inscriptions: see fig. 34a and b. Beadle 1995, 329–30, also suggests (on linguistic, paleographical and watermark evidence) that the copying of *Mankind* followed that of *Wisdom* "after some lapse of time."

255. Quotations from Beadle 1995, 333 and 319, where Hyngham's script and scribal practices are discussed.

256. The *Castle* stage design, which has been reproduced several times—as the frontispiece in Eccles 1969, for instance—provides a rare glimpse into how the playing space might have been arranged for a medieval performance and suggests both the involvement of the audience and the possibility of medieval theatre in the round: see Southern 1975 and Schmitt 1969.

257. Like that of Richard Cake who identifies himself as "of Bury" in a formulaic opening line for a will written on fol. 105r,

and John Plandon whose name appears in a code using Arabic numerals at the bottom of fol. 104r, and who may have been a member of a prominent Bury family: see McMurray Gibson 1986, 43 and 61n13.

258. Quotation from Bevington 1972, xix. On schoolboys as users of Hyngham's *Wisdom* and *Mankind* playbooks, see Olson, forthcoming.

259. Wodles may have been from Ipswich. See Eccles 1969, xxviii–xxix, and Bevington 1972, xix–xx.

260. Oliver also signs his (uncoded) name to *Mankind* on fol. 134r, once simply as "Olyu*er*," and a second time as he claims ownership of the book, calling himself the "true owner" (*verus possessor*), and though there may be something of a challenge in this, coming just above Hyngham's claim *super omnia*, Oliver was probably a later rather than a contemporary owner: see McMurray Gibson 1986, 43, on Oliver as a possible relative of the Bury physician Thomas Oliver. The name "gonolde" is written on fol. 108r of *Wisdom* in the same two codes used by Oliver, and a third time backwards with the first name Thomas.

35. Material added (s.xvi) to the back of *Wisdom* includes an explanation of how to write one code (called "grew"), and a demonstration of it and four others. Washington, DC, Folger Shakespeare Library, MS V.a.354, fol. 121v.

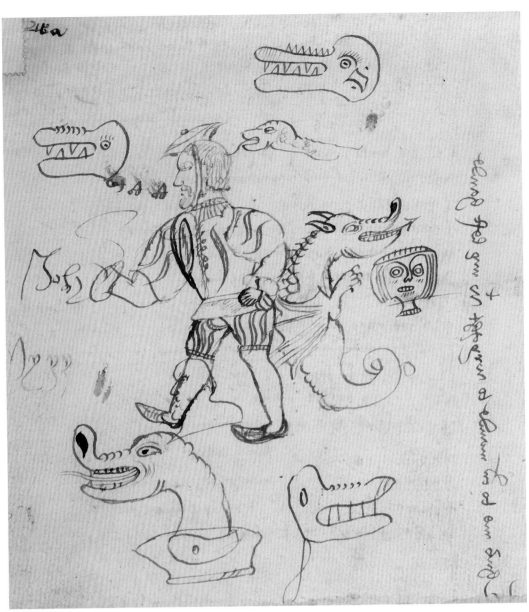

36a and b. On blank pages in *Wisdom* and *Mankind* informal drawings, mirror writing and a translation exercise all suggest use by young readers. Washington, DC, Folger Shakespeare Library, MS V.a.354, fols. 98v and 134v (inverted).

well (fig. 36b).[261] John was no great scholar, with both his rough script and his ungrammatical Latin leaving a good deal to be desired, but he certainly could have been a relatively young student or one who found little inspiration in his studies, possibilities that make good sense in the context of Bury's schools.

The medieval town of Bury St. Edmunds had three schools, all of them provided by the abbey: one near the cloister for monastic novices; the second a song and reading school to prepare those destined for the secular clergy; and the third a free school for the sons of Bury's burgesses.[262] All three came to an end with the dissolution of the monastic community in 1539, but the third appears to have survived as the town's free grammar school,

261. The name John appears many times in both *Mankind* and *Wisdom* and in more than one hand, with several instances similar to that beside the schoolboy's lament on fol. 134v; see also fig. 36a. Eccles 1969, xxxvii n.1 mentions the similarity between this lament and fifteenth-century English school book passages for boys to translate into Latin, which John attempts to do here. Educa-

tional use may also be indicated by practice letters or pen trials on fols. 104r, 123r, 124r, 133v and 134v (fig. 36b), though the first of these was likely written as a guide to the cipher that appears beneath it. The N. Town play manuscript also reveals hints of schoolboy scribbles and a cipher: see Spector 1991, xxv.

262. See McMurray Gibson 1986, 48.

and its 1550 statutes indicate a dramatic aspect to the syllabus, with the students studying the "chaster plays of Plautus and Terence" and performing a play "every year at the end of winter term."[263] Educating children through involvement in drama was hardly a new idea, of course: the tenth-century nun and author Hrotswitha of Gandersheim may even have written some of her Latin dramas very specifically for the noble and royal daughters she was responsible for teaching in her German monastery. Her

series of playlets, written in simple Latin with short, snappy, often amusing dialogue and some slapstick, celebrates the victories of prepubescent girls—the major characters—over threats to their chastity and integrity. The language of the plays is totally unlike the grandiose rhetoric of works by Hrotswitha dedicated to the king and to other important adults, and there are additional internal and external features that indicate a youthful audience.[264]

Very probably her female students performed these plays as an aspect of their education, just as many male students played parts in various kinds of drama for their schoolmasters, absorbing moral and grammatical precepts as they laughed at both the characters and themselves.[265] The comedies of Plautus and Terence, which were available in the abbey's book collection by c. 1150, could well have

263. McMurray Gibson 1986, 43, who notes how the free grammar school was founded "to compensate the town for the loss of the abbey school endowment" (42). On the grammar and other early schools in Bury, see also Page 1975, 306–24, who cites more than one instance in the seventeenth century when funds were paid out for the "schollers" to perform "a commodye," once when "the making of a stage" took place "at the Abby" (318–19).

264. Adams 1998, 13.

265. Orme 2001, 191, observes that "schoolmasters, who had the best access to groups of intelligent boys, seem to have used them as actors from early times," and emphasizes the appropriateness of boys for playing both women's and children's parts.

been used in similar ways in the free school at Bury[266] and it is entirely possible that the vernacular plays *Mankind* and *Wisdom*—taught and directed perhaps by a monk like Hyngham—would have found a place there as well. There are, in fact, a couple of connections between those plays and the free grammar school that support this theory. For one, the physician Thomas Oliver, who may have been a relative of the Robert Oliver who claims possession of both *Wisdom* and *Mankind*, donated books to the Bury school in 1595, and secondly, the Macro family who lent Folger MS V.a.354 their name was associated with the same school: Thomas Macro was among the school's elected governors in 1689, and his son Cox Macro (1683–1767), who owned the three playbooks in the Macro MS, was a prominent benefactor of the school's library.[267]

So there is good reason to think the Macro plays were used educationally in the free grammar school at Bury, and perhaps in its predecessors as well. *Wisdom* and *Mankind* would have been particularly effective for engaging the interest of students like John who (judging by his school exercise) found Latin more than challenging. Both plays demonstrate an appealing universality appropriate to an educational environment, with the character Mankind every Christian, every Christian possessed of a soul like *Wisdom*'s Anima, and the battle between vice and virtue that the moralities dramatize enacted in every soul. In addition,

the "high-spirited fun" of *Mankind* with its "comic villains" and scatological language would have held a special appeal for schoolboys, especially when it so irreverently parodies school books and school exercises of the time.[268] Nowadays, for instance, one of the low comic characters of the play, begs Mercy "to haue þis englysch mad in late*n*":

> I haue etu*n* a dyschfull of curd*ys*
> Ande I haue schetu*n* yow*r* mowth full of turd*ys*
> Now opyn yow*r* sachell w*yth* late*n* word*ys*
> And sey me þis in clerycall maner*e*.[269]

As Nicholas Orme says, "it is hard to resist the conclusion that Nowadays is a schoolboy or a character aimed at such boys."[270] The situation is similar with *Wisdom*, though a play of very different tones. Its exploitation of spectacle and visual effects; its many parts fit for boys, particularly choristers; its detailed attention to each character's costume, an interest very likely echoed in the drawings that appear along with the stage directions at the opening of the play (fig. 36a); and those extensive stage directions themselves, almost exclusively in English, would have suited well a young audience.[271] And as I mentioned above, *Wisdom*'s elaborate stage directions strongly suggest actual performance,[272] not only in the Macro MS but in a second, incomplete copy of the play found in Oxford, Bodleian Library, MS Digby 133 as well (see fig. 37b).

266. A mid-twelfth-century catalogue of the monastic library lists a manuscript containing plays by both Terence and Plautus, the latter little know elsewhere in England until the later Middle Ages, and in the late thirteenth century a Bury monk found these comedies compelling enough to include excerpts in the florilegium of classical authors he was compiling: see Thomson 1972, 633, and McMurray Gibson 1981, 63.

267. See McMurray Gibson 1986, 42 and 43, and 1981, 62–63, where she notes that Cox Macro owned other books that had come from the Bury abbey library.

268. Quotations from Eccles 1969, xliii.

269. Fol. 123v, ll. 130–34. The reference to "englysch mad in late*n*" "echoes one of the best-known basic schoolbooks of the day, *Informacio,* by the fifteenth-century Oxford schoolmaster John Leland," and the "sachell w*yth* late*n* word*ys*" "may refer to another well known school text, the Latin verse vocabulary known as *Bursa Latini*," while the two lines rhyming "curd*ys*" and "turd*ys*" parody "a school exercise" based on a standard "comic formula, combining nice and nasty things," often used in education: Orme 2001, 193, and see also 158–59 where he discusses both the use of scurrilous words and ideas by schoolmasters in their efforts to interest their pupils and advance their education, and the inclusion of the "I have something nice, and you have something nasty" formula in school notebooks, presumably to make learning more fun and appealing for boys. As Nowadays says of Mercy's teaching, "Me*n* haue lytyll deynte of yow*r* pley | Because ȝe make no sporte" (fol. 125r, ll. 267–68). Line numbers refer to Eccles 1969 and Bevington 1972.

270. Orme 2001, 194.

271. Parts especially well-suited to young actors include the Five Wits as "vyrgynes" (fol. 102r, following l. 164), the "screwde boy" (fol. 109v, following l. 550), the three troupes of six danc-

ers associated with the sinful Mights, and the "vi small boys in þe lyknes of dewyllys" who "rennyt owt from wndyr þe horrybyll mantyll of þe | Soull" (fol. 116v, following l. 912). As Riggio 1998, 66 and 204–5, notes, *Wisdom* "incorporates four liturgical chants," involving "processional movement and music," as well as three "riotous masque dances" including "raucous" minstrelsy with "tru*m*pes" (fol. 112r, following l. 692), "a ba[g] | pyp[e]" (fol. 113r, following l. 724) and "a horne | pype" (fol. 113v, following l. 752). On fol. 118r (following l. 996) the penitent Anima is described as singing "in þe most la | metabull wyse w*yth* drawte not*ys* as yt ys songyn in þe passyon wyk[e]," a direction that assumes some liturgical knowledge and supports Orme's suggestion (2001, 193) that "choristers" might well have played the singing parts. Bury St. Edmunds accepted and educated tonsured clerks at its song school from around 1200: see Orme 2001, 227, and Page 1975, 310–11. The drawings on fol. 98v of the Macro MS may reveal a practical interest in staging the character Lucifer, who appears "in a dewyllys [a] | ray wi*th*owt: *and wi*th*in as a prowde galonte" (fol. 105r, following l. 324), a costuming challenge that could indeed be depicted by the well-dressed man with a dragon at his back and the heads of others all around him (fig. 36a). See also Olson, forthcoming.

272. So, too, does the plain, workaday quality of Hyngham's playbooks, which may well have been produced with an understanding of the abuse suffered by scripts backstage. Such use of *Wisdom* and *Mankind* may also explain Hyngham's highly unusual continuation of leaf signatures into the second half of quires (see Beadle 1995, 321–22), a practice that seems redundant for reordering loose folios in normal reading situations but wise if the use anticipated might have resulted in playbooks so damaged and torn that identifying each half of a bifolium separately proved necessary. See the discussion in front plate 10.

37a and b. The *Candlemas Day* play (fol. 157v) bears the date 1512, a list of players, and (near the bottom) the name "Parfre;" the initials "M. B." (for Myles Blomefylde) and extensive stage directions in red appear at the beginning of *Wisdom* (fol. 158r). Oxford, Bodleian Library, MS Digby 133, fols. 157v–158r.

MS Digby 133, containing the *Conversion of St. Paul, Mary Magdalene,* and *Candlemas Day and the Killing of the Children of Israel,* as well as the incomplete *Wisdom,* is the second play manuscript firmly associated with Bury St. Edmunds, perhaps even with the abbey.[273] Like the plays of the Macro MS, each of the Digby plays was originally a separate manuscript, with *Wisdom* dating to the last quarter of the fifteenth century, while the other three were copied in the second decade of the sixteenth century. *Candlemas Day* is dated to 1512 no less than three times in the hand of the main scribe (twice on fol. 146r and once more on fol. 157v), and a hand of about half a century later informs us that "Ihon Parfre ded wryte thys booke" (again on fol. 157v; fig. 37a). John Parfre was a rich draper of Bury who was one of the town's most famous early-sixteenth-century benefactors, and since his will was proved in 1509,

273. On MS Digby 133 and its plays, see Baker, Murphy, and Hall 1982, ix–lxxii, and Baker and Murphy 1976a, vii–xiv. The text of *Wisdom* in the Digby MS is closely related to that in the Macro but incomplete, stopping about four hundred lines short of the end

in Macro. Riggio 1998, 1, 4, 6–18, and 75, argues that the Macro *Wisdom* was most likely copied from the Digby text before the final lines were lost. All of the Digby plays display East Midlands dialect, with more or less specifically East Anglian features.

he could not have been the scribe, but he may have been a sponsor of the play, or perhaps even the author, though given his prestige in Bury for centuries after his death, he may well have provided no more than a famous name for a later reader or sponsor to connect with the play.[274] The individual who was responsible for copying most of the *Candlemas Day* play appears to have copied the Digby *Wisdom* text over a decade earlier and in a more formal hand,[275] and that copy of *Wisdom* is doubly associated with Bury because it bears the initials—in the form "M. B." across the top of fol. 158r—of its sixteenth-century owner Myles Blomefylde, whose name appears also in the Digby *Conversion of Paul* and *Mary Magdalene* plays (fig. 37b).[276]

Born in Bury St. Edmunds in 1525, Myles was an alchemist and physician (Cambridge 1552) who owned more than twenty books, including a collection of works on the philosopher's stone and other alchemical matters which he copied himself, a late medieval play entitled *Fulgens and Lucres*, possibly a volume of Lydgate's poetry, and perhaps the Digby *Candlemas Day* play as well.[277] Myles was once examined for what may have been a charge of conjuring, but his esoteric interests appear to have landed him in less trouble than similar activities did his slightly older relative, the author William Blomefylde, who was tried for heresy in 1529.[278] Physician, philosopher, priest, linguist, alchemist, and more, William was also a monk of Bury St. Edmund's at some point in his career, and may well have been the source not only of Myles's copy of *Wisdom* but also of the *Candlemas* play that shares *Wisdom*'s scribe (if, indeed, Myles ever owned it), and perhaps the other two Digby plays as well. Alternatively, Myles may have

acquired some of his plays from a Chelmsford playbook, since he moved south to that town in the 1560s and became a prominent member of its churchwardens, the very body that concerned itself with producing and accounting for a number of the town's plays, as well as caring for its treasured playbook.[279]

Whether Myles obtained them from that playbook or from the Abbey of Bury St. Edmunds or from both, the plays in MS Digby 133 (with the exception of *Wisdom*) do appear to have been performed at Chelmsford in a kind of extended dramatic festival in the summer of 1562, in which the productions culminated in *Mary Magdalene*, "theatrically the most elaborate and demanding of all extant non-cycle dramas in English," and here divided into two separate plays for performance.[280] Though the Digby plays may well have been newly brought together for this postreformation festival, they were enjoying something of a second life in that performance, much as they were by being included in the sort of pseudoscientific collection of alchemy and astronomy found in MS Digby 133,[281] a manuscript that provides a striking contrast to the salvation chronicle format adopted by the Yorkshire Carthusian who composed his plays for Bod. MS E Museo 160. In both their late performance and the company they keep between their covers the Digby plays highlight two important trends revealed in this chapter: the extension via English writing of monastic thought and guidance into many, even unexpected aspects of late medieval life and the seemingly limitless potential for manuscripts of the medieval texts we read and teach to instruct and surprise us in ways modern editions alone never could.

274. See McMurray Gibson 1989, 126 and 209–210n92.

275. See Baker, Murphy, and Hall 1982, lxiv.

276. Blomefylde signed his full name at the beginning of the *Conversion* (fol. 37r), and the same hand writes the initials at the top of both *Mary* (fol. 95r) and *Wisdom* (fol. 158r). His hand is identified by Baker, Murphy, and Hall 1982, xvii, xxxii, and lxiv.

277. On Blomefylde and his books, see especially Baker and Murphy 1976b, where he is distinguished from his relative William, a monk of Bury, and the volumes he certainly and possibly owned are listed.

278. On Myles's conjuring charge, see Baker and Murphy 1976b, 377. On the charge of heresy against William, see Baker and Murphy 1967, 164. Myles provides much of what we know about William's varied career in an inscription he added to the copy of William's *Quintessens* copied by William himself (CUL MS Dd.3.83 art.6): see Baker and Murphy 1976b, MS number 14.

279. See Coldewey 1975, and Baker, Murphy, and Hall 1982, xiv–xv. Myles kept the churchwardens' accounts between 1582 and 1590.

280. Quotation from Coldewey 1975, 110, who uses the Chelmsford records of payments regarding sets, persons, and properties along with the Blomefylde link to argue that the plays performed in 1562 were in fact the three Digby plays (*Conversion, Mary,* and *Candlemas Day*).

281. Although the overall contents of MS Digby 133 may seem well-suited to both Blomefyldes—the plays rub shoulders in the manuscript with alchemical, magical, and astronomical treatises, including one by Galileo—and some of these may have been gathered in their time, it seems that all the texts now found in the manuscript were not drawn together until the seventeenth century, when both Myles and William were long gone: see Baker, Murphy, and Hall 1982, ix–xii. As Bevington 1972, xvii, notes, the morality plays of the Macro MS were also bound with a *Liber Alchemiae* at some point in their history, perhaps after coming into the hands of Cox Macro in the eighteenth century.

References Cited

Adamnan. 1874. *Life of Saint Columba, Founder of Hy. Written by Adamnan, Ninth Abbot of that Monastery*, ed. William Reeves. Edinburgh: Edmonston and Douglas. Online at: http://www.fordham.edu/halsall/basis/columba-e.html.

Adams, Gillian. 1998. "Medieval Children's Literature: Its Possibility and Actuality." *Children's Literature* 26:1–24.

Adams, Robert. 2002. "The R/F MSS of Piers Plowman and the Pattern of Alpha/Beta Complementary Omissions." *TEXT* 14:109–38.

Adams, Robert, Hoyt N. Duggan, Eric Eliason, Ralph Hanna III, John Price-Wilkin, and Thorlac Turville-Petre, eds. 1999. *The Piers Plowman Electronic Archive*, Vol. 1: *Corpus Christi College, Oxford MS 201 (F)*. Ann Arbor, MI: University of Michigan Press for The Early English and Norse Electronic Texts.

Akbari, Suzanne Conklin. 2002. "Orientalism and Nation in Chaucer's *Canterbury Tales*." In *Chaucer's Cultural Geography*, ed. Kathryn L. Lynch, 102–34. New York: Routledge.

Alford, John A. 1984. "Richard Rolle and Related Works." In *Middle English Prose: A Critical Guide to Major Authors and Genres*, ed. A. S. G. Edwards, 35–60. New Brunswick, NJ: Rutgers University Press.

Allies, Mary H., trans. 1898. *St. John Damascene on Holy Images*. Christian Classics Ethereal Library. London: Thomas Baker. Online at: http://www.ccel.org/ccel/damascus/icons.i.i.html.

Anderson, David, ed. 1986. *Sixty Bokes Olde and Newe: Manuscripts and Early Printed Books from Libraries in and near Philadelphia Illustrating Chaucer's Sources, His Works, and their Influence*. Knoxville: New Chaucer Society, University of Tennessee, Knoxville.

Andrew, Malcolm, and Ronald Waldron, eds. 1978. *Poems of the Pearl Manuscript: Pearl, Cleanness, Patience, Sir Gawain and the Green Knight*. Berkeley: University of California Press.

——, eds. 2007. *Poems of the Pearl Manuscript: Pearl, Cleanness, Patience and Gawain and the Green Knight*. 5th ed. Exeter: University of Exeter Press.

Aquinas, Thomas. 1913. *The "Summa Theologica" of St. Thomas of Aquinas*. Pt. III, First Number (QQ. I.–XXVI), Question 25, Article 4. Trans. by Fathers of the English Dominican Province. London: R. & T. Washbourne.

Astell, Ann W. 1999. *Political Allegory in Medieval England*. Ithaca, NY: Cornell University Press.

Aston, Mary. 1984. *Lollards and Reformers: Images and Literacy in Late Medieval Religion*. London: Hambledon.

Augustine, Aurelius. 1886. "Letter CLXIV." In *The Confessions and Letters of St. Augustine*, ed. Philip Schaff. A Select Library of the Nicene and Post-Nicene Fathers of the Christian Church, vol. 1. Buffalo: Christian Library.

Ayto, John, and Alexander Barratt, eds. 1984. *Aelred of Rievaulx's De Institutione Inclusarum: Two English Versions*. EETS 287. London: Oxford University Press.

Backhouse, Janet. 1999. *The Sherborne Missal*. Toronto: University of Toronto Press; London: British Library.

Baechle, Sarah. Forthcoming. "Vernacular Reading, Continental Models, and the Composition of Chaucerian Marginalia." PhD diss., University of Notre Dame.

Baker, Denise N. 2007. "Mystical and Devotional Literature." In *Companion to Medieval English Literature and Culture c.1350–1500*, ed. Peter Brown, 423–36. Oxford: Blackwell.

Baker, Donald C. 1986. "Is *Wisdom* a 'Professional' Play?" In *Wisdom Symposium: Papers from the Trinity College Medieval Festival*, ed. Milla Cozart Riggio, 67–86. New York: AMS Press.

Baker, Donald C., and John L. Murphy. 1967. "Late Medieval Plays of MS. Digby 133: Scribes, Dates, and Early History." *Research Opportunities in Renaissance Drama* 10:153–66.

——, eds. 1976a. *Digby Plays: Facsimiles of the Plays in MSS Digby 133 and e Museo 160*. Leeds: University of Leeds.

——. 1976b. "Books of Myles Blomefylde." *The Library* 31:377–85.

Baker, Donald C., John L. Murphy and Louis B. Hall Jr., eds. 1982. *Late Medieval Religious Plays of Bodleian MSS Digby 133 and e Museo 160*. EETS 283. Oxford: Oxford University Press.

Bale, Anthony. 2008. "From Translator to Laureate: Imaging the Medieval Author." *Literature Compass* 5.5:918–34.

Barasch, Moshe. 1992. *Icon: Studies in the History of an Idea*. New York: New York University.

Barnum, Priscilla Heath, ed. 1976. *Dives and Pauper*. EETS 275. London: Oxford University Press.

Barr, Helen, ed. 2009. *The Digby Poems: A New Edition of the Lyrics*. Exeter Medieval Texts and Studies. Exeter: University of Exeter Press.

Barratt, Alexandra, ed. 1992. *Women's Writing in Middle English*. London: Longman.

——. 1997. "Books for Nuns: Cambridge University Library MS Additional 3042." *Notes and Queries* (September): 310–19.

Barret, Robert W. 2009. *Against all England: Regional Identity and Cheshire Writing, 1195–1656*. Notre Dame, IN: University of Notre Dame Press.

Baswell, Christopher C. 1992. "Talking Back to the Text:

Marginal Voices in Medieval Secular Literature." In Morse, Doob, and Woods 1992, 121–60.

Beadle, Richard. 1978. "Plays and Playing at Thetford and Nearby 1498–1540." *Theatre Notebook* 32:4–11.

———. 1984. "Scribal Problem in the Macro Manuscript." *English Language Notes* 21:1–13.

———. 1991. "Prolegomena to a Literary Geography of Later Medieval Norfolk." In *Regionalism in Late Medieval Manuscripts and Texts*, ed. Felicity Riddy, 89–108. Cambridge: D. S. Brewer.

———. 1995. "Thomas Hyngham's Hand in the Macro Manuscript." In *New Science out of Old Books: Studies in Manuscripts and Early Printed Books in Honour of A. I. Doyle*, ed. Richard Beadle and A. J. Piper, 315–41. Aldershot: Scolar Press.

Beadle, Richard, and A. E. B. Owen, eds. 1977. *Findern Manuscript: Cambridge University Library MS Ff.1.6.* London: Scolar Press.

Beidler, Peter. 2000. "Chaucer's Wife of Bath's 'Foot-Mantel' and Her 'Hipes Large.'" *The Chaucer Review* 34:388–97.

Bell, Alexander, ed. 1960. *L'Estoire des Engleis by Geffrei Gaimar.* Oxford: Basil Blackwell.

Bell, David N. 1995. *What Nuns Read: Books and Libraries in Medieval English Nunneries.* Kalamazoo: Cistercian Publications.

Bennett, H. S. 1948. *Chaucer and the Fifteenth Century.* Rpt. Oxford: Clarendon Press.

Bennett, J. A. W., and G. V. Smithers, eds. 1966. *Early Middle English Verse and Prose.* London: Oxford University Press.

Benskin, Michael. 1990. "The Hands of the Kildare Poems' Manuscript." *Irish University Review* 20:163–93.

———. 1992. "Some New Perspectives on the Origins of Standard Written English." In *Dialect and Standard Language: In the English, Dutch, German and Norwegian Language Areas.*, ed. J. A. van Leuvensteijn and J. B. Berns, Verhandelingen van de Koninklijke Nederlandse Akademie van Wetenschappen, Afd. Letterkunde, Nieuwe Reeks 150, 71–105. Amsterdam: North-Holland.

Benson, C. David. 1997. "Introduction: The Annotations to the Manuscripts of the B-version of *Piers Plowman*." In Benson and Blanchfield 1997, 9–27.

———. 2001. "The Langland Myth." In *William Langland's Piers Plowman: A Book of Essays,* ed. Kathleen M. Hewett-Smith, 83–99. New York: Routledge.

———. 2003. "Trust the Tale, Not the Teller." In *Drama, Narrative and Poetry in the Canterbury Tales*, ed. Wendy Harding, 21–33. Toulose: Presses Universitaires du Mirail.

Benson, C. David, and Lynne Blanchfield. 1997. *The Manuscripts of Piers Plowman: The B-Version.* Woodbridge, Suffolk, UK: D. S. Brewer.

Benson, C. David, and Barry Windeatt. 1990. "The Manuscript Glosses to Chaucer's *Troilus and Criseyde.*" *The Chaucer Review* 25:33–53.

Benson, Larry D., ed. 1986. *King Arthur's Death: The Middle English Stanzaic Morte Arthur and Alliterative Morte Arthure.* Exeter: University of Exeter Press.

Benton, John F., trans. 1964. *Self and Society in Medieval France: The Memoires of Abbot Guibert of Nogent.* Toronto: University of Toronto Press.

Beston, John B. 1976. "Case Against Common Authorship of *Lay le Freine* and *Sir Orfeo.*" *Medium Aevum* 45:153–63.

Bevington, David, ed. 1972. *Macro Plays, The Castle of Perseverance, Wisdom, Mankind: A Facsimile Edition with Facing Transcriptions.* New York: Johnson Reprint Corporation.

Biblia Sacra: Iuxta Vulgatam Versionem. (1969) 1994. Stuttgart: Deutsche Bibelgesellschaft.

Birkholz, Daniel. 2009. "Harley Lyrics and Hereford Clerics: The Implications of Mobility, c. 1300–1351." *Studies in the Age of Chaucer* 31:175–230.

Blaess, Madelaine. 1975. "L'Abbaye de Bordesley et les Livres de Guy de Beauchamp." *Romania* 78:511–18.

Blake, N. F. 1973. *Caxton's Own Prose.* London: André Deutsch.

———. 1990. "Vernon Manuscript: Contents and Organization." In Pearsall 1990, 45–59.

Blanchfield, Lynne S. 1991. "The Romances in MS Ashmole 61: An Idiosyncratic Scribe." In *Romance in Medieval England*, ed. Maldwyn Mills, Jennifer Fellows, and Carol M. Meale, 65–87. Cambridge: D. S. Brewer.

Blyth, Charles R., ed. 1999. *The Regiment of Princes.* TEAMS: Middle English Texts Series. Kalamazoo: Medieval Institute Publications.

Bodleian Library MS 213. Fol.1r. Online at: http://bodley30 .bodley.ox.ac.uk:8180/luna/servlet/detail/ODLodl~1~1~ 40814~116745:Decameron-?sort=Shelfmark,Folio_Page& qvq=q:213;sort:Shelfmark,Folio_Page;lc:ODLodl~1~1&mi =184&trs=188.

Bodleian Library Online Catalogues of Western Manuscripts. Online at: http://www.bodley.ox.ac.uk/dept/scwmss/ wmss/online/.

Boenig, Robert, and Andrew Taylor, eds. 2008. *The Canterbury Tales.* Toronto: Broadview.

Boffey, Julia. 1985. *Manuscripts of English Courtly Love Lyrics in the Later Middle Ages.* Woodbridge, Suffolk, UK: D. S. Brewer.

Bosworth, Joseph, and T. Northcote Toller. Anglo-Saxon Dictionary. Online at: http://www.ling.upenn.edu/~kurisuto/ germanic/oe_bosworthtoller_about.html.

Botvinick, Matthew. 1992. "The Painting as Pilgrimage: Traces of a Subtext in the Work of Campin and His Contemporaries." *Art History* 15.1:1–18.

Bowden, Betsy. 1995. "Visual Portraits of the Canterbury Pilgrims 1484 (?) to 1809." In Stevens and Woodward 1995, 171–204.

Boyle, Leonard, and Michèle Mulchahey. (1969) 1991 rev. "Paleography and Codicology: An Elementary Vocabulary." Unpublished.

Brantley, Jessica. 2002. "Images of the Vernacular in the Taymouth Hours." In *Decoration and Illustration in Medieval English Manuscripts*, ed. A. S. G. Edwards, 83–113. London: British Library.

———. 2007. *Reading in the Wilderness: Private Devotion and Public Performance in Late Medieval England.* Chicago: University of Chicago Press.

Brennan, John P. 1973. "Reflections on a Gloss to the 'Prioress's Tale' from Jerome's 'Adversus Jovinianum.'" *Studies in Philology* 70:243–51.

Brewer, D. S. 1966. "Images of Chaucer 1386–1900." In *Chaucer and Chaucerians: Critical Studies in Middle English Literature,* ed. D. S. Brewer, 240–70. Tuscaloosa, AL: University of Alabama Press.

Brewer, D. S., and A. E. B. Owen, eds. 1975. *Thornton Manuscript (Lincoln Cathedral MS.91)*. London: Scolar Press.

Briquet, C. M. 1923. *Les Filigranes: Dictionnaire Historique des Marques du Papier*. 2nd ed. Paris.

Briscoe, Marianne G. 1989. "Preaching and Medieval English Drama." In *Contexts for Early English Drama*, ed. Marianne Briscoe and John C. Coldeway, 151–72. Bloomington: Indiana University Press.

British Library Catalogue of Manuscripts. Online at: http://www.bl.uk/catalogues/manuscripts/INDEX.asp.

British Library Catalogue of Medieval and Renaissance Illuminated Manuscripts. Online at: http://www.bl.uk/catalogues/illuminatedmanuscripts/welcome.htm and http://www.bl.uk/catalogues/illuminatedmanuscripts/searchMSNo.asp.

British Library MS Arundel 292. "Beginning of 'St Patrick's Purgatory' in a Collection of Devotional Writings," fol. 72r. Online at: http://www.bl.uk/onlinegallery/onlineex/illmanus/arunmancoll/b/011aru000000292u00072000.html. "Pressmark of Norwich Cathedral Library, in a Collection of Devotional Writings," fol. 114v. Online at: http://www.bl.uk/onlinegallery/onlineex/illmanus/arunmancoll/p/011aru000000 292u00114v00.html.

Brockman, Bennett A. 1975. "Children and Literature in Late Medieval England." *Children's Literature* 4:58–63.

Brook, G. L., ed. 1956. *The Harley Lyrics: The Middle English Lyrics of MS Harley 2253*. 2nd ed. Manchester: Manchester University Press.

Brooke, Iris. 1939. *Western European Costume: Thirteenth to Seventeenth Century*. London: George C. Harrap.

Broughton, Laurel. 2005. "The Prioress's Prologue and Tale." In Correale and Hamel 2003–5, 2:583–647.

Brown, Carleton. 1910. *Study of the Miracle of Our Lady Told by Chaucer's Prioress*. Chaucer Society Publications, 2nd ser., 45. London: Chaucer Society.

———. 1932. *English Lyrics of the XIIIth Century*. Oxford: Clarendon Press.

———. 1941. "The Prioress's Tale." In *Sources and Analogues of Chaucer's Canterbury Tales*, ed. W. F. Bryan and Germaine Dempster, 447–85. New York: Humanities Press.

Brown, Matthew. 2010. "Piers Plowman and Sacral Kingship, and the Dissident Chronicle Tradition in Fourteenth-Century England." PhD diss., University of Notre Dame.

Brown, Michelle P. 1990. *A Guide to Western Historical Scripts from Antiquity to 1600*. London: British Library.

———. 1994. *Understanding Illuminated Manuscripts: A Guide to Technical Terms*. Malibu: J. Paul Getty Museum; London: British Library. Online at http://www.bl.uk/catalogues/illuminatedmanuscripts/glossary.asp.

Brown, Nancy Pollard, and James H. McDonald, eds. 1967. *Introduction to The Poems of Robert Southwell*. Oxford: Clarendon Press.

Bryan, W. F., and Germaine Dempster, eds. 1958. *Sources and Analogues of Chaucer's Canterbury Tales*. Rpt. New York: Humanities Press.

Bühler, Curt F. 1940. "Lydgate's *Horse, Sheep and Goose* and Huntington's MS. HM 144." *Modern Language Notes* 55:563–69.

Burnley, David, and Alison Wiggins, eds. 2003. *Auchinleck Manuscript*. National Library of Scotland. Online at: http://auchinleck.nls.uk/.

Burrow, John A. 1983. "Autobiographical Poetry in the Middle Ages: The Case of Thomas Hoccleve." *Proceedings of the British Academy* 68:389–412.

———. 1994. *Thomas Hoccleve*. Authors of the Middle Ages 4. Aldershot: Variorum.

Burrow, John A., and A. I. Doyle, eds. 2002. *A Facsimile of the Autograph Verse Manuscripts: Henry E. Huntington Library, San Marino (California) MSS HM 111 and HM 744; University Library, Durham (England) MS Cosin V. III. 9*. EETS s.s. 19. Oxford: Oxford University Press.

Bynum, Caroline Walker. (1982) 1984. *Jesus as Mother: Studies in the Spirituality of the High Middle Ages*. Berkeley: University of California Press.

Caie, Graham. 1976. "The Significance of the Early Chaucer Manuscript Glosses (With Special Reference to the Wife of Bath's Prologue)." *The Chaucer Review* 10:350–60.

Calkin, Siobhain Bly. 2005. *Saracens and the Making of English Identity: The Auchinleck Manuscript*. New York: Routledge.

Camille, Michael. 1993. "Mouths and Meanings: Towards an Anti-Iconography of Medieval Art." In *Iconography at the Crossroads*, ed. Brendan Cassidy, 43–57. Princeton: Index of Christian Art, Department of Art and Archaeology.

———. 1995. *The Gothic Idol: Ideology and Image-Making in Medieval Art*. New York: Cambridge University Press.

———. 1996. *Gothic Art: Glorious Visions*. New York: Harry N. Abrams.

———. 1998. *The Medieval Art of Love: Objects and Subjects of Desire*. New York: Henry N. Abrams.

———. 2000. "Before the Gaze. The Internal Senses and Late Medieval Practices of Seeing." In *Visuality Before and Beyond the Renaissance. Seeing as Others Saw*, ed. Robert S. Nelson, 197–223. Cambridge: Cambridge University Press.

Cannon, Christopher. 1999. "Monastic Productions." In Wallace 1999, 316–48.

Carlson, David R. 1987. "The *Pearl*-Poet's 'Olympia.'" *Manuscripta* 31:181–89.

———. 2003. "The Woodcut Illustrations in Early Printed Editions of Chaucer's *Canterbury Tales*. In Finley and Rosenblum 2003, 73–119.

Carlson, John Ivor. 2007–8. "Scribal Intentions in Medieval Romance: A Case Study of Robert Thornton." *Studies in Bibliography* 58:49–71.

Carr, Emily. 1972. *Fresh Seeing: Two Addresses of Emily Carr*. Preface by Doris Shadbolt. Intro. by Ira Dilworth. Toronto: Clarke, Irwin.

Carruthers, Mary. 1990. *The Book of Memory: A Study of Memory in Medieval Culture*. Cambridge: Cambridge University Press.

Casson, I. F., ed. 1949. *Romance of Sir Degrevant: A Parallel Text Edition*. EETS o.s. 221. London: Oxford University Press.

Catalogue of Digitized Medieval Manuscripts. Hosted by the Center for Medieval and Renaissance Studies at the University of California, Los Angeles. Online at: http://manuscripts.cmrs.ucla.edu/.

Caviness, Madeline H. 1993. "Patron or Matron? A Capetian Bride and a Vade Mecum for Her Marriage Bed." *Speculum* 68:333–62.

Caxton, William. 1913. *Caxton's Mirrour of the World*, ed. Oliver H. Prior. EETS e.s. 110. London: Oxford University Press.

"Caxton's Chaucer: British Library Treasures in Full." 2003. Text by Kristian Jensen, ed. Colin Wight. Online at: http://www.bl.uk/treasures/caxton/homepage.html.

Christianson, Paul. 1989. "A Community of Book Artisans in Chaucer's London." *Viator* 20:207–18.

——. 1990. *A Directory of London Stationers and Book Artisans, 1300–1350*. New York: Bibliographical Society of America.

Clemens, Raymond, and Timothy Graham. 2007. *Introduction to Manuscript Studies*. Ithaca, NY: Cornell University Press.

Clifton, Nicole. 2003. "*Of Arthour and of Merlin* as Medieval Children's Literature." *Arthuriana* 13:9–22.

——. 2005. "*Seven Sages of Rome*, Children's Literature, and the Auchinleck Manuscript." In *Childhood in the Middle Ages and the Renaissance: The Results of a Paradigm Shift in the History of Mentality*, ed. Albrecht Classen, 185–201. Berlin: Walter de Gruyter.

Coldewey, John C. 1975. "Digby Plays and the Chelmsford Records." *Research Opportunities in Renaissance Drama* 18:103–21.

——. 2008. "The Non-Cycle Plays and the East Anglian Tradition." In *Cambridge Companion to Medieval English Theatre*, 2nd ed., ed. Richard Beadle and Alan J. Fletcher, 211–34. Cambridge: Cambridge University Press.

Colledge, Edmund, and Romana Guarnieri. 1968. "Glosses by 'M. N.' and Richard Methley to the *Mirror of Simple Souls*." *Archivio Italiano per la Storia della Pietà* 5:357–82.

Colledge, Edmund, J. C. Marler, and Judith Grant, trans. 1999. *Mirror of Simple Souls: Margaret Porette*. Notre Dame, IN: University of Notre Dame Press.

Colledge, Edmund, and James Walsh, eds. 1978. *Book of Showings to the Anchoress Julian of Norwich*. Parts 1 and 2 in 2 vols. Toronto: Pontifical Institute of Mediaeval Studies.

Connolly, Margaret. 1998. *John Shirley: Book Production and the Noble Household in Fifteenth-Century England*. Aldershot: Ashgate.

Copeland, Rita. 1991. *Rhetoric, Hermeneutics, and Translation in the Middle Ages: Academic Traditions and Vernacular Texts*. Cambridge Studies in Medieval Literature 2. Cambridge: Cambridge University Press.

Corpus Christi College, Oxford, MS 198 Facsimile. Online in Early Manuscripts at Oxford University at: http://image.ox.ac.uk/show?collection=corpus&manuscript=ms198.

Corpus Christi College, Oxford MS 201 Facsimile. Online in Early Manuscripts at Oxford University at: http://image.ox.ac.uk/show?collection=corpus&manuscript=ms201.

Correale, Robert M. 2005. "The Man of Law's Prologue and Tale." In Correale and Hamel 2003–5, 2:277–350.

Correale, Robert M., and Mary Hamel, eds. 2003–5. *Sources and Analogues of the Canterbury Tales*. 2 vols. Chaucer Studies 28 and 35. Cambridge: D. S. Brewer.

Couch, Julie Nelson. 2003. "The 'Child Slain by Jews' and 'The Jewish Boy.'" In *Medieval Literature for Children*, ed. Daniel T. Kline, 204–26. New York: Routledge.

Craven, Maxwell. 1983. "Sir Geoffrey de Finderne and his Flower." *Derbyshire Archaeological Journal* 103:91–97.

Cré, Marleen. 2000. "Women in the Charterhouse? Julian of Norwich's *Revelations of Divine Love* and Marguerite Porete's

Mirror of Simple Souls in British Library, MS Additional 37790." In *Writing Religious Women: Female Spiritual and Textual Practices in Late Medieval England*, ed. Denis Renevey and Christiania Whitehead, 43–62. Toronto: University of Toronto Press.

——. 2006. *Vernacular Mysticism in the Charterhouse: A Study of London, British Library, MS Additional 37790*. Medieval Translator 9. Turnhout: Brepols.

Cronin, H. S., trans. 1907. "The Twelve Conclusions of the Lollards." *English Historical Review* 22:292–304. Online at: http://www.courses.fas.harvard.edu/~chaucer/special/varia/lollards/lollconc.htm.

Davis, Norman, ed. 2004. *Paston Letters and Papers of the Fifteenth Century*. Pt. 1. EETS s.s. 20. Rpt. Oxford: Oxford University Press.

Day, Mabel, and J. A. Herbert, eds. 1952. *English Text of the Ancrene Riwle Edited from Cotton MS Nero A.XIV*. EETS o.s. 225. London: Oxford University Press.

de Hamel, Christopher. 1991. *Syon Abbey: The Library of the Brigettine Nuns and their Peregrinations after the Reformation*. Otley: Roxburghe Club.

——. 2001. *The Book: A History of the Bible*. London: Phaidon.

Dempster, Germaine. 1943. "Chaucer's Manuscript of Petrarch's Version of the Griselda Story." *Modern Philology* 41:6–16.

Denholme-Young, N. 1929–31. "An Early Thirteenth-Century Anglo-Norman MS." *Bodleian Quarterly Record* 6:225–30.

Despres, Denise. 1989. *Ghostly Sights: Visual Meditation in Late-Medieval Literature*. Norman, OK: Pilgrim Books.

——. 1994. "Cultic Anti-Judaism and Chaucer's Litel Clergeon." *Modern Philology* 91.4:413–27.

——. 2010. "Adolescence and Sanctity: *The Life and Passion of Saint William of Norwich*." *Journal of Religion* 90.1:33–62.

——. "Private Space and Self Reflection in Mary de Bohun's Psalter-Hours, Egerton 3277." Unpublished essay.

Dille Nielsen, Melinda. 2010. "Impersonating Boethius in Middle English Literature." PhD diss., University of Notre Dame.

Dobson, E .J. 1972. *English Text of the Ancrene Riwle Edited from B.M. Cotton MS Cleopatra C.vi*. EETS 267. London: Oxford University Press.

——. 1976. *The Origins of Ancrene Wisse*. Oxford: Clarendon Press.

Doiron, Marilyn. 1968. "Margaret Porete: *The Mirror of Simple Souls*, A Middle English Translation." *Archivio Italiano per la Storia della Pietà* 5:241–355.

Donaldson, E. Talbot. 1983. "Idiom of Popular Poetry in the Miller's Tale." In *Speaking of Chaucer*, ed. E. Talbot Donaldson, 13–29. Durham, NC: Labyrinth Press.

Dove, Mary. 2000. "Evading Textual Intimacy: The French Secular Verse." In Fein 2000c, 329–49.

Doyle, A. I. 1958. "Books Connected with the Vere Family and Barking Abbey." *Transactions of the Essex Archaeological Society*, n.s. 25:222–243.

——. 1982. "The Manuscripts." In Lawton 1982, 88–100.

——. 1983. "English Books in and out of Court from Edward III to Henry VI." In *English Court Culture in the Later Middle Ages*, ed. V. Scattergood and J. Sherborne, 163–81. New York: St. Martin's Press.

——. 1986. "Remarks on the Surviving Manuscripts of *Piers Plowman*." In *Medieval English Religious and Ethical Literature: Essays in Honour of G. H. Russell*, ed. Gregory Kratzmann and James Simpson, 35–48. Cambridge: D. S. Brewer.

——, ed. 1987. *The Vernon Manuscript: A Facsimile of Bodleian Library, Oxford, ms. Eng. Poet. a. 1*. Cambridge: D. S. Brewer.

——. 1989. "Publication by Members of the Religious Orders." In Griffiths and Pearsall 1989, 109–123.

——. 1990a. "The Shaping of the Vernon and Simeon mss." In Pearsall 1990, 1–13.

——. 1990b. "Book Production by the Monastic Orders in England (c.1375–1530): Assessing the Evidence." In *Medieval Book Production: Assessing the Evidence*, ed. Linda L. Brownrigg, 1–19. Los Altos Hills, ca: Anderson-Lovelace.

——. 1997. "Stephen Dodesham of Witham and Sheen." In *Of the Making of Books: Medieval Manuscripts, Their Scribes and Readers: Essays Presented to M. B. Parkes*, ed. P. R. Robinson and Rivkah Zim, 94–115. Aldershot: Scolar Press.

——. 1998. "English Carthusian Books Not Yet Linked with a Charterhouse." In *"A Miracle of Learning": Studies in Manuscripts and Irish Learning. Essays in Honour of William O'Sullivan*, ed. Toby Barnard, Dáibhí Ó Cróinín and Katharine Simms, 122–36. Aldershot: Ashgate.

——. 2000. "Ushaw College, Durham, ms 50: Fragment of the *Prick of Conscience*, by the Same Scribe as Oxford, Corpus Christi College, ms 201, of the B Text of *Piers Plowman*." In *The English Medieval Book: Studies in Memory of Jeremy Griffiths*, ed. A. S. G. Edwards, Vincent Gillespie, and Ralph Hanna, 42–49. London: British Library.

Doyle, A. I., and M. B. Parkes. 1978. "The Production of Copies of the *Canterbury Tales* and the *Confessio Amantis* in the Early Fifteenth Century." In *Medieval Scribes, Manuscripts, and Libraries: Essays Presented to N. R. Ker*, ed. M. B. Parkes and Andrew G. Watson, 163–212. London: Scolar Press.

Doyle, A. I., and Malcolm Parkes. 1979. "Paleographical Introduction." In *The Canterbury Tales: A Facsimile and Transcription of the Hengwrt Manuscript with Variants from the Ellesmere Manuscript*, ed. Paul G. Ruggiers, xix–xlix. Norman: University of Oklahoma Press.

Doyle, Kara A. 2006. "Thisbe out of Context: Chaucer's Female Readers and the Findern Manuscript." *The Chaucer Review* 40:231–61.

Driver, Martha. 2004. *The Image in Print: Book Illustration in Late Medieval England and Its Sources*. London: British Library.

Drogin, Marc. 1983. *Anathema: Medieval Scribes and the History of Book Curses*. Totowa, nj: Allanheld and Schram.

Duggan, Hoyt N., director. The Piers Plowman Electronic Archive. Ann Arbor, mi: Society for Early English and Norse Electronic Texts. Online at: http://www3.iath .virginia.edu/seenet/piers/.

Dutschke, C. W. et al. 1989. *Guide to Medieval and Renaissance Manuscripts in the Huntington Library*. 2 vols. San Marino, ca: Henry E. Huntington Library and Art Gallery.

Dutton, Elizabeth. 2008. *Julian of Norwich: The Influence of Late Medieval Devotional Compilations*. Cambridge: Brewer.

Dymmok, Roger. 1922. *Rogeri Dymmok Liber contra XII Errores et Hereses Lollardorum*, ed. Henry Stovell Cronlin. London: Kegan Paul, Trench, Trübner and Co. for the Wyclif Society.

Early Manuscripts at Oxford University. Oxford Digital Library. Online at: http://image.ox.ac.uk/.

Eccles, Mark, ed. 1969. *Macro Plays: The Castle of Perseverance, Wisdom, Mankind*. eets o.s. 262. London: Oxford University Press.

Eddy, Nicole. 2011. "Annotating the Winchester Malory: A Fifteenth-Century Guide to the Martialism, the Marvels, and the Narrative Structure of the *Morte Darthur*." *Viator* 42:283–305.

——. Forthcoming. "Marginal Annotation in Medieval Romance Manuscripts: Understanding the Contemporary Reception of the Genre." PhD diss., University of Notre Dame.

Edwards, A. S. G. 1972. "John Lydgate, Medieval Antifeminism and Harley 2251." *Annuale Mediaevale* 13:32–44.

——. 1981. "Lydgate Manuscripts: Some Suggestions for Future Research." In *Manuscripts and Readers in Fifteenth-Century England: The Literary Implications of Manuscript Study*, ed. Derek Pearsall, 15–26. Cambridge: D. S. Brewer.

——. 1991. "Beinecke ms 661 and Early Fifteenth-Century English Manuscript Production." *Yale University Library Gazette* 66 Supplement:181–196.

——. 1994. "Transmission and Audience of Osbern Bokenham's *Legendys of Hooly Wummen*." In *Late-Medieval Religious Texts and their Transmission*, ed. A. J. Minnis, 157–167. Cambridge; D. S. Brewer.

——. 1997. "The Manuscript: British Library ms Cotton Nero A.x." In *A Companion to the Gawain-Poet*, ed. Derek Brewer and Jonathan Gibson, Arthurian Studies 38, 197–219. Cambridge: D. S. Brewer.

——. 2005. "A New Text of *The Canterbury Tales*?" In *Studies in Late Medieval and Early Renaissance Texts in Honour of John Scattergood*, ed. Anne Marie D'Arcy and Alan J. Fletcher, 121–28. Dublin: Four Courts.

——. 2007. "Manuscripts and Readers." In *Companion to Medieval English Literature and Culture c.1350–c.1500*, ed. Peter Brown, 93–106. Oxford: Blackwell Publishing.

Elvin, C. N. (1860) 1971. *Elvin's Handbook of Mottoes*. Rev. R. Pinches. London: Heraldry Today.

Emmerson, Richard K. 1995. "Text and Image in the Ellesmere Portraits of the Tale Tellers." In Stevens and Woodward 1995, 143–70.

Erdmann, Axel, ed. 1911. *Lydgate's Siege of Thebes*. Pt. 1: The Text. eets e.s. 108. London: Oxford University Press.

Erler, Mary C. 1999. "Devotional Literature." In *Cambridge History of the Book in Britain*, vol. 3, *1400–1557*, ed. Lotte Hellinga and J. B. Trapp, 495–525. Cambridge: Cambridge University Press.

Evans, Murray J. 1995. *Rereading Middle English Romance: Manuscript Layout, Decoration, and the Rhetoric of Composite Structure*. Montreal: McGill-Queen's University Press.

Fein, Susanna. 1997. "Twelve-Line Stanza Forms in Middle English and the Date of *Pearl*." *Speculum* 72:367–98.

——. 2000a. "Introduction: British Library ms Harley 2253— The Lyrics, the Facsimile, and the Book." In Fein 2000c, 1–19.

——. 2000b. "A Saint 'Geynest under Gore': Marina and the Love Lyrics of the Seventh Quire." In Fein 2000c, 351–76.

——, ed. 2000c. *Studies in the Harley Manuscript: The Scribes,*

Contents, and Social Contexts of British Library MS Harley 2253. Kalamazoo: TEAMS.

———. 2005. "The Lyrics of Harley 2253." In *The Manual of Writings in Middle English 1050-1500*, vol. 11, ed. Peter G. Beidler, 4168–206, 4311–61. New Haven: Connecticut Academy of Arts and Sciences.

———. 2007. "Compilation and Purpose in MS Harley 2253." In Scase 2007, 67–94.

Fellows, Jennifer. 2008. "The Middle English and Renaissance *Bevis*: A Textual Survey." In *Sir Bevis of Hampton in Literary Tradition*, ed. Jennifer Fellows and Ivana Djordjević, 80–113. Cambridge: D. S. Brewer.

Field, Peter J. C. 2001. "Malory's own Marginalia." *Medium Aevum* 70:226–39.

Field, Rosalind. 1999. "Romance in England, 1066–1400." In Wallace 1999, 152–76.

Finlayson, John. 1990. "*Richard, Coer de Lyon*: Romance, History, or Something in Between?" *Studies in Philology* 87:156–80.

Finley, William K., and Joseph Rosenblum, eds. 2003. *Chaucer Illustrated: Five Hundred Years of the Canterbury Tales in Pictures*. New Castle, DE: Oak Knoll Press.

Finn, Patrick J. 2003. "Pre-Codex to Post-Code: Editorial Theory in the Second Incunabulum." PhD diss., University of Victoria.

Finnegan, Mary Jeremy. 1991. *Women of Helfta: Scholars and Mystics*. Athens, Georgia: University of Georgia Press.

Fisher, John H. 1988. "*Piers Plowman* and the Chancery Tradition." In *Medieval English Studies Presented to George Kane*, ed. Edward D. Kennedy, Ronald Waldron, and Joseph S. Wittig, 267–78. Woodbridge, Suffolk, UK: Boydell & Brewer.

Fleming, John. 1981. "Chaucer and the Visual Arts of His Time." In *New Perspectives in Chaucer Criticism*, ed. Donald M. Rose, 121–36. Norman, OK: Pilgrim Books.

Fletcher, Alan J. 1981. "Marginal Glosses in the N-Town Manuscript, British Library MS Cotton Vespasian D.VIII." *Manuscripta* 25:113–17.

———. 1982. "Layers of Revision in the N-Town Marian Cycle." *Neophilologus* 66:269–78.

———. 1985. "A Suggested Place of Origin of the Huntington 112 Copy of Walter Hilton's *Scale of Perfection*." *Notes and Queries* (March): 10–11.

———. 2008. "N-Town Plays." In *Cambridge Companion to Medieval English Theatre*, 2nd ed., ed. Richard Beadle and Alan J. Fletcher, 183–210. Cambridge: Cambridge University Press.

Folger Shakespeare Library, MS V.a.354. Folger Shakespeare Library. Online at: http://luna.folger.edu/luna/servlet/view/search?q=Call_Number="V.a.354"+&sort=Call_Number,MPSORTORDER1,CD_Title,Imprint&os=0.

Fredell, Joel. 1994. "Decorated Initials in the Lincoln Thornton MS." *Studies in Bibliography* 47:78–88.

———. 2009. "Design and Authorship in the *Book of Margery Kempe*." *Journal of the Early Book Society* 12:1–28.

Furnivall, F. J., ed. 1970. *Hoccleve's Works: The Minor Poems*. Rev. J. Mitchell and A. I. Doyle. London: Oxford University Press. (Orig. pub. 1892 as *The Minor Poems: Hoccleve's Works*, vol. 1, EETS e.s. 61.)

Furrow, Melissa. 1994. "'Þe Wench,' the Fabliau, and the Auchinleck Manuscript." *Notes and Queries* 239:440–43.

———. 1996. "A Minor Comic Poem in a Major Romance Manuscript: 'Lyarde.'" *Forum for Modern Language Study* 32:289–302.

Galbi, Douglas. 2003. *Sense in Communication*. Online at: http://www.galbithink.org/sense-s5.htm.

Galway, Margaret. 1949. 'The 'Troilus' Frontispiece." *Modern Language Review* 44.2:160–77.

Gaudio, Michael. 2000. "Matthew Paris and the Cartography of the Margins." *Gesta* 39.1:50– 57.

Gaylord, Alan T. 1995. "Portrait of a Poet." In Stevens and Woodward 1995, 121–42.

Gill, Louise. 1997. "William Caxton and the Rebellion of 1483." *English Historical Review* 112:106–18.

Gillespie, Alexandra. 2006. *Print Culture and the Medieval Author: Chaucer, Lydgate, and Their Books 1473 -1557*. Oxford: Oxford University Press.

———. 2008. "Reading Chaucer's Words to Adam." *The Chaucer Review* 42:269–83.

Gillespie, Alexandra, and Daniel Wakelin, eds. 2011. *The Production of Books in England, 1350-1500*. Cambridge Studies in Palaeography and Codicology. Cambridge: Cambridge University Press.

Gillespie, Vincent. 1999. "Dial M for Mystic: Mystical Texts in the Library of Syon Abbey and the Spirituality of the Syon Brethren." In *Medieval Mystical Tradition England, Ireland and Wales: Exeter Symposium VI*, ed. Marion Glasscoe, 241–68. Cambridge: D. S. Brewer.

———. 2006. "Haunted Text: Ghostly Reflections in *A Mirror to Devout People*." In *Text in the Community: Essays on Medieval Works, Manuscripts, Essays and Readers*, ed. Jill Mann and Maura Nolan, 129–72. Notre Dame, IN: University of Notre Dame Press.

Gillespie, Vincent, and A. I. Doyle, eds. 2001. *Syon Abbey with the Libraries of the Carthusians*. London: British Library.

Glasgow, University Library MS Hunter 409. "Chaucer's *Romance of the Rose*." Online at: http://special.lib.gla.ac.uk/manuscripts/search/detaild.cfm?DID=33474.

Glasgow, University Library MS Hunter 475. Fol.274v. Online at: http://special.lib.gla.ac.uk/exhibns/treasures/subject.html.

Golding, Brian. 1995. *Gilbert of Sempringham and the Gilbertine Order c. 1130-c. 1300*. Oxford: Clarendon Press.

Gollancz, Israel, ed. (1923) 1971. *Pearl, Cleanness, Patience and Sir Gawain: Reproduced in Facsimile from the Unique Ms. Cotton Nero A.x in the British Museum*. EETS o.s. 162. London: Oxford University Press.

Gombrich, E. H. 1979. "Giotto's Portrait of Dante?" *Burlington Magazine* 121:471–83.

Goodman, Jennifer R. 1995. "'That Wommen Holde in Ful Greet Reverence': Mothers and Daughters Reading Chivalric Romances." In *Women, the Book, and the Worldly*, ed. Lesley Smith and Jane H. M. Taylor, 25–30. Cambridge: D. S. Brewer.

Grabar, André. 1966. *Byzantium: Byzantine Art in the Middle Ages*. London: Methuen.

Grabar, Oleg. 1992. *The Mediation of Ornament*. Princeton: Princeton University Press.

Gray, Douglas, ed. 1975. *A Selection of Religious Lyrics*. Oxford: Oxford University Press.

Green, Daryl. 2009. "Scribal Confusion and Reception of the *Tale of Gamelyn*." Presented at the 44th International Congress on Medieval Studies, May 8, Kalamazoo.

Green, Richard F. 1989. "The Two 'Litel Wot Hit Any Mon' Lyrics in Harley 2253." *Mediaeval Studies* 51:304–12.

Greene, R. L. 1961. "A Middle English Love Poem and the 'O-and-I' Refrain-Phrase." *Medium Aevum* 30:170–75.

Gregory the Great. 2004. "Letter to Serenus." In *The Letters of Gregory the Great*, trans. with intro. and notes by John R. C. Martyn, 744–47. Toronto: Pontifical Institute of Mediaeval Studies.

Griffiths, Jeremy. 1992. "A Newly Identified Manuscript Inscribed by John Shirley." *The Library* 14, 6th ser.:83–93.

———. 1995. "Thomas Hyngham, Monk of Bury and the Macro Plays Manuscript." In *English Manuscript Studies 1100-1700*, vol. 5, ed. Peter Beal and Jeremy Griffiths, 214–19. London: British Library.

Griffiths, Jeremy, and Derek Pearsall, eds. 1989. *Book Production and Publishing in Britain 1375-1475*. Cambridge: Cambridge University Press.

Grindley, Carl J. 1992. *From Creation to Desecration: The Marginal Annotations of Piers Plowman C-Text HM 143*. MA thesis, University of Victoria.

———. 2001. "Reading *Piers Plowman* C-Text Annotations: Notes toward the Classification of Printed and Written Marginalia in Texts from the British Isles 1300–1641." In Kerby-Fulton and Hilmo 2001, 73–141.

Guddat-Figge, Gisela. 1976. *Catalogue of Manuscripts Containing Middle English Romances*. Munich: Wilhelm Fink Verlag.

Halligan, Theresa A., ed. 1979. *Booke of Gostlye Grace of Mechtild of Hackeborne*. Toronto: Pontifical Institute of Mediaeval Studies.

Hamburger, Jeffrey F. 1998. *The Visual and the Visionary: Art and Female Spirituality in Late Medieval Germany*. New York: Zone Books.

Hamel, Mary. 1983. "Scribal Self-Corrections in the Thornton *Morte Arthure*." *Studies in Bibliography* 36:119–37.

Hamer, Andrew. 1995. "The Verses on the Screens in Carlisle Cathedral." Unpublished report in the Cathedral Archive CCA F15.

Hanna, Ralph. 1984. "London Thornton Manuscript: A Corrected Collation." *Studies in Bibliography* 37:122–30.

———. 1987a. "Production of Cambridge University Library MS Ff.i.6." *Studies in Bibliography* 40:62–70.

———. 1987b. "The Growth of Robert Thornton's Books." *Studies in Bibliography* 40:51–61.

———. 1989a. "The Hengwrt Manuscript and the Canon of the *Canterbury Tales*." *English Manuscript Studies: 1100–1700* 1:64–84.

———. 1989b. "The Scribe of Huntington HM 114." *Studies in Bibliography* 42:120–33.

———. 1990. *The Ellesmere Manuscript of Chaucer's Canterbury Tales: A Working Facsimile*. Cambridge: D. S. Brewer.

———. 1993. *William Langland*. Aldershot: Variorum.

———. 1999. "Alliterative Poetry." In Wallace 1999, 488–512.

———. 2000a. "Reconsidering the Auchinleck Manuscript." In Pearsall 2000, 91–102.

———. 2000b. "Augustinian Canons and Middle English Literature." In *The English Medieval Book: Studies in Memory of Jeremy Griffiths*, ed. A. S. G. Edwards, Vincent Gillespie, and Ralph Hanna, 27–42. London: British Library.

———. 2004. "Rolle and Related Works." In *Companion to Middle English Prose*, ed. A. S. G. Edwards, 19–31. Cambridge: D. S. Brewer.

———. 2005. *London Literature, 1300-1380*. Cambridge: Cambridge University Press.

———, ed. 2007. *Richard Rolle: Uncollected Prose and Verse with Related Northern Texts*. EETS 329. Oxford: Oxford University Press.

Hanna, Ralph, and Jeremy Griffiths. 2002. *Descriptive Catalogue of the Western Medieval Manuscripts of St. John's College Oxford*. Oxford: Oxford University Press.

Hanna, Ralph, and Traugott Lawler. 2005. "The Wife of Bath's Prologue." In Correale and Hamel 2003-5, 2:351–403.

Hanson-Smith, Elizabeth. 1979. "Woman's View of Courtly Love: The Findern Anthology." *Journal of Women's Studies in Literature* 1:179–94.

Hardman, Phillipa. 1978. "A Mediaeval 'Library *in parvo*.'" *Medium Aevum* 47:262–73.

———, ed. 2000. *Heege Manuscript: A Facsimile of National Library of Scotland MS Advocates 19.3.1*. Leeds: University of Leeds.

———. 2003. "Presenting the Text: Pictorial Tradition in Fifteenth-Century Manuscripts of the *Canterbury Tales*." In Finley and Rosenblum 2003, 37–72.

———. 2004. "'This Litel Child, His Litel Book': Narratives for Children in Late-Fifteenth-Century England." *Journal of the Early Book Society* 7:51–66.

Harpham Burrows, Jean. 1984. "Auchinleck Manuscript: Contexts, Texts and Audience." PhD diss., Washington University.

Harris, Kate. 1983. "Origins and Make-up of Cambridge University Library MS Ff.1.6." *Transactions of the Cambridge Bibliographical Society* 8:299–333.

Hassall, A. G and W. O. 1961. *The Douce Apocalypse*. London: Faber and Faber.

Hatfield Moore, Deborah. 2001. "Paying the Minstrel: A Cultural Study of B. L. Harley 913." PhD diss., Queen's University, Belfast.

Havelda, John, and Fred Wah. 2007. *Know Your Place*. Porto, Spain: de Corrida Edições.

Heale, Elizabeth. 1995. "Women and the Courtly Love Lyric: The Devonshire MS (BL Additional 17492)." *Modern Language Review* 90:296–313.

———. 2004. "'Desiring Women Writing': Female Voices and Courtly 'Balets' in Some Early Tudor Manuscript Albums." In *Early Modern Women's Manuscript Writing: Selected Papers from the Trinity/Trent Colloquium*, ed. Victoria E. Burke and Jonathan Gibson, 9–31. Aldershot: Ashgate.

Hibbard Loomis, Laura. 1962. *Adventures in the Middle Ages: A Memorial Collection of Essays and Studies by Laura Hibbard Loomis*. New York: Burt Franklin.

Hilmo, Maidie. 1997. "Retributive Violence and the Reformist Agenda in the Illustrated Douce 104 MS of *Piers Plowman*." *Fifteenth Century Studies* 23:13–48.

———. 2001. "Framing Chaucer's *Canterbury Tales* for the Aristocratic Readers of the Ellesmere Manuscript." In Kerby-Fulton and Hilmo 2001, 14–71.

———. 2004. *Medieval Images, Icons, and Illustrated English Literary*

Texts: From the Ruthwell Cross to the Ellesmere Chaucer.
Aldershot: Ashgate.

———. 2007. "The Clerk's 'Unscholarly Bow': Seeing and Reading Chaucer's Clerk from the Ellesmere MS to Caxton." *Journal of the Early Book Society* 10:71–105.

———. 2009. "Iconic Representations of Chaucer's Two Nuns and Their Tales from Manuscript to Print. In Kerby-Fulton 2009, 107–35.

Hindman, Sandra L. 1986. *Painting and Politics at the Court of Charles VI.* Toronto: Pontifical Institute of Mediaeval Studies.

Hines, John. 2004. *Voices in the Past: English Literature and Archaeology.* Cambridge: D. S. Brewer.

"History of St. Hubert's Idsworth." Online at: http://www .homeshed.plus.com/bcichurches_netobjects/html/ history_of_st__hubert_s_idswor.html.

Hobbins, Daniel. 2009. *Authorship and Publicity before Print: Jean Gerson and the Transformation of Late Medieval Learning.* Philadelphia: University of Pennsylvania Press.

Hoccleve, Thomas. 1999. *Thomas Hoccleve, The Regiment of Princes,* ed. Charles R. Blyth. Kalamazoo: Medieval Institute Publications.

Hodges, Laura F. 2001. "Sartorial Signs in *Troilus and Criseyde.*" *The Chaucer Review* 35:223–59.

Hodgson, Phyllis, ed. 1944. *Cloud of Unknowing and The Book of Privy Counselling.* EETS o.s 218. London: Oxford University Press.

Hodnett, Edward. 1973. *English Woodcuts 1480–1535.* Oxford: Oxford University Press.

Holsinger, Bruce W. 1999. "Langland's Musical Reader: Liturgy, Law, and the Constraints of Performance." *Studies in the Age of Chaucer* 21:99–141.

Holy Bible Translated from the Latin Vulgate and Diligently Compared with Other Editions in Divers Languages (Douai, A.D. 1609; Rheims, A.D. 1582) Published as Revised and Annotated by Authority. 1914. London: Burns Oats and Washbourne Ltd.

Hornstein, Lillian Herlands. 1940. "Trivet's Constance and the King of Tars." *Modern Language Notes* 55.5:354–57.

Horobin, Simon. 2005. "'In London and Opeland': The Dialect and Circulation of the C Version of *Piers Plowman.*" *Medium Aevum* 74:248–69.

———. 2009a. "The Scribe of Bodleian Library MS Bodley 619 and the Circulation of Chaucer's *Treatise on the Astrolabe.*" *Studies in the Age of Chaucer* 31:109–24.

———. 2009b. "Adam Pinkhurst and the Copying of B. L. Additional 35287 B-Text of Piers Plowman." *Yearbook of Langland Studies* 23:62–91.

———. 2010. "The Professionalization of Writing." In *The Oxford Handbook of Medieval Literature in English,* ed. Elaine Treharne and Greg Walker, 57–66. Oxford: Clarendon Press.

———. 2010. "The Scribe of Bodleian Library, MS Digby 102 and the Circulation of the C Text of *Piers Plowman.*" *Yearbook of Langland Studies* 24:89–112.

Horobin, Simon, and Linne Mooney. 2004. "A *Piers Plowman* Manuscript by the Hengwrt and Ellesmere Scribe and its Implications for London Standard English." *Studies in the Age of Chaucer* 26:65–112.

Horobin, Simon, and Jeremy Smith. 2002. *An Introduction to Middle English.* Edinburgh: Edinburgh University Press.

Horobin, Simon, and Anne Wiggins. 2008. "Reconsidering Lincoln's Inn MS 150." *Medium Aevum* 77:30–53.

Horrall, Sarah M. 1990. "Middle English Texts in a Carthusian Commonplace Book: Westminster Cathedral, Diocesan Archives, MS H.38." *Medium Aevum* 59:214–27.

Horstman, Carl, ed. 1973. *The Minor Poems of the Vernon Manuscript: Pt I.* Side-notes by F. J. Furnivall. EETS o.s. 98. Millwood, NY: Kraus. Orig. pub. in 1892 by Kegan Paul, Trench, Trübner.

Hoste, A., and C. H. Talbot, eds. 1971. *Aelredi Rievallensis: Opera Omnia.* Corpus Christianorum Continuatio Mediaevalis 1. Turnhout: Brepols.

Hudson, Anne, ed. 1993. *Two Wycliffite Texts.* EETS o.s. 301. Oxford: Oxford University Press.

———, ed. (1978) 1997. *Selections from English Wycliffite Writings.* Toronto: University of Toronto Press for the Medieval Academy.

———, ed. 2001. *The Works of a Lollard Preacher:* The Sermon *Omnis plantacio,* the Tract *Fundamentum aliud nemo potest ponere* and the Tract *De oblacione iugis sacrificii.* EETS o.s. 317. Oxford: Oxford University Press.

———. 2003. "Langland and Lollardy?" *The Yearbook of Langland Studies* 17:93–105.

Huntington Library Manuscript Catalogue. Digital Scriptorium. Online at: http://scriptorium.columbia.edu/ huntington/search.html. List of Manuscripts at: http:// sunsite3.berkeley.edu/hehweb/toc.html. List of Authors at: http://sunsite3.berkeley.edu/hehweb/authors.html. List of Titles at: http://sunsite3.berkeley.edu/hehweb/titles.html.

Hussey, S. S. 1989. "Audience for the Middle English Mystics." In *De Cella in Seculum: Religious and Secular Life and Devotion in Late Medieval England,* ed. Michael G. Sargent, 109–22. Cambridge: D. S. Brewer.

———. 1990. "Implications of Choice and Arrangement of Texts in Pt. 4." In Pearsall 1990, 61–74.

Ingledew, Francis John. 1989. "Jerusalem, Babylon, Camelot: The Concept of the Court in the 'Pearl'-poet." PhD diss., Washington University.

Irvine, Martin. 1992. "'Bothe Text and Gloss': Manuscript Form, the Textuality of Commentary, and Chaucer's Dream Poems." In Morse, Doob, and Woods 1992, 81–119.

Jeffrey, David L. 1975. "Franciscan Spirituality and the Rise of English Drama." *Mosaic* 8:17–46.

———. 2000. "Authors, Anthologists and Franciscan Spirituality." In Fein 2000c, 261–70.

Jewitt, Llewellyn. 1863. "Findern and the Fyndernes." *The Reliquary* 3:185–97.

Johnson, Ian R., ed. 1999a. "*Osbern Bokenham, Legendys of Hooly Wummen: Prologus.*" In Wogan-Browne et al. 1999, 64–72.

———, ed. 1999b. "*Speculum Devotorum (Myrowre to Devout Peple): Prefacyon* (Extract)." In Wogan-Browne et al. 1999, 73–78.

Johnston, Michael. 2007. "A New Document Relating to the Life of Robert Thornton." *The Library* 8, 7th ser.: 304–13.

———. 2009. "Robert Thornton and *The Siege of Jerusalem.*" *Yearbook of Langland Studies* 23:125–62.

———. Forthcoming. *Romance and the Gentry in Late Medieval England.*

Jones, Terry. 1985. *Chaucer's Knight, The Portrait of a Medieval Mercenary.* London: Methuen.

Jones, Terry, et al. 2003. *Who Murdered Chaucer: A Medieval Mystery*. New York: St. Martin's Press.

Julian of Norwich. *Revelations of Divine Love*. Christian Classics Ethereal Library. Online at: http://www.ccel.org/ccel/julian/revelations.iii.i.html.

Jurkowski, Maureen. 1997. "The 'Findern Manuscript' and the History of the Fynderne Family in the Fifteenth Century." In *Texts and Their Contexts: Papers from the Early Book Society*, ed. John Scattergood and Julia Boffey, 196–222. Dublin: Four Courts.

Kane, George, ed. 1960a. *Piers Plowman the A Version: Will's Visions of Piers Plowman and Do-Well*. London: Athlone Press.

———. 1960b. "Editorial Resources and Methods." In Kane 1960a, 115–72.

Kane, George, and E. Talbot Donaldson, eds. 1975. *Piers Plowman the B Version: Will's Visions of Piers Plowman, Do-Well, Do-Better and Do-Best*. London: Athlone Press.

Keiser, George R. 1979. "Lincoln Cathedral Library MS.91: Life and Milieu of the Scribe." *Studies in Bibliography* 32:158–79.

———. 1980. "MS. Rawlinson A.393: Another Findern Manuscript." *Transactions of the Cambridge Bibliographical Society* 7:445–48.

———. 1983. "More Light on the Life and Milieu of Robert Thornton." *Studies in Bibliography* 36:111–19.

———. 1984a. "'To Knawe God Almyghtyn': Robert Thornton's Devotional Book." *Analecta Cartusiana* 106:103–29.

———. 1984b. *The Middle English "Boke of Stones," the Southern Version*. Brussels: Brepols.

Kelliher, Hilton. 1977. "The Historiated Initial in the Devonshire Chaucer." *Notes and Queries* 222:197.

Kellogg, A. L. 1960. "Chaucer's Self-Portrait and Dante's." *Medium Aevum* 29:119–20.

Kendrick, Laura. 1999. *Animating the Letter: The Figurative Embodiment of Writing from Late Antiquity to the Renaissance*. Columbus: Ohio State University Press.

Kennedy, Ruth, ed. 2003. *Three Alliterative Saints' Hymns*. EETS o.s. 312. Oxford: Oxford University Press.

Ker, N. R, ed. 1963. *The Owl and the Nightingale: Reproduced in Facsimile from the Surviving Manuscripts, Jesus College, Oxford 29 and British Museum Cotton Caligula A. IX*. EETS o.s. 251. London: Oxford University Press.

———. 1964. *Medieval Libraries of Great Britain: A List of Surviving Books*. 2nd ed. London: Royal Historical Society.

———, ed. 1965. *Facsimile of British Museum MS Harley 2253*. EETS o.s. 255. London: Oxford University Press.

Kerby-Fulton, Kathryn. 1990. *Reformist Apocalypticism and Piers Plowman*. Cambridge: Cambridge University Press.

———. 1997. "Langland and the Bibliographic Ego." In *Written Work: Langland, Labour and Authorship*, ed. Steven Justice and Kathryn Kerby-Fulton, 65–141. Philadelphia: University of Pennsylvania Press.

———. 2000a. "Professional Readers of Langland at Home and Abroad: New Directions in the Political and Bureaucratic Codicology of *Piers Plowman*." In Pearsall 2000, 103–29.

———. 2000b. "Prophecy and Suspicion: Closet Radicalism, Reformist Politics, and the Vogue for Hildegardiana in Ricardian England." *Speculum* 75:318–41.

———. 2001. "Langland 'In His Working Clothes'? Scribe D, Authorial Loose Revision Material, and the Nature of Scribal Intervention." In Minnis 2001, 139–67.

———. 2003. "The Women Readers in Langland's Earliest Audience: Some Codicological Evidence." In *Learning and Literacy in Medieval England and Abroad*, ed. Sarah R. Jones, 121–34. Utrecht Studies in Medieval Literacy 3. Turnhout: Brepols.

———. 2006. *Books under Suspicion: Censorship and Tolerance of Revelatory Writing in Late Medieval England*. Notre Dame, IN: University of Notre Dame Press.

———, ed. 2009. *Women and the Divine in Literature before 1700*. English Literary Studies. Victoria, BC: University of Victoria.

———. Forthcoming. "Confronting the Scribe-Poet Binary: The Case of the Z Text and the Evidence of London Reading Circles." In *Yearbook of Langland Studies*.

Kerby-Fulton, Kathryn, and Denise Despres. 1999. *Iconography and the Professional Reader: The Politics of Book Production in the Douce Piers Plowman*. Medieval Cultures 15. Minneapolis: University of Minnesota Press.

Kerby-Fulton, Kathryn, and Maidie Hilmo, eds. 2001. *The Medieval Professional Reader at Work: Evidence from the Manuscripts of Chaucer, Langland, Kempe, and Gower*. English Literary Studies. Victoria, BC: University of Victoria.

Kerby-Fulton, Kathryn, and Steven Justice. 1998. "Reformist Intellectual Culture in the English and Irish Civil Service: The *Modus Tenendi Parliamentum* and its Literary Relations." *Traditio* 53:149–202.

———. 2001. "Scribe D and the Marketing of Ricardian Literature." In Kerby-Fulton and Hilmo 2001, 217–37.

Kerr, Berenice M. 1999. *Religious Life for Women c. 1100–c. 1350: Fontevraud in England*. Oxford: Clarendon Press.

Kiefer, Lauren. 2003. "Selections from Gower's *Confessio Amantis*." In *Medieval Literature for Children*, ed. Daniel T. Kline, 45–61. New York: Routledge.

Kinch, Ashby. 2007. "'To thenke what was in hir wille': A Female Reading Context for the Findern Anthology." *Neophilologus* 91:729–744.

King, Pamela M. 2008. "Morality Plays." In *Cambridge Companion to Medieval English Theatre*, 2nd ed., ed. Richard Beadle and Alan J. Fletcher, 235–62. Cambridge: Cambridge University Press.

Klages, Mary. 1997. "Michael Foucault: 'What is an Author?'" Online at: http://www.Colorado.EDU/English/ENGL2012Klages/1997foucault.html.

Kline, Barbara. 1999. "Scribal Agendas and the Text of Chaucer's Tales in British Library MS Harley 7333." In *Rewriting Chaucer: Culture, Authority and the Idea of the Authentic Text, 1400-1602*, ed. Thomas A. Prendergast and Barbara Kline, 116–44. Columbus: Ohio State University Press.

Knapp, Ethan. 2001. *The Bureaucratic Muse: Thomas Hoccleve and the Literature of Late Medieval England*. University Park: Pennsylvania State University Press.

Knight, Stephen, and Thomas Ohlgren, eds. 1999. *Robin Hood and the Outlaw Tales*. TEAMS: Middle English Texts Series. Kalamazoo: Medieval Institute Publications.

Knott, Thomas A., and David C. Fowler, eds. 1952. *Piers the Plowman: A Critical Edition of the A-Version*. Baltimore: Johns Hopkins University Press.

Kocijančič-Pokorn, Nike. 1995. "Original Audience of *The Cloud of Unknowing* (In Support of Carthusian Authorship)." *Analecta Cartusiana* 130:60–77.

Kogman-Appel, Katrin. 2006. *Illuminated Haggadot from Medieval Spain: Biblical Imagery and the Passover Holiday*. University Park: Pennsylvania State University Press.

Koster Tarvers, Josephine. 1992. "'Thys ys my mystrys boke': English Women as Readers and Writers in Late Medieval England." In Morse, Doob, and Woods 1992, 305–27.

Krochalis, Jeanne. 1986. "Benedictine Rule for Nuns: Library of Congress, MS 4." *Manuscripta* 30:21–34.

Krug, Rebecca. 2002. *Reading Families: Women's Literate Practice in Late Medieval England*. Ithaca, NY: Cornell University Press.

Lagorio, Valerie. 1981. "Problems in Middle English Mystical Prose." In *Middle English Prose: Essays on Bibliographical Problems*, ed. A. S. G. Edwards and Derek Pearsall, 129–48. New York: Garland Publishing.

Laird, Edgar. 1999. "Geoffrey Chaucer and Other Contributors to the *Treatise on the Astrolabe*." In *Rewriting Chaucer: Culture, Authority, and the Idea of the Authentic Text, 1400-1602*, ed. Thomas A. Prendergast and Barbara Kline, 145–65. Columbus: Ohio State University Press.

Lancashire, Ian. 1984. *Dramatic Texts and Records of Britain: A Chronological Typography to 1558*. Toronto: University of Toronto Press.

Langdell, Sebastian. Forthcoming. "From Conversation to Conversation: A Study of Speech-Markers in the Early to Mid-Fifteenth Century Hocclevian Manuscript Tradition."

Latham, R. E. 1965. *Revised Medieval Latin Word-List from British and Irish Sources*. London: Oxford University Press.

Lawton, David, ed. 1982. *Middle English Alliterative Poetry and its Literary Background: Seven Essays*. Cambridge: D. S. Brewer.

Lee, Jennifer A. 1977. "The Illuminating Critic." *Studies in Iconography* 3:17–46.

Lerer, Seth. 1993. "Writing Like the Clerk: Laureate Poets and the Aureate World." In *Chaucer and His Readers*, 22–56. Princeton: Princeton University Press.

Lewis, Katherine J. 1999. "Model Girls? Virgin-Martyrs and the Training of Young Women in Late Medieval England." In *Young Medieval Women*, ed. Katherine Lewis, Noël James Menuge and Kim M. Phillips, 25–46. Phoenix Mill, Gloucestershire: Sutton Publishing.

Lewis, Robert E., ed. 1978. *Lotario dei Segni (Pope Innocent III): De Miseria Condicionis Humane*. Athens,: University of Georgia Press.

———. 1981. "Relationship of the Vernon and Simeon Texts of the *Pricke of Conscience*." In *So Meny People, Longages and Tonges: Philological Essays in Scots and Mediaeval English Presented to Angus McIntosh*, ed. Michael Benskin and M. L. Samuels, 251–64. Edinburgh: Middle English Dialect Project.

Lewis, Robert, and Angus McIntosh. 1982. *A Descriptive Guide to the Manuscripts of the "Pricke of Conscience."* Oxford: Medium Aevum Monographs.

Liu, Yin. 2005. "Richard Beauchamp and the Uses of Romance." *Medium Aevum* 74:271–87.

Lochrie, Karma. 1991. *Margery Kempe and Translations of the Flesh*. Philadelphia: University of Pennsylvania Press.

Lowes, John Livingston. 1908. "The Date of Chaucer's *Troilus and Criseyde*." *Publications of the Modern Language Association* 23:285–306.

Lucas, Angela, ed. 1995. *Anglo-Irish Poems of the Middle Ages*. Dublin: Columba.

Lucas, Angela, and Peter Lucas. 1990. "Reconstructing a Disarranged Manuscript: The Case of MS Harley 913, a Medieval Hiberno-English Miscellany." *Scriptorium* 44:286–99.

Lucas, Peter J. 1969. "John Capgrave O.S.A. (1393-1464), Scribe and 'Publisher.'" *Transactions of the Cambridge Bibliographical Society* 5:1–35.

Lumiansky, R. M., and David Mills, eds. 1973. *Chester Mystery Cycle: A Facsimile of MS Bodley 175*. Leeds: University of Leeds.

———. 1983. *Chester Mystery Cycle: Essays and Documents*. Chapel Hill: University of North Carolina Press.

Lydgate, John. 1966. "The Life of Our Lady." In *John Lydgate: Poems*. Intro., notes, and glossary by John Norton-Smith. Oxford: Clarendon Press.

Lydon, James. 1984. "The Middle Nation." In *The English in Medieval Ireland: Proceedings of the First Joint Meeting of the Royal Irish Academy and the British Academy*, ed. James Lydon, 1–26. Dublin: Royal Irish Academy.

MacBain, W. 1958. "Literary Apprenticeship of Clemence of Barking." *Journal of the Australasian Universities Language and Literature Association* 9:3–22.

Macrae-Gibson, O. D., ed. 1979. *Of Arthour and of Merlin*. Vol. 2, *Introduction, Notes, Glossary*. EETS 279. Oxford: Clarendon Press.

Manly, John M., and Edith Rickert. 1940a. *Descriptions of the Manuscripts*. Vol. 1 of *The Text of the Canterbury Tales: Studied on the Basis of All Known Manuscripts*. Chicago: University of Chicago Press.

———, eds. 1940b. *The Text of the Canterbury Tales: Studied on the Basis of All Known Manuscripts*. 8 vols. Chicago: University of Chicago Press.

Mann, Jill. 1973. *Chaucer and Medieval Estates Satire: The Literature of the Social Classes and the General Prologue to the Canterbury Tales*. Cambridge: Cambridge University Press.

Marshall, Ann. 2009. "Medieval Wall Painting in the English Parish Church." Online at: http://www.paintedchurch.org/.

Marshall, John. 1997. "'O ʒe souerens þat sytt and ʒe brothern þat stonde ryght wppe': Addressing the Audience of *Mankind*." *European Medieval Drama* 1:189–202.

Marshall, Simone Celine. 2002. "Notes on Cambridge University Library MS Ff.1.6." *Notes and Queries* 247:439–42.

Mason, Emma. 1984. "Legends of the Beauchamps' Ancestors: The Use of Baronial Propaganda in Medieval England." *Journal of Medieval History* 10:25–40.

Mather, Frank Jewett. 1912. "Dante Portraits." *Romanic Review* 3:117–22.

Matsuda, Takami. 2007. "*Sir Gawain and the Green Knight* and St Patrick's Purgatory." *English Studies* 88.5:497–505.

Mays, John B. 1995. *In the Jaws of the Black Dogs: A Memoir of Depression*. Toronto: Penguin.

Mazur, Ann. Forthcoming. "The Early Readers of Troilus." PhD diss., University of Virginia.

McAlindon, T. 1963. "The Emergence of a Comic Type in Middle-English Narrative: The Devil and Giant as Buffoon." *Anglia* 81:365–71.

McDonald, Nicola F. 2000. "Chaucer's *Legend of Good Women*, Ladies at Court, and the Female Reader." *The Chaucer Review* 35:22–42.

McGurk, P., ed. and trans. 1998. *Chronicle of John of Worcester: Volume III*. Oxford: Clarendon Press.

McIntosh, Angus. 1962. "The Textual Transmission of the Alliterative *Morte Arthure*." In *English and Medieval Studies Presented to J. R. R. Tolkien on the Occasion of His Seventieth Birthday*, ed. Norman Davis and C. L. Wrenn, 231–40. London: George Allen and Unwin Ltd.

———. 1963. "A New Approach to Middle English Dialectology." *English Studies* 44:1–11.

McIntosh, Angus, and Michael L. Samuels. 1968. "Prolegomena to a Study of Medieval Anglo-Irish." *Medium Aevum* 37:1–11.

McIntosh, Angus, Michael L. Samuels, and Michael Benskin. 1986–87. *A Linguistic Atlas of Late Medieval English*. 5 vols. Aberdeen: Aberdeen University Press.

McMunn, Meradith Tilbury. 1975. "Children and Literature in Medieval France." *Children's Literature* 4:51–58.

McMurray Gibson, Gail. 1981. "Bury St. Edmunds, Lydgate, and the N-Town Cycle." *Speculum* 56:56–90.

———. 1986. "Play of *Wisdom* and the Abbey of St. Edmunds." In *Wisdom Symposium: Papers from the Trinity College Medieval Festival*, ed. Milla Cozart Riggio, 39–66. New York: AMS Press.

———. 1989. *Theater of Devotion: East Anglian Drama and Society in the Late Middle Ages*. Chicago: University of Chicago Press.

McNamer, Sarah. 1991. "Female Authors, Provincial Setting: The Re-Versing of Courtly Love in the Findern Manuscript." *Viator* 22:279–310.

———. 2003. "Lyrics and Romances." In *Cambridge Companion to Medieval Women's Writing*, ed. Carolynn Dinshaw and David Wallace, 195–209. Cambridge: Cambridge University Press.

McSparran, Frances, and P. R. Robinson, eds. 1979. *Cambridge University Library MS Ff.2.38*. London: Scolar Press.

Meale, Carol M. 1990. "The Miracles of Our Lady: Content and Interpretation." In Pearsall 1990, 115–36.

———, ed. 1996. *Women and Literature in Britain, 1150–1500*. 2nd ed. Cambridge: Cambridge University Press.

———. 1999. "Tale and the Book: Readings of Chaucer's *Legend of Good Women* in The Fifteenth Century." In *Chaucer in Perspective: Middle English Essays in Honour of Norman Blake*, ed. Geoffrey Lester, 118–38. Sheffield: Academic Press.

———. 2006. "Chronology: Women and Literature in Britain, 1150–1500." In *Women and Literature in Britain, 1150–1500*, ed. Carol Meale, xi–xxxviii. Cambridge: Cambridge University Press.

Meech, Sanford Brown, and Hope Emily Allen, eds. 1940. *Book of Margery Kempe: The Text from the Unique Ms. Owned by Colonel W. Butler-Bowdon*. EETS o.s. 212. London: Oxford University Press.

Meredith, Peter. 1991. "Manuscript, Scribe and Performance: Further Looks at the N. Town Manuscript." In *Regionalism in Late Medieval Manuscripts and Texts*, ed. Felicity Riddy, 109–25. Cambridge: D. S. Brewer.

Meredith, Peter, and Stanley J. Kahrl, eds. 1977. *N-Town Plays: A Facsimile of British Library MS Cotton Vespasian D VIII*. Leeds: University of Leeds.

Middle English Dictionary. Online at: http://quod.lib.umich.edu/m/med/lookup.html.

Middleton, Anne. 1982. "The Audience and Public of 'Piers Plowman.'" In *Middle English Alliterative Poetry and Its Literary Background: Seven Essays*, ed. David Lawton, 101–23. Cambridge: D. S. Brewer.

Millett, Bella. 1992. "Origins of *Ancrene Wisse*: New Answers, New Questions." *Medium Aevum* 61:206–28.

Millett, Bella, E. J. Dobson and Richard Dance, eds. 2005. *Ancrene Wisse: A Corrected Edition of the Text in Cambridge, Corpus Christi College MS 402, with Variants from other MSS.* Vol. 1. EETS 325. Oxford: Oxford University Press.

Mills, Maldwyn, ed. 1973. *Six Middle English Romances*. London: J. M. Dent & Sons.

Minnis, Alastair. 1984. "*Cloud of Unknowing* and Walter Hilton's *Scale of Perfection*." In *Middle English Prose: A Critical Guide to Major Authors and Genres*, ed. A. S. G. Edwards, 61–81. New Brunswick, NJ: Rutgers University Press.

———. 1988. *Medieval Theory of Authorship: Scholastic Literary Attitudes in the Later Middle Ages*. 2nd ed. Philadelphia: University of Pennsylvania Press.

———. 1992. "Authors in Love: The Exegesis of Late Medieval Love Poets." In Morse, Doob, and Woods 1992, 161–92.

———, ed. 2001. *Middle English Poetry: Texts and Traditions: Essays in Honour of Derek Pearsall*. Yorks Manuscripts Conferences: Proceedings Series 5. York: York Medieval Press.

———. 2008. "*Nolens Auctor sed Compilator Reputari*: The Late Medieval Discourse of Compilatio. In *La méthode critique au Moyen Age*, ed. M. Chazan et G. Dahan, 47–62. Turnhout: Brepols.

———. 2009. *Translations of Authority in Medieval English Literature*. Cambridge: Cambridge University Press.

Mooney, Linne R. 2006. "Chaucer's Scribe." *Speculum* 81:97–138.

———. 2007. "Some New Light on Thomas Hoccleve." *Studies in the Age of Chaucer* 29:293–340.

———. 2008. "Locating Scribal Activity in Medieval London." In *Design and Distribution of Late Medieval Manuscripts in England*, ed. Margaret Connolly and Linne Mooney, 183–204. York: York Medieval Press.

———. 2011. "A Holograph Copy of Hoccleve's *Regiment of Princes*." *Studies in the Age of Chaucer* 33:263–96.

Mooney, Linne, Simon Horobin, and Estelle Stubbs. 2011. Identification of the Scribes Responsible for Copying Major Works of Middle English Literature, website supported by the Arts and Humanities Research Council of the UK, 2007–11. http://www.medievalscribes.com/ (mounted October 3, 2011, so not available to the present authors).

Mooney, Linne R., and Estelle Stubbs. Forthcoming. *Scribes and the City: London Guildhall Clerks and the Dissemination of Middle English Literature 1375–1425*. York: York Medieval Press. (Not available to the present authors.)

Moorman, Charles. 1975. *Editing the Middle English Manuscript*. Jackson: University Press of Mississippi.

Moran, James. (1960) 2003. *Wynken de Worde: Father of Fleet Street*. London: British Library and Oak Knoll Press in association with The Wynken de Worde Society.

Mordkoff, Judith Crounse. 1980. "Making of the Auchinleck Manuscript: The Scribes at Work." PhD diss., University of Connecticut.

Morris, Richard, ed. 1874–93. *Cursor Mundi.* 7 vols. EETS o.s. 57, 59, 62, 66, 68, 99, and 101. London: Oxford University Press.

Morse, C. C., P. R. Doob, and M. C. Woods, eds. 1992. *The Uses of Manuscripts in Literary Studies: Essays in Memory of Judson Boyce Allen.* Studies in Medieval Culture 31. Kalamazoo: Medieval Institute Publications.

Mosser, Daniel W. 2000. The Hengwrt Chaucer Digital Facsimile: Manuscript Description (2000). Online at: http://www.canterburytalesproject.org/pubs/HGMsDesc.html#N5.

———. 2008. "'Chaucer's Scribe,' Adam and the Henwgrt Project." In *Design and Distribution of Late Medieval Manuscripts in England,* ed. Margaret Connolly and Linne Mooney, 11–40. York: York Medieval Press.

A New Index of Middle English Verse. 2005. Julia Boffey and A. S. G Edwards. London: British Library. Updates and preserves the numeration of the original, *The Index of Middle English Verse* by Carleton Brown and Rossell Hope Robbins (New York: Printed for the Index Society by Columbia University Press, 1943)

Newman, Barbara. 2005. "What Did It Mean to Say 'I Saw'?: The Clash between Theory and Practice in Medieval Visionary Culture." *Speculum* 80 (2005): 1–43.

Noble, Thomas F. X. 2009. *Images, Iconoclasm, and the Carolingians.* Philadelphia: University of Pennsylvania Press.

Nolan, Maura. 2005. *John Lydgate and the Making of Public Culture.* Cambridge: Cambridge University Press.

Ogilvie-Thomson, S. J., ed. 1988. *Richard Rolle: Prose and Verse Edited from Longleat MS 29 and Related MSS.* Oxford: Oxford University Press.

Olsen, Kenna L. 2011. *Cleanness: A Diplomatic Edition with Textual, Codicologial, and Paleographical Notes.* Calgary: Publications of the Cotton Nero A.x. Project 1. Online at: http://www.gawain-ms.ca.

Olsen, Kenna L., and Murray McGillivray. 2011. *Cotton Nero A.x. Project Transcription Policy.* Calgary: Publications of the Cotton Nero A.x. Project 2. Online at: http://www.gawain-ms.ca.

Olson, Linda. Forthcoming. "To Make 'Jolite' of *Wisdom* and 'Harlotrie' of *Mankind*: Learning to Play in the Macro Manuscript."

Olson, Linda, and Kathryn Kerby-Fulton, eds. 2005. *Voices in Dialogue: Reading Women in the Middle Ages.* Notre Dame, IN: University of Notre Dame Press.

Olson, Mary C. 2003. "Marginal Portraits and the Fiction of Orality." In Finley and Rosenblum 2003, 1–35.

Olsson, Kurt. 1992. *John Gower and the Structures of Conversion.* Cambridge: D. S. Brewer.

Orme, Nicholas. 2001. *Medieval Children.* New Haven: Yale University Press.

O'Sullivan, Robin Anne. 2006. "School of Love: Marguerite Porete's *Mirror of Simple Souls.*" *Journal of Medieval History* 32:143–62.

Owen, Charles A. 1987. "*Troilus and Criseyde*: The Question of Chaucer's Revisions." *Studies in the Age of Chaucer* 9:155–72.

———. 1991. *Manuscripts of the Canterbury Tales.* Woodbridge, Suffolk, UK: D. S. Brewer.

Page, William, ed. 1975. *Victoria History of the County of Suffolk.* Vol. 2. Rpt. London: University of London.

Paquette, Johanne. 2009. "Male Approbation in the Sixteenth-Century Glosses to the Book of Margery Kempe." In Kerby-Fulton 2009, 153–69.

Park, David, and Sharon Cather. 2004. "Late Medieval Wall Paintings at Carlisle." In *Carlisle and Cumbria: Roman and Medieval Art and Archaeology,* ed. Mike McCarthy and David Weston, 214–31. Leeds: British Archaeological Association and Maney Publishing.

Parkes, Malcolm B. 1969. *English Cursive Book Hands 1250-1500.* Oxford: Clarendon Press.

———. 1976. "The Influence of the Concepts of *Ordinatio* and *Compilatio* on the Development of the Book." In *Medieval Learning and Literature: Essays Presented to R. W. Hunt,* ed. J. J. G. Alexander and M. T. Gibson, 115–43. Oxford: Clarendon Press.

———. 1978. "Punctuation, Pause and Effect." In *Medieval Eloquence,* ed. James J. Murphy, 127–140. Berkeley: University of California Press.

———. 1979a. *English Cursive Book Hands, 1250-1500.* Rpt. London: Scolar.

———. 1979b. *The Medieval Manuscripts of Keble College, Oxford: A Descriptive Catalogue.* London: Scolar Press.

———. 1991a. *Scribes, Scripts and Readers: Studies in the Communication, Presentation and Dissemination of Medieval Texts.* London: Hambledon Press.

———. 1991b. "The Literacy of the Laity." In *Studies in the Communication, Presentation, and Dissemination of Manuscripts,* ed. David Daiches and Anthony Thorlby, 555–77. London: Aldus.

———. 1993. *Pause and Effect: Punctuation in the West.* Berkeley: University of California Press.

———. 2008. *Their Hands before Our Eyes: A Closer Look at Scribes.* Aldershot: Ashgate.

Parsons, Kelly. 2001. "Red Ink Annotator of *The Book of Margery Kempe* and His Lay Audience." In Kerby-Fulton and Hilmo 2001, 143–216.

Partridge, Stephen. 1992. "Glosses in the Manuscripts of Chaucer's Canterbury Tales: An Edition and Commentary." PhD diss., Harvard University.

———. 1993. "The *Canterbury Tales* Glosses and the Manuscript Groups." In *The Canterbury Tales Project Occasional Papers,* ed. Norman Blake and Peter Robinson, vol. 1, 85–94. Oxford: Office for Humanities Communication.

———. 1996. "The Manuscript Glosses in the Wife of Bath's Prologue." In *The Wife of Bath's Prologue on CD-ROM,* ed. Peter Robinson. The Canterbury Tales Project. Cambridge: Cambridge University Press.

———. 1997. "Review of *The Ellesmere Chaucer: Essays in Interpretation.*" *Speculum* 73:885–90.

———. 2000. "Minding the Gaps: Interpreting the Manuscript Evidence of the *Cook's Tale* and the *Squire's Tale.*" In *The English Medieval Book: Studies in Memory of Jeremy Griffiths,* ed. A. S. G. Edwards, Vincent Gillespie, and Ralph Hanna, 51–85. London: British Library.

Patterson, Lee. 1987. *Negotiating the Past: The Historical Understanding of Medieval Literature.* Madison: University of Wisconsin Press.

Pearsall, Derek. 1970. *John Lydgate.* Charlottesville: University Press of Virginia.

———. 1977a. "The Iconography of Chaucer in Hoccleve's *De*

Regime Principum and in the *Troilus* Frontispiece." *The Chaucer Review* 11:338–50.

———. 1977b. "The *Troilus* Frontispiece and Chaucer's Audience." *The Yearbook of English Studies* 7:68–74.

———. 1981. "The 'Ilchester' Manuscript of Piers Plowman." *Neuphilologische Mitteilungen* 82:181–93.

———. (1978) 1982. *Piers Plowman by William Langland: An Edition of the C-Text*. Berkeley: University of California Press.

———, ed. 1984. *The Nun's Priest's Tale, A Variorum Edition of the Works of Geoffrey Chaucer*. Vol. 2, pt. 9. Norman: University of Oklahoma Press.

———. 1985. *The Canterbury Tales*. New York: G. Allen & Unwin.

———. 1989. "Gower's Latin in the *Confessio Amantis*." In *Latin and Vernacular: Studies in Late-Medieval Texts and Manuscripts*, ed. Alastair Minnis, 13–25. York Manuscripts Conference, Proceedings Series 1. Cambridge: D. S. Brewer.

———, ed. 1990. *Studies in the Vernon Manuscript*. Cambridge: D. S. Brewer.

———. 1992. *The Life of Geoffrey Chaucer: A Critical Biography*. Oxford: Blackwell.

———, ed. 1994a. *Piers Plowman: The C-Text*. Exeter Medieval English Texts and Studies. Exeter: University of Exeter Press.

———. 1994b. "Hoccleve's *Regement of Princes*: The Poetics of Royal Self- Representation." *Speculum* 69.2:386–410.

———. 1997. *John Lydgate (1371-1449): A Bio-bibliography*. English Literary Studies. Victoria, BC: University of Victoria.

———, ed. 2000. *New Directions in Later Medieval Manuscript Studies: Essays from the 1998 Harvard Conference*. Woodbridge, Suffolk, UK: Boydell and Brewer.

———. 2004. "The Manuscripts and Illustrations of Gower's Works." In *A Companion to Gower*, ed. Siân Echard, 73–97. Cambridge: D. S. Brewer.

———, ed. 2008. *Piers Plowman: A New Annotated Edition of the C-Text*. Exeter: University of Exeter Press.

Pearsall, Derek, and I. C. Cunningham, eds. 1977. *The Auchinleck Manuscript: National Library of Scotland Advocates' MS 19.2.1*. London: Scolar Press.

Pearsall, Derek, and Kathleen Scott, eds. 1992. *Piers Plowman: A Facsimile of Bodleian Library, Oxford, MS Douce 104*. Cambridge: D. S. Brewer.

Pearson, Andrea. 2005. "Spirituality, Authority, and Monastic Vows: An Antependium from the Community of Flines." In *Cistercian Nuns and Their World*, ed. Meredith Parsons Lillich, 323–63. Studies in Cistercian Art and Architecture 6. Kalamazoo: Cistercian Publications.

Peck, Russell, and Andrew Galloway, eds. 2006. *John Gower, Confessio Amantis*. Kalamazoo: Medieval Institute Publications.

Perryman, Judith. 1980. *The King of Tars: Edited from the Auchinleck MS, Advocates 19.2.1*. Middle English Texts 12. Heidelberg: Carl Winter.

Petti, Anthony G. 1977. *English Literary Hands from Chaucer to Dryden*. Cambridge, MA: Harvard University.

Philips, Chris. "Links and Bibliography on Heraldry." Online at: http://www.medievalgenealogy.org.uk/links/herrefs.shtml.

Phillips, Kim M. 2007. "Masculinities and the Medieval English Sumptuary Laws." *Gender and History* 19:22–42.

Philippus Presbyter. 1527. *In Historiam Iob Commemtariorum Libri Tres [sic]*. Basileae: Per Adamum Petrum.

Piehler, Paul. 1971. *The Visionary Landscape: A Study in Medieval Allegory*. London: Arnold.

Piper, Alan, and Meryl Foster. 1989. "Evidence of the Oxford Booktrade, about 1300." *Viator* 20:155–59.

Piper, Edwin Ford. 1924. "The Miniatures of the Ellesmere Chaucer." *Philological Quarterly* 3:241–56.

Pollard, Graham. 1978. "The *Pecia* System in the Medieval Universities." In *Medieval Scribes, Manuscripts, and Libraries: Essays Presented to N. R. Ker*, ed. M. B. Parkes and Andrew G. Watson, 145–61. London: Scolar Press.

Pratt, R. A. 1966. "Chaucer and the Hand that Fed Him." *Speculum* 41:619–42.

Preston, Jean, and Laetitia Yeandle. 1992. *English Handwriting, 1400-1650*. Binghamton, NY: Medieval and Renaissance Texts and Studies.

Price, A. Lindsay. 1994. *Swans of the World: In Nature, History, Myth, and Art*. Tulsa, OK: Council Oak Books.

Prime, Cecil T. 1960. *The New Naturalist: Lords and Ladies*. London: Collins.

Pseudo-Dionysius, the Areopagite. (1894) 2004. *The Celestial and Ecclesiastical Hierarchy of Dionysius the Areopagite*. Trans. John Parker. London, Keffington. Rpt. Whitefish, MT: Kessinger Publishing.

Radulescu, Raluca L. 2003. *The Gentry Context for Malory's Morte Darthur*. Cambridge: D. S. Brewer.

Raymo, Robert. 1986. "Works of Religious and Philosophical Instruction." In *A Manual of Writings in Middle English*, vol. 7, ed. Albert Hartung and J. Burke Severs, 2490–91. New Haven: Connecticut Academy of Arts and Sciences.

Reeves, Majorie, and Beatrice Hirsch-Reich. 1972. *The "Figurae" of Joachim of Fiore*. Oxford: Clarendon Press.

Reitz, Joan M. ODLIS—Online Dictionary for Library and Information Science. Online at http://lu.com/odlis/search.cfm.

Revard, Carter. 2000. "Scribe and Provenance." In Fein 2000c, 21–109.

———. 2004. "The Wife of Bath's Grandmother: Or, How Both Then Preached This Gospel throughout England and Ireland." *The Chaucer Review* 39:117–36.

———. 2007. "Oppositional Thematics and Metanarrative in MS Harley 2253, Quires 1–6." In Scase 2007, 95–112.

Richardson, Frances E., ed. 1965. *Sir Eglamour of Artois*. EETS 256. Oxford: Oxford University Press.

Rickert, Margaret. 1940. "Illumination." In Manly and Rickert 1940a, 561–605.

Riddy, Felicity. 2005. "Text and Self in *The Book of Margery Kempe*." In Olson and Kerby- Fulton 2005, 435–53.

Riddy, Felicity, and Nicholas Watson. 2005. "Afterwords." In Olson and Kerby-Fulton 2005, 454–57.

Riehle, Wolfgang. 1981. *The Middle English Mystics*. London: Routledge & Kegan Paul.

Riggio, Milla Cozart, ed. 1998. *The Play of Wisdom: Its Texts and Contexts*. New York: AMS Press, Inc.

The Riverside Chaucer. 1987. Ed. Larry D. Benson et al. 3rd ed. Boston: Houghton Mifflin.

Robbins, R. H. 1940. "Two Fourteenth-Century Mystical Poems." *Modern Language Review* 35:320–29.

———. 1954. "Findern Anthology." *Publications of the Modern Language Association* 69:610–42.

Roberts, Jane. 2005. *Guide to Scripts Used in English Writings up to 1500*. London: British Library.

———. 2011. "On Giving Scribe B a Name." *Medium Aevum* 80:231–54.

Robertson, Mary. "Description of the Discovery of Adam Pinkhurst." Online at: http://www.huntington.org/uploadedFiles/Files/PDFs/S06frontiers.pdf.

Rogers, Linda. 2009. "Pat Carfra: Song of the Storycatcher." *Focus* 21.10:16–17.

Root, Robert K. 1914. *The Manuscripts of Chaucer's Troilus: With Collotype Facsimiles of the Various Handwritings*. Chaucer Society, 1st ser. 98. London: Oxford University Press.

Rose, Christine M. 2001. "Chaucer's Man of Law's Tale: Teaching Through the Sources." *College Literature* 28.1:155–77.

Rosenblum, Joseph, and William K. Finley. 2003. "Chaucer Gentrified: The Nexus of Art and Politics in the Ellesmere Miniatures." *The Chaucer Review* 38:140–57.

Rouse, Robert Allen. 2008. "For King and Country? The Tension between National and Regional Identities in *Sir Bevis of Hampton*." In *Sir Bevis of Hampton in Literary Tradition*, ed. Jennifer Fellows and Ivana Djordjević, 114–26. Cambridge: D. S. Brewer.

Rufinus. 1842. "A Commentary on the Apostle's Creed." In *A Select Library of Nicene and Post-Nicene Fathers of the Christian Church*. 2nd ser., vol. 3. Oxford: James Parker.

Russell, George., and George Kane, eds. 1997. *Piers Plowman: The C Version*. London: Athlone.

Russell, Robert D. 1994. "'A Similitude of Paradise': The City as Image of the City." In *The Iconography of Heaven*, ed. Clifford Davidson, 146–61. Kalamazoo: Medieval Institute Publications.

Rycraft, Ann. 1973. *English Mediaeval Handwriting*. York, UK: Borthwick Institute, University of York.

Saenger, Paul. 1989. *A Catalogue of the Pre-1500 Western Manuscript Books at the Newberry Library*. Chicago: University of Chicago Press.

Sajavaara, Kari. 1967. "Relationship of the Vernon and Simeon Manuscripts." *Neuphilologische Mitteilungen* 68:428–39.

Salter, Elizabeth. 1967. "Introduction." In Salter and Pearsall 1967, 1–58.

———. 1988. *English and International: Studies in the Literature, Art, and Patronage of Medieval England*. Ed. Derek Pearsall and Nicolette Zeeman. Cambridge: Cambridge University Press.

Salter, Elizabeth, and Derek Pearsall, eds. 1967. *Piers Plowman*. York Medieval Texts. Evanston, IL: Northwestern University Press.

———. 1980. "Pictorial Illustration and Late Medieval Poetic Texts: The Role of the Frontispiece or Prefatory Miniature." In *Medieval Iconography and Narrative*, ed. Flemming G. Andersen et al., 100–23. Odense: Odense University Press.

Samuels, M. L. 1963. "Some Applications of Middle English Dialectology." *English Studies* 44:81–94.

Sandler, Lucy Freeman. 1989. "Notes for the Illuminator: The Case of the *Omne Bonum*." *Art Bulletin* 71:550–64.

———. 1996. *Omne Bonum: A Fourteenth-Century Encyclopedia of Universal Knowledge, British Library MSS Royal 6 E VI-6 E VII*. 2 vols. London: Harvey Miller.

———. 2004. *The Lichtenthal Psalter and the Manuscript Patronage of the Bohun Family*. London: Harvey Miller.

Sargent, Michael G. 1976. "Transmission by the English Carthusians of Some Late Medieval Spiritual Writings." *Journal of Ecclesiastical History* 27:225–40.

———. 1981. "Contemporary Criticism of Richard Rolle." *Analecta Cartusiana* 55:160–87.

———. 1983. "Walter Hilton's *Scale of Perfection*: The London Manuscript Group Reconsidered." *Medium Aevum* 52:189–216.

———. 1984. *James Grenehalgh as Textual Critic*. 2 vols. Salzburg: Institut für Anglistik und Amerikanistik.

———, ed. 2005. *The Mirror of the Blessed Life of Jesus Christ: A Full Critical Edition*. Exeter: University of Exeter Press.

Scase, Wendy. 1987. "Two *Piers Plowman* C-Text Interpolations: Evidence for a Second Textual Tradition." *Notes and Queries* n.s. 34:456–63.

———. 1989. *Piers Plowman and the New Anticlericalism*. Cambridge: Cambridge University Press.

———, ed. 2007. *Essays in Manuscript Geography: Vernacular Manuscripts of the English West Midlands from the Conquest to the Sixteenth Century*. Medieval Texts and Cultures of Northern Europe 10. Turnhout: Brepols.

Scattergood, John. 2000. "Authority and Resistance: The Political Verse." In Fein 2000c, 163–201.

———. 2001. "'Iste Liber Constat Johanni Mascy': Dublin, Trinity College, MS 155." In Minnis 2001, 91–101.

Schaap, Tanya. 2001. "From Professional to Private Readership: A Discussion and Transcription of the Fifteenth- and Sixteenth-Century Marginalia in *Piers Plowman* C-Text, Oxford, Bodleian Library, MS Digby 102." In *The Medieval Reader: Reception and Cultural History in the Late Medieval Manuscript*, ed. Kathryn Kerby-Fulton and Maidie Hilmo, 81–116. Studies in Medieval and Renaissance History, 3rd ser., vol. 1. New York: AMS Press.

Schibanoff, Susan. (1988) 1998. "The New Reader and Female Textuality in Two Early Commentaries on Chaucer." In *Writing after Chaucer: Essential Readings in Chaucer and the Fifteenth Century*, ed. Daniel J. Pinti, 45–80. Basic Reading in Chaucer and His Time 1. New York: Garland.

Schirmer, Walter F. 1952. *John Lydgate: A Study in the Culture of the XVth Century*. Trans. Ann E. Keep. London: Methuen and Co.

Schlauch, Margaret. 1941. "The Man of Law's Tale." In *Sources and Analogues of Chaucer's Canterbury Tales*, ed. W. F. Bryan and Germaine Dempster, 155–206. Chicago: University of Chicago Press.

Schleif, Corine, and Volker Schier. 2009. *Katerina's Windows: Donations and Devotion, Art and Music, As Heard and Seen through the Writings of a Brigittine Nun*. University Park: Pennsylvania State University Press.

Schmidt, A. V. C., ed. (1978) 1987. *William Langland: The Vision of Piers Plowman*. London: J. M. Dent and Sons.

———, ed. 1995–2008. *Piers Plowman: A Parallel-Text Edition of the A, B, C and Z Versions*. 2 vols. London: Longman.

Schmitt, Natalie Crohn. 1969. "Was There a Medieval Theatre in the Round? A Re- Examination of the Evidence." *Theatre Notebook* 23:130–42, and 24:18–25.

Schulz, H. C. 1937. "Thomas Hoccleve, Scribe." *Speculum* 12:71–81.

———. 1966. *The Ellesmere Manuscript of Chaucer's Canterbury Tales*. San Marino, CA: Huntington Library Press.

Scott, Kathleen L. 1982. "Lydgate's *Lives of Saints Edmund and*

Fremund: A Newly-Located Manuscript in Arundel Castle," *Viator* 13:335–66.

———. 1992. "The Illustrations of MS Douce 104." In Pearsall and Scott 1992, xxvii–xxxii.

———. 1995. "An Hours and Psalter by Two Ellesmere Illuminators." In Stevens and Woodward 1995, 87–119.

———. 1996. *Later Gothic Manuscripts: 1390-1490.* 2 vols. A Survey of Manuscripts Illuminated in the British Isles, vol. 6. London: Harvey Miller.

———, ed. 2000, 2001, and 2002. *An Index of Images in English Manuscripts from the Time of Chaucer to Henry VIII.* 3 vols. London: Harvey Miller.

———. 2002. *Dated and Datable English Borders c. 1395-1499.* London: British Library.

———. 2004. *English Manuscript Borders, c. 1395-1499.* London: British Library.

"Scribes and the City of London." City of London. Online at: http://www.cityoflondon.gov.uk.

Scudder Baugh, Nita. 1956. *Worcestershire Miscellany Compiled by John Northwood c.1400.* Philadelphia: Bryn Mawr College.

Seaton, Ethel. 1961. *Sir Richard Roos c. 1410-1482: Lancastrian Poet.* London: Rupert Hart-Davis.

Serjeantson, Mary S. 1937. "The Index of the Vernon Manuscript." *Modern Language Review* 32:222–61.

———, ed. (1938) 1971. *Legendys of Hooly Wummen by Osbern Bokenham.* EETS 206. Rpt. New York: Kraus.

Seymour, M. C. 1974. "Manuscripts of Hoccleve's *Regiment of Princes.*" *Edinburgh Bibliographical Society Transactions* 4.7:253–97.

———, ed. 1981. *Selections from Hoccleve.* Oxford: Clarendon Press.

———. 1982. "Manuscript Portraits of Chaucer and Hoccleve." *Burlington Magazine* 124:618–23.

———. 1995. *Catalogue of Chaucer Manuscripts.* Vol. 1, *Works before the Canterbury Tales.* Aldershot: Scolar Press.

———. 1997. *Catalogue of Chaucer Manuscripts.* Vol. 2, *The Canterbury Tales.* Aldershot: Scolar Press.

Shaner, Mary E. 1992. "Instruction and Delight: Medieval Romances as Children's Literature." *Poetics Today* 13:5–15.

———. 2003. "Sir Gowther (Advocates MS 19.3.1)." In *Medieval Literature for Children,* ed. Daniel T. Kline, 299–321. New York: Routledge.

Sharpe, Richard. 1997. *A Handlist of the Latin Writers of Great Britain and Ireland before 1540.* Publications of the Journal of Medieval Latin 1. Paris: Brepols.

Shonk, Timothy Allen. 1981. "Study of the Auchinleck Manuscript: Investigations into the Processes of Bookmaking in the Fourteenth Century." PhD diss., University of Tennessee, Knoxville.

———. 1985. "Study of the Auchinleck Manuscript: Bookmen and Bookmaking in the Early Fourteenth Century." *Speculum* 60:71–91.

———. 1998. "BL MS Harley 7333: The 'Publication' of Chaucer in the Rural Areas." *Essays in Medieval Studies* 15:81–90.

Siemens, Ray, ed., et al. 2009. "Drawing Networks in the Devonshire Manuscript (BL Add 17492): Toward Visualizing a Writing Community's Shared Apprenticeship, Social Valuation, and Self-Validation." *Digital Studies* 1.1. Online at http://www.digitalstudies.org/ojs/index.php/digital_studies/article/viewArticle/146/201.

Sisam, Celia, and Kenneth Sisam, eds. 1970. *The Oxford Book of Medieval English Verse.* Oxford: Clarendon Press.

Skeat, Walter W., ed. 1886. *The Vision of William Concerning Piers the Plowman in Three Parallel Texts.* Oxford: Clarendon Press.

Slade, Benjamin. 2002-3. "Bede's Story of Cædmon: Text and Facing Translation." From Bede's *Ecclesiastical History.* Online at: http://www.heorot.dk/bede-caedmon.html.

Smith, D. Vance. 2003. *Arts of Possession: The Middle English Household Imaginary.* Minneapolis: University of Minnesota Press.

Smith, Jeremy J. 1983. "Linguistic Features of Some Fifteenth-Century Middle English Manuscripts." In *Manuscripts and Readers in Fifteenth-Century England: The Literary Implications of Manuscript Study,* ed. Derek Pearsall, 104–12. Cambridge: D. S. Brewer.

———. 1988. "The Trinity Gower D-Scribe and His Work on Two Early *Canterbury Tales* Manuscripts." In *The English of Chaucer and His Contemporaries,* ed. Jeremy J. Smith, 51–69. Aberdeen: Aberdeen University Press.

———. 1996. *An Historical Study of English: Function, Form, and Change.* London: Routledge.

Smith, Sarah Stanbury. 1983. "'Game in myn hood': The Traditions of a Comic Proverb." *Studies in Iconography* 9:1–12.

Southern, Richard. 1975. *Medieval Theatre in the Round: A Study of the Staging of the Castle of Perseverance and Related Matters.* 2nd ed. London: Faber and Faber.

Spearing, A. C. 1970. *The Gawain-Poet: A Critical Study.* Cambridge: Cambridge University Press.

———. 1985. *Medieval to Renaissance in English Poetry.* Cambridge: Cambridge University Press.

Spector, Stephen, ed. 1991. *N-Town Play Cotton MS Vespasian D.8: I Introduction and Text.* EETS 11. Oxford: Oxford University Press.

Spielmann, M. H. 1900. *The Portraits of Geoffrey Chaucer.* London: Published for the Chaucer Society by Kegan Paul, Trench, and Trübner.

Spisak, James W., ed. 1983. *Caxton's Malory: A New Edition of Sir Thomas Malory's Le Morte Darthur Based on the Pierpont Morgan Copy of William Caxton's Edition of 1485.* Berkeley: University of California Press.

St. Alban's Psalter. "Beatus Page," p.72. Online at: http://www.abdn.ac.uk/stalbanspsalter/english/commentary/page072.shtml.

Staley, Lynn. 2005. *Languages of Power in the Age of Richard II.* University Park: Pennsylvania State University Press.

Stern, Karen. 1976. "London 'Thornton' Miscellany: A New Description of British Museum Additional Manuscript 31042." *Scriptorium* 30:26–37 (pt. 1) and 201–18 (pt. 2).

Stevens, Martin. 1981-82. "The Ellesmere Miniatures as Illustrations of Chaucer's *Canterbury Tales.*" *Studies in Iconography* 7-8:113–33.

———. 1995. "Introduction." In Stevens and Woodward 1995, 15–28.

Stevens, Martin, and Daniel Woodward, eds. 1995. *The Ellesmere Chaucer: Essays in Interpretation.* San Marino, CA: Huntington Library; Tokyo: Yushodo Co.

Stubbs, Estelle, ed. 2000. The Hengwrt Chaucer Digital Facsimile. Scholarly Digital Editions. Online at: http://www.sd-editions.com/hengwrt/home.html.

———. 2002. "A New Manuscript by the Hengwrt/Ellesmere Scribe? Aberystwyth, National Library of Wales, MS Peniarth 393D." *Journal of the Early Book Society* 5:161–68.

———. 2007. "'Here's One I Prepared Earlier': The Work of Scribe D on Oxford, Corpus Christi College, MS 198." *The Review of English Studies* n.s. 58:133–53.

Sugano, Douglas. 1994. "'This game wel pleyd in good a-ray': The N-Town Playbooks and East Anglian Games." *Comparative Drama* 28:221–34.

Taylor, Andrew. 1991. "Myth of the Minstrel Manuscript." *Speculum* 66:43–73.

Thaisen, Jacob. 2008. "The Trinity Gower D Scribe's Two *Canterbury Tales* Manuscripts Revisited." In *Design and Distribution of Late Medieval Manuscripts in England*, ed. Margaret Connolly and Linne Mooney, 41–61. York: York Medieval Press.

Theophilus. (1963) 1979. *On Divers Arts: The Foremost Medieval Treatise on Painting, Glassmaking, and Metalwork*. Trans. with intro. and notes by John G. Hawthorne and Cyril Stanley-Smith. New York: Dover.

Thompson, John J. 1983. "Compiler in Action: Robert Thornton and the 'Thornton Romances' in Lincoln Cathedral MS 91." In *Manuscripts and Readers in Fifteenth-Century England: The Literary Implications of Manuscript Study*, ed. Derek Pearsall, 113–24. Cambridge: D. S. Brewer.

———. 1987. *Robert Thornton and the London Thornton Manuscript*. Cambridge: D. S. Brewer.

———. 1991. "Collecting Middle English Romances and Some Related Book- Production Activities in the Later Middle Ages." In *Romance in Medieval England*, ed. Maldwyn Mills, Jennifer Fellows, and Carol Meale, 17–38. Cambridge: D. S. Brewer.

———. 2000. "'Frankis Rimes Here I Redd, / Communlik in Ilk[a] Sted . . .': The French Bible Stories in Harley 2253." In Fein 2000c, 271–87.

———. 2007. "Mapping Points West of West Midlands Manuscripts and Texts: Irishness(es) and Middle English Literary Culture." In Scase 2007, 113–27.

Thomson, R. M. 1972. "The Library of Bury St Edmunds Abbey in the Eleventh and Twelfth Century." *Speculum* 47:617–45.

Thorne, John. 2007. "Updating *Piers Plowman* Passus 3: An Editorial Agenda in Huntington Library MS HM 114." *Yearbook of Langland Studies* 20:67–92.

Thorp, Nigel. 1987. *The Glory of the Page: Medieval and Renaissance Illuminated Manuscripts from Glasgow University Library*. London: Harvey Miller.

Thorpe, James. 1978. *Chaucer's Canterbury Tales: The Ellesmere Manuscript*. San Marino, CA: Huntington Library Press.

Tolkien, J. R. R., and E. V. Gordon, eds. 1967. *Sir Gawain and the Green Knight*. 2nd ed., rev. Norman Davis. Oxford: Clarendon Press.

Trapp, J. B. 1959. "The Owl's Ivy and the Poet's Rays." *Journal of the Warburg and Courtauld Institutes* 21:227–55.

Trinity College, Cambridge, MS R.3.14. The Piers Plowman Electronic Archive. Online at: http://www3.isrl.illinois.edu/~unsworth/cyber-mla.2002/SNAG-0018.jpg.Tryon, Ruth Wilson. 1923. "Miracles of Our Lady in Middle English Verse." *Publications of the Modern Language Association* 38.2:308–88.

Tschann, Judith, and M. B. Parkes, eds. 1996. *Facsimile of Oxford, Bodleian Library, MS Digby 86*. EETS s.s. 16. Oxford: Oxford University Press.

Turville-Petre, Thorlac. 1989. *Alliterative Poetry of the Later Middle Ages: An Anthology*. Washington, DC: Catholic University of America Press.

———. 1996. *England the Nation: Language, Literature, and National Identity, 1290-1340*. Oxford: Clarendon Press.

Usk, Thomas. 1999. "The Testament of Love." In Wogan-Brown et al. 1999, 28–34.

Veeman, Kathryn M. 2010. "'Send þis booke ageyne hoome to Shirley': John Shirley and the Dissemination and Circulation of Manuscripts in Fifteenth-Century England." PhD diss., University of Notre Dame.

Viñas, Salvador Muñoz, and Eugene F. Farrell. 1999. *The Technical Analysis of Renaissance Illuminated Manuscripts from the Historical Library of the University of Valencia*. Cambridge, MA: Harvard University Art Museums; Valencia, Spain: Universidad Politécnica de Valencia.

Voaden, Rosalynn. 1996. *Prophets Abroad: The Reception of Continental Holy Women in Late Medieval England*. Cambridge: D. S. Brewer.

Wallace, David, ed. 1999. *Cambridge History of Medieval English Literature*. Cambridge: Cambridge University Press.

Walter, Katie. 2003. "The Meanings of Devotional Space: Female Owner-Portraits in Three French and Flemish Books of Hours." Online at: http://www.york.ac.uk/teaching/history/pjpg/devotional.pdf.

Warner, George. 1912. *Queen Mary's Psalter: Miniatures and Drawings by an English Artist of the 14th Century, Reproduced from Royal MS. 2 B. VII in the British Museum*. London: Trustees of the British Museum.

Warner, Lawrence. 2011. *The Lost History of Piers Plowman: The Earliest Transmission of Langland's Work*. Philadelphia: University of Pennsylvania Press.

Warwick, Countess of. 1903. *Warwick Castle and its Earls from Saxon Times to the Present Day*. Vol.1. New York: E. P. Dutton; London: Hutchinson.

Wasson, John M. 1997. "English Church as Theatrical Space." In *New History of Early English Drama*, ed. John D. Cox and David Scott Kaston, 25–37. New York: Columbia University Press.

Waterhouse, Osborn, and Normas Davis, eds. 1970. *Non-Cycle Plays and Fragments*. London: Oxford University Press.

Watson, Nicholas. 1989. "Richard Rolle as Elitist and Popularist: The Case of *Judica Me*." In *De Cella in Seculum: Religious and Secular Life and Devotion in Late Medieval England*, ed. Michael G. Sargent, 123–43. Cambridge: D. S. Brewer.

———. 1991. *Richard Rolle and the Invention of Authority*. Cambridge: Cambridge University Press.

———. 1999. "Middle English Mystics." In Wallace 1999, 539–65.

———. 2005. "The Making of *The Book of Margery Kempe*." In Olson and Kerby- Fulton 2005, 395–434.

Watson, Nicholas, and J. Jenkins, eds. 2006. *The Writings of Julian of Norwich*. University Park: Pennsylvania State University Press.

Webber, T., and A. G. Watson. 1998. *Libraries of the Augustinian Canons*. London: British Library.

Weston, David. 2000. *Carlisle Cathedral History*. Carlisle: Bookcase.

Wheatley, Edward. 1996. "Commentary Displacing Text: *The Nun's Priest's Tale* and the Scholastic Fable Tradition." *Studies in the Age of Chaucer* 18:119–41.

Whitbread, L. 1959. "Æthelweard and the Anglo-Saxon Chronicle." *English Historical Review* 74:577–89.

Wiggins, Alison. 2003. "Guy of Warwick in Warwick? Reconsidering the Dialect Evidence." *English Studies* 84:219–30.

Wilson, Edward, and Iain Fenlon, eds. 1981. *Winchester Anthology: A Facsimile of British Library Additional Manuscript 60577.* Cambridge: D. S. Brewer.

Williams Boyarin, Adrienne. 2009. "Sealed Flesh, Book-Skin: How to Read the Female Body in the Early Middle English *Seinte Margarete*." In Kerby-Fulton 2009, 87–106.

Wimsatt, James I., ed. 2009. *Chaucer and the Poems of "Ch."* Rev. ed. Kalamazoo: TEAMS.

Windeatt, Barry, ed. 2000. *The Book of Margery Kempe.* New York: Longman.

Wirtjes, Hanneke, ed. 1991. *The Middle English Physiologus.* EETS o.s. 299. Oxford: Oxford University Press.

Wogan-Browne, Jocelyn. 1996. "'Clerc u lai, Muïne u dame': Women and Anglo-Norman Hagiography in the Twelfth and Thirteenth Centuries." In Meale 1996, 61–85.

Wogan-Browne, Jocelyn, Nicholas Watson, Andrew Taylor, and Ruth Evans, eds. 1999. *The Idea of the Vernacular: An Anthology of Middle English Literary Theory, 1280–1520.* University Park: Pennsylvania State University Press.

Woodward, Daniel, and Martin Stevens, eds. 1995. *The Canterbury Tales: The New Ellesmere Chaucer Facsimile (of Huntington Library MS EL 26 C 9).* Tokyo: Yushodo Co.; San Marino, CA: Huntington Library Press.

Woolf, Rosemary. 1958. "Doctrinal Infuences on the 'Dream of the Rood'." *Medium Aevum* 27:137–53.

Wormald, Francis. 1937. "The Rood of Bromholm." *Journal of the Warburg Institute* 1.1:31–45.

Wright, Stephen K. 1983. "Durham Play of Mary and the Poor Knight: Sources and Analogues of a Lost English Miracle Play." *Comparative Drama* 17:254–65.

Wright, Sylvia. 1992. "The Author Portraits in the Bedford Psalter-Hours: Gower, Chaucer and Hoccleve." *British Library Journal* 18.2:190–201.

Wyclif, John. 1922. *Tractatus de Mandatis Divinis*, ed. J. Loserth and F. D. Matthew. London: Wyclif Society.

Wynn, Phillip. 1982. "The Conversion Story in Nicholas Trevet's 'Tale of Constance.'" *Viator* 13 (1982): 259–74.

Zettersten, Arne, Bernhard Diensberg, and H. L. Spencer, eds. 2000. *English Text of the Ancrene Riwle: The 'Vernon' Text.* Oxford: Oxford University Press.

Zieman, Katherine. 2008. *Singing the New Song: Literacy and Liturgy in Late Medieval England.* Philadelphia: University of Pennsylvania Press.

———. Forthcoming. "Escaping the Whirling Wicker: Ricardian Poetics and the Narrative Voice in *The Canterbury Tales*." In *Answerable Style: Form and History in Medieval English Literature*, ed. Frank Grady and Andrew Galloway. Columbus: Ohio State University Press.

Illustration Credits

Reproduced by permission of the Bibliothèque nationale de France
MS lat. 765, fol. 15r

Reproduced by permission of the Bodleian Library,
University of Oxford
MS Ashmole 61, fols. 16v, 17r
MS Bodley 619, fol. 1r
MS Bodley 686, fol. 1r
MS Bodley 902, fol. 8r
MS Digby 102, fols. 11v, 31v, 53v
MS Digby 133, fols. 157v, 158r
MS Douce 104, fols. 1r, 34r, 35r, 42r, 46r, 52v, 69r, 109v
MS Douce 262, fol. 118v
MS E Museo 160, fols. 140r, 140v, 141r, 151v
MS Eng. Poet. a. 1, fol. 105r, 125v, 126r, 126v, 265r, 394v
MS Junius 11, page 9
MS Laud. Misc. 416, fol. 226v
MS Rawlinson Poet. 223, fol. 183r

© *The British Library Board*
G.11586, sig. a1r (fol. 229r), sig. a3v (fol. 3v), sig. c4r (fol. 20r),
 sig. f5v (fol. 273v), sig. n8v (fol. 104v), sig. b5v (fol. 13v)
G.11587, sig. a2r
MS Add. 10053, fol. 83r
MS Add. 10574, fol. 60v
MS Add. 18632, fol. 99r
MS Add. 31042, fols. 8vb, 33r, 50r, 120r, 163va
MS Add. 31835, fol. 27r
MS Add. 37049, fols. 28v, 29r
MS Add. 37790, fols. 97r, 108v, 143v, 225r
MS Add. 59678, fol. 70v
MS Add. 61823, fol. 26r, 43v, 98v
MS Add. Ch. 41320
MS Arundel 292, fols. 3r, 71v, 72v, 7r
MS Arundel 38, fol. 65r
MS Cotton Cleopatra C VI, fol. 194r
MS Cotton Julius D VIII, fol. 40r
MS Cotton Nero A X, Art. 3, fol. 41r, 41v, 42r, 42v, 86r, 86v, 87r,
 91r, 94v, 95r, 124v, 129v, 130r
MS Cotton Nero D I, fol. 183v
MS Cotton Tiberius C VI, fol. 14r
MS Cotton Vespasian D VIII, fols. 73v, 74r
MS Egerton 2006, fol. 1r
MS Harley 2253, fols. 61v, 70v, 71r, 76r, 128r
MS Harley 2278, fol. 6r
MS Harley 2373, fol. 70v

MS Harley 4866, fol. 88r
MS Harley 7333, fols. 37r, 45v, 46r, 189r
MS Harley 913, fol. 3r
MS Lansdowne 851, fol. 2r
MS Royal 2 B VII, fol. 168v
MS Royal 6 E VI, vol. 1, fols. 1r, 1v
MS Royal 6 E VII, Part 2, vol. 2, fol. 531r
MS Yates Thompson 11, fol. 29r
MS Yates Thompson 13, fols. 10r, 12r, 30r

Reproduced by kind permission of the Syndics
of Cambridge University Library
MS Ee.3.59, fol. 21r
MS Ff.1.6, fols. 45r, 47v, 56r, 59v, 69v, 70r, 96r, 99v, 100r, 109vb,
 138v, 139r
MS Ff.6.33, fol. 40v
MS Gg.4.27, fols. 222r, 395r, 433r

Reproduced with the generous permission of Chetham's Library,
Manchester
MS 6709, fol. 173r

Reproduced with the generous permission of the Master and
Fellows of Corpus Christi College, Cambridge
MS 61, fol. 1v

Reproduced by permission of the President and Fellows
of Corpus Christi College, Oxford
MS 197, fol. 59v
MS 198, fols. 62r, 102r
MS 201, fols. 1r, 11r, 68r, 76v, 93r

Reproduced with the generous permission of the
Chapter of Durham Cathedral
MS 1.2 Arch. Dunelm. 60

Reproduced by permission of Durham University Library
MS Cosin V.III.9, fol. 95r

© *English Heritage, NMR*
Carlisle Cathedral Stall

Reproduced with the generous permission of the
Folger Shakespeare Library, Washington, DC
MS V.a.354, fols. 98v, 114v, 121r, 121v, 128v, 134v

Index of Manuscripts and Incunabula

Page numbers in *italics* refer to figures and are followed by their respective figure number in parentheses when available. Sigla in **bold** have been included for manuscripts referred to by sigla.

General Index

Page numbers in *italics* refer to figures and are followed by their respective figure number in parentheses.